Masterworks of the Gemäldegalerie, Berlin

Masterworks of the Gemäldegalerie, Berlin

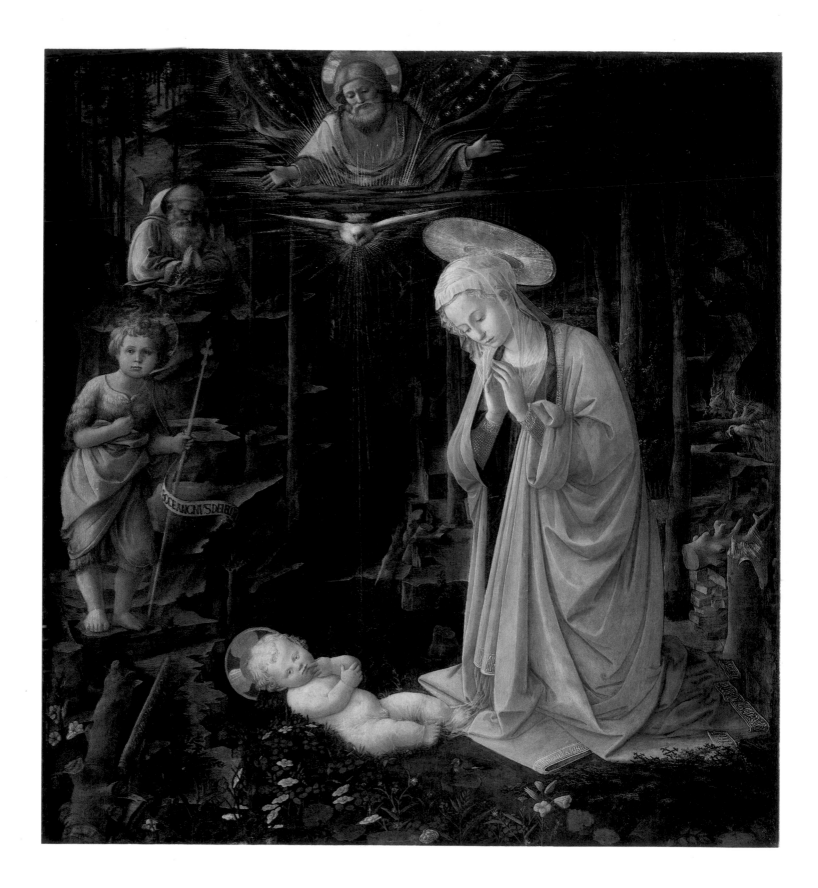

Masterworks of

THE GEMÄLDEGALERIE, BERLIN

With a History of the Collection

Harry N. Abrams, Inc., Publishers, New York

The publication of this book has been made possible by the
generosity of the Kaiser Friedrich Museum Association as patrons
of the Gemäldegalerie and the Sculpture Gallery.

Compiled by Henning Bock, Rainald Grosshans, Jan Kelch, Wilhelm H. Köhler and
Erich Schleier

Frontispiece: Fra Filippo Lippi, *The Adoration in the Forest* (p. 293)

Photos: Jorg P. Anders, Berlin; Gerald Schultz, Berlin; Bildarchiv Preussischer
Kulturbesitz, Berlin; Museum Archives

Translated from the German by John Gabriel

Library of Congress Cataloging-in-Publication Data

Masterworks of the Gemäldegalerie: with a history of the collection.

Bibliography: p.
Includes index.
1. Painting—Berlin (Germany)—Catalogs.
2. Gemäldegalerie (Berlin, Germany: West)—Guide-books.
I. Gemäldegalerie (Berlin, Germany: West)
N2230.A62 1986 759.94′074′031554 86–7937
ISBN 0–8109–1338–7

Times Mirror Books

Printed and bound in Italy

CONTENTS

PREFACE

When you come upon it in the residential and university suburb of Dahlem, the Berlin Gemäldegalerie might well seem very grand – a Neo-Classical edifice with three wings, built in 1912 along the lines of the Baroque county seats that once dotted the plains of Brandenburg, a lone reminder of Prussian history among the modern functional buildings of the Free University. Seven museums are housed in this building complex and its new additions: the Museums of Ethnology, Far Eastern, Indian and Islamic Art; the Department of Prints and Drawings; and the Galleries of Sculpture and Painting (the Gemäldegalerie). Collections of immense contrasts – Polynesian outriggers, splendid works by Riemenschneider and Rembrandt, statues of Buddha and Chinese scroll painting – vie for the visitor's attention. Yet it is just this variety that best characterizes the Berlin Museums' purpose. Ever since their founding in 1830 they have been devoted to collecting, studying and exhibiting the art and artefacts of all the world's cultures.

The Gemäldegalerie has its exhibition rooms in the 'old building', with about 650 paintings that illustrate the development of European art from the thirteenth to the eighteenth centuries. The collection, as you will see, is not large, and in sheer number certainly cannot match the great museums of Munich, London, or Paris. Yet a fine selection of masterpieces from van Eyck to Rembrandt, from Giotto to Tiepolo, from altarpieces of the Hohenstauffen period to paintings by Watteau and Gainsborough, puts our museum among the few in the world whose treasures are familiar to everyone seriously interested in art.

The tradition-conscious atmosphere of the gallery's rooms, however, is misleading. It tends to make one forget the long and often ugly history this collection has had to weather. One of the best public museums of painting even before the First World War, it was threatened by total destruction in 1945; and it would seem almost a miracle that despite irreparable losses – of over four hundred superb paintings – so much was saved from the ruins.

The inauguration of the Gemäldegalerie in 1830 was one result of the idealistic, cosmopolitan thinking of the generation around Wilhelm von Humboldt. After the Second World War the gallery was incorporated in the Prussian Cultural Heritage Foundation (Stiftung Preussischer Kulturbesitz) with its headquarters in the Western Sector of Berlin. This was also a far-sighted political decision, for in 1947 the State of Prussia, to which the museums owe their existence, was abolished. Its art treasures survive as a testimony to the great spiritual achievements of a troubled nation.

The present volume contains a selection of major works from the gallery which gives an impression of the scope and quality of the collection and its high-points. Let me say two things about the arrangement of this book. First, you may find that some of the commentaries, particularly those on Italian art, have a flavour of the history of ideas. What we wished to show, by example, is that research in art history must often negotiate a rocky road in order to explain the significance of a work in terms of its historical milieu. Much of our knowledge is still in the hypothesis stage and a great deal of further study is required. Secondly, we decided not to combine our small groups of French and Spanish paintings into national sections. Instead, we have classified them according to era and school. Thus you will find Fouquet and Marmion among the Old Netherlands artists; Poussin and Claude Lorrain, and also Velasquez and Murillo, in the Italian Baroque section; and Watteau and Chardin among German and English painters of the eighteenth century. Rigorous historians might object, but this arrangement corresponds to the system by which the collection was traditionally organized, as well as reflecting the emphases and departments of today's museum. This volume of reproductions and notes, in other words, mirrors the collection's history. To supplement it, we are planning a complete catalogue of

the museum's holdings, the first of its kind since the 1931 edition of our *Descriptive Catalogue*. That catalogue will contain an index of artists together with an illustrated section arranged by nation and school.

In retrospect, the post-war history of the Gemäldegalerie sometimes seems to have been a long series of East-West quarrels over its priceless contents. Yet we should not forget the tenacious and selfless efforts made by its members and employees, in public and behind the scenes, without which the gallery would never have been able to continue its work for the public good, nor have become the fine member-institution of the Prussian Foundation Museums it is today. It is to them, therefore, that I gratefully dedicate this book. My cordial thanks are also due to the Supporters' Association for the Galleries of Painting and Sculpture, the Kaiser-Friedrich-Museums-Verein, whose generosity has made the publication of this volume possible.

Berlin, May 1985

Henning Bock
Director, Gemäldegalerie
Staatliche Museen
Preussischer Kulturbesitz

Bruno Paul (architect)
The former Asiatic Museum, 1912
Today the Gemäldegalerie, Dahlem

THE HISTORY OF THE COLLECTION
BY HENNING BOCK

S. Blesendorff after A. Clerck
Frederick William, the Great Elector
Etching

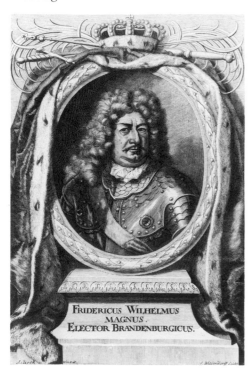

Our collection originally began with the seventeenth-century princes of Brandenburg and kings of Prussia. Of course they had begun decorating their residences with art before that time, in the sixteenth century; but apart from a few works by Lucas Cranach, purchased during a trip to Berlin in 1529 and over the following years by Prince Joachim III for his palace and the Protestant Cathedral, little of significance is recorded. Art collecting in the serious sense, indeed a considered taste in art, developed only later.

The Thirty Years' War of 1618–48 laid waste any modest prosperity which Brandenburg's rulers may have achieved – and it was certainly modest by comparison with the pomp and glory of the great towns and residences of south and central Germany. Not until 1640, when Frederick William, the Great Elector (1640–88), took the throne, did Brandenburg's rise to European rank begin. His relations with the House of Orange in Holland, the years he spent at the court of Governor Frederik Hendrik, and his studies at the University of Leyden (1634–6), had been an education in taste for the gifted statesman. On his maternal grandmother's side Frederick William was a great grandson of William I of Orange, and his marriage to Luise Henrietta in 1646 consolidated this tie. In Holland he experienced a country that had been largely spared the devastation of war and which enjoyed unparalleled economic and cultural prosperity.

In addition to his familiarity with Dutch painting, Frederick William also had a great interest in Italian art. His humanist education had been broad enough to take him beyond the Dutch masters, whose intimate world was basically like his own, on to the idealistic world of antiquity. He expanded the Kunstkammer at Berlin Palace, acquiring coins, cameos, bronzes and vases, and Greek and Roman sculpture. Later, Frederick William also organized excavations within his own territories to unearth ancient relics, and began collecting Far Eastern porcelain and rarities from Africa.

On the death of the Dutch Governor's wife, Amalie von Solms, Frederick William's kinship with the House of Orange brought a bequest of forty-two (or forty-three) paintings to Berlin, among them works by Rubens, van Dyck, Roelant Savery, and Jan Brueghel the Elder. These were exhibited at Berlin Palace, in a small room known as the *Schildereiengalerie*. The only painting in the present collection which can be traced back to this bequest is Titian's *Portrait of a Young Man*. When William III, King of England and grandson of Amalie von Solms, died in 1702, another portion of the Heritage of Orange, as it was known, fell to Brandenburg-Prussia. Besides a number of minor Dutch masterpieces, two fine early works by Rembrandt have come down to us from this bequest, the *Rape of Proserpina* and the canvas known as *Minerva*.

After the political, military and economic rise of Prussia to become a kingdom under Frederick I (1688–1713) and his puritanical, even bigoted successor, Frederick William I (1713–40), there began an epoch that more than any other shaped Prussia's image for better or worse. Frederick II, the Great, was a lifelong and uncritical admirer of everything French, even when political alliances among the great powers of Europe, which now included Prussia, made France an enemy. He spoke, wrote and thought in French, and had no high opinion of his native language and literature. His active interest in contemporary French painting, however, lasted only twenty years or so, up to the Seven Years' War (1756–63), the period in which he commissioned most of the elaborate new buildings or additions to his personal apartments at Potsdam, Charlottenburg and Berlin Palace – and at Rheinsberg, which had been rebuilt while he was still Crown Prince.

Frederick's acquisitions began in 1734, when his father, Frederick William I, gave him the small castle at Rheinsberg and a stipend which allowed him to live as befitted his rank. At last the young, musically gifted Crown Prince could escape his father's tyranny and associate with friends of his own choosing. His life at Rheinsberg to 1740 was a continuous

round of conversation and debate on French and classical literature, philosophy and science, concerts, theatre and masquerades. At the regular dinner parties of about fifteen select guests, the prince was surrounded by such gifted contemporaries as the architect and painter Georg Wenzeslaus von Knobelsdorff, Antoine Pesne, artist and director of the Berlin Academy, the renowned Kapellmeister and composer Johann Gottlieb Graun, the flautist Johann Joachim Quantz, and, at the harpsichord, Carl Philipp Emanuel Bach.

Suitable surroundings for Frederick's short-lived idyll were created by von Knobelsdorff, who rebuilt the castle on Grienerick Lake and landscaped its park. The dreams of his Spartan youth seemed to have come true in its carefully composed vistas and seem to be reflected in the paintings by Watteau, Lancret and Pater which he now began to collect enthusiastically. The carefree Regency and Rococo art lifted Frederick and his 'Court of the Muses' far above the pomp and parades of the capital. With the rebuilding of Rheinsberg, with his new paintings, the wit and intelligence of his companions, the joy of music, and his own poetry inspired by Roman idylls, Frederick created an Arcadia in the midst of the Brandenburg sands. Painting was only one facet of this ideal world; yet a year before reality asserted itself, he could report proudly to his sister, Wilhelmine, Margravine of Bayreuth, that he had already filled two rooms with pictures, most of them by Watteau and Lancret.

On 31 May 1740, Frederick was crowned, and all the power and wealth of the Prussian State stood at his disposal. He moved from his beloved Rheinsberg to the royal residences at Berlin, Charlottenburg, and, most importantly, Potsdam. At all these places, impatient and peremptory, Frederick had new apartments built or the old ones refurnished in *Le style moderne*. The exquisite décor required pictures to match, and these he ordered, often with precise requirements, from Paris. Helping to arrange purchases were Count Rothenburg, Prussian attaché in Paris; Marquis d'Argens; Francesco Algarotti, a Venetian who also served as middleman to the Dresden Court; and Antoine Pesne, official painter to the Prussian Court. Gradually the collection grew to several hundred works. Watteau, master of *fêtes galantes*, was represented by nineteen paintings, among them his *Signboard for the Art Dealer Gersaint* (acquired in 1745) and *Embarkation for Cythera* (documented at Potsdam since 1765).

But Frederick could not be long without a refuge from his official duties, so he designed a small Palace for the park at Sanssouci which was built under von Knobelsdorff's supervision in 1745–7. Except for paintings and a few sculptures from the recently acquired Polignac collection, installed at the existing Small Gallery on the north side of the park. Frederick's paintings were again exhibited as part of the elaborate decoration.

Art historians characterize this epoch in Prussia as 'Frederician Rococo', but this really touches on only one aspect of Frederick's collecting activity. The *fêtes galantes* period was certainly a happy time in the King's life, full of projects and ideas which a circle of superb artists transformed into reality; but the period was short. In the early 1750s Frederick's requirements changed, and with them his view of art. More than a mere change of taste, his turn to the great and lasting art of van Dyck, Rubens, Rembrandt, Poussin and Correggio grew out of the monarch's realization that the duties of his high office must be taken seriously and that among the demands they placed on him was the need for outward show. Though he still sometimes made an exception, he struck Watteau, Lancret and Pater from his purchasing list and replaced them with the classical masters.

For this new collection Frederick took nothing from the old one at Berlin Palace, but built it up exclusively from new acquisitions. Whether he was led more by personal preference or by reasons of state, with an eye to the great collections at Dresden, Kassel or Salzdahlum in Brunswick, we can only conjecture. At any rate, Frederick commissioned his Chief Architect, Johann Gottfried Büring, to add a gallery to the east side of Sanssouci Palace. Begun in spring 1755, work was soon interrupted by the outbreak of the Seven Years' War, and not until 1764 was the gallery completed. It was a long, single-storey building with a central bay and tower, its façade design based on that of the Orangery. A square of massive central columns was the sole interior division, and at the east end a chamber was set aside for the smaller paintings. An exquisite, if rather austere, colour scheme of gold, white and green provided a noble setting for the great classical works on which Frederick had now set his eye – all of them, characteristically, large compositions

Georg Friedrich Schmidt
after Antoine Pesne
Frederick the Great, 1764
Engraving

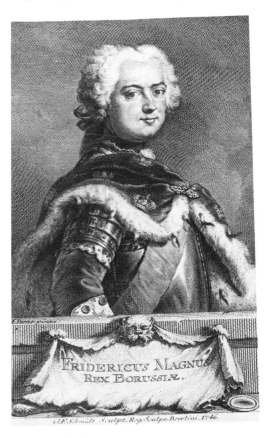

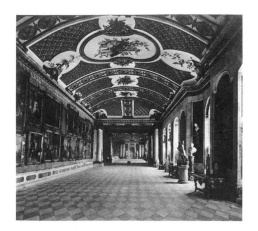

Sanssouci
The Picture Gallery, 1755–64
Interior

with figures; no still lifes, landscapes, or genre subjects found their way into the great hall.

This independent gallery-building, the first at any of the royal residences in Germany, was widely acclaimed by Frederick's contemporaries. Even the exacting Gottfried Schadow recalled in his memoirs of 1849 that the Potsdam Painting Gallery was 'the most glorious hall of pictures in Europe'.

The hanging of the pictures still followed the late Baroque style of covering the walls with hardly a gap between the frames. Nevertheless, an attempt – the first of its kind – was made to arrange the works historically, with Dutch art in the east wing and Italian in the west wing. Compared with the collection of August III in Dresden, however, the Potsdam gallery remained a modest endeavour, particularly as Frederick refused to pay what were even then horrendous prices for masterpieces of the first order, which would have completely overtaxed Prussia's budget. He also invariably trusted his own judgement above anyone else's, with the result that errors and mistaken attributions to great and renowned artists could hardly be avoided. There remained, none the less, an impressive body of major works which left the collection's rank undiminished. The catalogue prepared by Matthias Oesterreich, Gallery Inspector, listed in its second edition of 1770 a total of 168 paintings, sixty-five of them Italian, ninety-six of the Flemish and Dutch schools, and seven of the French school.

*

The more conservative Frederick grew during his final years at Sanssouci, the more fiercely his policies were resisted, particularly among the progressive artists of Berlin. The first condition of any meaningful change, they knew, would have to be a fundamental reform of the Academy of Fine Arts and Mechanical Sciences, which during the eighteenth century had sunk to insignificance. No revival of contemporary art was possible without a reform of the Academy, insisted Berlin's artists, with Daniel Chodowiecki foremost among them. And Frederick, perhaps surprisingly, listened to them and found their proposals convincing. Shortly before his death in 1786, he nominated a new curator, the capable and circumspect Minister of State von Heinitz, who immediately took the necessary steps.

Von Heinitz's most important decision was to establish annual exhibitions at the Academy along French, English (and also Dresden) lines, where recent work of German and foreign artists could be seen. These made contemporary art accessible to a bourgeois public for the first time (and later, under Frederick William III and IV, provided a source of paintings and sculptures for the royal residences). At the same time, there was a plan to open the royal collections to the public. The Minister of State managed to obtain permission for a limited number of artists to study and copy the paintings in the collection, arguing that like the treasures in the royal libraries, these classical masterworks should gradually be made accessible to all in the name of public education.

Frederick the Great's successor, Frederick William II (ruled 1786–97), devoted much energy to furthering this aim. He had the royal collections placed under the jurisdiction of the Academy, and in 1787 named an artist, Johann Gottlieb Puhlmann (1751–1826) as Inspector of Galleries in Berlin and Potsdam – this despite Frederick the Great's declaration that, since no further purchases need be made, the collection would not require an inspector after Matthias Oesterreich died. Frederick William II also established prizes for the best works in each genre at the annual Academy shows. And though these and other measures represented only a small part of a wider programme of administrative and judicial reform, they spurred and decisively shaped later developments.

As far as museum planning was concerned, the nomination of Alois Hirt, an archaeologist, to the chair of Art Theory at the Academy proved to have far-reaching consequences. Hirt (1759–1837) had lived in Italy from 1782, and was familiar with progressive tendencies in European thought which attributed a key role to fine art in the public sphere. In an address to the Academy on the occasion of Frederick William II's birthday in 1797, Hirt explained his plans for a great public museum. The best works in sculpture, painting and craftsmanship from all the royal Prussian collections, he said, should be brought to Berlin, where they would serve as a school of good taste for the entire nation. Not only were the works selected to be of high artistic quality, but they were to be

Sanssouci
The Picture Gallery, 1755–64
Exterior

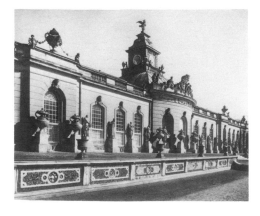

exhibited in a way that illustrated the historical development of the arts, school by school and epoch by epoch. The unique character of each period, each country, and every artist, must be made manifest, Hirt explained. His idealistic aim, in short, was to enlist the fine arts in a programme that combined an appreciation of beauty with a general, historical education.

This dual task of a public museum – to show fine and beautiful works of art which had been collected and arranged according to scholarly, historical criteria – remained the keynote of every discussion about the Berlin museums from that point on and has shaped their character and purpose down to the present day.

The King was impressed by Hirt's suggestions. To him, art was not a mere decorative adjunct to the royal palaces and apartments, not a treasure to be hoarded but to be shared with people generally. Though he realized that the troubled times were not conducive to the building of a new museum, the King requested Hirt to outline a provisional scheme. Working rapidly, Hirt had finished his project by September 1798; but it was too late for Frederick William II's approval. The plans presented to his successor, Frederick William III, foresaw a massive square edifice at the most prominent site in central Berlin, the Forum Fridericianum, next to the Arsenal and across from Knobelsdorff's Opera House. The ground floor was to house the department of antiquities, and the upper floor the collection of paintings. The rooms were to be fitted with tall windows whose lower sections could be closed by means of wooden shutters, which, as Hirt assured, would 'create lighting conditions of the kind artists have in their studios'. And as to the purpose of the new museum, its designer again stressed that 'a gallery ought to be an education in good taste, which means that the first principle of any gallery should be logical order in the arrangement of its works of art'.

The museum idea was beginning to find support in other quarters as well. The Chairman of the Royal Kunstkammer, Jean Henry, had developed his own conception of a general, public museum of art by 1804, a scheme which continued the universal approach of the old *Kunstkammer* collection – natural sciences, fine art, and cultural history under one roof.

The vicissitudes of politics, however, put an end to both of these ambitious projects. All the effort invested in them came to nothing when Prussia was totally defeated on the battlefield in 1806. Worse still, as Napoleon's armies were decimating the Prussians at Jena and Auerstädt on 14 October, preparations were under way to bring the art treasures from Berlin and Potsdam to safety in Küstrin. The crates, some containing valuable paintings from Potsdam, fell into French hands and were immediately transported to Paris. A short time later, a French Trophies of War Commission under Vivant Denon, whom his own officers mockingly called '*voleur à la suite de la Grande Armée*', requisitioned some of the finest things in the royal palaces for the new Musée Napoléon in Paris. A highly knowledgeable connoisseur, Denon chose 123 paintings, most of them Old German and Old Netherlandish, including sixteen by Cranach (his *Fountain of Youth* among them) and a number by Baldung Grien and Altdorfer. He also chose Correggio's famous *Leda*, Rembrandt's *Samson Threatening His Father-in-Law* and *Samson and Delilah*.

In spite of these serious losses, the notion of establishing a public museum in Berlin continued to be discussed, if with a shift of emphasis. Prussia's defeat had set off a wave of reform proposals which aimed at nothing less than reshaping the state and its administration from top to bottom and infusing new life into moribund institutions. Wilhelm von Humboldt projected far-reaching educational reforms in which both the museum and the newly founded university (1809) had their place, for, in his eyes, the humanities and natural sciences had an equal contribution to make to the education of liberal-thinking, well-rounded individuals.

Yet though the university was able to open its doors by 1810, plans for the museum made little headway. The first task at hand was to take stock of the remaining royal collections. Christian von Mecheln (1737–1817), a Swiss publisher and etcher, and librarian to Queen ⟨...⟩ undertook a complete inventory which revealed that despite losses, the collections ⟨...⟩ained a total of 80 statues, 133 busts, 29 vases and 2,244 paintings. The King ⟨...⟩ a selection of these works be put on temporary exhibition in the university ⟨...⟩ting Minister of State von Dohna and Privy Counsellor Wilhelm von ⟨...⟩ task of choosing suitable items.

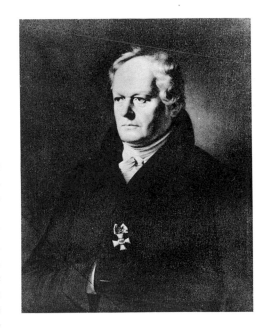

Anonymous artist
Alois Hirt

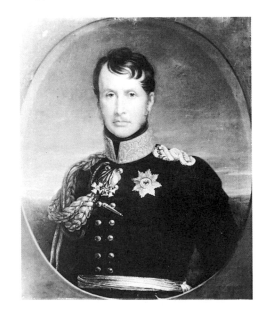

François Gérard
Frederick William III
Copy

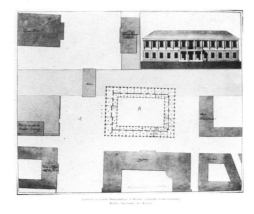

Alois Hirt
Plans for the museum building in Berlin,
1798
Pen and wash

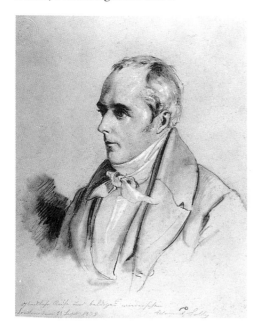

Wilhelm Hensel
Edward Solly
Drawing
Berlin, Nationalgalerie SMPK

Again political events intervened, but this time for the better. Following Prussia's victory in 1814, Frederick William III went to Paris and saw the erstwhile Musée Napoléon. He was deeply impressed, not only by its opulence, but also by the systematic arrangement of its collections. In 1815, the Napoleonic Era definitely over, the King ordered the stable buildings of the Academy on Unter den Linden to be rebuilt to house a museum. Its inaugural exhibition was to consist of the art treasures brought back from Paris.

*

The idea of creating a public museum, however, had another consequence: the systematic purchase of individual works and entire collections with the ambitious aim of comprehensively illustrating the history of art. The first spectacular acquisition was made before the year 1815 ended. While in Paris in 1814, the King had seen a collection amassed by the brothers Vincenzo and Benedetto Giustiniani, principally during the early seventeenth century, which had been on view in Paris since 1812. Prominent among its 158 paintings were masterpieces of the early Roman Baroque, including Caravaggio's *Doubting Thomas*, *Amor Victorious*, *Christ on the Mount of Olives*, and *St Matthew, Evangelist*. The Giustiniani collection also contained fine examples of the work of Baglione, Baburen, Terbrugghen, Honthorst and Vouet, Claude Lorrain and Guido Reni. Now, these artists certainly did not conform to the Neo-Classical taste then prevalent in Prussia, which epitomized Raphael and the late Italian Renaissance; nevertheless, the Prussian government decided to buy the Giustiniani Collection for a price of 500,000 francs. Not surprisingly, when it went on exhibition in 1826, no one praised it very highly, and we have little means of knowing today how significant the collection actually was: too many of its major works were destroyed by fire in 1945 at the Friedrichshain shelter where they were stored during the war. Of the five Caravaggios only *Amor Victorious* and (at Sanssouci) *Doubting Thomas* survived the catastrophe.

Another attempt to purchase a whole collection for the projected museum went awry. In 1815, von Altenstein, Prussian Minister of Culture, saw the famous collection of early German and Dutch paintings which the brothers Sulpiz and Melchior Boisserée had brought together at Heidelberg. Very much taken by it, he asked Karl Friedrich Schinkel if he could make some arrangement with the Boisserées to sell their collection to Prussia. Thanks to his negotiating skill, Schinkel drafted a contract acceptable to all before the year was out, which involved a payment of 200,000 guilders, a life pension for the collectors, and the transfer of their treasures to Berlin. Yet though the Boisserées had refused tempting offers from other countries and reached a basic agreement with the Prussian government, the contract was never signed. The Minister of Finance withheld his approval, arguing that the quality of the collection did not justify the expense. The Old German school, he maintained, was no model for the art of the present or the future and therefore did not deserve inclusion in the new museum. This triumph of the fiscal arm spoiled a unique opportunity. Ten years later King Ludwig of Bavaria bought the Boisserée Collection, which has been a mainstay of the Old Pinakothek in Munich ever since.

While medieval German art found slow acceptance in Prussia, a hesitation due partly to the enthusiasm shown for it by the Romantic school, Italian art became a key facet of the new collection with the purchase of the Solly Collection in 1821. Edward Solly (1776–1848), an English merchant, was the younger partner in the London firm of Isaac Solly & Sons. Specializing in the Baltic Sea trade during the Napoleonic Period, the Sollys had prospered immensely. Edward lived in Berlin, where he brought together a collection of over 3,000 paintings with the help of agents scattered all over Europe. His main interest was Italian art, the development of which he hoped to illustrate from its beginnings to its apogee in Raphael and the High Renaissance. After Napoleon's demise and the lifting of the blockade, however, business slackened and Solly's firm came into difficulties. Thou[gh] he had received 200,000 thalers from the Prussian government in settlement of old cl[aims] he was forced in 1819 to put up his collection as security on a further 200,000-th[aler loan.] His situation did not improve, however, and Solly finally made over his e[ntire collection to] Prussia on 21 November 1821, against compensation to the sum of 500,00[0 thalers.]

Thus it was that the Prussian state collections, their new museum s[...]

enriched at one fell swoop by works of truly inestimable value. The old, rather haphazard royal collection, increased first by purchases in Paris and then by the Giustiniani Collection, had now been placed on a broad and solid foundation. When in 1823 the unfortunate Solly was compelled to relinquish his house on Wilhelmsstrasse, 677 pictures were selected for the museum, another 538 went to decorate the royal palaces, and the remainder were put in storage. The Trecento was represented by Giotto, Taddeo Gaddi, Bernardo Daddi, Lorenzetti, Lippo Memmi, Allegretto Nuzi, and others. Of the much more comprehensive Quattrocento group, Filippo Lippi's *Madonna in the Wood*, Botticelli's *St Sebastian*, Mantegna's *Presentation in the Temple*, and Carpaccio's *St Stephen* deserve special mention, as do, from the early sixteenth century, an early Raphael Madonna, Titian's *Self-portrait*, Lotto's *Christ Taking Leave of Mary*, and Savoldo's *Lady of Venice*. The Solly Collection also contained such superb examples of early Netherlandish and German painting as two wings of the Ghent Altar by the van Eyck brothers (demanded as war reparation by the Belgian government in 1918, though Solly had purchased them from the dealer Nieuwenhuys), Holbein's *The Merchant Gisze*, and the delightful little *Portrait of a Lady* by Petrus Christus.

*

The problem of housing these new collections, however, still had to be solved. To save money, the government initially intended to convert the former royal stables at the Academy, Unter den Linden, and Hirt and Schinkel drew up a plan for this in 1815 (it was Schinkel's first involvement in the museum). The considerable sum of 200,000 thalers was finally granted for conversion work in 1822; but a few months later a quite different project made all previous planning obsolete.

On 8 January 1823, Karl Friedrich Schinkel, architect, High Privy Counsellor for Building, and Professor of Architecture at the Academy, showed his plans for an autonomous new museum to the King. Schinkel's project revealed not only architectural skill but a brilliant mind for city planning. Siting the new museum at the Lustgarten north of the palace, he envisaged a spacious square flanked by Arsenal, Schlüter's Baroque palace façade, and a cathedral, which would provide a noble introduction to Berlin's most magnificent thoroughfare, Unter den Linden. The museum's façade, an imposing colonnade fronting the square, conformed to the scale of the surrounding structures yet set a contrasting aspect which emphasized the high moral aspirations of this first public museum in Prussia.

The superb solution to the protracted debates seems to have convinced the administration immediately, particularly Frederick William III, who approved the project on 30 April. Due to unfavourable site conditions, the cornerstone could not be laid until 9 July 1825, but by 10 November 1826, rough construction was finished and the traditional *Richtfest* could be celebrated. The new building was inaugurated on 3 August 1830, the King's sixtieth birthday, after what was even by today's standards an astonishingly short construction time of five years.

In 1828, Schinkel and Gustav Waagen, later Director of the Gemäldegalerie, wrote a paper in which they stated their aims so succinctly that it deserves to be quoted. After pointing out that the Berlin collections were still the only ones in Europe to be compiled and shown according to systematic, scholarly criteria, the two authors concluded that the museum's 'first and true purpose consists in awakening in the public mind a sense of visual art as one of the most important branches of human culture, and when this has been awakened, to nourish and develop it to an ever finer sense. All the various interests of individual classes in society must be subordinated to this general purpose. By far the most pressing need is to give artists ample opportunity for study. Only then can the interests of art scholars be taken into consideration. Thirdly and finally, knowledge of art history should be generally encouraged and the dissemination of this knowledge be made as wide as possible ... However, this is not to say that aesthetic interests may not be combined to a certain extent with historical interests, if only this first and fundamental principle is kept in mind: enjoyment first, then edification.'

What was it about Schinkel's museum plan that immediately convinced his con-

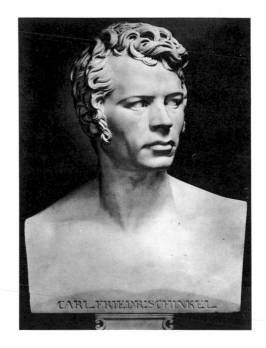

Friedrich Tieck
Karl Friedrich Schinkel, 1819
Marble
Berlin, Nationalgalerie SMPK

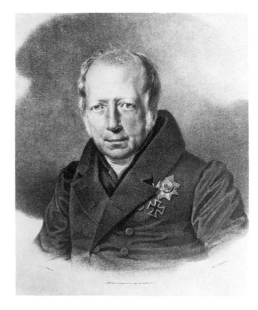

Oldermann, after F. Krüger
Wilhelm von Humboldt
Lithograph

15

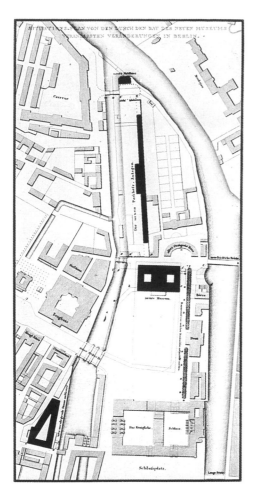

Site plan of the old museum between palace, cathedral and customs buildings

temporaries? He succeeded, I think, in combining outer display with inherent nobility in a building that perfectly symbolized the meaning of Prussia's historic collections. The row of columns which his imposing temple presented to the square completely concealed the two storeys within. A broad flight of steps led up to the entrance and into a spacious rotunda, which served as the entrance hall and hub of the exhibition rooms grouped around it. Before visitors went on to the halls of sculpture on the ground floor and painting on the first, this awesomely solemn domed room, as Schinkel wrote, was to 'put them into a receptive mood, ready to enjoy, appreciate and find insight into all that the building harbours'. Based on the Pantheon in Rome, this hall was intended for meditation not exhibition: it was to be a space consecrated to the experience of art.

The arrangement of the exhibition rooms that opened out from this domed hall reflected the museum's dual aim of providing enjoyment and edification. The first floor was divided into forty small rooms which contained a total of 1,198 paintings, selected from the original collection by a museum commission under Wilhelm von Humboldt; their authenticity and attribution were carefully investigated by Gustav Waagen in a critical catalogue. Schinkel's spacious halls were divided by wooden partitions that extended only part of the way to the ceiling, allowing diffuse light from the high windows – skylights had not yet been added – to fall on the paintings on the side walls. These were reserved for major works, while associated paintings of more historical than aesthetic interest hung close together on the rear walls. Each section was devoted to a certain school or group and was captioned accordingly. The colour scheme of the exhibition spaces was wonderfully festive, dominated by red and gold. We have since become so accustomed to monochrome, usually pale-toned, walls that Schinkel's conception may strike us as garish. But it had a deeper purpose, that of integrating the paintings – in their famous, standard Schinkel frames – completely with their architectural surroundings. Art, architecture and ornament had yet to be strictly separated, which is why Schinkel's colour scheme and the furnishings of the gallery represent a fascinating chapter in the history of museum design and artistic taste. Sabine Spiro has attempted to reconstruct the original scheme. 'Schinkel,' she writes, 'chose a dark red wallpaper with a shaded pattern in dark greyish-blue, and, for the smaller rooms, paper with large flower décor. The twenty-six pine partitions were also covered with this paper, which was pasted over burlap; walls and doors were framed with gilded mouldings and the plinth marbled in greenish encaustic. Between the ceiling beams, which were decorated with plaited bands and meanders in red, yellow stars gleamed on a white ground. The cornice above the partitions and along the rear wall was gilded, as were the hanging arrangements for the pictures. The protective railings in front of the pictures made do with black enamel . . . Contributing to the brightness of the rooms was the tone of the window casings, which were marbled in very light hues.'

It was an opulent yet a rational and quite thrifty scheme, though as construction proceeded Schinkel made every attempt to convince the authorities that costlier materials should be used. However, they were not willing to grant the necessary funds.

*

No one person, of course, deserves all the credit for making Berlin's long-awaited museum a reality. It was the result of dedicated and persistent effort by many. Though it was Alois Hirt who gave the sign in 1797 and incessantly bombarded the King and ministers with suggestions and memoranda, the museum idea was gradually taken up by a younger generation who had the enthusiastic support of Crown Prince Frederick William. Besides Hirt, Schinkel was involved as architect in all the planning stages, later assisted by the sculptor Rauch, the painters Dähling and Wach, the restorer Schlesinger, and, as consulting art historian, by Dr Gustav Waagen. Wilhelm von Humboldt, an idealist philosopher who was also eminently efficient in practical matters, certainly provided great and possibly decisive inspiration, though his official duties allowed him to concentrate on the project only twice – in 1809, during his sixteen months as Chief of the Prussian Ministry of Culture, and in 1829, when he headed the Museum Furnishing Commission.

A man who devoted himself to the collection and museum like no other was Freiherr Karl Friedrich von Rumohr (1785–1843). Rumohr was a universally gifted, financially

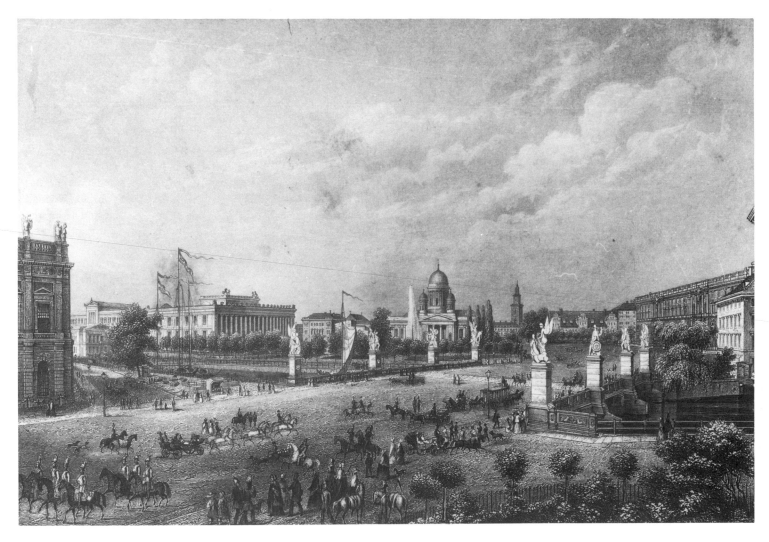

independent connoisseur of Italian art rare in Germany at that time. His important *Italienische Forschungen* appeared in 1827–32, and when in Italy he was able to acquire several paintings for the museum, among them such significant works as Botticelli's large *Madonna* from Santo Spirito in Florence, Piero di Cosimo's *Mars and Venus*, the *Portrait of a Girl* by Lorenzo di Credi, and Franciabigio's *Portrait of a Young Man*. A critical philosopher, historian, and essayist who even wrote a book on *The Spirit of Cooking* (1822), Rumohr was a friend of von Humboldt, Hegel, Schlegel, Tieck, and Goethe, and belonged to the intimate circle of Crown Prince Frederick William. Although he never held public office, his practical and moral support for the museum was invaluable. He modified and clarified Hirt's systematic exhibition scheme, and it was probably as much at his as at Wilhelm von Humboldt's instigation that Hirt's predominantly antiquarian (that is, historical) approach was tempered by an appreciation of the aesthetic qualities of art.

The artistic quality of a painting is more important to a museum than its historical interest; in Wilhelm von Humboldt's words, only the beautiful in art can educate, and it is this which places art and science on the same level. This fundamental assumption of von Humboldt's philosophy was central in the intellectual optimism that pervaded nineteenth-century Berlin, and it was the museum founders' main justification for their conception of a public museum.

A special place in this inspired and high-minded circle of artists, universal historians, and connoisseurs was held by Gustav Waagen. His career may perhaps stand as a typical example of the scholarly life in nineteenth-century Prussia, a life devoted completely to education and service to a state whose ingrained thrift was only matched by the high demands it placed on itself. Waagen was born in Hamburg in 1794, the son of a minor painter, and studied art history at Breslau (1812) and Heidelberg (1818). While in the army

The Palace Bridge with the old museum, cathedral and palace, 1855
Steel engraving

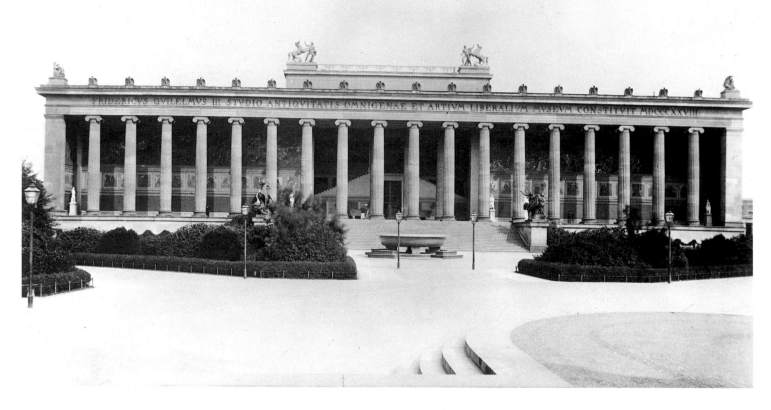

Karl Friedrich Schinkel
The old museum, 1823–30

Karl Friedrich Schinkel
Floor-plans of the old museum, 1825

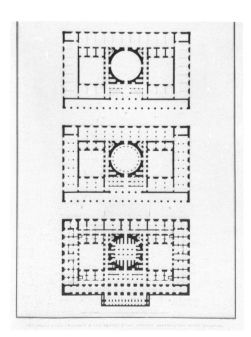

he saw and marvelled at the Musée Napoléon in 1814. In 1818 he met the Boisserée brothers in Heidelberg, who at the time were still negotiating with Berlin about the transfer of their collection. When Waagen's dissertation on Hubert and Jan van Eyck was published as a book in 1823, Rumohr tracked the author down and persuaded him to come to Berlin. Waagen's great knowledge of European and world art, his infallible critical eye, and his connoisseurship of medieval painting in particular, made him a leading candidate for the commission which ordered the Solly Collection in 1823. The critical catalogue of the Gemäldegalerie that he edited in 1830 caused a furore as he did not shrink from attacking the accepted attributions which were often lavish with great names; nor was he afraid of public controversy if that was what a scholarly justification of systematic cataloguing and organization of the collections entailed. Though he was initially overshadowed by Rumohr, and Wilhelm von Humboldt tried in vain to make the museum directorship attractive to his brother Alexander, Gustav Waagen was none the less nominated to the post because the King refused to countenance any suggestion that Rumohr deserved it.

Waagen's career as a Prussian civil servant in Berlin was not successful in a material sense. Continually plagued by money worries, he regularly put in for special leave to travel, returning again and again to England where he made a lasting name for himself as one of the leading experts on European painting. His *Works of Art and Artists in England*, published in 1838, and his three-volume *Art Treasures in Great Britain* (1854) are still astonishingly erudite, accurate, and well-written accounts of the great English art collections of the day. In 1857 he was even commissioned by Prince Albert to oversee the planning of the great Manchester Exhibition. This exhibition, which reflected Waagen's profound knowledge of early Italian art, proved significant for England in helping to set the stage for the Pre-Raphaelite movement. Waagen died in 1868 while on a journey to Copenhagen.

*

With the inauguration of its new home in 1830, the Gemäldegalerie had a firm base on which to begin a considered expansion of the collection. Initially, Gustav Waagen was able

to make a number of fine acquisitions, among them Titian's *Girl with Fruitbowl* (in 1832), Rogier van der Weyden's *Bladelin Altar* (in 1834), Spanish paintings from the collection of Baron Matthieu de Favier, Paris (in 1835), and Cornelis de Vos's charming portrait of his two children (in 1837).

The idealism and fervour of the founders' generation, however, had begun to ebb, and different interests now came to the fore. The issue of Enjoyment versus Edification began increasingly to be decided in favour of the latter. Perhaps most symptomatic of this emphasis on scholarship and expertise was the naming of Dr Ignaz von Olfers, in 1839, as Director General of Museums. Though Olfers devoted all his energy to expanding the collections, his policy diverged ever further from the idealistic aims formulated by Wilhelm von Humboldt and Schinkel. In his view, the museums were to serve mainly as repositories of expert knowledge, institutes which in the academic discipline of the visual arts must hold their own against the concentrated scholarship of Berlin University. He found particular support for his ideas among leading archaeologists, who thought that the museums' educational task could be performed best by exhibiting plaster casts of the finest classical sculpture alongside the museums' few originals, and indeed by making these the focus of the entire museum group.

Ludwig Knaus
Friedrich Gustav Waagen
Berlin, Nationalgalerie SMPK

What may have suited the archaeological department was bound to be more than harmful to the Gemäldegalerie and the Department of Prints and Drawings. It is said that Director General von Olfers prevented the purchase of Michelangelo and Raphael drawings from the estate of Sir Thomas Lawrence by arguing that with the 40,000 reichsthaler he would save, he could buy plaster replicas of the *Horsetamers* at the Roman Quirinal! This kind of thinking was to prove fateful to the Gemäldegalerie and its acquisition policy, though its full effects were not immediately felt.

In the meantime, a quite different event had given everyone reason for optimism. In 1840, Crown Prince Frederick William (IV), art-lover and talented historian, became King of Prussia, exactly a hundred years after the predecessor he most admired, Frederick II. The middle classes placed great hope in this liberal monarch who seemed one of their own, and they expected long-overdue reforms which initially, at least, were almost realized.

The years until the March 1848 Rising abounded with projects, whose political significance may still be perceived today from plans and the few buildings that have survived. They give an idea of the broad intellectual and political stream in which the Royal Museums could prosper and expand; this included such different projects as the completion and restoration of Cologne Cathedral (from 1842, after the Church Schism had been overcome) to fantastic plans for a Protestant cathedral between palace and museum in Berlin; and the great hospital complex at Bethanien to the *Krollsche Oper* at the edge of the Tiergarten. The old eighteenth-century Protestant cathedral, which Schinkel had already restored and integrated in his museum ensemble, was particularly close to Frederick William IV's heart. The church, he thought, needed yet another refurbishment to symbolize a renascence of Christian faith and to create a national Protestant cathedral as a counterpart to the Catholic cathedral at Cologne. 'I am building my cathedral not for its Protestant congregation in Berlin,' admitted the monarch, 'but in my capacity as Protestant leader of the Protestant Church of Germany; and seeing that I hope to complete Cologne Cathedral, I should be granted the right if not actually to execute such a gigantic project, then at least to plan it.' This project gave birth throughout the remainder of the century to innumerable plans, from the fantastic to the merely outsized, which also had their effect on museum planning. Finally, on 17 June 1894, the cornerstone of the new cathedral, which still stands in East Berlin, was laid.

Karl Friedrich von Rumohr, 1828
Lithograph

Frederick William IV, after establishing his summer residence at Sanssouci in Potsdam, began expanding the park in 1844 to include the Church of Peace and Marly Garden. He and Schinkel, in the 1830s, had already conceived a grand Via Triumphalis behind the palace, probably the largest and most ambitious project of the Romantic period in Germany. Work on the avenue was begun under Persius in 1842, but it was never completed. The King's desire to restore Sanssouci Palace to its original state even led him to attempt to nullify a democratic decision made by his predecessor, Frederick William III. A cabinet order signed on 30 June 1840 declared that all works that had been at Sanssouci before the Gemäldegalerie had opened were to be returned there.

Franz Krüger
Frederick William IV

This order might well have been carried out had it not been for the negotiating skills of the Director General, who managed to convince the King that copies of the paintings would suffice. Potsdam nevertheless remained his dream. 'The entire enclave of Potsdam and beyond, over the shoreline hills on the Havel River, transformed into a most glorious, grandiose, mile-wide landscape painting that has come to life,' mused the Romantic on the throne; and traces of this vision are still visible in the countryside around Potsdam, scarred by the Second World War and Germany's partition.

In this larger context were also plans to expand the museum which got underway immediately the Crown Prince had taken the throne. These aimed not only at providing space for a continually growing collection but at establishing 'a refuge for the arts and sciences' on Spree River Island in central Berlin. This vision, and the Monarch's own architectural ideas for its realization, led to plans drawn up by the architect Friedrich Stüler (1800–65), which retained their validity for generations to come.

Stüler's project foresaw a shifting of the planning focus from the Lustgarten adjoined by palace, cathedral and museum, to the northern end of the large island that divided the River Spree. He envisaged the new museum as a complex of great halls, colonnades, two- and three-storey exhibition buildings, all crowned by a temple of the arts. His designs were visionary and sensible, and also charged with political symbolism. This is his own description: 'If we are to satisfy, with a great building complex, the ever-growing need for facilities devoted to the arts and sciences and, as far as humanly possible, to unite everything that belongs together there, then efforts must be made to secure a spacious site at the city centre yet away from the noise of traffic. This complex should be linked with the reconstructed Cathedral and its cemetery hall, the whole thus gathering into itself the highest spiritual emotions of the populace and forming a focus of a kind which probably no other capital city can boast.'

After Stüler had drawn up a general plan for the gigantic undertaking based on the King's sketches, work got underway on a New Museum behind Schinkel's original building. Though construction was begun in 1843, various delays prevented its completion until 1859. With the New Museum, the royal contractor and his architect created a decorative unity of museum architecture and contents which was quite opposed to the austere, Neo-Classical style of the Schinkel period in Berlin. In fact, the new building had been earmarked for the Egyptian collection and Department of Prints and Drawings. But thanks to the intervention of the Director General, the collection of plaster casts was given a prominent place there which continual acquisitions strengthened. Then, in 1861, Consul Wagner's collection of contemporary German art came to Prussia as a bequest, and the last bastion against modern art in the museums fell. Despite the great Wilhelm von Humboldt and his injunctions, a modern museum, the National Gallery, was established to house the new collection in 1864, and an imposing new building was erected between 1866 and 1876.

This general development of the Berlin Museums – their physical expansion, increasing comprehensiveness, and primarily scholarly orientation – should be kept in mind to understand the role played by the Gemäldegalerie during the thirty eventful years to 1872. At first, all signs were propitious. In 1840 the King put a 100,000-thaler stipend at Gustav Waagen's disposal for a protracted buying trip through Italy. Waagen managed to acquire about seventy paintings in Florence and Venice during 1841 and 1842; these included two large altarpieces by Moretto, several mythological subjects by Tintoretto and Veronese, and also a number of fine sculptures. On his return the following year, Waagen succeeded in securing the collection of Reimer, the Berlin book-dealer, which consisted mostly of Dutch genre paintings. Other significant purchases of the period were the *Deidesheimer Altar* from Nuremberg in 1844, the *St John Altar* and *Mary Altar* from the collection of King William II of Holland in 1850, Raphael's *Madonna Terranuova* in 1854, and the two unique *Hohenstauffen Altar Panels* in 1862. Yet not even these acquisitions could hide the fact that interest had shifted to other departments, or that financial subsidies, not only to the Gemäldegalerie, were continually shrinking. By 1865 the funds available to all of the museums totalled only 15,000 thalers.

*

The period between the wars of 1870–1 and 1914–18 was a time of unprecedented

expansion for Berlin, which rose to be the political centre of Germany and the industrial, business and scientific capital of the new empire. The city's population tripled from 774,452 in 1870 to 2,071,257 in 1910. Berlin's museums also prospered, becoming the unique repositories of world art and culture we know today. The founders' generation had dedicated them to the ideal of liberally educated people; now, Berlin's economic improvement and financial resources, unknown to other German museums, led to an almost total triumph of faith in historically oriented museum science. The Berlin museums led in every field. Famous scholars and researchers in the history of art, archaeology, and the various branches of world art, brought a systematic collecting activity and scholarly evaluation which remained without parallel.

As regards the historical departments of the museums and the Gemäldegalerie in particular, this period is indissolubly linked with two names, men who established the gallery's ranks as largest and most important division of the entire museum group: the museums' protector, Frederick William, Crown Prince and later – too late – Frederick III, German Kaiser for ninety-nine days (with his English wife, Crown Princess Victoria), and second, Wilhelm von Bode. On 16 June 1871, the Franco-Prussian War at an end, Kaiser William I named the Crown Prince Protector of Royal Museums (royal they remained because they were Prussian rather than national or imperial, though they certainly could claim to represent the German nation abroad). Thanks to Frederick William's understanding, to his untiring aid and innovative thinking, the true *spiritus rector* of the museums, Wilhelm von Bode, was able to give free rein to his inexhaustible energy and ideas.

At no other period could a man like Bode have been so eminently successful as in the decades between 1871 and 1914. Born in Calvörde (Brunswick) in 1845, Bode briefly studied law before turning to art history, in which he took his Ph.D. at Leipzig in 1870. In 1872, a junior barrister, he asked for leave to become an assistant in the sculpture department with permission to work in the Gemäldegalerie as well. In 1883 he advanced to director of the Gallery of Sculpture, becoming Head of the Gemäldegalerie in 1890 and finally Director General of Museums in 1905. Not until 1920 did he retire from his other posts to devote himself exclusively to the Gemäldegalerie, which he headed until his death in 1929.

These dry dates, of course, say very little about Wilhelm von Bode's fascinating, always controversial personality – that of a man who was highly respected and greatly feared both in his own country and abroad. The best character study of Bode came from the pen of one of his most outspoken opponents, the Berlin art critic and writer Karl Scheffler. 'Bode is actually a leftover from the previous generation,' wrote Scheffler, 'that race of strong-willed, not yet weak-nerved, and quite unsentimental parvenus who shaped the aspect of the New Germany after 1870. He is a practical organizer among art historians, a *realpolitiker* of art, something on the order of a Bismarck of museums ... Much of the imperial, boom-year mood still hovers about him, and his thinking and feeling blend Prussian method with American enterprise. A new breed of gallery manager was born with Bode. Yes, perhaps even a sensational one. He is also a worker in the grand manner, who achieves in a matter of decades what others would need centuries to do. This man with the hawk's profile has without doubt imposed his personal regime and demanded his own way so self-righteously that he has managed to get his hand in really every German museum ... Never has there existed a Right Honourable more remarkable than he.'

Bode's independent means assured him a lifelong freedom of movement and even enabled him to give paintings to his museum when State funds reached one of their periodical low ebbs. Despite continual illness, he placed the highest demands on himself relentlessly. He was a brilliant universal historian who took a passionate interest in all fields of museum research, and he was also a specialist and leading authority on fifteenth- and sixteenth-century Italian painting and sculpture, and on Dutch and Flemish Baroque painting. Bode was equally a connoisseur of sculpture, bronzes, furniture, and even of historic picture frames, to which he attached great importance in the presentation of the gallery's works. His memory for pictures was infallible and precise, his judgement incorruptible. His scholarly works, published in bulky volumes, were so pioneering and fundamental that their results have since become part of general knowledge. He knew every collector and art dealer in Europe, and there were only a few rare pieces, including

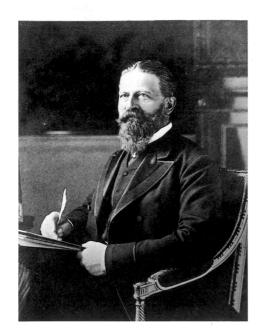

Emperor Frederick III as Crown Prince,
c.1880

those purchased by his sharpest competitor, the National Gallery in London, that escaped his attention or, if at all possible, incorporation into the Berlin collection.

But to return to the early years of Bode's career. Director General von Usedom was making one last attempt to rescue the old notion of an edifying collection of plaster replicas extending from antiquity to the present. He even considered building, on the Museum Island site behind the New Museum, a great structure largely reserved for this collection; but the project never came to fruition.

In 1874, thanks to years of effort on the part of Julius Meyer, the gallery succeeded in acquiring the collection of Bartholdt Suermondt, an Aachen industrialist. The Crown Prince had used all his influence to convince the Prussian parliament that the collector's price, one million gold marks, was not too high. Extraordinary funds like this were repeatedly made available by the Ministry of Finance when it was a question of acquiring masterpieces for the museums – for example, a sum of two million gold marks in 1884 exclusively for buying painting and sculpture of the Christian era. To give just one comparison, during the same period the old Pinakothek in Munich had an annual purchasing fund of no more than 10,000 marks.

With the Suermondt Collection, which Waagen had already catalogued in 1859, first-rate works of the early German and Netherlandish schools entered the gallery. Jan van Eyck's *Church Madonna*, paintings by Altdorfer, Holbein, and Baldung set new accents in a still modest department of German art. The increase of famous names in the Dutch rooms was even greater – five paintings by Frans Hals alone, including *Boy Singing with Flute* and *Malle Babbe*, which Courbet had shortly before copied in Aachen (and which is now in the Kunsthalle, Hamburg); then five works by Ter Borch, Vermeer's *Lady with Pearl Necklace*, and paintings by Steen, Brouwer, Rubens, Ruisdael and others.

No wonder the exhibition rooms on the top floor of the Old Museum had become hopelessly overcrowded, despite conversion work between 1872 and 1878 which improved lighting conditions by replacing the side windows with skylights.

Julius Meyer, now frequently aided by the young Bode, took advantage of the favourable economic situation to purchase many fine works, particularly in England, where more and more masterpieces from the superb private collections were now for sale. Among Bode's acquisitions was Rembrandt's famous *Portrait of the Mennonite Preacher Anslo and his Wife*, from the collection of Lord Ashburnham – who, however, would not agree to sell until Bode proved the seriousness of his intentions by purchasing Pollaiuolo's *Portrait of a Young Woman* (1894).

The Amsterdam master probably fascinated and moved Bode more deeply than any other artist. He was able to add thirteen paintings to the gallery's Rembrandt collection, of which *Man in a Golden Helmet*, acquired in 1897, soon achieved almost legendary fame. This painting, from an English private collection, came to be identified with certain Pan-Germanic tendencies then in flower, which found their most popular expression in a book called *Rembrandt als Erzieher* – as teacher and guide. Published anonymously ('by a German'), the tract quickly went through an incredible number of editions. Later, its author Julius Langbehn revealed his identity and his countrymen honoured him with the title of 'the Rembrandt German'.

Bode's contribution to Rembrandt research, by contrast, consisted of a five-volume book in which he reviewed and summed up current knowledge of the Dutch master. In spite of the rigorous gleaning-out of over-generous attributions which has since reduced Rembrandt's accepted œuvre to a fraction of its former size, Bode's acumen and connoisseurship remain impressive.

His almost uncanny sense for the favourable opportunity led to similar increases in the Flemish department. Fifteen paintings by Rubens were acquired by Bode (eight of which, large compositions with figures, were lost in 1945 when fire destroyed the stocks that had been evacuated to Friedrichshain bomb shelter). For the German department, which had not a single Dürer, Bode purchased seven paintings by that artist in the short time between 1882 and 1889, four of them from British collections. The Italian collection profited no less by his expertise, with significant new acquisitions such as the predella panels by Masaccio (in 1880) and paintings by Botticelli, Signorelli, Titian, Bellini and Carpaccio.

It would lead too far afield to describe Bode's almost obsessive purchasing activity in

detail. Suffice it to say that by 1914 he had succeeded in making the Berlin collection a complete record of European painting from the thirteenth to the eighteenth centuries which in terms of quality and systematic arrangement was unique in the world at that time. The only definitely under-represented fields were eighteenth-century English and French painting. A handful of English works had come to the gallery, largely as gifts, on the inauguration of the new Kaiser Friedrich Museum in 1904; French painting was slighted because, still associated with Frederick the Great, it was considered of more historical than aesthetic interest. Frederick's collection of Watteau, Pater and Lacret remained in the royal residences at Berlin and Potsdam.

Bode did not rely exclusively on departmental goodwill and government money for his purchases. He also approached those industrialists, businessmen and bankers who, during Germany's boom years, had built up collections that could match, or even surpass, public ones. Not surprisingly, the largest private collections amassed in Germany during the few decades between 1880 and 1914 were to be found in Berlin. They must have been superb, judging by the opulent volumes which are all that remains in witness. These were often written by Bode himself, who admittedly did not expect his services to go unrewarded in the way of gifts or financial support for the royal museums. Among these potential patrons were men of such stature as James Simon, M. Kappel, Oscar Huldschinsky, Carl Hollitscher, von Kaufmann, Carstanjen, Beckerath, Hainauer, Oppenheim, and many more.

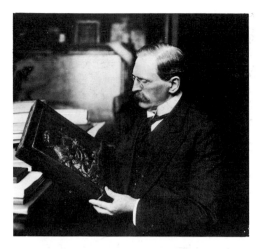

Wilhelm von Bode,
c.1890

Only James Simon, however, showed his gratitude more than abundantly for Bode's efforts, becoming probably the greatest private supporter and patron of the Berlin Museums ever. He was Jewish, and like many Jews in Berlin he was dedicated to German national unity and had a strong sense of the obligations attached to his position in society. Owner of Germany's largest textile firm with an annual turnover of more than 600 million marks, Simon began collecting art in 1882 with Bode's assistance and advice. His collection was beautifully exhibited in his house on Tiergartenstrasse (almost next to the present site of the new Museum of Applied Arts). He also financed the museum's archeological expeditions – *Nofretete* was unearthed on one; Simon co-founded the Museum of German Ethnology, he established orphanages, and, indeed, was philanthropically active in many areas. On the opening of the Kaiser Friedrich Museum in 1904 he donated the larger part of his Italian Renaissance collection, with works by Mantegna and Bronzino, sculptures and finely crafted objects – a total of 350 pieces. A special room in a private house was reserved for Simon's collection, bearing witness respectfully and impressively to his generosity.

Private initiatives of this kind, Bode realized, would benefit the museums most if channelled through a supporters' association. In 1897, the Kaiser-Friedrich-Museums-Verein, named in honour of Emperor Frederick, who had died in 1888, was established to further the Painting and Sculpture Galleries. Its list of members was headed by Emperor William II and included such prominent men as Karl von der Heydt, F.A.Krupp, Max Liebermann, Rudolf Mosse, Friedrich Sarre, Leo Bernstein, Arnold Guilleaume, Walter Rathenau, and Louis Ullstein – names that stand for a key phase in the economic and cultural development of Berlin. This association of private supporters enabled Bode to act quickly, without bureaucracy, when government endeavours to buy some fine work of art proved insufficient. Some of the most valuable and beautiful pieces in today's gallery still belong to the Kaiser-Friedrich-Museums-Verein, whose activities on behalf of the museum have continued unabated to this day.

*

Hardly had its new building been inaugurated than the Gemäldegalerie was pressed for space, and during the 1870s the need to expand grew increasingly obvious. The exhibition rooms on the top floor of the Old Museum were hopelessly overcrowded; not even conversion work and a complete reorganization of the collection could alleviate matters more than temporarily. Frederick William IV's grandiose vision of Museum Island as a 'refuge for the arts and sciences' in downtown Berlin – capital of the Empire since 1871 – had not been forgotten. When the Berlin Society of Architects and Engineers sponsored a competition for an expansion of the museums in 1882, the response was overwhelming.

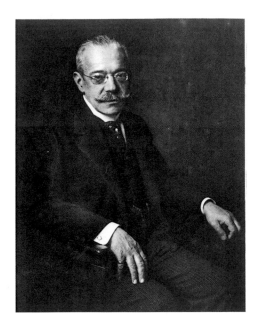

James Simon,
c.1915

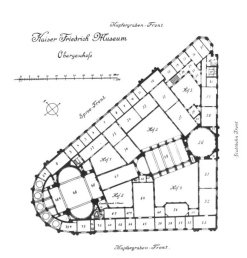

Ernst Eberhard von Ihne
Ground-floor plan of the Kaiser Friedrich
Museum, 1904

The number and variety of entries showed how seriously this project was taken in the new imperial capital, particularly by Bode, who was out to create a new type of museum. Besides more space, what he really wanted was to re-order and thus re-interpret the museum's collection. Previously, the art of each period had been divided by the medium, but Bode thought in terms of historical epochs. This is why the final project for a new gallery at the northern end of Museum Island was expressly conceived as a Renaissance museum where painting and sculpture would be exhibited together, in surroundings decorated and furnished in the Renaissance style.

However, there were many obstacles in the way of its realization. A branch of the new inter-urban railway, crossing Museum Island, left only a narrow triangular site for the museum at the island's northern point, and this posed great architectural difficulties. The death of Kaiser Frederick III in 1888 brought all progress to a halt, until Bode finally intervened with his successor, William II. The Kaiser issued an imperial order, and Ernest Eberhard von Ihne, court architect, was commissioned in 1898 to complete the building. The Kaiser Friedrich Museum, named in memory of its former protector and containing the Gemäldegalerie and Sculpture Gallery and the numismatic collection, was officially inaugurated by William II on 19 October 1904. Today it lies in the Eastern sector of the city and bears the name Bode Museum.

The museum was an architecturally impressive terminus for Museum Island, although its location between the railway line, Spree River and Kupfergraben canal, with barracks and clinics on the opposite shore, was rather prosaic, and its main entrance was at some distance from the square where palace, cathedral and other museums were concentrated. Its long rows of pilasters above a massive Neo-Renaissance foundation and the soaring dome over its rounded façade lent the building a monumental dignity quite in keeping with its purpose of a repository of Renaissance art.

The Gemäldegalerie moved into the rooms on the upper floor. Bode, as obstinate with his architects and building authorities as he was sensitive to the harmony of decoration, colour schemes, antique furnishings and picture frames, apparently succeeded in creating an atmosphere that tremendously heightened the effect of the collection. 'By no means did we intend to imitate the model of other museums of arts and crafts,' he summed up in his memoirs. 'On the contrary, we conceived these monumental settings as placing the works of art in surroundings that suited their period and character and which would enhance their effect and be as faithful as possible to their original intention. Had we gone so far as to copy old rooms, we should have impaired the nobility and calm of the paintings, and done harm to the nature and significance of the museum.'

Yet Bode's plans went still further. In February 1907 he wrote a memorandum projecting the development of the entire museum group as he saw it. Since the Kaiser Friedrich Museum was already overcrowded and much of importance had to remain in storage, he wrote, the next step would have to be the construction of another new museum – a Museum of German Art, in which art of all the northern European countries could be brought together under one roof. Germany did not yet possess a museum of this kind, neither at Nuremberg nor at Munich, wrote Bode. 'A German Museum would present an abundance of beautiful individual pieces which, taken together, would give the first true and correct picture of the German style in the arts. A recognition of this uniquely Germanic quality would in turn contribute to the refinement and development of modern German art, and would help stimulate and improve it.'

Bode's ideas found rapid acceptance, and he engaged the brilliant architect, Alfred Messel, to plan the new building. Messel (1853–1909) had already designed the Landesmuseum in Darmstadt and a series of department stores and office buildings that put him in the first rank of modern German architects. His plans called for a great U-shaped structure of three wings, with a courtyard open to the canal side and a Doric colonnade connecting the two projecting wings. Art of three civilizations was to find a home here: late antiquity and Pergamon Altar in the central tract, Oriental art with a Near Eastern Department in the south wing, and Germanic art in the north wing, the German Museum proper. After Messel's death in 1909, Ludwig Hoffman became supervisor of the project. But technical and financial problems delayed its completion until after the First World War, and Bode did not experience the realization of his idea. The new building was

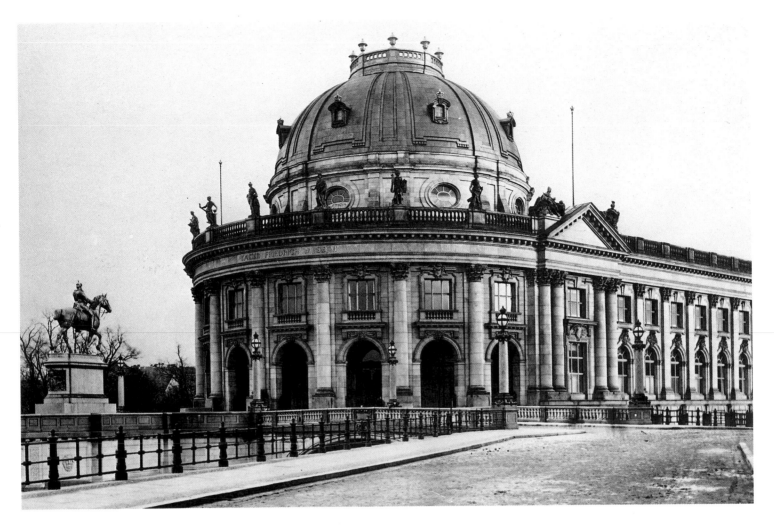

opened to the public in 1930, on the occasion of the Berlin Museum Centennial.

Bode's comprehensive plans also included the far-sighted suggestion to relocate a portion of the non-European collections in the suburb of Dahlem, this making more space available in the central museum buildings. Since Dahlem, a former state demesne, had already become the home of several scientific institutes attached to the university, among them the Kaiser-Wilhelm-Gesellschaft (later Max-Planck-Gesellschaft), Bode's idea amounted to creating a new combined centre of the arts and sciences in Berlin. Construction of a new Museum of Asian Art, designed by Bruno Paul (1874–1968), began in 1913.

The Kaiser Friedrich Museum, 1904

*

The outbreak of war brought all these ambitious projects to an end. Work in Dahlem ceased in 1915. By 1921 it was decided to abandon Bode's general plan and temporarily use the unfinished Museum of Asian Art to store the ethnological collection.

The First World War and its consequences also critically weakened the Gemäldegalerie. Article 247 of the Versailles Treaty stipulated the return to Belgium of the panels of van Eyck's *Ghent Altar* which had been in Berlin since Solly purchased them in 1818, and also the two wings of the *Löwen Altar* by Dieric Bouts, acquired for the museum by Waagen in 1834. The great Berlin private collections, built up with Bode's help and advice, were dispersed or left Germany altogether during the inflation. Only James Simon again, in 1919, donated a large group of sculptures, paintings and applied art to the museums, a gesture intended as a sign of warning to his country that it was in dire need of moral and spiritual renewal.

Bode's original museum conception celebrated one last triumph. To commemorate the

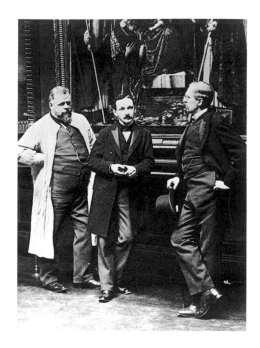

Wilhelm von Bode, Max J. Friedländer
and the restorer Mr Hauser
(From right to left)

hundredth anniversary of the Berlin Museums, the Messel Building (with the German Museum, the Pergamon Museum and the Near Eastern Department) was inaugurated on 2 October 1930. The installation of the German Museum still faithfully reflected Bode's ideas. Medieval Christian art was on the ground floor and art of the Post-Renaissance period upstairs, the paintings and sculptures together: in this way Bode's vision of a Renaissance museum, equally compelling for its art of the Germanic nations, was realized.

As reorganization of the Kaiser Friedrich Museum became necessary during the 1930s, however, a new generation of museum curators gradually prevailed. They looked askance on Bode's notion of presenting all the arts of each epoch together, and believed that what really counted was the individual work of art in its aesthetic autonomy. The Berlin Revival Style in museum installation – 'historicism' – had had its day. Up to the 1936 Olympic Games, sculptures and paintings were exhibited separately, against light-coloured walls, and a puristic narrowing-down replaced Bode's expansive historical approach. The results can still be seen in the structure of Berlin's museums to this day, for the generation who pioneered this reorientation stipulated the same strict division of the artistic genres when the city's museums were rebuilt after the Second World War.

When the Nazis came to power in 1933 there were changes of an incomparably more injurious kind. Their inhuman racial policy led to the dismissal, emigration or demotion to inferior posts of many of the museums' finest scholars. The Director of the Gemäldegalerie, Max J. Friedländer, was relieved of his office and emigrated to Holland. Hermann Voss, unrivalled connoisseur of Baroque painting, was transferred to Wiesbaden. The Nazis' propaganda exhibition, *Degenerate Art*, and subsequent pillaging of the museums struck a blow at the National Gallery and its modern collection from which it never completely recovered.

On the outbreak of war in 1939, the museums were immediately closed and their collections temporarily put in storage in the basement of the Kaiser Friedrich Museum. In 1942 and 1943, as the air raids on Berlin grew increasingly threatening, the paintings and sculptures were taken to massive anti-aircraft shelters which seemed to offer the best protection imaginable. They were indeed safe – until after the capitulation.

By late January 1945 the Red Army had reached the Oder River. The Nazi regime declared Berlin a fortress to be defended to the last. At this point, the Director General of Museums managed to convince Hitler to order the evacuation of the most valuable portions of the collections from the Berlin shelters to depots which were made ready in

Kaiser Friedrich Museum
James Simon Room, 1904

Western Germany. This happened on 8 March 1945; three days later the first shipment left Berlin. A total of six shipments were made, the last on 7 April, just before the Russian armies sealed off the city. Sixty-two cases containing 1,225 paintings reached Thuringia by road, where they were stored at Kaiseroda-Merkers Salt Mine, on the Werra River near Eisenach. Several hundred authentic old frames and about four hundred paintings, most of which were too large to fit into the pit cages at the mine, remained behind in the Friedrichshain shelter. Another thousand paintings were left in the Kaiser Friedrich Museum basement.

Berlin capitulated on 2 May and Germany on 8 May. A week later several serious fires broke out in the shelter at Friedrichshain, which in the meantime had been occupied by Russian troops and was hermetically sealed. Though what caused the fires has never been adequately determined, they very probably destroyed all the State Museum treasures in the shelter. The Gemäldegalerie apparently lost all the paintings it had stored at Friedrichshain, among them such irreplaceable works as Signorelli's *Pan as God of Nature*, three major paintings by Caravaggio, monumental altar panels by Fra Bartolommeo, Francia, Moretto, and Sarto; eight works by Rubens, four by van Dyck, all of the Jordaens paintings, and many by Murillo, Zurbarán, Vouet, and Lebrun. Russian troops confiscated about 230 paintings from the basement of the Kaiser Friedrich Museum, which had suffered serious bomb damage. By 17 May, despite the chaotic circumstances, a new City Council for Greater Berlin had been established. One of its tasks was the supervision of the former State Museums, and work began to recover and secure what was left.

American troops occupied the evacuation point at Kaiseroda Mine on 4 April. A week later, General Eisenhower and his staff came to inspect the mine, which in addition to art treasures contained the gold reserves of the German Imperial Bank. On 15 April, the U.S. Monuments and Fine Arts Section removed all the paintings to Frankfurt, then to Wiesbaden, where a central art collecting point had been established at the Landesmuseum under the supervision of the U.S. military government. As a consequence of the Yalta Agreement, Thuringia and Saxony were relinquished to the Soviets on 1 July. In November 1945, 202 major works belonging to the Berlin Gemäldegalerie were taken finally from Wiesbaden to Washington DC and deposited at the National Gallery of Art.

Though evacuation saved the gallery's collection, in the nick of time, from the total destruction which certainly awaited it in Berlin, it was now dispersed and divided among the Allied powers, mainly the United States and Russia. Whatever the future held in store,

Kaiser Friedrich Museum
Cinquecento Room, 1904

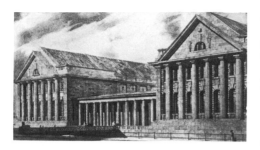

Alfred Messel
Project for extensions on Museum Island
(German Museum in left wing), 1908

the existence and structure of the Berlin Museums were now inextricably involved in world politics and the East-West confrontation. Their home city of Berlin, like Germany itself, had been divided.

On 25 February 1947, the Allied Control Commission formally abolished the State of Prussia. The Berlin Museums became collections without a country.

<div style="text-align:center">*</div>

Those few museum employees who stayed in Berlin during the final days of the Third Reich did what they could to secure the damaged museum buildings and what works of art remained. Yet since the greater part of the Gemäldegalerie's stocks were in Wiesbaden, their fate was largely in the hands of the American art officer there, though he had German museum staff to assist and advise him. Shortly after Ernst Holzinger, Director of the Städel Institute in Frankfurt, joined this group as expert adviser, an exhibition of part of the gallery's collection was arranged for February 1946, and further exhibitions followed.

Finally, in February 1948 President Truman agreed to return the paintings stored in Washington. A bill to this effect was passed in Congress, but it included a rider by Senator Fulbright that before the collection returned to Germany it was to be shown in thirteen American cities because it had been kept from the public eye for years in the National Gallery depots. This travelling exhibition proved a spectacular success, and by the time it ended in Toledo in March 1949, over two-and-a-half million people had seen it. The net proceeds of $300,000 went to the Emergency Assistance Fund for German Children. The paintings arrived back in Wiesbaden in May, and were placed under German jurisdiction. The responsible authority was now the Regional Government of Hessia at Wiesbaden.

In the meantime, however, political developments dashed all hopes that the collection might be returned to Museum Island in Berlin. A monetary reform carried out in the three Western zones of occupation on 20 June 1948, was joined by the three Western sectors of Berlin. A few days later the Russians blocked the access routes to the city, and the heroic airlift began that insured Berlin's survival until the blockade was lifted on 11 May 1949. The previous autumn, two separate city councils had convened in Berlin, and on 23 May 1949 Western Germany received a new constitution, the *Grundgesetz*, establishing the German Federal Republic with provisional capital in Bonn. October 7, 1949, saw the formation of the German Democratic Republic to the East, with the Eastern sector of Berlin as its capital. The division of the city – and its museums – was sealed for the unforeseeable future.

This brief review of key dates in four years of German post-war history might serve to

German Museum *Room with early*
German painting and sculpture, 1930

28

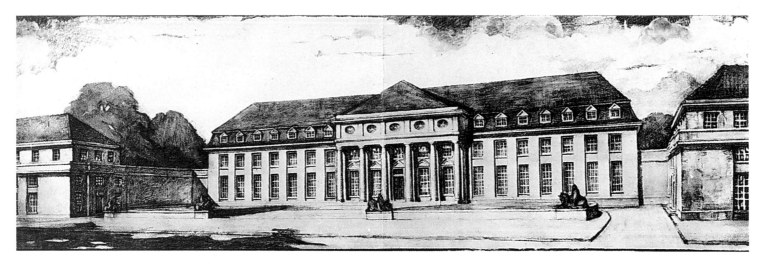

give some idea of the often dramatic difficulties faced by the Berlin Museums as a result of the Cold War. Nothing less was at stake than their continued existence and coherence. To anyone who is interested in more information on this period, I recommend Irene Kühnel-Kunze's first-hand account of the Berlin Museums from 1939–59, a vivid record of troubled and often bizarre times.

Bruno Paul
Design for the Asiastic Museum in Dahlem, 1913

*

The West Berlin City Council began laying the groundwork for a return of the museums' collections soon after its inception; and the unfinished Asian Museum in Dahlem, which had survived the war in comparatively good shape, was repaired to house them. It opened in December 1949 with an exhibition of part of the ethnological collection.

The fate of the Gemäldegalerie stocks, however, was still uncertain. The Hessian government hesitatingly agreed to lend a small number of paintings to Berlin for a series of eleven temporary exhibitions. They were reluctant to do more because the legal status of property, formerly belonging to Prussia, had yet to be determined among the new federal and regional German administrations. A first exhibition of 149 paintings from Wiesbaden none the less went on view in the Dahlem museum buildings on 2 October 1950. The exhibition was opened with a moving address by Ernst Reuter, Mayor of Berlin, who pointed out that the harsh political struggles over Berlin lent the exhibition the character of a dramatic testimony to the city's link with the Western world.

Bruno Paul
Site Plan of Museum Buildings in Dahlem, 1913

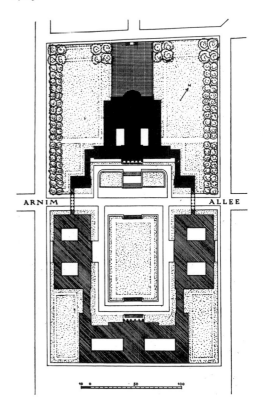

Yet the Hessian government remained adamant against returning the Gemäldegalerie collection. It was at this critical point that private initiative again tipped the scales. The Kaiser-Friedrich-Museums-Verein, founded in 1897 to support the gallery, lodged a suit against the State of Hessia in 1951 for the restitution of works of art belonging to them – and won. The significance of these legal proceedings was increased still more by the fact that such world-famous paintings as van Eyck's *Christ Crucified* and Rembrandt's (?) *Man in a Golden Helmet* were among the works at issue. Then, on 7 July 1955, the state governments of Baden-Württemberg, Berlin, Hessia, Lower Saxony, Northrhine-Westphalia, Rhineland-Pfalz, and Schleswig-Holstein signed an administrative agreement which stipulated the return to Berlin (West) of the former Prussian art treasures. This was followed on 25 July 1957 by a federal bill establishing the *Stiftung Preussischer Kulturbesitz* or Prussian Cultural Heritage Foundation, placing under its sole administration all the cultural assets that had formerly belonged to the Prussian State and which were now within the jurisdiction of the federal constitution. The foundation was to function solely as trustee, expressly emphasized in the bill, which defined its purpose as follows: 'To keep, maintain and enlarge the Prussian cultural heritage assigned to its care for the German nation, until other arrangements are made after reunification.'

Although legal difficulties prevented the foundation from beginning work until 1961, all the evacuated paintings had been returned to Berlin by May 1957, and as far as space permitted, were exhibited at the old Dahlem Museum. By the end of 1958 the Soviet Union

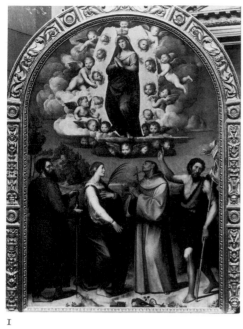

1

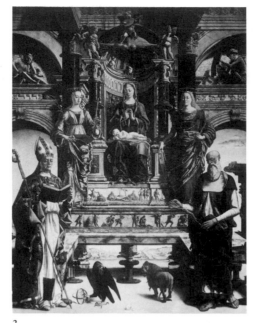

2

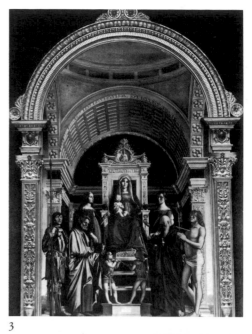

3

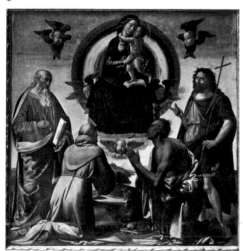

4

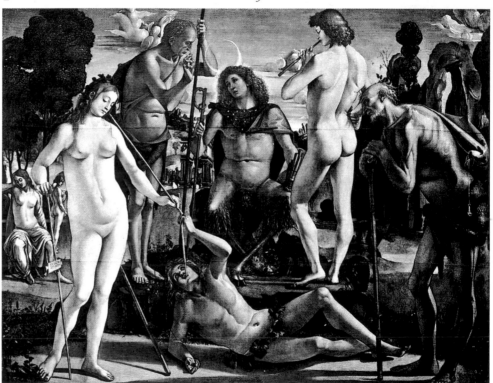

5

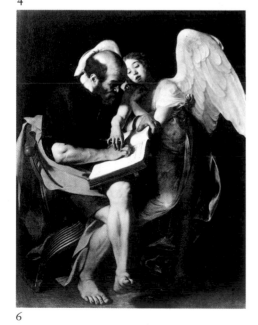

6

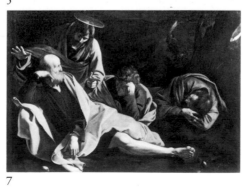

7

8

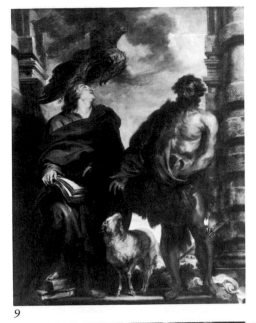

9

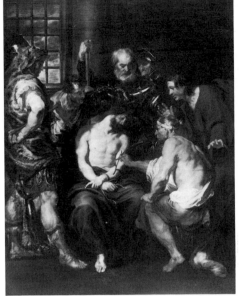

10

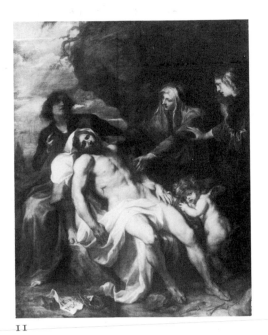

11

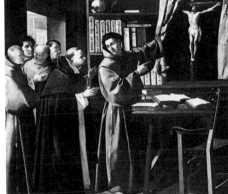

12

15

13

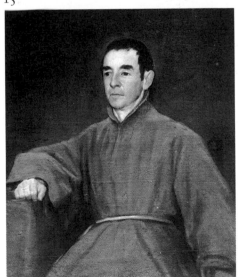

16

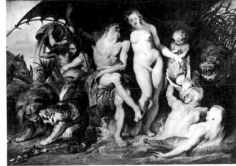

14

Figs 1–16 During the war it proved impossible to evacuate the gallery's entire collection to places outside Berlin. A considerable part was stored in an anti-aircraft bunker there, and in May 1945, over four hundred paintings were destroyed by fire, including these sixteen:

1 Giacomo Francia, *The Virgin as Queen of Heaven*
2 Cosma Tura, *The Virgin Enthroned*
3 Alvise Vivarini, *The Virgin Enthroned*
4 Domenico Ghirlandaio, *The Virgin and Child in a Gloriole, Worshipped by Four Saints*
5 Luca Signorelli, *Pan as God of Nature*
6 Caravaggio, *St Matthew with the Angel*
7 Caravaggio, *Christ in the Garden*
8 Charles Lebrun, *Portrait of the Cologne Banker Everhard Jabach with his Family*
9 Anthony van Dyck, *John the Baptist and John the Evangelist*
10 Anthony van Dyck, *The Mocking of Christ*
11 Anthony van Dyck, *The Lamentation of Christ*
12 Peter Paul Rubens, *The Conversion of Paul*
13 Bartolomé Esteban Murillo, *St Anthony of Padua with the Christ Child*
14 Peter Paul Rubens, *Neptune and Amphitrite*
15 Francisco de Zurbaran, *St Bonaventura and St Thomas Aquinas*
16 Francisco Goya, *Portrait of a Monk*

General Dwight D. Eisenhower (centre) inspecting the evacuated paintings in the Kaiseroda Mine

Botticelli's *Madonna with Singing Angels* in the National Gallery of Art, Washington D.C., its condition being checked before its return to Germany in 1948 by a War Department representative, a National Gallery restorer and Dr Irene Kühnel-Kunze, the German representive

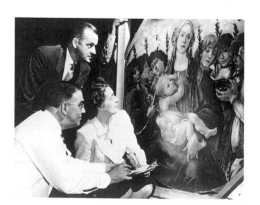

had also returned, to East Berlin, the works of art confiscated in 1945. Since then a portion of this collection, about nine hundred items, has been on view in the Bode Museum, formerly Kaiser Friedrich Museum.

And from then, too, the old Asian Museum in Dahlem has been the home of the Gemäldegalerie – a provisional solution not robbed of its charm by the years. Set among the new scientific institutes of the Free University, this Neo-Baroque structure under a wide-spreading cornice still exudes a quiet if rather heavy sense of dignity much in keeping with the traditions it represents. About 650 paintings on view from the original stocks, supplemented by new acquisitions, provide a lucid and impressive overview of European painting from the thirteenth to the eighteenth centuries. Those who recall the old Kaiser Friedrich Museum will naturally feel the painful absence in Dahlem of the large canvases that lent the former collection such nobility; but they have gone up in flames, a loss which not even an unlimited purchasing budget could repair. Now the small and medium-sized paintings predominate, filling the rooms with an atmosphere of intimacy very conducive to the enjoyment of fine works of art.

Some of the gaps torn in the collection by war, particularly in the Flemish and Italian departments, have of course been closed by new acquisitions. The previously quite small collection of eighteenth-century art has also grown in recent years, with additions ranging from Longhi, Tiepolo and Panini to Boucher, Restout, Largillierre, Vigée-Lebrun, and Vernet. And a group of English paintings has at last added the names Reynolds, Gainsborough, Raeburn, Lawrence, and Hoppner to our lists, all now represented by major portraits.

The old problem of insufficient space began to plague us again, but no further expansion of the Dahlem Museum was possible. Only a new building that fulfilled all the technical and conservational conditions would insure the gallery's undisturbed future growth. The provision of new facilities has been discussed continually since the early 1960s, yet as I write this twenty years later, none of the many suggestions has got beyond the planning stage.

*

As early as 1949, the Building Office of the Berlin Senate had already begun developing plans for an extension of the Dahlem Museum, in spite of the fact that the adjoining sites were gradually required by the Free University, which had expanded rapidly since its founding in 1948. The Trustees of the museums therefore decided, in 1962, that suitable facilities for the Prussian heritage collection could be provided in the Western half of the divided city only by a decentralized plan. The maintenance of these assets was after all a national task, whose scope far transcended the provision of funds for research, collection and presentation.

The planned State Museum complex was accordingly divided among three locations. While ethnology and the three Asian departments were to remain in Dahlem, as Bode had foreseen, early history and prehistory, classical antiquity, and the Egyptian Museum were to be housed in existing buildings near Charlottenburg Palace; new museums of Western art were to be erected on the outskirts of Tiergarten Park, in the former embassy quarter. A core already existed there: the National Library (1967), Scharoun's Philharmonic Hall, and the New National Gallery designed by Mies van der Rohe, built 1964–8. Together with these facilities, the new museums would form an arts centre in the heart of Berlin, a worthy successor to Museum Island and its long tradition.

The optimistic 1960s had given birth to a project of truly epoch-making scope. Yet a two-phase design competition that began in 1965 stipulated the same division of the collections by genre and field which had been tenaciously adhered to since the 1930s. It was hoped that the architectural form of the great new complex would outwardly integrate what the museums inside had to present as a collection of independent units.

The entry by Rolf Gutbrod of Stuttgart perfectly fulfilled this condition, and in 1968 the Foundation Council commissioned him to draw up final building plans. Gutbrod's basic conception, which remained unchanged through decades of official reconsideration and public debate, foresaw a centrally located, asymmetric, gently inclined plaza opening to the

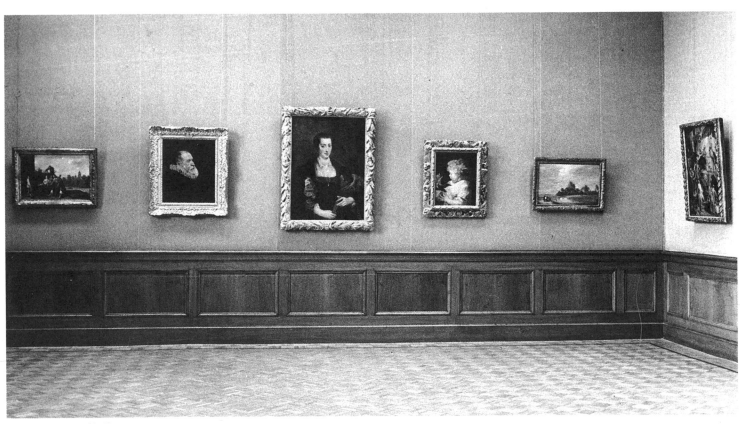

The Gemäldegalerie, Dahlem
The Rubens Room, 1983

The Gemäldegalerie, Dahlem
The Multscher Room, 1984

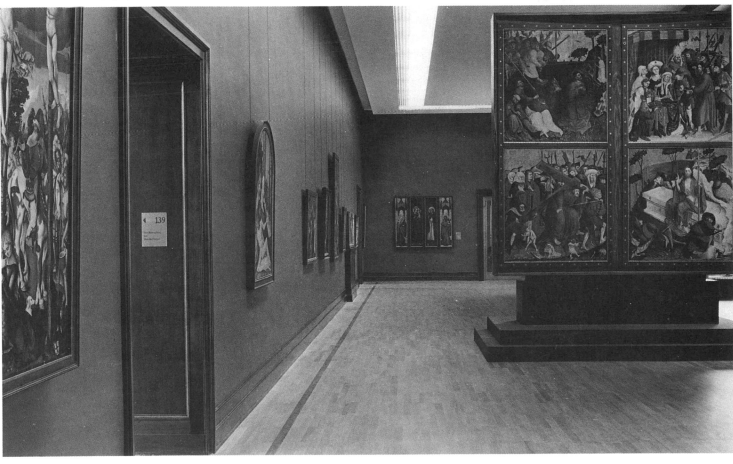

Rolf Gutbrod
Model of new museum buildings near Tiergarten Park, 1983
The Gemäldegalerie wing is in the left foreground

existing St Matthew's Church Square at the heart of the museum complex. The architect described his first design as open architecture integrated with its surroundings – Tiergarten Park – as far as such integration was feasible in a huge and multifarious complex of this type. The buildings for the four collections of Western art, wrote Gutbrod, would be 'grouped in a three-quarter arc around the square as around a megaron, and extend radially to the perimeter of the site. The courtyards between the two wings would be landscaped, allowing the vegetation of the Tiergarten to extend deeply into the built-up area and to combine with the sites of the adjacent structures into pleasing, open spaces.' The inclining *piazzetta*, as the architect called it, would lead visitors gradually out of the bustle of the city, up to a spacious entry hall, and then into the areas of art – the museums proper.

For the Gemäldegalerie this 'architectural landscape' initially foresaw an informal succession of interior spaces on different levels – a compelling architectural solution whose effect derived from unexpected openings and vistas, variations in room size and height, and the alternation of closed and open spaces. Museum practice, however, would not be gainsaid; what might enhance a modern collection would not really do justice to classical, thirteenth- to eighteenth-century painting, which is seen to best effect in comparatively small-scale, clearly defined rooms. Larger rooms whose proportions recall the palatial residences of earlier centuries might also be considered, since only in spaces like that do the large paintings of the Baroque period and eighteenth century look 'right'.

The ensuing discussion among architects and museum people on the function of the new museum and the demands placed on it by the nature of the collection, developed into a phase-by-phase planning process that lasted almost twenty years and finally resulted in a conception of the new Gemäldegalerie as a two-storey complex grouped around two interior courts. The advantage of this plan is that, despite the height of the building, almost every room on both floors will receive natural daylight, which shows paintings to better advantage than any sophisticated artificial lighting system yet devised. On both floors, rooms with skylights will alternate with smaller, side-lit rooms in an informal but carefully planned sequence. This will provide change and interest, breaking up the long files of rooms typical of nineteenth-century museums, while at the same time permitting the painting to be clearly arranged by historical period – as they have been in Berlin since 1830 when the first exhibit was mounted in the city's first museum. Works of the Medieval and

Renaissance periods are to be exhibited on the ground floor, and the Baroque and eighteenth-century collection upstairs. Visitors will be provided with a guide to lead them through the collection chronologically, or they may take advantage of all the rooms' easy accessibility to go straight to works that especially interest them.

For the present and several years to come, however, our visitors will still have to make their way to Dahlem to see the Gemäldegalerie in the old building conceived by Wilhelm von Bode and designed by Bruno Paul. As the history of the Berlin Museums has repeatedly shown, the road from conception to realization can sometimes be long and rocky.

Rolf Gutbrod
Schematic plan of the Gemäldegalerie in the new Tiergarten museum complex, 1981

GERMAN PAINTING OF THE THIRTEENTH TO THE SIXTEENTH CENTURY

BY WILHELM H. KÖHLER

Westphalian (first third of the thirteenth century)
Altarpiece with Three Fields

Oak, 81 × 194 cm (31⅞ × 76¾ in)
Acquired from the Wiesenkirche, Soest,
1862
Cat. no. 1216 A

In 1858, concealed behind fourteenth-century altarpieces in the Wiesenkirche at Soest, Westphalia, two thirteenth-century altarpieces were discovered which have since come to be classified among the incunabula of German altar painting. Since both antedate the church they were found in, they must have been installed in an earlier building, perhaps even on the same site. Recognizing their great significance for the history of art, the Royal Museum in Berlin purchased them without delay. The older of the two paintings, one of the earliest painted altar retables anywhere in Germany, was executed about 1230; the other presumably twenty to thirty years later.

The earlier painting, an irregular rectangular panel divided into three fields, illustrates the meaning of Christ's sacrifice. In the centre field, dominated by an image of the Crucifixion, Christ's figure has been made larger than the others to emphasize its importance. Only a few witnesses are present: Mary and John and Mary's faithful attendants at the left, on the side of the good, where Jesus turns his head; and at the right, the Roman captain with soldiers and figures representing Jews, from whom the Saviour averts his face. Above these groups, on a parapet symbolizing a higher plane of existence, Ecclesia, a personification of the Christian church, appears at the left accompanied by an angel. With the blood of Christ flowing into her goblet, the Church symbolically receives sacrament and means of grace. On the same level at the right, an angel castigates a figure representing the synagogue, an embodiment of the Old Testament, Old Covenant and Judaism, who is divested of her crown and with it her former power. Above the arms of the cross is a third, heavenly realm in which angelic choirs rejoice.

On the left-hand panel, we see Christ bound and led before the high priests. Caiphas, seated with another priest behind the table, asks him, 'How long do you intend to keep us waiting? If you are the Saviour, then admit it openly.' Behind the group, evoked with a few eloquent lines, rise the walls and battlements of Jerusalem. The blue cloth draped over them may symbolize the city's mourning, or perhaps only the lateness of the hour.

The image at the right shows Mary and her attendants at the mouth of the cave where Christ was buried, which is empty except for his shroud. The angel seated on the sarcophagus (which very much resembles an altar) points triumphantly to the empty tomb, as if to proclaim that Christ has arisen. And at the right, asleep, are the Roman soldiers who were set to guard the grave.

The essence of Christian salvation has been rendered here with the utmost simplicity of means. The story begins with the inquisition of Christ, who faces his accusers alone, abandoned by his followers. This scene may be taken to introduce the Passion, which reaches its climax in the central depiction. Here the cross is flanked by Ecclesia and Synagogue, with the victory of the former over the latter symbolically heightening the redemption which Christ's sacrifice brings to man. In the corners of the two fields to right and left, are images of the prophets with inscribed scrolls. These are citations from Scripture prophesying the coming of a Messiah, a prophecy fulfilled with the life and death of Jesus. Thus the figures of the prophets, with those of Ecclesia and Synagogue, give visible form to the agreement of the Old and New Testaments in assuring that man's covenant with God will continue unbroken. The truth of Holy Scripture stands confirmed. The scene at Christ's empty grave, finally, by illustrating his resurrection, affirms the Christian promise that death will be overcome. The separate images and their elements form a meaningful whole, emphasizing Christ's sacrifice as the central event in the story of salvation, an event symbolically repeated in celebrations of the mass at the altar.

The outward form of this retable reveals much about the origin of painted altarpieces of this kind. In the late Middle Ages shrines containing relics of saints were frequently exhibited above the mensa. These shrines were often made of gold and silver, and

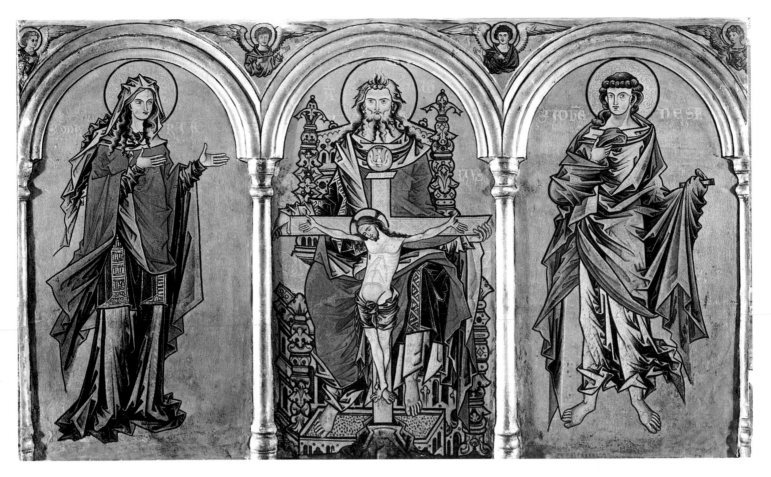

encrusted with precious stones, pearls, and enamels. The early retables that superseded such shrines apparently adopted certain features of their form and decoration. The peaked curves along the top of the present altarpiece, whose central division recalls the triptych form, may be an example of this derivation. The panel and its fields have frames ornamented in relief, recalling goldsmiths' work, as does the convexity of the two round fields, which heightens the effect of their gilded grounds. The painting technique itself, in clear, brilliant colours applied in rather broad, flat areas, was apparently influenced by enamelwork. Borrowings such as this from other techniques indicate that the altarpiece is a very early example of its genre.

Stylistically speaking, the treatment of the figures reveals certain transitional traits. Some of them still have garments draped in parallel folds that describe ovals or arcs around the figures' limbs or the objects they hold: soft, flowing curves that derive from an earlier style. Other draperies show the sharp, angular, crystalline forms typical of a more modern approach which entered thirteenth-century painting from the Byzantine tradition. Art historians have coined a vivid term to characterize it: the angular style.

While the earlier of the two altarpieces stands at the beginning of this stylistic phase, the second, later one (illustrated above) reveals the angular style in its full maturity. The Holy Trinity is represented – God the Father, Son and Holy Ghost – interlinked in the centre to form what is known as a throne of mercy, while on the flanking panels Mary and John the Evangelist appear as intercessors. Everything in the image has been resolved into sharp, angular, prismatic shapes which seem to jostle one another in continual, agitated motion, giving the impression of profound inner feeling and contained energy. This semi-abstract heightening of the pictorial elements suggests a date shortly before this stylistic phase ended, about 1265–70.

Westphalian, after 1250
Altar Superstructure in Three Compartments, with Mercy Seat
Berlin, Gemäldegalerie SMPK

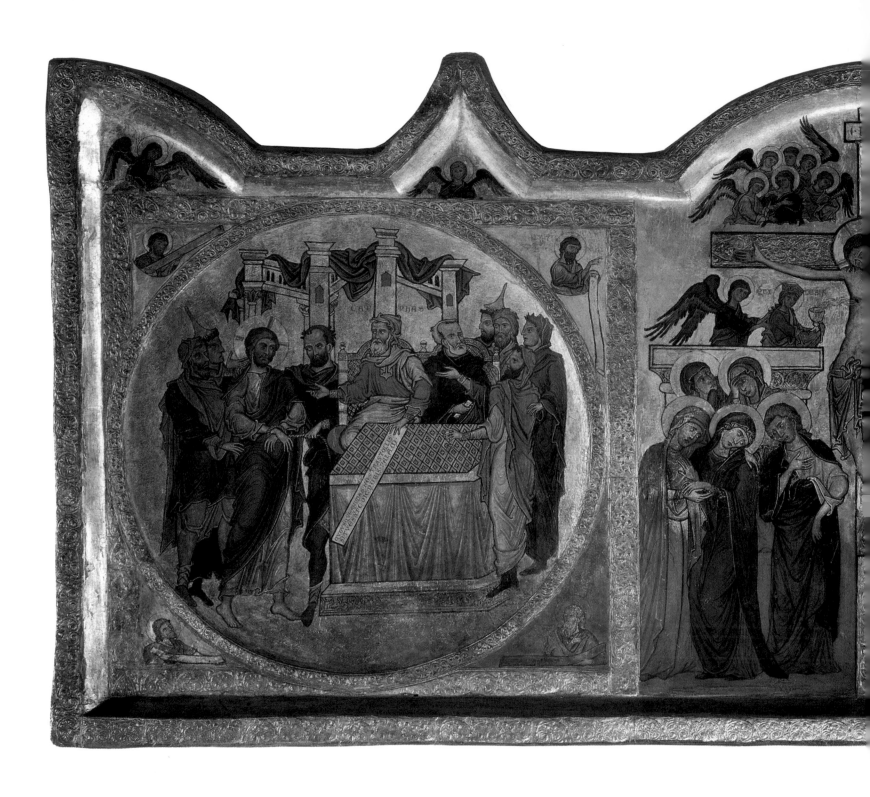

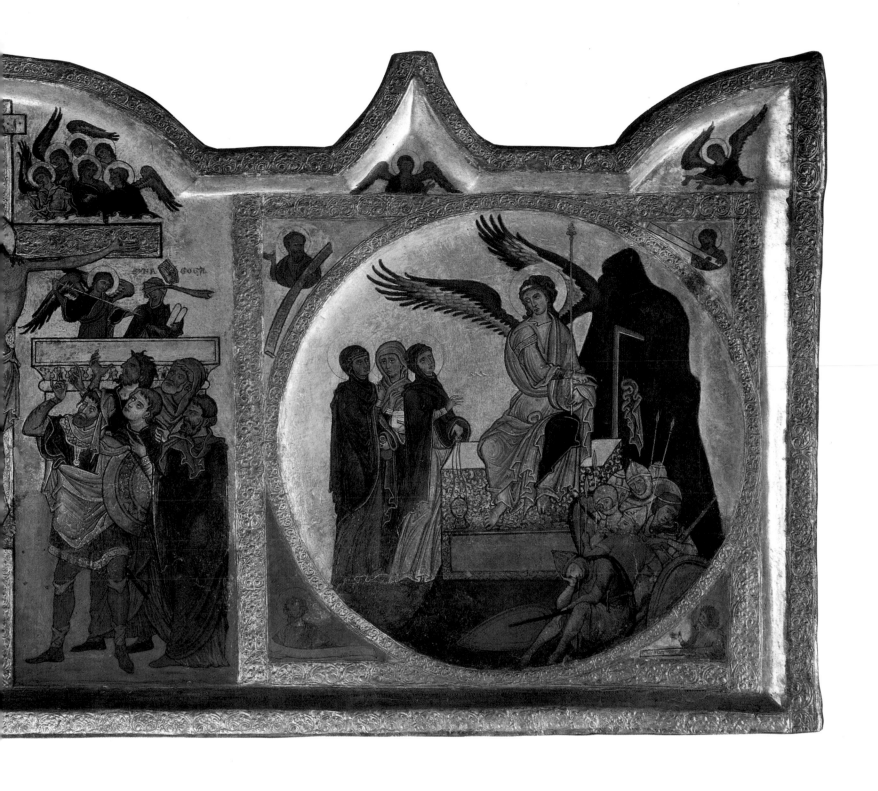

Master of Cologne (*c.*1320–30)
The Cologne Diptych
The Virgin Enthroned with Child – Crucifixion

Oak with frames, each panel 49.5 × 34 cm
(19½ × 13⅜ in), each image 40.5 × 25 cm
(16 × 9⅞)
Acquired 1902
Cat. no. 1627

This painting, named after its town of origin – it was kept during the last century at St George's Church in Cologne – is a rare example of a type of liturgical implement. It was made, as its small size indicates, not as a retable for a church but as a miniature altar for private, domestic use. A diptych or double panel, it is hinged to permit the wings to be opened and closed like a book. This arrangement derived from the writing tablets of antiquity, which were often made of costly materials and served as gifts, a primarily ecclesiastical tradition to which our diptych also belongs. Its versatility, allowing it to be viewed from different sides, reflects the traditional custom of celebrating religious holidays with greater display while reserving plainer imagery for daily worship.

This less ornate aspect of the altar is visible when the two panels are closed. On the back right-hand panel Christ's monogram IHS, an abbreviation of IEHUS, is inscribed in black on a red ground. Above and below it appear a cross and three nails, the instruments of torment that symbolize Christ's passion. The outside left panel bears a depiction of the Annunciation, with the Angel Gabriel and Mary against a simple, monochrome background in red. Both the symbolic image and the figurative one are characterized by a modest simplicity that suggests they were used in daily religious services throughout the year.

The interior depictions are much more richly ornamented by comparison. The tendrils filling their gold-leaf grounds are crafted in relief like fine jewellery, and their frames beautifully coloured. The frames also have two different types of hollows. Those at the corners are round and shallow, and apparently contained droplets of glass in imitation of precious stones; the other cavities, twice as deep, probably held sacred relics under pieces of crystal or glass. The private altar, in other words, doubled as a reliquary, a dual function seen in several other examples from the Cologne region.

On the main display side of the altar, the left panel depicts Mary as Queen of Heaven, seated on a throne with the Child on her lap. The rose-branch she holds is part of the multifarious symbolism of the rose traditionally associated with the Virgin. Like the bride in the Song of Solomon, Mary was compared to a thornless rose, a woman without sin. On the right panel, we see Christ on the cross, lamented by angels. Beneath the cross stand the Apostle John and the Prophet Isaiah, with a scroll which reads 'IPSE VULNERAT[US] EST PROPT[ER] INIQUITATES N[OST]RA[S]' ('But he was wounded for our transgressions'. Isaiah 53:5), a passage from the Old Testament thought to prophesy Christ's sacrifice. The Crucifixion, combined with an image of the Virgin and Child, invites the faithful to meditate on the fundamental symbols of Christianity.

The dating of this triptych varies from 1300 to 1350. Comparisons with illuminated manuscripts from the Cologne area place it between 1320 and 1330.

Cologne Master, *c.*1320–30
The Cologne Diptych
Exterior: *The Annunciation*

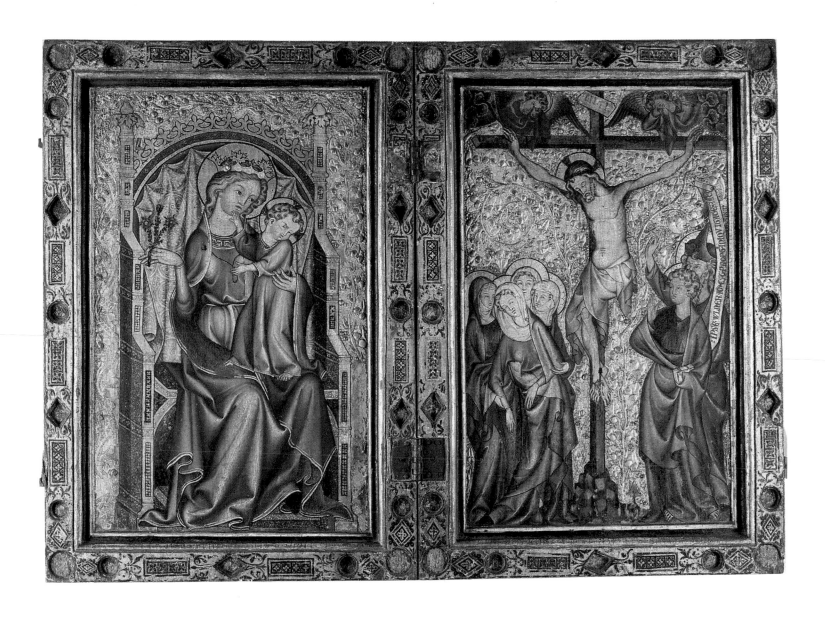

Bohemian School (c.1350)
The Virgin Enthroned with Child
(Madonna of Glatz)

Canvas over poplar, 186 × 95 cm
(73¼ × 37½ in)
Acquired from the Gymnasium in Glatz
by the Kaiser-Friedrich-Museums-Verein,
1902; received by the gallery, 1905
Cat. no. 1624

This major altar painting of the Bohemian School was acquired by the gallery's supporters' association in 1902 from the Gymnasium in Glatz, a town near the border between Silesia and northern Bohemia. Called the *Madonna of Glatz* after its place of origin, it eloquently testifies to the flowering of art which took place at the court of Charles IV in Prague at that period. The image shows the Virgin with the infant Jesus, seated on a throne constructed of elaborate architectural motifs; she receives a crown from the angel hovering above her. The orb in her lap, her sceptre with fleurs-de-lis, and the second orb presented to her by the kneeling angel at the right, are attributes characterizing Mary as Queen of Heaven, *regina coeli*. The Child grasps a scroll symbolizing Holy Writ, whose prophecies have been fulfilled by his birth. At the top of the image, two angels spread a beautifully embroidered canopy while below them two others lean from windows, swinging censers. The gesture of the angel at the left centre was probably meant to call attention to the painting's donor, who kneels devoutly at the foot of the throne.

The complex shape of the throne and its exquisite materials were chosen to symbolize a divine edifice. Yet much in contrast to its marble wings and jewel-encrusted sides, the back of the throne is made of plain boards, perhaps in allusion to the cedarwood used to build the Temple of Solomon. The two lions crouching in the little temple-like structures at the top likewise recall Biblical descriptions of King Solomon's throne and temple. This Old Testament reference characterizes the Christ Child as a New Solomon, seated on the throne of His mother's lap; with Jesus, Solomon's wisdom is reborn, and Mary becomes the seat of divine wisdom. The image abounds with symbolic allusions of this kind, including a star in the gilding above the throne, which is a reference to one of the names by which Mary was known: *stella maris*, 'star of the sea'.

Though complete in itself, the surviving panel is a fragment. It was originally framed with smaller images in the manner of Italian devotional paintings. From a seventeenth-century manuscript we know that the small pictures surrounding the main panel at that period included a Nativity, Circumcision, Flight into Egypt, and Jesus in the Temple – in short, a series of scenes from the life of the Virgin (*Depictae in parvis imaginibus curae Divae Virginis ut . . .*).

The donor kneeling at the lower left, in an archbishop's vestments with a patriarchal cross, has laid his insignia at Mary's feet in humble offering. Based on these attributes, he has been identified as Ernst von Pardubitz, first Archbishop of Prague. He went to school in Glatz, studied in Italy and Paris, and was consecrated bishop in 1343. Only a year later, he convinced Pope Clement VI in Avignon to raise Prague to the rank of an Archbishopric, which made the city autonomous of the Archbishopric of Mainz. About 1350, Archbishop von Pardubitz founded an Augustinian monastery in Glatz, to whose chapel he presumably donated the altarpiece in our collection. This event would place its date of execution at no later than 1350.

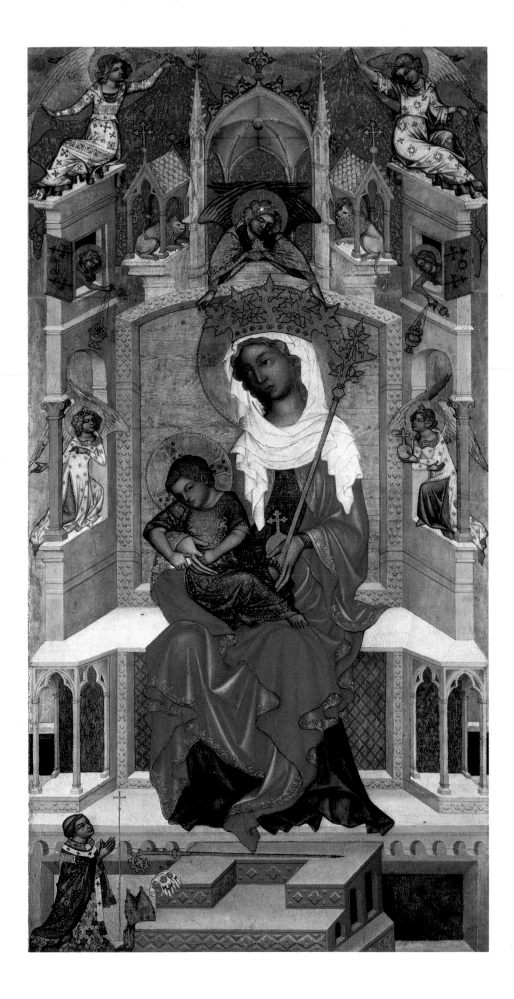

Bohemian School (*c.*1360)
The Crucifixion
(*The Kaufmann Crucifixion*)

Canvas over panel, transferred to canvas,
top in gable form, 67 × 29.5 cm
(26⅜ × 11½ in)
Collection of Richard von Kaufmann,
Berlin
Acquired as a gift from P. Cassirer,
F. W. Lippmann (Berlin) and H. Helbing
(Munich), 1918
Cat. no. 1833

Missal, St Pölten (?), *c.*1360
Canon page: *The Crucifixion*
St Pölten, Diözensanbibliothek, Hs. 56

This tall, narrow panel, whose original frame has not survived, was probably the centre section of a small domestic altar with folding wings which presumably contained further events of the Passion. Their climax on Golgotha is depicted here in a composition dominated by the looming Crucifix and the writhing bodies of the two thieves. The three crosses dramatically divide the picture plane, the flanking ones repeating the austere yet decorative horizontals and verticals of the Crucifix. As angels descend to lament Christ's sufferings, a crowd mills below, a tumultuous scene which the artist has rendered lucid by choosing a view from above. The mourners are gathered in the left foreground: St John, supporting Mary; Mary Magdalene embracing the cross; and a third woman, mournfully averting her face. Behind and above them is Longinus, the blind man who opened Jesus's wound with a lance and was cured of his infirmity by the blood that fell on his eyes. To the right of the cross, the executioner's henchmen fight over Christ's robe, and behind them are Roman legionaries, with the figure of the Good Captain rising above them. He has recognized the Saviour, and declares with a gesture towards him that he is verily the Son of God. Behind him, another henchman raises the vinegar-soaked sponge to Christ. His lance, with that of Longinus, forms an almost symmetrical triangle.

The crowded, jostling figures with their excited faces, troubled glances and agitated gestures, reveal the deep emotions that this event has awakened in its witnesses. Even the folds of their garments seem fraught with tension. The drawing and modelling of the forms are precise and lucid, the line has calligraphic sharpness. The colours, light and brilliant yet strangely veiled in effect, subtly underscore the significance and symbolism of each figure in the scene. In its acuity and detail the treatment seems closer to a miniature illumination than to an easel work. The gold background was unfortunately restored at a later date.

Some authors believe this *Crucifixion* was modelled on a Bologne miniature of 1346–50, the canon page from a missal now in the Archivio di S. Pietro, Rome (*L'Arte*, 1907, p. 108). This image may indeed have inspired certain passages in the composition, and the fact that it is a miniature would seem to corroborate the link.

The regional origin of this small altar panel is still a matter for conjecture. It is traditionally attributed to the circle of Bohemian artists active at the Court of Charles IV, and many good reasons exist in support of this assumption. However, a stylistic connection with Austrian altarpieces has also been pointed out, especially with the painted panels of the *Verdun Altar* in Klosterneuburg (*c.*1330–1). Nor should similarities with such later works as the canon page of a missal at St Pölten be overlooked (Hs. 56; left). Since there was much cross-fertilization between Bohemia and Austria at that period, and both regions were subject to the same artistic influences, it is difficult to draw a hard and fast line between them.

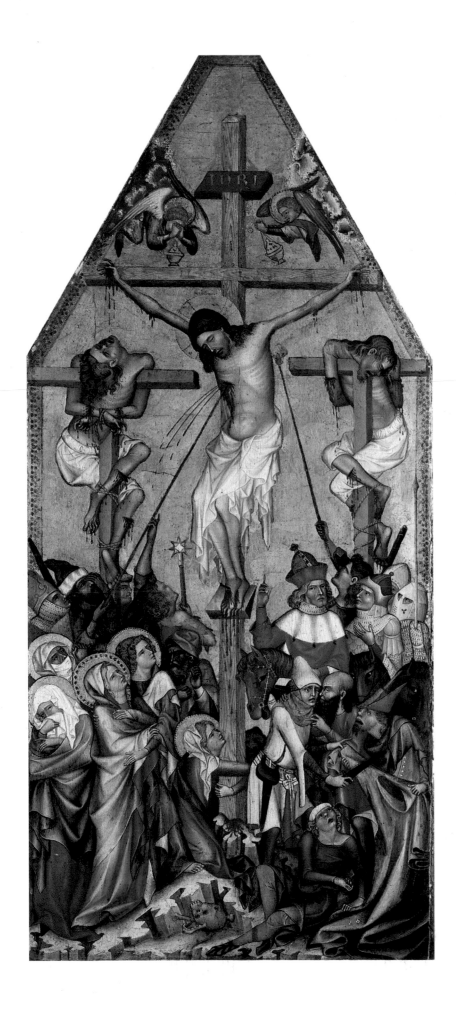

47

Master of the Older Holy Kinship
Triptych with the Virgin and Child
St Elizabeth (left) – *The Virgin and Child in Paradise* (centre) –
St Agnes (right)
First third of the fifteenth century

Oak, centre section with original frame,
40 × 35.5 cm (15¾ × 14 in), each wing
with frame, 40 × 17.5 cm (15¾ × 6⅞ in)
Acquired with the Solly Collection, 1821
Cat. no. 1238

This domestic altarpiece is a miniature version of the large, three-part church retables known as triptychs. Like them, its central panel is flanked by two wings of half its width, which are hinged to close over it. Yet unlike larger altars, whose wings usually have scenes on both sides, the backs of all three panels here are painted plain red.

The middle panel of our triptych shows Mary with the Christ Child on her lap, accompanied by four saintly virgins. They are resting in a meadow dotted with many varieties and colours of flowers, a garden sequestered from the outside world. While Mary's crown characterizes her as *regina coeli*, Queen of Heaven, her attendants have names inscribed in their haloes and attributes to identify them. St Dorothy, the maiden in blue next to Mary, wears a wreath of red and white roses in her hair, and is presenting a basket full of rose petals to the Infant. From Caesarea in Cappadocia, St Dorothy suffered martyrdom during the persecution of Christians under Emperor Diocletian; her roses allude to a miracle that occurred during her torments. She was also among the Fourteen Holy Helpers, and with Saints Margaret, Barbara, and Catherine, belonged to the *virgines capitales*.

St Margaret, in a red dress and green mantle at Mary's right, holds out the cross with which she banished the devil who, during her martyrdom, appeared to her in the guise of a dragon. Seated in the left foreground, clad in a shimmering cloak of yellow and red, is St Catherine, who was of an Alexandrian royal house. Caesar Maxentius, enraged by her profession of Christianity, tried to force her to sacrifice to the heathen gods; she refused and was condemned to be broken on the wheel. Though spared by the intercession of an angel, she was fated to die by the sword. This weapon and a fragment of the wheel appear here as St Catherine's attributes.

St Barbara, seated in the right foreground and wearing a red mantle, holds a miniature tower in her lap that signifies the tower to which her father banished her. She, too, chose death rather than abjure her faith.

The garden with its surrounding arbour where Mary rests with her attendants (a *hortus conclusus*) recalls a metaphor in the Song of Solomon, the bride as an enclosed garden (4:12). This was one of the names by which the Virgin was known. The garden symbolizes her purity and the Immaculate Conception, but it also identifies Mary with this Old Testament bride and pictures her among flowers that perpetually bloom – in the Garden of Eden, Paradise. This symbol of divine and everlasting peace, often associated with the Virgin in medieval painting from about 1400 on through the fifteenth century, was a devotional image marked by mystical faith which visualized the bliss that the Mother of God and the saints enjoyed in Heaven.

The two panels flanking the main image represent individual saints. At the left we see St Elizabeth, Countess of Thüringia, a German noblewoman who lived in Marburg and devoted herself to the care of the needy and infirm. Here she is shown with a poor cripple to whom she hands a warming cloak. On the right is St Agnes with a lamb. St Agnes died a martyr's death rather than relinquish her virginity, and the white lamb is an attribute alluding to her vow. At the same time, the similarity of her name to the Latin for lamb (*agnus*) links her with Christ, the Lamb of God, who took the sins of the world upon himself.

The images of this altar are identified with femininity throughout. While in the centre Mary is united with her *virgines capitales*, St Elizabeth at the left embodies charity, and St Agnes at the right the self-denial of chastity. The consistency of these allusions suggests that the altar may well have been commissioned by a woman, perhaps by a nun.

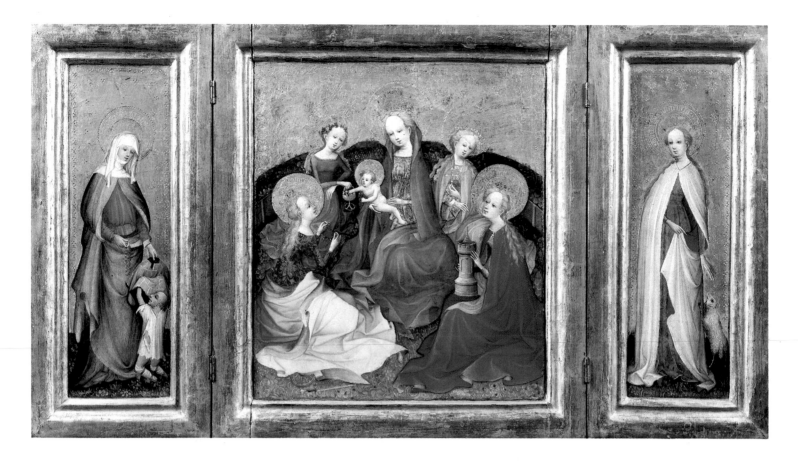

Its style is characterized by colours of a flower-like delicacy, principally in combinations of contrasting and iridescent tones, and even with some complementary contrasts. The draperies have the gentle, clinging curves typical of the International Gothic style known as the supple or soft style, which predominated around 1400. The figures' heads, small, rather doll-like, and lacking in profound expression, their elongated limbs and torsos, and their mannered gestures and poses, all reflect an ideal of beauty current in the courtly society of the period. The tendency to miniaturize things – the attributes, for example, and even the instruments of torture – to the point of making them resemble toys, also reveals a love of delicacy at all costs. Though a gentle, lyrical, even sentimental and precious mood was not uncommon in late Gothic art in general, it was particularly marked in the painting of the Cologne region.

In terms of style, our *Triptych with the Virgin and Child* is closely related to an altarpiece representing the Holy Kinship from the Church of St Herbert in Cologne. Several other, stylistically similar paintings have been associated with this work, and the presumed artist was given the pseudonym of Master of the Holy Kinship. To distinguish him from another anonymous artist who painted a Holy Kinship towards the end of the century, he has also been called Master of the Older Holy Kinship. He was active during the first third of the fifteenth century.

Martin Schongauer (c.1445/50–91)
The Nativity
c.1480

Oak, 37.5 × 28 cm (14¾ × 11 in)
Acquired 1902
Property of the
Kaiser-Friedrich-Museums-Verein
Cat. no. 1629

Martin Schongauer of Colmar, an artist of unsurpassed power and a man of great gentleness, brought late Gothic painting in Germany to perfection. His lyrical style earned him the nickname 'Hipsch Martin' or 'Martin Schön' (Pretty Martin) during his lifetime, and after his death he was celebrated as *pictorium gloria*, the glory of all artists. His influence on German and Netherlandish art at the close of the fifteenth and far into the sixteenth century cannot be estimated highly enough. Known to us today primarily as a printmaker, he made great numbers of engravings, 116 of which have survived. They were widely known throughout Europe and continued to inspire artists long after his death. Among those who went to Colmar in the hope of working with Schongauer was Albrecht Dürer; though he arrived too late to meet him personally, Dürer's art was decisively shaped by the traditions of Schongauer's workshop. Most of Schongauer's paintings were destroyed by iconoclasts or fell prey to the vicissitudes of time. The handful which have come down to us, however, leave no doubt of his superb gifts. One of the most mature and beautiful of these is surely *The Nativity*, executed in about 1480 and now in Berlin.

Here, Schongauer recounts the Christmas story, how Joseph and Mary found shelter in a stable near a cave at the side of the road where Jesus was born. But to the familiar Bible account he has added certain legendary elements which derive partly from artistic tradition, partly from mystical writings – diverse sources which he has none the less lucidly arranged and welded into a meaningful whole. The infant Jesus lies on the ground in swaddling clothes, whose white colour, the lightest in the entire picture, symbolizes the unearthly radiance which legends say emanated from the Child. He is indeed the centre of interest around which everything in the painting is grouped. All the other figures face or glance towards him in adoration. Mary, closest to Jesus in every sense, is moreover visually linked with him by the folds of her mantle. Though Joseph stands at some distance, the same kind of visual link is provided by his stick and bag in the left foreground. Even the animals in the manger turn towards the Child. The fact that the ox is nearer to him than the ass may signify, as one interpretation suggests, that they stand for the Old and New Testaments.

While the Holy Family and the animals are sheltered in the stable as in a sanctified sphere, the shepherds who have come to worship the new-born King remain outside. The relationship of each of the figures to Christ is simply and unmistakably expressed in terms of physical proximity or distance. We as observers are also made to feel very much a part of the events, as if we were actually standing in the stable ourselves. And the shepherds at its entrance, a young, a middle-aged, and an old man, seem to signify that the worship of Christ knows no age barriers.

The posts and beams of the stable divide the picture plane, lend the composition solidity, and lead the eye by their perspective lines back into the distance, where shepherds tend their flocks in a broad, sunny valley. Yet the dark of night can still be sensed over the stable, as in the Christmas story, where the Star of Bethlehem shone so brightly that it turned night to day. This is a good example of the ease with which Schongauer combined features of Christian legend with symbolic allusion. His glowing, jewel-like colours further heighten the clarity of the composition.

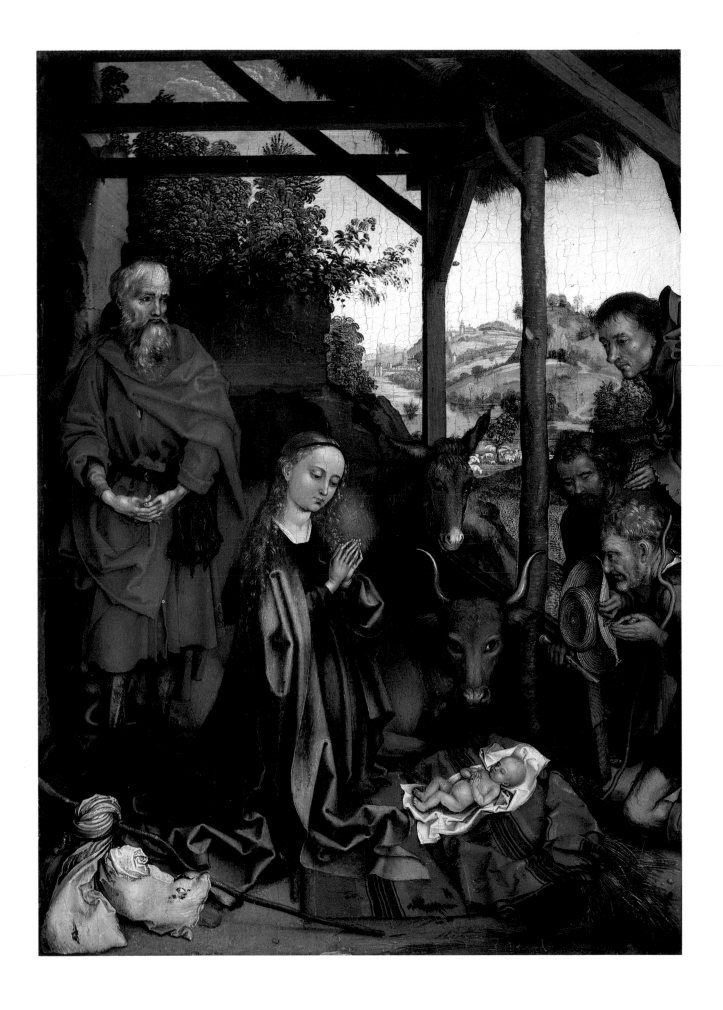

Konrad Witz (*c.*1400–pre-1446)
The Queen of Sheba before Solomon
*c.*1435–7

Oak, 84.5 × 79 cm (33¼ × 31⅛ in)
Gold background renewed at a later date
Acquired 1913
Cat. no. 1701

Konrad Witz was born in Rottweil on the Neckar, in about 1400. History first records his name in 1434, the date of his joining the Guild in Basel, where he obtained civic rights in 1435. He apparently spent the next two years working on a large altarpiece devoted to themes from the *Speculum humanae salvationis* or *Mirror of Human Salvation*, presumably for St Leonhard Church, Basel. Very few other works by Witz have come down to us. His recorded frescoes have vanished, and most of his other paintings were damaged by the iconoclasts who stripped churches and chapels on the Upper Rhine with particular thoroughness. Sections of a later altarpiece may still be seen in Geneva. A short time after completing it in 1444, but before 1446, Witz died.

Witz was one of the great artistic innovators of the Upper Rhine region. Realism had begun to emerge in Netherlandish painting in the early fifteenth century, exemplified by the van Eycks and Robert Campin, and Witz's very personal version supplanted the courtly, transcendental style of International Gothic. The figures in his paintings have a stocky, square-built look about them as if they had been constructed of cubes and prisms. The drapery falls in sharp angular folds whose edges catch the light, and glow against the deep adjacent shadow. This stark modelling creates a wonderful effect of volume and depth. The same preoccupation is evident in the pictorial space, which Witz attempted to depict in its true size and depth. He also took great pains to reproduce the appearance of things, the surface qualities of different types of cloth and metal, of wood and masonry. Fidelity to reality was his credo.

The audience of the Queen of Sheba with King Solomon (1 Kings 10: 1 ff.) is one of eight images on the inside wings of the altar known as the *Heilsspiegel* or *Mirror of Salvation Altar*. The centre panel has been lost, and we know nothing about its subject-matter. The surviving inside wings depict themes from the *Speculum humanae salvationis*, a devotional book of fourteenth-century Dominican mysticism in which Old Testament and historical events were related to the life and sufferings of Christ. These connecting themes grew out of the idea that the incarnation of Christ and his sacrifice to redeem mankind were predestined from the beginning of the world by a plan of salvation. Past events, it was believed, repeatedly prophesied events to come.

The Queen of Sheba's meeting with Solomon, to whom she brought offerings of gold and spices, found various interpretations in the Middle Ages. Some believed it prefigured the Three Kings, who also came from the East to worship the Christ Child, a reading which lent Jesus the aspect of a New Solomon. Others thought that just as the Queen of Sheba went to Solomon to receive his wisdom, so the Church went out from all nations of the earth to receive the word of God. The *Mirror of Salvation* gives still another interpretation: the Queen's joy at experiencing Solomon's wisdom corresponds to the bliss of saved souls as they contemplate the face of Christ in heaven.

The wisdom illuminating Solomon's face and the reverential aspect of his visitor are superbly rendered in Witz's painting. The composition has been reduced to essentials. The two figures are linked by a single but eloquent gesture, the offering of a gift. Seated regally on a bench, Solomon receives the Queen's humble adoration as she kneels before him. The other scenes on the inside panels of the altar are painted with similar reserve and noble conciseness.

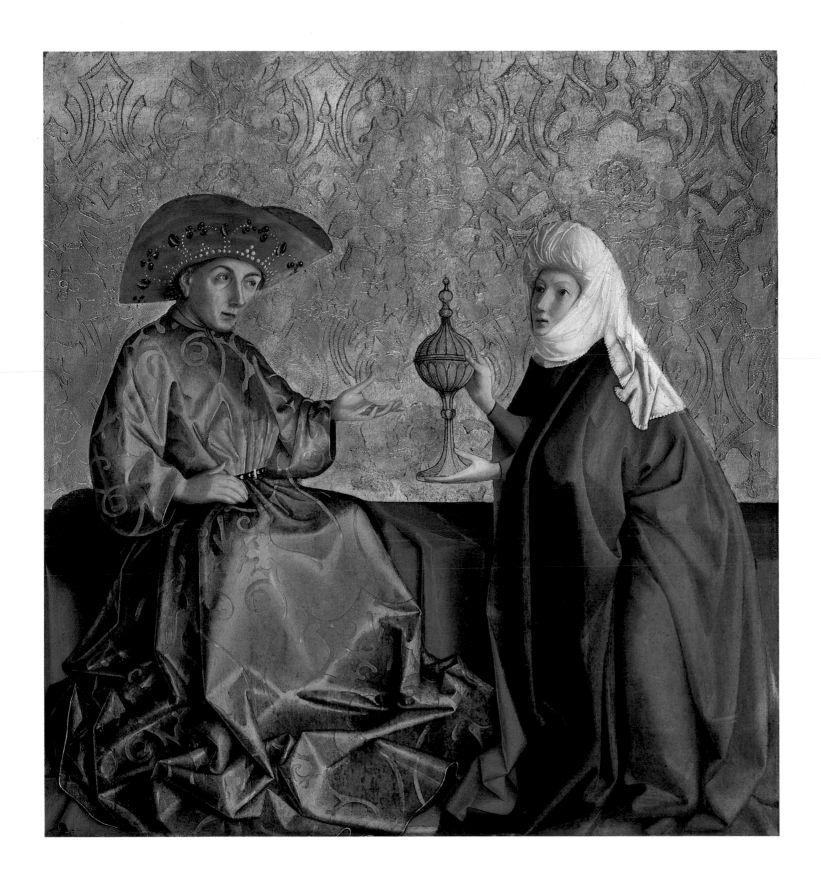

Attributed to Konrad Witz
The Crucifixion
*c.*1445–50

Panel, transferred to canvas, 34 × 26 cm
(13⅜ × 10¼ in)
Acquired 1908
Cat. no. 1656

Near a path worn into the meadows by wagons passing on their way to town, the cross has been raised, solitary on a grassy knoll. Mary with two attendants, and John are gathered in mourning, and John wrings his hands in silent appeal. To their left a clergyman, probably the painting's donor, kneels in prayer. (It was common practice for donors of altars or devotional images to have themselves included in sacred scenes, perpetuating their piety in the timelessness of art.) Three other figures are visible to the right, in the middle ground, perhaps on their way home, last stragglers from the crowd that had come to see the spectacle. The day is almost over; the mourners remain alone beneath the cross, which stands starkly against the brilliant glow of the evening sky. This composition makes the sadness of the scene immediate and tangible.

We as spectators are made to feel that the Golgotha of legend is no longer distant in space and time but is present here and now, in a stretch of countryside that somehow seems familiar. The bays and rocky promontories in the background have been identified as those of Lake Constance, Lake Geneva or Lake Annecy; but whether this assumption is correct or not, the city of Jerusalem that the town on the shore certainly represents, and the martyrdom that takes place before it, have been brought home to us. The temperate, European surroundings contribute to an emotional heightening of the scene, and the realism of the depiction gives it immediacy and encourages empathy. The cross, slightly inclined and foreshortened, the wheel-rutted path winding into the background, the cliffs projecting one behind the other into the lake, and the cloud strata against the setting sun, all lead the eye gradually into the distance, and evoke great depth. In a landscape we can experience, or re-experience, in this way, the climax of Christ's sufferings takes on a degree of reality which no hieratic crucifix against a numinous gold ground could ever attain. Seen in this light, the artist's striving to reproduce things as they are might signify a new kind of faith, a new way of illustrating the meaning of Christ's sacrifice and making Christian tenets manifest.

It was this realistic approach to landscape, the light flooding the scene, modelling the forms, and throwing everything into sharp contrast, the effect of atmosphere and space, and not least the profound melancholy with which the figures are infused, that led historians to attribute this painting to Konrad Witz. Instrumental in helping Netherlandish realism to its breakthrough on the Upper Rhine, Witz, in his late *St Peter Altarpiece* of 1444 in Geneva, set the story of St Peter fishing for souls in a real landscape – the shores of Lake Geneva – thus creating probably the first landscape portrait in the history of German painting. The present lakeside scene with Crucifixion follows models of this kind. However, the painting has certain traits which are difficult to reconcile with Konrad Witz's accepted œuvre: the facial types, the comparative softness and suppleness of form, and the striated, often parallel vertical folds of the drapery. Idiosyncrasies in the treatment of the landscape and the singularly magical effect of the evening twilight place the painting among a group of works associated with a *Lamentation (Pietà)* in the Frick Collection, New York. These are assumed to have been executed in Savoy or Provence, and most commentators agree in dating them about 1445–50.

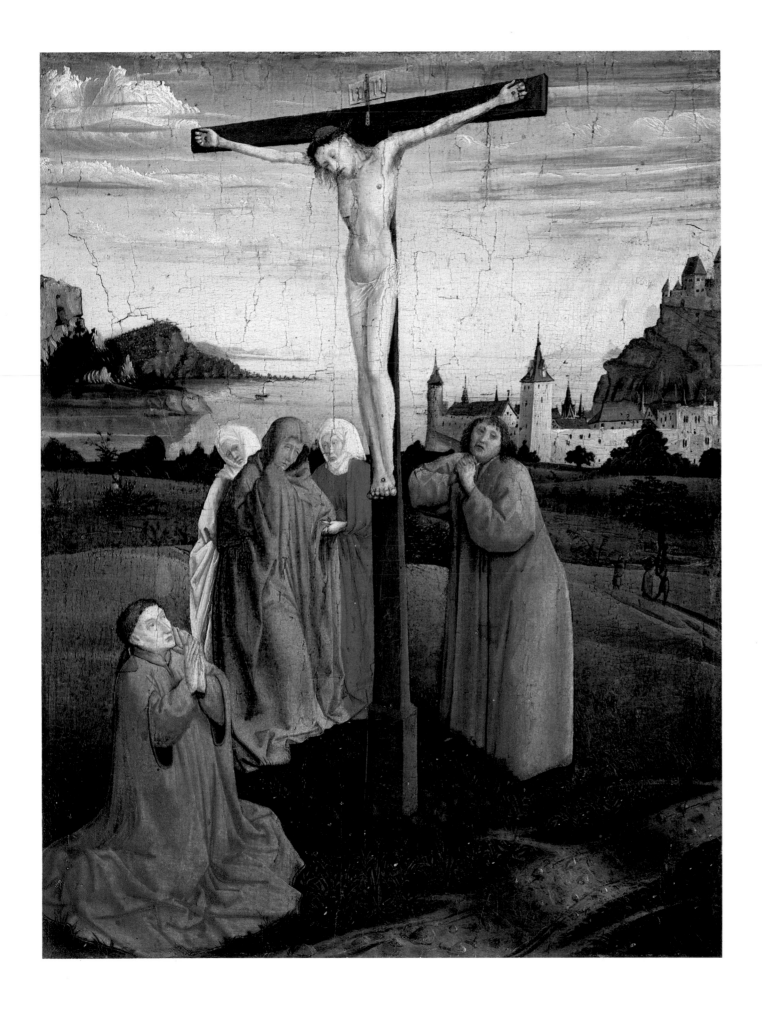

Master Lcz (active *c*.1480–1500)
Christ before Pilate
c.1500

Pine, 77.5 × 60 cm (30½ × 23⅝ in)
Formerly in the Strache Collection,
Dornbach near Vienna
Acquired as a gift, 1917
Cat. no. 1847

Master Lcz
Reconstruction of the *Strache Altar*
c.1500

This panel was once part of an altarpiece which was dismantled, and its paintings were dispersed after having been in the collection of Dr Strache, of Dornbach near Vienna. The other side panels included a *Flagellation* (Paris, Louvre), *Christ Crowned with Thorns* (Nuremberg, Germanisches Nationalmuseum), and a *Crucifixion* (private collection). The centre panel of the original altarpiece was an image of *Christ Praying on the Mount of Olives* or *The Agony in the Garden* (Darmstadt, Hessisches Landesmuseum). Two wings depicting individual saints – a *St Jacob* (at Sigmaringen) and a *St Lawrence* (at Darmstadt) – were apparently also part of the original group. The latter, at any rate, has the same provenance as the central panel. The anonymous artist was long known, after the owner of the panels, as the Master of the Strache Altar, but subsequently stylistic similarities were detected with engravings of 1492–7, signed 'Lcz'. This signature still poses a riddle. Judging by other works of the artist's hand, including a painted *Crucifixion* dated 1485 with a view of Bamberg in the background (Nuremberg, Germanisches Nationalmuseum), 'Lcz' must have been active in that city. Attempts have been made to associate him, on stylistic grounds, with the Bamberg artists' family of Katzheimer. Some authors have even suggested that Lucas Cranach's father may be the mysterious 'Lcz'. About one thing, however, there can be little doubt – that our anonymous master was trained in Nuremberg. His firm drawing and delineation of character, and the striking intensity of his colour, make him one of the most original painters in Franconia before Dürer.

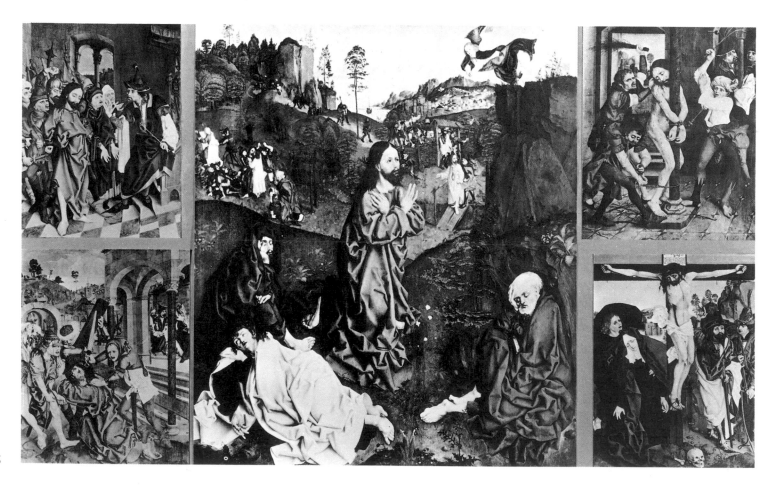

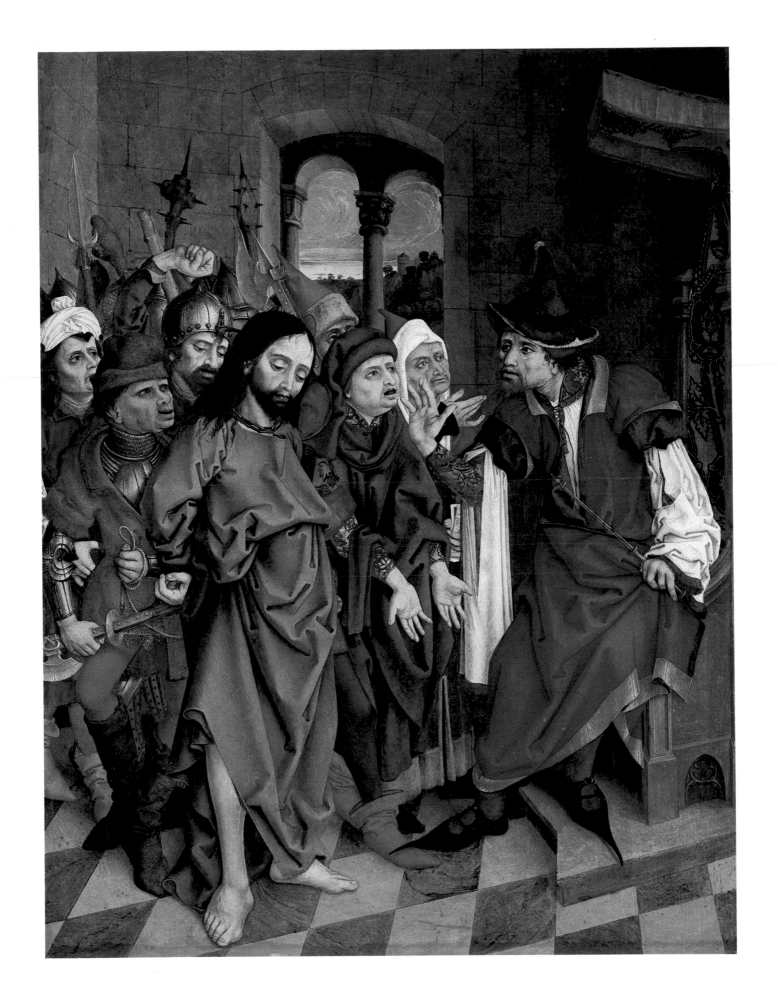

Hans Multscher (c.1400–67)
Wings of the 'Wurzacher Altar'
1437

Fir, each panel 150 × 140 cm (59 × 55 in)
Collection of The Truchsess of Waldburg-Zeil, Wurzach Castle
Acquired as a gift from Sir Julius Wernher, London
Cat. no. 1621 A–G

Hans Multscher, sculptor and wood-carver, was head of a workshop in Ulm. We know of his existence from several contemporary documents and a number of surviving sculptural pieces, though whether he ever worked in the painting medium remains uncertain. Signed with his name are the eight panels of a destroyed altarpiece of 1437 illustrated opposite, four scenes from the Life of the Virgin, and four from Christ's Passion. Their subjects, composition, and certain technical features suggest that they were originally arranged as follows:

Scenes from the Life of the Virgin (see p. 62):

The Nativity	The Adoration of the Magi
The Descent of the Holy Spirit – Pentecost	The Death of the Virgin

Scenes from the Passion (see p. 63):

The Agony in the Garden	Christ before Pilate
The Bearing of the Cross	The Resurrection

Along the bottom edge of *The Death of the Virgin* is a master's device and an inscription reading: 'bitte[n] got für hanssen muoltscheren vo[n] riche[n]hofe[n] burg[er] ze ulm haut d[a]ß werk gemacht do man zalt MCCCCXXXVII [1437].' A shorter inscription above the chapel arches in the *Pentecost* panel contains basically the same information – the name of the master of the workshop combined with a prayer for intercession. This was the common form of signature in the fifteenth century. Further lettering is found on the background tower in the *Adoration* panel – a tablet with a coat of arms bearing the inscription 'Roma'. The coat of arms itself is not that of the town of Landsberg, as some have assumed, but bears the letters 'SPQR' (*senatus populusque romanus*), a reference to the fact that Christ's birthplace was located in Roman territory. Another interesting detail is the hospital coat of arms held by a monkey above the column in *The Death of the Virgin*. Since it contains no tinctures of any kind, it cannot have been meant to stand for any particular hospital. By including it, the artist probably wished to identify the building in which the Virgin died as a hospital or infirmary.

These eight panels, arranged in pairs one above the other, originally formed the inside and outside of the altar wings. The arrangement illustrated derives from the architectural elements which continue from one panel to the next in the Life of the Virgin series. Which scenes were on the front and which on the back of the wings has been established from certain technical features of the wooden panels themselves, and these corroborate the sequence of events depicted. The four scenes from the Life of the Virgin form an integral composition, and they were no doubt originally on the outside of the altarpiece. This is confirmed by their inscriptions, which during the fifteenth century were almost always painted on the outside of such retables. The scenes from Christ's Life and Suffering, moreover, have a white pattern painted over the gilded ground which marks them as the costlier, more opulent inside of the altar reserved for special religious holidays. In short, the original altarpiece contained a sequence devoted to Mary on the outside of its wings and one devoted to Christ's Passion on the interior. The central panel, which has not survived, probably represented a Calvary or Crucifixion group. Though attempts have been made to reconstruct the central shrine using a statue of the Virgin by Multscher from Landsberg, they are misleading because they are based on false assumptions.

Hans Multscher
Wurzacher Altar
Detail: Second inscription in the Pentecost panel

The images are characterized by drastic realism, the artist having portrayed sacred figures and other participants alike as rough and rustic, sometimes positively ugly, and occasionally even brutal. This realism, seeing the Holy Family not as ideal figures but as real people, representatives of the life of the time, and giving Biblical events the appearance of everyday scenes, reveals a new understanding of the Scriptures. Perhaps influenced by contemporary Passion Plays, this approach brought Christianity closer to the daily lives and experiences of the faithful than ever before in Christian art. In this regard the stylistic influence of Netherlandish-Burgundian art also makes itself apparent.

According to the earliest written record, these panels were once in the collection of the Truchsess of Waldburg-Zeil in Wurzach, which is why they were collectively called the *Wurzacher Altar*. Though some authors believe they originated from Landsberg, there is no definite proof for this assumption. Nor has recent research been able to turn up evidence that the church at Landsberg, to which reconstruction attempts would assign the altar, ever existed in that city.

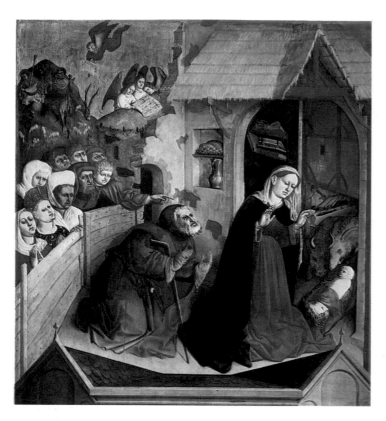

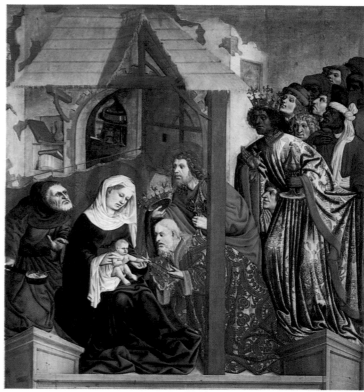

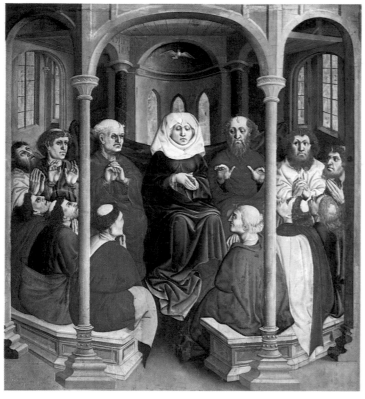

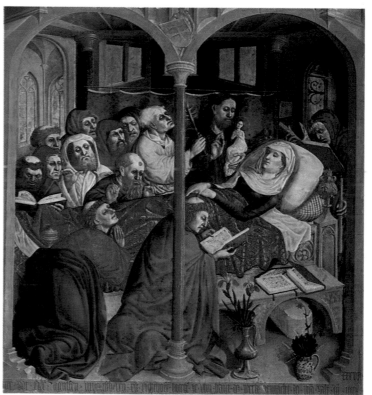

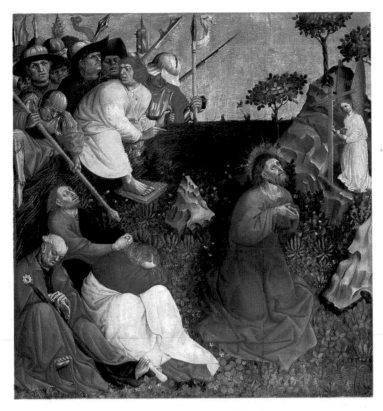

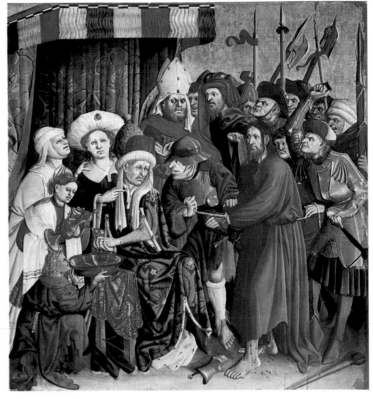

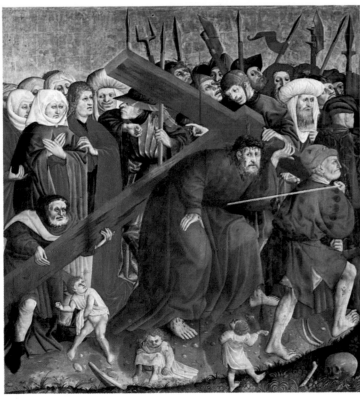

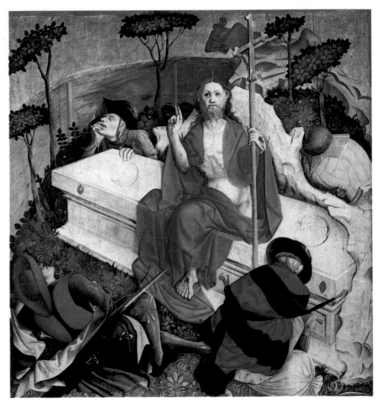

Albrecht Dürer (1471–1528)
The Madonna with the Siskin
1506

Poplar, 91 × 76 cm (35⅞ × 30 in)
Signed lower left: 'Albertus durer
germanus faciebat post virginis partum
1506', and monogrammed 'AD'
(interlocked)
Imhoff Collection, Nuremberg; Emperor
Rudolf II, Prague; The Marquis of
Lothian, Edinburgh
Acquired 1893
Cat. no. 557 F

Albrecht Dürer
The Infant Christ
Preliminary drawing for *The Madonna
with the Siskin*
Formerly Bremen, Kunsthalle

The Virgin, clothed in blue, is seated on a throne in the midst of a spacious landscape, holding the Child on a red cushion in her lap. The boy at her feet, giving her a bunch of lilies-of-the-valley, is John the Baptist, recognizable from his cloak of camel's hair and the cross of staves held by the angel accompanying him. Mary's right hand rests on a book, while Jesus, his thin shirt slipping from his shoulders, plays with a sucking-bag, the medieval version of a pacifier. A siskin has settled on his raised left arm, and he inclines his head as if to listen to its song. Mary's head and shoulders are set off by the brilliant red canopy of the throne, the rest of which is hidden; to the right and left we look out over a broad valley with farmhouses and ruins set among trees. Two cherubim hover above the Virgin's head, about to crown her with a wreath of red and white roses. On the table at the lower left lies a slip of paper with Dürer's inscription: *Albertus durer germanus faciebat post virginis partum 1506 AD* (his interlocked monogram).

This date of 1506 places the painting in Dürer's Venice period. From other sources we may infer that he executed it at about the same time as his large *Feast of the Rosary* (Prague), painted for German merchants in Venice. In fact, his *Madonna with the Siskin* is a Virgin with rosary too – the garland of roses above her head. This crown of roses held by angels symbolizes the eternal bliss promised to Mary, and the red and white of their blossoms represents the mysteries of the rosary, the sufferings and joys of the Virgin's life. Other symbolic allusions include the lilies-of-the-valley, which are among the first flowers to bloom in spring; a sign of regeneration which stands here for the advent of Christ. They have also been traditionally associated with the Virgin and the Immaculate Conception because of their perfume and the chaste whiteness of their blossoms. And their name – *convallaria* – recalls a passage in the Song of Solomon which was often applied to Mary: 'I am the rose of Sharon, and the lily of the valleys.' As for the siskin, this bird is reputed to feed on thistles and thorny seeds, making its appearance here a reference to the crown of thorns and the Passion. The message it is whispering in the Child's ear, then, may be understood to presage his mission and the suffering it will entail. The bird becomes a symbol of the inexorable link between Christ's incarnation and his fate on the cross. The book so prominently displayed stands for the Scriptures, whose prophecy that a new King would be born is now fulfilled. Nor are the ruins in the background mere picturesque additions. In the iconography of the period they signified the ruins of King David's palace, where according to Christian legend the stable stood. The palace both alludes to Jesus's royal origins in the House of David, and symbolizes decline, the demise of the old covenant. Through Christ, God entered a new covenant with mankind.

The motif of the Christ Child with siskin apparently has a long tradition in art, as can be seen from a *Virgin* from the town of Most in Bohemia, painted before 1350. Dürer's inclusion of the young John in his *Madonna* suggests Italian compositions, which he probably saw during his stay in Venice. Presumably Dürer brought the picture back with him to Nuremberg, since only if he did so can a number of sources be interpreted as referring to it. It entered our collection at a late date, in 1893.

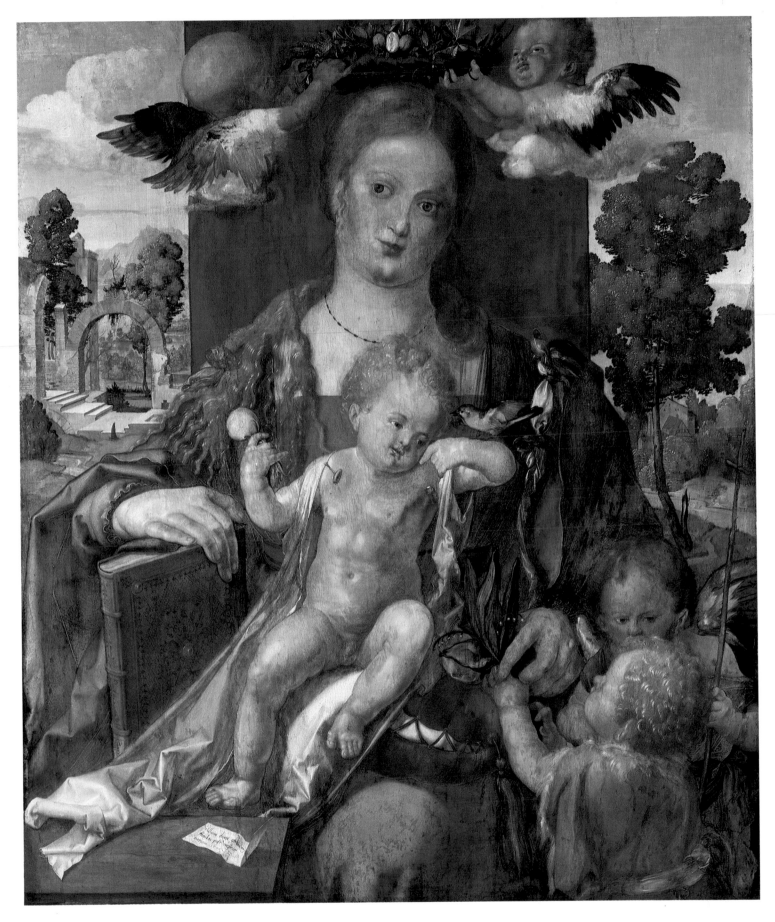

Albrecht Dürer
Portrait of a Girl in a Red Barett
1507

Parchment mounted on panel,
30.4 × 20 cm (12 × 7⅞ in)
Signed upper left: '1507 AD' (interlocked)
Imhoff Collection, Nuremberg
Acquired as a gift from P.D.Colnaghi,
London, 1899
Property of the
Kaiser-Friedrich-Museums-Verein
Cat. no. 5571

Here the head and shoulders of a young girl appear against a dark background, as if in close-up, almost entirely filling the picture plane. The girl, her head slightly inclined, has a pensive look; her light blonde curls billow out from beneath the red barett, framing the delicate rosy blush of her face. Decorating her barett is an exquisite piece of jewellery, a mounted ruby with dependent pearl.

Though the girl's head is depicted frontally, her strangely absent gaze is directed past the observer. Her dress of carmine red has a wide green band bordering the low, square-cut *décolleté*. In the upper left corner Dürer has inscribed the date 1507 and his monogram, AD.

There has been some debate about whether the painting was done in Venice, where Dürer worked from 1505 to the late autumn of 1507, or after his return to Nuremberg. Judging by the model's evidently German costume, the latter is probably the case. The girl's identity is not known, nor indeed whether this is a portrait in the strict sense at all. Some commentators think it may be an invented head of the kind Dürer frequently executed. The slight asymmetries of the features, however, would suggest that he worked from life. Old inventories mention the painting several times, and one mistakenly calls it a portrait of a boy – perhaps on account of the barett. Though the cut of the dress really leaves no doubt as to the model's sex, later critics have continued to detect an androgynous expression in her face.

The painting has had no lack of admirers through the centuries, and two copies show that artists were among them. The first of these, mentioned in seventeenth-century Vienna, has been lost. A second copy was executed by Peter Corduer, a Dürer specialist of Nuremberg. During the first half of the seventeenth century Corduer made several copies of the master's paintings, frankly marking his authorship by placing a 'c' above Dürer's monogram. His imitation of the present painting was in the collection of the Ebner Cabinet in Nuremberg until after 1800, when sometime during the early nineteenth century the 'c' was deleted in the hope of transforming the copy into an original. After that episode, the painting was lost to sight until just a few years ago, when it was acquired by the Vienna Academy.

Copy after Albrecht Dürer
by Peter Corduer
Nuremberg, *c.*1630–5
Vienna, Akademie der Bildenden Künste

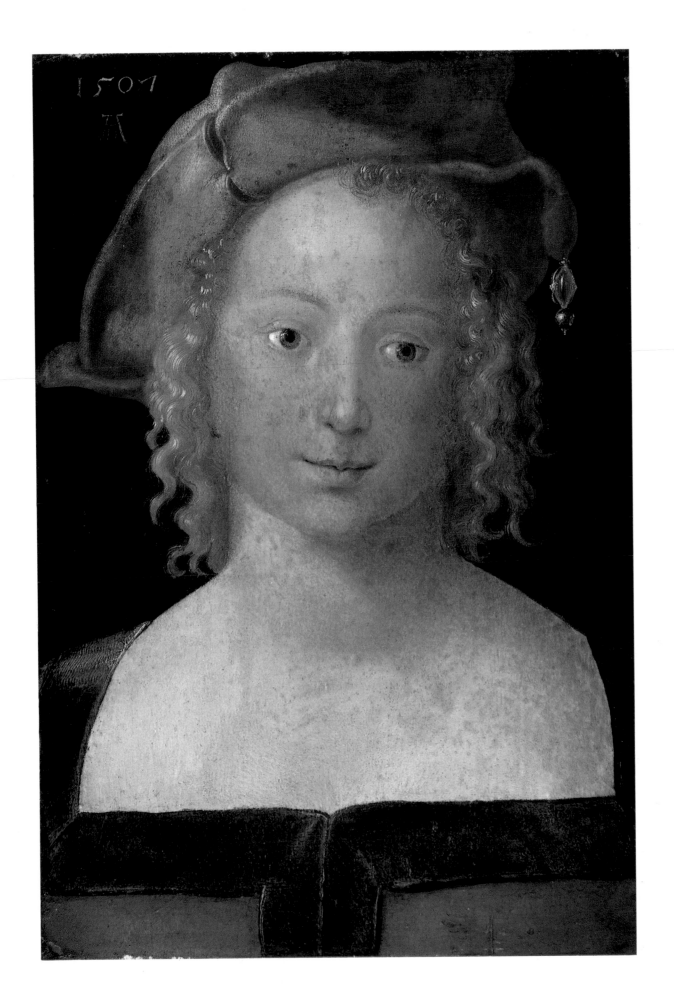

67

Albrecht Dürer
Portrait of Hieronymus Holzschuher
1526

Linden in original frame with sliding cover embellished with arms of Holzschuher and Müntzer families, 51 × 37 cm (20 × 14½ in)
Inscribed upper left: 'HIERONIM[VS] HOLTZSCHVER ANNO DO[MI]NI 1526. ETATIS SVE. 57'; monogrammed upper right: AD (interlocked)
Acquired from the Holzschuher Collection, Nuremberg, 1882
Cat. no. 557 E

Albrecht Dürer
Sliding cover of *Portrait of Hieronymus Holzschuher*
Berlin, Gemäldegalerie SMPK

Dürer's *Portrait of Hieronymus Holzschuher* was preserved at Nuremberg until late in the last century, apparently largely forgotten for long periods. First rediscovered with the early nineteenth-century revival of interest in the German Renaissance, about 1812, the portrait became the talk of the town. So astonishingly new and modern did it seem that Sulpiz Boisserée, a great connoisseur and collector of old art, thought it was a fake. 'A rogue of the first order,' he wrote to his brother, 'has had his hand in this.' The idiosyncracies of Dürer's style were present in such concentration here that Boisserée thought he detected the exaggeration of a forger's hand. He was mistaken, for the painting was not unknown to earlier periods and many records of it existed; and today it is considered one of the finest of Dürer's late portraits. The inscription at the upper left names its sitter: 'HIERONIM[VS] HOLTZSCHVER ANNO DO[MI]NI 1526. ETATIS SVE. 57' (that is, painted in the sitter's fifty-seventh year). Herr Holzschuher belonged to one of the powerful Nuremberg families involved in municipal government. After advancing in 1499 to the Inner Council, he became Junior Mayor in 1500 and Senior Mayor in 1509. In 1514 he was elected as *Septemvir* to the High Council, in whose hands the affairs of the town rested. Holzschuher was also among Dürer's personal friends.

The artist has concentrated here on Holzschuher's massive head and shoulders. Unlike the sitters in many of Dürer's portraits, he turns towards us, fixing us with his brilliant eyes, in which the lights and reflections of the room shimmer. Judging by the mixture of kindness and scepticism in his gaze, Holzschuher must have been a man of frank and fearless character. For all the softness of the modelling, which follows every surface, furrow and protuberance of the face, its forms are sharply, even mercilessly delineated. The slight asymmetry of the features, and the furrowed forehead, are carefully observed. The sitter's rather austere expression is mitigated by gently arched, sensitive lips and by silvery hair encompassing his high-complexioned, ageing face like a wreath. The hair in itself is a masterpiece of variety and interest. From the long, flowing curves of locks and strands above, to the tranquil lines in the moustache emphasizing the shape of the mouth, to the thickly intertwined beard, Dürer's brush has traced a silvery weave that has a fascination all its own.

For all the undoubted realism of this portrait, Dürer clearly intended to do more than reproduce the appearance of an individual. His close study of character leads us to believe that we know more about the sitter than a face can be expected to divulge. And this characterization is so heightened as to transcend the individual to become a general type. This was no official portrait, however. The old frame in which it is still mounted has a sliding wooden cover, decorated with the allied arms of the families of Holzschuher and Müntzer, from which Holzschuher's wife came. This cover, inserted between the dark-stained inner frame and an outer frame of light ashwood, was meant to protect the portrait, which was presumably kept in the family and rarely exposed. Perhaps it owes its excellent condition to this very circumstance.

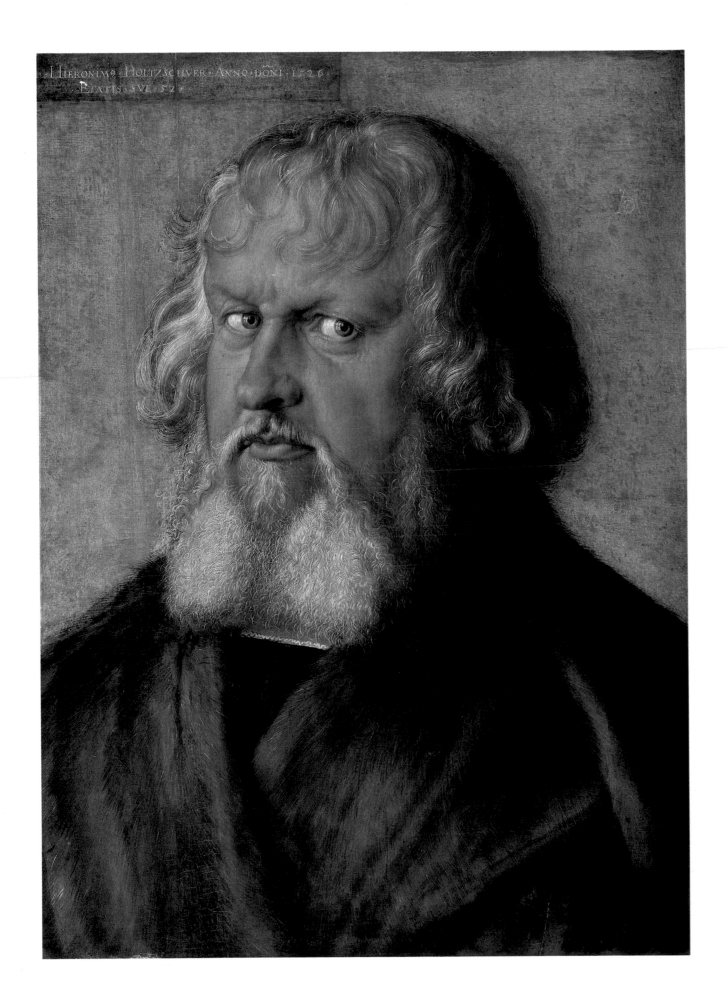

Hans Suess von Kulmbach (c.1480–1522)
Adoration of the Magi
1511

Linden, 153 × 110 cm (60¼ × 43¼ in)
Signed left, on the post: '1511 HK'
(interlocked)
Acquired from the Fr.v.Lippmann
Collection, Vienna, 1876
Cat. no. 596 A

Hans Suess von Kulmbach
Head of Joseph
Drawing
Erlangen, Universitätsbibliothek

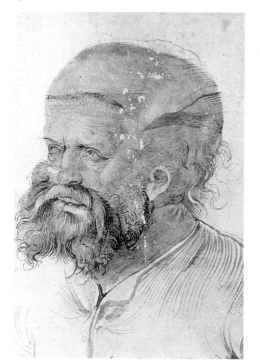

The Adoration scene is set in the ruins of an ancient palace, with the Virgin and Child seated before a column of greenish marble. The three wise men from the East and their retinue have followed the star to Bethlehem, and give obeisance to the new-born King. Two of them kneel before the Christ Child, offering gifts. The young African king at the left brings a covered chalice made of chased gold. Opposite him, an old monarch in a red robe trimmed with ermine kneels before the Virgin, presenting a bowl of gold coins for which the Infant stretches out his hands. A third monarch, an exquisitely clad Oriental in a turban, approaches with his attendants from the rear. His gaze seeking the Child, he takes from his servant a pear-shaped, chased silver goblet. Through the arch behind him is a spacious landscape with men approaching on horseback, some of them in Polish costumes, and one leading a camel. At the left edge of the painting is the stable; on its corner-post is a slip of paper with the date 1511, and below it Kulmbach's interwoven monogram HK. Behind Mary, Joseph talks with two noblemen from the king's retinue. A night sky over-arches the ruined walls, illuminated by the Star of Bethlehem, while in the distant valley, bright daylight still suffuses fields and woods.

According to legends, the ancient ruin where Christ was born was all that remained of the once glorious Palace of David. Here it symbolizes Christ's origin from the tribe of David, and at the same time graphically illustrates that the era of David and the Old Covenant is over. The column behind the group, recalling the column against which Christ was scourged, anticipates the Child's destiny and future suffering. The Three Kings are distinguished from one another both by age and by race. While the African king is young, the Oriental is middle-aged and the third, whose costume seems European, has reached venerable old age, signifying that every generation has come to worship the new-born King. And the three races to which the Magi belong show that all three continents of the known world – Africa, Asia and Europe – are present at the great event. Among the attendants is one whose features are strikingly individual: the man in a black cap beneath the archway. This is presumably a portrait of the donor.

The *Adoration of the Magi* is the middle panel of a disassembled folding altar. Two other panels, *The Presentation in the Temple* and *Flight into Egypt*, are still at the Na Skalce Monastery in Cracow, as is a copy of the *Adoration*. We may conclude that the original Altar of the Virgin was executed for a Cracow church – perhaps that of the Na Skalce Monastery – and was long located there. Two preparatory drawings for the heads of Mary and Joseph are now in the collection of the Erlangen University Library.

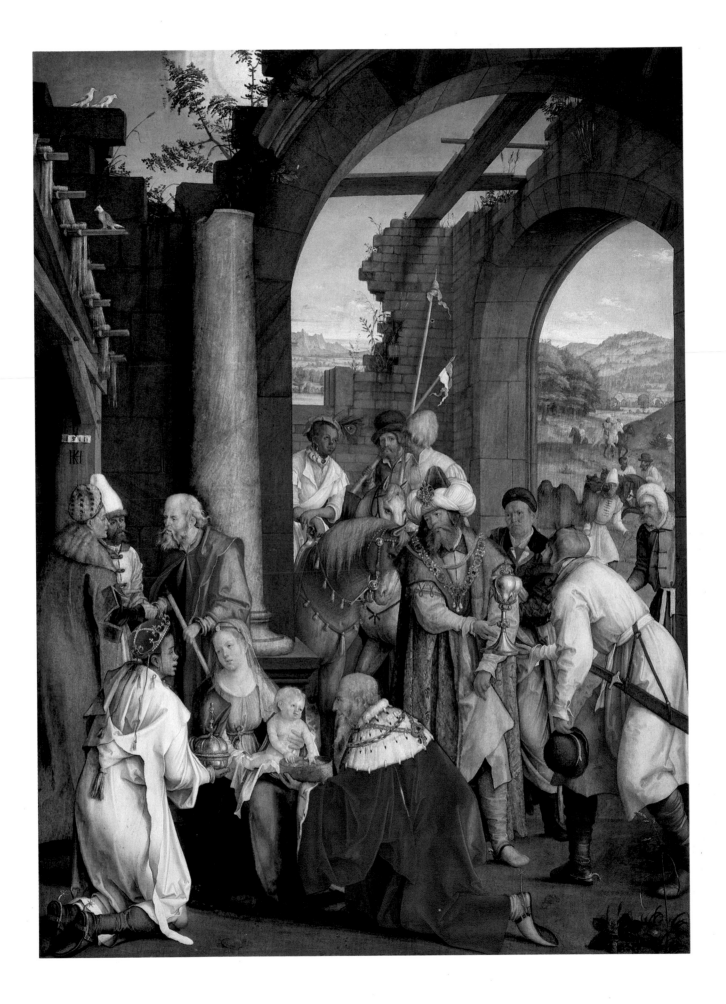

Hans Baldung, called Grien (1484/5–1545)
Three Magi Altarpiece
1507

Linden, central panel 121 × 70 cm
(47⅝ × 27½ in), wings each 121 × 28 cm
(47⅝ × 11 in)
Domkirche Halle an der Saale, 1838
Acquired 1872
Cat. no. 603 A

Hans Baldung, called Grien
Altarpiece of the Three Magi
Exterior of wings. Left: *St Catherine*
Right: *St Agnes*
Berlin, Gemäldegalerie SMPK

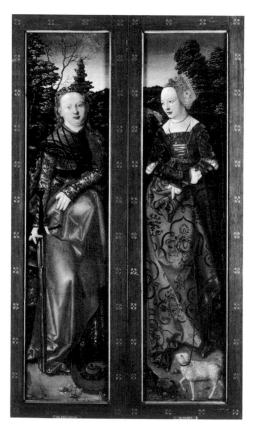

Shortly after leaving Dürer's workshop, Hans Baldung Grien executed two alterpieces for a church in Halle, traditionally thought to be St Liebfrauen, the Church of the Blessed Virgin. One of these was the *Three Magi Altarpiece*, a three-part folding altar with hinged wings which can be closed over the central panel to conceal the main display side. When the wings are closed, images of two female saints are visible, St Catherine and St Agnes. St Catherine, on the left, was an Alexandrian noblewoman who resisted Caesar Maxentius's attempts to make her renounce her Christian faith and suffered martyrdom by the wheel and sword. St Agnes, depicted on the outside of the right-hand panel, was a Roman martyr of about AD 300. The lamb she is leading refers to the consonance of her name with *agnus* ('lamb') and also alludes to her faith in Christ, the Lamb of God.

The middle panel represents the three Wise Men from the East who have come to worship and present their gifts to the Christ Child. Their different ages suggest that reverence for the new-born King knows no age barriers, while the African and Oriental monarchs symbolize the continents which join with Europe in bringing their offerings. An embodiment of Europe may be seen in the standing figure in the centre, whose penetrating gaze and individual features suggest that he may represent the painting's donor. A portrait of this man also appears – as Emperor Diocletian – on the related *St Sebastian Altar* in Nuremberg, which also includes a self-portrait by Baldung. In all probability, the donor was a member of the Wettin family, the princely house of Saxony. Several of its members have been suggested, among them Ernst von Wettin, Archbishop of Magdeburg and Bishop of Halle at the time the altar was executed. Other authors believe it was commissioned by his brother, Frederick the Wise, Elector of Saxony. The figure's cap, worn aslant and topped by a floral wreath, has many key features in common with the lozenged chaplet of the Saxon arms, and may be an allusion to them.

Depictions of two saints in knightly armour are on the interior of the wings. St George, on the left, was a legendary Cappadocian soldier who served the Emperor Diocletian. Most renowned for freeing a princess from the clutches of a dragon, St George was patron saint of all knights and soldiers. Opposite him on the right wing is St Mauritius or Maurice, leader of the Theban Legion, who suffered a martyr's death. As patron of the Archbishopric, he was also of great importance to the town of Halle. The Moritzburg citadel on the heights above the town was erected in his name by Archbishop Ernst of Magdeburg, one of the presumed donors of the present altar.

The *Three Magi Altar* is a companion work to the *St Sebastian Altar* in Nuremberg, which is dated 1507. It is not known for which church these retables were created. At the beginning of the last century they were both at Nuremberg Cathedral, possibly commissioned for that Cathedral by Archbishop Ernst in 1507. A comparison of styles indicates that the altar now in our collection must have preceded the one at Nuremberg, though both were among the first works Baldung executed after leaving Dürer's workshop. The emphasis on the figures, which dominate the composition, is new for him and quite foreign to the art of Dürer. Brilliant colours and a joy in representing shimmering textiles and highly polished metal are also characteristic of Baldung's style. These features have suggested Cranach's influence, some of whose paintings Baldung probably saw in Saxony.

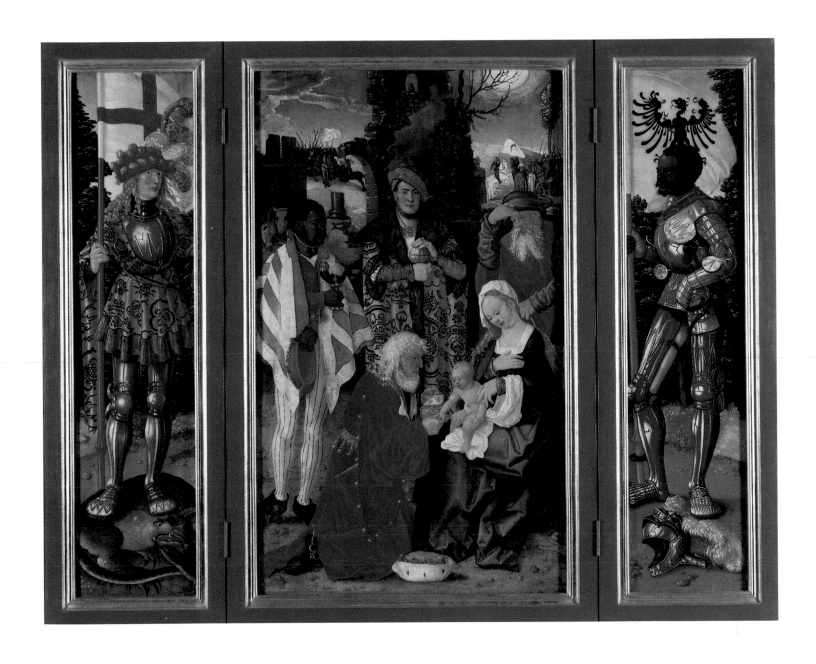

Hans Baldung, called Grien
Pyramus and Thisbe
*c.*1530

Linden, 93 × 67 cm (36⅝ × 26⅜ in)
Acquired 1920
Cat. no. 1875

Here an ancient story (Ovid, *Metamorphoses* IV, 55 ff.) is recounted in contemporary costume. Pyramus and Thisbe, children of neighbouring families in Babylon, loved each other against their fathers' wills. They agreed to meet one night at a spring outside the city. Thisbe arrived first, but only to confront a lioness which had come to slake its thirst at the spring after a kill. Thisbe fled, leaving her veil behind; the wild beast tore it, sullying it with blood. All Pyramus found when he came on the scene were the lioness's tracks and the bloody veil. Distraught at the apparent death of his loved one, he killed himself. Thisbe, returning to find Pyramus dying, realized what had happend and turned her lover's sword against herself.

In the painting, Pyramus lies prostrate on the ground in his blood, a dagger in his breast, his red cloak spread out beneath him. He is clad in a blue doublet and yellow hose; his blue, plume-trimmed hat has slipped from his head. The pose of the figure, depicted diagonally from below and extremely foreshortened, lends it decorative grace even in death. Thisbe, in a red gown with a pale skirt, has apparently just come upon her lover's body and wrings her hands in despair. Behind the couple rises a fountain and two pools; Pyramus's head has sunk on to the pools' steps. The central column of the upper trough is crowned by a winged *putto* that may signify Cupid, symbol of the couple's love. In the background, the buildings of a town or castle grounds are visible. The scene is set in a glowering, blue-black night; the clouds part at the upper right to reveal a whitish-yellow glare of moonlight that tinges the clouds and suffuses the landscape with dim, cold illumination.

Ovid's tale, a variant of which also appeared in the *Gesta Romanorum*, one of the widest-read narratives of the Middle Ages, tells of the love of two young people and how they died for its sake. Their sacrifice for love and mutual faithfulness was frequently cited as an example of great virtue. As such the Pyramus and Thisbe story often appeared together with similar themes in cycles of paintings representing the virtues.

Baldung executed the present painting about 1530, and at the same time three other subjects from classical antiquity: *Hercules and Antaeus*, *The Sacrifice of Marcus Curtius*, and *Mucius Scaevola at Porsenna*, stories similarly illustrating exemplary virtue.

Such mythological themes were often infused with a Christian message during the Middle Ages, Pyramus's death, for instance, being treated as a symbol of Christ's sacrifice. However, certain differences among the four paintings just mentioned would seem to indicate that they were not meant as an integral sequence. The assumption that they were is a shaky one at best.

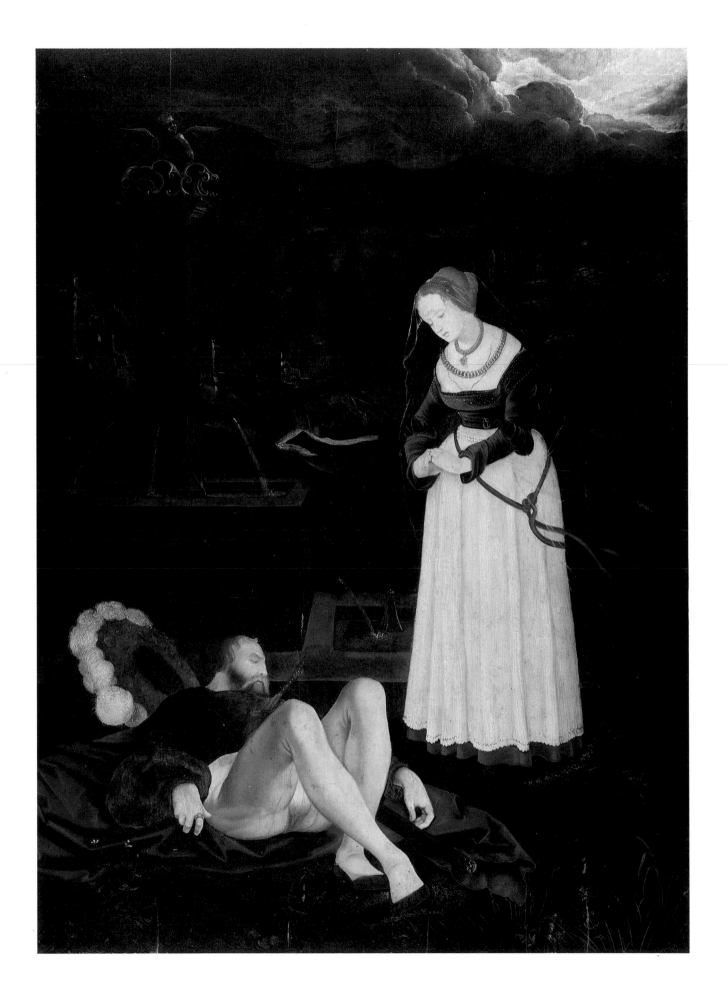

Lucas Cranach the Elder (1472–1553)
Portrait of a Law Scholar's Wife
1503

Conifer, 52.5 × 36.2 cm (20⅝ × 14¼ in)
Collection of
Prince Schwarzburg-Rudolstadt
Acquired 1923
Cat. no. 1907

Cranach has placed his sitter before rugged mountain scenery much in contrast to her red gown with its elaborate gold embroidery. Her hair is wrapped in a kerchief, a sign that she is a married woman. An elaborate belt and the many rings on her fingers underline the impression of prosperity which the artist evidently wished to give here.

Behind the sitter's shoulders, two trees are silhouetted against the sky on the right and left, linking the foreground figure with the background mountains, human being with environment. But the trees are more than a formal device. While the tree on the left is in full, green leaf, the other is almost bare – a contrast that visually evokes the course of the seasons, indeed the transience of all life. The idea of birth and death, growth and decay, is translated into visual symbolism which enriches the significance of the portrait image.

Never intended to stand alone, the picture was originally half of a double portrait or perhaps even the right wing of a portrait diptych. Its counterpart represents the lady's husband, a lawyer clad in rich, red robes (Nuremberg, Germanisches Nationalmuseum). This portrait is dated 1503. According to a later pencil note on the back (which has since become illegible) the sitter was a certain Stephen Reuss of Constance, member of the law faculty and Rector of Vienna University. Based on this information, the Berlin painting was long known as *Portrait of Frau Reuss*. Subsequent investigation, however, has revealed that the office of university rector was incompatible with marriage during the period in question. This makes the identification of the portrait with Stephen Reuss doubtful. The sitter's costume and attributes nevertheless characterize him as a jurist of Vienna University.

Though Cranach did work in Vienna in 1503, it proved difficult to attribute this portrait to him, since his work from 1500 to 1505, when he becomes court artist in Wittenberg, long remained in obscurity. Not much more is known even today about the early œuvre of this artist, who was almost contemporaneous with Dürer and who was active presumably from about 1490. Our portrait of a woman was classed as a Dürer in the nineteenth century probably because of its high quality. Later it was attributed to Albrecht Altdorfer, then to Hans von Kulmbach. Not until the 1890s were those paintings gradually associated with Cranach and they are now classified as belonging to his early œuvre. In 1903, the Nuremberg *Portrait of a Law Scholar* and our female portrait were exhibited side by side for the first time, and since then no one has doubted that they belong together. The dating of our portrait is based on this perception.

Lucas Cranach the Elder
Portrait of a Law Scholar, 1503
Nuremberg, Germanisches
Nationalmuseum

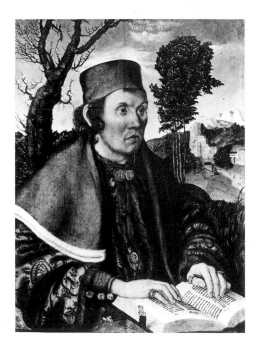

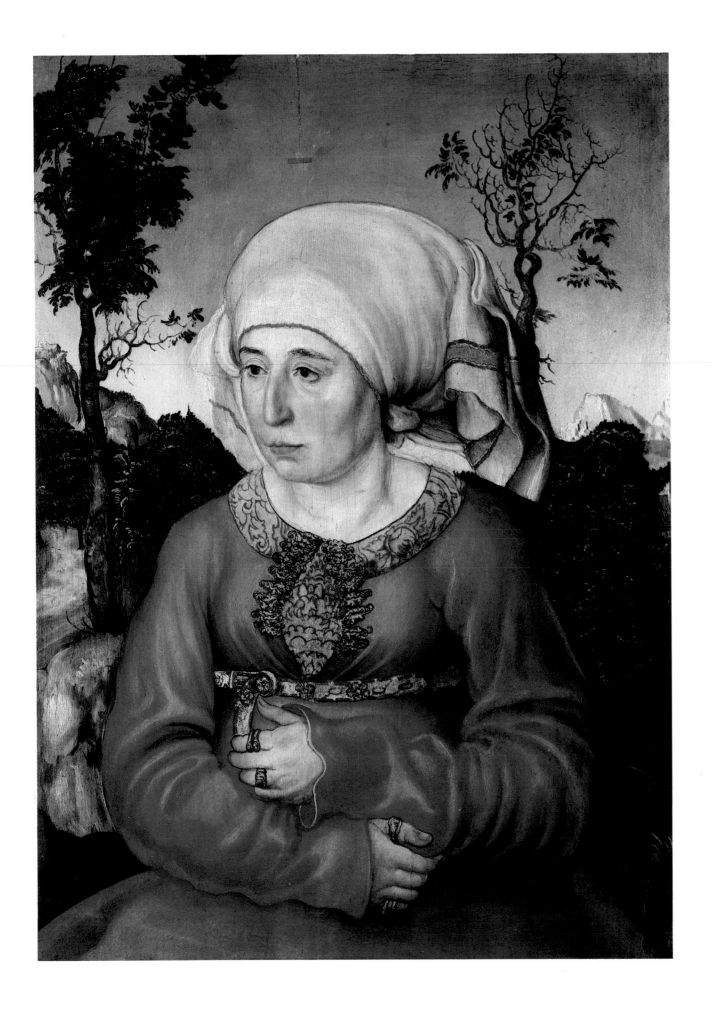

Lucas Cranach the Elder
Rest on the Flight into Egypt
1504

Red beech, 70.5 × 53 cm (27¾ × 20⅞in)
Signed bottom on two slips: 'LC'
(interlocked) and '1504'
Galleria Sciarra, Rome, 1873; K.Fiedler
Collection, Munich
Acquired 1902
Cat. no. 564A

Albrecht Dürer
The Holy Family with Rabbits,
*c.*1496–7
Woodcut

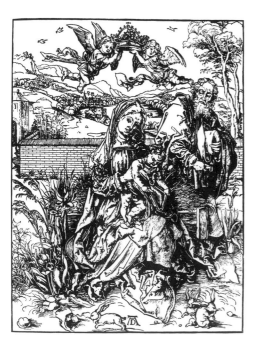

The Holy family rests on a grassy slope, Mary at the edge of a path leading up from the right, with the Child standing in her lap. Behind her is Joseph, hat in hand and leaning on his staff. Three young and beautifully clad angels in the centre sing and play the flute, surrounded by five *putti*. As one listens, another sleeps with his head resting on a mossy boulder behind the group. At a spring coming from the rock a third infant angel fills a pilgrim's flask opened at the side. Two others are bringing gifts to the Child – a strawberry plant with blossoms and fruit, and a live bird, a goldfinch, struggling in the grasp of the *putto* at the left. An abundance of plants and flowers, among them primroses, thistles, columbine and fumitory, lend the wild spot the appearance of a garden in bloom. The scene is set off by a middle ground consisting of a bluff at the left, where a young spruce grows among other trees both green and bare, a yellowing old fir in the middle, and a birch at the right. In the background ranges of steep hills lead back to the mountains on the horizon.

This depiction of *The Flight into Egypt* is unusual, and it is interspersed with many symbolic and legendary allusions. The flowering garden sequestered among hills surely represents a haven of peace; many of its plants refer symbolically to Mary and Jesus and the events of their lives. While the strawberry was considered a fruit of paradise, columbine and primrose were often symbolically associated with the Virgin and Child as well as with Christ's Passion. The thistle, too, being a thorny plant, recalls his Crown of Thorns and his agony. Underlying the tranquil peace of the scene is a foreboding of torment to come. The spring derives from the legend where Jesus made the rock give water to refresh a weary pilgrim, water that transformed the waste into a garden. The angels singing and playing enhance the other symbolic references and contribute to the paradisal aspect of Mary's and Joseph's resting place, where worldly cares give way to divine joy.

Cranach's composition was apparently influenced by some of Dürer's prints. Several motifs in Dürer's *Holy Family with Rabbits* of 1496–7, for instance, anticipate those in the painting. Cranach himself later, in 1509, repeated the composition in a series of woodcuts, and a quite faithful copy of this painting is still to be seen in Vienna. Its existence suggests that Cranach must have executed his *Rest on the Flight* before leaving Vienna for Wittenberg.

This is Cranach's earliest signed and dated work (1504). Before it became known, art historians had great difficulty reconstructing the years before the artist's Wittenberg period and establishing convincing attributions. Very few had ever seen the painting, and had to rely on descriptions. Not until 1892 was it publicly exhibited for the first time, in Munich, a crucial event for research on Cranach's early period. His *Rest on the Flight* is certainly one of the most charming and aesthetically significant paintings he ever executed.

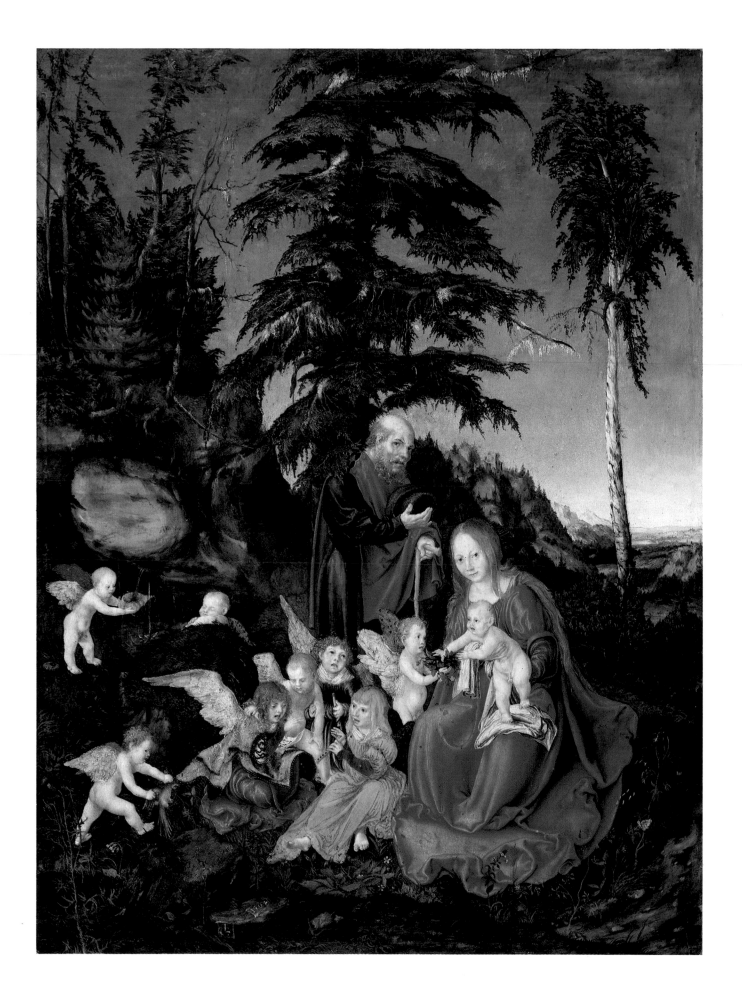

Lucas Cranach the Elder
The Fountain of Youth
1546

Linden, 122.5 × 186.5 cm (48¼ × 73⅜ in)
Inscribed lower centre with the sign of the
winged snake and date, 1546
From the Royal Palaces, Berlin
Cat. no. 593

A longing for immortality, for perpetual youth, can give rise to visions of being born anew, of sloughing off the pains and weariness of age. In the past, rejuvenating powers were attributed to the four elements – earth, water, fire and air – which were thought to embody magical, procreative and purifying forces. Everyone had seen how nature refreshes herself in the course of the seasons – awakening in spring, maturing in summer, bearing fruit in autumn, and wasting in winter only to revive again. This power to create new life continually from the old, it was believed, could also help the ageing to recover their youth. A miraculous rejuvenating force was attributed especially to fire and water. The legendary phoenix, consumed in flame and emerging from the ashes in new glory and youth, is only one instance of human longing for reincarnation, expressed in many and varied myths, legends, and fairy-tales. Somewhere in the wilderness, in unexplored territories far from the habitations of man, existed a fabled source, a spring or lake whose water had the power to wash away the traces of old age. Whoever bathed there would emerge transformed. The story and the belief were widespread in Cranach's times.

By the late Middle Ages the Fountain of Youth legend had already entered literature. A poem on the subject by the Nuremberg poet Hans Rosenplüt enjoyed wide popularity in fifteenth-century Germany. Two years after Cranach painted his *Fountain of Youth*, Hans Sachs wrote a poem whose motifs recall those in Cranach's image. And though it is unique in being the only known large easel-painting on the theme, Cranach's *Fountain of Youth* by no means stands alone. Representations in the graphic arts are not rare, and frescoes also exist. There were many variations of the fable, from the traditional fountain where pilgrims of both sexes gathered, to some where only women bathed.

A belief in the purifying powers of water also underlay the ritual washings common in many religions. Christian baptism, one such ritual cleansing from sins, provided a parallel with the ancient fable and brought it into the religious sphere. In a book entitled *Badenfahrt* (Strasbourg, 1514) Thomas Murner, a humanist philosopher of Alsace, described baptism as a fountain of youth for the soul. This idea inspired many artists, among them Jean Bellegambes, who in a painting now at Lille depicted a baptismal font filled with the blood of Christ, a crucifix emerging from the font like the shaft of a fountain. Personifications of the virtues, Caritas and Spes, help the faithful to the font where their sins will be washed away.

Cranach's *Fountain of Youth* is rather more secular by comparison. Far from the town, whose roofs and towers are visible on the horizon, a rectangular basin, with steps leading down into it, lies among gentle hills and meadows. This fountain is apparently reserved for women, who approach from a rugged and parched mountain region that evokes the infirmities of old age. Unable to help themselves, the women are being brought by carts or waggons, on stretchers, even pick-a-back, to the edge of the pool, where girls help them to undress. One submits to her doctor's last sceptical inspection before taking the plunge. Their different personalities are well characterized, their poses and gestures contributing to reveal expectant hope, doubts, even fears. While some of them descend resolutely into the basin, others sit vacillating on its edge, waiting to be convinced, by force if need be. They enter the water infirm, helpless, deformed by age, and as they pass through it the women's wrinkles are magically smoothed, their sallow skins take on tone, until on the other side they emerge girlish and desirable. There a gallant gentleman receives them, pointing the way to a tent where they may dress. Adorned in new gowns and jewellery they enter a round dance, consort with cavaliers, take their places at table. It is a courtly group spending a pleasant day in the country with dancing, feasting and flirting, a joy in life and youth revived that are symbolically echoed in the sylvan surroundings. Here are the green

fields and verdant vegetation of a pleasure-garden while behind, dry precipices symbolize old age.

The nature of the fountain's rejuvenating power is suggested by the figures presiding from the column in its centre: Cupid, god of love, and Venus, goddess of love and beauty. The revivifying forces are in them, and through love these forces take effect. But why is it that only women experience the magical metamorphosis in Cranach's fountain? A contemporary of his, Rabelais, gives the answer in *Gargantua and Pantagruel* (Book 5, chapter 21). Here we read how Pantagruel, among countless other incredible happenings in the 'Realm of Quintessence', sees old crones melted down and recast into girls of fifteen and sixteen. Asking whether old men were not similarly transmuted, he is told, no – only the society of young women can rejuvenate *them*.

Cranach's *Fountain of Youth*, in other words, is a fountain of love. He has reinterpreted this ancient theme and given it a new and ironic twist to accommodate the sophisticated tastes of his noble patrons.

The painting, signed and dated 1546, has traditionally been classified as a work of Lucas Cranach the Elder. However, it was twice attributed to his son, Lucas, once erroneously and again wrongly. The disposition of the landscape elements as pictorial symbols; the drawing of the figures, varied and assured yet fluent; and the thin, transparent paint application, are sure signs of Cranach the Elder's mature style.

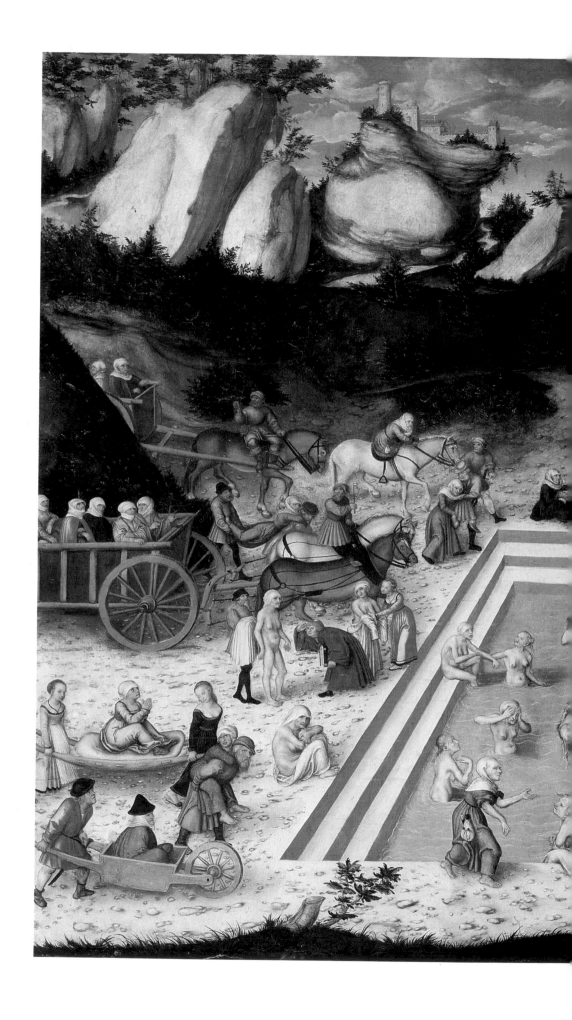

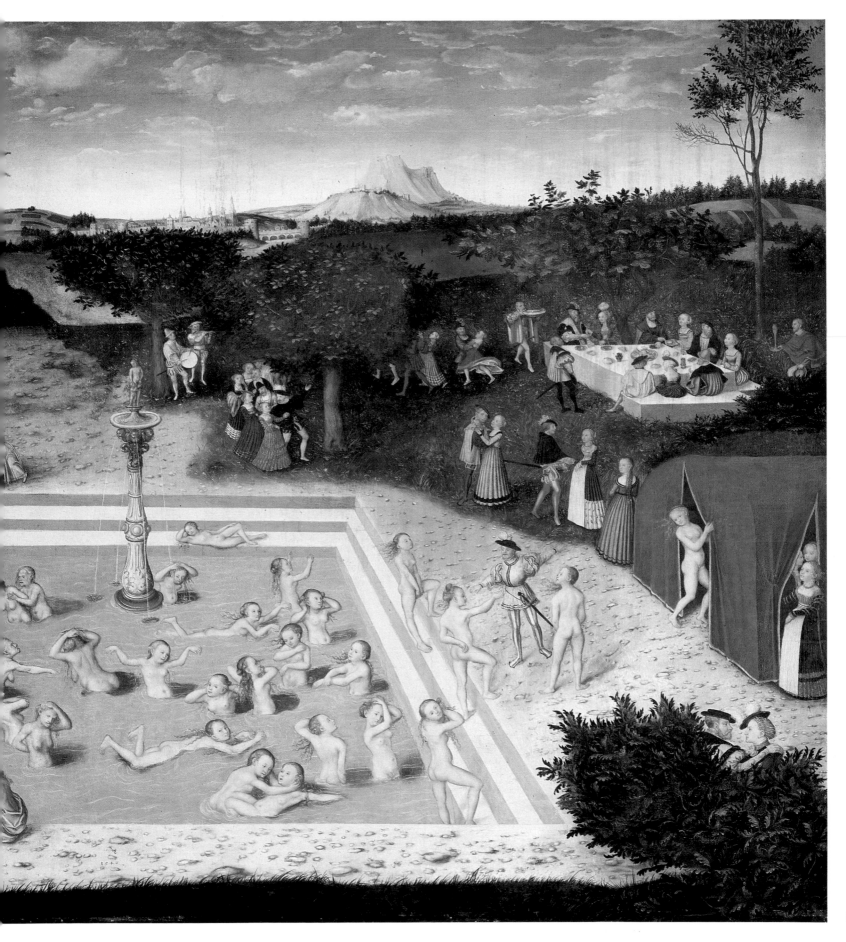

Hans Burgkmair (1473–1531)
Wings of an Altarpiece
St Ulrich – St Barbara
*c.*1518

(St Ulrich)
Conifer, 105.2 × 41.2 cm (41½ × 16¼ in)
Acquired 1843
Cat. no. 569

(St Barbara)
Conifer, 105.3 × 41.3 cm (41½ × 16¼ in)
Acquired 1843
Cat. no. 572

These depictions of St Ulrich and St Barbara are fragments of an altar retable which was destroyed and for the most part lost, apparently all except for the two present panels. That they were originally juxtaposed may be gathered from such formal characteristics as the way the figures face each other, the related colour schemes, the treatment of the foreground, and from the hills and mountains in the background, which evidently form a continuous panorama. That is to say, the compositions must have stood next to one another in the original altar, as here, and accordingly must have formed the outside of its hinged wings. They give an idea of how the retable probably looked in a closed position. The size of the panels, however, is not that of the original wings. Their compositions, together with certain technical findings, clearly indicate that they have been cut down considerably. Traces of the original image boundary are detectable only along their vertical edges. The imagery also shows that the panels were once larger. The sword at St Barbara's feet, the weapon with which she was put to death, was probably completely visible in the original state of the image. And what are we to make of the mysterious dark object resembling a stone at the lower right of the St Ulrich panel? On closer observation, it seems more like a shoe. An entire figure might conceivably have been cut away here. Further inferences about the original proportions of the panels may be drawn from comparisons with other altars by Burgkmair. Apparently the Berlin panels have been considerably reduced in height, causing a noticeable constriction of the figures, altering and disturbing the relation of figure to landscape. Nevertheless, the two saints in their exquisite and gloriously coloured garments are monumentally conceived, and their poses are both dignified and highly expressive.

On the left panel, St Ulrich appears in the vestments of a bishop, grasping the symbol of his office, a crozier. His garb is very elaborate and ornate, with red and gold brocade set off by green velvet and shot silk taffeta shimmering in blue and red. The fish in his hands, a pike, is his personal attribute. St Ulrich was born in 890 and Bishop of Augsburg from 923 to 973. He later became patron saint of the Swabian city. Wishing to reward a messenger, the bishop gave him a cut of meat, having forgotten that it was a day on which meat-eating was a sin. The messenger was about to denounce him for it when the meat was transformed into a fish. A miracle had saved the bishop from the charge of breaking ecclesiastical law.

The right-hand panel shows St Barbara, who is also beautifully and elaborately costumed, wearing a crown set with pearls. She holds a communion chalice, and a palm frond that symbolizes her martyrdom. St Barbara lived during the third century, when persecution of Christians was at its height; she was the lovely daughter of a rich unbeliever who locked her up in a tower to keep her from temptation. Yet even here Christ's message reached her and she was converted to the faith. When her father heard of this, 'his love turned to hate' and he delivered her over to the authorities. Seeing that she remained steadfast, he himself demanded her execution, and she was beheaded. The sword at the bottom of the painting alludes to her martyrdom. And as a sign of her fearlessness in the face of death, for which the condemned traditionally invoke her saintly patronage, she bears the attribute of the chalice of the last communion.

The identity of the two saints depicted here suggests that the retable of which they were part was originally intended for the town of Augsburg. Stylistically, the panels are closely related to the images of saints on the *St John Altar* of 1518, now at the Old Pinakothek in Munich. Their dating, *c.*1518, is based on this similarity.

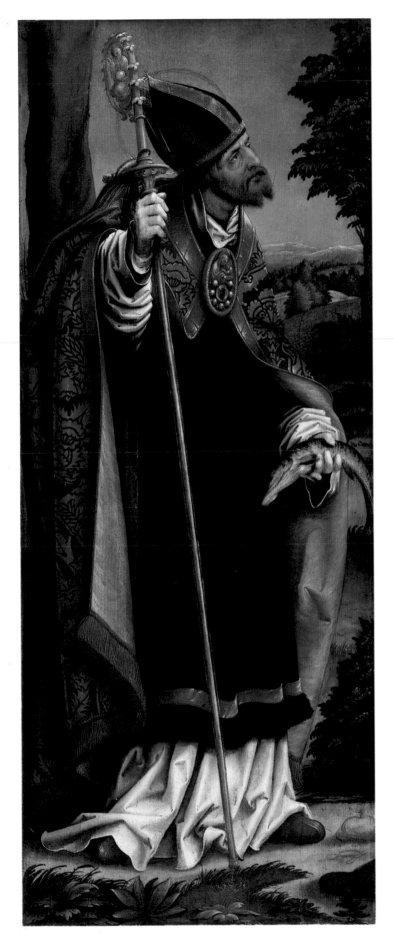
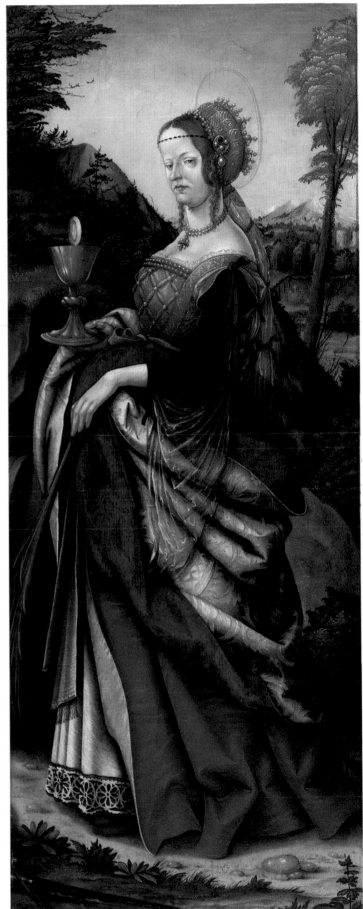

Albrecht Altdorfer (*c.*1480–1538)
Rest on the Flight to Egypt
1510

Linden, 57 × 38 cm (22½ × 15 in)
Signed lower left, on the tablet:
'A[l]b[er]tu[s] Altorffer pictor Ratis
ponen[sis] in salutem a[n]i[ma]e hoc tibi
munus diua maria sacrauit corde fideli
1510. AA' (interlocked)
Fr. v. Lippmann Collection, Vienna
Acquired 1876
Cat. no. 638 B

Dominating the foreground of this image is a great fountain, with a wide, shallow bowl and a central column richly ornamented with figures. Mary, seated beside it in a throne-like chair, lets the Christ Child down to dabble in the water and marvel at the playful antics of the *putti*. From the right Joseph enters, bringing a handful of cherries to his wife. An unusually intimate and personal mood pervades this rendering of the flight into Egypt, which is charged moreover with Scriptural and symbolic allusions.

The fountain itself recalls the spring in the Bible story that began to flow when the weary travellers desired refreshment. Another reference to this passage may be seen in the cherries Joseph holds, which are like the fruit on the palm tree that bent down to the Holy Family. The legends also record that when the young Jesus entered the town of Sotina its graven idols and temples fell to the ground. Altdorfer evokes this event by ruins of old Romanesque churches which in his day stood for the past in general and the Old Covenant and Judaism in particular. The broken statues also allude to this passage, as probably do the figures surmounting the fountain like raised idols – a Cupid with bow and two arrows, and a bearded man holding a winged object. What this object represents and who its bearer may be, cannot be said with any certainty. Graphically clear, though, is the significance of the gradual metamorphosis from pale, cold stone at the top of the column to pulsating life and colour in the figures closest to the water and the Christ Child. The Virgin and Child become 'a well of living waters', 'the fountain of life' (Song of Solomon 4:15; Psalm 36:9). Behind the devastated town at the right, rugged, mountainous countryside extends along the shore of a lake into the distance. Altdorfer later used a similar landscape in another painting, a *Crucifixion* (at Kassel). Some authors believe the artist modelled it on real scenery, a stretch of countryside near Wörth, on the Danube. True or not, Altdorfer certainly transformed the scenes he knew and adapted them to the story he wished to tell. The rather gentle mountains along the Danube have shot up into rugged precipices and seemingly impassable ranges. The drama of this landscape, a visual evocation of Mary and Joseph's arduous journey, serves also to counterpoint the idyllic scene at the fountain.

In the dedicatory inscription on the base of the fountain, Altdorfer consecrates his picture, with pious heart, as an offering to the Blessed Mary. The painting is certainly a very personal and moving profession of faith.

Albrecht Altdorfer
The Rest on the Flight into Egypt
Detail: Dedicatory inscription

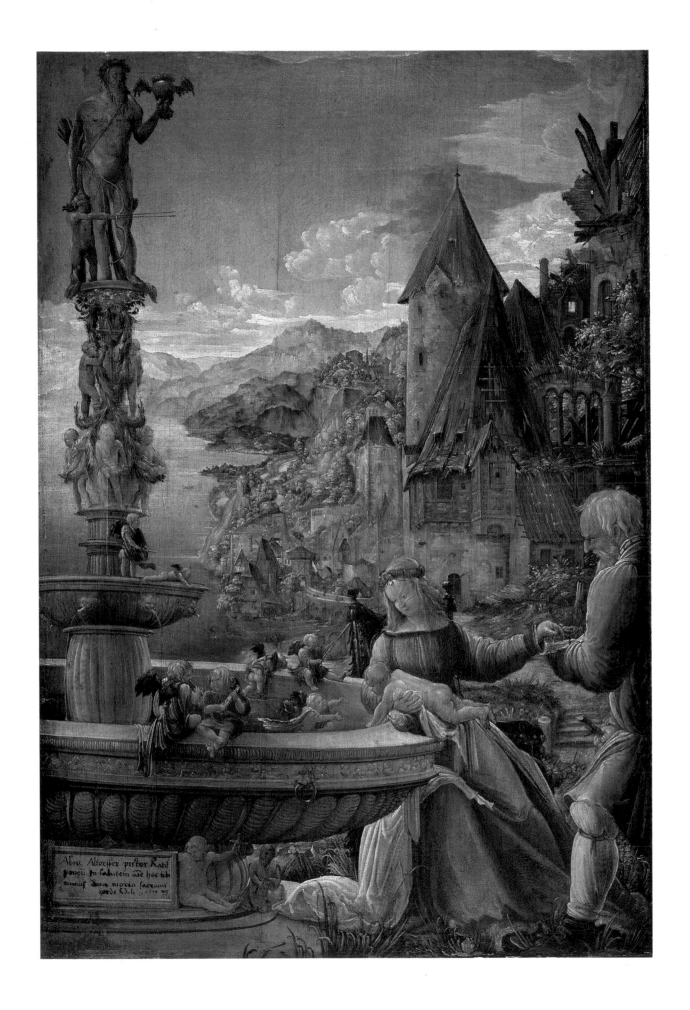

Albrecht Altdorfer
Christ on the Cross between the Two Thieves
c.1526

Linden, 28.7 × 20.8 cm (11¼ × 8⅛ in)
Signed bottom: 'AA' (interlocked); on
the reverse, allied arms, largely effaced
Acquired as bequest of M. Weber, Berlin,
1886
Cat. no. 638 D

Here Altdorfer depicts the Crucifixion in open country, the three crosses on a low rise, stark against the sky. Behind them extends a rolling plain dotted with bushes and trees, with paths winding through the fields to villages and castles in the distance. Just right of centre is a group of farm buildings on a hill, at the foot of which a town spreads along the shore of a lake or ocean bay. Ranges of mountains, rugged and icy, grow increasingly dim in the blue haze towards the horizon. The clouds glow pink in the sun, whose light breaks through with white-gold brilliance for the last time before the storm-clouds close.

The three victims are dead, the execution over. The onlookers have left the scene; a few people are still visible in the background on their way home. The mourners, too, are preparing to go, John supporting Mary and accompanied by an attendant and by Joseph of Arimathaea, pleading and gesticulating. Nicodemus and a yeoman raise the ladder to recover Christ's body. In the foreground, ignored by the others, Mary Magdalene sits on a mound with her back turned, before her a jar of ointment and linen bandages. Head in hand, abandoned and disconsolate, her pose reflects the day's terrible events, the horror of the last hour. These are echoed again in the livid illumination and glowering clouds. The darkness that engulfed the land in the hour of Jesus's death is symbolized here by clouds of night gathering while twilight is still in the sky. This dramatic illumination reflects and recapitulates the events of the day.

Altdorfer relates the Crucifixion story in a personal way unlike most representations. The true theme of his devotional image is the melancholy and mourning that followed the Saviour's death. As numerous copies show, his painting found many emulators and admirers. It is signed at the lower centre with the monogram AA, but not dated. Stylistic similarities with another *Crucifixion* dated 1526 in the Germanisches Nationalmuseum, Nuremberg, indicate that it may have been executed the same year, or perhaps slightly later.

Albrecht Altdorfer
The Mount of Calvary, 1526
Nuremberg, Germanisches
Nationalmuseum

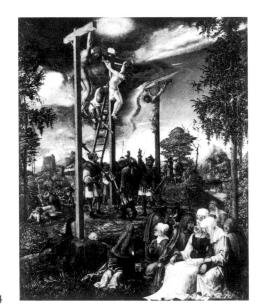

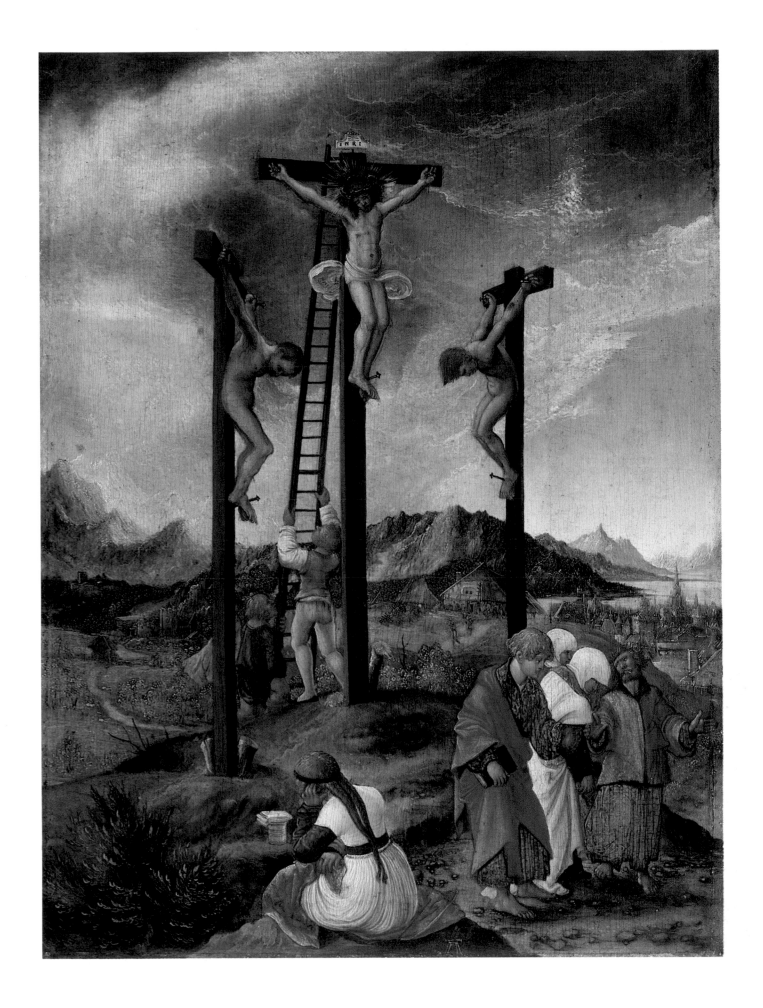

Wolf Huber (1480/5–1553)
The Flight into Egypt
c.1525–30

Linden, 56.2 × 56.6 cm (22⅛ × 22¼ in)
On loan from the Lipperheide Collection,
Kunstbibliothek SMPK, Berlin

The Holy Family fleeing into Egypt, after Joseph had been warned by an angel in a dream that Herod's soldiers were abroad – that is the story Huber depicts here. Mary cradles Jesus in her arms as Joseph leads the ass; and Joseph, staff and sack across his shoulder, searches Mary's face with a look of tender concern. An ox, there to provide sustenance on the journey, trots on a lead in the family's wake. Their path takes them through rough country which evokes the desert waste of the story; the rocky promontory they are crossing symbolizes the harshness of their exodus. In the background, icy peaks recall the solitude and the dangers that await the travellers in unknown territory far from human habitations – represented here by the town in the distant river valley far below.

To emphasize the family's closeness and to give visual coherence to the group, Huber has turned them to gaze towards one another, and disposed the figures and animals in a circular configuration. Back-lighting from the left lends them monumental presence. The forbidding aspect of the countryside is softened by fir trees with fresh green shoots, magically illuminated by morning light that makes the crisp air of dawn almost palpable. The shaggy trunk on the left represents a palm tree, a motif inspired by an engraving of *The Flight into Egypt* by Dürer. It served many artists as a model, and Huber has freely adapted it here. This palm tree, as the Bible story relates, bent its boughs down to the travellers so that they might pick its fruit.

The present panel is a fragment of an altar retable. Only one other panel has survived, a *Visitation of St Elizabeth by the Virgin*, now in the Bavarian National Museum at Munich. Investigations of the two panels and their stylistic features have shown that they came from an altar to the Virgin, executed some time between 1525 and 1530.

Wolf Huber
The Visitation of St Elizabeth
Munich, Bayerisches Nationalmuseum

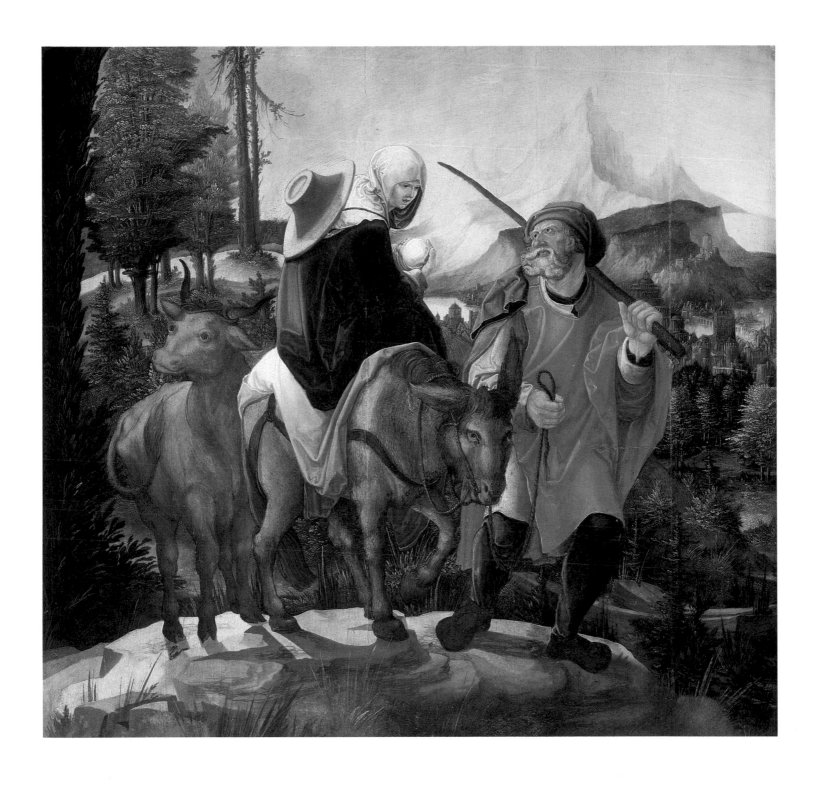

Christoph Amberger (*c.*1500–61/2)
Portrait of Sebastian Münster, Cosmographer
*c.*1552

Linden, 54 × 42 cm (21¼ × 16½ in)
Inscribed verso in a sixteenth-century
hand: 'Sebastian Münster Cosmographus.
Seines Alters 65 gemalt Ao 1552'
From the von Praun Cabinet, Nuremberg
Acquired for the King of Prussia together
with *Portrait of Emperor Charles V*
through the dealer Frauenholzer, 1819
Cat. no. 583

Christoph Amberger
Portrait of Emperor Charles V,
*c.*1532
Berlin, Gemäldegalerie SMPK

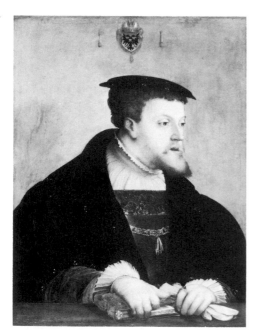

The portrait is of an ageing man with ruddy complexion and sprouting beard which casts a silvery shimmer over his gentle, resolute features. White hair shows beneath the broad, black barett, and the embroidered collar of his white shirt is delicately pleated and ruffled at the neck. Over it he wears a red doublet and black coat, a *houppelande*, trimmed with greyish-white, light-brown tipped fur. A table or parapet covered in red velvet, on which his fingers rest, is before him. This red band along the bottom of the painting, together with the background, to which shadows lend depth, frames the figure in a unified pictorial space. The painting's effect derives largely from a colour harmony in green, two shades of red, and black. The lighting is also unique: it is frontal and strikingly brings out the thoughtful, even pensive cast of the sitter's features.

According to an inscription on the back of the painting, this sitter was Sebastian Münster, a great scholar of the sixteenth century. He was born on 20 January 1488, in the town of Ingelheim in Rhine-Hesse. Destined by his parents for the clergy, he entered the Franciscan Order at eighteen, then attended university at Heidelberg, Löwen and Tübingen. In 1509 he began to learn Hebrew from a fellow monk, Konrad Pellikan of Ruffach, Alsace, which was to prove decisive for his scholarly career. After studying mathematics, astronomy, cartography and geography at Tübingen in the years 1514–18, he followed Pellikan to Basle, where he became acquainted with the writings of Martin Luther. At the University of Heidelberg, as Professor of Hebrew from 1524 to 1529, Münster presumably began to fall away from the Old Church. An appointment to the Chair of Hebrew formerly held by his mentor at Basle, which had just been reformed, eased his conversion to Protestantism. Subsequently, Münster devoted himself to ancient languages and to geography. Among his many writings and the volumes he edited, two stand out: the first Bible in Hebrew to be printed in Germany, of which he was editor, and a six-volume description of the entire known world at that time. This *Cosmographia*, as its short title runs, summed up the geographical knowledge of the period, was translated into many languages, and continued to be reprinted far into the seventeenth century (twenty-one editions by 1628). In 1547 Münster was elected Rector of the University of Basle and had reached the apex of his career. He died in Basle on 23 May 1552. The present day has paid its own tribute to his memory by reproducing this portrait, reversed, on the 100 Deutsche Mark banknote.

Amberger's portrait bears an inscription on its reverse side which, though not by the artist himself, does show traits of a sixteenth-century hand. It translates, 'Sebastian Münster, Cosmographer. Painted in his 65th year of age, anno 1552.' He must have sat to Amberger only a few months before his death.

Amberger, a master in the Augsburg Guild since 1530, was one of the major German painters of the second third of the century. During his lifetime he was renowned primarily for his portraits. He had been to Italy, and had met Titian in Augsburg, so he was well acquainted with Italian painting of the period. The gallery possesses another work by his hand: a portrait of Emperor Charles V in delicate tones of silver-grey and violet, equally compelling in its psychological penetration and assured technique. This painting dates from about 1532, the beginning of Amberger's master period. His portrait of Sebastian Münster, with its frontal lighting and deep, luminous palette, is characteristic of his late style.

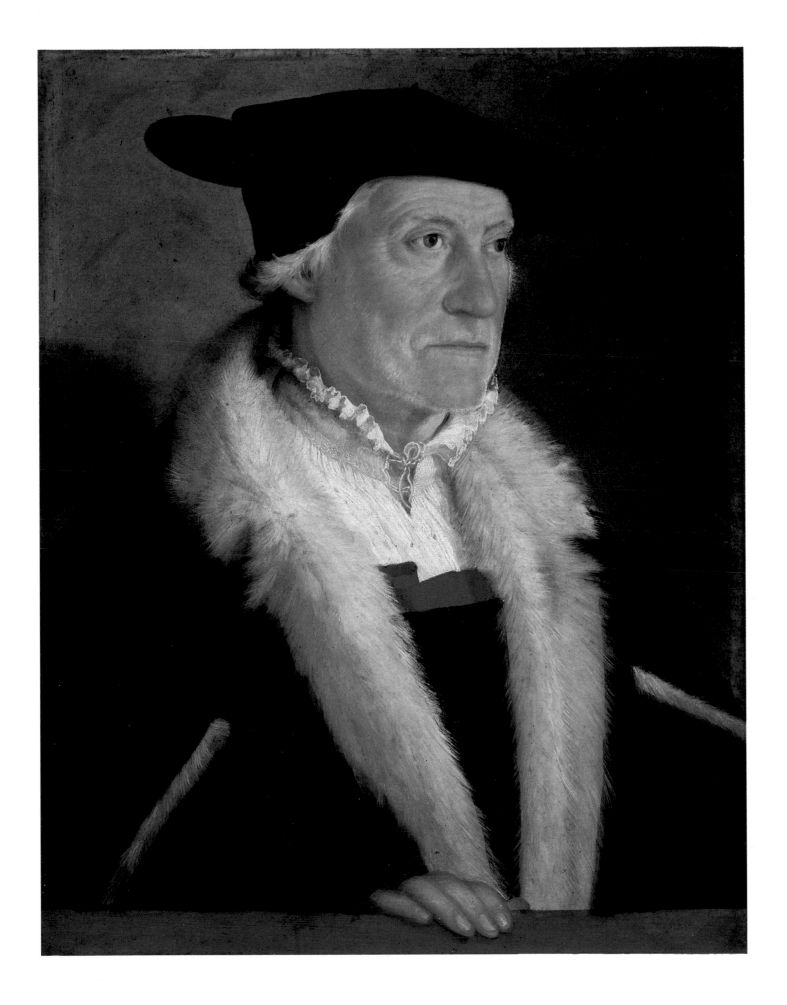

Hans Holbein the Younger (1497/8–1543)
Portrait of Duke Anton the Good of Lorraine
*c.*1543

Oak, 51 × 37 cm (20 × 14½ in)
Inscribed: 'AETATIS SVAE 54'
Collection of Sir I.E.Millais, London
Acquired 1897
Cat. no. 586 D

As the inscription says, the bearded gentleman who sat to Holbein for this portrait was fifty-four years old at the time. Shown in three-quarter profile, he wears a voluminous black coat over a doublet with red sleeves and a barett ornamented with golden tags. This costume marks him as a man of high rank.

The sitter's identity is uncertain, and there are many conjectures. Perhaps the most plausible, based on comparisons with other portraits, identifies him as Duke Anton the Good of Lorraine (1489–1544). Duke Anton spent most of his active life serving in the armies of Francis I of France. His nickname, 'the Good', alludes to the benevolence with which he ruled his territories. Yet though Duke Anton's age tallies with that given in the portrait, difficulties arise when we try to imagine when and where he could have met Holbein in order to sit for him. That he could have travelled to England at that period is doubtful, since he was in ill health; and it is not recorded that Holbein was in France at the time. The evidence for this interpretation, then, is rather tenuous, but still it remains more plausible than any other that has been advanced.

The portrait is memorable in its simplicity of form and the expressive poignancy of the sitter's composed features. The hands, so often present in Holbein's portraits, are not visible here; indeed there is nothing to distract from the countenance with its tight-pressed lips, and its pensively lowered gaze clouded with a touch of melancholy. This expression is at once determined, thoughtful and impassively noble.

The reduction of the composition to essentials and its focus on the expressive force of the sitter's features suggest Holbein's late period. Presumably the painting was finished, one of the last by his hand, in 1543.

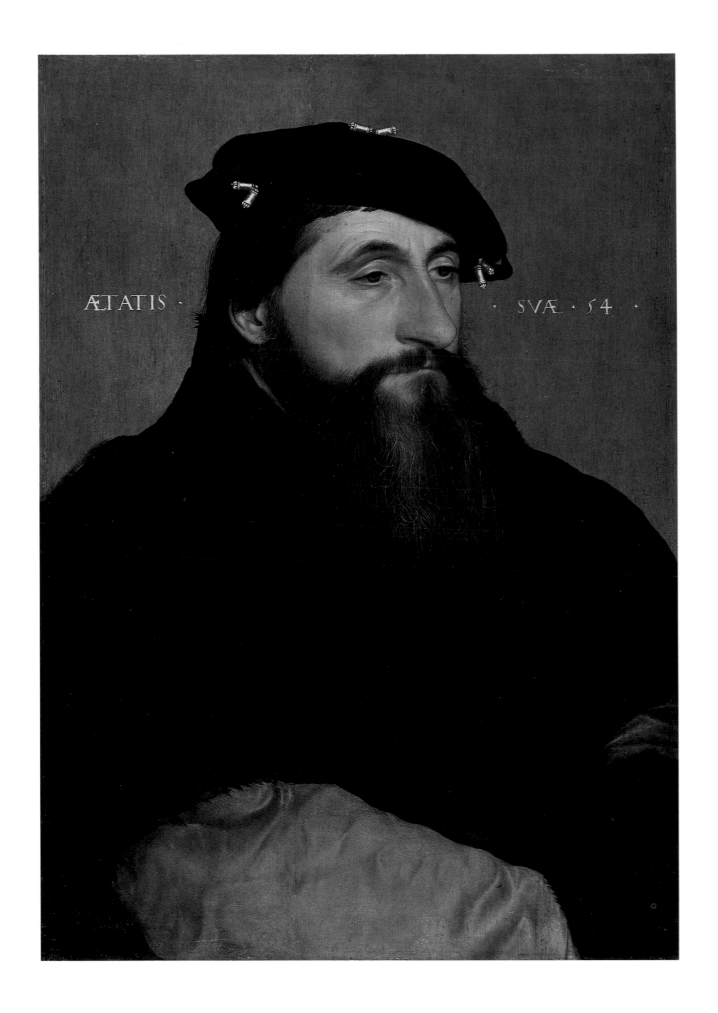

ÆTATIS · · SVÆ · 54 ·

Hans Holbein the Younger
Portrait of Georg Gisze, Merchant
1532

Oak, 96.3 × 85.7 cm (38 × 33¾ in)
Inscribed on slip upper left centre: (see text)
Collection of Duc d'Orleans, Paris
Acquired with the Solly Collection, 1821
Cat. no. 586

Hans Holbein came from a family of Augsburg artists, and learned his trade from his father, one of Germany's finest painters in the years before and after 1500. From 1515 he worked in Basle, and later in Lucerne for a time (1517–19). He spent the years 1526–8 in the Netherlands and England, then returned for a short period to Basle. Back in England in 1532, he became court artist to Henry VIII in 1537, a position from which he exerted a lasting influence on sixteenth-century English art. Holbein died of the plague in London, in 1543.

It was probably at the outset of his second stay in London, in 1532, that he executed this portrait of Georg Gisze, a merchant of Danzig. It is a true and evocative likeness, with everything in the painting – inscriptions and letters, tools of trade, decorations, even the room itself – contributing to the characterization of the sitter. In the midst of these eloquent surroundings is a young man, superbly dressed, a finely wrought dagger in his belt. Everything about his appearance suggests prosperity. His work-table, covered with a costly Oriental rug, is in a panelled office whose walls are painted green and fitted with shelves for books and utensils. On a slip pinned to the wall is an inscription in Greek and Latin which translates, 'Distich on the portrait of Georg Gisze. What you see here depicts Georg's features and aspect; thus is the quickness of his eye, thus have his cheeks rounded. In his thirty-fourth year, this Year of Our Lord 1532.'

Judging by the languages of this inscription, Herr Gisze must have enjoyed a humanistic education. This is confirmed by his Latin motto, written on the wall at the left: 'No pleasure unearned'. The letter he is opening, and others on the wall, reveal his address: the *Stahlhof* or Steel Yard in London, seat of the influential merchants of the German *Hansa* there. The sample seals and return addresses on the letters show that Gisze maintained a wide correspondence. Books, boxes and implements are scattered on the shelves and a book, a pair of scissors, writing utensils, a seal, and a signet ring lie on the table. A gilded brass clock and a Venetian glass vase complete the still life. The clock, showing time and measuring it in regular intervals, evokes both the virtue of moderation and the transience of all earthly things. In a similarly dual way, the glass vase is transparent, lucid and pure, and yet fragile and transient, like the flowers it contains – carnations, rosemary, hyssop, perhaps charlock. The blossoms are still fresh, but will have wilted by tomorrow. And they also convey symbolic allusions to love, fidelity, purity and humility, virtues and qualities attributed to the man portrayed. The counting-room we see him in is an attribute that characterizes his station in life, his profession and status.

This room is by no means as realistically depicted as might appear at first sight. When you try to imagine how the figure, table, and walls are related in space, you quickly realize that there is hardly enough room behind the table for someone to stand. To emphasize the figure's importance Holbein has purposely enlarged it in relation to its surroundings. He has also brought the back wall forward, perhaps to ensure the clarity of the many symbols and inscriptions. These proportional and spatial discrepancies are deliberate, yet skilfully veiled so as to ensure verisimilitude. That Holbein worked at this impression may be seen from textural traces on the painting's surface and in underlying paint layers, visible in X-rays. He made many changes during the painting process. Originally the model seems to have been depicted frontally, and the corner of the room lay to the left. The composition may have been similar to the *Portrait of a Banker* by Jan Gossaert in Washington, which also shows the sitter frontally, surrounded in his office by the tools of his trade. Netherlandish portraits of this kind very likely inspired Holbein; perhaps his patrons even suggested he emulate them. By altering his original composition, however, he gave the image a different perspective, and the resulting structure makes it difficult for spatial inconsistencies to be detected. The room surrounds the man like a shell, close and intimate.

Jan Gossaert
Portrait of a Banker,
*c.*1530
Washington, National Gallery of Art

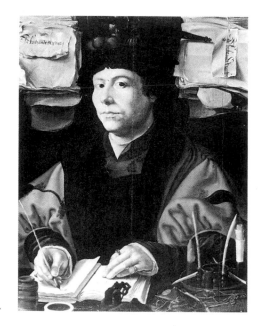

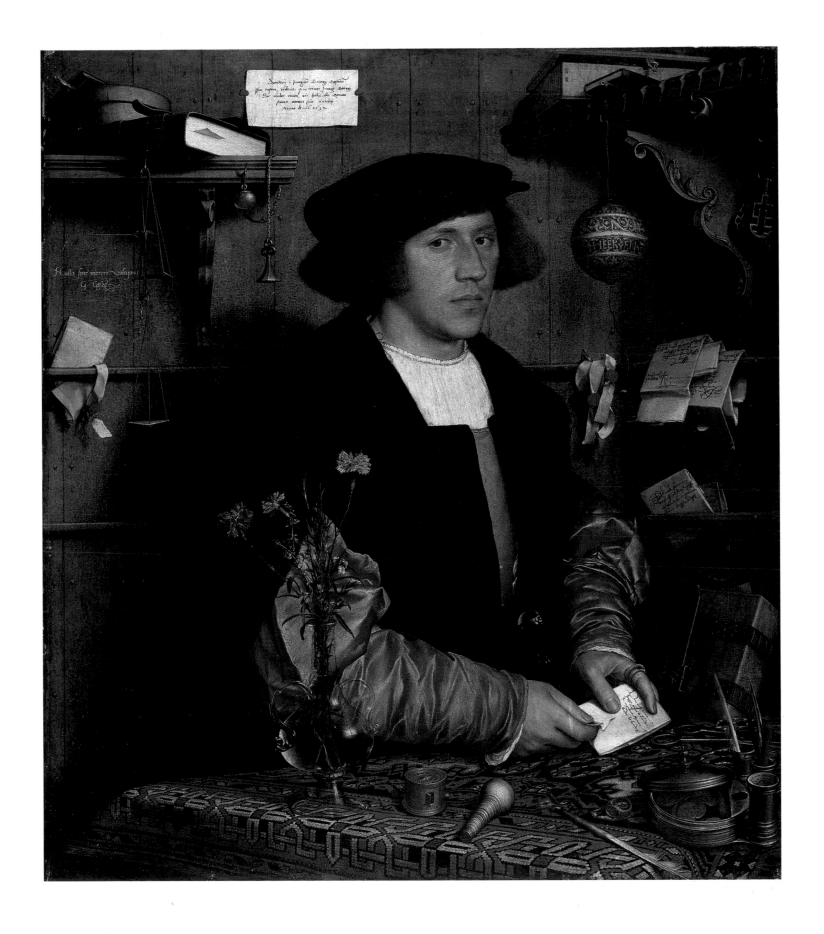

The many and varied objects in it are rendered with the immediacy of a still life, yet remain subordinate to the essential theme, the portrait itself. The seemingly random arrangement of the things in the room and their owner's simple activity give an impression of vital, immediate presence, a slice of life. This multiplicity of surfaces, textures, materials is nevertheless carefully ordered and contributes to a feeling of comfortable intimacy.

The artist's intention might be described as recording an individual's appearance, elucidating the nature of his activity and status, and surrounding him with typical attributes that evoke his personality and character. It is conceivable that the erotic allusions conveyed by carnations refer to Gisze's engagement to Christine Krüger, on which occasion this portrait of her fiancé may have been commissioned. The elaborateness of the composition and its sumptuous paint handling make it one of the finest portraits of Holbein's London period.

NETHERLANDISH AND FRENCH PAINTING OF THE FIFTEENTH AND SIXTEENTH CENTURIES

BY RAINALD GROSSHANS

hand he grasps her left wrist, a gesture that in the Middle Ages signified respect, but also mourning. The golden crown Mary wears, and the splendid jewels and pearls encrusting her gown, are badges of her distinction and exaltation as Queen of Heaven. Each shimmering stone, in colour and in the qualities attributed to it, was symbolically associated with the Virgin Mary during medieval times. Even church interiors such as this possessed that symbolism. From the early Christian period, Mary was often compared to the house or temple of the Lord, since Christ lived in her womb as in a temple. Obvious references to Mary's elect position are found in the reliefs of the Annunciation and Coronation which van Eyck has represented in the tympana on the choir screen. These images stand for the beginning of the work of redemption and the climax of the Virgin's life. At the top of a spire on the screen is a sculpture of Mary mourning beneath a cross suspended from the vault above. This juxtaposition recalls that Mary, by sharing in the sorrows of her son, contributed to his work of salvation.

An angel and a priest sing from an antiphonary in front of the high altar in the choir. Their garments characterize them as deacons, and they represent the close link between sacrament and redemption, as well as the everlasting mass of the millennium. The clearest hint towards an explanation of this image was given by van Eyck himself in the inscription he made on the original frame, which has not survived. Its text was taken from a medieval hymn in praise of the miraculous birth and Mary's purity. In one of its verses she is compared to sunlight which can penetrate a window without breaking it, a simile for the woman who conceived yet remained a virgin. No wonder van Eyck devoted such care to the rendering of light in this image – light as a symbol of God and the Virgin Mary. That this allusion was conscious is verified by the letters embroidered on the seam of Mary's dress, part of a longer inscription taken from the Wisdom of Solomon, Apocrypha (7:29 and 26): 'She is more beautiful than the sun and excels every constellation of the stars, and compared to the light, she is found to be superior. For she is a reflection of eternal light and a mirror of the working of God and an image of his goodness.' Remembering that the choir of every Gothic church pointed east, it might seem odd that the sunlight in this painting, instead of shining from the south as it would in reality, falls into the church from the north. In other words, the light represented here is not natural but eternal, a light independent of the course of the sun and stars. This symbolism of light finds its most complex expression in the burning candles that flank the statue of the Virgin in a niche of the screen. There is a striking similarity in the pose of this cold statue and that of Mary, who confronts us with such a semblance of life. One is tempted to speak of a miraculous awakening, an incarnation. Visions of this kind are found again and again in the various legends of the saints. The most famous of these is probably the vision of the Virgin experienced by St Bernard of Clairvaux, which fundamentally shaped his life and the Cistercian Order of which he was founder.

Because two copies of Jan van Eyck's *Madonna in the Church* have been combined with portraits of donors to form diptychs, it is safe to assume that our panel was originally the left wing of a small, two-part altar. The copy made by the Bruges Master of 1499 (Antwerp, Koninklijk Museum voor Schone Kunsten) is probably a faithful facsimile of van Eyck's lost composition. It was commissioned by Christiaan de Hondt, who from 1495 to 1509 presided as abbot over the renowned Ter Duinen Cistercian monastery near Veurne. One of his successors also had himself portrayed on the exterior of this small altar. This replica certainly testifies to the high regard in which Jan van Eyck's work stood long after his death.

SALVE · REGINA · MISERICORDIE ·

Bruges Master of 1499 (after
van Eyck)
The Diptych of Christiaan de Hondt
Antwerp, Koninklijk Museum voor
Schone Kunsten

Robert Campin (c.1375–1444)
Portrait of Robert de Masmines

Oak, 28.5 × 17.7 cm (11¼ × 7 in)
Acquired 1901
Property of the
Kaiser-Friedrich-Museums-Verein
Cat. no. 537 A

Robert Campin
The Thief on the Cross with Two Onlookers
Fragment of the right wing of a triptych
Frankfurt am Main, Städelsches Kunstinstitut

This portrait is among the most impressive achievements of early Netherlandish portraiture. And though it owes its effect to such artistic factors as great immediacy and merciless fidelity to life, the personal appearance of the sitter certainly contributes to it. When he saw the portrait at the London auction of Sir Hope Edwards's collection in 1901, Max J.Friedländer, the great connoisseur of Netherlandish art, attributed it to the Master of Flémalle. This attribution is still valid, though the anonymous master is now generally associated with Robert Campin, a painter of Tournai. Campin headed a workshop from which artists of the rank of Jacques Daret and Rogier van der Weyden came. Even more importantly, with Jan van Eyck he was one of the first artists in the Netherlands to achieve a transition from the late phase of the European Gothic style to a new realism. An expansion and deepening of the pictorial space, realistic detail, and the plastic conception of the figures are among the essential factors in the monumental quality and the immediacy that is characteristic of his best work. These qualities are strikingly present even in the fragment which is all that remains of Campin's triptych with *Deposition*, and which has a section of the right sidepiece showing *The Thief on the Cross with Two Onlookers* (Frankfurt am Main, Städelsches Kunstinstitut).

An equally monumental presence and fidelity to appearances mark Campin's work in portraiture, particularly his likeness of Robert de Masmines. The constricted format, the white background, and the incomparable verisimilitude in the treatment of the flesh, all contribute to the sitter's vitality. His heavy face and double chin, curly hair and deeply lined forehead suggest a dominating personality, strong-willed and fond of life, a man whose worldliness borders on the carnal. The portrait is so astonishingly true to life that only on a second look does a lack of psychological penetration become evident.

The question of this fascinating personality's identity has often been asked. Robert de Masmines is the most plausible of the various names advanced: he was counsellor and military commander under the Burgundian Dukes John the Fearless (d.1419) and Philip the Good (d.1467). De Masmines was knighted during the siege of Rheims in 1420, and in January 1430 was accepted into the Order of the Golden Fleece. Before the year was out, he died in battle with the armies of Liège, near Bouvignes, in the service of Philip the Good. What adds to the convincing identification of de Masmines is not so much the other few portraits of him, but the fact that a second version of this picture has come down to us. Formerly owned by the Counts of van de Straten-Ponthoz, whose ancestors were related to de Masmines, the second version is now in the Thyssen-Bornemisza Collection (Castagnola-Lugano). If we assume that the sitter was indeed de Masmines, and remember that the Order of the Golden Fleece was to be worn at all times, then the fact that it is missing from the present portrait (right) would date it to before January 1430. If all these considerations hold, this portrait could have one of the earliest reliable dates in the history of Netherlandish painting.

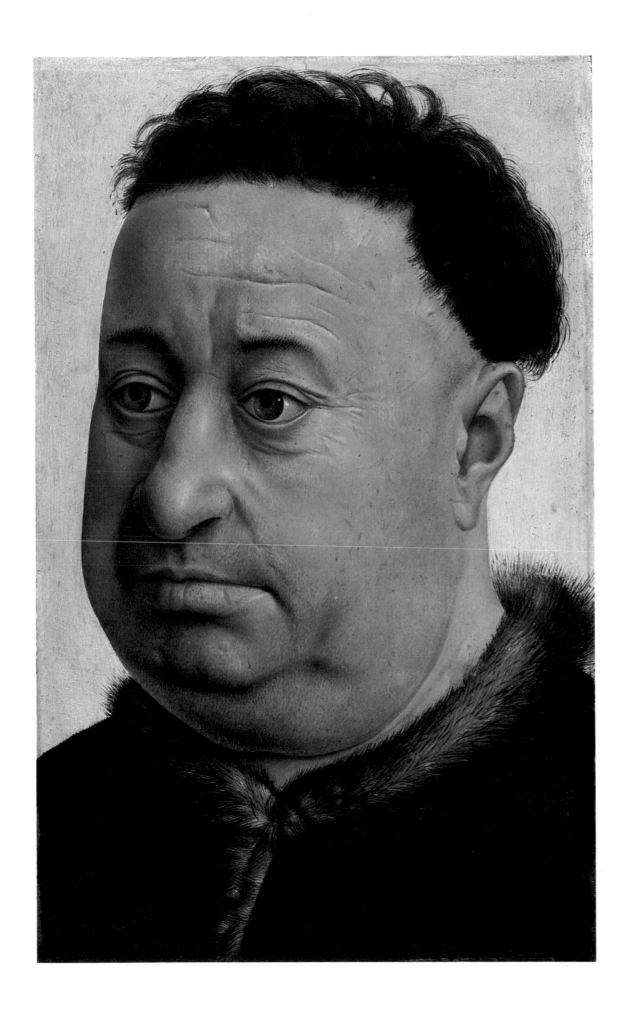

Petrus Christus (c.1410–72/3)
The Virgin and Child with St Barbara and a Carthusian Monk
(Exeter Madonna)

Oak, 19 × 14 cm (7½ × 5½ in)
Collection of the Marquis of Exeter,
Burleigh House
Acquired 1888
Cat. no. 523 B

In 1444, three years after the death of Jan van Eyck, Petrus Christus, independent Master of his art, became a citizen of Bruges, where he lived and worked for about the next three decades. There is much to indicate that he had been a pupil of van Eyck, for he did not hesitate to base his compositions on his Master's, apparently even finishing works van Eyck had left uncompleted. This led many to call him an imitator who was unable to shake off his predecessor's tremendous influence. Yet, though he undeniably never achieved van Eyck's diversity, nor perhaps wished to, Christus enriched his work with innovations that have led to a more positive evaluation. His special strength was a lucid and logical pictorial structure that aimed at integrating figures and surroundings. Petrus Christus was the first Netherlandish artist to reconceive traditional laws of perspective, a pioneering exploration which paved the way for such artists as Dieric Bouts, Aelbert van Ouwater and Geertgen tot Sint Jans.

In about 1450, Christus painted the present *Virgin and Child*, a miniature-like panel in which he freely reinterpreted Jan van Eyck's *Madonna with a Carthusian Monk between St Barbara and St Elizabeth* (New York, Frick Collection). Van Eyck had died before finishing this painting, and it was completed by a pupil, perhaps by Christus himself. The donor of this much larger painting was Jan Vos, Prior of the Genadedal Carthusian Monastery near Bruges from 1441–50. When he left to become Prior of the Nieuwlicht Monastery outside Utrecht, Vos took the large panel with him, apparently commissioning Petrus Christus to do a facsimile to replace it.

That, in brief, is the rather unusual story of the origin of our small panel, a story that of course leaves many questions unanswered. The image includes a portrait of its priestly donor in the white Carthusian habit, which is tied with a cord at his waist and covered by a cape-like scapulary and cowl. He kneels in prayer before the Virgin and Child, who raises his right hand in blessing and in the left holds a crystal globe symbolizing his universal sovereignty. Behind the donor stands St Barbara, with her symbol, a tower, beside her. A palm frond, representing martyrdom, in her right hand, she respectfully touches the donor's shoulder, beseeching the Virgin for her good grace and protection for him. The scene is set in an open hall with leaded windows above arcades. A broad valley with hills, woods, fields, and a riverside town, lies beyond.

The houses, streets and inhabitants are lovingly rendered in great detail. Puddles from the rain gleam on the paths; smoke rises from chimneys. A woman is spreading laundry out to bleach in her garden, while a maid fills a bucket at a well. The streets are filled with people promenading, watching the boats on the river, or going about their everyday errands. This view of a well-populated country town with its countless little events invites the eye to linger and gives the painting a special charm. At the same time, it conveys a deeper meaning – that the Blessed Virgin and Child have entered the earthly world, bringing a promise of redemption to mankind.

Jan van Eyck and follower
The Madonna with a Carthusian Monk between St Barbara and St Elizabeth
New York, Frick Collection

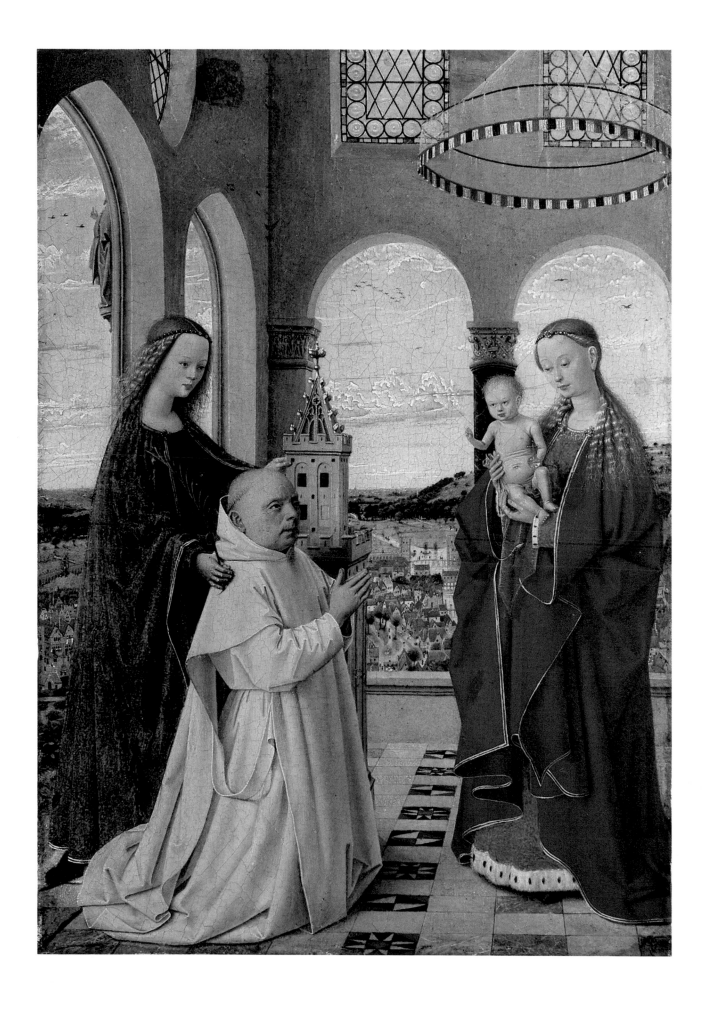

Petrus Christus
Portrait of a Young Woman

Oak, 29 × 22.5 cm (11¼ × 8⅞ in)
Acquired with the Solly Collection, 1821
Cat. no. 532

This artist and his contribution to the development of portraiture as an independent genre have been widely underestimated. For the first time in Netherlandish painting, Petrus Christus represented people in real settings which gave his portraits great immediacy and presence. It was a means of heightening individuality of which neither Robert Campin (Master of Flémalle) nor Jan van Eyck took advantage. Christus's step from empty, neutrally coloured backgrounds to interiors representing the natural ambience of the sitters changed portraiture profoundly.

The portrait of a young woman in our collection, the only one of its type known to be from Petrus Christus's hand, shows the model in an interior before a greyish-brown wall with brown wainscot. Light shining diagonally from the left front defines spatial relationships, and creates a tension between figure and surroundings that evokes great emotional immediacy. It is almost as if we were meeting this young woman personally, were somehow admitted to her private world.

The model gazes out attentively towards the viewer. She wears a tall cap of black velvet edged with gold braid and tiny pearls, and tied under her chin with a broad band. Her three-tiered golden necklace is set with pearls, and her blue dress trimmed with ermine. A transparent veil, gathered in front with a pin, covers her shoulders and *décolleté*. The velvet loop on the headdress emphasizes her high forehead, as does her hair combed back in the fashion of the period, which also brings out the lovely clear contours of her face. Slanting almond eyes gaze out inquiringly from beneath carefully plucked brows. These eyes, and a seemingly overlarge ear, convey an impression of concentrated attention. The girl's pale face, with its dark eyes and finely chiselled lips, is strangely fascinating. Despite her aristocratic dignity, the narrow shoulders, slender neck, and delicate body make her appear incredibly fragile. All these traits contribute to her enigmatic child-woman air.

Who she is we do not know, though there have been endless attempts to find out. None of the identities suggested, including that of the wife of Edward Grymeston, whom Petrus Christus portrayed in 1446 (London, National Gallery), has more than circumstantial evidence. The model's costume seems to indicate that she lived in France, not the Netherlands, as it is similar to those in a number of pictures including a miniature in the *Livre de cur d'amour épris* by René d'Anjou (*c.*1465; Vienna, Österreichische National-bibliothek). Though the painting was acquired in a frame inscribed 'Opus Petri Christophori', no precise records of its provenance exist. It may nevertheless be assumed that the portrait was once in Florence, in the collection of Lorenzo de' Medici (1449–92). The inventory of this collection mentions a portrait of a French lady (*una testa di dama franzese*) and expressly names its author as Petrus Christus (*Pietro Cresti da Bruggia*).

Embarkation to the Island of Love
Detail of miniature from the *Livre du cœur d'amour épris* of René d'Anjou
Vienna, Österreichische Nationalbibliothek

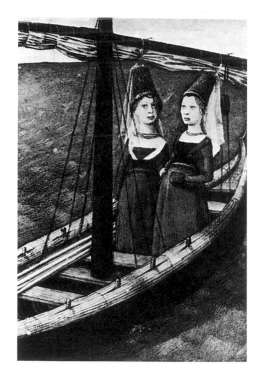

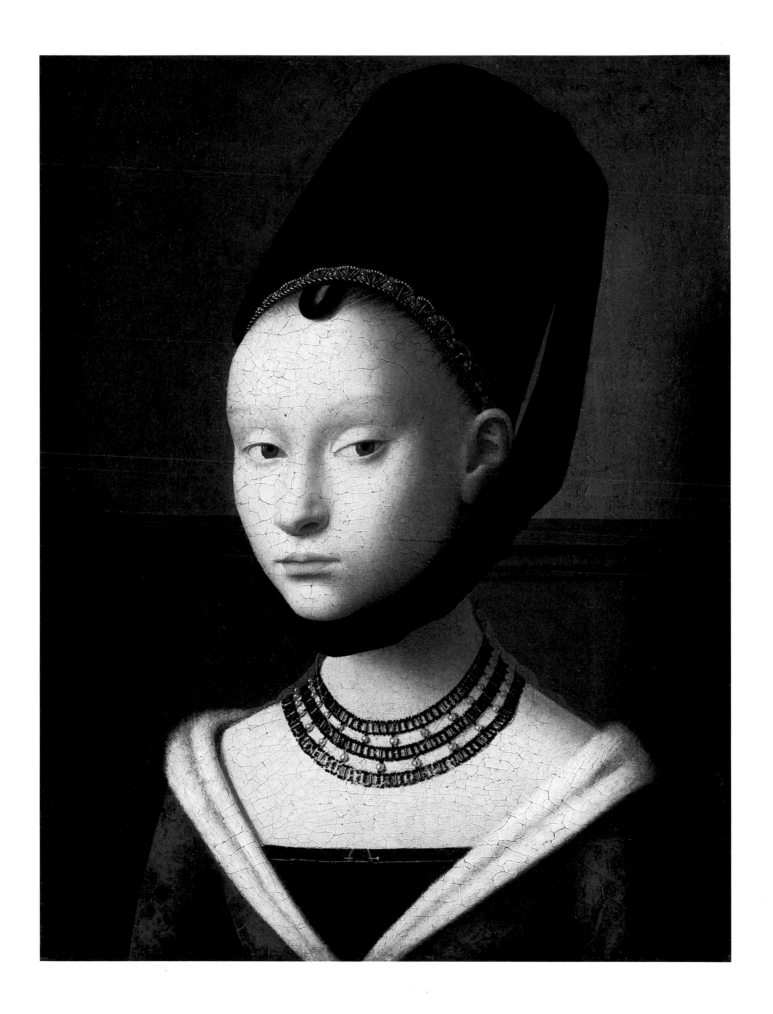

Rogier van der Weyden (1399/1400–64)
The Middelburg Altarpiece
(Bladelin Altarpiece)
*c.*1450

Oak, central panel 91 × 89 cm
(35⅞ × 35 in),
each wing 91 × 40 cm (35⅞ × 15¾ in)
Purchased by the dealer Nieuwenhuys in
1833 in Mecheln, from the family of
Baron Snoy
Acquired 1834
Cat. no. 535

Rogier van der Weyden, whose contemporary fame rivalled that of Jan van Eyck, worked in a compellingly austere pictorial form and in a tactile, realistic style which decisively shaped northern European art. He was the central figure in Netherlandish painting during the second half of the fifteenth century.

The first name by which this altar is known derives from the town for which it is traditionally said to have been made; the second name is from its donor, Pieter Bladelin (*c.*1410–72). Bladelin advanced from being a tax-collector of his birthplace, Bruges, to omnipotent Minister of Finance in Burgundy and Treasurer of the Order of the Golden Fleece. He was an outstanding personality in a period rich in extraordinary men. The power of the state of Burgundy was in its natural wealth and in the riches of its first representatives whom the reigning dukes won to their side with gifts and protection. Life at court with its fêtes and tournaments and chivalric ideals, set the tone of Burgundian society, in which Bladelin – knight, high financier, and influential adviser to Philip the Good – played a leading role. Among the tasks entrusted to him was the raising of funds for a crusade against the Turks. In 1440 he was given the important mission of ransoming Charles of Orléans from the English prison where he was kept since the defeat of the French knights at the Battle of Agincourt in 1415.

Bladelin's rapid rise, his political influence and wealth were astonishing even by contemporary standards. Among the uses to which he put his seemingly inexhaustible fortune was the building of a new town – Middelburg, in a stretch of open land north-east of Bruges. Bladelin moved in to his castle there, one of the first buildings to be finished, in 1450. In 1460 there was the consecration of the town church for which Rogier van der Weyden's altarpiece was made.

This altar is among the works that represent Rogier's perfect art. Not surprisingly, it soon came to be regarded as a model achievement and was often copied. One of these copies, still on view today in the Middelburg church, together with an illustration of Bladelin's castle in *Flandria Illustrata* (1641) – which is based on the town architecture in the *Bladelin Altarpiece* – provides convincing arguments for the origin of the altar and its donor's name.

The Birth of Christ, the focus of the work's form and content, is represented on the central panel. The Child lies on the floor of the stable beneath its ruined roof, worshipped by Mary and Joseph, three angels, and Pieter Bladelin, the donor. Another group of three angels approaches from above, while in the distant landscape to the left the Annunciation to the Shepherds is shown. In the background right a town's inhabitants go about their daily tasks.

Continuing old traditions, Rogier's depiction of the Birth of Christ is enriched with allusive motifs. The Romanesque architecture of the stable stands for a past age whose end was marked by the birth of the Redeemer and His promise of a coming age of grace. The massive column supporting the roof was associated in the Middle Ages with the miraculous birth and, as a reference to the column of the Flagellation, with the sufferings Jesus would later undergo. The candle Joseph holds, its dim light outshone by the Child's divine aura, is a motif apparently taken from the *Revelations* of St Birgit of Sweden (1303–73). All these symbols refer to a new era of salvation for mankind.

Accompanying the Holy Family is a figure representing Pieter Bladelin, who kneels reverently in prayer. He is dressed in the black robe trimmed with fur that was worn by the dukes of Burgundy and their courtiers. Another sign of Bladelin's high social position are the pointed shoes, whose length indicated the wearer's rank and title. As compellingly as in his other (independent) portraits, Rogier has caught the donor's energetic and sharply cut features, recording them for posterity with great penetration.

The altar's central painting is supplemented by the images on its flanking wings. On the left is a version of the heavenly vision seen by Caesar Augustus, as told in the *Legenda aurea*. Augustus, pressed by his senators to show proof of his divine origin, asked a sibyl if a more powerful sovereign than he had ever been born. Suddenly at noon on the day of Christ's birth, the Madonna and Child on an altar appeared to him in the sky. Told by the oracle that this Child was all-powerful, Augustus made an offering of incense to the vision and from then stopped demanding to be worshipped as divine. In the left painting, Augustus, the Western emperor, kneels before the vision, making his sacrifice with his crown held humbly in his hand. Next to him is the sibyl prophesying the significance of the heavenly omen, which is witnessed by three men from the emperor's retinue.

Bladelin's Castle in Middelburg
From Antonius Sanderus, *Flandria Illustrata*, 1641

As counterpoint, the right-hand panel depicts the Annunciation to the Kings of the East. The Three Magi kneel at the foot of a hill, looking up in devout astonishment at the Star of Bethlehem, in whose centre the Christ Child shines. This is another instance of the artist's reliance on the *Legenda aurea*, which tells how the star-child told the monarchs to go to Judea and proclaim the miraculous birth of the Redeemer to all the world. This legend also says that the Magi washed themselves – symbolic purification – to prepare for the vision they would see. Rogier shows them bathing in the river that winds through the landscape in the distance.

The painting on the altar, therefore, was meant above all to represent Christ's incarnation, His birth among men, and its Annunciation to the Orient and the West. The harmonious palette and masterly composition, with its realistic landscape vistas, help communicate the underlying significance of this work with an immediacy of appeal which could be felt by the faithful.

The great verisimilitude of Rogier van der Weyden's art astonished his contemporaries, as may be gathered from the words of Cyriaco d'Ancona, an Italian antiquarian, who said in 1449, '. . . one sees the faces he wished to depict living and breathing . . . and one might say especially that the many garments and mantles of various colours . . . have been fashioned excellently, and the vivid fields, flowers, trees, the cultivated and shadowed hills, the ornamented halls and forecourts, the gilding like true gold, the pearls, gems and everything else have been made by all-creating Nature herself rather than by the hand of a human artist.'

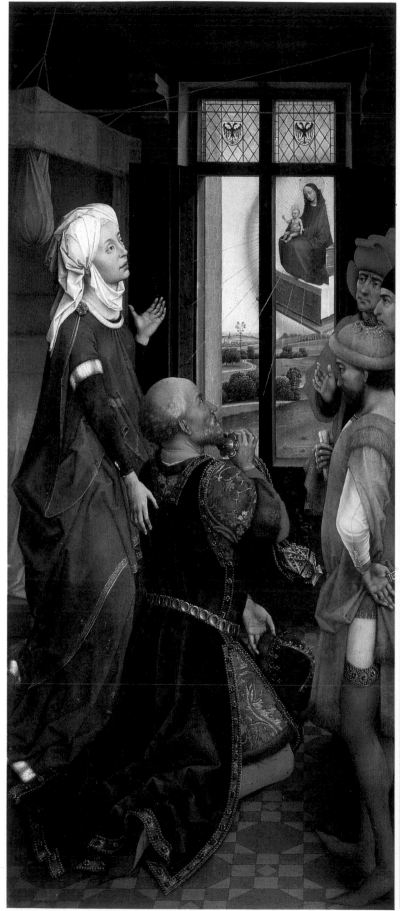
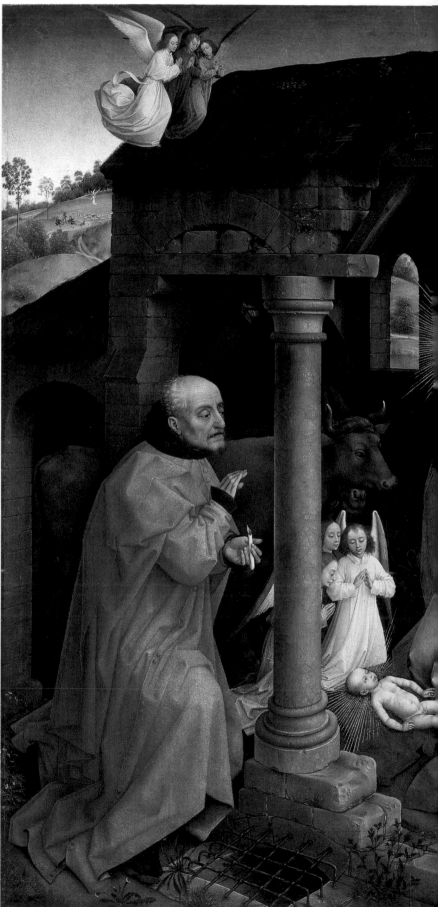

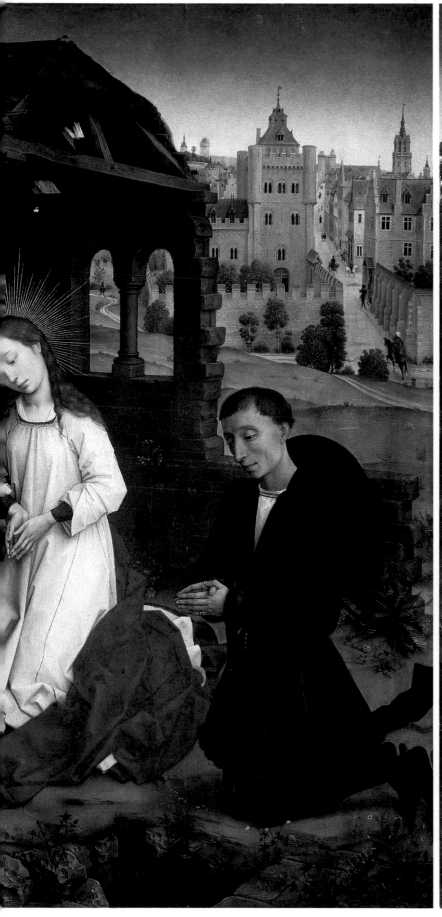
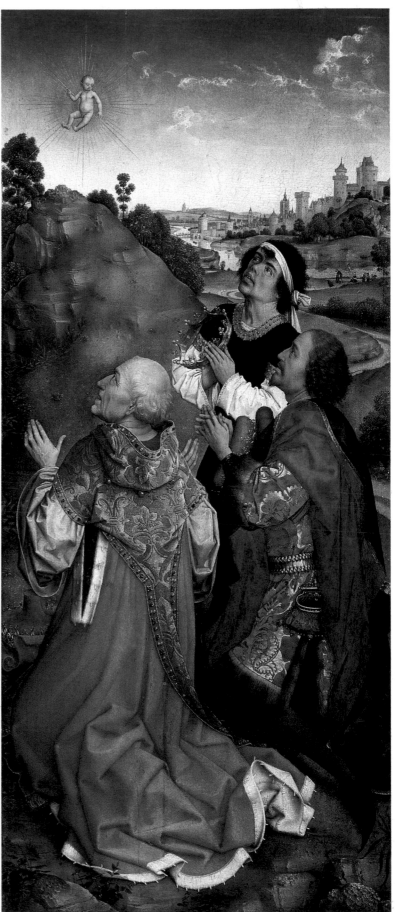

Rogier van der Weyden
Portrait of a Young Woman with a White Headdress
*c.*1435

Oak, 47 × 32 cm (18½ × 12½ in)
Soltikoff Collection, St Petersburg
Acquired 1908
Cat. no. 545 D

Among the highest praise Rogier van der Weyden received was a mention, during his lifetime, by the great theologian and philosopher Nicolaus von Cues (1401–64). His self-portrait in the Brussels Town Hall moved von Cues so deeply that in his *De visione dei* (1452) he called its painter '*maximus pictor*' and compared his eloquent gaze with that of an 'all-seeing God'. The motif of eye-contact and face-to-face dialogue with the spectator was an innovation in portraiture, pioneered in the Netherlands by Jan van Eyck and Rogier van der Weyden. However, only one portrait by Rogier with a direct gaze has come down to us. This is his *Portrait of a Young Woman with a White Headdress*, and its human warmth and revelation of soul is unmatched by any other work he did in this genre.

Unlike most portraits of the period, in which the models appear reserved and introverted, or gaze off into the distance, or in the votive diptychs turn reverently towards the Virgin, this young woman's eyes seek and meet our own; they have an expression seemingly full of interest and sympathy. Of the type known as half-figure, the portrait shows the model from the waist up, turned slightly to the right. Her youthful, vivacious face is framed by a two-piece Flemish headdress of white linen, secured by a few skilfully placed pins. Beneath the finely woven, translucent cloth her high forehead is visible, conforming with the ideal of feminine beauty at that time; a more elaborate *hennin* headdress was also worn by ladies of the court. Rogier's model wears a much plainer and less exalted version of this bonnet which shows she belonged to the upper-middle class rather than to the more fashionably dressed aristocracy. The white cloth with its starched folds brings out the delicate complexion of the sitter's face and the lovely lines of its contours. Her simply cut dress, made of grey woollen material, has ample folds in the sleeves and is gathered together in close pleats over her breast. Her hands, ornamented with rings, rest one over the other on an imaginary parapet at the bottom edge of the painting. The background is treated in a dark, neutral colour. The figure is composed to fill the pictorial plane almost entirely, with arms and hands intersected by the image borders.

This *Portrait of a Young Woman* is generally attributed to Rogier's early period. It was probably painted in about 1435, the year he was named Town Artist in Brussels. Obvious similarities to the portraits of his teacher, Robert Campin, are still detectable here, as may be seen from a comparison with Campin's portrait of a lady in the National Gallery, London. Another portrait worth recalling to gauge the true significance of Rogier's innovation is Jan van Eyck's famous portrait of his wife (1439; Bruges, Groeninge-museum). A common feature of the two portraits is the direct way in which the women meet the spectator's eye. Yet while the gaze in van Eyck's work seems reserved and detached, that in Rogier's has a much more immediate and intimate character. Both, of course, reveal a new and psychologically acute perception of the sitters' personalities, and their similarities have raised the question of whether Rogier, like van Eyck, had not recorded his own wife's features in *Young Woman with a White Headdress*.

However, verifiable clues to her identity are missing, and the young woman Rogier painted so vividly and without any trace of official pomp must remain anonymous.

Jan van Eyck
Margareta van Eyck, 1439
Bruges, Groeningemuseum

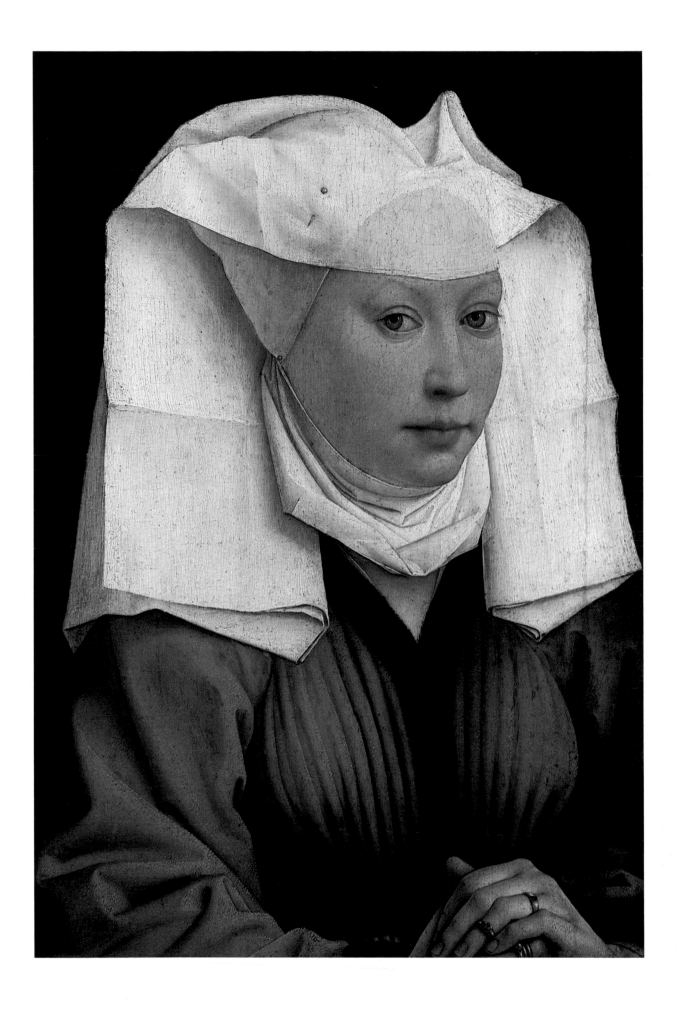

Rogier van der Weyden
The St John Altarpiece

Oak, each panel 77 × 48 cm (30⅜ × 18⅞ in)
Acquired 1850 from the collection of King
William II of Holland (left and central
panels) and in England (right panel)
Cat. no. 534 B

The *St John Altarpiece*, which belongs to Rogier's late period, follows the same basic arrangement as his early *Miraflores Altarpiece*, also in our collection – three equally sized, fixed panels with each scene set in a portal of elaborately rendered architectural motifs.

The scheme of the retable begins on the left panel with the birth and naming of John the Baptist. Beneath the arch in the foreground stands Mary with the infant John in her arms. She looks towards Zacharias, who sits opposite her on a stool, recording the name of his son revealed to him by an angel. Not believing that a son would be born to him, Zacharias had been struck dumb by the Lord. But when he wrote down John's name, 'his mouth was opened immediately, and his tongue loosed, and he spoke, and praised God' (Luke 1:64). The Virgin's presentation of the infant John to Zacharias, however, is recounted not in the Gospels but in the widely read *Legenda aurea*, which Rogier follows here. Behind Mary and Zacharias the lying-in room is visible – coffered ceiling, tile floor, hearth and sideboard – where Zacharias's wife Elisabeth rests in a canopied bed. A maid smoothes the bedclothes while expecting a visit from a woman and girl who enter the house in the background, through the door in the rear wall of the room. The Apostles James the Less, Philip (left), and Thomas and Matthew (right) are represented on the portal frame. The reliefs above them show the angel appearing to Zacharias; Zacharias struck dumb, leaving the temple; the marriage of Joseph and Mary; and the Annunciation, Visitation and Nativity. The juxtaposition of these scenes unmistakably illustrates the close ties between Christ's life and that of John the Baptist, who prepared the way for him.

The central image is devoted to Christ's baptism as the most significant event in the story of salvation. Christ is represented frontally, standing up to his knees in the water of the River Jordan, which flows through a broad valley in the distance. John stands next to him, his right arm raised to perform the baptismal rite. In the right foreground an angel kneels, gazing up at Christ and holding his garment. Over Jesus's head hovers the dove of the Holy Spirit, as the heavens open behind to reveal God the Father, who utters the words: '*hic est filius meus dilectus in quo michi bene complacui ipsum audite*' ('This is my beloved Son, in whom I am well pleased; hear ye him'). Besides relating the historical event, van der Weyden clearly emphasizes the sacramental meaning of the baptism of Christ by placing it in a central position. On the columns of the portal are figures of the Apostles Peter and Andrew (left) and James the Great and John the Evangelist (right). The hollow moulding above contains a series of reliefs consecutively depicting Zacharias's prophecy of John's mission; John praying in the wilderness, and baptizing the Pharisees and Sadducees; and Christ being tempted three times by Satan.

The third panel of the altarpiece represents the beheading of John the Baptist. In the foreground Salome, exquisitely dressed, receives John's head on a salver from the executioner. The way this man has tied his skirts up behind and rolled up his sleeves graphically emphasizes the horror of the proceedings. He and Salome, finding it impossible to look each other in the face, turn away demonstratively, as if realizing the heinousness of the deed. Beneath the executioner's sword, on the steps leading down to his subterranean dungeon, lies the body of John the Baptist, hands bound, blood gushing from his neck. To the right is a walled palace courtyard, where two witnesses mourn the victim. As the Gospels record (Matthew 14:2–12 and Mark 6:17–29), John publicly accused Herod of having committed adultery with Herodias, his brother Philip's wife; Herod took John prisoner without, however, daring to put him to death. Then Herodias's daughter, Salome, danced for Herod, and he was so enthralled that he promised to grant her every wish. Goaded by her mother, the girl demanded John's head. Herod was unable to recant, and ordered him killed.

Behind the execution scene beneath the portal, a wide passageway extends over two low

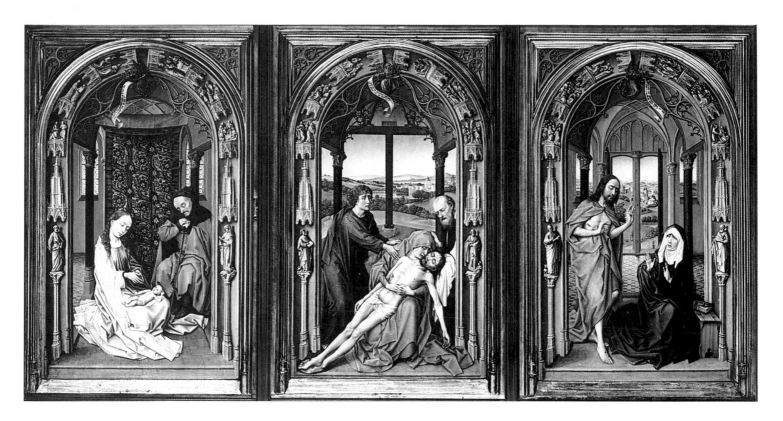

tiers of steps to a hall in the background, where Herod and Herodias are seated at a banquet. Salome kneels to present the Baptist's head to her mother, who, guilty of his death, stabs at the head in uncontrollable rage.

In the vertical mouldings Rogier has placed statues of the Apostles Paul and Bartholomew (left) and Thaddeus and Matthias (right). The reliefs along the arch represent John being questioned by priests and Levites; revealing Christ as the Messiah; warning Herod; being cast into prison; visited by disciples; and finally, Salome dancing before IIcrod. This last scene immediately precedes the beheading of John the Baptist. In this way, the three central events of the altar panels arc placed in a larger context and, through renderings of simultaneous events from the life of Christ, are vividly and concretely linked with the story of salvation.

Rogier van der Weyden
Miraflores Altarpiece
Berlin, Gemäldegalerie SMPK

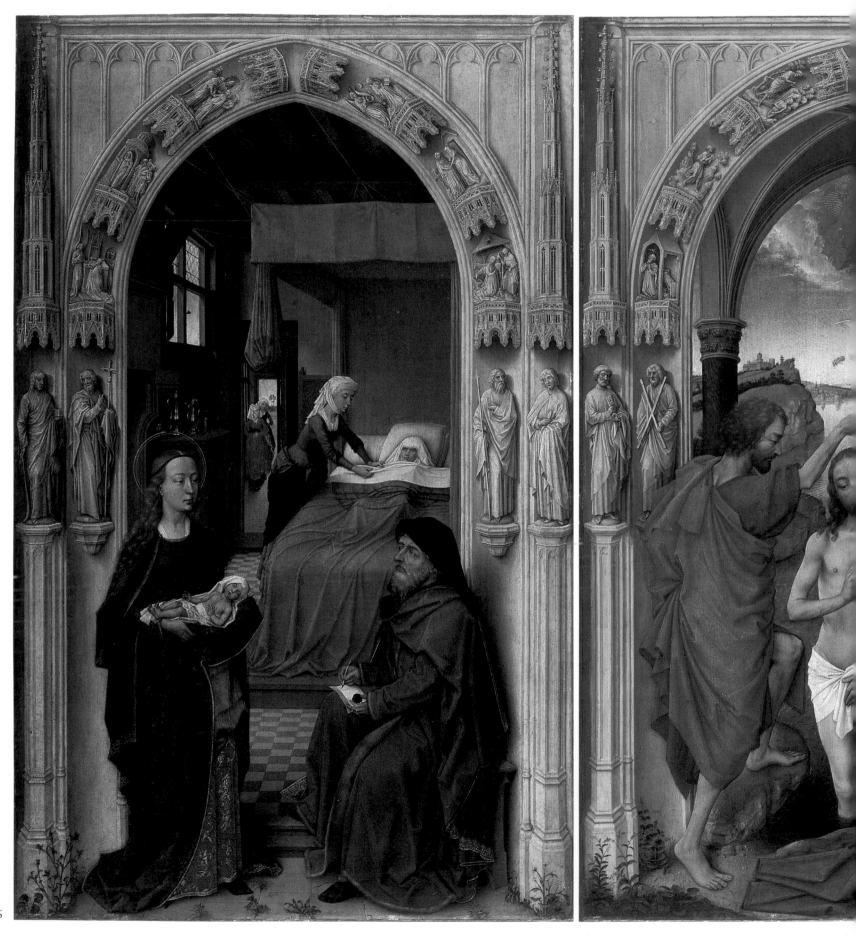

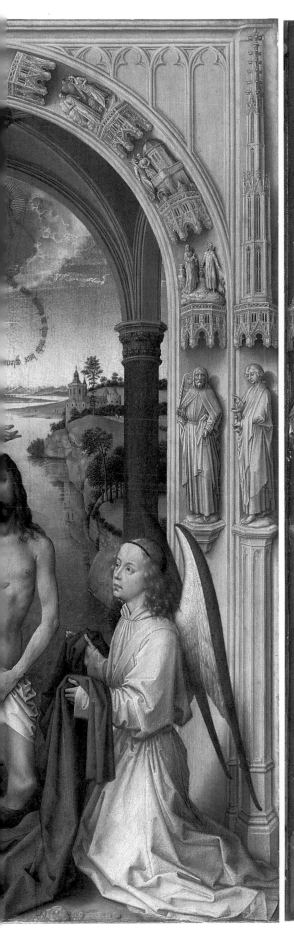
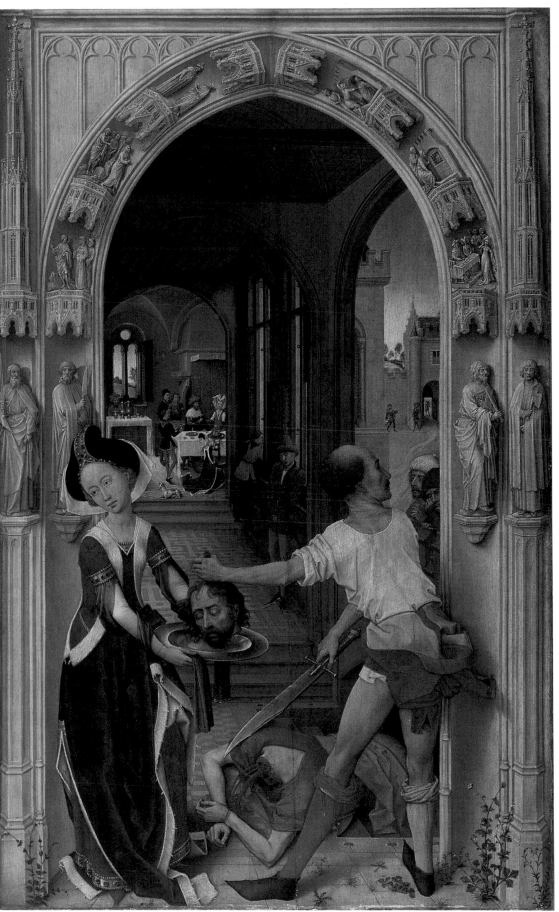

Jacques Daret (1400/3–68)
The Visitation

Oak, 57 × 52 cm (22½ × 20½ in)
Acquired with the Solly Collection, 1821
Cat. no. 542

Daret is first recorded in 1418, as 'being present at the house' of Robert Campin, who was earlier called the Master of Flémalle. After receiving his training there, he was officially apprenticed in 1427 with Rogier van der Weyden, and in 1432, earned the title of independent master. Daret's achievement was recognized and honoured early, as can be seen from commissions for extensive decoration work for a court festivity arranged by Philip the Good in Lille (1454), and for the marriage of Charles the Bold with Margaret of York, celebrated at Bruges in 1468. In the years 1434–5, 1441, and 1452, Daret worked for the St Vaast Abbey in Arras. The few pictures of his that have survived the intervening centuries stem from his first years of activity for that monastery. These are a total of four paintings which once formed the outside wings of an altarpiece executed in 1434–5 for the Lady Chapel in the monastery church. The donor was Jean du Clercq (b.1376), Abbot of St Vaast from 1428–62. Installed in the chapel in July 1435, Daret's altarpiece, as a contemporary witness records, was greatly admired by the participants at the congress then taking place in Arras, which led to a reconciliation between Philip the Good of Burgundy and Charles VII of France, and which has been recorded in history as the Peace of Arras.

A further report, from the year 1651, contains a precise description of the altarpiece with its wings painted by Daret. The central shrine was carved, with a representation of the Coronation of the Virgin in the middle, flanked on both sides by statues of the Twelve Apostles. To this shrine were attached two small wings, at the sides of its high, pinnacled superstructure, as well as two larger wings flanking the central shrine itself. The interiors of all four wings carried golden fleurs-de-lis on an azure ground, visible at both sides of the carved shrine when the altar was open. In a closed position, the exteriors of the wings with Daret's paintings of the life of the Virgin could be seen. These were originally crowned, on the two smaller panels, by an Annunciation scene which has not survived. Below it, in chronological order from the left, appeared *The Visitation* (Berlin, Gemäldegalerie SMPK), *The Nativity* (Lugano, Thyssen-Bornemisza Collection), *The Adoration of the Magi* (Berlin, Gemäldegalerie SMPK), and *The Presentation in the Temple* (Paris, Musée du Petit Palais).

The Visitation, based on the Gospel of St Luke (1:39–56), depicts the encounter of Mary and Elisabeth, wife of Zacharias and mother of John the Baptist. Jean du Clercq, the altar's donor, kneels in the left foreground, a devout witness to the event. His coat of arms hangs behind him on a tree; St Vaast Abbey is in the background in the middle of a flat lowlands landscape.

Jacques Daret
Altarpiece from St Vaast Abbey, Arras:
exterior of wings
The Visitation
Berlin, Gemäldegalerie SMPK
The Nativity
Lugano, Thyssen-Bornemisza Collection
The Adoration of the Magi
Berlin, Gemäldegalerie SMPK
The Presentation in the Temple
Paris, Musée du Petit Palais

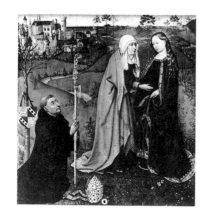
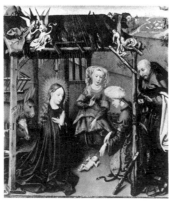
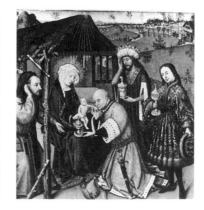
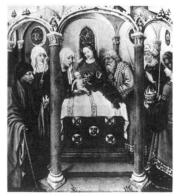

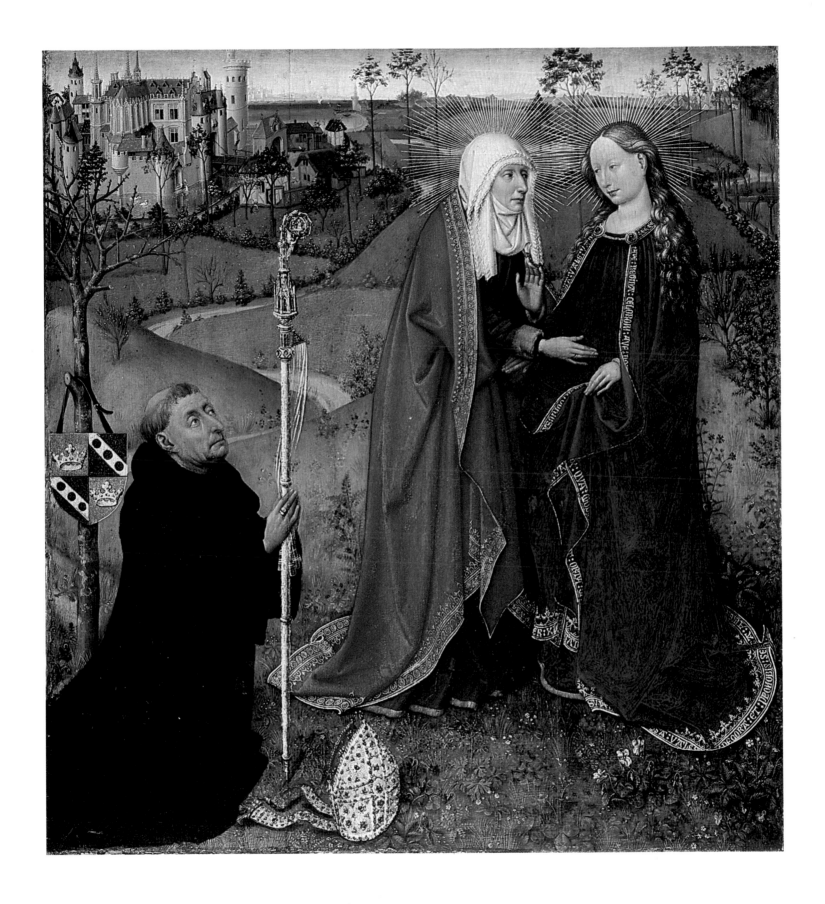

129

Jean Fouquet (c.1420–c.1480)
Estienne Chevalier with St Stephen

Oak, 98 × 86 cm (38½ × 33⅞ in)
Acquired 1896
Cat. no. 1617

Fouquet, the first French painter of international significance, was widely admired during his lifetime for the versatility of his talent. His portrait of Pope Eugene IV, painted in Rome from 1443 to 1447 and hung in the sacristy of S. Maria sopra Minerva, found a place of honour in the *Trattato d'architettura* (1460/4) written by the Florentine sculptor and architect, Filarete. It was also highly praised by Francesco Florio, an Italian traveller. When he saw it with other works by Fouquet in 1477, Florio remarked: 'I compare the old depictions of saints with modern ones, and think how Jean Fouquet surpasses other painters of every century with his art.'

Fouquet worked in Tours, the most important intellectual and cultural centre in France at the time, and the residence of Charles VII (1403–61) and Louis XI (1423–83). Though Fouquet did not become royal court artist until 1475, numerous paintings and book miniatures established his reputation early. The rarified taste of the Tours court and of his patrons, Mary of Cleve, the powerful Chancellor Guillaume Jouvénal des Ursins, and the influential Treasurer Estienne Chevalier, found its perfect expression in Fouquet's art. His priceless and richly illuminated *Book of Hours*, created for Estienne Chevalier, testifies just as eloquently to this as the painting here of Chevalier with St Stephen. The panel once formed the left half of a diptych that hung over Chevalier's grave in the choir of Notre-Dame in Melun, outside Paris. Originally, the panels had an elaborate frame, covered in blue velvet and ornamented with gilded medallions with Biblical scenes; these were interspersed with the first letters of the donor's Christian name in pearl embroidery. Some time after 1775, the diptych was taken down, its frame removed, and the panels sold separately. Fortunately the donor panel came into the possession of the poet Clemens Brentano and his brother Georg, who at that time owned a large portion of the famous Fouquet miniatures now at Chantilly. The panel was acquired for the museum in 1896, from the Brentano family; its counterpart with an image of the Virgin had entered the Antwerp Museum in 1840.

Estienne Chevalier, a native of Melun, rapidly advanced in the course of his career from *Secrétaire du roi* to *Trésorier de la France*. Under Charles VII and Louis XI he was entrusted with important diplomatic missions and amassed a considerable fortune. Fouquet's depiction of his determined features gives some idea of the great power and influence Chevalier must have wielded. Beside him is his name-saint, Stephen, his right hand resting on Chevalier's shoulder; in St Stephen's left hand, a book and sharp-edged stone symbolize his martyrdom. The rendering of St Stephen's spiritualized features is impressive. In the background, a wall in the Renaissance style, divided by pilasters and with inlays of coloured marble, recedes in sharp perspective. The donor's names are engraved on the plinth.

The saint and donor are turned towards the Virgin whose image appears on the panel that once formed the right part of the diptych. Angels in red and blue surround the Virgin's throne, which is richly encrusted with pearls and gems. She herself is a slender young woman whose dignified yet challenging pose seems strangely lascivious. Long tradition has it that Mary's features are those of Agnes Sorel (c.1422–50), the influential mistress of Charles VII, whose last will and testament Chevalier was appointed to execute. An eighteenth-century inscription on the back of the Madonna panel states that Chevalier donated the diptych in memory of Agnes Sorel. This sort of profanation was certainly not foreign to the bizarre, contradictory spirit of the era, which has been so aptly termed the 'autumn of the Middle Ages'.

Jean Fouquet
The Virgin and Child
Antwerp, Koninklijk Museum voor
Schone Kunsten

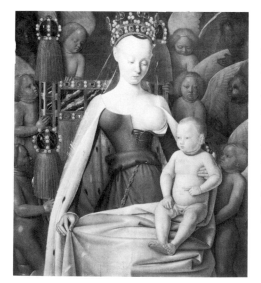

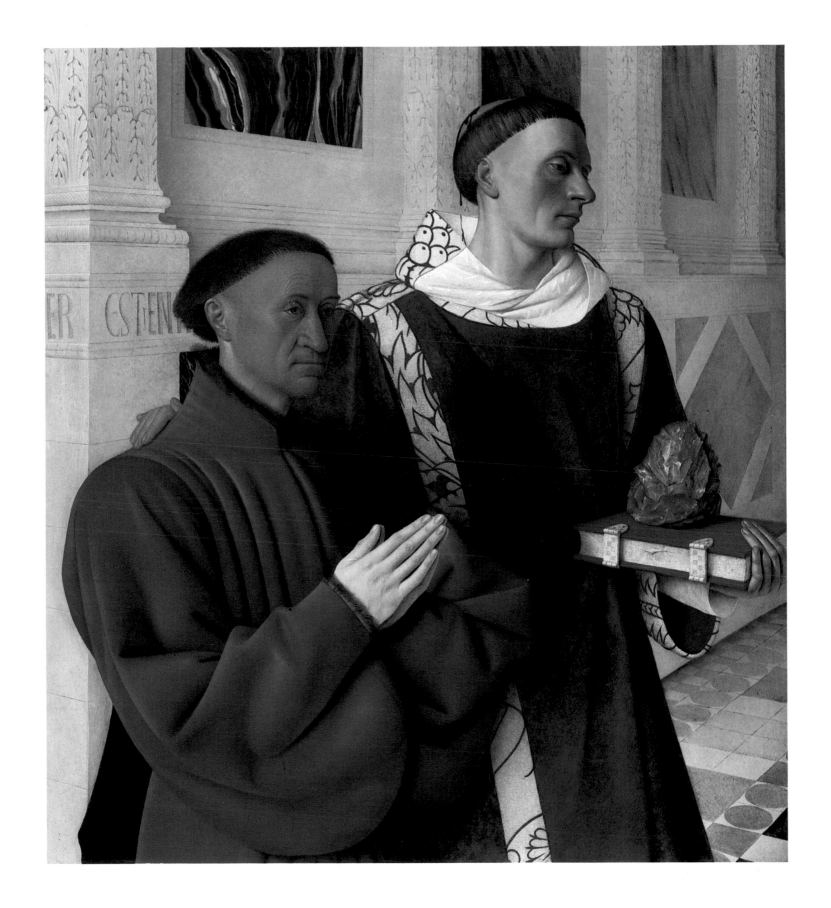

Simon Marmion (*c.*1425–89)
The Wings of the St Omer Retable: The Life of St Bertin

Oak, each wing 56 × 147 cm (22 × 57⅞ in)
Acquired 1905
Cat. nos. 1645 and 1645 A

Simon Marmion, who worked in Amiens, Valenciennes and for a time in Tournai, was among the greatest French artists of the later half of the fifteenth century. Even the earliest records praise him as a *Prince d'enluminure* and attest to the wonder with which the abundant and superbly rendered natural detail of his miniatures was received.

Marmion's major work and the point of departure for a reconstruction of his œuvre, which combined inspiration from French and Netherlandish art, is the altarpiece he did for the St Bertin Benedictine Abbey at St Omer in northern France.

The donor of this retable, which was installed in 1459 on the high altar of the abbey church, was Guillaume Fillastre, Bishop of Verdun (1437–9), Bishop of Toul (1449–60), Abbot of St Bertin (1450–73), Bishop of Tournai (1460–73), Chancellor of the Order of the Golden Fleece, and confidant of Philip the Good, the powerful Duke of Burgundy. Though the exquisite altarpiece remained in the abbey until 1791, like so many other ecclesiastical treasures it was damaged in the French Revolution. The central shrine, richly ornamented with sculptures in fine goldsmith work, was destroyed and melted down. All that survived were the wings by Marmion. After entering the collection of William II of Holland in the early nineteenth century, they came into the possession of the Prince of Wied, from whom they were acquired for the Berlin Museums. Originally, the ends of both wings were capped by pinnacled superstructures, but these were removed in the early nineteenth century and are now in the National Gallery, London. The two altar wings and associated fragments really cannot give more than a slight idea of the elaborate original retable and its monumental effect. In its open position, it was over 6 m (19 ft 8 in) wide.

The backs of the two wings are painted in *grisaille*. These exterior sides were visible when the altarpiece was closed and represented its 'everyday' aspect. At the left are Mark and Micah, John and Solomon, and the Archangel Gabriel, who is associated with the Virgin of the Annunciation on the right wing. The figures of David, Matthew, Isaiah, and Luke appear on her right. The kings, prophets, and four Evangelists, who carry banderoles

Simon Marmion
Saint-Omer Retable
Exterior of wings

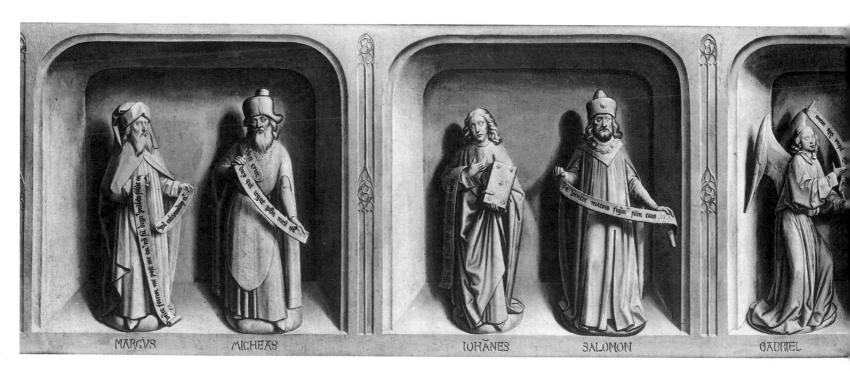

MARCVS MICHEAS IOHÃNES SALOMON GABRIEL

and are identified by names inscribed beneath them, are arranged in pairs in painted niches flanking the Annunciation scene. These figures also refer to the painting on the original altar shrine, which bore an image of the Crucifixion at its centre with a gilded Tree of Life above it to symbolize Christ's work of salvation and its passing on to men through the wine of the Eucharistic blood.

The images on the inside of the wings that once flanked the gilded shrine are particularly striking for their colour scheme of great brilliancy and crystal clarity, and for their extraordinary abundance of detail. Together these images form a comprehensive cycle of five scenes, separated by elaborate architectural motifs, that record events from the life of St Bertin, the founder and titular saint of the monastery.

St Bertin was born in about 615 near Coutances (Manche) and died on 5 September 698. He entered the monastic order in Luxeuil (Haute Saône), became bishop of Thérouanne (Pas-de-Calais), and founded the Sithiu Monastery – renamed St Bertin in 1100 – whose abbot he was from 670 to his death. From the year 745 he was revered as a saint.

The sequence begins in the left corner of the left altar wing, with a depiction of the donor, Guillaume Fillastre, dressed in a bishop's vestments and kneeling before an open missal. A chaplain stands behind him. An angel hovering above him carries his coat of arms. Other angels, singing and playing, are represented on the superstructure of the image (now in London). The donor's gaze is directed towards the adjacent scenes from the life of St Bertin – his birth, then his investiture in the monastery of Luxeuil, where he is shown once in the foreground, humbly kneeling beneath the church portal, and again in the background, praying before the choir screen. The following scene, devoted to St Bertin's pilgrimage, shows him being received, with the monks Ebertramne and Momelin, by St Omer in Thérouanne. Next comes a rendering of the dedication and construction of the new monastery, with St Bertin accepting the gift of land from the rulers of the demesne, the knight Adrowald, whose castle is in the background near the River Aa. On the water is a boat with the saint and his attendants, who are being guided by an angel of the Lord to the place destined for the monastery.

The story continues on the right wing with the Miracle of the Wine. This legend recounts how the knight Waldbert, having neglected to receive the monastery's blessing, is thrown from his horse while hunting. Waldbert send his page to St Bertin for a consecrated drink, and when he arrives at the monastery, an empty cask miraculously fills with wine. Here, the monk Duodon kneels before the cask as the page and St Bertin witness the miracle. The next scene shows the knight, healed and converted, renouncing the world to enter the

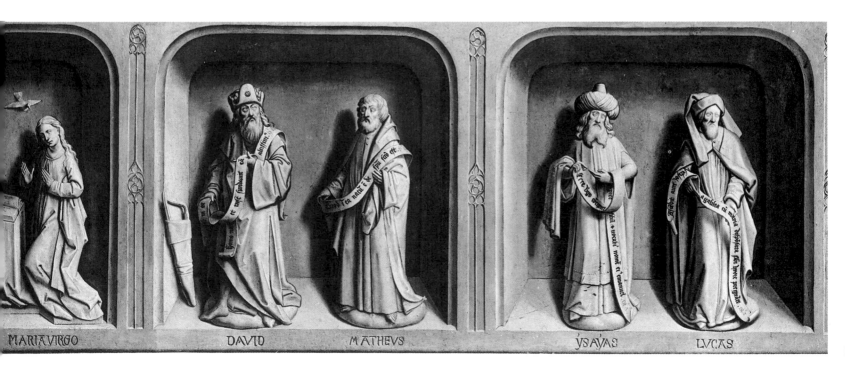

MARIA VIRGO DAVID MATHEVS YSAYAS LVCAS

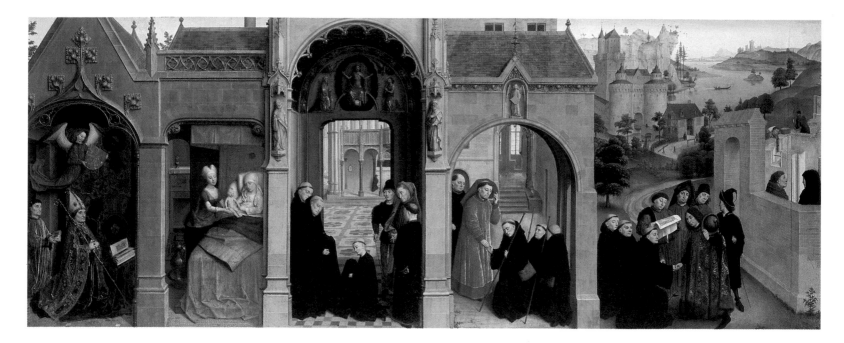

monastery with his son. Their example is followed by four other Breton noblemen in the next image. The walls of the Gothic cloister in the background of these two scenes have a continuous frieze of the Dance of Death, a symbol of the transience of all earthly things, which strikes awe into the hearts of the young noblemen looking at it. Nor was St Bertin himself spared the temptations of the flesh, for in the following compartment we see him confronted with the apparition of a lovely woman finely dressed but the claws for feet – a demon of the underworld, being exorcised by St Martin of Tours. In the final scene of the sequence, St Bertin lies on his deathbed, mourned by a noble patron of the monastery and by monks who administer the last sacraments. The superstructure that once capped this scene, now in London, shows St Bertin's soul ascending to heaven.

The brilliance of the palette and the detail of the rendering prove Marmion's extraordinary talent as a miniaturist. The handling of light is also remarkable; it plays across the architectural motifs in subtle nuances and lends an atmosphere of unprecedented intimacy to the rooms. From the dimly lighted donor's cell and saint's death-room, the illumination gradually strengthens into the brilliant sunlight flooding the landscape, which served as a transition to the shimmering, gold-encrusted sculptures of the original central shrine.

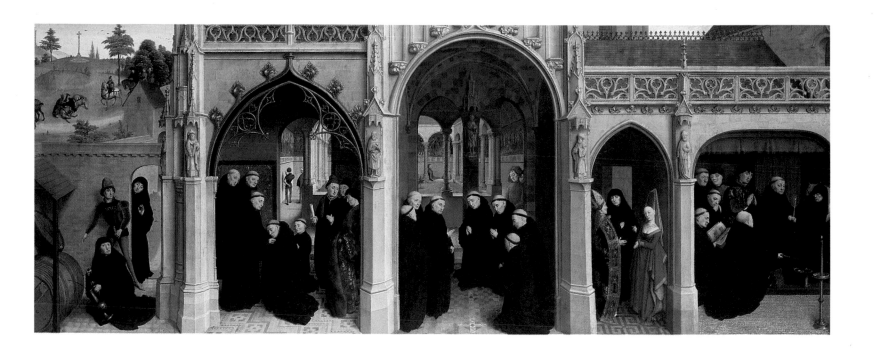

Dieric Bouts (1410/20–75)
Christ in the House of Simon the Pharisee

Oak, 40.5 × 61 cm (16 × 24 in)
Acquired from the Collection of A. Thiem,
1904
Cat. no. 533 A

The event pictured here goes back to the story in St Luke's Gospel (7:36–50) where Simon the Pharisee invites Jesus to eat with him. During the meal a woman of the town appears, a sinner not named by the Evangelist but who later came to be identified with Mary Magdalene, the sister of Lazarus. She kneels before Jesus, washes his feet with her tears, dries them with her hair, kisses and anoints them with oil. The Pharisee is scandalized and reproves Christ under his breath, 'This man, if he were a prophet, would have known who and what manner of woman this is that toucheth him: for she is a sinner.' Jesus replies with a parable, explaining his behaviour to Simon in a form he can understand. There was once a creditor, Jesus begins, who had two debtors, one of whom owed five hundred pence and the other fifty, and both of whose debts he forgave. Which of these would love him more? 'I suppose that he, to whom he forgave most.' replies Simon without hesitation. Then Jesus recalls that Simon had neither kissed nor anointed him when he entered the house and that he had received more abundant gifts from the outcast woman at his feet than from the rich Pharisee. For that reason, many sins would be forgiven her, 'for she loved much: but to whom little is forgiven, the same loveth little'. And to the sinner, 'Thy faith hath saved thee; go in peace.'

According to the *Legende aurea* of Jacobus de Voragine (1230–98/9), it was Mary Magdalene 'who in the time of grace first did penitence; who chose the best part; who at the feet of the Lord heard His word and anointed His head; who stood next to the cross at the death of the Lord; who there prepared ointment, to anoint His body; who did not forsake the grave when the apostles went away; to whom Christ first appeared after His Resurrection; and whom He made Apostle of the Apostles.'

The scene is set in the shallow space of a room with a wooden, barrel-vaulted ceiling. Two side-entrances lead to another room on the right, and to a colonnaded forecourt on the left through which a distant landscape is visible. In the centre of the room is a table set with plates of smoked fish, earthen jars, glasses, knives and bread – a beautifully composed still life in its own right. Simon is seated behind the table in the middle, bending forward at the unwelcome interruption of his meal; his mouth is slightly open as if he were about to express his disapprobation of the scene. Christ, seated as a guest of the house at his host's right, looks down calmly at the woman kneeling before him, blessing her act with his raised right hand. Astonishment and discomfiture also characterize the pose and gesture of Peter, seated to the left of the Pharisee, while John turns to the priest kneeling beside him as if to explain. This figure at the right is a portrait of the painting's donor. In the white robes of a Carthusian monk, he kneels reverentially at the side of the table, hands folded in prayer, his distinguished face turned aside, looking into the indeterminable distance.

Dieric Bouts, a native of Haarlem, received his first artistic training there before emigrating to the southern Netherlands. He settled in Louvain in about 1445, married in 1448, and soon had achieved great renown and considerable prosperity. In 1468 he was elevated to the prestigious position of Town Artist of Louvain. Bouts's major works were painted on commissions from the Municipal Council and the religious orders of this famous university town. Sint Pieterskerk in Louvain still preserves his famous triptych with *The Last Supper*, painted from 1464 to 1467 for the Brethren of the Holy Sacrament.

Though the painting in our collection antedates his major works, it already contains all the essential traits of Bouts's art – a lovingly delineated interior with carefully planned and balanced illumination, shimmering intense colours, and figures who appear self-engrossed, as if withdrawn into themselves. The compelling and memorable simplicity of this image has struck many later observers. Besides the artist's son, Aelbrecht Bouts, a number of other masters have taken this treatment of the theme as a model and a point of departure for their own compositions.

Aelbrecht Bouts (after Dieric Bouts)
Christ in the House of Simon the Pharisee
Brussels, Koninklijke Musea voor Schone Kunsten

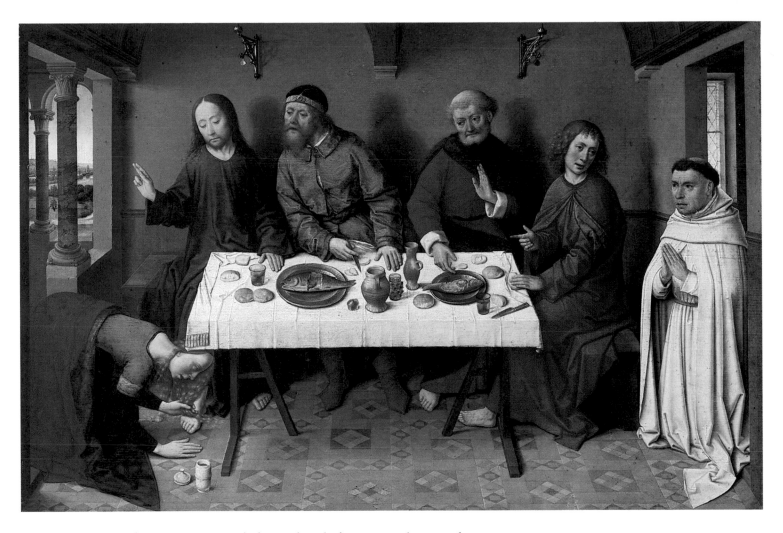

The fascination of Dieric Bouts's work derives largely from a superb sense of interior space, developed during his training in the northern Netherlands and through profound study of the work of Petrus Christus and Rogier van der Weyden. The role of space is so dominating in solidly positioning the figures, which appear so static and immutable, that the time factor seems eliminated. This is the key to the timeless and often enigmatic sublimity of Dieric Bouts's art.

Hugo van der Goes (1440/5–82)
The Adoration of the Magi
(Monforte Altarpiece)
c.1470

Oak, 147 × 242 cm (57⅞ × 95¼ in); centre raised 9 × 76.3 cm (3½ × 30 in), originally higher but cut down by about 70 cm (27½ in) at an unknown later date. Acquired from the Monforte de Lemos Monastery, northern Spain, 1914
Cat. no. 1718

By the time Hugo van der Goes became an independent master in his home town of Ghent in 1467, Petrus Christus and Dieric Bouts in Bruges and Louvain had reached artistic maturity, and Hans Memling had just received citizen's rights in Bruges two years before. Van der Goes's advance to become the leading artist in Ghent, which was the site of the van Eyck brothers' magnificent altarpiece, led to the renascence of that city as a centre of art.

Van der Goes's achievement is even more remarkable because of the fact that all the works by him known today were done in only fifteen years. His major work was created for Tommaso Portinari, a representative in Bruges of the Medici Florentine banking house. This altarpiece, now in the Uffizi in Florence, attributed to van der Goes on the basis of Vasari's reports, formed the point of departure for a reconstruction of the artist's œuvre.

In 1473 van der Goes was nominated Dean of the Ghent Artists' Guild, but only held this office for a short time. In the spring of 1477, at the height of his fame, he entered the 'Rode Klooster' near Brussels as a lay brother. Despite a serious mental illness he remained active there until his death in 1482. Albrecht Dürer, who travelled through the Netherlands in 1520–1, noted in his diary the names of those artists he considered the greatest: Jan van Eyck, Rogier van der Weyden, and Hugo van der Goes.

The present altarpiece, named after its place of origin, the remote Monforte de Lemos Monastery in northern Spain, belongs among the artist's first major achievements. It is not known how the work came into the possession of this monastery, which was founded in 1593. Nor has it been determined who commissioned it, or the church for which it was originally intended.

The Adoration of the Magi was once the central panel of a large triptych. The intricate moulding of the old frame still bears iron hinges on its sides where movable wings were originally mounted. Replicas of the altarpiece (particularly of the middle panel) by contemporaries and followers of the artist, indicate that the composition was soon regarded as exemplary. This, however, was no insurance against the damage inflicted on it and on so many fine works of art in later centuries. Among other things, the wings of the altar were lost, and the rectangular top extension of the central panel truncated. Of the angels descending from above, only the hems of their garments remain.

This huge and imposing altar, which with opened wings measured almost 6 m (19 ft 6 in) wide, takes us into a new sphere of early Netherlandish art. It is a mature work that shows van der Goes at the zenith of his powers. The figures, unusual in their physical monumentality and inner grandeur, are convincingly integrated in the surrounding space, and possess a presence and dignity previously unknown in Netherlandish art. It is highly indicative that at the Monforte Monastery, this painting was ascribed to Rubens.

Probably no second Biblical event challenged the imagination of the faithful as much as the story of the Adoration of the Magi. So strikingly different from the Nativity, this story is recounted only in the Gospel of St Matthew (2:1–12). Seeing a new star in the sky and interpreting it as a sign that the King of the Jews had been born, three wise men from the East went to Jerusalem where they asked Herod how to find the birthplace of the new king. Troubled by this question, Herod gathered his chief priests and scribes in counsel, and they pointed the way to Bethlehem. Led by the star, the three Magi found the Child, whom they worshipped and to whom they made offerings of gifts.

This simple story was later embroidered by theology and popular faith. Tertullian decided the wise men were kings, and Origines then said there were three because of the three gifts mentioned in St Matthew. The names they are still popularly known by today, Caspar, Melchior and Balthasar, first occurred in the ninth century. During the High Middle Ages the three kings were regarded as emissaries from the three then-known kingdoms of the world: Europe, Africa and Asia. This explains why one of them was so

often depicted as a Negro or Ethiopian.

In front of a ruined wall of a once magnificent palace, Mary is seated in tranquil dignity looking down at the naked Child, whom she gently supports in her lap with both hands. The Infant's attention is not so much captured by the great men who have come to pay obeisance to him as directed towards the spectator, at whom he looks. Joseph kneels in the foreground, having bared his head to greet the three kings. The eldest, kneeling in prayer before the Infant, has humbly removed his ornate crown. Before him on a stone is his gift, a chalice full of coins. The second king also kneels and with a gesture of his hand expresses deep reverence as his page beside him presents his offering. At the right, as if completely lost in wondering adoration, stands the African king, holding an exquisite vessel. The three kings are compellingly characterized, among other things by their different ages – a motif that arose in the fourteenth century and symbolizes the three ages of man. Behind the third king near the right edge of the painting, and behind the low barrier in the centre, are the royal retinues, who are involved in the event in various ways. The shepherds in the distance, according to a fourteenth-century tale by Johannes von Hildesheim, told the kings about the miracle they had witnessed and showed them the way to the stable. These shepherds were considered the elect among the Jews, just as the kings were the elect among heathens. Their combined appearance in this painting may be understood as a reference to the unifying force of the church established by Christ. To the left is an opening view of a village street, where the villagers watch as the kings' knights cross a bridge and dismount to lead their horses.

The iris blossoms next to the ruined wall in the foreground were associated at that period with the sword which, as Simeon predicted (Luke 2:35), would pierce Mary's heart at the sight of her son's suffering. According to the *Revelations* of St Birgitta of Sweden, written in the late fourteenth century, 'Like the leaf of the iris, Mary had two very sharp edges: her heartrending pain over the agony of her son, and her steadfast defence against all the cunning of the Devil. So, truly, Simeon had prophesied that a sword would pierce her soul. For she was compelled to feel at her heart this sword's sharp blade as often as she foresaw in her mind's eye the wounds and torments of her son, whose witness she became at the Passion.' The columbine growing in the right foreground, venerated for its miraculous healing powers during the Middle Ages, belongs in the same symbolic context, being frequently used as a reference to the Virgin.

The stately calm and extraordinary monumentality of the realistic figures far transcend anything achieved in Netherlandish art until then. The worship of the future Monarch of the World has rarely been so memorably embodied as in the contrast between the newborn Infant, unconscious of his mission, and the venerable aspect of the eldest king with his worn, heavy hands folded in prayer. Here the mystery of salvation is given devout and compelling expression, whose truth to life does not detract at all from the formal sublimity of the composition.

Hugo van der Goes
The Adoration of the Magi (Monforte Altarpiece)
Reconstruction of original state of central panel

Hugo van der Goes
The Lamentation of Christ

Canvas, 53.5 × 38.5 cm (21 × 15⅛ in)
Acquired as gift from O. Huldschinsky, 1900
Cat. no. 1622

Painted in tempera on canvas, this work is among the few of its kind – once known as 'Tüchlein' or 'little cloths' – which have survived from the fifteenth century. The fragile paint surface, the canvas material, and the damp climate north of the Alps, have taken their toll on these paintings, and the surviving ones are often in poor condition. Hugo van der Goes's *Lamentation* is interesting for this reason, but also because it is an early example of the compositional form of a group with half-figures.

The painting shows Christ's next of kin mourning his death. They are drawn together and united in their shared sorrow, expressed by the artist with great subtlety. In the foreground, a youthful Mary, head inclined, crosses her hands over her breast in a gesture of profound submission. Supporting her is John, Christ's favourite disciple, his hand on her shoulder in an attempt to console her. To their right, Mary Magdalene expresses her sorrow, wringing her hands and turning her tear-stained face aside. The group is completed by the two other Marys, Mary Salome and Mary Jacobi, one with hands raised in lament and the other dabbing the tears from her eyes. Golgotha beneath a strip of blue sky is visible in the background. The painting's colour scheme, once accented by John's brilliant red mantle and Mary's blue gown, now appears faded and subdued.

The composition and its story are of course incomplete without the focus of the group's lamentation – the image of the dead Christ which once formed the companion-piece. Though numerous copies of the two canvases, especially a remarkable reinterpretation by Hans Memling (Granada, Capilla Real), conveyed an impression of the original, the companion-piece to the *Lamentation* was not discovered until 1950. Now in the Wildenstein Gallery, New York, *The Deposition* focuses entirely on the presentation of Christ's body by three men who hold it up frontally towards the spectator. The lifeless body with the wound in its side and its dangling arms forms the centre of interest; a shadowy Golgotha and the ladder on which Christ was taken from the cross are the only suggestions of the place and time of the event.

The two companion paintings are now generally referred to as *The Small Deposition*, to distinguish them from van der Goes's *Large Deposition*, a horizontal composition that has not survived though it has been recorded in over forty copies made in the sixteenth century.

The lasting admiration these compositions have inspired surely owes much to the adaptation of the half-figure to a subject full of action and involving many figures. This enrichment in form and content shaped the development of the 'narrative half-figure image' in Netherlandish painting far into the sixteenth century. Van der Goes's *Lamentation* proves how very well suited this genre was to concentrating interest solely on the figures' emotions and moods, and to achieving a corresponding concentration of pictorial content.

Hugo van der Goes
The Deposition
New York, Wildenstein Gallery

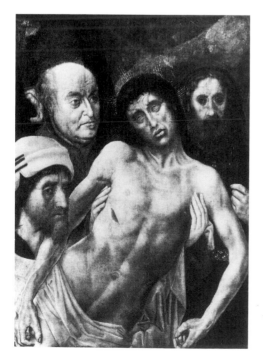

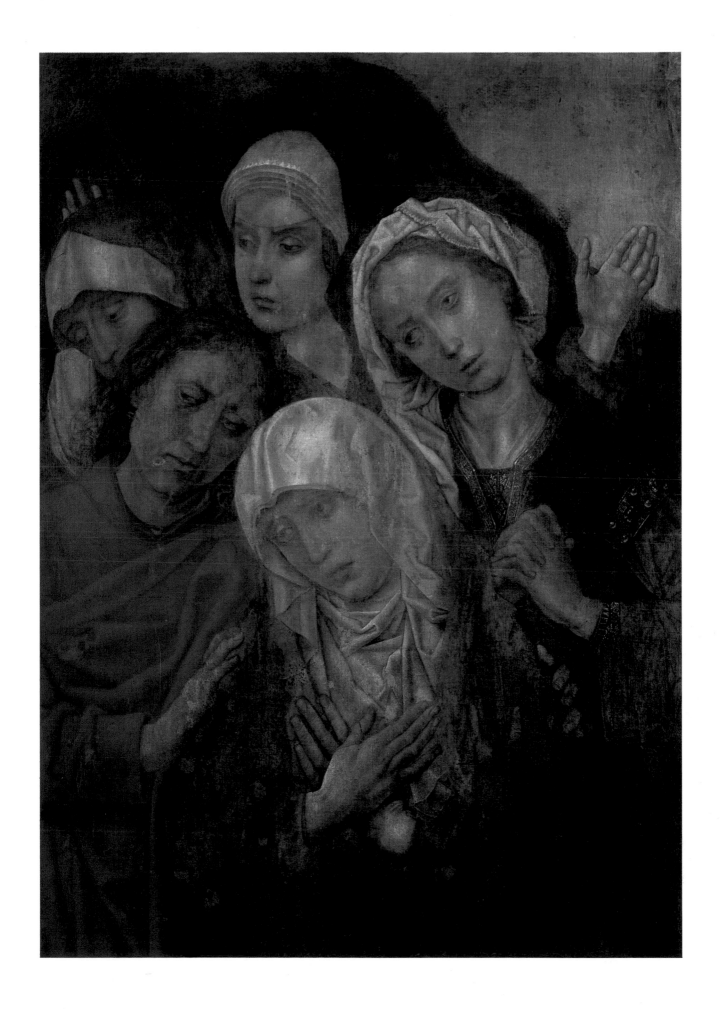

Hugo van der Goes
The Adoration of the Shepherds
*c.*1480

Oak, 97 × 245 cm (38⅛ × 96½ in)
Collection of the Infante, Don Sebastian,
Pau Castle (southern France)
Acquired from the estate of Christina of
Bourbon, Madrid, 1903
Cat. no. 1622 A

This painting was probably done in about 1480, during the artist's last productive years. By that time van der Goes had gone into retreat as a lay brother of the 'Rode Klooster', in Soignies Forest near Brussels, where his step-brother Nikolaus also lived as a monk. Terrible bouts of depression had moved the artist to renounce the world and submit himself to a severe, monastic regime. According to the monastery chronicles of 1509–13, the prior of 'Rode Klooster' was a lover of art who granted van der Goes many favours and privileges. Travels to Louvain and Cologne are mentioned, as well as visits from such high-ranking men as Archduke Maximilian, who later became Emperor Maximilian I. The artist spent the last years of his life in constant worry that he would not be able to finish the commissions that reached him even in his monastic isolation.

Due to its unusual size, *The Adoration of the Shepherds* has sometimes been considered a predella, that is, the substructure of an altarpiece. This is unlikely for a number of reasons. The most important is its striking difference from his *Adoration of the Magi* of Monforte – its completely new approach in drawing, modelling and palette. The colours have a comparatively subdued character, corresponding to a simplification of line in the drapery and contours of the figures. The change might be summed up as an increase in the dynamic quality of pictorial form.

Mary and the Child in the manger are worshipped by angels while, from the left, shepherds approach hurriedly, falling to their knees or apparently halting in mid-stride with astonished wonder at the miracle before their eyes. Details such as the half-open mouth of the man panting with the exertion of his run, are rendered with great virtuosity. The image is framed on the left and right by two half-figures whose exaggerated size clearly distinguishes them from the smaller figures of the Adoration scene. These figures, identified as prophets, have opened the curtains concealing the great event of salvation, the birth of Christ. They stand aside to proclaim the incarnation of God and its profound significance to the observer. Though the theme of Old Testament prophets revealing the truth of the New Testament was familiar in medieval art, van der Goes's rendering of it is quite original. He may have been inspired by the popular liturgical Christmas plays that were performed near the altar and whose characters included prophets announcing the incarnation. Whatever the case, he has translated the theological message into a humanly moving one which speaks directly to the feelings of the faithful.

A striking detail is the open curtain hanging from a very realistic rod along the top edge of the painting. Old inventories and traditional iconography show that altar curtains of this type were in use from the early Middle Ages and became a common feature of altars in the fourteenth and fifteenth centuries. These curtains were fastened to movable arms or to rods mounted on columns at both sides of the altar. They had a decorative function too, as shown by the variety of materials and colours used; green cloth such as that in the painting is expressly mentioned in an entry in the 1479 inventories of the Bruges Tanners' Guild. The main purpose of such curtains, however, was to prevent the priest from being disturbed by the many people gathered around the altar during mass, and at the same time to emphasize the sanctity of the sacramental ceremony. This special task of altar curtains, and the priest's role, were wonderfully described by Berthold von Chiemsee, who in 1535 wrote: 'The priest at the altar must not turn around; for whoever lays his hand on the plough and looks behind him, is unfitted for the Kingdom of God. Therefore, there are usually two curtains on both sides, so as to signify that the altar is the inner, most Holy tabernacle behind the curtain.'

The sacramental symbolism of the image is underlined by the sheaf of grain lying in front of the manger. It conveys a reference to Christ's words, 'I am the bread which came down from heaven' (John 6:41). The Church understood this passage to refer both to the

incarnation and to the Sacrament of the Last Supper. The parallels between the Child in the manger and the bread on the altar are central to van der Goes's painting. Not only does he narrate the unprecedented event of Christ's birth and the shepherds' adoration; beyond that, he points to the coming sacrifice of Christ and to its continual, symbolic renewal in mass and communion.

The plants in the foreground also deserve closer inspection. These are herbs used in medieval medicine to whose healing qualities were attributed specific symbolic meanings. At the far left is herb-robert (*Geranium robertianum*) with its pink blossoms, reddish tinged, feathered leaves, and beak-shaped seeds. Then speedwell (*Veronica officinalis*) and black nightshade (*Solanum nigrum*), recognizable from its black berries and white flowers. Herb-robert was highly valued throughout the Middle Ages and was used to cure many illnesses. The names by which it was popularly known in Germany, God's Gift and God's Grace Herb, emphasize its great therapeutic powers. According to Paracelsus (1493–1541), the drug distilled from herb-robert strengthened the heart and was also effective in relieving symptoms of depression. Speedwell was a frequently used herb in medieval medicine known popularly in Germany as 'cure of all ills' and 'all-heal'. In Hieronymus Bock's *Kreutterbuch*, speedwell is recommended among other things as a cure for dizziness, failing memory, and stomach ailments.

Black or deadly nightshade, a poisonous plant, yields a drug with a pain-killing and soporific effect. It has been known as a reliable sedative since ancient times. Not surprisingly, deadly nightshade was also popularly believed to be good against witchcraft. It used to be placed in babies' cradles to drive away demons. Tradition has it that nightshade was much esteemed by shepherds, who used it to cure various animal diseases. These notions were so familiar to the artist and his contemporaries that he has represented the Christ Child holding a blossoming sprig of deadly nightshade in his right hand. This suggests that the Child is protected from all evil, and that the demons of the underworld are powerless against him. In his *Portinari Altarpiece* (Florence, Uffizi), van der Goes depicted the Devil incarnate concealed in the shadows of the stall, to show that with Christ's birth, his power was broken. The same idea echoes in the *Legenda aurea*, where we read, 'The birth of Our Lord was also munificent in great good. The first good is protection against the Devil. For now the Evil One may not injure us so gravely as he formerly did.'

The multiple symbolism of the image is combined with an equally compelling composition, symmetrically arranged and yet extremely dynamic. This, with the timeless immediacy of its content and feeling, reveals Hugo van der Goes's extraordinary artistic stature.

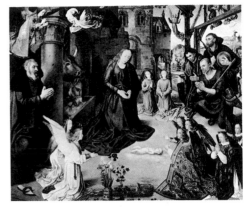

Hugo van der Goes
Portinari Altarpiece
Central panel
Florence, Uffizi

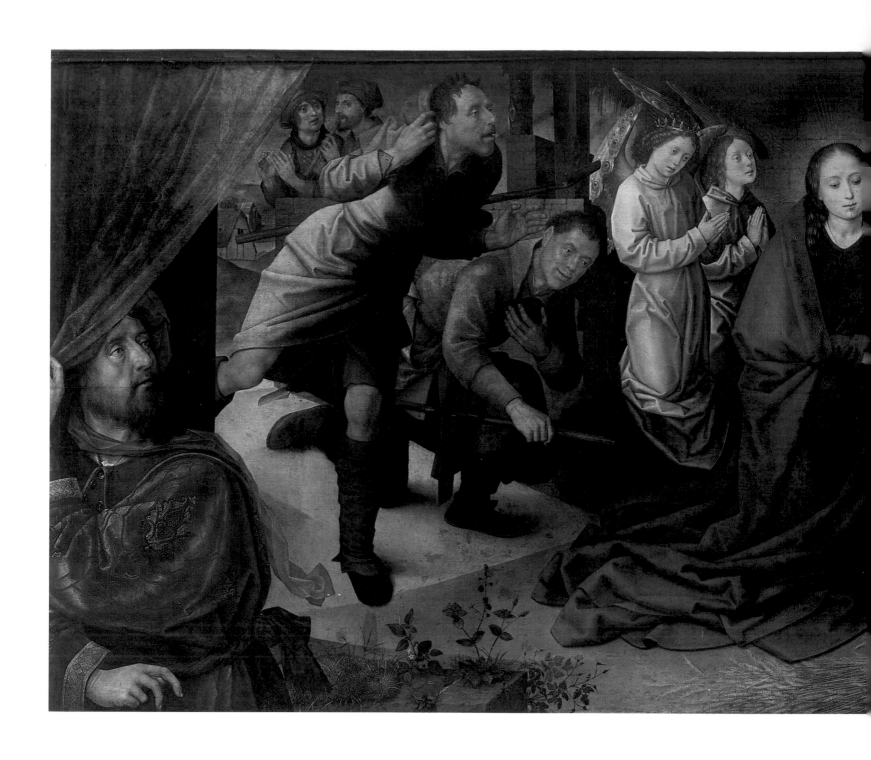

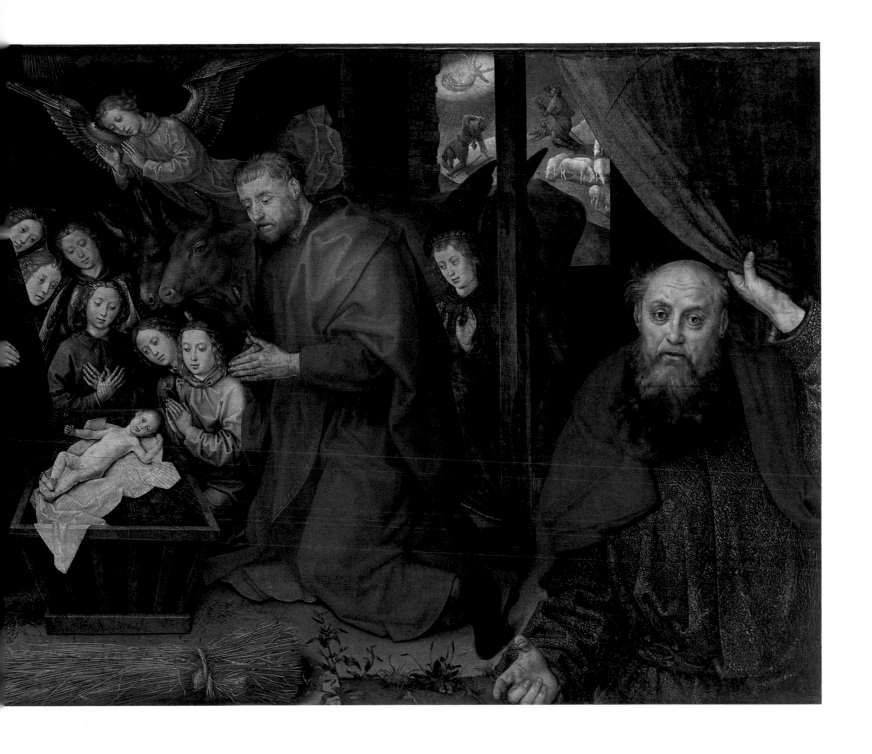

Aelbert van Ouwater (c.1415–c.1475)
The Raising of Lazarus
c.1450–60

Oak, 122 × 92 cm (48 × 36¼ in)
Acquired from the collection of the
Marchese Mamelli, Genoa, 1889
Cat. no. 532 A

The only knowledge we have of Ouwater, a highly significant figure in the development of northern Netherlandish art in the fifteenth century, is based on a report by Carel van Mander, painter, poet and art writer of Haarlem. In his *Schilderboeck*, van Mander maintains that prior to Ouwater, the northern Netherlands produced no artist to match Jan van Eyck (c.1390–1441) or Rogier van der Weyden (1399/1400–64). Thanks to Ouwater, who lived at about the same time as van Eyck, the county of Holland was able to join the powerful cities of Flanders and Brabant in contributing to the glorious tradition of Netherlandish art.

Van Mander's book is particularly important for its description of two works by Ouwater which were in the Grote Kerk in Haarlem before the Spanish invaders took them as booty in 1573. Speaking of his *Altarpiece of the Roman Pilgrims* with *The Apostles Taking Leave of Jesus* (which has not survived), van Mander praises Ouwater's superb skill in painting landscape. He then goes on to give a detailed account of *The Raising of Lazarus*: 'There was a quite large vertical panel by Ouwater there, an under-painted copy of which I have seen, namely *The Raising of Lazarus*. The original, along with other beautiful works of art, was removed under false pretences by the Spanish after the siege and surrender of Haarlem, and taken to Spain. The Lazarus was a very fine and extremely lucidly treated nude by the standards of the time. The painting also showed temple architecture which was lovely though its columns and other elements were a bit small. On one side stood Apostles, on the other were Jews. A few pretty ladies were also present, and in the background a crowd of people peered through the little columns of the choir. Heemskerck [Haarlem artist, 1498–1574] often used to pore over this painting insatiably, and once he said to its owner, who was his pupil, "My son, what can these people have eaten?" which was as much as to say that these masters must have spent incredible time and effort to achieve this type of thing.' This report by van Mander led to the rediscovery and purchase of the panel. Reputedly once in the possession of King Philip II of Spain, it is the only known work by Ouwater to have survived.

The traditional theme of Christ raising Lazarus is treated in a new and unusual way, and the design and composition of figures and space are also new. Every nuance of the light shining through the windows of the ambulatory has remarkable clarity. In the play of light and shadow, the columns of the choir, the window embrasures, arcades and ambulatory columns take on great sculptural relief. By contrast, the wall separating the choir from the passage is held in a neutral tone to provide a suitable background for the figures in front of it.

The story of the miracle performed by Christ in Bethany near Jerusalem is told in the Gospel of St John (11:1–45). Lazarus lay ill in the house of his sisters, Martha and Mary, who went to Jesus and asked him to come quickly. Jesus, knowing that Lazarus had died, delayed to explain to his disciples that this sickness was for the Glory of God. When they finally arrived in Bethany, his disciples heard that Lazarus had been in the grave for four days. After meeting Martha and telling her that he is the resurrection and the life, Jesus raised Lazarus: 'And when he thus had spoken, he cried with a loud voice, Lazarus, come forth. And he that was dead came forth, bound hand and foot with graveclothes: and his face was bound about with a napkin' (John 11:43–4).

This is the dramatic climax of the events in the painting. Lazarus, arisen from the open grave in the floor, sits on the stone facing the viewer, the shroud across his legs. His hands are thrown up in astonishment as he looks, dazed, into the distance. Christ stands next to him at the left, blessing him with a raised hand. At Christ's side, Mary faces her brother, kneeling in prayer. Martha and three disciples complete the group around Jesus. Standing opposite them is a group of Jews in rich clothes who had come to console Mary. Now,

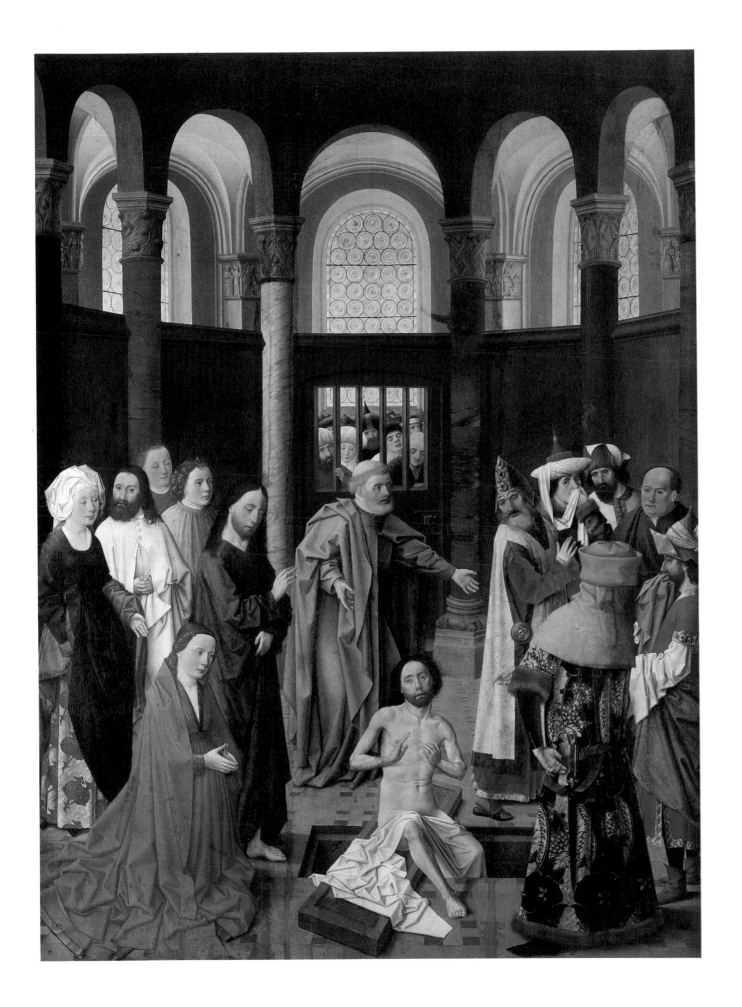

Hieronymus Bosch
St John on Patmos
Reverse: Scenes of Christ's Passion in circular arrangement

fantastically shaped wings which, like its clothes, hands and face are suffused with a whitish blue tone that merges with the sky. In the pale sun-disc surrounded by clouds is the apparition of the apocalyptic woman who from the twelfth century was identified with the Virgin Mary. She holds the Child in her lap, wears a starry crown, and is seated on a crescent moon (Apocalypse 12 : 1). Transfixed by the vision, St John prepares to record it in his book. Next to him is his symbolic animal, the eagle, which Bosch has pictured as a falcon, a bird more familiar to him. It keeps a sharp eye on the writing implements at his master's feet as at the right, a demon with an iron hook, afraid to steal them, retreats, throwing up his arms in fright. This is one of the strange hybrid creatures familiar from many of Bosch's paintings. Above a spherical abdomen pierced by an arrow, its pale human face perches with emaciated features and a bespectacled nose. A burning sphere on its head, its pointed wings, the tail, and the legs of a gecko (a nocturnal lizard), characterize the creature as an emissary of Realms of Darkness.

The painted reverse of the panel is similarly populated by demons, dim and shadowy forms against the dark background. There are suggestions of a figure riding on a fish, of a man in a helmet carrying a ladder, of a huge jug, a bell, a harp, and a flock of birds emerging from a huge fish with a gaping mouth. It is like gazing into the eternal night of outer space – were it not for the flowers scattered here and there, a sign that what Bosch has depicted in this picture is the earth plunged in darkness and overrun by demons.

In the centre of the pictorial field hovers a round disc in monochrome hues and suffused with light, whose outer ring shows the Stations of the Cross in rapid succession. Beginning with the Agony in the Garden, the sequence runs clockwise through Christ's Arrest, His appearance before Pilate, the Flagellation, the Crowning with Thorns, the Carrying of the Cross and the Crucifixion, and closes with the Entombment. Finally the Crosses on Golgotha appear, raised above a broad plain. While Mary and John remain alone beneath the Cross, a woman holding a child by the hand rushes away from the scene. The darkness behind the city on the far horizon gradually lightens until, at the Entombment, the glorious light of Easter morning dawns. The Resurrection scene is missing; yet its consolation is symbolized, in the centre of the disc, by a steep cliff rising out of still waters on a broad landscape plain. A fire burns in a cave as a huge bird spreads its wings on the peak. This is a pelican, tearing its breast to feed its young with its own blood – a legend symbolizing the blood sacrifice of Christ and the salvation of mankind.

Bosch leads the eye in three stages from the darkness dominated by demonic forces on earth, through the dawning light of Christ's sufferings, to the brilliance at the centre which promises hope of salvation. In this way he gives concrete form to the dualism between the Christian doctrine of salvation and the threat of infernal intervention. It would seem as though the artist had consciously illustrated the passage from St John, 'And the light shineth in darkness; and the darkness comprehended it not' (John 1 : 5).

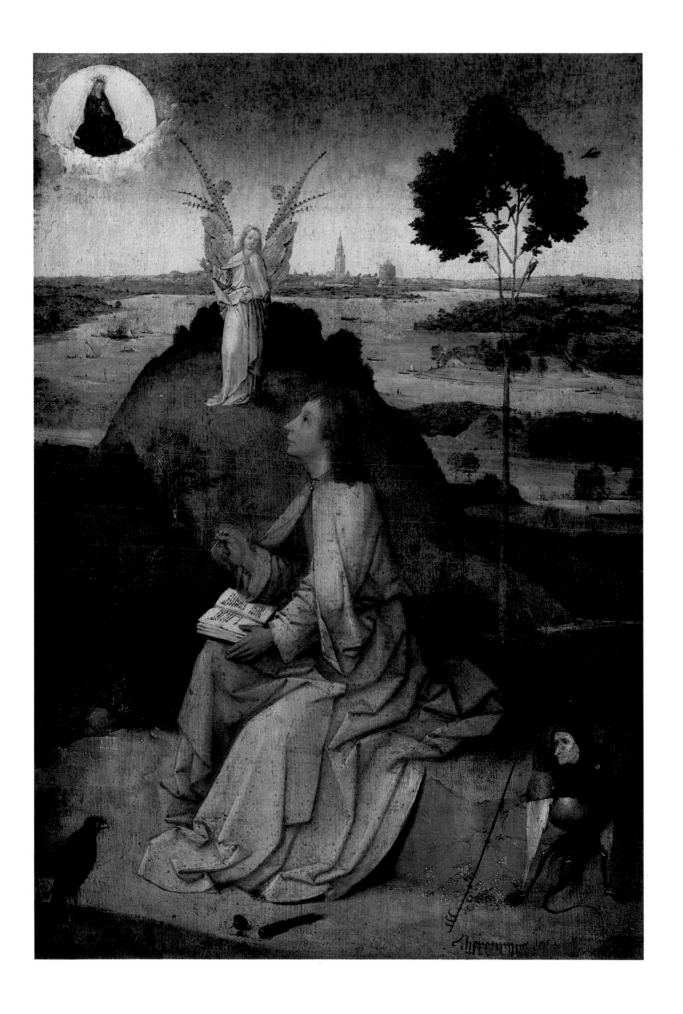

Geertgen tot Sint Jans (1460/5–before 1495)
John the Baptist in the Wilderness

Oak, 42 × 28 cm ($16\frac{1}{2}$ × 11 in)
Acquired from the Percy Macquoid
Collection, London, 1902
Cat. no. 1631

Like Aelbert van Ouwater, Geertgen tot Sint Jans was active in Haarlem and decisively influenced the development of painting in the northern Netherlands. His name, which means 'Little Gerrit who lives among the Knights of St John', points to his close ties with this religious order, for whom he created many fine works of art. The intimate character of this image of their patron saint suggests that it once served the pious devotion of one of the St John brethren.

The saint has sat down to rest on a grassy outcrop in the middle of a wood. Thoughtful, his chin resting in his hand, he gazes wide-eyed into the distance. Over a cloak of dark brown camel-hair he wears, draped over his shoulders, a blue mantle that falls to the ground in abundant folds. His head is surrounded by an aureole of golden rays; his bare feet, which he absent-mindedly rubs together, show that he has walked strenuously, far from human habitation. His tranquil melancholy contrasts strangely with the profusion of the countryside. It is summer, the season of vital growth and awakened life. Swifts cleave the air, rabbits nibble the fresh leaves, a hare frolics; we see a magpie hopping through the grass, pheasants shooting out of the bushes, deer browsing beneath shady trees, and a heron exploring the swampy banks of a pond for food. Our eye is gradually led over the rolling meadows, a meandering brook, the pool reflecting the sky, and clumps of trees into the distance, where the roofs and towers of a town, symbolizing human habitation, shimmer before the blue mists of a far mountain range. All this contributes to the feeling of St John's seclusion, his profound solitude.

At the holy man's side rests a white lamb, rays of gold emanating from its head. The lamb symbolizes Christ, of whom St John said, 'Behold the Lamb of God, which taketh away the sin of the world' (John 1:29). The object of his tragic meditation, then, is the agony which Jesus was destined to suffer for the sake of divine mercy and forgiveness of sins, a theme also evoked symbolically by the blue columbine growing at his feet and the thorn-studded thistle at the right.

This is no arid waste in which John prepares himself for his task of Christ's precursor, but a wooded wilderness devoid of human life which Geertgen, like many northern European artists, equated with the deserts of the Christian legend. And it was from the contrast between tranquil countryside and the bitter thoughts troubling the man that the artist derived his enigmatic image, which is both lyrical and dramatic. Since the early Christian years, the births of Christ and of John the Baptist had been associated with great seasonal changes and celebrated at the winter and summer solstices. John's moving words, *'Illum oportet crescere, me autem minui'* ('He must increase, but I must decrease': John 3:30) were always related to the changing length of days. It seems that the artist, too, has alluded to this custom of placing St John's birth in summer's green abundance in order to link indissolubly his tragic end with the death of Christ.

Yet regardless of the multifarious meanings in this devotional image, its landscape represents an innovation that no artist before Geertgen had achieved – a contrast and a mutual heightening of mood with landscape and figure.

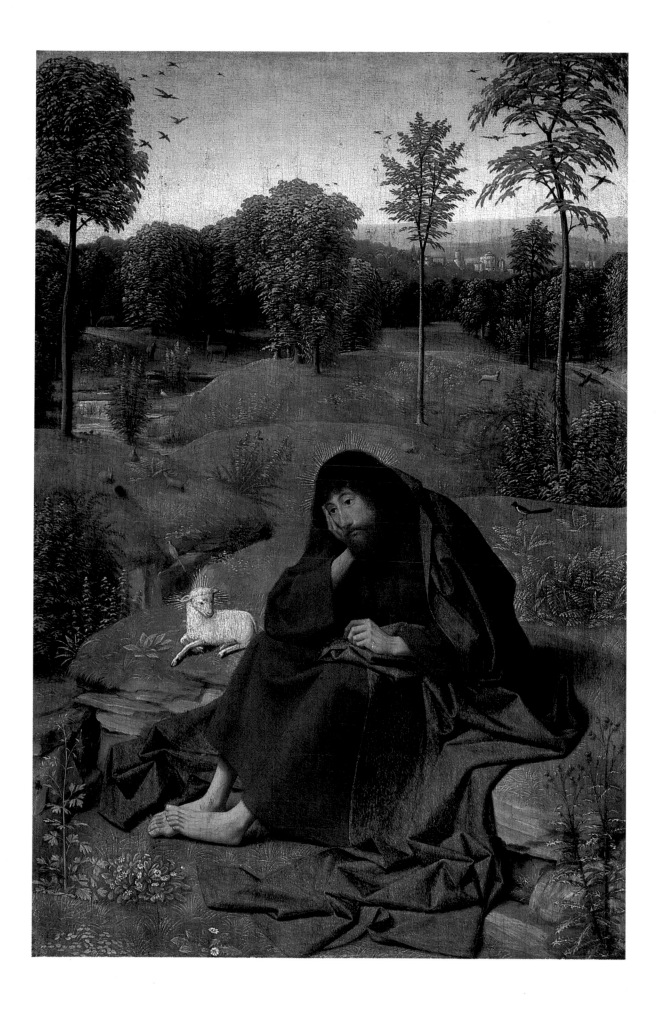

Hans Memling (*c*.1435–94)
The Virgin with Child
1487

Oak, cut on all sides and subsequently
enlarged on all four sides, dimensions of
original panel 41.5 × 31.5 cm (16⅜ × 12⅜ in)
Acquired 1862
Cat. no. 528 B

Memling's merit was to sum up in an inimitable way the achievements of his great
predecessors, from the van Eycks through Rogier van der Weyden to Hugo van der Goes.
The last major Netherlandish master of the fifteenth century, he put the final touches to this
resplendent epoch of painting. His extraordinary technical skill, his superb execution, and
the absolute harmony of his rich colour schemes, gave the spirit of Netherlandish art its
most lucid expression. Memling's images are joyful and unconcerned in mood, and
elegantly decorative in effect; they are more narrative than dramatic in character. The
tranquil beauty of his Madonnas, his meditative saints, and his landscapes like parks in the
freshness of summer, come very close to the sensibility and outlook of Romanticism. It is
not surprising that the nineteenth-century rediscovery of old Netherlandish art began with
Memling.

A characteristic equilibrium of pictorial structure and a palette based on a harmony of
blues, reds and greens are seen in this *Virgin and Child*, which belongs to the artist's late
period. A bright yet mild light suffuses everything in the image – figures, the gently rolling
summer landscape, and the undisturbed plane of a brilliant blue sky that is almost
cloudless. Mary, oblivious of her suffering, faces the observer in tranquil, composed
beauty, her eyes cast down. Everything in her vicinity has a charm that is difficult to
describe but which culminates in the gentle way she cherishes the Child and hands Him an
apple.

From the early Middle Ages, the apple signified the forbidden fruit of the Tree of
Knowledge which Eve picked for Adam. The old antithesis between Mary and Eve
reverberates here. As St Birgit of Sweden (d.1373) recorded, the Virgin herself once told
her in a vision that 'Just as Adam and Eve forsook the world for an apple, we, my Son and I,
have recovered the world with a heart.' For Memling, the presentation of an apple
conveyed the additional significance of Christ's taking the sins of the world upon himself to
redeem mankind.

All the many images of the Madonna created by Memling are infused with the profound
reverence felt for the Virgin at that time. The painting in our collection was most likely
commissioned by Benedetto Portinari (b.1466) as the central panel of a small triptych
whose wings, a portrait of Portinari and an image of his patron saint, St Benedict, are now
in the Uffizi in Florence.

Hans Memling
The Portinari Triptych 1487
St Benedict
Florence, Uffizi
The Virgin and Child
Berlin, Gemäldegalerie SMPK
Portrait of Benedetto Portinari
Florence, Uffizi

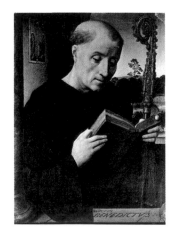
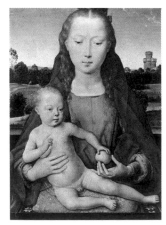
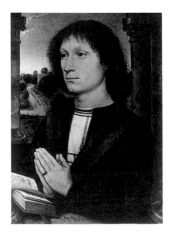

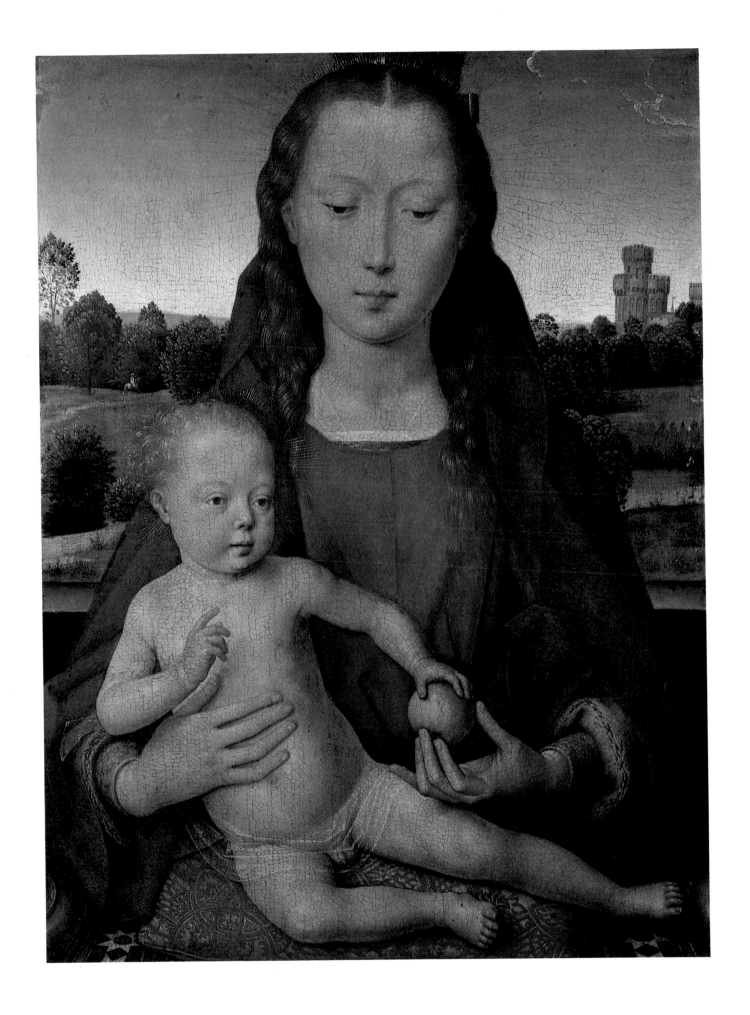

Gerard David (c.1460–1523)
Christ on the Cross
c.1515

Oak with rounded top, 141 × 100 cm
(55½ × 39⅜ in)
Acquired with the Solly Collection, 1821
Cat. no. 573

Gerard David was born in the northern Netherlands, in the town of Oudewater, Holland. As the influence of Geertgen tot Sint Jans in David's early work suggests, he probably received his first training in Haarlem. In 1484 he emigrated to Bruges, where Hans Memling was a leading master. Here he became a member and later the head of the artists' guild and received many commissions from the town council. David painted his major works in Bruges where, apart from short interruptions, he lived and worked for the rest of his life. He seems to have spent some time in Antwerp, since an entry of 1515 in the register of the Antwerp Artists' Guild records the acceptance of a 'Gheraet van Brugghe, scildere'. At that period, Bruges had lost its importance as a harbour due to the silting up of the Swijn, the city's connection to the sea, while Antwerp was beginning to establish itself as a new trade centre. Though this meant new artistic opportunities, David may have found the changing climate uncongenial. In any event, he returned to Bruges, where as the last major representative of its great tradition he enjoyed a high reputation.

Gerard David's achievement links the best in fifteenth-century Netherlandish art with the new concerns of the Renaissance. His imagery is characterized by a tranquil monumentality and a lucid organization of the figures, which are modelled in great relief and integrated with their surroundings in an unprecedented way. In this regard, David's art marked a decisive step forward in the development of a unified pictorial space. Indicatively, the first pure landscapes known in the history of art are by his hand – on the wings of an altarpiece now at The Hague, Mauritshuis. *Christ on the Cross* stems from the artist's late period. Its palette, dominated by harmonies of green and blue, is strangely cool and reserved, and yet, thanks to a great range of nuance, is extremely subtle. This consistent simplification of colour, which creates a strong atmospheric effect, corresponds to a rendering of the events that is both poignant and moving in its simplicity. These traits are particularly marked in David's later work.

The Crucifix on the heights of Golgotha stands at a slight angle, pointing into the distance. Christ looks down at the mourners beneath Him – Mary Magdalene nearest the cross, then the Virgin Mary, supported by John, and finally Mary Salome and Mary Jacobi. With the words *'mulier ecce filius tuus'* (Woman, behold thy son. St John 19:26) Christ entrusts his mother to the care of his favourite disciple. The reserved sadness of the mourners seems to have communicated itself to the centurion and his men, who stand aside to deliberate. Other troops are visible in the background, returning to Jerusalem. This detail indicates that, instead of representing a particular moment of the happenings, the artist wished to illustrate their timeless significance, anticipating his later extreme reduction of the motif (Genoa, Palazzo Bianco). The impression of timelessness is increased by the ragged clouds scudding across the sky, and by the spacious landscape with its low mountains that shimmer in the blue twilight and converge behind the vertical of the cross.

Gerard David
Christ on the Cross
Genoa, Palazzo Bianco

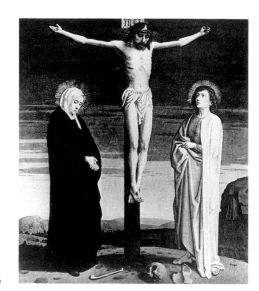

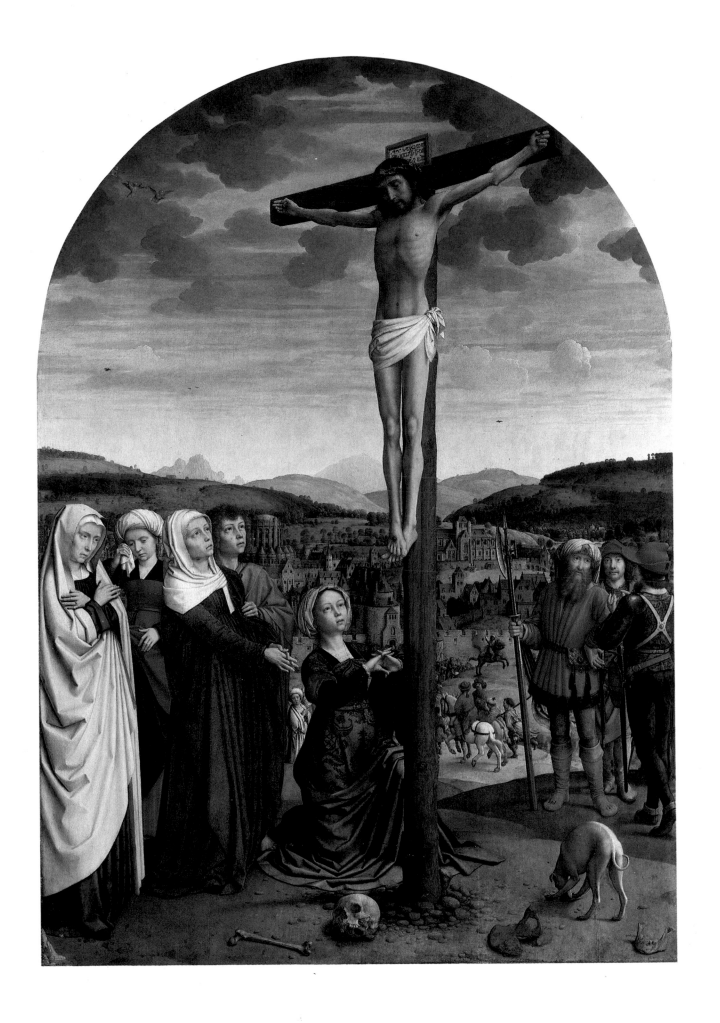

Quinten Massys (1465/6–1530)
The Virgin Enthroned with Child
*c.*1520

Oak with fluted top, 135 × 90 cm
(53¼ × 35½ in)
Acquired 1823
Cat. no. 561

Massys, born in Louvain, was the son of a blacksmith, and legend has it that he learned his father's trade. His artistic training must have been thorough, because it enabled him to hold his own among the 'Mannerists of Antwerp', where he settled and became a free master in 1491. Massys built on the achievements of fifteenth-century Netherlandish painting, particularly those of Dieric Bouts and Hans Memling, who were active in Louvain and Bruges. He developed a personal idiom in which fifteenth-century Dutch tradition and Italian Late Renaissance art, above all that of Leonardo da Vinci, blended into a harmonious unity. Important commissions from the guilds and fraternities of the prosperous trading town made him Antwerp's foremost master, and his style influenced many later artists. Besides devotional images, altarpieces and genre scenes, Massys also created medals and portraits. In 1517, Erasmus and his friend Petrus Aegidius sat to Massys for a double portrait which they sent as a memento to their common acquaintance, Thomas More. In his letter of thanks, the great statesman and humanist praised Massys as the rejuvenator of ancient art, perfectly characterizing his special role in the transition to a new epoch.

The present panel, dated about 1520 from Massys's late period, is one of the finest of the many works he devoted to the theme of the Virgin enthroned. Mary is depicted full figure and almost life-size, seated on a carved stone throne whose sideposts are ornamented with columns of polished reddish marble. Its back consists of an open arch with Gothic tracery whose curve follows the semicircular top edge of the panel. Mary is dressed in a blue gown with silk sleeves in opalescent pink and bluish grey; a brilliant red mantle falls in soft folds over the base of the throne to the coloured tiles of the floor. A delicate translucent veil covers her hair, spreading over her shoulders and around the Child kneeling in her lap.

The motif of the kiss, which lends this solemn image of the Virgin a touch of intimacy, derives from Italian art – more precisely from Leonardo da Vinci and his followers. The treatment of the faces, delicate and with barely perceptible transitions from light to shade, similarly shows Massys' knowledge of Leonardo's paintings. A debt to Netherlandish realism, by contrast, is evident in the treatment of the landscape and the superbly rendered still life on the small table before the throne. The distant background vistas show the influence of Joachim Patenier's approach, for whose landscapes Massys sometimes supplied the figures. Incidentally, this collaboration between specialists set a precedent for what later became a widespread practice.

Central to the symbolic content of the image is the fenced garden with its rose-hedge and fountain behind the throne. This element evokes the 'enclosed garden' in the Song of Solomon, a simile associated with the virginity and purity of the Mother of God. The foreground still life also possesses symbolic meaning. Cherries represent the fruits of Heaven, and the apple symbolizes the original sin which Christ's advent overcame; bread and wine refer to the sacrifice and redemption symbolically renewed in celebrations of the mass.

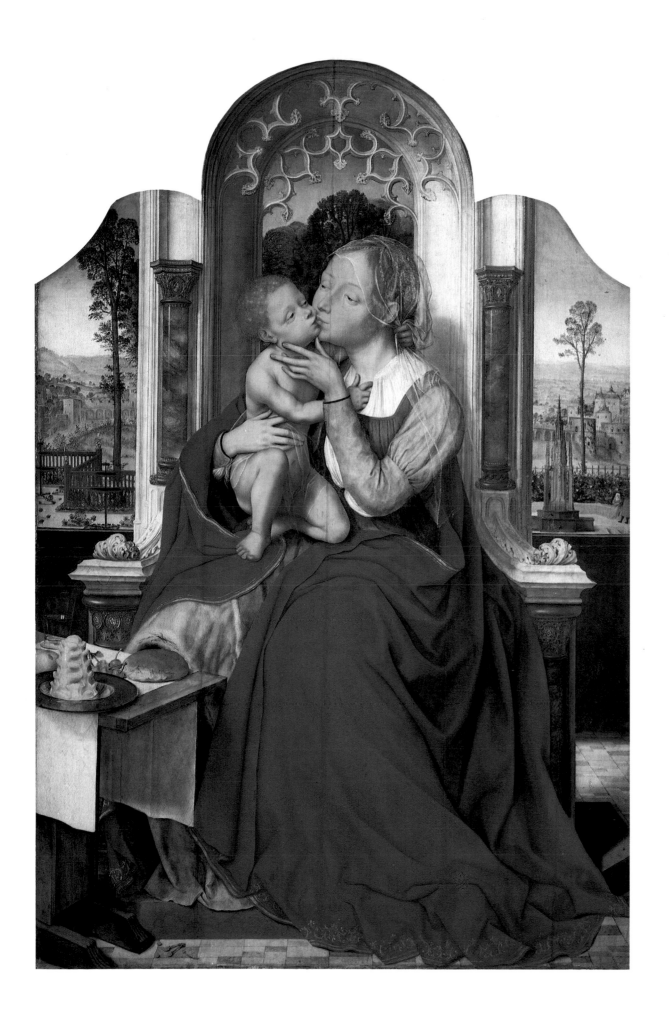

Joos van Cleve (1480/5–1540)
Triptych with the Adoration of the Magi
*c.*1515

Oak, central panel 72 × 52 cm
(28¾ × 20½ in), each wing 69 × 22 cm
(27⅛ × 8⅝ in)
Acquired from the Reimer Collection,
Berlin, 1843
Cat. no. 578

Joos van Cleve
Triptych
Exterior of wings
St Christopher and St Sebastian
Berlin, Gemäldegalerie SMPK

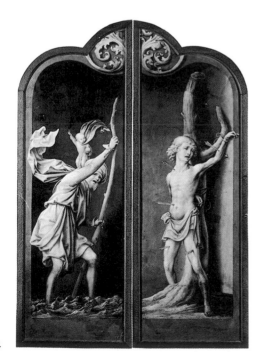

Few artists thought it necessary to sign their works until well into the sixteenth century. This put art historians in the paradoxical position of having to invent makeshift names for the creators of major groups of paintings, while not being able to associate any of these with the names of the numerous active artists recorded in contemporary sources. The creator of the present triptych was long known only as Master of the Death of the Virgin, a pseudonym derived from two altarpieces on this theme at Cologne and Munich. In all probability, however, he is identical with the 'Joos van Cleve alias van der Beke' mentioned in the Antwerp records, an artist who became an independent master there in 1511 and served as Dean of the Artists' Guild in 1519 and 1525. Joos van Cleve, a native of the Lower Rhine region and probably a pupil of Jan Joest van Kalkar, was decisively influenced in Bruges, through the art of Hans Memling and Gerard David. In Antwerp, he was impressed with Patenier, Massys and the 'Antwerp Mannerists'. A trip to Italy appears to have acquainted him with the art of Leonardo da Vinci. Joos van Cleve's altarpieces and portraits were known and admired far beyond the borders of the Netherlands; he worked for a time as court artist to Francis I of France, and travelled to England to paint a portrait of Henry VIII.

It was during his early period that van Cleve created the present small altarpiece with *The Adoration of the Magi*, which once served private devotion. In its closed position, the wings show St Christopher and St Sebastian, figures in *grisaille* dramatically set off by the reddish-brown painted niches in which they stand. By contrast, the interior of the altar glows in brilliant colours. The central panel and wings are linked by a landscape vista beneath a blue sky growing lighter towards the horizon, which extends across the entire width of the altar. Dominating the centre panel are imposing palatial ruins with arches, columns, pilasters, and a gilded statue. Mary is seated in the foreground with the Child on her lap, his hands extended towards the kings who have come to present their gifts. Their clothes and features evoke the three regions of the then-known world – Europe, Africa and Asia. Kneeling before Christ, the Western monarch is identified by the chain of the Order of the Golden Fleece. Behind them Joseph looks on reverentially, hat in hand; at the left are an ox and ass at the feeding trough. In the distance, near a group of strangely-shaped rocks, the arrival of the three kings' retinues is depicted. The spacious landscape with its abundant and carefully observed details still owes much to the landscape style of Joachim Patenier, with whom van Cleve occasionally collaborated.

The right side-panel shows St Barbara with a book and pen in hand, identified by her symbol, a massive tower, looming behind her. On the left side-piece is St Catherine, dressed in elaborate robes and a crown which signify her royal origins. She holds a sword whose point rests on a wheel studded with iron teeth. According to the legend, St Catherine was condemned to be broken on the wheel, but her prayers were answered, and fire fell from heaven to consume the wheel. Nevertheless, she was executed by the sword, and her body borne by angels to Mount Sinai. The artist has rendered the miraculous burning wheel in the distant landscape, with the same fond fidelity to detail that characterizes the altar as a whole.

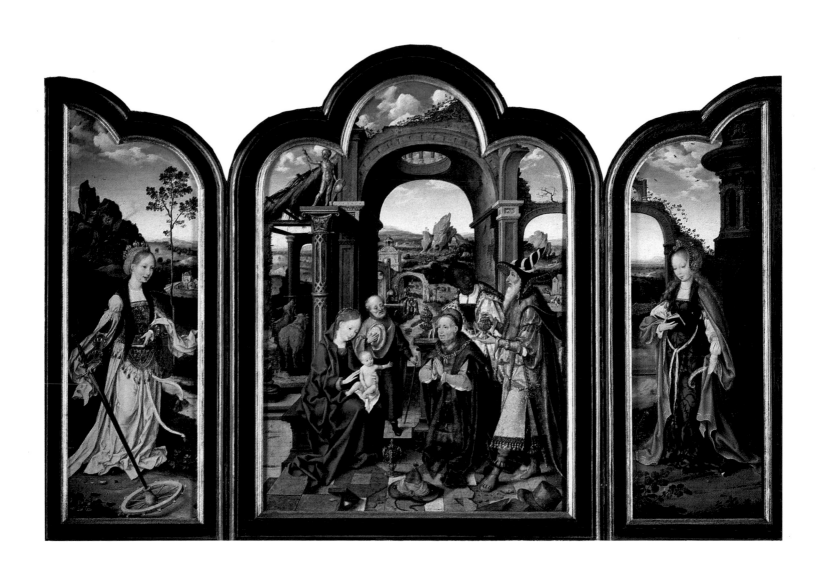

Joachim Patenier (c.1480–1524)
The Rest on the Flight into Egypt
c.1520

Oak, 78 × 62 cm (30¾ × 24⅜ in)
Acquired with the Solly Collection, 1821
Cat. no. 608

Robert Campin
The Madonna at the Fireplace
Leningrad, Hermitage

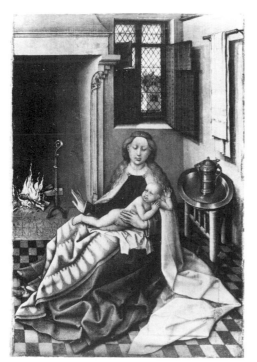

Patenier worked in Antwerp, becoming a free master there in 1515. About 1520–1, Dürer visited the cosmopolitan town and, meeting Patenier, recorded in his travel diary that he was a 'good landscape painter' – the first use of this term in the history of art. Influenced by Bosch, David and Massys, Patenier's landscapes combined a fine observation of detail with a sense of universal order which paved the way for Pieter Bruegel the Elder, and consequently formed the point of departure for late sixteenth-century landscape art in the Netherlands. His overview or universal landscapes were unique, and they were widely distributed and admired far beyond the borders of his country.

The Virgin and Child in the foreground of his *Rest on the Flight into Egypt* were not painted by Patenier himself but by an artist from the studio of Joos van Cleve. In his conception of the figures, this anonymous artist relied on the great Netherlandish tradition, basing their pose on the *Madonna at the Fireplace* by Robert Campin (Leningrad, the Hermitage).

As if seen from the air, a vast landscape with mountains and fields, plains and watercourses, trees and buildings, extends to the far horizon. The eye roams over this expanse of countryside as over an intricate tapestry, a natural scene infused with human order and expressing the divine order of the universe. The unity of the image derives from the masterly way in which the artist has evoked depth and atmosphere. An abundance of carefully observed details forms and reforms kaleidoscopically into a comprehensive yet ever-changing image. Led into the distance, the eye rests first on bizarre cliffs raised against the clouds, then moves unhindered to the horizon where seemingly endless forests spread and ships sail from the harbour onto the plain of the sea. The impression of depth and expanse is remarkable, and it is created by the use of only a few local colours, but in many nuances that extend from warm greens and browns to a cool, crystalline, pastel blue.

Combined with this superb colour handling and detailed reportage is an equally conscientious description of the happenings associated with the Holy Family's flight into Egypt. These many and strange events are not described in the Bible but in the books of the Apocrypha, particularly the Gospel of Pseudo-Matthew, which influenced literature and art from the Middle Ages to the Renaissance more than the Scriptures themselves. This book tells how the Holy Family came to the town of Sotina near Hermopolis, and how, when they entered the temple, the heathen idols disintegrated and crashed to the ground. In the painting, this temple appears high on the flank of the cliff, and beside the path leading to it is an idol toppling off its column. The spring emerging at the roots of a tree in the foreground alludes to another miracle described in the legend. And the birds fearlessly approaching Mary and the Infant signify that the animal realm, too, recognizes the Lord, as in the story, where lions, leopards, and all variations of wild beasts meekly accompany the Holy Family on their journey.

The humble village on the right, near the mouth of the river, represents Bethlehem, where Herod's soldiers slaughter innocent children as their mothers vainly attempt to protect them. The artist depicts successive events simultaneously, to illustrate that the significance of the Flight became apparent only in its consequences. Among these were also the Miracle of the Harvest, a legend frequently recounted in Netherlandish art. When the Holy Family left Bethlehem to escape Herod's vengeance, they met peasants sowing grain in the fields. Joseph implored them to tell their pursuers that they had passed while the wheat was being sown. Then, miraculously, the wheat ripened overnight, and by morning it was ready for harvest. Herod's men, misled by the peasants information although it was quite true, gave up the chase. The artist symbolically illustrates this miracle in the two adjacent fields outside the town, one freshly sown and the other ready for cutting.

Not only the scenes set in the landscape, but also the flowers and plants growing there

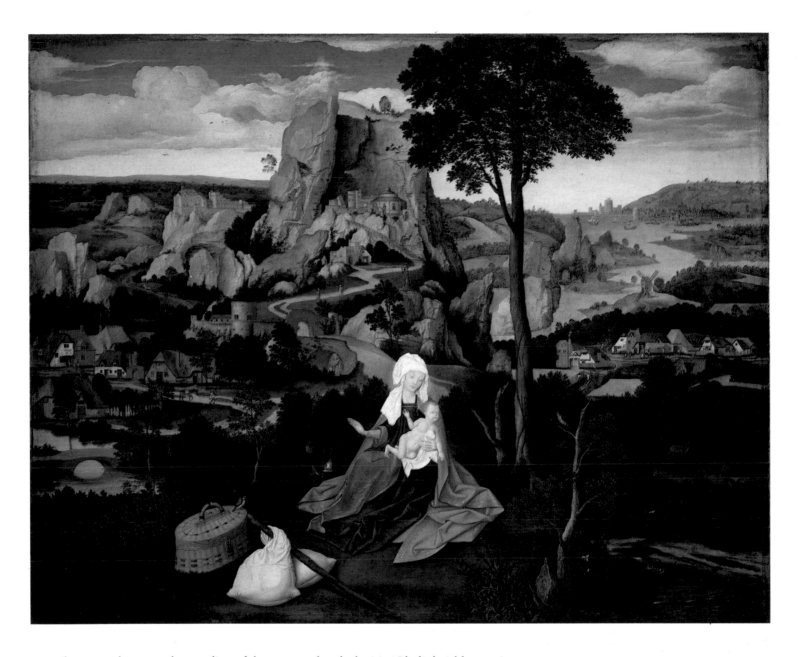

contribute to a deeper understanding of the events related: the iris (*Gladiolus*) blossoming at the spring in the foreground, like the thorns of the thistle, allude to Christ's Passion and the redemption it promises to mankind. This symbolic reference is only one of the many aspects of Patenier's imaginative landscape, which abounds in wonders and surprises.

Antwerp Master (*c.*1520)
The Beheading of John the Baptist

Oak, 48 × 35 cm (18⅞ × 13¾ in)
Acquired as gift from Frau Hainauer,
Berlin, 1906
Cat. no. 630 C

Thanks to a liberal trade policy, Antwerp had become a serious competitor to Bruges and Ghent by the fifteenth century, and during the sixteenth century it advanced to be the largest harbour and commercial city in northern Europe. An international crossroads, Antwerp exerted a great attraction to artists. Its prosperity and wide mercantile relations created ideal conditions for the export of works of art throughout the world. As the guild lists indicate, artists from everywhere in Europe flocked to Antwerp, and the number of studios burgeoned. The exchange of artistic and workshop information at that period must have reached proportions previously unknown in the Netherlands. The wishes of individual patrons now began to count less than the tastes of a broad sector of purchasers for whom works of art were created *en masse*. This stockpiling against future demand also facilitated export trade in art on an unprecedented scale.

Antwerp's many workshops, most of whose masters are known today only by the pseudonyms later given them, turned out devotional images and altarpieces decorated with sculptures and painting for export throughout the Continent, from Scandinavia to Portugal. Among the anonymous artists active in early sixteenth-century Antwerp who painted numerous variations of some subjects – as illustrated by their pseudonyms – were the Master of the von Groote Adoration, the Master of the Antwerp Adoration, the Master of the St John Martyrdom, the Master of 1518, and the Master of the Munich Adoration, who is also known by the name of Pseudo-Bles. This last artist, who painted *The Adoration of the Magi* in Munich (Alte Pinakothek) with its spurious signature 'Henricus Blesius', stands out from the large group of anonymous artists collectively known as the 'Antwerp Mannerists'. The present panel, *The Beheading of John the Baptist*, can also be attributed to him; it is a characteristic work, and much finer in quality than the average productions of this group.

An open square partly bordered at the left and back by high façades with round towers, columns, pilasters and narrow windows, forms the imaginative setting for the execution scene. Still gripping his sword, the executioner places John's head on a platter held out by Salome, who is accompanied by two ladies-in-waiting. The body lies on the ground, blood gushing from the severed neck. Next to it stands an elaborately dressed soldier, his back turned to us – and to the execution; he is talking with two other men, one of whom has a falcon perched on his hand. In the background, John, his hands tied, is being led to the block by the executioner and his henchmen. In the open hall of the palace, Salome dances for Herod and as a reward she has demanded John's head. On the far right is a view of mountainous country with men around a fire. Apparently this scene was meant to represent the immolation of John's remains, which took place later by order of Emperor Julian the Apostate.

The lucid and brilliant palette of this masterfully composed image, its elaborate architecture, and the fantastic costumes show the hand of a skilled craftsman. These features, together with the artist's penchant for elegantly artificial poses and gestures, elongated figures, and a certain calculated picturesqueness in the way the figures overlap, are characteristic traits of 'Antwerp Mannerism', a style in which late Gothic and Renaissance approaches were combined to achieve new and unexpected visual effects.

Antwerp Master, *c.*1520
The Adoration of the Magi
Munich, Alte Pinakothek

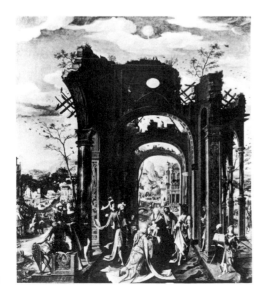

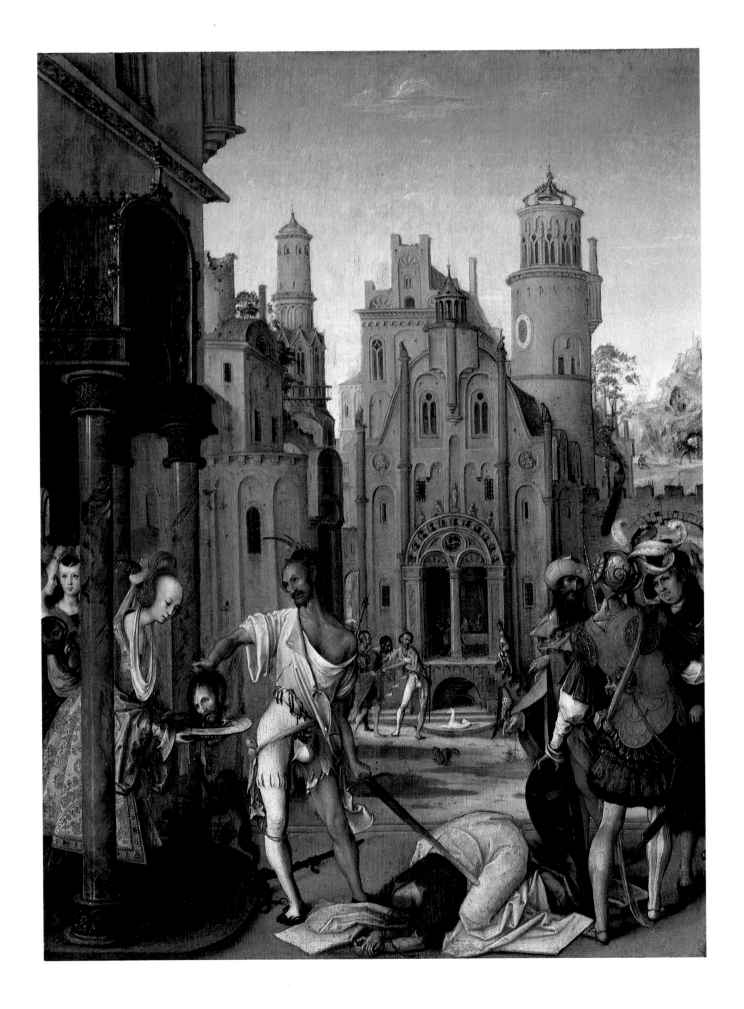

Jan Gossaert (1470/80–1532)
The Agony in the Garden
*c.*1510

Oak, 85 × 63 cm (33½ × 24⅞ in)
In the Gottfried Winkler Collection,
Leipzig, during the eighteenth century
Acquired 1848
Cat. no. 551 A

Jan Gossaert was admitted in 1503, as 'Jennyn van Hennegouwe', to the artists' guild in Antwerp, where he lived and worked as an independent master until 1507. In the retinue of Philip of Burgundy (1465–1524) he undertook an Italian journey in 1508–9 which profoundly influenced his later work. While in Rome, Gossaert made drawings of antique sculptures and buildings for his influential patron, and later painted mythological subjects for Philip's castle at Walcheren. After following Philip to Utrecht when he was named bishop there in 1517, Gossaert worked for Philip's nephew, Adolf of Burgundy, in Middelburg. In addition he was active at the courts of Margaret of Austria and Christian II of Denmark, and served the Marquise Mencia de Mendoza, the third wife of Henry III of Nassau. Gossaert's many talents, his profound knowledge of the great fifteenth-century masters, his study of Dürer's prints, and his exhaustive work on the monuments of antiquity established his unique position in Netherlandish art. Besides devotional paintings and altarpieces, he concentrated on portraits and mythological subjects which compellingly presaged the release of art from ecclesiastical strictures.

Gossaert's *Agony in the Garden* was probably executed about 1510, shortly after his Italian journey, though the impressions he gained at Rome were yet to become apparent. As the Gospels relate, on the evening after the Last Supper, Christ went with his disciples to the Mount of Olives. Asking them to watch with him, he withdrew to kneel down and pray: 'Father, if thou be willing, remove this cup from me: nevertheless not my will, but thine, be done. And there appeared an angel unto him from heaven, strengthening him. And being in an agony he prayed more earnestly: and his sweat was as it were great drops of blood falling down to the ground. And when he rose up from prayer, and was come to his disciples, he found them sleeping for sorrow' (Luke 22: 42–5). Then Judas Iscariot, leading the priests and elders of the temple, entered the garden of Gethsemane to greet Christ with the kiss which was the pre-arranged sign of his betrayal.

Gossaert's subject is Christ's agonized soul-searching in the face of inevitable death, not the dramatic moment of his arrest. These are the last hours of the night Jesus had to endure alone, 'grieved unto death', as his disciples slept. A waning crescent moon casts pale unreal light on the clouds, the rocky wooded hill, and the distant towers of Jerusalem. Light gleams on the youthful face of Christ, streaming with sweat and tears, and touches the upturned face of Peter, asleep in the foreground with his sword beside him. Next to him, overcome by weariness, John and James rest with their heads in their hands. An angel descends from heaven to Christ, who has placed the chalice and host before him on a rock. Approaching from the open city gates in the background, Judas leads the search party to the garden, their weapon and armour gleaming in the moonlight, torches held high to light their way through the gloom.

This work, one of the earliest and most compelling nocturnal scenes in art, proves Gossaert a painter of extraordinary virtuosity. The illumination, striking yet astonishingly subtle, points up the inner drama of the Biblical event.

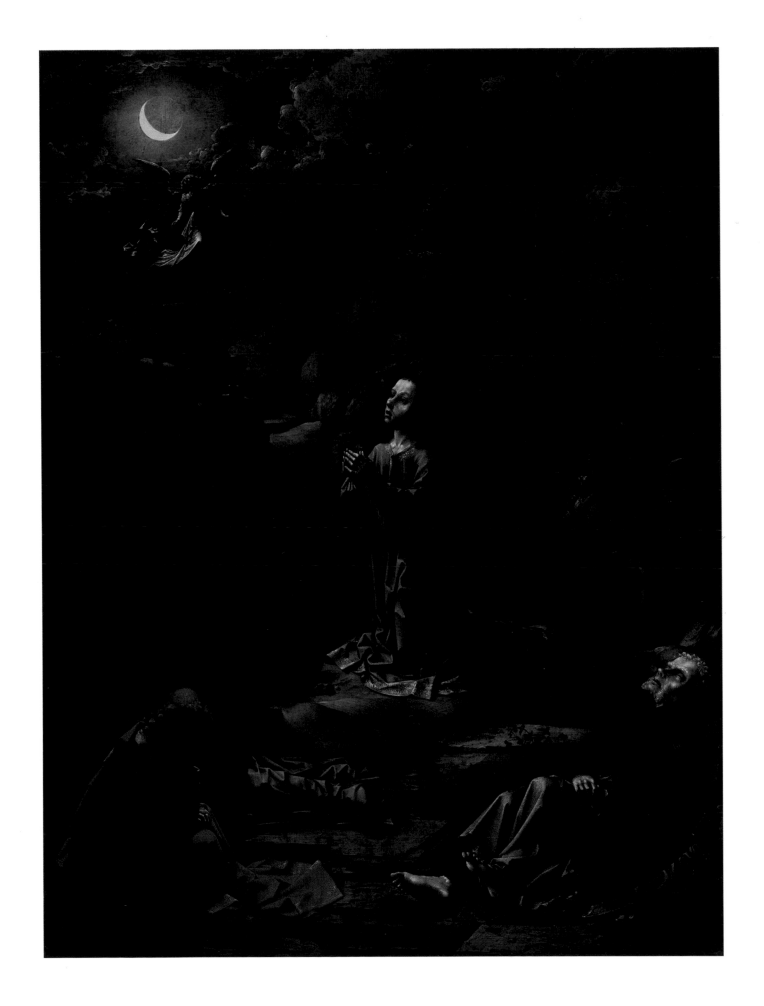

Anthonis Mor (1517/20–1576/7)
Portrait of Two Canons
1544

Oak, 74 × 96 cm (29⅛ × 37¾ in)
Signed: 'Anthonis mor fecit 1544'
Acquired 1859
Cat. no. 585 A

Anthonis Mor
Self-portrait, 1558
Florence, Uffizi

Apart from a very few religious subjects, Anthonis Mor devoted himself almost exclusively to portraiture. In this field he is justifiably considered the greatest Netherlandish artist of his period. His impressive portraits of Habsburg Spanish court society brought him international renown. Some of the most powerful personalities of the time vied for the privilege of sitting to Mor, among them Philip II of Spain, Cardinal Granvella, Margaret of Parma, the Duke of Alba, William of Orange and Mary Tudor.

Anthonis Mor came from Utrecht, where he began his career as a pupil and an assistant of Jan van Scorel (1495–1562). In 1547 he settled in Antwerp as an independent master. A short time later he went to Brussels to enter the service of Antoine de Granvella (1517–86), then Bishop of Arras, later Cardinal and Minister under Charles V, Philip II, and Margaret of Parma. Granvella, who played a key role in Habsburg politics, considered the artist 'his own man'. Thanks to his protection, Mor obtained numerous commissions from important people of the highest ranking nobility. In 1548, he is said to have travelled in Granvella's retinue to the Imperial Diet at Augsburg, where he met Titian. Whether or not this is true, Titian's portraiture decidedly influenced Mor's own approach and contributed to his unique style. In 1550 Mor went to Spain and Portugal, where he worked at the courts in Valladolid, Lisbon and Madrid. He returned to the Netherlands in 1553, and the following year, as court artist of Philip II, he went to London for the Spanish King's marriage to Mary Tudor, Queen of England. After another journey to Spain he lived and worked in Utrecht and Antwerp, where he strongly influenced such artists as Frans Pourbus (c.1540–81) and Adriaen Thomasz. Key (c.1544–84), just as earlier he had influenced the Spanish court painters Alonso Sánchez Coëllo (1531/2–88) and Juan Pantoja de la Cruz (1553–1608). Mor's *Self-portrait* of 1558 (Florence, Uffizi), very much in the manner of his aristocratic portraits and containing a reference to the Greek painter Apelles, testifies to an awareness of his high social position and the considerable freedom he enjoyed at the royal courts he served.

Portrait of Two Canons of Utrecht Cathedral of 1544 is the earliest known work by Mor. Still very much indebted to the art of his teacher, Jan van Scorel, it recalls that artist's groups of Jerusalem pilgrims at Utrecht and Haarlem. Its most striking feature is perhaps the incredibly tangible presence of the two figures, who emerge bodily from the dark grey background. Their white gowns seem to glow, and the treatment of the folds and delicately graduated modelling reveal an artist of great sensibility. Even greater emphasis is placed on the faces of the two men, with heightened colour in what is otherwise a very reserved, almost monochrome palette. Every contour of their faces, whether brightly illuminated or cast in shadow, is defined with short, fine brushstrokes in a manner extremely unusual for the period and verging almost on pointillism. This vivacious play of light and shade lends the faces immediacy, which not even the austere profile pose of the one can mitigate. In this regard, Mor had already clearly begun to surpass his teacher, Jan van Scorel.

The obvious discrepancies between this portrait and his later works are surely due to the demands of his patrons, who cannot have allowed him a great deal of freedom here. They stipulated the half-figure portrait type, the procession of figures, and the detailed personal information which was to be included in the picture. Beneath the two clergymen is a painted inscription tablet with their family arms and two quatrains which record for posterity their names, ranks, and the date of their pilgrimage to Jerusalem. The red cross of Jerusalem appears at the centre of the white field.

The figures portrayed are Cornelis van Horn and Anthonis Taets van Ameronghen, canons of Utrecht Cathedral who, as members of the Jerusalem Brethren, had made a pilgrimage to the Holy Land and Jerusalem. The date of van Horn's journey is given as 1520 – over twenty years before this commemorative portrait was painted. The men's

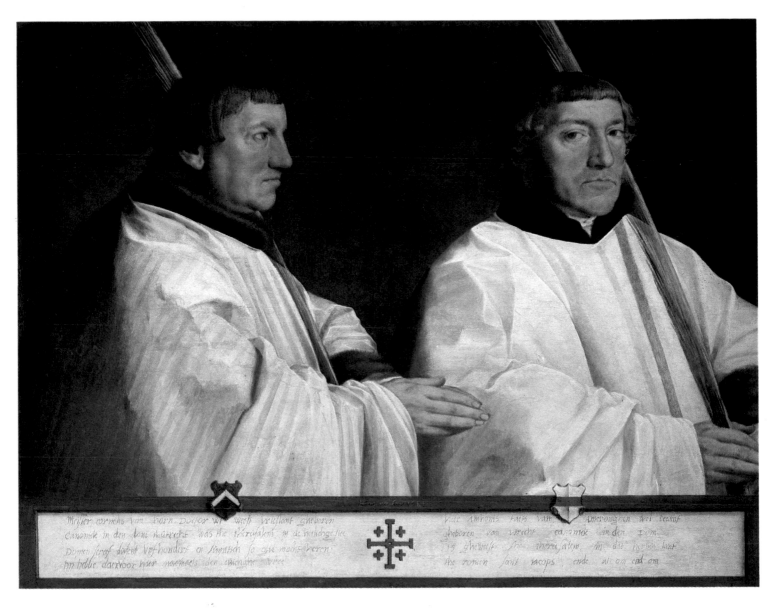

piously folded hands, the palm fronds over their shoulders, and the inscription itself, all testify to a devout faith that their pilgrimage has helped them attain redemption and eternal peace.

Like the sequential portraits of Jan van Scorel, Anthonis Mor's double portrait marks an important stage in the development of group portraiture in the Netherlands, which was to culminate in the seventeenth century with Frans Hals's and Rembrandt's images of regents and guilds.

Pieter Bruegel the Elder (1525/30–69)
The Netherlandish Proverbs
1559

Oak, 117 × 163 cm (46 × 64¼ in)
Signed lower right: 'BRVEGEL 1559'
First mentioned in the inventory of
Peter Stevens, official of the Antwerp Poor
Relief, 1668
Acquired 1914
Cat. no. 1720

Lodovico Guicciardini, in his 1567 description of the Netherlands, called this artist 'Pietro Brueghel di Breda', indicating that he may well have been born and brought up in the town environment of Breda rather than in the country. His date of birth was probably some time between 1525 and 1530. Emperor Charles V (1500–58), monarch of the Netherlands, was about thirty years old at the time, and Philip II (1527–98) had just been born. The Netherlands enjoyed unprecedented prosperity in that period, yet by the time Bruegel died, the country had been laid waste by the Duke of Alba's armies and the population had taken up arms in defence. During these turbulent historical changes, Bruegel's work developed into the most brilliant and significant contribution made by any artist of his time.

Shortly after being admitted as independent master to the Antwerp Artists' Guild in 1515, Bruegel went to live in Italy for several years. What impressed him there was not so much the art of antiquity or contemporary Italian painters but the sublime vistas of the Alps, the Tessin Valley and the region around St Gotthard, which had a lasting effect on his conception of landscape. In 1555 Bruegel was back in Antwerp, where he made drawings for the publisher Hieronymus Cock which were engraved and found wide distribution. In Brussels in 1563 he married the daughter of Pieter Coecke van Aelst, the artist who according to Carel van Mander's report (1604) was Bruegel's teacher. Bruegel left many friends behind in Antwerp, among them the humanist and geographer Abraham Ortelius (1527–98). Ortelius introduced him to a circle of Catholics who, infused with Erasmus's philosophy, condemned the intolerance of State and Church. The sense of tolerance and humaneness that informs Bruegel's work and still moves us so deeply today, certainly owed much to his Antwerp friends. Yet he soon found appreciative patrons in Brussels as well. Among them was no lesser figure than Cardinal Antoine Perrenot de Granvella (1517–86), confidant of Philip II of Spain and adviser to Margaret of Parma.

The connoisseurs of the period thought of Bruegel as a congenial successor to Hieronymus Bosch, who had died ten years before Bruegel's birth. Yet Bruegel himself was destined to die young. In a Latin obituary of about 1573, his friend Ortelius wrote, 'Revered by the manes, Pieter Bruegel was doubtless the greatest painter of his time. No one would dare to deny this, except an envious man, a rival, or someone to whom this master's art was completely foreign. To tell the whole truth, I would repeat that not only was he the greatest painter, but he contained within himself the entire universe of painting. And this Bruegel I extol painted many things that cannot be painted, as Pliny once said when speaking of Apelles. In all his works he continually strove to reveal more than could be seen on the surface of his pictures.'

In the year 1559, a watershed in Bruegel's career, he painted *The Netherlandish Proverbs* and *The Battle between Lent and Carnival* (Vienna, Kunsthistorisches Museum). These, the first of his large paintings, introduced a highly productive period that established his reputation and for which he is still admired today.

The Dutch language of Bruegel's time was richer in proverbs than it is now, and interest in vernacular speech was widespread, as may be seen from the *Adagiorum Collectanea*, a famous compendium of idiomatic Latin proverbs by Erasmus of Rotterdam. This interest developed veritably encyclopaedic proportions in Bruegel's mind.

Shortly before completing his *The Netherlandish Proverbs*, Bruegel made a drawing of the *elck*, the proverbial everyman who, armed with a lantern, rummages through a pile of barrels, baskets and sacks. Like the man beside him, shown tugging at the corners of a blanket, he thinks only of his personal advantage. The caption to the engraving based on the drawing says, 'All over the world, everyone sees only himself, and hopes to find himself in all things. But how can anyone find himself when everyone is looking? We all fight for an advantage (the longer straw), some from above, others from below. Almost nobody knows

himself. Those who realize this will see wonders.' This insight is surely central to an understanding of Bruegel's painting.

The first visual compendium ever made of over one hundred proverbs and idioms, its images are as realistic as the concise characterization it gives of typical human behaviour. Each scene can stand alone; though they take place simultaneously, the events illustrated have all the incidental and random character of everyday life. A village on a river near the sea forms a spacious stage for the seemingly mundane activities of its inhabitants. They play against a backdrop of a farmhouse, dilapidated huts, a stony bridge with a pillory and tower, a marketplace – the focus of events – and a farmstead among wheatfields near a wood. The plain of the open sea spreads into the distance, shimmering in the brilliant sunlight of a late-summer day.

The various scenes are linked by subtle colour combinations, with salient points in the composition marked by strong reds and blues. Dominating the centre is the blue of a cloak which a young woman in a bright red dress hangs over the shoulders of her old, infirm husband. One of the painting's early titles derives from this motif of a blue cloak, a common symbol of deception. The same title appears on an engraving published in Antwerp in 1558, which may have been one source of inspiration for Bruegel's image. Its caption reads in part, 'Most call this the cloak of blue, but worldly folly would better do.' The notion that folly and self-deception were the source of all unhappiness found its most poignant contemporary expression in Erasmus of Rotterdam's *Praise of Folly* (1511).

The other early title of our painting, *Topsy-turvy World*, goes back to the reversed globe prominently displayed on the house at the left of the picture, a symbol of the absurdity of human existence. The figures in the painting are accordingly characterized not as individuals but as typical representatives of their social class, strutting across the stage like mindless marionettes, oblivious of their surroundings. The *mise en scène* of this play recalls Rabelais's description of Pantagruel's journey to the Kingdom of Quintessence (1564), whose inhabitants' strange antics embody proverbial human absurdities.

Bruegel, too, following this *leitmotiv* of a topsy-turvy world, pillories every variety of the illogicality, absurdity and foolishness in human behaviour. People fill in a well after the calf has drowned, and carry lights under bushels in broad daylight. Other scenes allude to the Seven Deadly Sins, supplemented by such other negative qualities as deception, lying and cant. This is a world that pays obeisance not to God but to the devil. Even the clergy decorate the face of the Lord with a false beard of flax.

Obviously, Bruegel's painting contains a great deal of acid criticism, and its basic tenor is pessimistic. Yet it is more than a depiction of human life as a farce destined to play itself out no matter how much we should wish to change it. By helping people realize and understand the absurdity of their actions, Bruegel hoped to improve people, and in this regard his message is as apt today as ever.

Franz Hogenberg
The Blue Mantle, 1558
Engraving (detail)

179

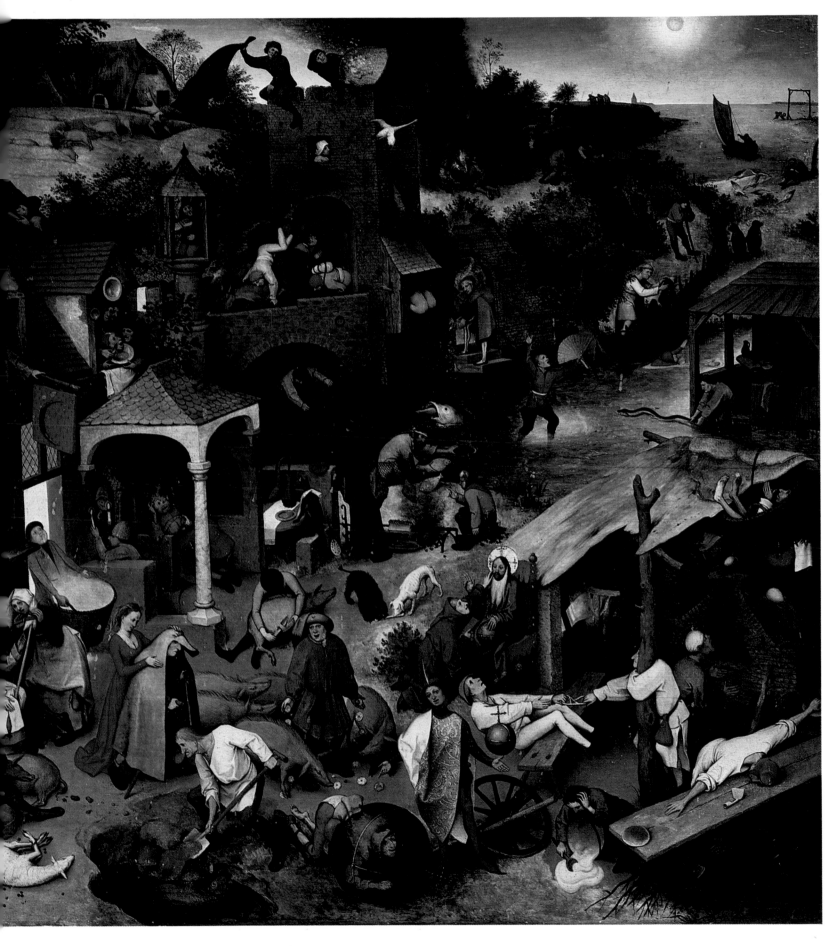

The Proverbs

1 Their roof is tiled with tarts (they live in a land of plenty; a fool's paradise)

2 They were married over a broomstick (without going to the trouble of obtaining a church blessing)

3 The broom is sticking out there (the master's away; when the cat's away, the mice will play)

4 He looks through his fingers (can afford to be indulgent, or never look a gift horse in the mouth)

5 Now the knife's out (an open challenge)

6 There stand the wooden shoes (to wait in vain)

7 They've got each other by the nose (trying to trick each other)

8 The die is cast

9 Fools are always dealt the best cards

10 It depends on the fall of the cards

11 Shitting on the world (in utter disgust)

12 Topsy-turvy world (the opposite of the way it should be)

13 To pull something through the eye (between the blades) of a pair of scissors (to make a dishonest profit)

14 Keep at least *one* egg in your nest (a nest egg; something for a rainy day)

15 To have a toothache (possibly: to fool others by malingering)

16 a) He's pissing at the moon (attempting the impossible, or barking at the moon)
b) He has pissed at the moon (his enterprise has failed)

17 He's got a hole in his roof

18 An old roof needs a lot of patching

19 The roof has laths (there are eavesdroppers)

20 An inn at the sign of the chamber-pot (instead of a tankard; it's a crazy world)

21 To shave a fool without lather (give him the bum's rush; take him for a ride)

22 Something growing out of the window (an open secret, or truth will out)

23 Two fools under one cap (like to like; folly loves company)

24 a) A fellow shooting a second arrow to find the first (foolish misdirected perseverance)
b) Shooting all his arrows at once (and having none left when he really needs one)

25 She could tie the devil himself to a pillow (spiteful obstinacy overpowers the devil himself)

26 He's a pillar-biter (a hypocrite)

27 She carries fire in one hand and water in the other (is two-faced, deceitful)

28 a) He's frying a herring for the roe (throwing a sprat to catch a herring, that is, to sacrifice a trifle to gain something substantial)
b) His herring's not frying this time (his plans are going awry)
c) The lid fell in on him (he's been left holding the bag)

29 a) There's more in it than a gutted herring (more to it than meets the eye)
b) The herring will hang by its own gills (everyone must bear the consequences of his own mistakes)

30 He's sitting in the ashes between two stools (having missed his opportunity, failed through indecisiveness)

31 What good is smoke against iron? (why fight the inevitable?)

32 The spindles are falling in the ashes (something is failing, going on the rocks)

33 Let the dog in, and he'll go into the larder (a loss that might have been expected, or give him an inch and he'll take a mile)

34 The sow pulls the bung in this house (it's poorly managed; negligence will be punished)

35 He's banging his head against a brick wall

36 He's in armour (up in arms; fighting mad)

37 He's belling the cat (attempting a difficult task, or letting the world know what he's up to, usually with dire results)

38 Armed to the teeth

39 He's an iron-eater (a bully, tough customer, eats nails for breakfast)

40 He's feeling the hens (counting his chickens before they are hatched)

41 He's always gnawing the same bone (involved in a thankless, futile task, or continually harping on something)

42 The sign of the shears (the pickpocket's symbol; a clip joint)

43 He speaks with two mouths (out of both sides of his mouth; with a forked tongue)

44 One shears sheep, the other pigs (rich man, poor man, or some people have all the luck)

45 All that bleating and so little wool (much ado about nothing)

46 Shear them but don't skin them (do not pursue your advantage at any price)

47 Patient as a lamb

49 a) One winds that the other spins (to spread rumours, gossip)
b) Don't let the black dog interfere (because he could ruin everything, or with gossips in the house, the watchdog may sleep)

49 To carry a bushel of light to the sun (waste one's time)

50 To light candles for the devil (make friends in all camps because they might come in useful)

51 Confessing to the devil (telling one's secrets to one's worst enemy)

52 An ear-blower (putting a flea in someone's ear; scandal-mongering)

53 The crane entertaining the fox (from Aesop's *Fables*: two deceivers conniving, whereby one will be deceived)

54 What good is a pretty plate when it's empty?

55 He's a skimming ladle (a flatterer, sycophant)

56 It's chalked up (a debt or unkindess that will not be forgotten)

57 He's filling in the well after the calf drowned (shutting the door after the horse has bolted)

58 He's got the world spinning on his thumb (on a string; everything is going his own way)

59 To put a spoke in someone's wheel (put an obstacle in his path)

60 One must stoop to get on in the world (stoop to conquer)

61 He's tied a flaxen beard on God (His excessive piety probably conceals a selfish motive)

62 He's casting roses (pearls) before swine (Matthew 7:6)

63 She's putting the blue mantle on her husband (deceiving him)

64 The pig's been stuck in the belly (the matter is clinched; there's no going back now)

65 Two dogs over one bone (to fight bitterly over a thing; symbol of envy, strife, malice)

66 Sitting on hot coals (to be anxious and extremely impatient)

67 a) A roast must be basted
b) It's good luck to piss on the fire
c) His fire is pissed out (he's completely discouraged)

68 There is no turning a spit with him (he's uncooperative, a spoil-sport)

69 a) He catches fish with his bare hands (by taking them out of other people's nets; i.e. lazy but clever)
b) To throw a smelt to catch a cod (same meaning as 28a)

70 He's fallen through the basket (been given the cold shoulder by a woman, or otherwise failed)

71 He's hanging between heaven and earth (between the devil and the deep blue sea; an insoluble situation)

72 She's taken the hen's egg and let the goose egg go (made a bad choice out of greediness)

73 He's yawning at the stove, or You have to yawn a long time to out yawn the oven (to bite off more than you can chew, overestimate your own abilities, or fight a losing battle)

74 He can't make it from one load to the next (cannot live within his budget)

75 He's looking for the hatchet (for an excuse), and, He can use his lantern at last (let his light shine)

76 It's a hatchet with a handle (a good proposition? The meaning is uncertain)

77 It's a hoe without a handle (perhaps a doubtful proposition or unripe plan)

78 Spilled porridge cannot be scraped up again (there's no use crying over spilled milk; what's done is done)

79 They're pulling for the longer end (each concerned only for his own advantage)

80 He's hanging on tight (or: love is on the side where the money bag hangs)

81 a) He's standing in his own light
b) If you look for someone in the oven, you must have been there yourself (only he who is wicked himself thinks badly of others)

82 He's playing in the pillory (drawing attention to his own shame, or People who live in glass houses should not throw stones)

83 He's fallen from the ox to the ass (made a bad bargain)

84 One beggar pities the other outside the door

85 Anybody can see through a plank with a hole in it

86 a) To rub one's bottom on the door (to make light of one's own misfortune)
b) To have one's burden to bear

87 He's kissing the ring (showing insincere respect, ingratiating himself)

88 He's fishing behind his net (expending useless effort)

89 Big fish eat little fish

90 He can't bear to see the sun shine on the water (envy of one's neighbour)

91 He's throwing money into the water (squandering it, throwing it out of the window)

92 They shit through the same hole (being bosom friends)

93 Something is like an outhouse over a ditch (obvious, a clear-cut matter)

94 He's trying to kill two flies with one blow (and being too ambitious, will probably miss them both)

95 She's watching the stork (daydreaming, wasting her time)

96 You can tell a bird by its feathers (or a man by his acts)

97 He hangs his cloak to the wind (is an opportunist)

98 He tosses feathers to the wind (all his effort has been in vain; to work unsystemmatically)

99 The best straps are cut from someone else's leather (it's easy to be generous with others' property)

100 The pitcher goes to water until it breaks (everything has its limit)

101 He's got an eel by the tail (is involved in a difficult and probably futile undertaking)

102 It's hard to swim upstream (to oppose custom or generally accepted opinion)

103 He's hanging his habit on the fence (forsaking his familiar life without knowing what the new one will bring)

104 This proverb has not been identified with certainty, but it may be either:
a) He sees bears dancing before his eyes (as a result of hunger)
b) Wild bears prefer each other's company (in the derogatory sense of birds of a feather flock together)

105 a) He's running like his arse was on fire
b) If you eat fire, you'll fart sparks (if you court danger, don't wonder at the results)

106 a) Leave the gate open, and the pigs will get into the corn
b) Where the corn decreases, the pigs increase (i.e. get fatter. You don't get something for nothing; or, One man's loss is another man's gain)

107 He doesn't care whose house burns down as long as he can warm himself at the coals (he profits by others' misfortune)

108 A cracked wall will soon fall

109 It is easy to sail before the wind

110 He keeps an eye on the sail (is alert, knows which way the wind blows)

111 a) Who knows why geese go barefoot? (there is sure to be some reason)
b) If the Lord didn't intend me to keep geese, I'll let them be geese (mind my own business)

112 Horse droppings are not figs (beware of swindlers)

113 Dragging the log (a jilted suitor, or slaving at a senseless task)

114 Fear makes an old woman trot (brings out unexpected qualities, or necessity is the mother if invention)

115 He shits on the gallows (is fearless and incorrigible and will likely come to a bad end)

116 Where there is carrion, there are crows

117 When the blind lead the blind, they both fall in a ditch

118 The journey is not yet over when one can discern church and tower (the goal is reached only when one has finally completed one's task)

One final proverb relates to the sun in the sky: Every plot, however finely spun, finally comes to the sun (nothing remains hidden)
(Based on the translation by Haijo and Monique Westra)

Pieter Bruegel the Elder
Two Chained Monkeys
1562

Oak, 20 × 23 cm (7⅞ × 9 in)
Signed lower left: 'BRVEGEL MDLXII'
First mentioned in the inventory of Peter Stevens, official of the Antwerp Poor Relief, 1668
Acquired 1931 (Friedländer Foundation Fund)
Cat. no. 2077

Albrecht Dürer
The Madonna with the Long-tailed Monkey
*c.*1498
Engraving

This unusual painting was executed in 1562, shortly before Bruegel moved from Antwerp to Brussels. It represents two monkeys chained to an iron ring in an arched window opening. The heavy chains, the massive masonry, and the low opening increase the impression of inescapable captivity. The animals are apparently resigned to their lot. While one cowers with a bent back, staring absently in front of him, the other fixes us with an unmoving, wide-eyed stare that seems almost human. This gaze and the nutshells scattered on the ledge are the only signs that the animals have not been completely abandoned. The attitudes of creatures sapped of vitality by captivity are characterized with great empathy.

As though seen from a high tower, a spacious plain suffused with light opens out beyond the dungeon window. In the mist, Antwerp lies with its harbour and the jutting tower of the Onze Lieve Vrouwekatedraal; in front of it, the broad River Schelde flows into the distance, where water and sky merge. The contrast between the depressing closeness of the dim room and the bright sunshine outside, with birds in the sky and ships evoking the freedom of distant shores, heightens the feeling of captivity within.

The simple yet carefully considered composition of the small panel and its limited colour range of nuances in grey and brown, suggest an equally straightforward and poignant meaning. Yet perhaps because of this concentration in form and content, interpretations of the image diverge widely.

In terms of composition, Bruegel may well have taken hints from such engravings as *Four Monkeys* by Israhel van Meckenem or *Madonna with the Long-tailed Monkey* by Dürer. Studies from life, however, were more important. The animals depicted belong to the family of long-tailed monkeys, a species called *Cercocebus torquatus* whose natural habitat reaches from Cape Verde, West Africa, to the southern parts of what was then the Congo and is now Zaire. Monkeys of this type were imported as curiosities into the Netherlands by Portuguese Indiamen who picked them up on the west coast of Africa. They were popular pets, and drew high prices. 'I paid 4 golden guilders for little monkeys,' noted Dürer in 1520, during his stay in Antwerp.

Though Bruegel's depiction shows evidence of minute observation, he cannot have intended it merely as a realistic animal study. Associations with the artist's life – his imminent move to Brussels, his marriage, and his loss of independence – would also seem rather unlikely. It is more plausible that the tiny panel was meant as a going-away present for a friend left behind in Antwerp. Some observers see a bitter allusion to the town's inhabitants here, while others advance the quite different political interpretation that the chained monkeys represent the Dutch population suffering under the yoke of Spanish tyranny.

In short, the painting has inspired many explanations. Those based on the symbolic or allegorical meanings associated with monkeys throughout the history of art are the most plausible: man is seen as enslaved by his instincts, prisoner of his own carnal, animal desires. Bruegel's monkeys in chains, then, would allude metaphorically to human beings who for the sake of dubious pleasures – symbolized here by broken, empty nutshells – are willing to sacrifice their freedom. The animals' captivity suggests the self-enslavement of people who, ignoring the Christian virtues, play havoc with destiny and can expect to meet a sad end. This captivity is self-chosen, Bruegel seems to say, since no one need succumb to it who has enough strength of will to recognize that moderation and sense are the best guides to a meaningful life. This critical view of human nature underlies many of the enigmatic allegories of the artist who later was all too unthinkingly labelled 'Peasant Bruegel'.

Pieter Aertsen (1507/8–75)
Marketwoman at a Vegetable Stand
1567

Oak, 111 × 110 cm (43¾ × 43¼ in)
Signed top: '1567 · 16 · AVG P.A.'
(with trident, Aertsen's device, between
the initials)
Acquired 1961
Cat. no. 3/61

Pieter Aertsen
The Cook
Brussels, Koninklijke Musea voor Schone
Kunsten

Still life did not become a subject thought worthy of art until quite late in its history, largely because of the tenacious notion that artists were called to higher things than depicting trivial, everyday objects. Artists of the Netherlands, however, made an immense contribution to the development of the still-life genre, with Pieter Aertsen and his nephew, Joachim Beuckelaer, doing the groundwork. Their paintings represent the point of departure from which the artists of the seventeenth century, increasingly specializing in particular aspects of still life, went on to superb achievements.

After an apprenticeship in Amsterdam, Aertsen settled in Antwerp in about 1530. Though he became well known and prosperous there, he nevertheless returned to Amsterdam in 1555. His work was much in demand, particularly the still lifes, which are said to have gained him a commission for an altarpiece for the Oude Kerk in Amsterdam. He had established his reputation with religious subjects, but it was the realism of Aersten's still lifes that fascinated and impressed his contemporaries most. In his book *Den grondt der Edel Vry Schilderconst* Carel van Mander marvelled, 'For you imagine you see things of every variety, and yet they are all nothing but paint, which he knew how to mix so that they seem to become robustly alive, the surface to take on sculptural relief qualities, and mute objects seem to speak, dead ones to live.'

The painting in our collection, from the artist's late period, is dominated by a peerless still life of fruit and vegetables. A deluge of harvest produce and kitchen and table ware, painted in intense, glowing colours, is displayed on an inclining stand. The sensual appeal is stressed by the inviting gesture of the young farmwoman seated among this plenty. Wearing a large straw hat, a red dress with a black bodice and white collar, and a grey-blue apron, she offers baskets of cucumbers, pumpkins and parsnips, radishes, cabbages, grapes, apples and peaches, walnuts and chestnuts. Waffles, bread and baked delicacies are also on display, as well as butter, exotic lemons, and a salted herring.

The produce indicates that the season is autumn, a time of preparations for winter; but its formal, still-life presentation points beyond this to symbolize nature as experienced by man. Underlying much of Aertsen's imagery are notions associated with the four Seasons, the four Elements, or the five Senses, though this last reference, as in the present painting, is often only indirect. Aertsen frequently included in the backgrounds of his paintings some religious scene, such as Christ's visit to Mary and Martha, the disciples at Emmaeus, or Jesus with the woman caught in adultery. Yet far from being merely an excuse to paint still life, such religious scenes refer to other human needs beside the sensual side of their nature. As in so many of Aertsen's works, the figures in the background here, a couple embracing, warn that the pleasures of the flesh, *voluptas carnis*, can threaten spiritual welfare, a message clearly emphasized by the empty wagon and the idle horse. By contrast, the vendor among her wares and the peasant driving his ox to market, can be measured, both literally and figuratively, by the fruits of their industry.

Yet the products of physical labour spread out so convincingly before our eyes are not the measure of all things. The lemon, in art a traditional emblem for superficial beauty, has bitter flesh. It evokes the doubtfulness of pleasures whose consequences can be equally bitter, since they entail a loss of peace of mind, even of one's soul. The herring, which strikes a seemingly strange note in the still life, was a traditional Lenten dish. It brings fasting to mind, a practice meant to help human beings resist sensual temptation and lead them on the path of righteousness. Seen in this light, Aertsen's image indeed contains a message. Illustrating the dualism of life, it reminds us that for the sake of spiritual welfare, earthly possessions must be used well.

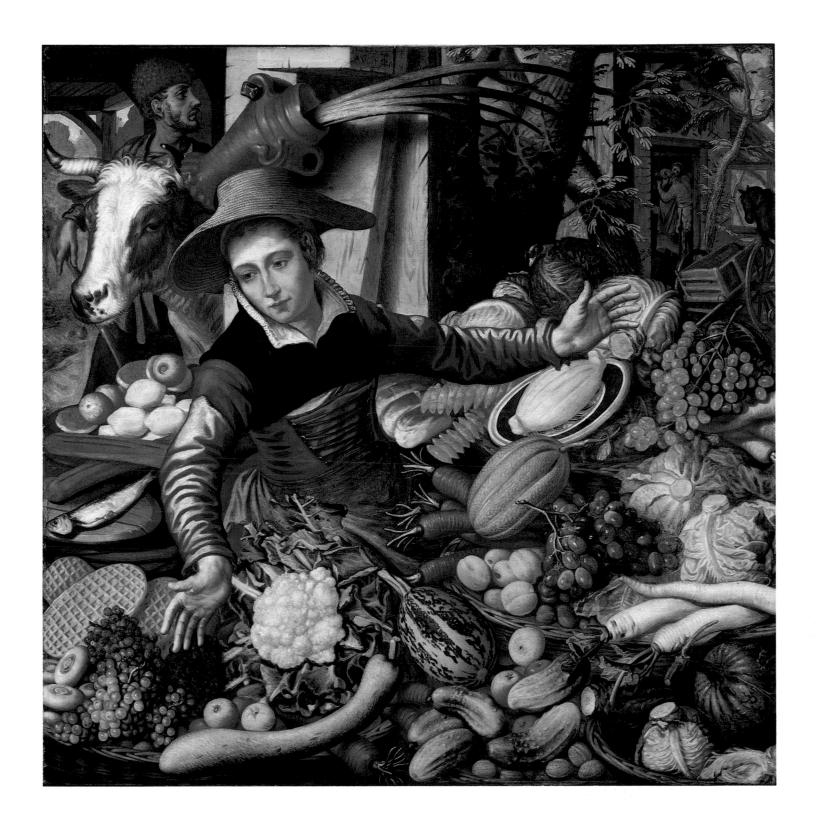

FLEMISH AND DUTCH PAINTING OF THE SEVENTEENTH CENTURY
BY JAN KELCH

Peter Paul Rubens (1577–1640)
St Sebastian
*c.*1618

Canvas, 200 × 128 cm (78¾ × 50⅜ in)
Acquired 1878
Cat. no. 798 H

Sebastian, a Roman officer during the reign of Diocletian, was condemned to be executed for his Christian faith. By a miracle he survived the archers' arrows; yet when he publicly accused the Emperor of persecuting Christians, Diocletian had him clubbed to death.

Rubens shows St Sebastian, his body pierced by arrows, bound to a tree trunk in the foreground of a landscape. The bow and quiver at the lower left symbolize his martyrdom. Clad only in a loincloth, the almost life-sized nude figure nearly fills the entire height of the pictorial field. It is illuminated by light falling from the upper left, and stands out in strong contrast to the dark trees and overcast sky.

The crucifixion of Christ was depicted in similar terms. According to traditional doctrine, the sufferings of Christian martyrs, who were revered as contributing to the work of salvation, mirrored the agony of Christ. This concordance was particularly close with St Sebastian, whose martyrdom by arrows and miraculous survival clearly paralleled Christ's crucifixion and resurrection. This is one reason why Sebastian's sufferings at the hands of Roman archers, rather than his death by clubbing, entered pictorial tradition as the motif most often associated with the St Sebastian legend.

Rubens has concentrated the meaning of the event in a single figure of great emotional force. The herculean limbs bound and pressed into passivity, and the tortured body looming far above the low horizon, are pictorial examples of the counter-reformation with which the Catholic Church in the southern Netherlands challenged the spread of Calvinism in neighbouring Holland, and which included a demonstration, in religious imagery, of its superior doctrine.

Rubens's *St Sebastian* is a highly individual expression of his experience in Italy. The pose is almost a mirror-image of that in Mantegna's version of the subject (Vienna, Kunsthistorisches Museum), whose small figure Rubens enlarged to life-size, giving it a sculptural massiveness. In force of design, the image compares to the monumental figures of Michelangelo, even to the famous statue of *Laocoön*, whose configuration is recalled here by the motif of the torso swelling outwards from a slight turn of the hips. The saint's expressive features are similar to those of the *Dying Alexander*, a Hellenistic marble head (Florence, Uffizi) which was included in pictorial and literary tradition as an *exemplum doloris*, a rendering of the death agony worthy of emulation. The realism of the still life composed of a bow, a quiver and arrows, like the pronounced chiaroscuro, suggests the influence of Caravaggio. In the treatment of the landscape, by contrast, Rubens follows the northern tradition, conceiving it as the place of action and allowing it to convey its own meaning. As if to mirror the drama of the event, the foreground illumination skimmers again in the cool yellow twilight on the far horizon.

In the lucidity and balance of its pictorial means, this image of *St Sebastian* is among the works with which the Flemish master set lasting standards for the Late Baroque style, bringing it to full fruition. Rubens himself spoke of 'the flower of my things' when together with other paintings he offered this one, in 1618, to Sir Dudley Carleton, English Ambassador at The Hague, in exchange for his collection of antiquities.

The Dying Alexander
Florence, Uffizi

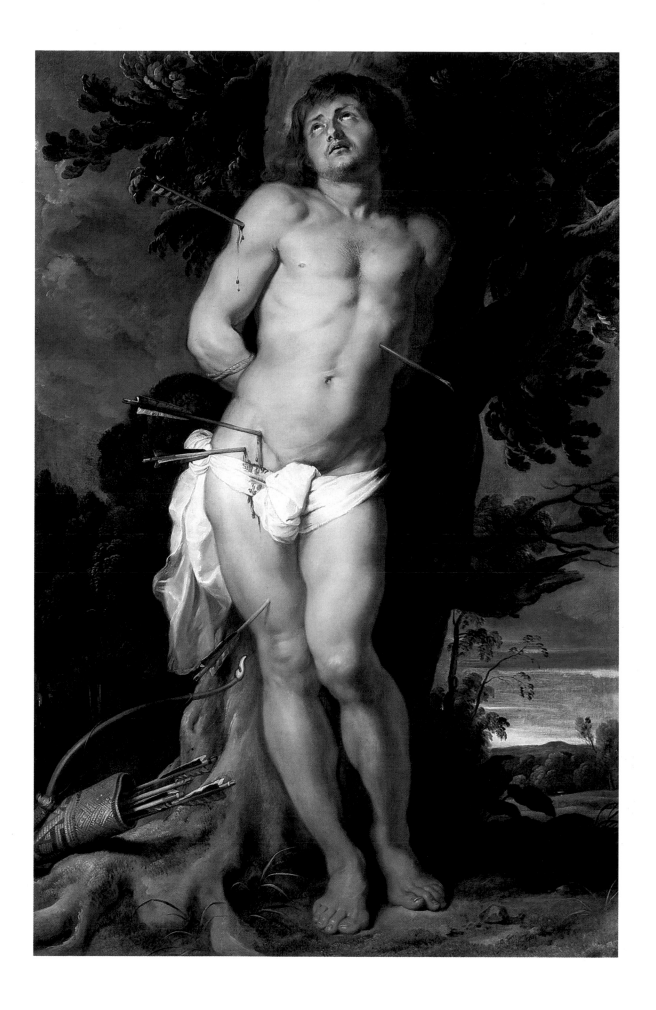

Peter Paul Rubens
Perseus and Andromeda
*c.*1622

Oak, 100 × 138.5 cm (39⅜ × 54½ in)
Pasquier Collection, Paris, 1755; in the
Picture Gallery, Sanssouci, from 1764
Acquired from the Royal Palaces, Berlin,
1830
Cat. no. 785

Hendrick Goltzius
Venus Felix
Drawing
Haarlem, Stichting Teyler

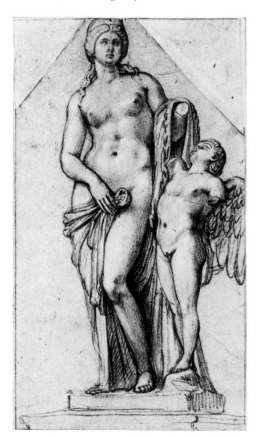

It was the Roman poet Ovid who, in his *Metamorphoses*, transmitted and popularized the ancient story of Perseus and Andromeda. Andromeda, daughter of King Cepheus of Ethiopia, was bound to a cliff to be sacrificed to a terrible sea-monster. This fate was ordained by Poseidon to punish the pride of the king's wife, Cassiopeia, who compared her own and her daughter's beauty with that of the Nereids. Perseus, returning on Pegasus from his victory over Medusa, saw the captive princess and, entranced by her loveliness, approached her, saying, 'Not chains like these do you deserve/But the bands that unite ardent lovers./Now the maiden cannot speak, does not dare/To address a man, and were her hands not tied,/She would hide her innocent face in them.'

In Ovid's version of the story, the encounter between Perseus and Andromeda precedes the hero's battle with the sea-monster. Rubens, whose narrative skill lives up to the highest Homeric standards, combines the two scenes. The monster already lies dead in the water as Perseus, in the red mantle of the victor, loosens Andromeda's fetters. Two *putti* assist him, while three others romp around Pegasus, one helping another up on the horse's back as a third holds the reins. Set on an outcrop at some distance from the spectator, the story unfolds chronologically from left to right, to the triumphant meeting of the two protagonists. Their complementary poses, one active, the other passive, and the contrast of shining armour next to delicately modelled flash, emphasizes the awakening love described in Ovid's poetry. Never at a loss for apt quotations from classical art to underline his message, Rubens has modelled the figures of Andromeda and the *putto* who is helping to untie her on the *Venus felix* (Rome, Vatican Collection). The artist may have seen this sculpture while he was in Rome, or perhaps Hendrick Goltzius introduced him to it.

Rubens painted several variations of the Andromeda myth, interpreting it slightly differently each time. Among these are a late work, also in the Berlin Gallery, and an almost identical version in the Hermitage, Leningrad, which was done immediately before the painting discussed here. In the Hermitage composition, Perseus, holding the weapon of a Medusa shield, dominates at the centre. The sea-monster at his feet, Pegasus reined in by *putti*, and Andromeda being released by other infant angels, are arranged around him concentrically like symbols of his valour; and a figure of Fama crowns him with a wreath to signify his heroic victory. This treatment of the theme could be interpreted as a political allegory. There are, in fact, paintings in which Andromeda personifies a city, a nation, or a religion which, threatened by the monster of an enemy power, internal division, or heresy, is saved by a soldier or king in the guise of Perseus.

The Berlin painting, however, does not seem to contain allusions of this kind. Rather, it is as if the artist took the Horatian principle *'ut pictura poesis'* ('let poetry be like painting') literally, and, vying with the poet's art, tried to create a visual narrative whose lucid form and feeling could stand beside the great verses of Ovid.

192

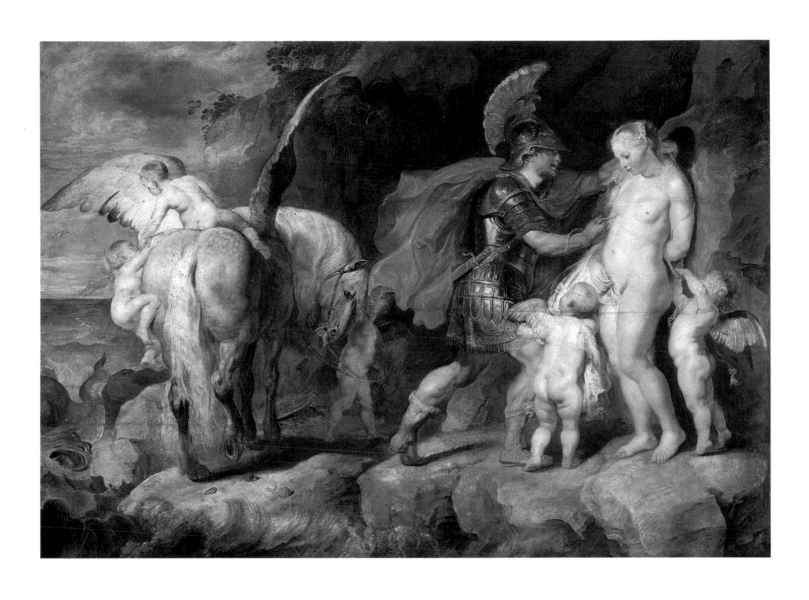

Peter Paul Rubens
Child with a Bird
(Philipp Rubens?)
c.1624–5

Oak, 50.8 × 40.5 cm (20 × 16 in)
In the Picture Gallery, Sanssouci, 1770
Acquired from the Royal Palaces, Berlin
Cat. no. 763

Here Rubens has captured that mixture of excitement and trepidation with which children play with animals, in this case a startled bird fluttering on a short string. The colour accents are distributed with great subtlety, the delicate reddish heightenings of the flesh colours rising to brilliance in the coral necklace, and complemented by the green tones of the bird's feathers and the golden blonde of the child's hair. These colours, by being set against a contrast between the dark background and bluish white chemise, are made to shine out.

The allegorical significance of the bird motif is thought by some authors to be connected with the *Reductorium morale* of Petrus Berchorius (mid-fourteenth century). There, the goldfinch, which is easily tamed and can be trained to sing in captivity, is compared with men who, in the familiar confines of religion or church sing praises of God. A reference to the efficacy of religious training in producing good Christians would certainly not be out of place in this portrait of a child. Another implication might be seen in the coral necklace. In the emblematic literature of the seventeenth century, coral, which grows hard and takes on its beautiful colour only when it is removed from the water – its home, so to speak – is seen as a symbol of early training in courage to resist the world's temptations and dangers.

The combined motifs of child and bird, however, may have no deeper meaning than the artist's desire to enliven his composition by introducing a contrast and a bit of drama. Songbirds were popular pets at that time, and necklaces of coral, thought to be good charms against evil influences, were worn by many children.

Though Rubens's portraits were as highly regarded as his other works, he does not seem to have received commissions to portray individual children. The children he painted were his own, from his two marriages; he may also have painted children from his wider family circle, if the recent identification of this portrait with Philipp, Rubens's nephew, is correct. Philipp, born in 1611, became his charge when Rubens's brother died at an early age. Rubens has rendered the charm of childhood compellingly; the countless possibilities of the child's later development are contained as if in suspension – a universal reference that might speak against the suggested identification of Philipp. Behind the unique individuality of all his young sitters, Rubens perceived the sublime beauty of angels or *putti*, which was how he often depicted his own children in religious or mythological pictures. The boy in our portrait, too, has been cast as an angel elsewhere, for instance in *Madonna with Flower Wreath* (Munich, Alte Pinakothek). This was his first role in the present painting as well. Originally larger, the panel had a horizontal format that must have shown the boy in an expanded narrative and with further motifs respectively. Why Rubens rejected this first version, painted about 1613–14, cannot be determined. At any rate, he had the original panel cut diagonally along the child's profile and through his shoulder and chest, and on the new piece joined on at the left, added hands and a bird. In the process of integrating this motif with the existing figure he repainted the entire image, including a vestige of angel's wings on the shoulders, which X-ray analysis has revealed beneath the paint layer of the dark background.

The present, definitive version, most likely executed about 1624–5, might indeed be classed in the portrait genre, were it not that the artist's original intentions remain quite clear. What other reason can he have had for making the child's locks so angelically lovely?

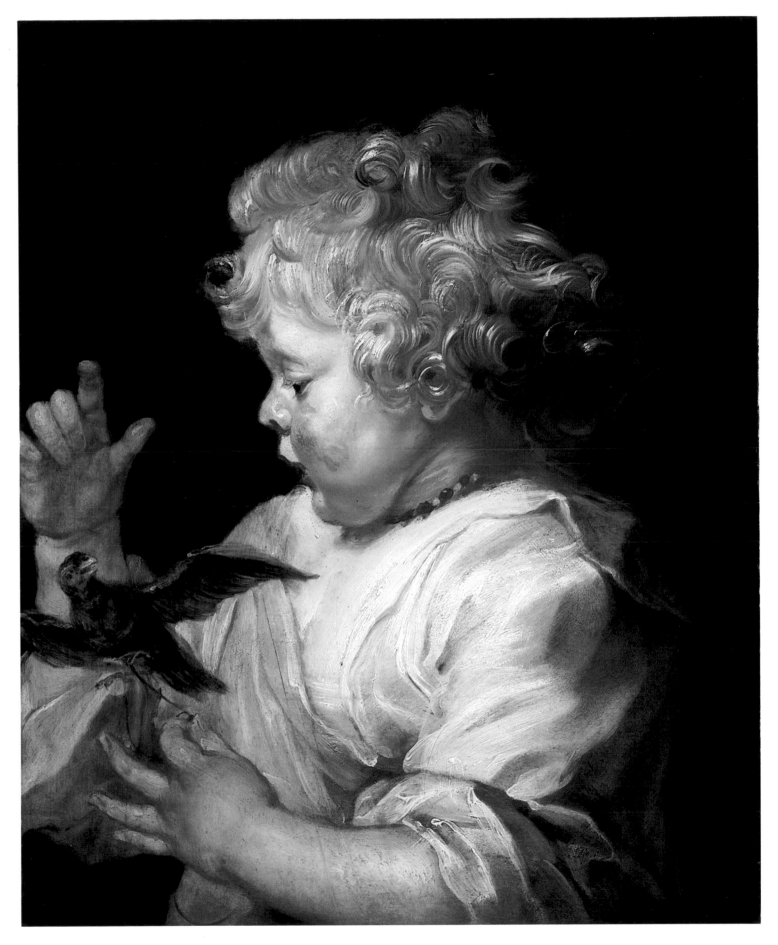

Peter Paul Rubens
Landscape with Cows and Duck Hunters
c.1635–8

Oak, 113 × 176 cm (44$\frac{1}{2}$ × 69$\frac{1}{4}$ in)
Collections of the Duc de Richelieu, Paris,
1677; Lord Cavendish, London, 1815;
Earl of Burlington, Holker Hall,
Lancaster; Duke of Devonshire, Leeds,
1868
Acquired 1927
Cat. no. 2013

In the foreground of heavily wooded meadowland, a herd of cows grazes on the bank of a stream. Women from the nearby farm are occupied in milking and filling jugs, while another, with upstretched arms, balances a wooden tub of milk on her head. Rays of the setting sun filter through the leaves and cast deepening shadows of a warm brown. The mild light of dusk lends shimmering brilliance to the tones of the women's skin, a red blouse, a deep blue dress, or the ochre and rust-brown hues of the animals' coats; yellow highlights on the vessels evoke a more precious metal than brass. Thanks to illumination and colours, the landscape has the character of an idyll, which not even a sudden shotgun blast can disturb for long. This interruption caused by a hunter crouching to the right of the stream only heightens the tranquil mood of the scene.

Though Rubens was primarily a historical painter and made only guest appearances among the landscape specialists, his work in this genre brought seventeenth-century Flemish landscape art to culmination. He mastered a great range of natural imagery, from fantastically rugged mountain vistas and violent storms to sun-drenched southern fields and motifs from his own, familiar lowlands. These last images are very much in evidence here, in a landscape whose essential elements – arrangement of figures, narrative, and composition – go back to such paintings of about two decades before as *The Farm at Laeken* (London, Buckingham Palace) and *Polder Landscape with Cows* (Munich, Alte Pinakothek).

Connections with the Munich painting are particularly close, since the three cows and central group of two seated women were derived from it. Other self-citations are the motif of the cow relieving itself near the stream, and the animal at the far left edge (which is cut off in the Munich version). The pasture setting with the milking scene, the land that slopes down to the foremost pictorial plane, and the distant vista opening out at the left are also comparable. Besides these visible analogies, invisible ones have also been detected. X-rays have revealed, in places corresponding to the Munich piece, gnarled willow trunks in the right foreground, a dark-coloured cow in profile at the centre of the composition, and a cowherd with a milk jug. These findings indicate that the genesis of the Berlin landscape must have been a second version of the Munich painting by Rubens's own hand.

It is characteristic of the artist's working method that pictorial solutions, once found, were retained and often repeated. In the present case, by leaving out elements or painting over them, by adding or shifting them in the composition, even by changing the picture format (which he made considerably wider and higher than the Munich version), and by modifying colour and illumination, Rubens created an entirely new landscape.

Elaborating the straightforward approach of the Munich piece, the artist enriched the composition and correspondingly enlivened his palette, developing a chiaroscuro that captured both the objective appearance and atmospheric essence of the landscape. This chiaroscuro, based on subtle and harmonious colour nuances, not on a monochrome scale, enabled him to use a variety of motifs without jeopardizing the continuity of the whole. Besides the splendid effect of the design, it is above all to its emotional content, its view of nature as the embodiment of human ideas or sentiments, that this late work, like all Rubens's later landscapes, owes its rank.

Peter Paul Rubens
Polder Landscape with Cows
Munich, Alte Pinakothek

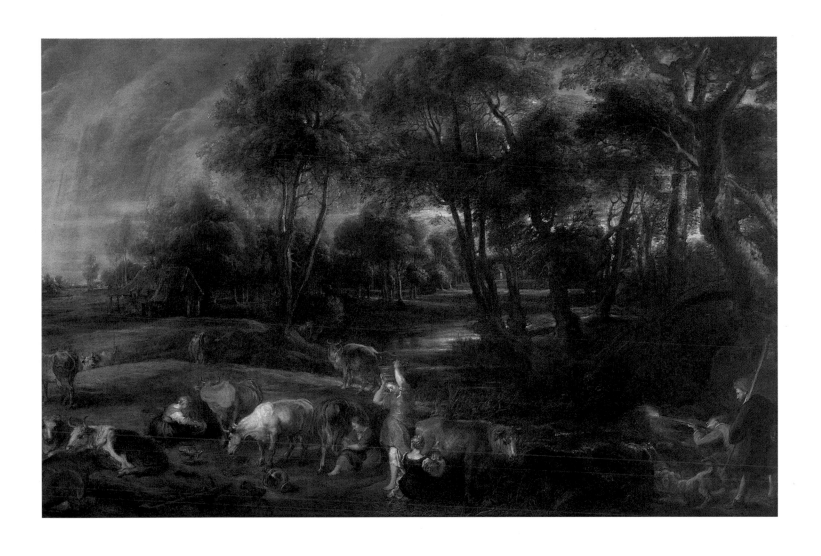

Peter Paul Rubens
Portrait of Isabella Brant(?)
*c.*1626

Oak, 97.3 × 71.5 cm (38¼ × 28⅛ in)
Acquired 1903
Cat. no. 762 A

The seated subject, holding a fan and turned slightly to the right, is portrayed life-size and three-quarter length. She gazes directly at the observer. Her face, neck and hands, brilliantly illuminated, shine against the deep red of the background and the dark, primarily blue tones of her dress. This concentration of light corresponds to brushwork that, smooth and controlled in the blushing glazes of the flesh, becomes looser in the background, and finally grows tentatively sketchy in the rendering of the various textures of the gown. This differentiation in touch lends each part great objective realism while emphasizing its autonomous value-qualities which, together with the rich palette and illumination, create an effect of fascinating and festive variety. The model's pose is correspondingly informal and her social status apparently incidental. Portrayed in strictly personal terms, she faces the observer with unaffected frankness. This naturalness of expression is heightened by a composition that flows, as if organically and with gradual shifts of axis from the sleeves, circumscribing the figure through hands, torso, head and gaze.

The immediacy of the sitter's presence and the fact that her rank is not emphasized, would place her among the artist's relatives, a consideration that has led to her identification as Isabella Brant (1591–1626), Rubens's first wife. However, this assumption is still questioned for various reasons. Some details of her features and her youthful appearance diverge from the almost contemporaneous *Portrait of Isabella Brant* of 1626 (Florence, Uffizi) which shows her considerably aged and perhaps marked by illness. This work, probably intended as a memorial, was executed shortly after Isabella died on 20 June 1626, presumably of weakness after an attack of the plague.

The Berlin panel, which as X-rays have shown, consists of two chronologically separate versions, has also been called a posthumous portrait. On the original paint layer of the first version, done some time around 1622, is a portrait sketch resembling the *Isabella* in the Cleveland Museum. In both her right hand grasps the folds of a pleated bodice, pressing it towards her. Other similarities revealed by X-ray are a scalloped bodice seam and a starched, turned-up lace collar. The same gesture and costume are present, in modified form, as in the Florence portrait. What seems decisive for the identification of the first Berlin version, however, is how some facial details are read. The eyebrows, just visible in the X-ray, appear originally to have been more highly arched, while in the final version, unlike the securely identified portraits of Isabella, they are turned up towards her temples. The hypothesis that this is a posthumous portrait, which attempts to reconcile these obvious facial differences with a desire to retain the portrait's present title, assumes that Rubens may have developed it from an existing portrait that was in his studio. The different appearance of the model – or, if you will, the entirely new personality in the definitive version of the Berlin portrait – may have resulted from the artist's desire to create a youthful and idealized image of his dead wife.

Peter Paul Rubens
Portrait of Isabella Brant
Cleveland, The Cleveland Museum of Art,
Mr and Mrs William H. Marlatt Fund

198

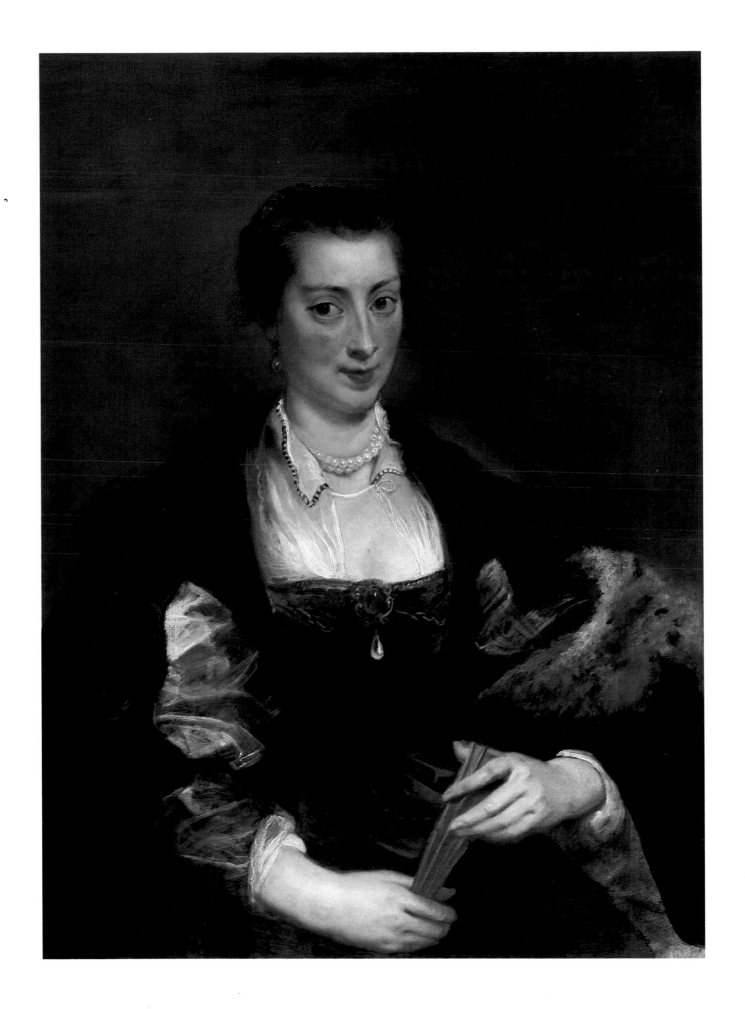

Peter Paul Rubens
St Cecilia
*c.*1639–40

Oak, 177 × 139 cm (69⅝ × 54¾ in)
From the Royal Palaces, Berlin, 1830
Cat. no. 781

This life-sized figure dominating the picture represents St Cecilia, patron saint of music. She sits slightly inclined to the left and the back, singing and playing the virginal. With greatly contained emotion she gazes heavenward, inclining her head as if to catch strains of the celestial music which inspires her. Angels cavort around her: one clambers up the instrument as if to immerse himself physically in the melody, while behind the open score two other angels watch and listen. The scene is set in opulent, columned architecture, with a view across the distant plains of Flanders.

Symbolic motifs enrich the composition. At the upper right, a *putto* draws a curtain aside and brings a wreath of roses, the emblem of St Cecilia's virginity and chastity. Her steadfast faith is symbolized by the massive column at whose base she sits. The little dog asleep at the lower right, often found in depictions of the saint, was a symbol of marital faithfulness. It probably alludes to Cecilia's unconsummated marriage to husband Valerian, whom, on their wedding day, she converted both to Catholicism and to a physically pure, Christian love. Husband and wife, as the *Legenda aurea* relates, suffered martyrs' deaths during the reign of Caesar Alexander Severus or Marcus Aurelius.

Some commentators have been prompted by the picture's rich palette to speak of synaesthesia, a principle followed by many Baroque artists. The colour combinations do seem to echo harmonies of sound. Translucent, cool, whitish flesh tones with blushes of red on cheeks and lips; brilliant emerald green in the gold-trimmed velvet gown, complemented by a carmine red in the drapery at the upper right; the soft black of the cape whose lining shimmers golden yellow at the wrist; and finally, the countless shades of ochre and dull red suffusing the skirt – all these colour accents are so consciously developed that, beyond their descriptive character, they must have significance in a larger context. The differentiation achieved through the multiple colours softens the monumental quality of the figure and architecture, giving the sacred image its intimacy and individuality that reveal her origins in the artist's personal life. The model for this saint, who has negligently slipped off her shoe and let her hair down, was Helene Fourment, Rubens's second wife.

The painting undoubtedly belongs among the artist's last works. An impetuous handling of some parts of it has, I think wrongly, been attributed to Rubens's poor health. From about 1626 he began to suffer from attacks of gout, which became more violent during his final years until in March 1640 they led to a partial paralysis of his hands. However, to blame sketchy passages, such as the *putto* with drapery, on the artist's weakened physical condition, is to ignore the care with which, for example, the capitals of the columns or the ornament band on the instrument are rendered. The mixture of summary and finely articulated forms more likely resulted from a principle of design, in which primary elements were distinguished from secondary ones. This, moreover, heightened the variety of an already bursting composition, transforming it from an unpretentious record of chamber music at home into a Baroque performance of great refinement and sensibility.

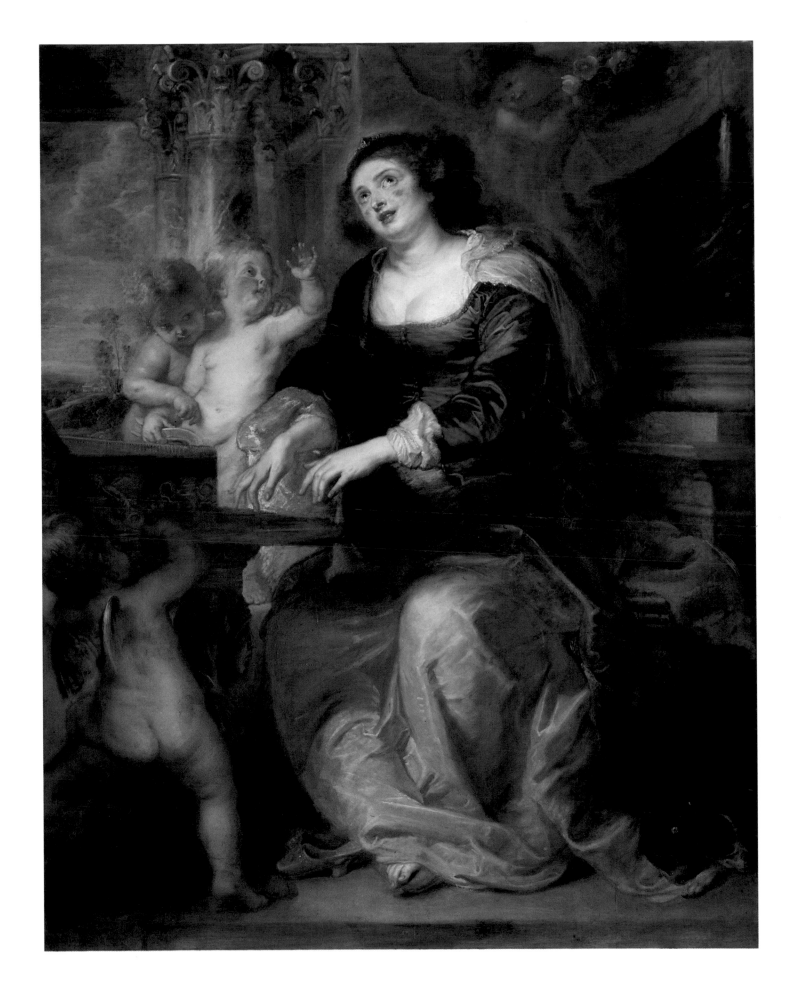

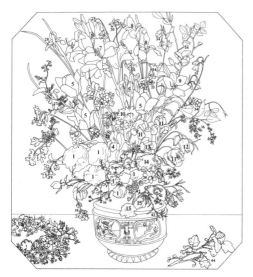

Bouquet of Flowers
Diagram by Marina Heilmeyer

Botanical Key by Marina Heilmeyer and Bernhard Zepernick

No.	Name	Latin name	Flowers in	Cultivated in Europe since
1	Moss-rose	Rosa certifolia	June–July	1573
2	Marigold	Calendula officinalis	June–Autumn	Filled variety since late 16th cent.
3	Ragged-lady	Nigella hispanica	June–August	1596
4	Iris	Iris pseudacorus	May–July	Native
5	Tulip	Tulipa	April–May	Mid-16th cent.
6	Narcissus	Narcissus tazetta	May	1557
7	Madonna lily	Lilium candidum	June–July	One of the oldest cultivated flowers
8	Iris	Iris xiphioides	June	1568
9	Tiger-lily	Lilium bulbiferum	May–June	1596
10	Peacock anemone	Anemone pavonina	May–June	Late 16th cent.
11	Iris	Iris germanica	May–July	Native
12	Fritillary	Fritillaria meleagris	April–May	1572
13	Peony	Paeonia officinalis	May–June	Before 1500
14	Guelder-rose	Viburnum opulus	May–June	Native
15	Marsh marigold (double)	Caltha palustris 'multiplex'	March–May	Native
16	Forget-me-not	Myosotis alpestris	May–July	Native
17	Dog-violet	Viola canina	April–June	Native
18	Lily of the valley	Convallaria majalis	May–June	Native
19	Mock jasmine	Philadelphus coronarius	June–July	Native
20	Crown anemone	Anemone coronaria	April–May	1596
21	Cornflower	Centaurea cyanus	May–July	Native
22	Gillyflower	Matthiola longipetala	May–June	16th cent.
23	White narcissus	Narcissus poeticus	April–May	c.1600
24	Sweet-william	Dianthus barbatus	June–August	1554
25	Hawthorn	Crataegus monogyna	May–June	Native
26	Daffodil	Narcissus pseudo-narcissus	April	c.1600
27	Bird cherry	Prunus padus	May	Native
28	Siberian iris	Iris sibirica	June	Native
29	Turk's cap	Lilium martagon	May–June	Native
30	Pink	Dianthus superbus	July–August	1583
31	Pyramid bellflower	Campanula pyramidalis	July–August	1569
32	Jonquil	Narcissus jonquilla	April–May	1565
33	Cross of Jerusalem	Lychnis chalcedonica	June–July	1561
34	Dog-rose	Rosa canina	June	Native
35	Snowdrop	Leucojum vernum	March–April	1420
36	Lilac	Syringa vulgaris	May	Mid 16th cent.
37	Ramson	Allium ursinum	May	1561
38	Narcissus	Narcissus triandrus	April–May	1579
39	Squill scilla	Scilla bifolia	March–April	1568
40	Jasmine	Jasminum officinale	June–August	1548
41	Immortelle	Helichrysum arenarium	July–September	Native
42	Auricula	Primula auricula	April–June	Native
43	Rosemary	Rosmarinus officinalis		Old medicinal herb
44	Currant	Ribes rubrum		Native

The flowers in the wreath:

No.	Name	Latin name	Flowers in	Cultivated in Europe since
1	Carnation	Dianthus	June–August	Mid 16th cent.
2	Borage	Borago officinalis	May–July	Very old cultivated plant
3	Primula	Primula clusiana	April	1583
4	Nasturtium	Tropaeolum minus	July–September	1573
5	Cyclamen	Cyclamen purpurascens	June–September	1600

Anthony van Dyck (1599–1641)
Portraits of a Genoese Nobleman and his Wife
c.1622–6

These two companion-pieces, with seated models in life-size and full figure, were painted during van Dyck's visit to Italy (1621–7), the happiest period of his career, which he spent in the harbour town of Genoa in Liguria.

Though the couple has not yet been identified, the man's black cap and the paper in his right hand at least indicate that he was a high official. The same objects appear in van Dyck's *Portrait of Gian Vincenzo Imperiale*, a Genoese procurator (Washington, Widener Collection). This similarity suggests that the nobleman in our painting also held the position of procurator, a financial official next in power only to the doge in the aristocratic ruling hierarchy of the Genoese city-state. That he and his wife belonged to the highest circles may be inferred from their distinguished and rather distant manner, the simple elegance of their dress, which was modelled on that of the Spanish Court, and finally from the architectural setting, whose pilasters and columns on high pedestals increase the imposing effect of figures seen from a low vantage point. Yet the pomp of their surroundings pales before the personalities themselves, who need not show their awareness of rank. Bolstered by this self-confidence, the kindly indifference of the lady and the man's imperious yet mistrustful gaze seem like extreme expressions of the same attitude.

Portraits of this kind brought van Dyck wide recognition and well-rewarded commissions from noble families, for whom most of his work was done. Relying first on Rubens, whose Antwerp studio he entered as a precociously talented young man of seventeen, and then taking cues from the courtly portrait style of Titian, van Dyck developed those nonchalantly distinguished portrayals which even today are regarded as the quintessence of nobility. Although his late portraits sometimes slipped into a rather dry and facile elegance – partly because of the great number of commissions he had to fulfil in his influential position of Court Artist to Charles I of England (from 1632) – his reputation as the greatest of Rubens's successors and one of the major portraitists of his age remains secure.

Canvas, each 200 × 116 cm ($78\frac{1}{4}$ × $45\frac{5}{8}$ in)
Palazzo G. Balbi Collection, Genoa, 1773; purchased 1828 in Genoa for David Peel, London, by the English artist David Wilkie
Acquired 1900
Cat. nos 782 B, 782 C

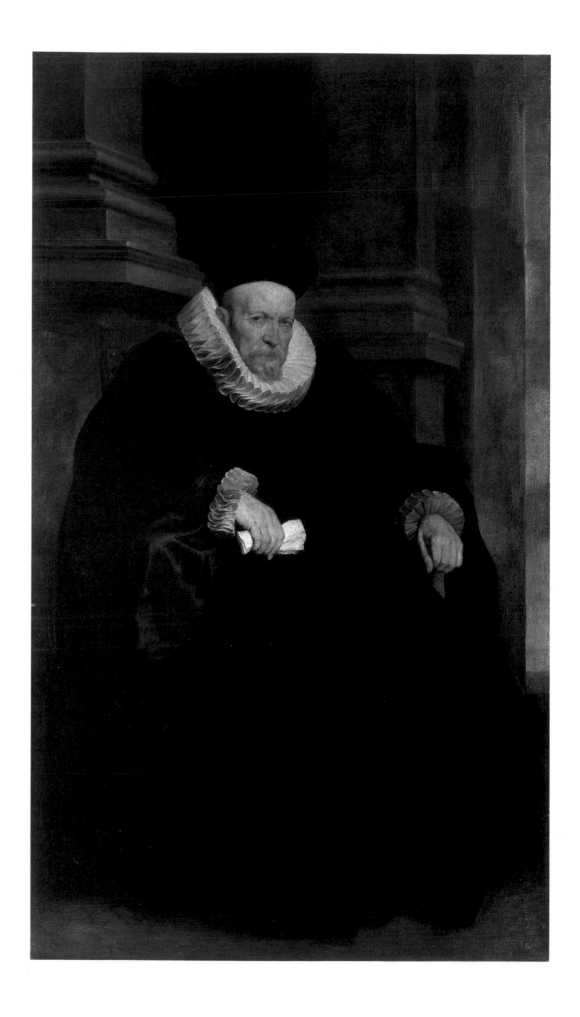

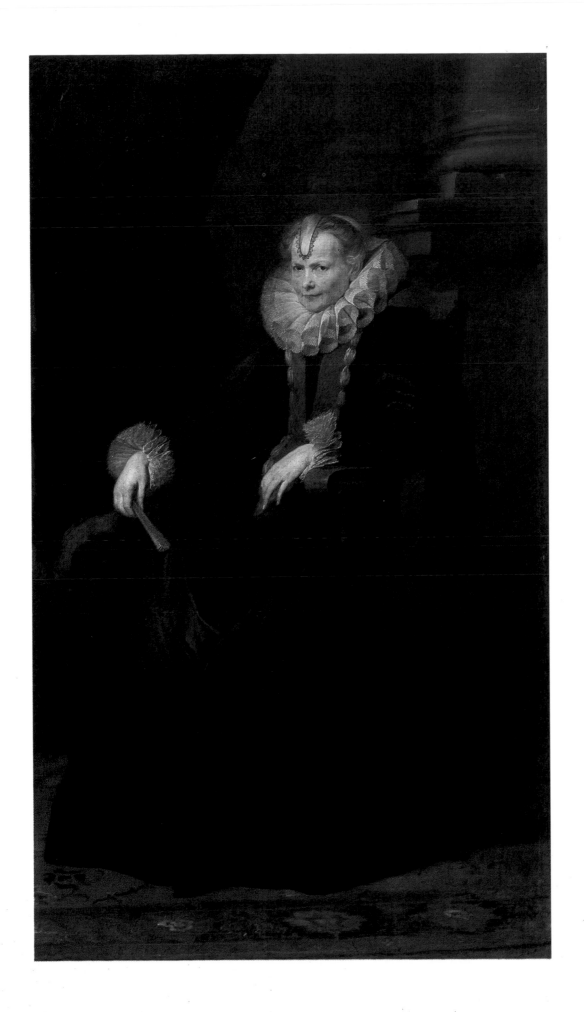

Jacob Jordaens (1593–1678)
The Rape of Europa
c.1615–16

Canvas, 173 × 235 cm (68⅛ × 92½ in)
Acquired 1981
Cat. no. 2/81

Ovid records the classical tale of Jupiter's abduction of Europa in the second book of his *Metamorphoses*. 'Sovereignty and love do not mix well,' he ironically says when the god transforms himself into a steer to mingle with the herds of King Agenor of Phoenicia; these Mercury had driven to the very place on the seashore frequented by Europa, the king's daughter. Drawn by the beauty and gentleness of the animal, 'that strutted so grandly, with no sign of threatening attack', and urged on by her companions, Europa mounts the snow-white steer whose head she has garlanded with flowers. 'Yet slowly the god, stepping deceptively, left dry land/Gradually behind, forsook the shore for the water, and/Moving deeper and deeper, abducted his prize through the sea.'

This is a scene that invites staging with a full cast. Jordaens has assembled sixteen actresses in front whose life-sized figures reach far above the low horizon. On the left is Europe on the steer of Jupiter, to whom a garland is proffered by Mercury in the guise of an old woman; at the right are the maidens of Tyre, the companions of Europa's youth. The seaside setting does not appear, Jordaens having illustrated the events solely through the figures' poses and gestures. Nor is 'illustrated' quite the right word. The figures are very close together in shallow space, each interlocked and superimposed like strata. Their attitudes correspond. Resting on the ground, crouching and kneeling, or standing, some bent slightly forward and others at their full height, with arms outstretched – nude bodies observed in many attitudes and complex, foreshortened twists and turns fill the picture more from bottom to top than from front to back.

The palette heightens a composition already effective in itself. The lively colours of the clothes, harmonizing with flesh tones that alternate between suntan and cool paleness, give the painting an opulently festive character. Like a skilled decorator, Jordaens derives strengths from this basic design and focuses the illumination to bring out well-placed ornamental forms – blossoms with the brilliance of gems, exquisite jewellery, the straw-blonde of modishly dressed coiffures, even the shine of a wide-open eye.

Palette and design point to a date during the artist's earliest phase, which began after he finished his training with Adam van Noort in Antwerp and earned the title of Master in 1615. Jordaens's early style was shaped above all by his knowledge of Rubens. A vigorous, suggestive plasticity of form clearly indicates that his high standard was that of Rubens's sculpturally classical figures. Among his most direct adaptations is the central figure of the present painting. Jordaens's Europa, in appearance and pose, is similar to the Rubens sketch, *Silenus and Aegle* of about 1611–13 (Windsor Castle). Other links might be shown, but without prejudice to the quite unique talent of an artist who expressed Flemish tradition with an almost primitive freshness of conception. If Rubens relied on an extreme range of noble, classical and classically derived figures to achieve an ideal of sublime humanity, Jordaens remained rooted to a much greater extent in local soil. His choir of maidens has a rustic look, with something of the insouciant freshness and raciness of Flemish countrywomen. It was above all this aspect of his achievement that earned Jordaens recognition as having been 'the truest Fleming' among the Flemish artists of his times.

Peter Paul Rubens
Silenus and Aegle and other Figures
Drawing
Her Majesty Queen Elizabeth II,
Windsor Castle

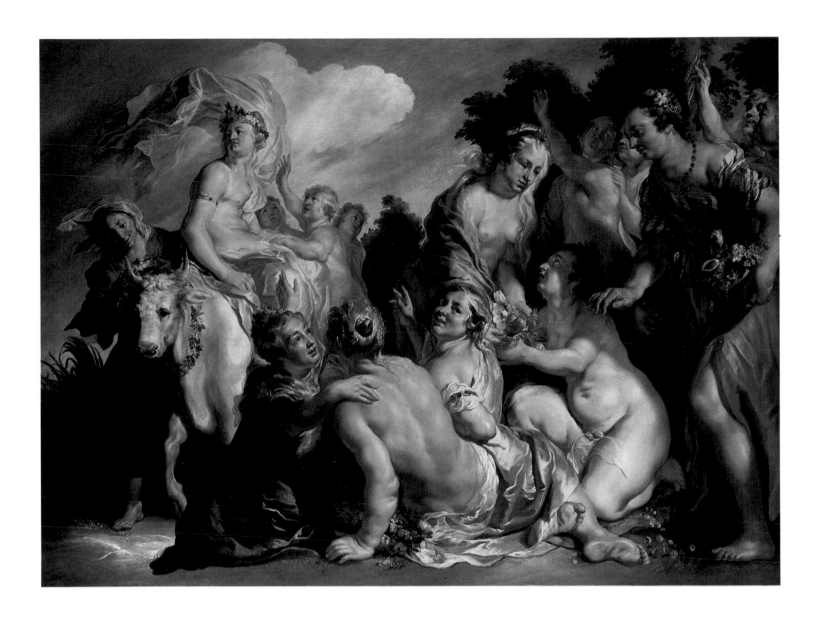

Cornelis de Vos (1585–1651)
Magdalena and Jan-Baptist de Vos
c.1622

Canvas, 78 × 92 cm (30¾ × 36¼ in)
Acquired 1837
Cat. no. 832

With a touch of just noticeable surprise at the interruption, these two children look out at the observer with great candour from large, dark, brilliant eyes, while the cherries and peach that had their undivided attention a moment ago seem forgotten. This motif of fruit held in a child's hand would appear to have significance. Ripe in form, colour, and by implication taste, the fruit suggests the freshness and sweetness of children's nature, though the comparison need not have been conscious. The vivaciously modelled faces, cheeks heightened with a touch of rose, have so much natural charm that they speak for themselves, and they speak of a close and loving relationship between the artist and his models.

These are Magdalena (baptized 19 September 1618) and Jan-Baptist (baptized 6 December 1619), the artist's two eldest children. Their features also appear in the large group portrait in the Brussels Museum, which shows the artist with his family.

Like most parents who see their own social prestige reflected if not in the behaviour then at least in the outward appearance of their offspring, Cornelis de Vos has depicted his two children for his and our sake and not for their own. Their exquisite clothes, trimmed with an abundance of fine lace, evoke the really quite honourable parental maxim that for one's own progeny, only the best is good enough; yet it also reveals some of the complacency of high position.

De Vos indeed earned a reputation and prosperity by his craft. No less an artist than Rubens later asked his co-operation on large commissions, though de Vos's rather sober approach cannot have harmonized well with Rubens's Baroque exuberance of form. Nor was he able, with his historical pictures, to make notable contributions to Flemish painting, which was superb in this genre. His gift of lucid observation found a more suitable expression in portraiture, which demands more objectivity. This quality, together with the basical conservativeness of his art, soon made de Vos the leading portrait painter of the Antwerp bourgeoisie, whose sense of self-importance he infused with a dignified gravity matched by no other artist. He allowed himself more freedom in his children's portraits, which were much admired by his contemporaries and whose vivacity and harmonious colour come closer to Rubens than any other of de Vos's works. Why he chose to portray his own two children against the background of a gloomy twilit landscape, is difficult to say. The afterglow in the sky contrasts strangely with the youthful bloom of his models. Perhaps the mood of pathos that suffuses the landscape was meant to evoke, by contrast, a father's pride and hopes in his children.

Cornelis de Vos
The Artist and his family
Brussels, Koninklijke Musea voor Schone Kunsten

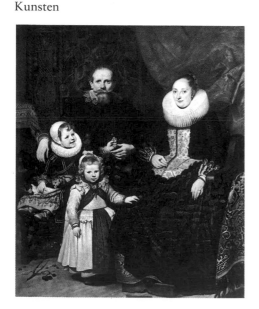

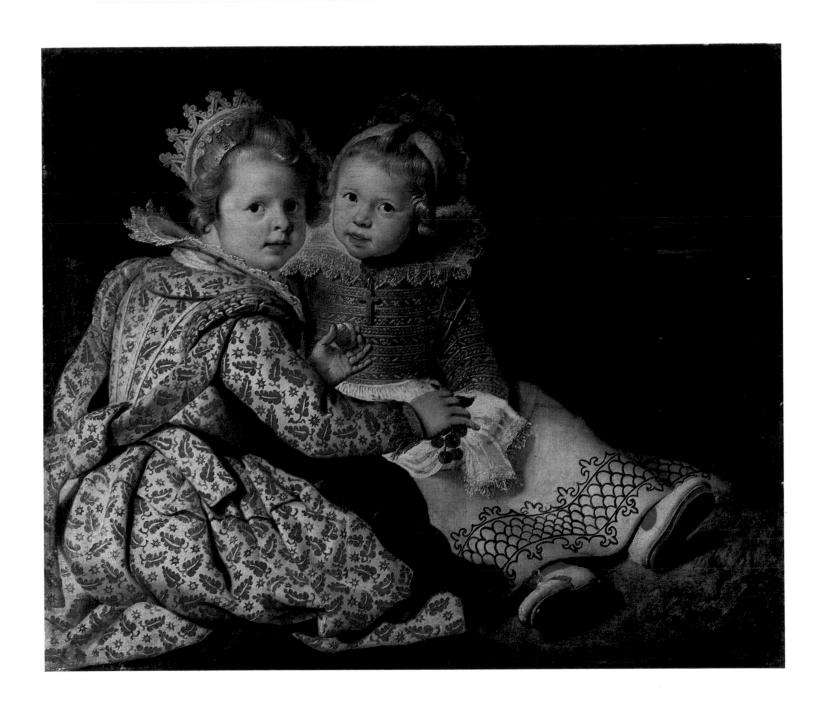

David Teniers the Younger (1610–90)
The Artist with his Family
*c.*1645–6

Oak, 38 × 58 cm (15 × 22⅞ in)
Monogrammed on the leg of the table:
'DTF'
Collection of the Duc de la Vallière;
Neues Palais, Potsdam, 1773
From the Royal Palaces, Berlin, 1830
Cat. no. 857

David Teniers the Younger
The Artist and his Family
English art trade, 1975

An ornamented stone door-frame with balustrade where a monkey perches, not unlike a heraldic animal, is behind the group of figures in the left foreground; to their right, calm water flows to the far shore with a village church among trees. These motifs are carefully poised in a composition whose balance is enhanced by an alternation of nearness and distance: a terrace with some of the good things in life, and a landscape view that gives the impression of a desirable idyll. This is a refined setting in which Teniers has pictured himself and his family. He is seated at a table playing the viola da gamba, with his wife, Anna Brueghel, and his son David, both holding songbooks. The pageboy bringing a glass of wine may be a portrait of the artist's younger brother, Abraham, and the man standing in the doorway and looking on probably also belongs to the family.

Judging by the ages of the two boys, the painting must have been executed in about 1645 or 1646. Another authentic version in an upright format (English art trade, 1975) may be associated with it. In that version, the almost identical ensemble of figures is expanded by the motif of a standing woman playing a lute in front of the table with her back turned to the spectator. As X-ray analysis has revealed, the Berlin panel originally included a similar figure, which the artist painted out, or rather, for whom he substituted the drapery spread over the balustrade, the '*Trumscheit*' leaning against the door frame, and the still life with a musical instrument and musical score on the table. Perhaps what disturbed him was the anonymity of this averted figure, which would have heightened the genre character of the group portrait still more; or perhaps the figure's assertive upright pose was felt to shift the balance of the lateral composition too far to one side.

Teniers's penchant for music, especially for playing the viola da gamba, at which he is said to have been a virtuoso, is well documented. It is not surprising that he chose to represent himself and his family performing music at home, a motif that certainly suggests the congeniality and harmony of his domestic life. Beyond that, this painting may very well contain an allusion to the theory of art. The hierarchy of the arts was still a great subject of debate during Teniers's times. While music had long enjoyed the rank of an intellectual discipline, painters still had to struggle up from the depths of mere artisans. The main point of contention was an improvement of the professional and social status of painters, who were subject to the strict rules of guilds devoted primarily to the interests of craftsmen. Grouped together with house-painters, decorators of carriages and ships, with gilders, bookbinders and embroiderers, artists had begun to feel that their interests were definitely under-represented. Teniers was Dean of the Antwerp Lucas Guild from 1644 and later, having resigned from this institution, became a founding member of the town's first art academy. So he was certainly aware of this problem, and his self-portrayal as a musician probably reflects this awareness. The assurance and poise with which he assumes the musician's role here reflect on his real profession and confirm its worth.

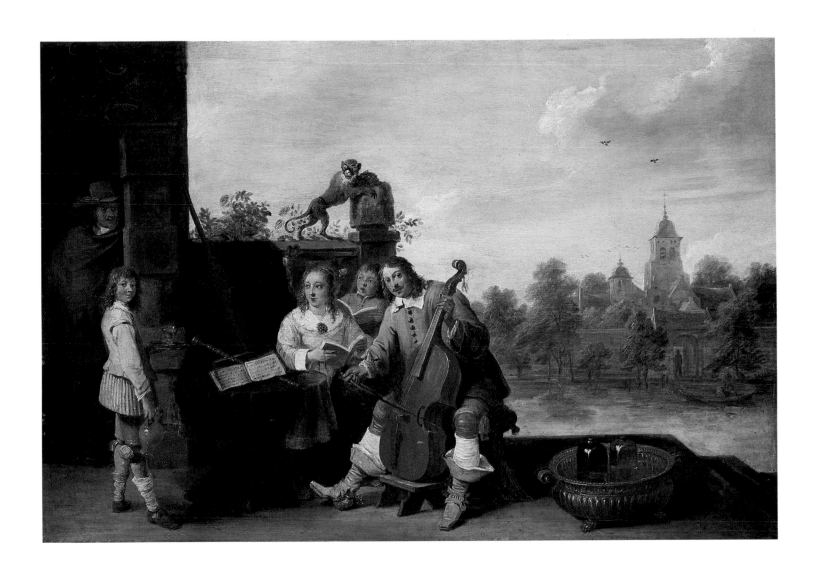

Frans Hals (1582/3–1666)
'Malle Babbe'
c.1629–30

Canvas, 75 × 64 cm (29$\frac{1}{2}$ × 25$\frac{1}{8}$ in)
Acquired with the Suermondt Collection, 1874
Cat. no. 801 C

Jan Steen
Baptizing a Child
Berlin, Gemäldegalerie SMPK

A slip with the words '*Malle Babbe van Haarlem …*' (roughly, 'Crazy Babette of Haarlem'), is attached to the back of this canvas. Though this title was a later addition, it seems to reflect the artist's intention faithfully, which was to shed light on a doubtful aspect of human behaviour rather than to create a traditional portrait.

The vivacity of the life-size half-figure comes from its abrupt counter-movement. Though the model glances aside with a raucous laugh, her upper body remains turned to the right, the line of her shoulders leading the spectator's eye back – and to the open pewter tankard in front of her. This tankard sets a vertical line, which is repeated in the owl perched on the woman's shoulder – two perpendiculars which set off and augment the oblique, opposing movements of her head and torso. Loose brushwork that only condenses in her face into descriptive modelling, and is otherwise limited to summary indications of form in slashing strokes, increases the impression of a spontaneous and seemingly random slice of life. It is no wonder that the nineteenth century admired Dutch paintings in the '*Malle Babbe*' style as prototypes of realistic art. Gustave Courbet's 1869 copy of the painting is a case in point (Hamburg, Kunsthalle). Yet as much as Hals anticipated a later approach in his virtuoso yet invariably objective rendering, the content of his works remained just as exclusively rooted in Baroque thinking, with its penchant for a didactic and moral message.

Malle Babbe's attribute, the owl, is an ancient symbol of wisdom. Yet being a nocturnal bird that avoids the light of day, it also embodies such darker aspects of human behaviour as stupidity, foolishness, and drunkenness. Which of these traits is alluded to here may be seen from the arrangement, along a diagonal from lower left to upper right, of the motifs of tankard, grimacing laugh, and immobile owl. The saying, '*zoo beschonken als een uil*' ('drunk as an owl'), which by Hals's time was in common usage, would be a fitting caption for a personification of the vice of alcohol abuse. Not without humour and empathy, Hals seems to have recommended moderation by negative example here.

The assumption that '*Malle Babbe*' has a companion-piece in '*Pickled Herring*' (the so-called *Mulatto*; Leipzig Museum), a stock type in contemporary Dutch farces, would seem unlikely on stylistic grounds. Nevertheless, just such a pair of paintings – Hals in miniature, so to speak – has been traced in the background of Jan Steen's *Baptizing a Child* (also in the Berlin Gallery). Here, *Malle Babbe Smoking* (present whereabouts unknown) and *Pickled Herring Drinking* (Kassell, Staatliche Gemäldesammlungen) are cited quite obviously for their moral significance. It is not by accident that the two pictures hang on the wall above a group of people carousing around a table, surrounded by children who eagerly imitate the adults' bad habits, already learning to enjoy the taste of wine (right) and of tobacco (left).

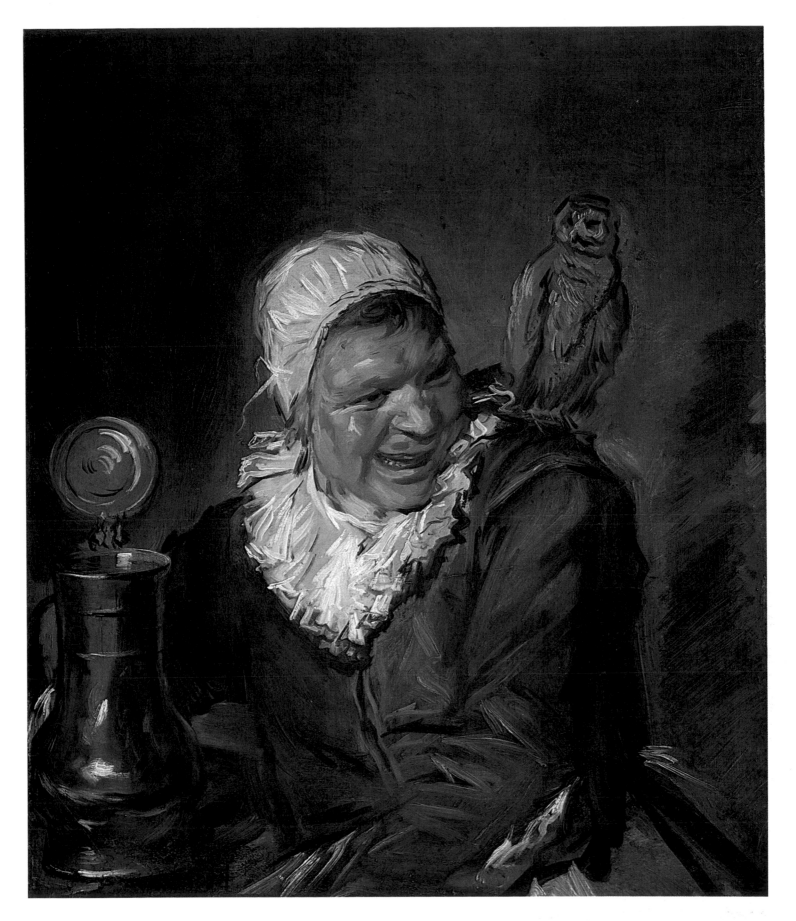

Frans Hals
Catharina Hooft with her Nurse
*c.*1619–20

Canvas, 86 × 65 cm (33⅞ × 25½ in)
Acquired with the Suermondt Collection, 1874
Cat. no. 801 G

The child dressed in Italian brocade and fine Brussels lace has been identified from recently discovered documents. Catharina Hooft, born in 1618 and the daughter of Pieter Hooft, a jurist of Amsterdam, was living with her parents in Haarlem when this portrait was done. In 1635 she married Cornelis de Graeff, later mayor of Amsterdam. In keeping with her rank as one of the country's first ladies, towards the end of the 1640s she and her husband sat for a life-size, very dignified portrait by the Amsterdam artist Nicolaes Elias (East Berlin, Bodemuseum). She never parted with the portrait Hals made of her as a child. After her death in 1691 at Ilpenstein Castle, it passed to her son; in the records of his estate, it was listed under the title, '*Een Minne met een Kindje*' ('A Nurse with a Little Child').

It is not likely that Hals thought of Catharina as a 'little child' when he portrayed her with such regal sovereignty. The contrast between her brocade gown, painted with old-masterly precision, and the plain dress of her attendant, sufficiently indicates the social difference between them. There may be the same significance in the way she extends her arm to the nursemaid's breast and the bell-rattle she holds like a sceptre.

Whether its decorous composition evokes rank or not, the decisive message of the painting is certainly conveyed by the models themselves, whose features have been captured with great penetration. A grasp of personal uniqueness and its dependence on a real environment – that was the new and fundamental discovery of Dutch portraiture, which, before Rembrandt, was largely shaped by Frans Hals. In the present portrait, too, differences in social status are mitigated by an emphasis on individual worth. The nursemaid's diffident smile reveals an awareness of her role. Like a mother, and performing a mother's office, she voluntarily subordinates herself to the little girl's self-confident gesture and follows her gaze to look towards the observer. The apple, on which they focused their attention a moment ago, is now forgotten. This effect of instantaneousness contributes a great deal to the individuality of the people portrayed. Instead of looking down at us from disdainful heights like the figures in aristocratic portraits, they face us eye to eye, on the same level, as if frankly seeking contact. In short, we feel them to be people like ourselves. And thanks to the superb illusionism of Hals's portrayal, their presence remains vital beyond the limitations of one period and the strictures of a portrait commission.

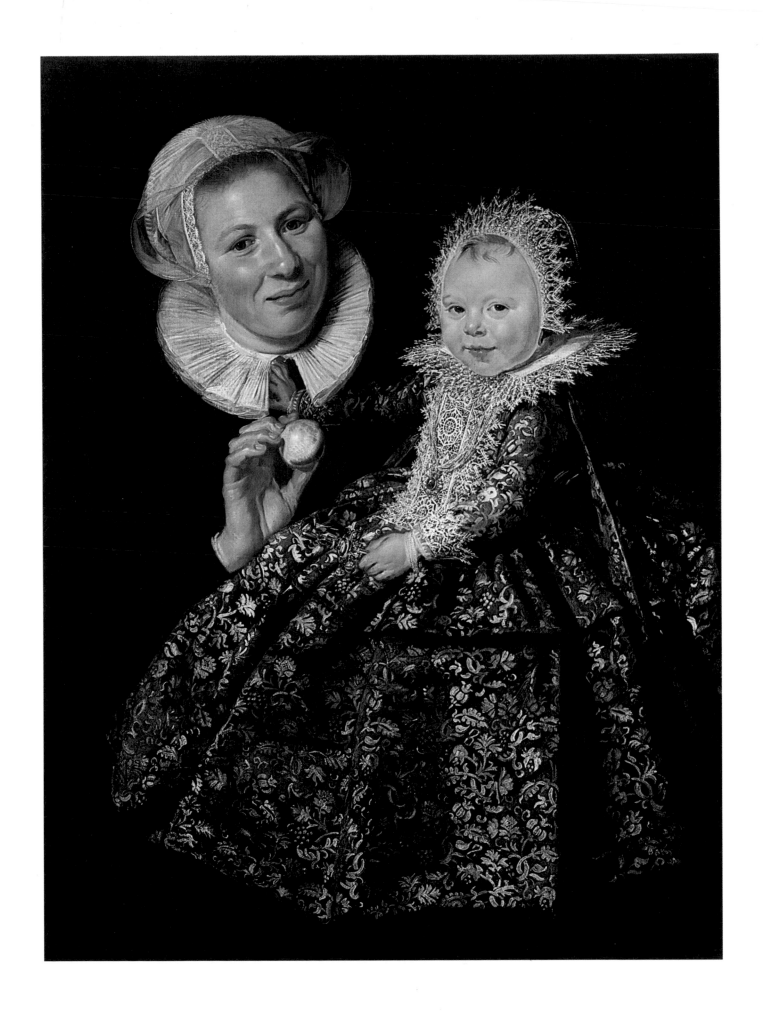

Thomas de Keyser (1596/7–1667)
Portrait of a Lady
1632

Oak, 79.1 × 52.4 cm (31⅛ × 20⅝ in)
Monogrammed top, on the door: 'TDK'
(interlocked) '1632'
Acquired 1982
Cat. no. 1/82

Thomas de Keyser
Portrait of a Gentleman
Paris, Musée du Louvre

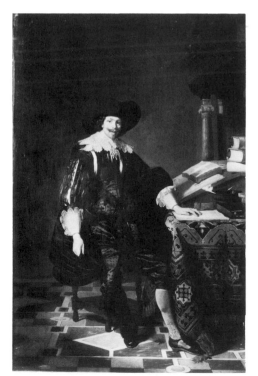

Though the subject of this portrait (whose counterpart, *Portrait of a Gentleman*, hangs in the Louvre) has not yet been identified, there can be little doubt about her social status. Her superb and festive dress, the fine Oriental carpet on the table, the patterned inlay of the floor tiles, even the mouldings of the door, in the most tasteful of Neo-Classical styles, are all unmistakable signs of her prosperity and rank. Yet she herself, of course, embodies these qualities best. Seated erect and stately, she looks out as though, just having suppressed a start of surprise at the interruption, she were quite prepared to receive us.

This delicate nuance of expression corresponds, in terms of style, with the careful brushwork and subdued, shimmering palette. The noble black of the satin dress acts as a foil to heighten the warm flesh tones, and also effectively brings out such accessories as the wide latticed collar and matching lace gauntlets, and the exquisite gold brocade trimming of the bodice, whose colour and shield-like shape are charmingly repeated and softened in the more evanescent gold of the bows on the sleeves. Rings, an abundance of pearls, golden chains, and an egret feather complete her toilette, which was obviously intended for a festive occasion. In view of the model's age, this occasion can only have been her marriage, and the gown her bridal dress. The portrait was probably made to commemorate this, which would justify its association with the Parisian *Portrait of a Gentleman*.

A decorous composition that sublimated the model's real world was characteristic of portraiture in Amsterdam. In Holland's largest and richest town, art invariably had an undercurrent of ostentation. Thomas de Keyser, being the son and pupil of Hendrick de Keyser, a highly regarded architect and master of courtly portrait sculpture, grew up surrounded by art intended for official use. And he would probably have cleaved to traditional conventions had Frans Hals, in nearby Haarlem, not confronted him with innovations. Hals's glimpses of spontaneous emotion and gesture helped him loosen the strictures of a set formula, and, thanks to other inspiration from Haarlem, he developed a predilection for the cabinet piece. De Keyser later owed his ability to employ this genre to superb effect to the courtly portrait style of Antwerp. In the figurative compositions of van Dyck he found that *grandezza* of presence in which the tension between personality and official role was resolved and synthesized. And it is just this vital combination of individual worth and social claim which de Keyser developed into the main expressive trait in his *Portrait of a Lady*.

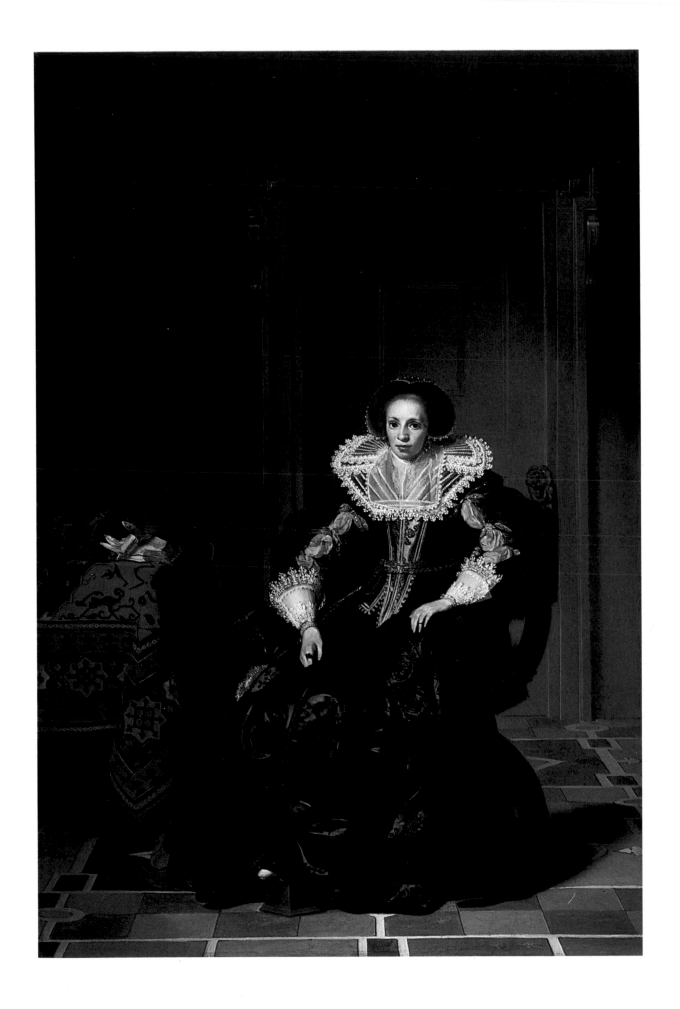

Rembrandt (1606–69)
Self-portrait with Velvet Barett
1634

Oak, 58.3 × 47.5 cm (23 × 18¾ in)
Signed lower right: 'Rembrandt f. 1634'
In the Picture Gallery, Sanssouci, 1764
From the Royal Palaces, Berlin, 1830
Cat. no. 810

Unlike any other artist before him, Rembrandt applied himself to the study of his own face, and in painting, drawing and engraving created an autobiographical record that extended from his early youth to the final years of his life.

A deep fissure in his life and his artistic development, seen particularly in his self-portraits, came with Rembrandt's move from Leyden to cosmopolitan Amsterdam in 1631. He decided on this change mostly because he expected profitable portrait commissions. Though he always considered himself as primarily a history painter, it was above all the many commissioned portraits he painted during his early years in Amsterdam that laid the basis for his financial and social advancement. Professional success was followed by private happiness when in 1634 he married Saskia van Uylenburgh, daughter of a prosperous lawyer of Friesland.

This painting, which dates from the year of Rembrandt's marriage, is a life-sized bust that shows the artist looking out at the spectator with an abrupt turn of his head. While one shoulder is met at about chin height by the left edge of the painting, the other dips diagonally in a gentle curve to the lower right corner. The asymmetry of these outlines heightens the aggressive effect of the way he turns his deeply shadowed, narrowed and penetrating eyes on his spectator, as though the artist intended to meet the exacting demands of an environment he himself has invested with profundity and pathos. The way his face is divided vertically by a sharp contrast of light and shade reveals a desire to idealize the naturally rather heavy and irregular features. Unlike the self-portraits of his early Leyden period, in which Rembrandt depicted himself without social reference, as if in spiritual and spatial isolation, he represents himself here as a successful artist whose gentlemanly elegance attests to his frank enjoyment of prosperity and social recognition.

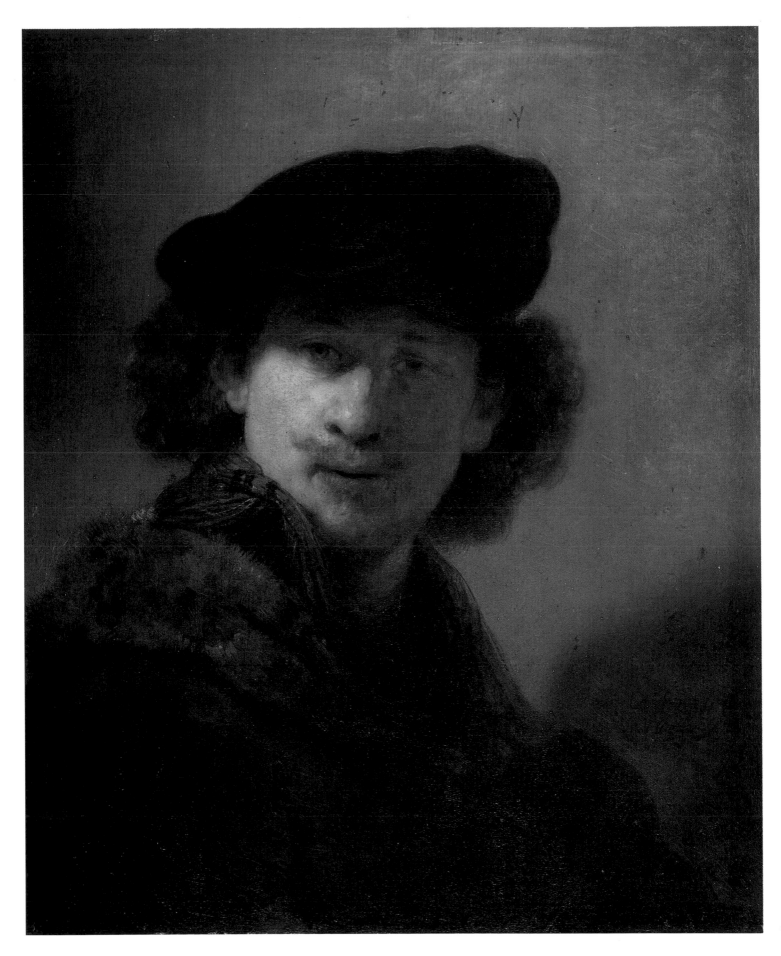

221

Rembrandt
The Mennonite Preacher Anslo and his Wife
1641

Canvas, 176 × 210 cm (69¼ × 82⅝ in; upper corners rounded)
Signed lower left: 'Rembrandt f. 1641'
Collections of Cornelis van der Vliet, Amsterdam, 1767; Sir Thomas Dundas, London, 1794; Lord Ashburnham, London, 1894
Acquired 1894
Cat. no. 828 L

Cornelis Claesz Anslo (1592–1646) was both a prosperous entrepreneur and one of the leading Dutch Mennonite ministers, pastor of the Waterland parish in Amsterdam. Though Rembrandt's choice of a huge format with life-size figures suggests a prosperous businessman's commission, his portrait is devoted solely to Anslo's personality and religious calling. Looking up from the Bible that lies open on his work-table, the clergyman turns to speak to his wife, Aeltje Gerrittse Schouten (1589–1657). He lends weight to his words by a gesture of his left hand, which marks the centre of the composition and whose suddenness is so vividly rendered that the hand seems to emerge bodily from the picture plane. His wife's humble attention would seem to indicate that the pastor seeks a dialogue by 'brotherly admonition': the central importance of this in Mennonite doctrine was based on Matthew 18: 15–20. That Anslo indeed fulfilled his minister's office with 'churchly rigour' at home as well as among his flock, is shown by the notes which Cornelis van Vliet, a descendant of Anslo, transcribed in 1767.

Rembrandt had depicted Anslo once before, alone, in an etching also dated 1641. This slightly earlier work prompted Joost van den Vondel, the most famous Dutch poet of the seventeenth century, to compose a quatrain that roughly translates, 'Oh, Rembrandt, paint Cornelis's voice/ The visible is his least important aspect/ The invisible is perceptible only through the ear/ Whoever would see Anslo must hear him.' Expressed here is above all the widespread Protestant belief that in communicating the Christian faith, the word definitely took precedence over the image. Though the seventeenth century found the Mennonites more liberal and less opposed to the painted image than at the close of the sixteenth century, the theological dispute over word and image, hearing and seeing, spirit and body, was still very much alive. A case in point is Rembrandt's portrait etching itself, in which the motif of a picture turned against the wall, standing on the floor next to Anslo, beneath its empty nail, quite unambiguously decides the primacy of word over image.

But Vondel's verses might be construed with equal justification as a criticism of Rembrandt, or rather, of the capacity of visual art in general to convey sounds, including the utterances of a great preacher. Now if this were true, then the artist might have taken the quatrain as a challenge to show what he could do, replying to it in an extremely convincing way with this painting. By expanding a portrait to a double portrait, Rembrandt provided an audience for the minister's words and gave direction to his gesture. The meaning and effect of his words become clear in the attentive and empathetic attitude of his wife. The true subject of the image, then, is the spoken word, which is both embodied in the juxtaposition of two figures and unites them in a visually dramatic dialogue.

Rembrandt
The Mennonite Preacher Anslo, 1641
Etching

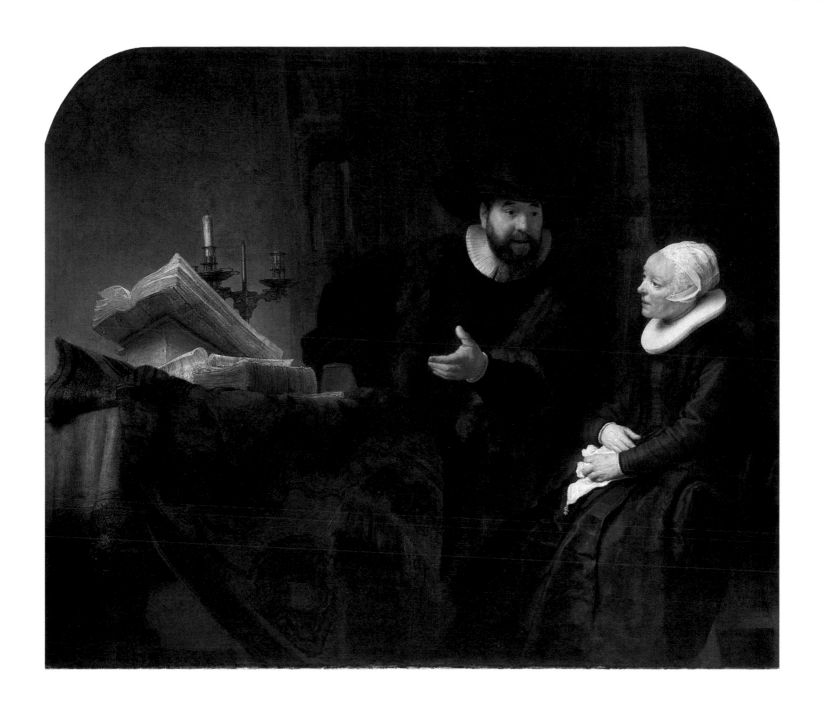

Rembrandt
Susanna and the Two Elders
1647

Mahogany, 76.6 × 92.7 cm
Signed lower right: 'Rembrandt f. 1647'
Collections of E. Burk, London, 1769;
Sir Ed. Lechmere in the Rydd
Acquired 1883
Cat. no. 828 E

Seeing Susanna, lovely wife of the rich Joachim of Babylon, two elders grow 'foolish and set their eyes so fixedly on her that they could not gaze heavenwards nor think either of God's word or of punishment'. As they know she bathes in her garden at about noon, they wait for her there. 'No one can see us, and we are inflamed with love for you; so grant us our will. If you refuse, we shall testify that we discovered you alone with a young man.' But Susanna fearfully replies, 'If I should do such a thing, it would mean my death; but if I do not, I will never escape your grasp. But I would rather fall innocent into the grasp of men than sin against the Lord.' Susanna is brought to trial, the two elders give false evidence against her, and she is condemned to death. As she is being led to her execution, young Daniel recognizes her innocence in a vision and exposes the elders, who are put to death in her place.

With its erotic overtones and a moral exemplifying marital virtue bolstered by Christian faith, the story of Susanna surprised in her bath became one of the most popular subjects of Baroque painting. Rembrandt chose to represent its dramatic climax. Susanna has left her clothes on a parapet and is just walking down the curved stone steps into the water when one of the elders comes up behind her and grasps the remaining cloth around her hips. Bent forward in fright, she turns her face to the viewer as if appealing for help. The other intruder, propped on a cane, passes through the garden gate without taking his eyes off Susanna's nakedness for a moment.

The composition is based on an initial version executed in the mid-1630s, which the artist reworked into the present version of 1647. This finding is confirmed by X-ray analysis, as well as by a number of drawings by Rembrandt and his studio which relate to the first and final versions. The alterations made in the original composition, involving a deletion or at least dampening of over-violent movements, faithfully reflect the artist's stylistic development during the 1640s. After the great Baroque compositions that characterized his work of the previous decade and culminated in *The Night Watch* of 1642 (Amsterdam, Rijksmuseum), a serenity of expression, and simplicity and lucidity of design, now predominated. In the final version of *Susanna*, the picture is divided into two contrasting halves: the left recedes through twilit 'empty' space to the shadowy architecture of a castle in the background, while the right, with its overgrown, arching cliff emerging in the foreground, is reserved for the closely grouped figures and the narrative itself. The illumination reaches its highest intensity here on Susanna's body and the exquisite red of her clothes, beside which she has demurely placed her shoes. A sensitively toned atmospheric chiaroscuro unites these two very different parts of the composition into a single, shimmering, light-suffused whole.

The two versions developed in this painting, and another *Susanna* of 1634 (The Hague, Mauritshuis), go back to a work of 1614 by Rembrandt's teacher, Pieter Lastman (also in the Berlin Gallery). In about 1633, Rembrandt made a drawing after this composition, which he must have admired, already re-forming it in terms of the paintings named above (Berlin, Kupferstichkabinett SMPK).

Pieter Lastman
Susanna and the Two Elders, 1614
Berlin, Gemäldegalerie SMPK

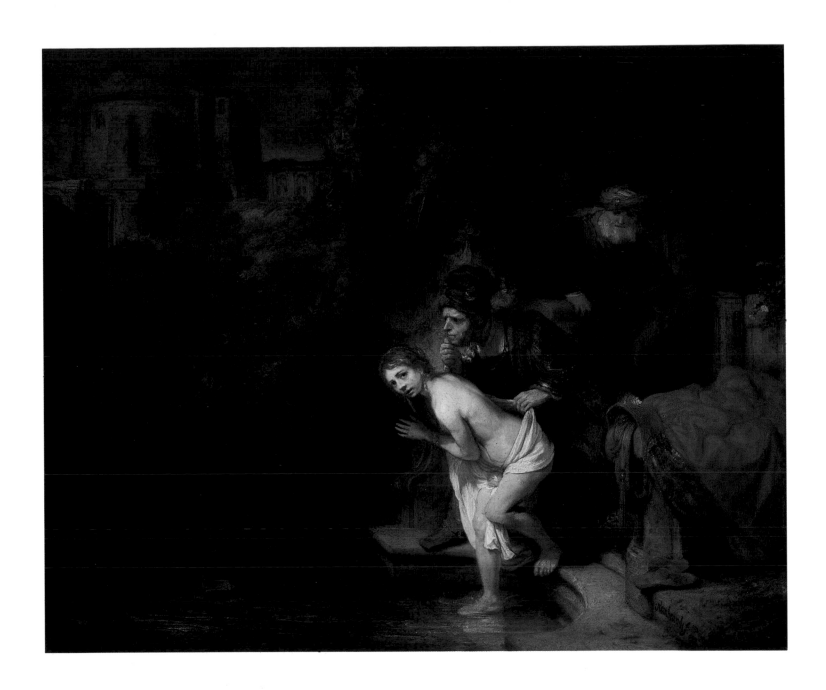

Rembrandt
Portrait of Hendrickje Stoffels
*c.*1659

Canvas, 88.5 × 67 cm (34⅞ × 26⅜ in)
Acquired 1879
Cat. no. 828 B

Hendrickje Stoffelsdr. Jaeger (*c.*1625/7–63) began to keep house for Rembrandt in about 1649. Their relationship was a marriage in all but name. When Hendrickje became pregnant in 1654, she was called before the church council, required to do penitence, and excluded from Holy Communion. Rembrandt was in no position to legalize the bond because if he remarried, he would have been obliged by his first wife's will to repay half of her inheritance to her family; and the money had been spent long before. By the close of the 1640s his financial position was so dire that he could not have raised a sum of this size. He had debts on the great house he had arranged to buy in 1639 by instalments; a passion for collecting continually led him to buy objects of art and exotic curiosities at high prices, bringing him to bankruptcy in 1656 and, over the next two years, to the compulsory sale of his house and collection. To protect his income from creditors, he began in 1660 to work *pro forma* as an employee of an art dealing firm founded by Hendrickje and his son Titus. What little we know about this period indicates that Hendrickje stood by Rembrandt faithfully through all his difficulties. It is not surprising that their neighbours considered her his wife.

Rembrandt's portrait here, a life-size half-figure, shows Hendrickje turned slightly to the left, leaning against the upper frame of a Dutch door. As if by an unconscious movement of her shoulders, the key or ring on the cord around her neck has slightly shifted. Rembrandt apparently attached just as much significance to this simple adornment as to the fine pearl bracelet, for whether it is a ring or key, both symbolized marital or housewifely virtue. Though Hendrickje looks directly out of the picture, she seems to take little notice of the spectator. Rather, her casual pose and devoted attention suggest the presence of Rembrandt, whom she watches at work. The relationship between artist and model here becomes extremely intimate, so much so that we almost seem to be intruding.

The loose, free paint handling corresponds with the model's relaxed attitude. The glowing reds of her dress and the white of her chemise, laid on in broad swaths of impasto, emerge boldly from depths of shadow. Only her face and throat are rendered in compact strokes and modelled in full sculptural relief, which is heightened by the luminosity of their colours in a mild reflected light. Rembrandt derived two key elements of his late style from his penchant for Venetian painting – chiaroscuro as a means to unified design, and increasingly, design through colour. His involvement with Venice shows again here. The configuration of the motifs suggesting movement – torso turned, head slightly inclined, one arm across the breast and the other raised – are found in essence in a half-figure *Portrait of a Young Woman* by Palma Vecchio.

Palma Vecchio
Portrait of a Young Woman
Berlin, Gemäldegalerie SMPK

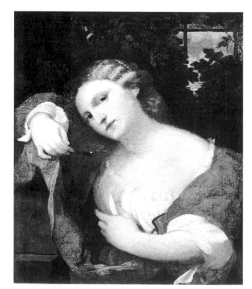

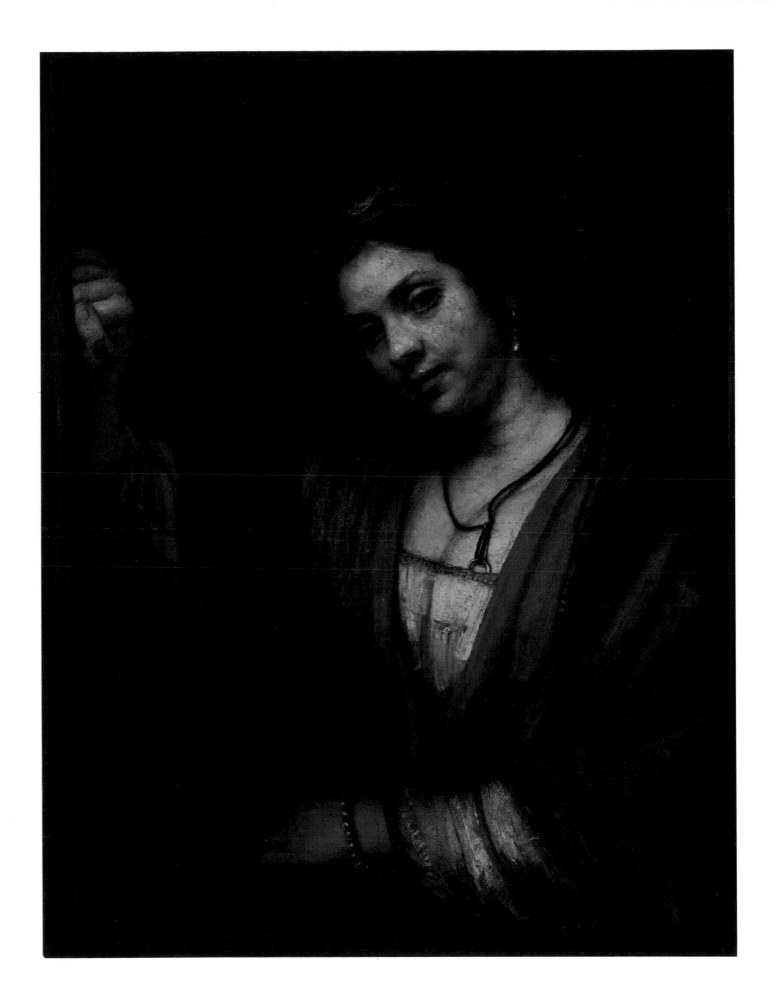

Rembrandt
Moses Breaking the Tablets of the Law
1659

Canvas, 168.5 × 136.5 cm (66⅜ × 53¾ in)
Signed lower right: 'Rembrandt f. 1659'
In the Picture Gallery, Sanssouci, 1764
From the Royal Palaces, Berlin, 1830
Cat. no. 811

When Moses descended from Mount Sinai to bring the Israelites the tablets of the Law he had received from the Lord, he found his people dancing around the golden calf. 'And it came to pass, as soon as he came nigh unto the camp, that he saw the calf, and the dancing; and Moses' anger waxed hot, and he cast the tables out of his hands, and brake them beneath the mount' (Exodus 32: 19). In Rembrandt's image the figure of Moses, three-quarter length and life-size, dominates the plane. Above his head he holds the two tablets of the Law, the front one inscribed with the last five of the Ten Commandments in Hebrew: he is about to throw and break both tablets. Framed at the centre of the composition by his upraised arms and the dark tablets, Moses' head seems to glow with divine light. This alludes to a later event in the Bible story, where Moses shows his people the new tablets he had hewn from rock at God's behest. 'And it came to pass, when Moses came down from Mount Sinai with the two tables of testimony in Moses' hand ... that Moses wist not that the skin of his face shone while he talked with him. ... And afterward all the children of Israel came nigh; and he gave them in commandment all that the Lord had spoken with him in mount Sinai' (Exodus 34: 29, 32).

In combining the two events into a single, simultaneous breaking of the old tablets and the presentation of the new, Rembrandt followed pictorial tradition. Francesco Parmigianino, in his fresco for the Madonna della Steccata church in Parma, had established a composition of the same subject with a formally related figure, and Rembrandt may have known this from an engraved reproduction made by D. Fontana in 1644.

It has been assumed that the painting was originally much larger in size, having been conceived to hang over the fireplace in the jury room of the Amsterdam Town Hall, and that the artist reduced its dimensions after his patrons had rejected it. Though this cannot be confirmed, there is no doubt that the looming figure of Moses, rendered from an extremely low vantage point, was meant to be viewed from a distance, and that therefore the painting must have been intended for a room of considerable size. In any event, here as in another late work in the Berlin Gallery, *Jacob Wrestling with the Angel*, Rembrandt approaches the planarity and emphasis on contour of the main style of his period, Neo-Classicism. The elemental force of his message and conception, however, are undiminished.

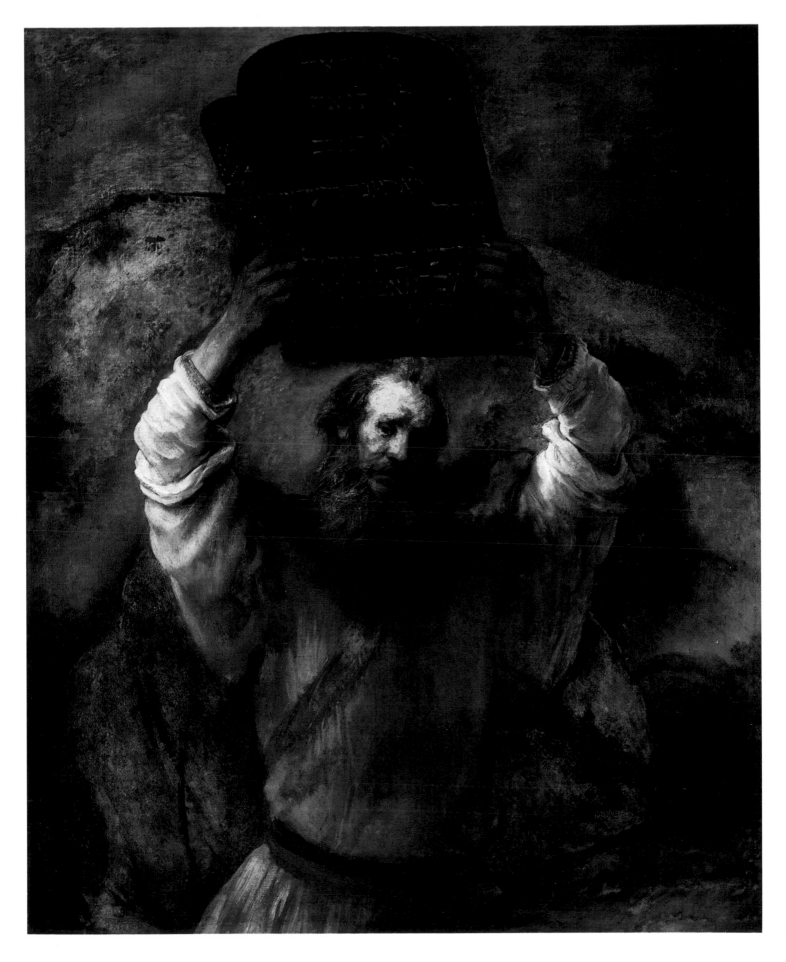

Gerard Dou (1613–75)
The Young Mother
c.1660

Oak, top rounded, 49.1 × 36.5 cm
(19⅜ × 14⅜ in)
Collections of the Duc de Choiseul, Paris,
1787; the Duc de Praslin, Paris, 1793;
Mr de la Hante, London, 1814; the Earl of
Grosvenor, London, c.1829; the Duke of
Westminster, London
Acquired 1974
Property of the
Kaiser-Friedrich-Museums-Verein
KFMV 269

A young mother preparing to nurse her baby is interrupted by a little girl who comes from behind and distracts the baby with the merry sound of a bell-rattle. This delightful scene is set in an elegantly furnished bourgeois interior with an adjacent room visible in the left background.

The painting is one of the finest examples of Gerard Dou's mature style. Using colours applied so smoothly as to leave almost no visible trace of a brushstroke, Dou brought the form and the feel of each object and material to perfection – not by delineating them with graphic precision but by immersing them in atmospheric tones of light and shade. The brass of the chandelier, whose ornamental shape literally crowns the scene, reflects the light in a warmer shimmer than the cool silver of the candlestick. The mother's velvet house-jacket seems palpably different in texture from the rough weave of the tapestry draped in Baroque curves in the foreground. As Joachim van Sandrart reported, the artist worked '*mit Hülf der Augengläser*' (with the aid of a magnifying glass), which might well explain the unmatched precision in the rendering of the grain of the floorboards or the wickerwork of the cradle.

The point of departure for Dou's subtle technique and chiaroscuro was the early work of his teacher, Rembrandt. Yet what was for Rembrandt only a transition to a sweeping, painterly style, became the guiding principle of his student's œuvre. With tenacious independence Dou developed the style to perfection, and his efforts were widely admired and imitated. They brought him recognition as the founder and most significant representative of the Leyden school of 'fine painting'.

So much exactitude astonished his contemporaries. Mayor Orlers of Leyden, for example, wrote that 'No one who saw him work could help marvelling at his care and remarkable execution.' Among the exquisite gifts that official Holland sent to Charles II of England in 1660, were pictures by Dou, including his *Young Mother* of 1658 (The Hague, Mauritshuis) and presumably also the Berlin panel. The general high regard in which Dou was held far surpassed Rembrandt's reputation. And this remained unchanged during the subsequent, classicizing period. Not until the second half of the nineteenth century, with the spontaneous, painterly approach of Realism and Impressionism, did a reaction against Dou's 'smooth manner' set in. In 1901, his renowned *Woman with Dropsy* of 1663 was removed from the Salon Carré, the gallery of honour in the Louvre – an outward sign that Dou had been demoted from the ranks of masters of the first order. But he remained a major representative of Dutch genre painting.

During the period to which this painting belongs, Dou's technical finesse could compare to that of Gerard ter Borch or Jan Vermeer, though he was not able to achieve their concentration of design or emotional force. He remained in the first instance an artist of surfaces, in the positive sense of the term. In the Berlin panel, the rich interrelations of form, colour, light and atmosphere are treated with the devoted care of a still-life painter, celebrated with precision, if you like. Thus the normal intimacy of mother and child is raised to a special realm revealed to the spectator's eye by the swept-up curtain – a common device in Dou's work.

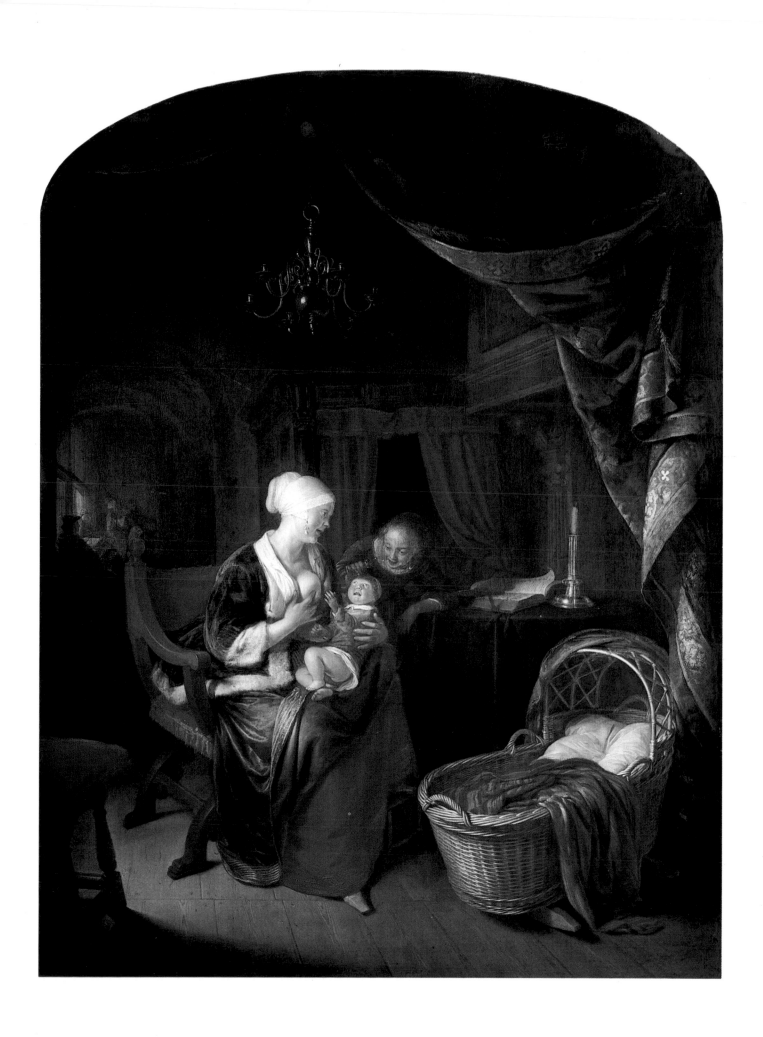

Gerard ter Borch (1617–81)
'The Parental Admonition'
c.1654–5

Canvas, 70 × 60 cm (27½ × 23⅝ in)
Acquired 1815
Cat. no. 791

An engraving of this painting, made in 1765 by J.G. Wille, has the caption, 'Instruction Paternelle'. It was under this title, accepted by no less a connoisseur than Goethe, that the painting became famous. Yet it does not appear to represent a domestic scene after all, judging by the youthfulness of the persons depicted, and also by the somewhat blasé attitude of the supposed father, whose uniform shows he is a military man. And this gentleman's true intention is by no means moral, as may be seen from the coin in his raised right hand.

The subject here is love for sale, and the room where the transaction takes place, with its curtained four-poster bed and dressing table, is well furnished for the purpose. If the gentleman, who believes that *'Auro conciliator Amor'* (money smooths the path of love), is making his offer for the lady Goethe called that 'glorious figure in the richly draped white satin gown', then the woman beside him has probably arranged the match. Nor can the decorous way in which she raises the wine glass to her lips clear her of this dubious role.

Ter Borch treated the theme of prostitution several times – shortly before 1650, in *Gallant Proposal* (Moscow, Pushkin Museum), and in about 1662–3, in *Young Couple Drinking Wine* (Berlin, Gemäldegalerie SMPK). In both works the amorous encounter is reduced to its main protagonists, who appear as three-quarter length figures facing one another in front of a neutral background. The masters of the Utrecht School devoted themselves much earlier to this type of genre scene, though in large-format compositions with vigorous chiaroscuro in the style of Caravaggio. Ter Borch's approach is much more reserved by comparison. Serenity and emotional moderation are the predominant traits of his art, and he refined them throughout his career. The works just mentioned illustrate this development, and particularly *The Parental Admonition*, which belongs among the finest accomplishments of his mature style.

A clue to the dating of the painting to the period shortly before 1655 is provided by a copy from the hand of Casper Netscher, a pupil of ter Borch, which is dated 1655 (Gotha Museum). No less than twenty-four repetitions, partial copies, and replicas of the Berlin painting exist, which shows how much it set an example. The slightly earlier version in the Amsterdam Rijksmuseum gives the scene in a broader format. There, the pictorial field is extended to the right, and the motif of a dog is included – a rather mongrelly looking one who slinks with his tail between his legs behind the gentleman's chair. Perhaps the animal was meant to allude to his master's unrestrained instincts. That the gentleman seriously intends a proposal of marriage, as has recently been suggested, would seem unlikely because of the 'negative motif' of the dog, if for nothing else. And though ter Borch omitted the dog from the Berlin version, it was surely not to show the scene in a more positive light but to increase the noble effect of the Amsterdam composition by freeing it of disturbingly obvious references. His choice of a narrower format eliminated the dog in any case, and more importantly, brought a narrowing down of the field of vision that gives the group of figures greater formal cohesion and heightens the compositional value of the standing woman. This figure, seen from behind, her head slightly bowed, leaves the spectator very much in suspense about her decision. But in all ter Borch's genre scenes, the story's end remains a tantalizing, open question.

Gerard ter Borch
'The Parental Admonition'
Amsterdam, Rijksmuseum

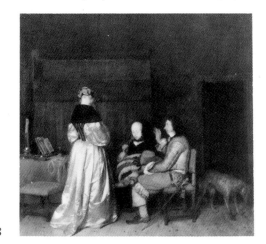

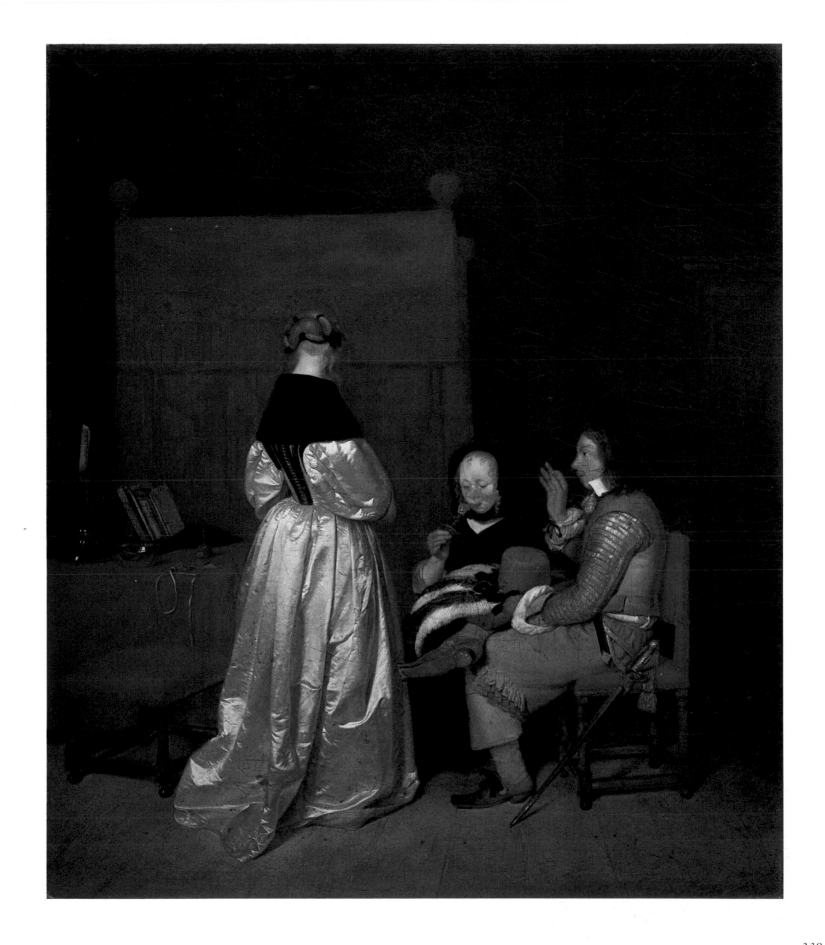

Pieter de Hooch (1629–84)
The Mother
c.1661–3

Canvas, 92 × 100 cm (36¼ × 39⅜ in)
Acquired 1876
Cat. no. 820 B

Smiling down into the wicker cradle beside her, a woman laces her bodice. The intimate scene, which speaks of a mother's care for her child, is set in a comfortably furnished middle-class interior. An alcove bed with striped curtains is in the background and there are Delft tiles on the rear wall. Through the living-room door at the right, a little girl stands in the front entrance, the door open to the bright sunshine. A simple contrast between the dim room in the foreground and the light-filled foyer behind gives a compelling effect of spaciousness to the interior, which is divided into two almost equal halves that cover two planes parallel to the picture surface but at different depths. The architecture of interiors was indeed the point of departure for all de Hooch's paintings of domestic life. As early as 1658 he conceived spaces that had a referential quality previously unknown. Constructed by exact perspective, amply dimensioned and comfortably furnished, his rooms took on autonomous pictorial value, that is, their effect no longer depended exclusively on the figures that inhabit them. No less an artist than Jan Vermeer, a colleague of de Hooch's in Delft and three years younger, was inspired by de Hooch's 'architectural' gift. But Vermeer also narrowed the focus of his compositions and brought the human figure more strongly into play and, thanks to his ability to design in colour and light, created images that far transcend mere objectivity. Not that de Hooch's means were limited to the description of objective appearances. Cases in point here are the delicately shimmering highlights on the brass warming pan and candlestick, or the intense red of the cradle blanket, bodice and skirt – colour stresses that lead the eye in premeditated steps over the mirror-smooth floor tiles and towards the sunny entrance. This harmony of colour and light evokes an intimate atmosphere which not only suits the scene represented but seems to raise it to a more sublime world.

Mothers themselves did not necessarily nurse their infants in early seventeenth-century Holland; those in better circumstances, at least, usually employed a nursemaid. And accordingly, voices were raised to remind mothers of their natural duty. In 1625, the poet Jacob Cats moralized, '*Een die haer Kinders baert, is moeder voor een deel,/Maar die haer Kinders sooght, is moeder in 't geheel*' ('A woman who bears children is mother only in part, but one who nurses them herself is a complete mother'). And Johan van Beverwijk, a doctor, wrote in 1651 that the mother who breastfeeds her baby not only gives it nutrition but instils moral and intellectual capacities as well. With this as background, de Hooch's contemporaries must have attached a special significance to his painting, for what he depicted was the positive example of a mother who has nursed her baby and remains seated beside the cradle with affectionate care. In addition to maternal virtues, he also alludes to those of a housewife who in the place of activity which society has allotted her, the home, ensures that everything is spotlessly clean and orderly.

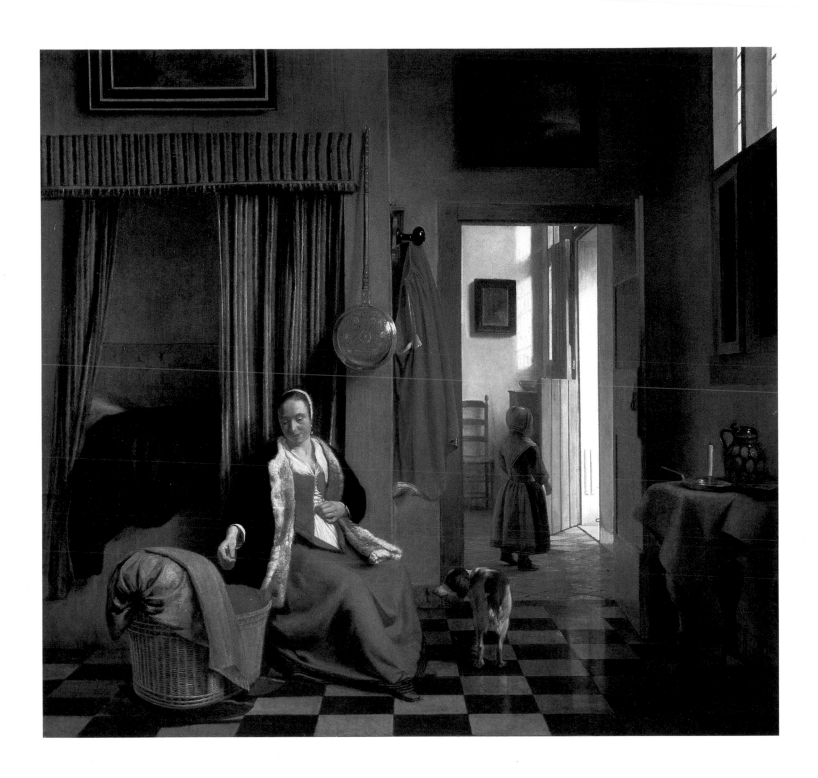

Jan Vermeer van Delft (1632–75)
The Glass of Wine
*c.*1660–1

Canvas, 66.3 × 76.5 cm (26⅛ × 30⅛ in)
Acquired 1901
Cat. no. 912 c

From the two windows at the left – particularly the nearest one – cool daylight illuminates a young woman seated at a table drinking wine, and an elegantly dressed gentleman standing beside her. She holds the emptied glass up to her face as if to avoid his expectant eyes, for though he has no glass himself he is ready to refill hers from the jug in his hand. There seem to be amorous possibilities although the scene has nothing indelicate or blatantly erotic about it. The zither may also be significant. This instrument was a common symbol of harmony, but it also conveyed dissolute living.

The contained serenity in the attitudes of the two figures is matched in the structural clarity of the interior. A corner of the room is represented, in simple one-point perspective, a right-angled projection. The lines of the bench and table recede to the same vanishing point as the wall, as does, in more complex perspective, the diamond pattern of the floor tiles. A right angle is retained even with the figures: her profile with his frontal view. Only in the cavalier's glance and the placing of the chair with the instrument are divergent directional references given, likely to underscore the significance of these motifs. This is also true of the window, which is slightly ajar and has a coat of arms with a female figure holding intertwined ribands. A corresponding figure is among the emblems published by G. Rollenhagen in 1613. The ribands, it turns out, represent a harness, an attribute of temperance. '*Serva modum*' (preserve moderation) is this emblem's motto.

Previously, Vermeer rendered the domestic interior with an extremely narrow focus, giving a close-up view of the human figure and its immediate surroundings. Now, for the first time, he abandons this close view, allowing the observer to step back, gain distance on the scene, and widen his field of vision. The interior is no longer perceived as an auxiliary to the figure, but vice versa – the figures seem part of, as they are framed by, the expanded interior view.

Innovations of this kind point to the influence of Pieter de Hooch's first masterworks. De Hooch also worked in Delft and was three years older than Vermeer. His interiors of about 1658 were primarily conceived and designed in terms of the architecture of interior space. This in itself represented a great contribution to the development of art, for de Hooch was among the first Dutch genre painters to give his figures a 'natural environment'. Nor does it detract from his accomplishment that Vermeer, a talent of the very first rank, was immediately able to improve upon the de Hooch interior. This is particularly clear in the Berlin painting, whose precisely calculated construction is as impressive as an illusionistic technique that extends to different surface textures without ever succumbing to mere objective description. In the light-suffused atmosphere everything takes on a quality that transcends the real. The girl's silk dress shimmers with the cool and noble tones of fresh roses. Now, this admittedly makes it rather difficult to see an allusion in this figure to the dangers of intemperance. Aesthetic factors nevertheless do not preclude the artist's interest in content. The gloomy landscape on the wall, visually associated with the man, and the restless way in which the light plays over the figures, set tones of suspense that contrast with the cultivated order of the interior and suggest a corresponding emotional disquiet in the two people who meet there.

Emblem from *Selectorum Emblematum*
G. Rollenhagen (ed.)
Arnheim, 1617

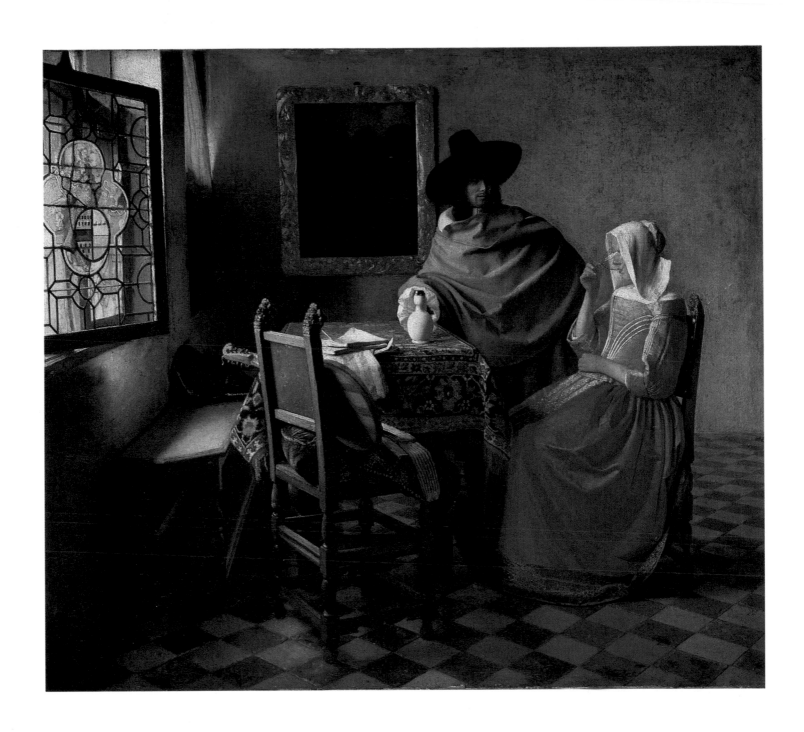

Jan Vermeer van Delft
Young Lady with a Pearl Necklace
*c.*1660–5

Canvas, 55 × 45 cm (21⅝ × 17¾ in)
Signed on the tabletop: Meer
Acquired with the Suermondt Collection,
1874
Cat. no. 912 B

In cool light filtering through a leaded window, a young woman stands at a table looking into a mirror on the wall opposite her to see how the string of pearls with its pale yellow ribbon suits her. Her tranquil pose and expression are in keeping with the careful way the things on the table are arranged, as if for a still life; among them are aids to beauty and vanity such as a powder puff, a comb and a jewellery box. The motif of a woman before a mirror can be traced in Netherlandish painting as far back as Hieronymus Bosch, and it was popularized in Holland shortly after 1650 by Gerard ter Borch. It was an allegory of pride and vanity, and, interpreted morally, an allusion to the emptiness and transience of all worldly concerns. A mirror flatters the lovely woman who looks into it; yet what she sees is an illusion, for just as no one can capture an image in a mirror, every human being's time on earth is momentary compared to the eternity of God.

Most of Vermeer's interiors – in contrast, say, to *The Glass of Wine* in Berlin – were conceived as narrowly framed close-ups of the human figure and the immediate surroundings. This idea may have been derived from comparable pictorial solutions by ter Borch or Frans van Mieris the Elder, yet it was Vermeer who concentrated its effect to the highest degree in formal composition and emotional message. Here, in keeping with the mood of calm evoked by the figure's pose, the image structure is predominantly horizontal and vertical. With the exception of the chair that, foreshortened, occupies the lower right corner and intervenes between the figure and spectator, the surrounding space is defined by motifs arranged at right angles to one another and in layers from the front to the back. And since the pale back wall of the room appears to come forward, the multicoloured foreground scene seems to occupy a very shallow space. If in Rembrandt's paintings the background invariably dissolves in shadow and the brightest light collects around the figures, with Vermeer the figures stand out in accentuated colour against light grounds. This is a reversal of the light-dark relation. In terms of colour scheme, too, Vermeer introduced significant innovations. While in Rembrandt's imagery the areas of deep shadow are sometimes completely colourless, even the darkest passages in Vermeer's paintings still have colour – such as the ultramarine of the Delft faience vase here, and the soft blue in the table drapery. The greatest intensity of colour is seen in half-light. While the yellow of the curtain pales because of its proximity to the source of light, that in the girl's fur-trimmed satin jacket shines with great brilliancy. These two passages of yellow are also a kind of frame within the frame for the back wall, which is painted with superbly delicate modulations of colour. Who but Vermeer would have dared to put this 'empty' plane in the centre of an image? Of course the wall motif has more than a strictly objective meaning; it also works as a force field across which the girl communes with her own image in the mirror.

Vermeer's optical discoveries were long overlooked. It was not until the nineteenth century that Realists and Impressionists achieved similar results from close observation of light. All the qualities of Vermeer's design in light and colour seem united in his *View of Delft* (The Hague, Mauritshuis), the painting that led to a Vermeer revival when the French politician and journalist Bürger-Thoré saw it in 1842 and described its genius. The collection of this sensitive connoisseur and friend of Corot also once contained *Young Lady with a Pearl Necklace*.

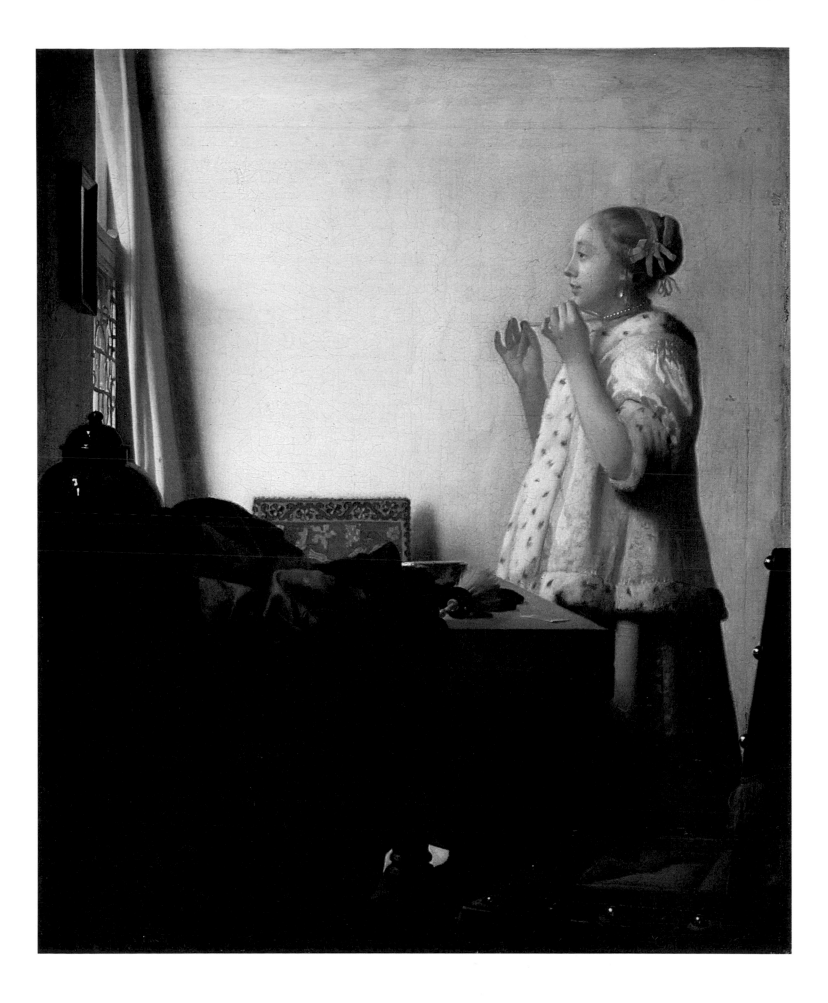

Gabriel Metsu (1629–67)
The Family of Dr Valckenier, Mayor of Amsterdam
*c.*1657

Canvas, 72 × 79 cm (28¾ × 31 in)
Signed lower left: 'G. Metsu'
Tschiffeli Collection, Berne
Acquired 1832
Cat. no. 792

A large patrician family has gathered to be portrayed in their elaborately furnished living-room. In keeping with the family hierarchy the master of the house seated expansively at the table, and his son bringing in a falcon, dominate the left half of the picture, while his wife and three other children, the youngest held by a young woman, are slightly crowded in the same space opposite. Pride in prosperity, status and the honour of high social position – this was certainly what the artist's patron wished him to embody in his portrait with his family. And Metsu conformed to this wish by giving the figures an attitude of formal dignity, by emphasizing the fashionable elegance of their clothes and carefully evoking its variety of materials and colours, and finally by rendering with equal precision the luxury of the family's surroundings, which include gold-embossed leather wall-covering, paintings in elaborate frames, a great, columned fireplace, and a finely carved stone portal.

The painting was earlier in the possession of Maria Petronella Geelvinck (1769–1831), a native of Holland and wife of Frans Anton Tschiffeli, City Councillor of Berne. It was formerly called *Family of the Merchant Geelvinck*, because supposedly it never left Frau Tschiffeli-Geelvinck's family. Yet, although material recently discovered has confirmed this assumption, it has not confirmed the identification of the sitters as Geelvincks. In fact, they were close relatives of the family, the Valckeniers.

Dr Gillis Valckenier (1623–80), Mayor of Amsterdam, graduated from the University of Leyden and entered civic service there in 1647. He was first named alderman in 1649, and from 1665 served several terms as mayor of Amsterdam, an office his father had held before him. In 1648 he married Jacoba Ranst (1622–75). Their first child died, but their second, a son, Wouter, was baptized on 11 October 1650, in the Oude Kerk in Amsterdam. The boy in the painting, about six years old, is Wouter, and the falcon he so proudly has perched on his hand is the family emblem. Jacoba Ranst is represented with her daughter Eva Catharina, about two years old (she was baptized in March 1655), while Rebecca, about four (baptized in April 1653) plays with a puppy on the floor. The youngest child, Peteranna (baptized in July 1656) is held by a young woman whose plain dress has suggested to some commentators that she is a servant or nursemaid. However, she may very well be Anna Ranst (d.1679), the baby's aunt and sponsor, who remained unmarried and helped in her sister's household throughout her life.

Though the painting takes us into the cultivated world of patrician Amsterdam and the portraits may express more of their social status than their individuality, its dignified and serious mood is not at all tinged with pretention or pomp. Families like the Valckeniers owed their advancement and influence to bourgeois values, and it is to bourgeois concerns that the image is devoted. The grouping of the figures (and their small scale) creates an intimacy that, with the liveliness introduced by the children and the detailed painting of the domestic environment, lends the picture some of the character of a genre scene.

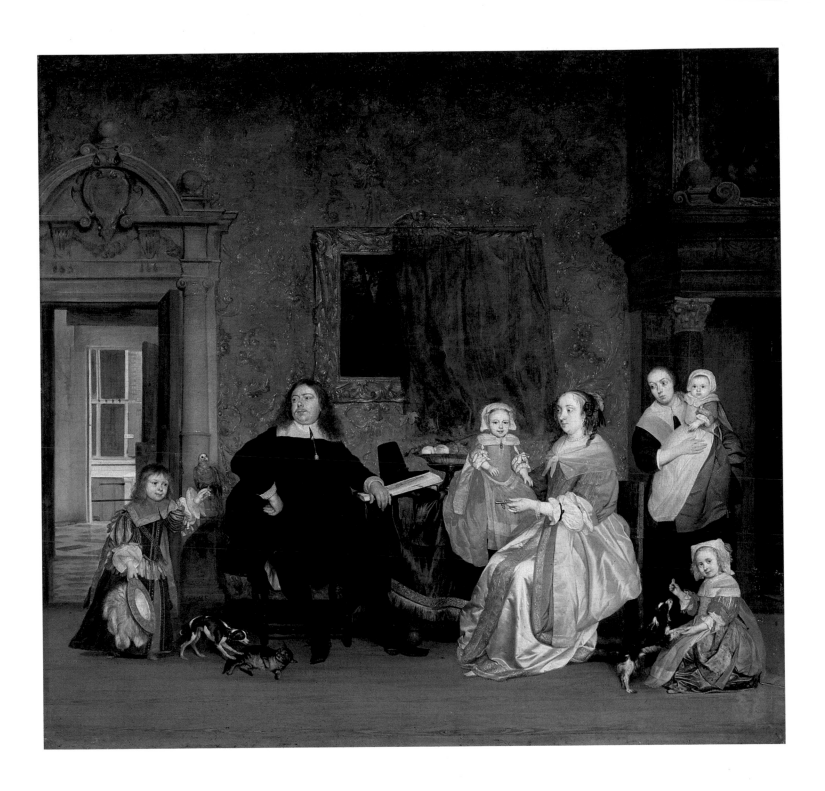

Jan Steen (1625/6–79)
The Garden of an Inn
*c.*1660

Canvas, 68 × 58 cm (26¾ × 22⅞ in)
Signed on the table: 'JSteen'
From the Royal Palaces, Berlin, 1830
Cat. no. 795

Warm sunlight filters down through the canopy of leaves outside an inn, where pleasure seekers have gathered for refreshment. A woman seated in the foreground holds a goblet to her boy's lips, and she is ready to refill the goblet from the great pewter jug as if she were sure he wants more. The brilliant red of her jacket, and, behind her, the trellis post, which is a strong vertical accent, show that she is the main protagonist of the crowded scene. Nor is it by chance that the slate with the innkeeper's bill hangs on the post directly above her. Opposite her, a man relaxes with one foot on the bench, skinning a herring that he apparently has just bought from the fish dealer at the head of the table.

It was previously thought that the group represented the artist himself with his wife and children, and indeed Jan Steen ran a brewery for a time. His self-portraits, however, speak against this. It is not even clear whether the painting here is a family scene at all. The two men laughing at the spectator seem to owe their existence to a homily, '*Jemand een bokking verkopen*' ('to sell somebody a red herring'), which did not then mean to put people off the track but to put them sharply in their place. This reprimand could have been directed at mothers who bring their children to places where alcohol is consumed, and if so, then Steen's intention is to make parents pause to consider better ways to bring up their children – a subject that was already much debated in Steen's time and to which he devoted many works. Here, he has augmented his great storytelling talent by drawing the spectator into the debate, for the two men appeal directly to us for a decision.

Pithy phrases from the colloquial usage of the period, from emblematic literature, or from the theatre, are often found illustrated in Steen's versatile œuvre, which mostly consists of genre scenes from the life of the Dutch middle class and peasantry; these show the basically moral and educational purpose of his art. Though he did not initiate major stylistic developments like his more specialized colleague, Jan Vermeer van Delft, the imaginative variety of Steen's compositions, the humorous detachment of his narratives, and especially the virtuosity of his execution, made him one of the outstanding representatives of Dutch genre painting in the seventeenth century.

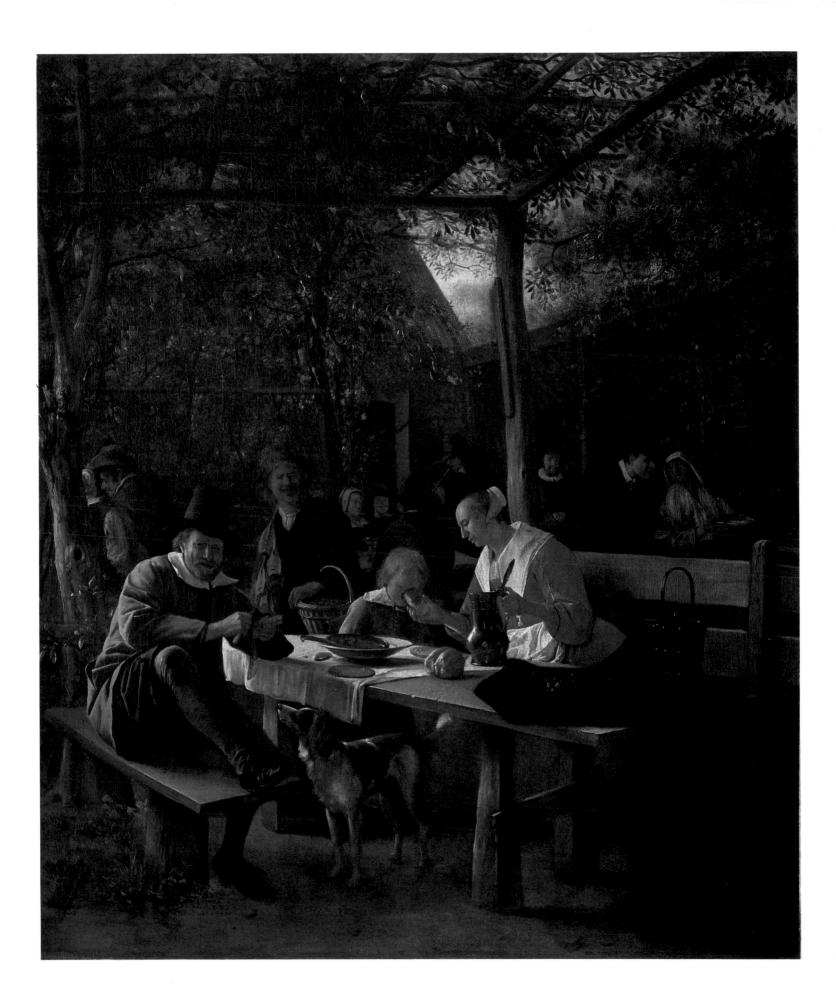

Jan Steen
Men Quarrelling over Cards
*c.*1664–5

Canvas, 90 × 119 cm (35½ × 46⅞ in)
Monogrammed lower left on carved
stone: 'JS'
Acquired with the Suermondt Collection,
1874
Cat. no. 795 B

Men playing cards outside a country inn have become involved in a violent quarrel. Peasants on the right brandish knives and a pitchfork at a gentleman in doublet and knee-hose who is drawing his sword, while a little girl and a woman try to prevent him using it. The elderly man behind the table also seems to have kept calm despite the turbulence, and tries to pacify both sides. Slate, cards and the backgammon game on the ground suggest that the loser of the game has started the argument, and that one of the players has been accused of cheating. The disgruntled loser is probably the swordsman, because the small winnings are scraped together on the peasant's side of the table. The copious pewter jug in the foreground shows that alcohol has contributed to bringing events to a head. A man with a pilgrim's banner leaves the ugly scene without further trouble, while the peasants at the left, including one peering out at the inn door, seem – in the bleary-eyed way of most public house *habitués* – to find it rather comical.

Steen again proves himself an imaginative narrator here, a characteristic quality that is certainly matched by a skill in composing subjects rich in people. The many gestures and movements called for by the theme have been integrated into a carefully ordered whole, and what initially seems hopeless confusion turns out on second glance to follow a premeditated plan. The figures are arranged in the style of a relief across the wide format, not simply one next to the other but in alternations of more or less compact groupings at various depths, violent and calm attitudes, and in pronounced or subdued colour. This accentuates the dramatic climax of the plot, the encounter between peasant and gentleman, without detracting from the rhythmic expressiveness of the whole.

Human behaviour is pilloried here. The antagonists who lose all self-control when they have a weapon in their hand embody *Ira* (Anger), one of the seven deadly sins. And the reasons for their error – alcohol and gambling – are set directly before our eyes through the empty jug and the backgammon game.

A glance is enough for us to recognize, however, that Steen's grasp of human weaknesses has nothing bombastically moralistic about it. The peasant at the far right looks out at the spectator with a conniving laugh; indeed all the figures act theatrically and are characterized as comic types. Similarly the gentleman with the sword is not meant to represent a soldier. His clothes and the studied drama of his pose mark him as an actor – Capitano, the incorrigible braggart of the *Commedia dell'arte*, a figure who is absolutely harmless and whose histrionics are thus easily contained by a woman and a little girl. Steen often used stage characters and stage-like scenes in his pictorial narratives: and his personality was most attuned to comedy with its mixture of light entertainment and moral instruction.

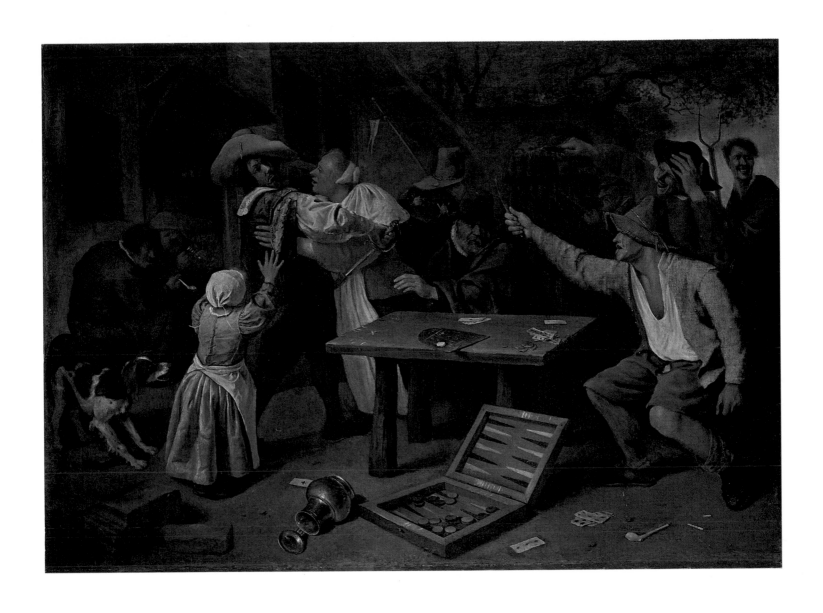

Isack van Ostade (1621–49)
Frozen Canal with Sleds and Ships
*c.*1645

Oak, 21 × 24.5 cm (8¼ × 9⅝ in)
Signed lower left: 'Isack Ostade'
Acquired as the gift of a Parisian art
dealer, 1813
Cat. no. 1709

Across the frozen expanse of an inland waterway, framed by the bare branches of a tree and by the masts of boats caught in the ice, people walk and skate, push or let themselves be pushed in sledges, and guide horse-drawn sleighs that are heaped with goods. While in the foreground half-melted, caked snow, a filigree of grass on the bank, and the branches of the tree, are painted with a precision that throws them into high relief, the figures are treated as accessories whose contours dissolve in the misty winter air to indeterminate silhouettes. A few local colours in the front – the subdued carmine of a dress, a touch of lemon yellow under the dull blue of a cap, even the impasto white in the coat of a grey horse – become subdued in carefully graduated perspective, and then merge with the softly toned browns of the middle distance and the background. This treatment emphasizes the landscape at the expense of the figures. Instead of merely being a setting for the colourful narrative, the landscape itself becomes an image of winter.

This emphasis was untypical of Isack van Ostade, whose favourite subjects were figures and particularly genre scenes from the daily life of the peasantry. Inspired by his brother Adriaen, whose pupil he was, he observed rural people going about their daily tasks among the picturesque disarray of their cottages, or in the market-place, on a village road outside an inn where coachloads of travellers arrived and departed, or on the banks of a river, in scenes sometimes bathed in the warm colours of summer, sometimes suffused with cold, grey-blue winter light. Outdoor views of this kind interested the artist more and more as his career progressed; figures and accessories increasingly declined in compositional importance, and the landscape spread out unencumbered before the eye. Towards the end of his short life Isack finally accomplished a sensitive balance between figure and landscape, though he only occasionally crossed the borderline into pure landscape painting. Nevertheless, his works in this genre deserve to be considered achievements of an unusual kind. The present view of an icebound canal, arched over by a frosty blue sky and greyish-lilac clouds, does not exhaust itself in visual description of a familiar and quite undramatic slice of nature; its delicate nuances of light and colour raise it to the level of a poetic image of a mood. The subjectivity of the artist's interpretation comes through, and this frees the spectator of the need simply to register what he is shown: it stimulates his own subjective reaction. The great emotional appeal of this image, which recalls Rembrandt's *Winter Landscape* of 1647 (Kassel, Staatliche Kunstsammlungen), gives some idea of the grave loss to Dutch landscape painting when Isack van Ostade died at an early age.

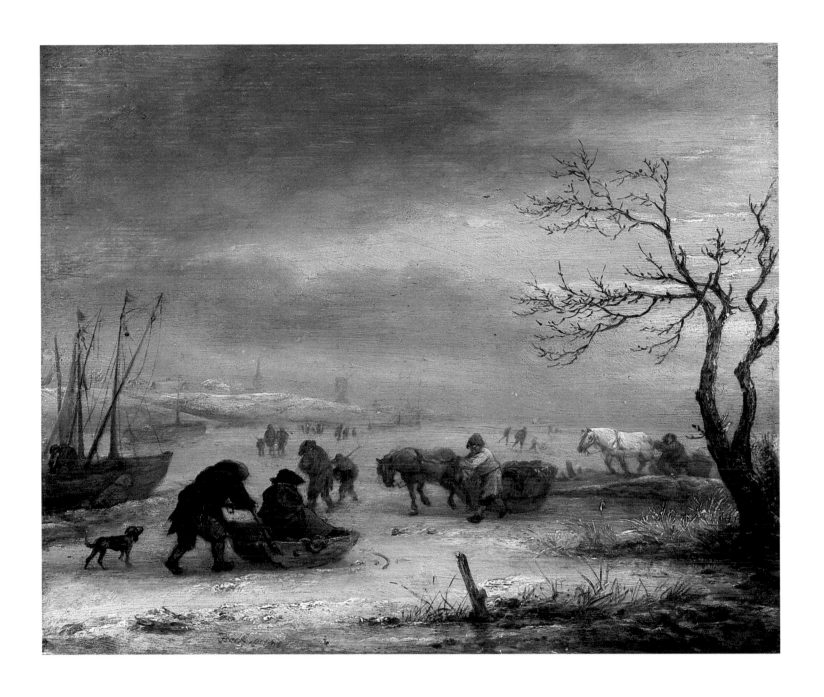

Philips Wouwerman (1619–68)
Winter Landscape with Wooden Bridge
c.1660

Oak, 28.5 × 36.5 cm (11¼ × 14⅜ in)
Acquired 1908
Cat. no. 900 F

A picturesque, rickety wooden footbridge over a frozen stream is the centre of interest here; it stops the eye in the middleground before it moves across the winter vista beyond. Though the flat land of Holland is evoked, it is only by means of this circumscribed foreground. And although this is populated, the tiny figures seem strangely lost, and their activities take up much less room than the great space given to them. In other words, the foreground, instead of serving merely as a setting for figures, remains an integral part of the landscape view.

Only when seen in this way does the image fully reveal its abundance of carefully observed natural details: the sensitively toned reflections on the ice sloping into dark, deep water beneath the bridge; the transitions between packed, crusted and fresh-fallen snow on the right bank; the rise at the left with its traces of old snow mingling with the brownish clumps of last autumn's grass; the masonry of the bridge, which decay has reduced to rounded shapes much like those of the surrounding countryside – indeed everything built by human hands seems weathered as if it had not been built at all but created by nature herself, and soon to be reclaimed.

It is, above all, this variety of superbly perceived detail that shows the artist's devotion to his Dutch homeland. Nor did his eye for detail make him lose the larger scene from view – the great dome of sky, whose cool light casts a subduing, atmospheric veil over the variegated colours of things, and whose stupendous cloud formations have been made, with an eye to unifying the composition, to repeat in softened form the angular contrasts of the bridge construction and of the bare tree. Nothing has been left to chance in this carefully arranged composition, which is why it cannot be explained simply as a record of natural appearances. Though it may give the impression of a straightforward description of a real place, the image is none the less mostly arranged consciously and is enriched with human ideas and emotional values. Take the ice-covered branches of the tree, shimmering pale against the gathering clouds of a snowstorm: this skeletal line evokes feelings that are slightly ominous, as if it were a sign for all to see that the forces of nature can imperil human existence.

Pure landscapes of this type, as profound and compelling as those by Jacob van Ruisdael, are found only occasionally in Wouwerman's prolific œuvre. He preferred subjects of equestrian scenes with thoroughbred animals and fashionably dressed figures. It was particularly to this genre, in which he created imagery of great variety and appeal, that Wouwerman owed his high reputation during his lifetime and posthumous fame during the Neo-Classically oriented eighteenth century.

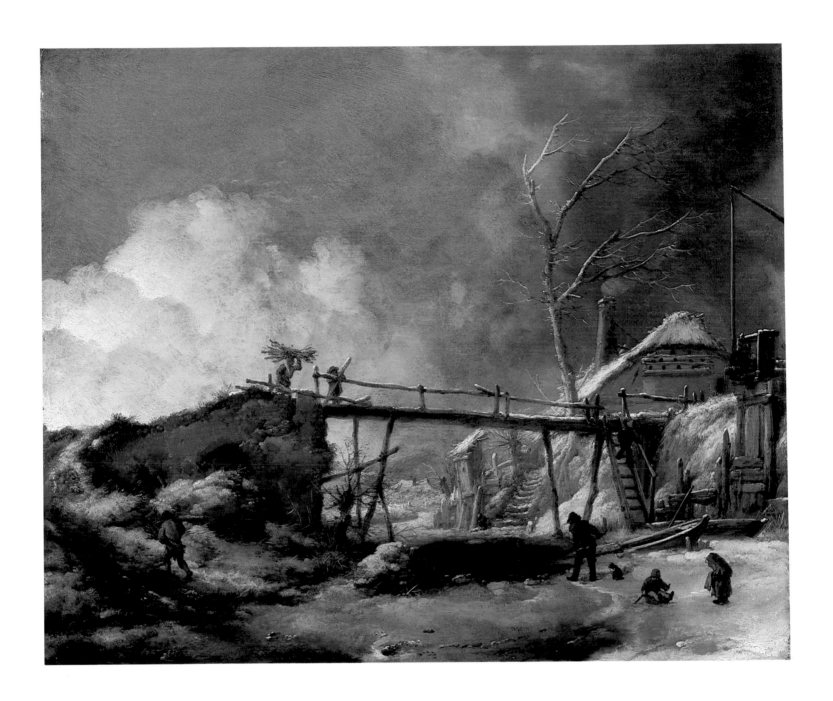

Jacob van Ruisdael (1628/9–82)
Damrak Square in Amsterdam
c.1675–80

Canvas, 52 × 65 cm (20½ × 25½ in)
Signed lower left: 'JvRuisdael'
(JvR interlocked)
Acquired with the Suermondt Collection,
1874
Cat. no. 885 D

The building in the left middleground is the old Municipal Scales House in Amsterdam, a public institution to determine correct weights and ensure that buyers and sellers received what was due to them. Under its projecting roof lie bundles of goods waiting to be put on the scales in the entrance. To the right is a view of the Damrak, the town's inland harbour, crowded with boats, its far shore lined by warehouses; above the gabled roofs the tower of the Oude Kerk rises into the evening sky. The square is full of people out promenading, groups of elegantly dressed ladies and gentlemen, some stopping now and then to look at the wares offered by a fishmonger or vegetable seller. These people were not painted by Ruisdael, who was no figure specialist himself, but probably by Gerard van Battem, a skilled artist of Rotterdam.

Ruisdael was very familiar with the place he depicted here. After moving from Haarlem to Amsterdam in 1657, he lived near Damrak Square. In 1670 he found rooms on the south side of the square, where he spent the rest of his life. The view from his windows was probably very similar to that here, though it is not a *vedute* in the strict sense, that is, not a topographically precise delineation of one aspect of the town. Compared with the preliminary drawing in the Brussels Museum, the proportions of the buildings have been altered. To give the municipal scales more compositional weight, Ruisdael reduced the height of the buildings at the left and of the church tower. And while in the drawing, the Scales House is in the shade and the buildings to the right brightly illuminated, this distribution of dark and light is reversed in the painting. The Scales House emerges from the shadows of its architectural surroundings in a cool greyish-blue – a perfect foil for the elaborate town arms of Amsterdam on the upper façade, which glow in delectable colour in the twilight. Distinguished in this way, the building, a solid structure that is higher than everything else in the painting and projects into the square like a portico, takes on a monumental presence.

Primarily a painter of landscape, Ruisdael turned to the city rather late in his career, probably because it suited his growing penchant for ample form. Though architectural motifs might well have been thought to put strictures on his creative imagination, his townscapes by no means fall behind his compelling renderings of natural scenes. Just as in his landscapes Ruisdael visualized growth and decay in the many trees beneath heavily clouded skies, in his views of towns he transcended mere sober, straightforward description. They too were painted 'uyt den gheest' ('from the spirit'), and raised to poetic images of emotion and mood.

Jacob van Ruisdael
View of Damrak Square
Drawing
Brussels, Koninklijke Musea voor Schone
Kunsten

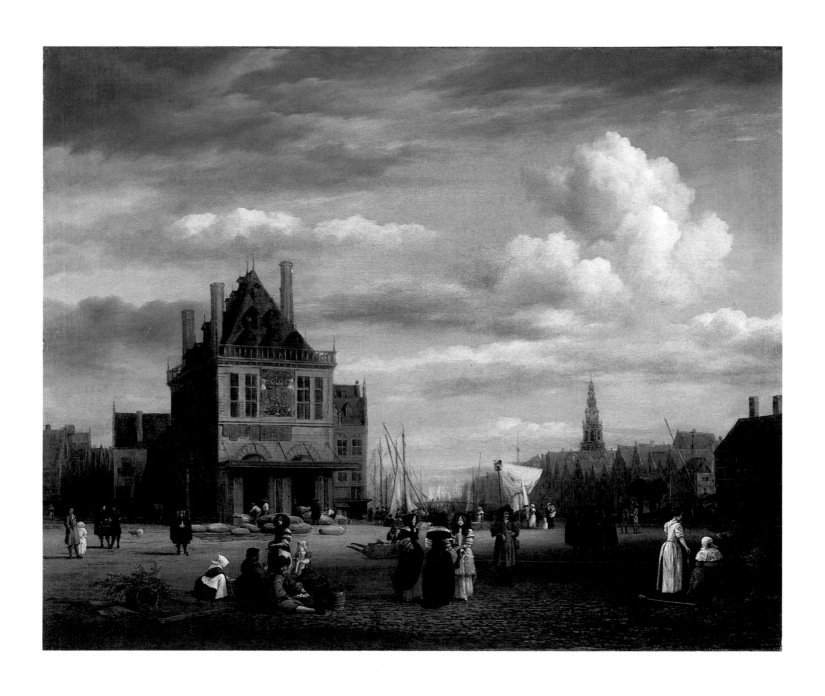

Jacob van Ruisdael
Landscape with a View of Haarlem
*c.*1670–5

Canvas, 52 × 65 cm (20½ × 25½)
Signed lower right: 'JvRuisdael'
(JvR interlocked)
Acquired with the Suermondt Collection,
1874
Cat. no. 885 C

Ruisdael was born in Haarlem, where he also spent his apprenticeship and the first years of his career as an independent artist. Only much later – long after moving to Amsterdam – did he begin to use his home town as a subject for his art. Distant views of Haarlem as in this painting are among the finest examples of Ruisdael's fully mature landscape style. From about 1670 he began to include them in his rich and varied repertoire of themes.

From the high vantage point of the dunes north-west of Haarlem, near Bloemendaal, we look across the plain to the shimmering red roofs of the town and the huge bulk of Sint Bavo. To its left the Bakenesser Church, St Jans Kerk and the Klokhuis are visible, and to the right, the Town Hall, Nieuwe Kerk and, on the ramparts at the edge of the city, a line of windmills. The bands of sunlight and shadow that cross the plain reflect the great expanse of cloud and sky above the low horizon. In the foreground, set off by woods, long strips of linen have been spread out to bleach in the fields, a familiar sight in the environs of old Haarlem. The bleaching of linen – most of it Dutch, but some imported from Germany, England and Scandinavia – was among the town's most important commercial enterprises, and the clear water from the dunes was perfect for the purpose.

In almost all of his *Haarlempjes*, as this type of landscape created by Ruisdael and developed by Jan van Kessel and Jan Vermeer van Haarlem was then known, the artist gave particular prominence to the motif of linen bleaching. For him, it must have held a significance beyond the typical trait of a certain area. As the Dutch poet Jan Luiken once wrote, linen bleached in the sunshine was like snow and evoked the memory of saved souls. Then he quotes from the Bible: 'And to her was granted that she should be arrayed in fine linen, clean and white: for the fine linen is the righteousness of saints' (Revelation 19:8). In view of the penchant of Dutch painters for combining realism with transcendant meaning, it is certainly conceivable that Ruisdael intended the bleaching to be understood as an ethical allusion to the virtues of purity and innocence of soul. As early a commentator as Goethe, in his essay 'Ruisdael als Dichter' (1813), marvelled at the comprehensive symbolism of the artist's works. An interplay of natural appearances with deep allusions is indeed a prime trait of Ruisdael's œuvre, which brought seventeenth-century Dutch landscape painting to its most impressive heights.

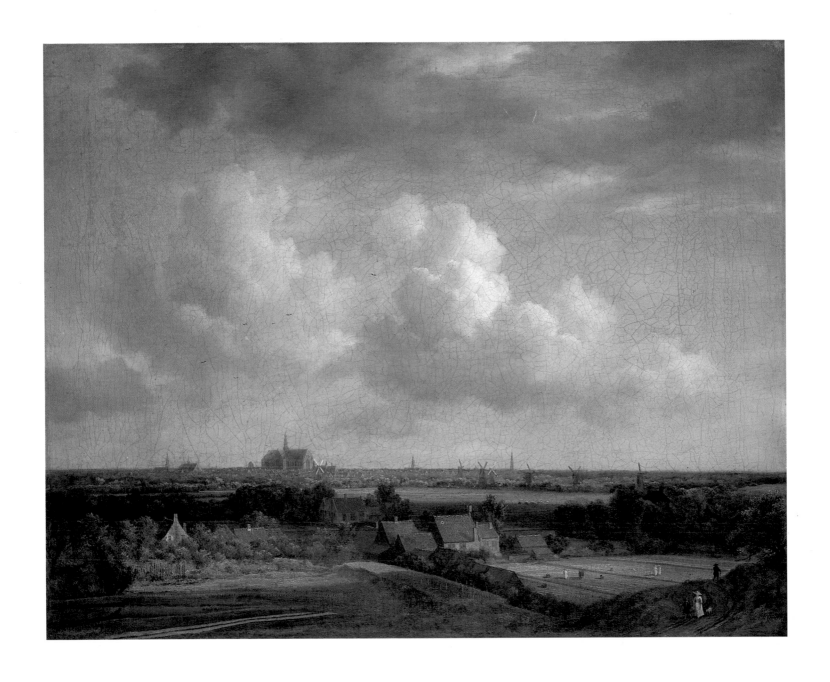

Meindert Hobbema (1638–1709)
Village Road under Trees
*c.*1665

Canvas, 97 × 128.5 cm (38⅛ × 50½ in)
Formerly in the Royal Palaces, Berlin
Acquired 1926
Cat. no. 1984

A village road meanders from the foreground past trees and farmhouses to the deep middle ground, where it forks at a clump of trees, bringing the eye up short; the distant horizon is obscured. Instead of evoking the vast plains of Holland, the artist has chosen an intimate view enclosed by trees, whose variety he has organized in three symmetrical planes – gathered in groves around the houses on the right and left, and looming solitarily in the centre. Trunks, limbs and branches have sinuous, rhythmic curves against the leaves, into whose range of greens the light blue of the sky plays as much as the brown, ochre, and pale grey tones of the landscape.

Though Hobbema shared his preference for trees in full leaf with his teacher, Jacob van Ruisdael, he never emulated the latter's compact, dense groupings. The contours of his trees open out fan-like against the sky, and indeed wherever there are closed areas they are scattered, interspersed with spaces that reveal what lies beyond – slopes in the land, sometimes a section of open horizon, and always the shadowed, interior masses of the trees' foliage. Space in Hobbema seems transparent, expansive: it is evocative of a harmonious coexistence of nature with man and his works. For unlike Ruisdael's imagery, in which the force of the elements is everywhere, Hobbema's landscapes show nature in a state of calm. And he underscores this calm by the delicacy of his line, the sensitiveness of his handling of light and colour, giving the natural scene an appearance of singularity, of cultivation. The village street here seems suffused with the peace of Sunday. Though the furrows in the sandy soil show that much traffic passes through, there are only a few people to be seen, walking at their ease like promenaders in a park beneath the gentle blue sky and the clouds touched with warm tawny sunlight.

This approach to nature certainly conformed with the sophisticated tastes of Dutch middle-class society in the late seventeenth century. Yet surprisingly, Hobbema's work was not particularly well received. To improve his financial position he became a *wijnroier* or inspector of wines in 1668. After taking on this work, which ensured him a tolerable income for the rest of his life, his skill remained undiminished though he painted less. If it were not for his most famous and finest work, *The Avenue of Middelharnis* (1689; London, National Gallery), the late phase of Dutch landscape art, which had already begun to exhaust itself in decorative formulas, would have been shallow indeed.

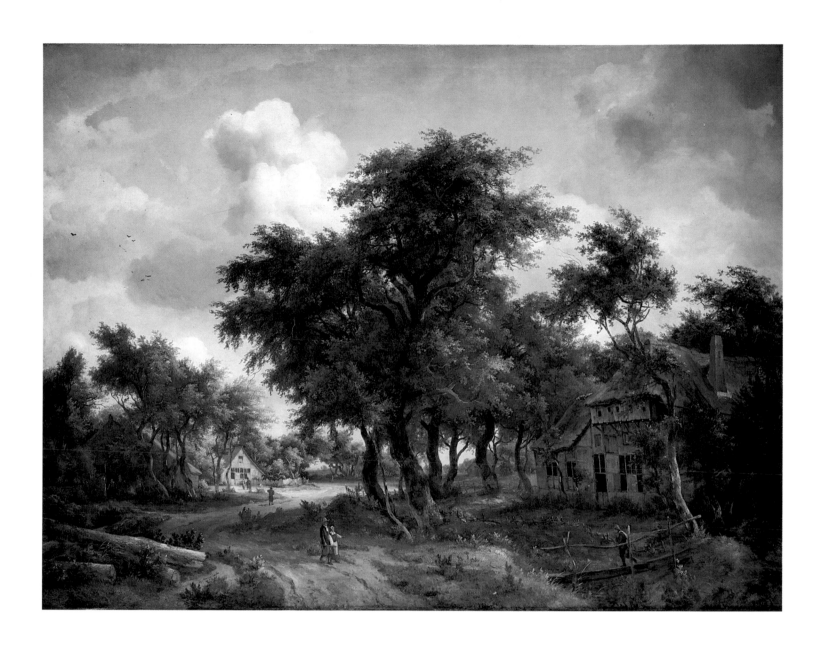

Willem Kalf (1619–93)
Still Life with Chinese Porcelain Bowl
1662

Canvas, 64 × 53 cm (25¼ × 20⅞ in)
Signed lower left: 'W KALF 1662'
Acquired 1899
Cat. no. 948 F

Arranged here on a marble-topped table covered with an East Persian carpet gathered into rich folds, a few exquisite objects glow in dim half-light against a dark ground. The centre of interest, compositionally emphasized as the primary motif, is a Chinese sugar bowl of the Wanli period (1573–1619) with applied figures in relief. These figures, arranged in pairs, have been identified as Immortals of Taoism. The lid of the bowl is decorated with a figurine of a Fo dog. A lemon with a dangling arabesque of peel, a Seville orange, and a small knife with an agate handle complete the arrangement on a silver tray, presumably from an Amsterdam workshop. The sugar bowl and fruit are probably intended to flavour the red and white wine served in glasses of three beautiful shapes – a slim flute glass which marks the central axis of the composition, a Venetian-style glass at the left, and a large *roemer* at the right.

Kalf repeatedly depicted, in various arrangements, all the table ware here, which can still be found in exact or similar versions. From a collector's point of view, at least, his still lifes do seem like documents of exquisitely crafted objects whose form and aesthetic effect he thought worth recording. But few would deny that he saw beneath the surface of things. The pocket clock at the left, marking the passing of time, the peach stones on the plate, even the twilight of the room, seem to signify the uselessness of worldly ostentation and material possessions, which, like human life itself, are all too transient.

In the still lifes executed before 1653, the year he moved to Amsterdam, Kalf favoured precious metal objects whose extremely crowded arrangements evoke the irreverent notion of hastily piled booty. By contrast, the paintings of the Amsterdam period, to which this one belongs, show things carefully chosen for their variety of texture, form and colour and in continually new, pyramidal groups. And now the striking character of the objects as well as the beauty of the artist's painting come into full play. In the light shining into the dark room from the left, the rough yellow peel of a lemon or the subdued red of an orange appeal to the eye no less than the Chinese bowl, whose natural delicacy is almost magically heightened by sensitively modulated chiaroscuro. This perfect harmony of motif with design established Kalf as a major representative of the Classical phase of seventeenth-century Dutch still-life painting.

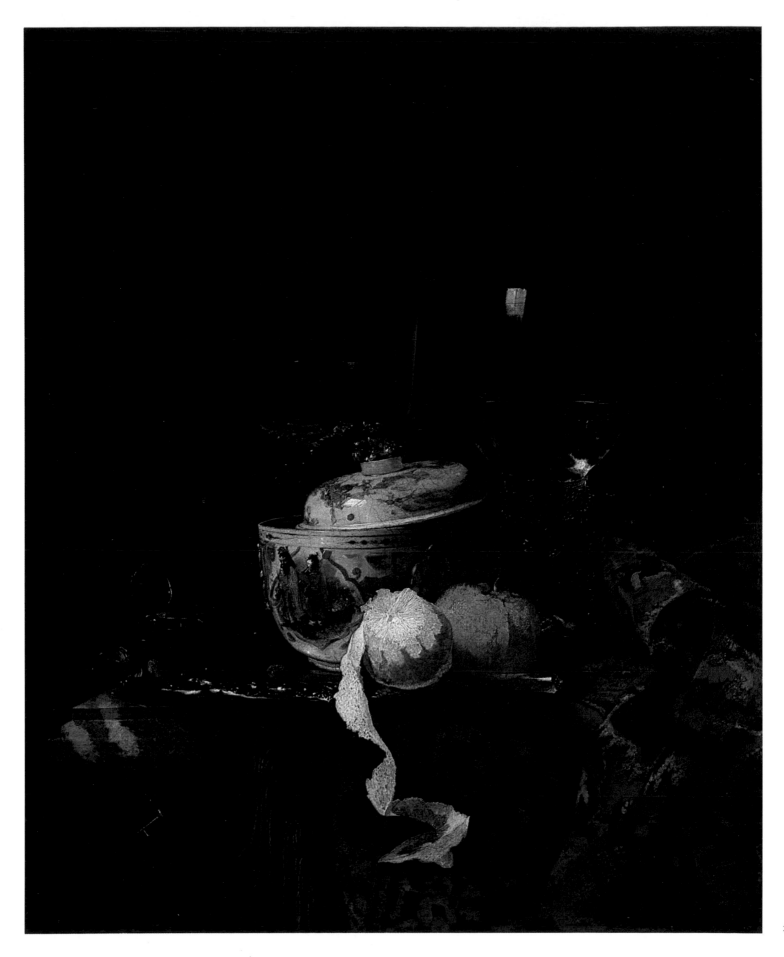

Jan Davidsz de Heem (1606–83)
Still Life with Fruit and Lobster
*c.*1648–9

Canvas, 95 × 120 cm (37⅜ × 47¼ in)
Signed upper right: 'Jan de Heem f.'
Acquired 1975
Cat. no. 3/75

Adam van Vianen
Pitcher, 1614
Gold-plated silver
Amsterdam, Rijksmuseum

De Heem was born and trained in Holland. In keeping with his artistic environment in Utrecht and Leyden he first painted small-format still lifes with simple arrangements – in Utrecht, mostly flowers and fruit, to which he added Vanitas motifs in Leyden. De Heem's rendering is always objective and the pictorial structure strictly ordered and self-contained. The colours in his paintings appear subdued by soft light, and, particularly in the Vanitas motifs, the palette is often reduced to monochrome tones of greyish-brown in very delicate light-and-dark gradations. In 1636 he moved to Antwerp. There, in the cultural centre of the southern Netherlands and Rubens's sphere of influence, which extended to the leading Flemish still-life painters of the time, Frans Snyders, Adriaen van Utrecht, and the internationally recognized Daniel Seghers, de Heem's approach changed profoundly. It was a mark of his artistic and intellectual stature that he was able to adopt these new ideas frankly, without belying his origins in Dutch pictorial tradition. Consequently, he bridged the stylistic gap between Flemish and Dutch painting and synthesized the two.

Described as a combination of these opposites in a new pictorial unity, the present painting shows a great variety of objects on a large canvas, but rendered in fine detail: a decorative sweep of line which is none the less subordinated to the static, triangular composition; and a richness of palette in which the colours merge in the toned chiaroscuro of subdued illumination. What is the significance of the abundance of fine fruit, crustaceans, exotic shells and costly objects such as a prominently placed pitcher made of a nautilus shell in a gold-plated silver mount? The notion that these things have simply been represented without a motive, as the makings of a superb meal, would seem to be contradicted by the care with which they have been arranged into an ostentatious display. The pleasures of the table are not alluded to here, but the morally dubious aspect of exaggerated devotion to them. It is not even necessary to cite the motif of the clock, commonly used in Netherlandish still life to symbolize transience and the need for moderation, to realize that this super-abundance is a warning against gluttony and a reminder that the things of this world do not last. Doubtless the artist's contemporaries admired the skill with which he heightened the natural beauty of these things, but all the same, it is precisely the sumptuous and tactile quality of his painting that calls the luxury of the display into question.

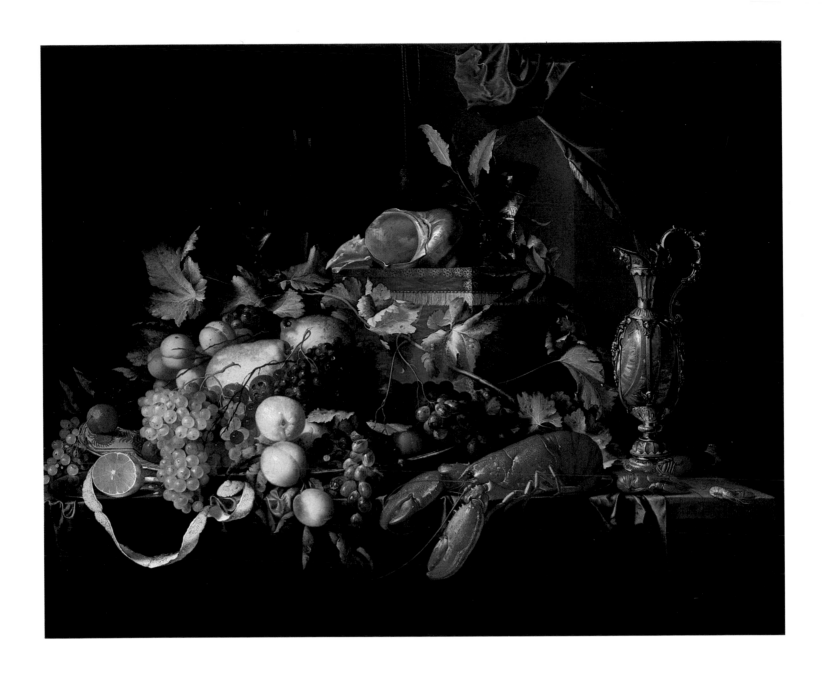

Giotto di Bondone (1266/7 [or 1276]–1337)
The Death of the Virgin
c.1310

Poplar, top in the form of a low gable,
height at centre 75 cm (29½ in), at sides
51 cm (20 in), width 179 cm (70½ in)
Acquired 1914
Property of the
Kaiser-Friedrich-Museums-Verein
Cat. no. 1884

Giotto's *Death of the Virgin* was acquired through Langton Douglas in London for the Kaiser-Friedrich-Museums-Verein in 1914 shortly before the outbreak of war. It was the last of several important acquisitions in the field of Trecento painting which, since the turn of the century, Wilhelm von Bode was able to add to the remarkable group of early Italian paintings which had entered the gallery with the Solly Collection in 1821 (Ugolino da Siena, 1904–11; Simone Martini, 1901). Giotto's panel had been in the Davenport Bromley Collection since the mid-nineteenth century and earlier in that of Cardinal Fesch (d. 1839), which had been sold in 1841 and 1845. Nothing is known about its fate from the second half of the sixteenth to the eighteenth centuries.

This is one of the four panels by Giotto which Lorenzo Ghiberti, in the second of his *Commentarii* (1445/55), described as having been in the possession of the Frati Humiliati together with a chapel and a large crucifix. This order presided over the church and convent of Ognissanti in Florence at that period. As Ghiberti wrote about one of the panels, 'the death of Our Lady, around her angels and twelve Apostles and Our Lord, was rendered with great perfection'. Another was the great *Maestà* or *Ognissanti Madonna* (now in the Uffizi), which is stylistically closely related to *The Death of the Virgin*. Ghiberti does not specify the location of the 'Dormitio', but it is probably identical with the altarpiece by Giotto which, according to a document of 1417, was installed on the altar 'beside the door of the choir on the right side'. Vasari wrote in 1550 that it leaned ('*appoggiata*') on the choir screen ('*tramezzo*'). He called it a '*tavolina*', which would seem to indicate that he had not seen it for some time. He described it enthusiastically, quoting Michelangelo's praise: 'The uniqueness of this story could not have been represented more naturally or truly.' The citation appears in the second edition of Vasari's *Lives* of 1568, in which he notes that the painting was no longer in the Ognissanti church. Apparently he did not know what had become of it.

The elongated and low horizontal format of the panel with its flat gabled top, unusual in altarpieces, resembles the gabled *dossales* that were quite common in Tuscan painting of the last quarter of the thirteenth century but which were superseded, after 1300, by polyptychs and upright altarpieces. These were usually divided into five fields with arched tops. For his *Death of the Virgin*, in other words, Giotto used an already rather outmoded format, and to represent a subject that was not depicted on other *dossales*.

The Virgin's body is being gently lowered by one of the Apostles onto a shroud spread by two tall angels over a sarcophagus, decorated with inlay work. Behind the sarcophagus, invisible to the mourners, Christ cherishes Mary's soul in the guise of a newborn infant. A single Apostle kneels before the casket, seen from the back; at either end, two angels, smaller than the others, hold the death watch with candles in their hands. Among the mourners approaching from the left are two women and several Apostles, including Peter. Reading a prayer from a book, he occupies a place of prominence in the centre of the group. To his right is perhaps Barnabas, then perhaps Paul, in a red garment, bearded and already balding; then to his right, in a green mantle, John, shown in a frontal pose bending disconsolately over the body and wringing his hands. Other Apostles and angels approach the foot of the sarcophagus from the right. One of them holds a half-covered censer and blows on it mightily. The bearded, grey-haired Apostle (Matthew?) in the green robes immediately next to Christ sprinkles Holy Water on the corpse.

The composition is slightly asymmetrical. While the group of Apostles and angels rises from the right to the height of Christ's figure, paralleling the diagonal of the gable, the line of heads on the left rises at less of an angle; and behind Paul, in the contour of the figure of John, it declines again to the centre.

The question of authorship, that is, whether and to what extent Giotto painted the

panel, as well as that of dating within his œuvre, has remained controversial to this day. At the time Bode purchased the painting in 1914, F.M. Perkins published it, identifying it with a work of Giotto's described in the sources, and dating it to the second decade of the fourteenth century. Berenson then immediately questioned Giotto's authorship, though he was later to recant. Most scholars have followed Perkins in recognizing the panel as a work primarily by Giotto's hand (for example, Sirén, Offner, Longhi, and the majority of younger Italian art historians). Friedrich Rintelen, on the other hand, denied Giotto's authorship in 1923, calling the panel a 'trivialization' of his art. Oertel agreed (1949, 1953, and in the Berlin Gallery of Painting Catalogues of 1975 and 1978), stating in 1953 that 'not even the design for the whole composition can possibly go back to Giotto himself'. He followed a hypothesis expressed by Marchini (1938) that the panel represented a scaled-down workshop version of a lost monumental fresco by Giotto that belonged to the cycle of frescoes depicting scenes of the Life of the Virgin in the Tosinghi Chapel in S. Croce. However, the surviving production of Giotto's workshop contains no examples of unaltered replicas of compositions previously produced there (M. Boskovits, Catalogue of the Gemäldegalerie, Berlin, 'Frühe Italienische Malerei', 1986). Suggested dates have ranged from the first years of the fourteenth century to Giotto's final years, about 1325–30 or even later. Most critics, however, follow Perkins's dating to the second decade, just as recent Italian scholars have commented on the panel's stylistic affinity to the frescoes in the Peruzzi Chapel, S. Croce. Though these were for a long time dated around or after 1320, more recent studies suggest 1310–13 (Previtali, 1967). The style of *The Death of the Virgin* is obviously more developed and advanced than the austere style of the Arena Chapel frescoes in Padua (1303–5); its lines are sharper and the rhythmic articulation of forms more agitated. Also, because of its stylistic closeness to the Uffizi *Maestà* or *Ognissanti Madonna*, which is generally placed in the first decade, the present panel probably dates to around or shortly before 1310 (Boskovits, 1986).

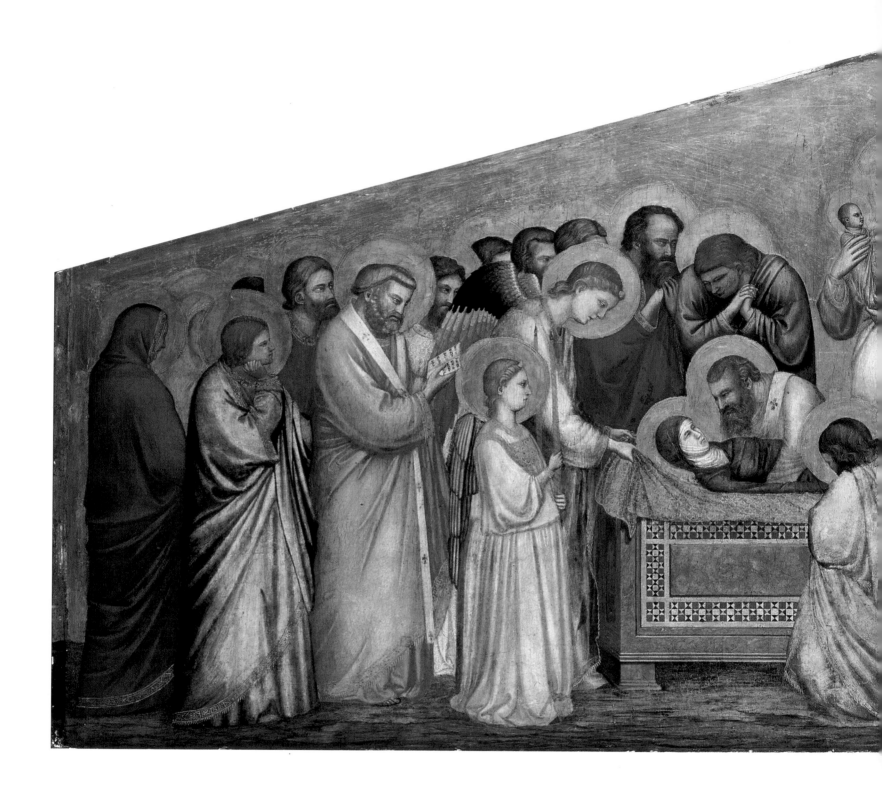

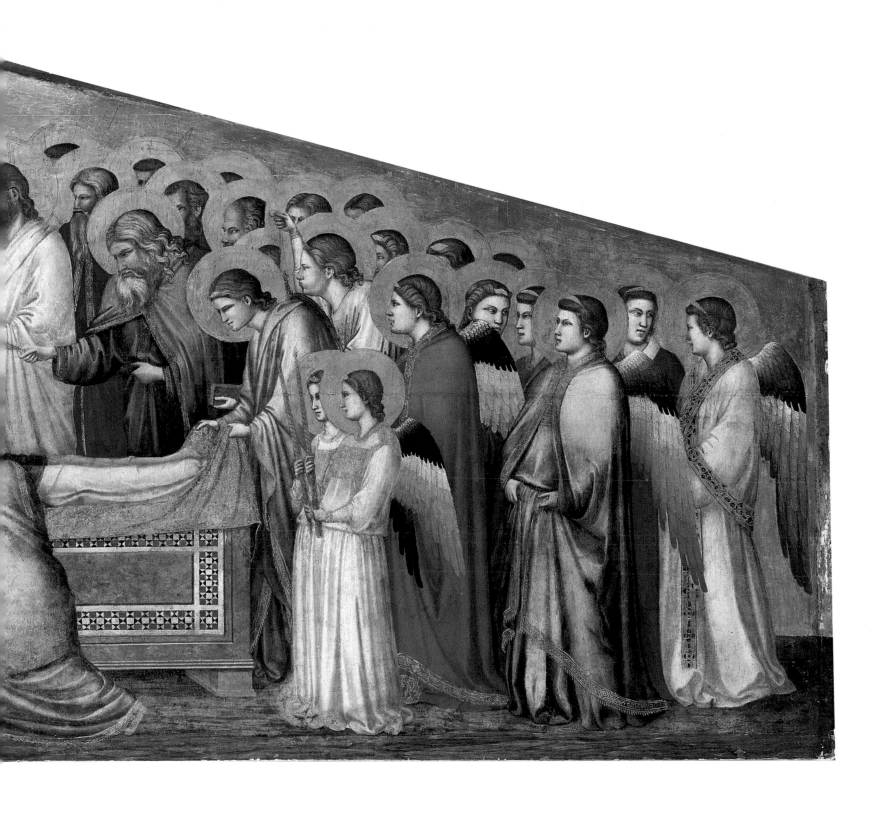

Simone Martini (*c.*1284–1344)
The Entombment of Christ
*c.*1340

Poplar, 23.3 × 16.6 cm (9⅛ × 6½ in)
Acquired 1901
Cat. no. 1070 A

After Duccio, who was presumably his teacher, and together with Pietro and Ambrogio Lorenzetti, Simone Martini was the leading Siennese painter of the fourteenth century, and in contrast to the Florentine oriented Lorenzetti brothers, he embodied Siennese art in its purest form. He was moreover one of the greatest Italian artists of the Gothic style. His art combined elegance of drawing, jewel-like brilliancy of colour, and great technical finesse with acute observation of nature and a narrative skill based on deep psychological penetration.

In 1315, already a renowned master, Martini executed a large *Maestà* in fresco for the Palazzo Pubblico in Sienna. In 1317, for the King of Naples, Robert of Anjou, he painted an altar panel with St Louis of Toulouse (Naples, Museo di Capodimonte), followed in 1319 by a large polyptych in Pisa. In the early 1320s he worked in Orvieto, and presumably was active in Assisi towards the end of the 1310s. Most of his work during the 1320s, however, was done in Sienna, where in 1333 he dated and signed, with Lippo Memmi, the altarpiece of the Annunciation to the Virgin for the cathedral there (now in Florence, Uffizi). In 1335–6 he moved to the Pope's court at Avignon, where he died in 1344. Among the works of his last period were frescoes for the vestibule of Notre-Dame-des-Doms; a small panel with the Holy Family dated 1342 (Liverpool); and a small portable altar with four scenes of the Passion, one of which is the Berlin *Entombment*.

According to the very convincing reconstruction by Van Os-Rinkleff Reinders (*Nederlands Kunsthistorisch Jaarboek*, 1972), the four Passion scenes were originally arranged in a row, side by side, of course in chronological order of the events, which runs from left to right as follows: *Christ Carrying the Cross* (Paris, Louvre), *The Crucifixion* (Antwerp), *The Deposition* (Antwerp), and *The Entombment* (Berlin). The two middle panels formed the fixed centre section of the altar, and *Christ Carrying the Cross* and *The Entombment* its left and right wings. Still visible today on the back (exterior) of the left wing are the arms of the Orsini family of Rome. Presumably the Berlin panel also once bore these arms on its reverse, but they were destroyed when the panel was thinned and afterwards cradled. Since there are no traces of hinges or framing, it cannot be said whether the altar could be folded, that is, whether its wings could be closed. In a closed position the Orsini arms would have been visible on the outside of the wings, while the two Antwerp panels of *The Annunciation* would have appeared on the back of the central section – the reverses of *The Crucifixion* and *The Deposition*. The artist's signature once extended across the lower frames of the four panels, and is still partly legible: HOC OPVS (on *Christ Carrying the Cross*, obscured by new gilding); PINXIT (on *The Crucifixion)*; SYMON (on *The Deposition*); and on the lost frame of the Berlin *Entombment*, presumably SENENSIS or DE SENIS or the date.

In the foreground of *The Deposition*, there is the kneeling figure of the donor, a bishop or cardinal deacon. This is probably Cardinal Napoleone Orsini, who died in 1442 in Avignon and was known to have been associated with Martini. If he was truly the donor of the piece, Martini must have painted it in Avignon. It later came to Dijon, presumably in connection with the marriage of the two of the cardinal's nephews with ladies of the high Burgundian aristocracy. Later it was donated to the Carthusian monastery in Champmol near Dijon, where it was recorded in 1791. During the nineteenth century the four panels were dispersed. The altarpiece had considerable influence on artists of Provence and Burgundy.

Not only are the original frame and coat of arms on the back of the Berlin panel missing, but the image itself has been altered. The sky with its reddish sunset glow was added over the original gold background, possibly in the early fifteenth century.

The panel shows Christ's body lying on a shroud spread over an open marble

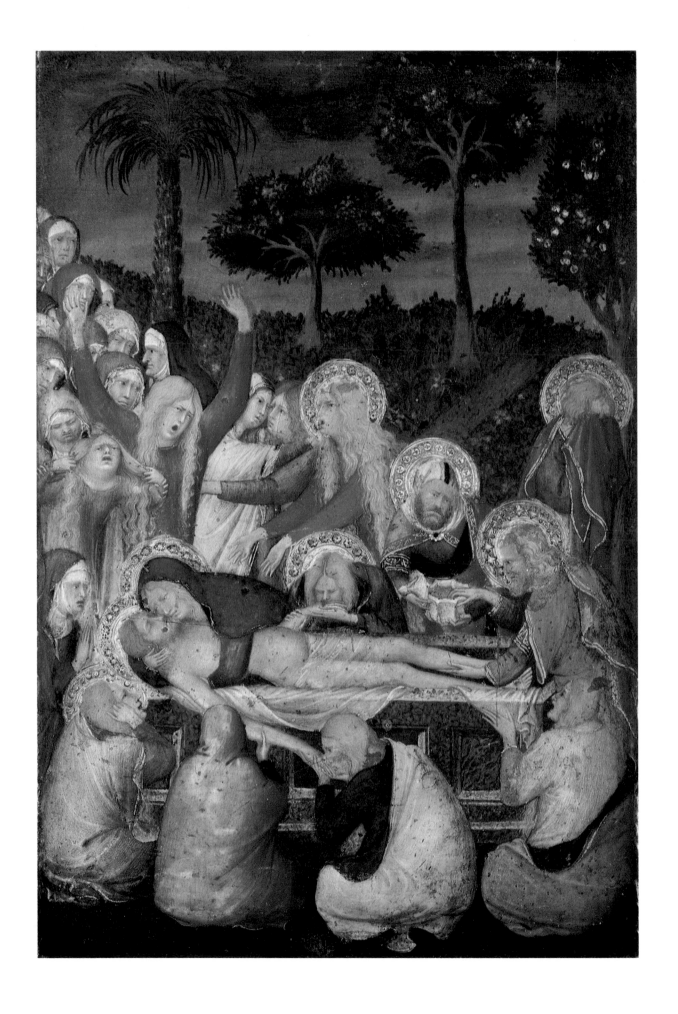

Simone Martini
Panels of the Orsini Altar:
1 *Angel of the Annunciation*
Antwerp, Koninklijk Museum voor
Schone Kunsten
2 *The Annunciation*
Antwerp, Koninklijk Museum voor
Schone Kunsten
3 *Christ Carrying the Cross*
Paris, Musée du Louvre
4 *The Crucifixion*
Antwerp, Koninklijk Museum voor
Schone Kunsten
5 *The Deposition*
Antwerp, Koninklijk Museum voor
Schone Kunsten
6 *The Entombment*
Berlin, Gemäldegalerie SMPK

sarcophagus. Mary embraces Christ as Nicodemus, on the right, brings a jar of spices and Joseph annoints Christ's feet. Behind them, on the far right, John averts his face from the scene to hide his tears. Mary Magdalene, the figure in the centre in a red gown, her long blonde hair in disarray, stretches out her arms to the dead Christ. On the left are two women in similar clothes and with similarly loosened hair, but without haloes, one of them throwing up her arms in desperation, the other tearing her hair. Around the sarcophagus, disciples and woman attendants sit or kneel. The haloed female figures probably represent Mary Jacobi and Mary Salome, who according to the Gospels (Matthew 27:55–6) were eye-witnesses to the death and burial of Jesus. Whether the old woman kneeling on the left of the grave represents St Claire of Montefalco, as Brink assumes (Paragone, 1977), remains uncertain.

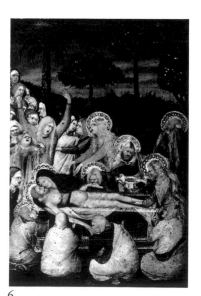
1

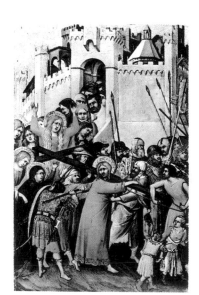
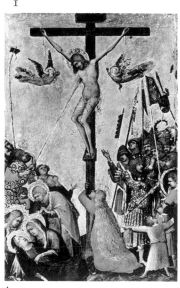
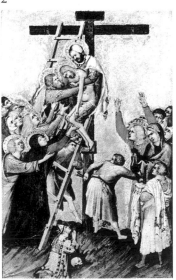

3
4
5
6

Gentile da Fabriano (c.1370[?]–1427)

The Virgin Enthroned with Child, Two Saints, and a Donor
Around or shortly before 1400

Gentile da Fabriano is generally considered one of the leading Italian masters of the courtly style known as International Gothic, which originated in Burgundy and northern France and which he helped to spread in the key artistic centres of Italy. He was admitted to the Florence Artists' Guild in 1422, the same year as Masaccio, and worked in Florence from 1425–6 before going to nearby Sienna and to Orvieto. Gentile's fame was established by an altarpiece painted in 1423 for Palla Strozzi and intended for his family chapel in S. Trinita, and the high altarpiece for S. Niccolò Oltrarno (1425). For a time he was the most renowned painter in Florence, though his reputation was soon to be eclipsed by Masaccio. Gentile influenced such artists as Fra Angelico, and his pupils included Jacopo Bellini and Domenico Veneziano. In January 1427 he went to Rome to execute, on commission from Martin V, a cycle of frescoes in the Lateran Basilica; however, he died before he could finish them, in the autumn of the same year. Little is known about his early development; the origins of his art and its influences are still matters of conjecture. Gentile came of a well-to-do family of Fabriano in the Marches. The first established date in his career is 1408, when he received payment in Venice for an altarpiece (now lost). While in Venice he was commissioned to do fresco scenes in the Sala del Maggior Consiglio of the Doge's Palace, in connection with a general renovation of the interior decoration (1409, 1411, probably to 1414). The years 1414–19 he spent in Brescia, where he painted frescoes in the chapel of the Broletto for Pandolfo Malatesta. By the second half of the year 1420 he was already in Florence.

Gentile's date of birth has been set anywhere between 1360 and 1385. The year 1370 is generally accepted (Boskovits, 1986), though in his recent monograph of 1982, K. Christiansen suggests 1385. While those who propose the earlier date assume that Gentile was already active as an independent artist when his widowed father returned to a monastery in 1390, Christiansen believes that he was entrusted, barely five years old, to his grandfather's care. These questions are not without bearing on the Berlin panel, which is one of Gentile's earliest surviving works, if not the very first. It apparently comes from S. Niccolò in Gentile's birthplace, Fabriano. When the church was restored or rebuilt in 1630, the painting was removed. In 1660 it was in the possession of the Leopardi family in Osimo (the Marches), and in the early nineteenth century it was owned by a collector in Matelica (the Marches) who sold it in 1828. In 1829 it was in Rome where, according to Kugler, it was acquired by the Prussian Ambassador, Bunsen, apparently for the Crown Prince, who lent it in 1837 and later, as King Frederick William IV, donated it to the gallery.

Almost all commentators agree in associating the panel with a Madonna panel in Perugia and with the large polyptych from S. Maria di Valle Romita near Fabriano (now Milan, Brera). Controversy still reigns, however, with regard to the chronology and dating of these works, and recently even a new proposal for the original function of the Berlin panel has been made. Its dating varies from 1390–5 (as the earliest work done in Fabriano) to 1408–14, Gentile's Venetian period. The latter dating is proposed by only a minority of art historians. The proponents of a relatively early date, which would place the panel after the great Milan polyptych, conclude on a date of 1400 or shortly after on the basis of a correspondingly early dating of that work. Christiansen, by contrast, places the polyptych in the Venetian period, 1410–12. Though he agrees in this with those scholars who believe the Berlin panel to precede the Milan altarpiece, he dates it rather later than most, about 1406–8, shortly before Gentile's stay in Venice. Boskovits (1986) dates the panel a little before 1400 and the polyptych at about 1405.

The work's original function is a matter of some importance. Though it is generally considered an altar painting (Boskovits, 1986), Christiansen (1982) thinks it originally belonged to a sepulchral monument.

Poplar, 131 × 113 cm (51½ × 44½ in), top rounded
Inscribed on a fragment of original frame, lost in 1945: 'gentilis de fabriano opus'
Presented by Frederick William III, 1837
Cat. no. 1130

But to turn to the image itself. Mary is seated on a simple, bench-like throne with a red cushion, both hands supporting the Christ Child standing on her knee. The Child gazes down on and blesses the donor, who kneels in prayer on the lower left. This figure, seen in profile to the right, is represented on a smaller scale than the others. Behind the throne are two slender trees, each of which has seven angels concealed among the foliage, singing and playing. Turned towards the Virgin on the sides of the throne are two saints: on the left, St Nicolas of Bari (patron saint of the church from which the panel comes), in an exquisite vermilion cloak set with stars. He hold a crozier and three golden balls, his attributes, in his right hand, and with his left blesses the donor and presents him to the Virgin. At the right of the throne is St Catherine of Alexandria, princess and Christian martyr, in her right hand the palm frond of martyrdom and in her left a book. She is in a superb gown of plum colour over silver, with a pattern of flowering branches, and lined with white fur. Over her shoulders is a pale lilac-blue, fur-lined mantle which she gathers up with her left hand. The seams of her copious sleeve and the gathered mantle form soft, undulating lines similar to the hem of the Virgin's gold-embroidered mantle – traits of the style of International Gothic. The throne and figures are in front of a dark green, flower-studded meadow, above which the gilded background extends. The compositional type here is that of a *Sacra Conversazione*, for which parallels are found in altar paintings in the Veneto and the Marches.

Umbrian and Siennese painting of the late Trecento, as well as Venetian painting, and late-Trecento Lombardian miniatures have been named as possible influences on Gentile's early style. According to Christiansen, Gentile might well have seen Lombard miniatures even in the Marches, where they influenced other artists as well. It is not necessary to assume 'several years of work in Lombardy' before the Berlin panel was executed, as Oertel has done (1975). Boskovits (1986) sees precursors of Gentile's early work in the late-Trecento masters of Umbria and the Marches. The iconography of the *Madonna degli Alberetti* (that is, 'with little trees') is indeed Venetian or Veneto-Marchian, as is the shape of the panel with its unusual low-arched top (Boskovits). This author bases his dating to the years shortly before 1400 on considerations of fashion, among other things. Christiansen believes that the first decisive influence on Gentile came from Zanino di Pietro, who was in Bologna in 1389 and 1394–1405, and in Venice in 1407, and who also supplied paintings to the Marches but reviewers of his book have been sceptical about this hypothesis. Christiansen also sees the influence of Lombardian miniature painting. Despite these diverging opinions, it seems clear that Gentile did the Berlin panel at the start of his career, in his home town, and that he need not have travelled to other art centres to create it. Not until the subsequent large polyptych from S. Maria di Valle Romita near Fabriano, which Christiansen believes was painted in Venice, does Lombard influence make itself felt – through Michelino da Besozzo, a Lombard artist who worked for a time in Venice.

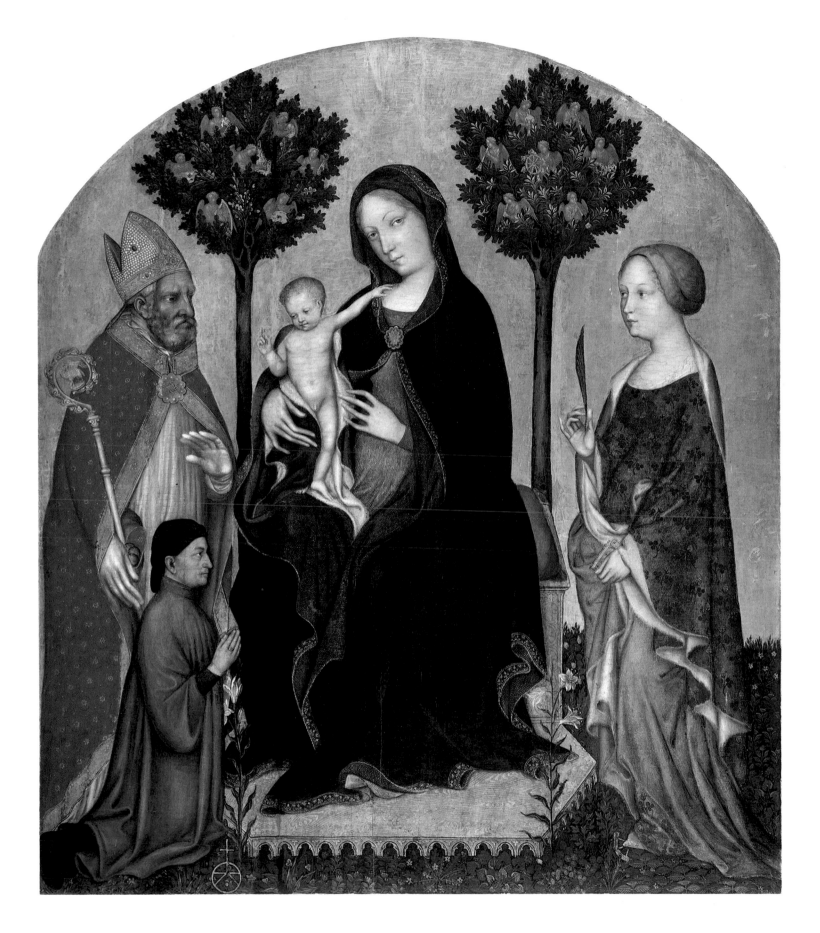

Piero della Francesca (1420/2–92)
Landscape with St Jerome Penitent
1450

Chestnut, 51.5 × 38 cm (20¼ × 15 in); with original frame 59 × 45.7 cm (23¼ × 18 in)
Inscribed on *cartellino* lower right, on tree trunk, and dated 1450: 'PETRI DE BVRGO / OPVS . M̃/CCCCL'
Acquired 1922
Cat. no. 1904

Piero della Francesca
Landscape with St Jerome
State before cleaning
Berlin, Gemäldegalerie SMPK

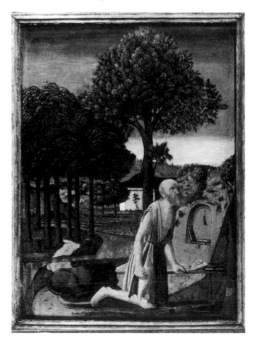

After the First World War, his life nearing its end, Wilhelm von Bode was able to acquire two further significant examples of Early Italian Renaissance painting: in 1924, a predella panel by Sassetta, and in 1922 this *Landscape with St Jerome Penitent* by Piero della Francesca, a master not then represented in the Berlin Gallery. Though the picture was fortunately signed and dated, the state in which von Bode acquired it and published it in 1924 revealed extensive parts by another hand. While Berenson (1932) declared that only the figure was authentic, Longhi (*Piero della Francesca*, 1942) rightly included the surrounding area, the bench with books, the cliff with its niche and books, and the inkwell and lion, though he said that Piero had left the painting unfinished and that it had been completed by someone else towards the end of the fifteenth century. The treatment of the compact foliage, uniform sky and the chain of hills with their awkward line, dull colours and thick impasto, obviously deviated from Piero's touch. In 1968 Robert Oertel, then director of the gallery, decided that the painting should be cleaned, and the gallery's then chief restorer, Hans Böhm, carefully removed the overpaint with a scalpel. When restoration was completed in 1972, it revealed that the original image was by no means unfinished. Piero's painting appeared for the most part intact, without significant gaps, and largely preserved, particularly in the parts with trees, sky, and landscape. What proved to have been most damaged by an earlier, too drastic cleaning was the figure, which until then had been considered the only element in the picture by Piero himself. The original, intense blue sky with its characteristic flat and sharply contoured white clouds came back to light – the same sky familiar from such works as *The Baptism of Christ* (London), *The Flagellation* (Urbino), Piero's frescoes in S. Francesco in Arezzo, and *The Resurrection* (San Sepolcro). The sky now extended down to the hill above the house, and the chain of higher hills disappeared. The trunks and crowns of the trees, whose contours had been extended over the sky blue, recovered the loose, transparent texture familiar from the Arezzo frescoes (*Adoration of the True Cross*), *The Baptism of Christ*, and *St Jerome with Donor* (Venice, Academy). As X-rays revealed, Piero had first blocked in the trees' basic structure, the trunk and limbs, and then added the foliage over them. His delicate, light green meadows had been concealed beneath a layer of dirty brownish-green. But most importantly, the stream meandering through the wood towards the ford in the foreground has recovered its original, light ivory colour. The reflections of the trees, which had been almost completely obscured, are now back in their full beauty – recalling those in *The Baptism*. Everything in the image has become lighter, more translucent, suffused with light. The penitent's robe, previously a dull blue, now shimmers in delicate lilac-grey heightened with white, and he has a light-green tendril of a plant around his waist.

In his right hand St Jerome hold a stone, and in his left (sadly very damaged) a rosary of oblong, white pearls. Lying on the ground beside him is his red cardinal's hat, the strongest accent of local colour apart from the green of the meadows and the blue of the sky. The books on the bench and in the rocky niche are arranged carefully like a still life. Their precise detail, the rendering of clasps and cords serving as place-markers, the brilliant colours of their bindings, edges, and fittings, suggest that Piero may have had Netherlandish models in mind – or before his eyes, since he could have seen a painting by Rogier van der Weyden at the Ferrara court where he was working at the time, or perhaps even a Jan van Eyck. A *St Jerome* commissioned from van Eyck by Cardinal Albergati and completed by Petrus Christus, was in the Medici collections in 1492 (and may be identical with the Detroit painting; cf. R. H. Oertel, *Studies . . . in honor of Millard Meiss*, 1978). Bartolomeo Fazio, in his *De Viris Illustribus* (Naples, 1456), described a work by van Eyck that was apparently in Urbino at that period.

The results of cleaning not only disprove Longhi's hypothesis that the picture was

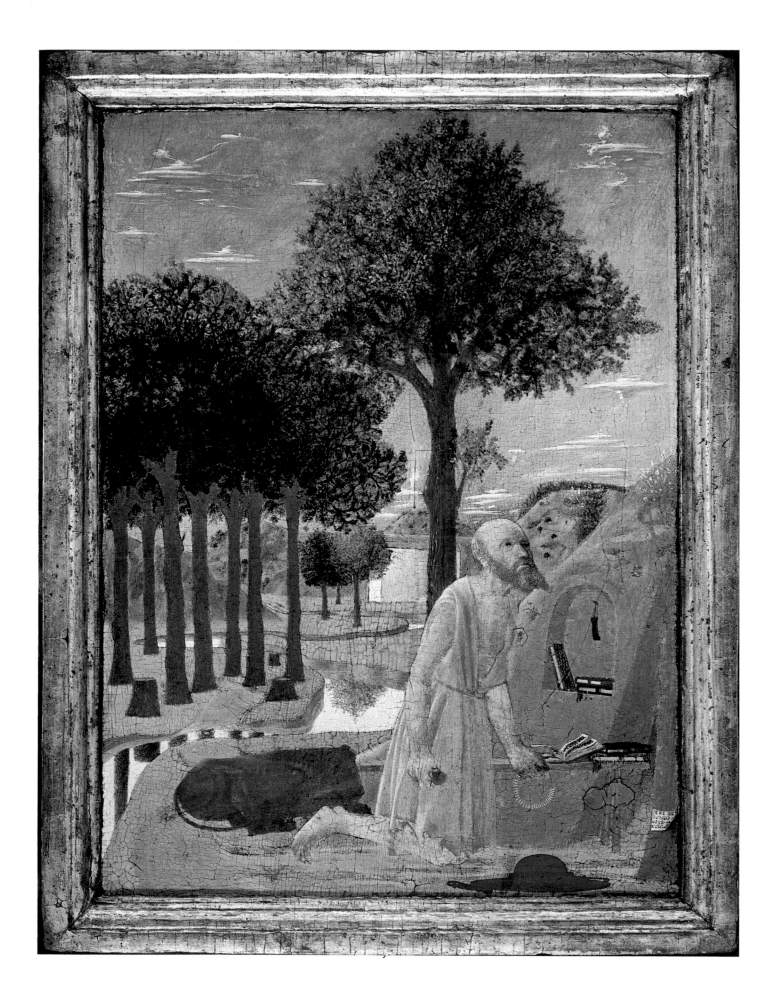

unfinished, but make his reservations about the signature and date superfluous. The date of 1450 suggests that Piero did the painting in Ferrara, where he was active at the court of Lionello d'Este from 1449 (or perhaps 1446–7). His *St Jerome Penitent* is a small devotional image that was surely kept out of the public eye. Salmi, in his *Piero della Francesca* (1979), writes that it may be one of the paintings Vasari mentions, those 'small pictures he painted for the Duke of Urbino' (Guid' Antonio da Montefeltro or his son, Duke Federico II). A direct derivation from Piero's original image in its state before it was painted over by another artist, which Oertel dates to the third decade of the sixteenth century, is seen in an altar lunette in the Gualino Collection, Galleria Sabauda, Turin. This image of St Jerome in the wilderness, measuring almost two metres in length, has been ascribed to Nicola di Maestro Antonio d'Ancona, who was active in the Marches in the second half of the fifteenth century. How this provincial artist could have had access to Piero's original image, however, remains uncertain.

A much more direct reference to Piero's *St Jerome* is found in a St Christopher fresco by Bono de Ferrara, presumably of 1451 and formerly in the Eremitani Church, Padua (destroyed in the Second World War), which also showed the meandering stream with reflections (Oertel, 1978; R. Cocke, *Burlington Magazine*, 1980). The fact that the river motif is a necessary ingredient of the St Christopher iconography but not of the St Jerome iconography, has led Oertel to assume a lost St Christopher landscape by Piero which might not only have inspired Bono's fresco but been Piero's own point of departure for his *St Jerome*. Similar links exist with Jacopo Bellini, who worked in Ferrara in 1441, and whom Piero may have visited on a journey from Ferrara to Venice, as Longhi already suggested in 1942 in connection with the Venice *St Jerome*. Piero might also have been inspired by the depictions of St Jerome penitent in a landscape which Sano di Pietro of Sienna repeatedly included in the predellas of altarpieces (1436, 1444; cf. Oertel, 1978). In none of his other works does the landscape play such a predominant role, nor is the figure constricted so tightly into a corner as in the Berlin painting. It is conceivable that while he was assisting Domenico Veneziano on the choir frescoes in S. Egidio, Florence (1439), Piero may have seen that artist's *Adoration of the Magi* tondo (Berlin), in which the landscape also holds such a significant place.

Nicola di Maestro Antonio D'Ancona (attributed to)
Landscape with St Jerome Penitent
Turin, Galleria Sabauda, Gualino Collection

Master of the Osservanza (active in Sienna c.1430–50)
St Anthony Abbot at Mass
c.1435

In a side chapel of a Gothic church whose dark grey and white striped columns recall those of Sienna Cathedral, a priest reads mass, assisted by a choirboy. The young man listening in the foreground is St Anthony the Hermit, still in secular costume but his head already surrounded by a halo. He is represented again in the right background, kneeling down and probably in the act of taking his vows. St Anthony the Hermit (also known as the Great, or St Anthony Abbot) was born in about AD 250 in Egypt. As the *Legenda aurea* relates, at the age of twenty he was inspired by the words of Christ at a church service, '. . . go and sell that thou hast, and give to the poor' (St Matthew 19:21) and he gave away everything he owned and spent the rest of his life as an ascetic and penitent.

The Berlin painting belongs to a series of eight surviving panels with scenes from the saint's life, which used to be attributed to Sassetta. It was Longhi (*Critica d'Arte*, 1940) who recognized that they must have been done by an artist whose style resembled Sassetta's but was slightly more archaic, an artist he called, after a triptych dated 1436 in S. Bernardino dell' Osservanza in Sienna, the Master of the Osservanza – a name that soon found wide acceptance. The series consists of six upright panels (including the Berlin panel) and two of horizontal format. Graziani (*Proporzioni*, 1948) grouped these eight images around a fragmentary panel of *St Anthony Abbot* (Paris, Louvre) to reconstruct a presumed altarpiece devoted to the saint, arranging three upright panels one above the other at each side of the central image, and the two broader panels in the predella area. Oertel (1975), however, realized that the figure of the Saint in the Paris fragment was once a standing figure rather than a seated one as Graziani had believed. Laclotte (*Retables italiens du XIIIe au XVe siècle*, Paris, 1978) then determined that instead of a central panel, it must have been one of the side panels of a polyptych, and that therefore it did not belong to the eight St Anthony scenes after all but to a different polyptych. In other respects Laclotte agreed with Graziani's reconstruction, in which only the central predella panel was still missing.

As the scene represented in the Berlin panel indicates, it is the first in the sequence. The others are *St Anthony Gives His Possessions to the Poor* (Washington), *The Temptation of St Anthony by a Devil in the Guise of an Angel* (New Haven, Yale University Art Gallery; horizontal format), *St Anthony Harassed by Demons* (New Haven), *St Anthony in the Wilderness* (New York, Metropolitan Museum, Lehman Collection), *The Meeting of St Anthony and the Hermit Paul* (Washington), and *The Death of St Anthony* (Washington; horizontal format).

As P. Scapecchi recently pointed out (*Arte Cristiana*, 1983), in 1870 two of the eight panels were in the collection of Count Caccialupi, Macerata (the Marches), which included other fifteenth-century Siennese paintings. Moreover, a member of this family lived in Sienna during the fifteenth century. From this, as well as from the presence of Siennese works of the period in the Marches (S. Severino), Scapecchi concluded that the St Anthony altarpiece to which the eight scenes belonged was intended for a Franciscan church in the Marches. Accepting Laclotte's conclusions with regard to the Louvre panel, he assumed that it was the side panel on the extreme left of a five-part polyptych with the eight scenes from St Anthony's life arranged in the predella. This last assumption, however, would seem unlikely because of their different formats (six upright panels each about 47 cm high and two horizontal ones 36.5 and 37.7 cm high) and the narrow, upright format and corresponding vertical wood grain of six of the panels, which would certainly have been unusual in a predella. Laclotte (1978), noting this inconsistency, rejected the possibility of this arrangement.

In the forthcoming catalogue of Italian paintings in the Lehman Collection (Metropolitan Museum of Art, New York), J. Pope-Hennessy and L. Kanter reject Scapecchi's

Poplar, 46.8 × 33.4 cm ($18\frac{1}{2} \times 13\frac{1}{8}$ in)
Acquired 1910
Cat. no. 63 D

1 *St Anthony at Mass*
Berlin, Gemäldegalerie SMPK

2 *St Anthony Gives his Possessions to the Poor*
Washington, National Gallery of Art, Kress Collection

3 *St Anthony Leaving the Monastery*
Washington, National Gallery of Art, Kress Collection

4 *The Temptation of St Anthony*
New Haven, Yale University Art Gallery

5 *St Anthony Harassed by Demons*
New Haven, Yale University Art Gallery

6 *St Anthony in the Wilderness*
New York, Metropolitan Museum of Art, Lehman Collection

7 *The Meeting of St Anthony and the Hermit Paul*
Washington, National Gallery of Art, Kress Collection

8 *The Death of St Anthony*
Washington, National Gallery of Art, Kress Collection

reconstruction. Returning to Graziani's view, they assume that the St Anthony scenes were once arranged in tiers of four each to flank a central St Anthony figure, perhaps a painted panel, perhaps a sculpture. Yet while Graziani's sequence began at the upper left with the Berlin panel and continued downwards to the predella, then ran from top right to bottom right, Pope-Hennessy and Kanter, on the basis of technical evidence, reverse the sequence, from lower left to upper left, and from lower right to upper right, making the two broad-format panels the concluding scenes at the top of the altar instead of assigning them to the predella, as Graziani did.

Some scholars distinguish two different hands within the group of eight panels. Pope-Hennessy, for instance, in 1956 reascribed those which seemed to him higher in quality to Sassetta. Carli (1957) retained these, including the Berlin panel, for the Master of the Osservanza, attributing the qualitatively weaker group to Sano di Pietro. Taking the opposite view, Oertel (*Katalog der Gemäldegalerie*, 1975), attributed the panels of higher quality to Sano di Pietro. Italian art historians tend to insist on the homogeneity of the group and its attribution to the Master of the Osservanza.

That the authorship of these panels has remained one of the most controversial problems of fifteenth-century Siennese art, in itself shows how closely the artist adhered to Sassetta – his ideal and possibly his teacher. This is particularly true of the Berlin panel, which except for *The Death of St Anthony* (Washington, National Gallery of Art), is the only one in the cycle to depict an interior. *St Anthony Abbot at Mass* is one of the finest of the eight panels. The light-suffused, crystal clarity of the spacious Gothic church interior, its perspective construction, which is empirically convincing if not fully precise, the geometric purity and elegance of form whether in architecture or figures, are all stylistic features which the author of the Berlin panel shares with Sassetta, indeed which he owes to his example.

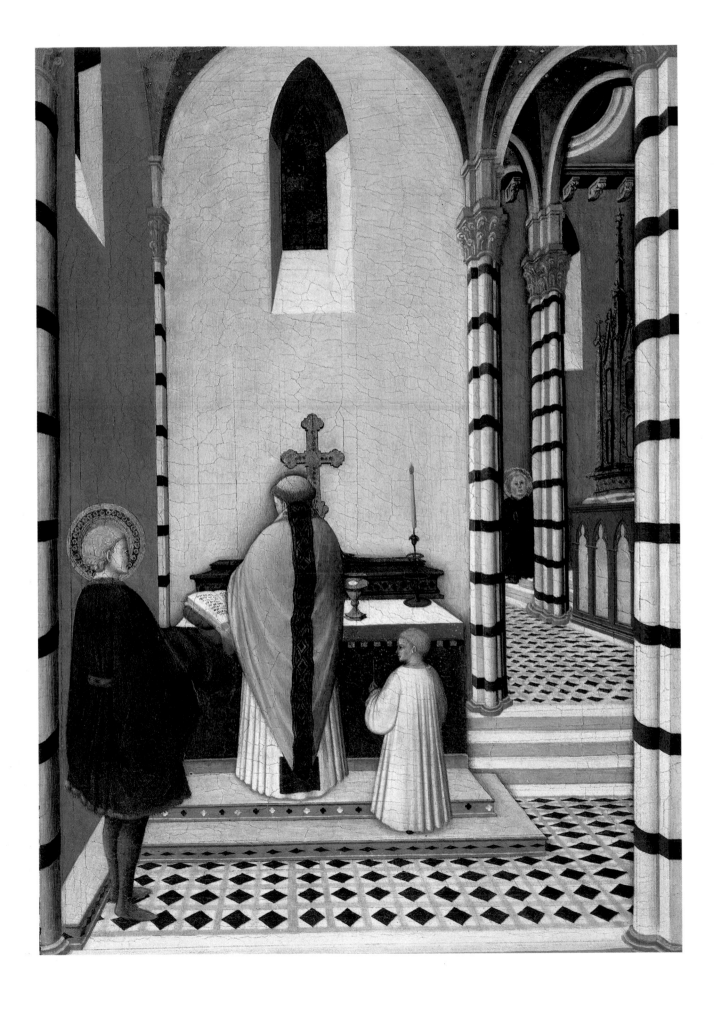

Andrea di Bartolo di Simone, called Andrea del Castagno
(c.1419–57)
The Assumption of the Virgin
c.1449–50

Poplar, 131 × 150.5 cm ($51\frac{1}{2}$ × $59\frac{1}{4}$ in)
Presumably acquired with the Solly
Collection, 1821
Cat. no. 47 A

As his pseudonym indicates, Andrea del Castagno came from the town of Castagno in the Mugello near Florence. His first documented work, now lost, was a fresco on the façade of the Palazzo del Podestà depicting the members of the Albizzi conspiracy of 1433, who were hanged in 1440 after the Battle of Anghiari. Soon after completing this political commission at the age of twenty-one, Castagno left Florence. In 1442 he was in Venice, where together with Francesco da Faenza he painted frescoes in the apse vault of a chapel in San Zaccaria. Back in Florence by 1444, he was paid for a cartoon for a stained-glass window in the cathedral there, and accepted into the Artists' Guild. In 1447 he created frescoes of the Last Supper and Stations of the Cross in the refectory of S. Appollonia, and in November 1449 was commissioned by Ser Lionardo di Francesco de' Falladanzi da Orte, the rector of a small church in the centre of town, S. Miniato fra le Torri, to paint the altarpiece which is now in Berlin. Castagno finished this work in April 1450, and by the summer, he was already engaged in the famous *Uomini Illustri* frescoes in the Villa Carducci, at Legnaia near Florence. Then, from 1451–3, he continued the fresco cycle begun in 1439–45 by Domenico Veneziano in the choir of S. Egidio (S. Maria Nuova), but broke off work because of disagreements with the monastery. In 1455–6 he executed the famous fresco of the equestrian monument of Niccolò da Tolentino in the cathedral, and in May 1457 completed his final work, *The Last Supper* fresco in the refectory of S. Maria Nuova. He died of the plague in the autumn of that year, at the age of only thirty-eight.

Castagno was influenced above all by Donatello's sculpture and Domenico Veneziano's painting. Vasari praised 'the force in the movements of [his] figures and male and female heads', his 'earnestness of expression', and good drawing, but he also noted that Castagno's forms and colours tended to be 'harsh and garish'. With his strong sculptural modelling and sharply contoured, harsh, even sometimes crude treatment of form, Castagno introduced a new style that influenced painters of the next generation such as Antonio and Piero del Pollaiuolo. In 1754 the altarpiece now in Berlin was still *in situ* in S. Miniato, which was demolished in 1785. It entered the Berlin Gallery in 1821, with the Solly Collection.

It shows the Virgin dressed as a nun, seated and gazing upwards in prayer, before a glory of fiery clouds shaped like a mandorla that merges from the sarcophagus and is borne heavenwards by four angels. In the sarcophagus are the roses and lilies which, as the *Legenda aurea* relates, surrounded the Apostles during the Assumption – the roses revealing the presence of martyrs, and the lilies that of angels and virgins. The boldness of the poses and movements of the flying angels – especially the one at the lower left, seen in three-quarter view from below – and their draperies fluttering in the wind, already struck Vasari, who commented on the angels of the *Annunciation* formerly in S. Egidio.

The central group is flanked by two standing figures in courtly costume, St Julian at the left, and St Minias at the right who looks up towards Mary. Minias was one of the patron saints of Florence and the titular saint of the church for which the altar panel was intended. According to legend, he was a soldier who in about AD 250 was beheaded on the outskirts of town, at the place now marked by the church of S. Miniato al Monte. Later he came to be considered an Armenian prince, which explains the sceptre and crown here, above which his foreshortened halo reflects the flaming clouds of the Virgin's aureole. St Minias is in a brilliant vermilion tunic and red hose, and gathers up his dark green, cape-like mantle in his left hand. Opposite him is St Julian (Hospitator), a young Christian knight and martyr. Poised with his left foot slightly raised, he looks out of the picture and presents a sword, a symbol of his inadvertent murder of his parents (a subject also represented in Masaccio's predella scene in Berlin). He is in a vermilion mantle lined with wine-red cloth patterned

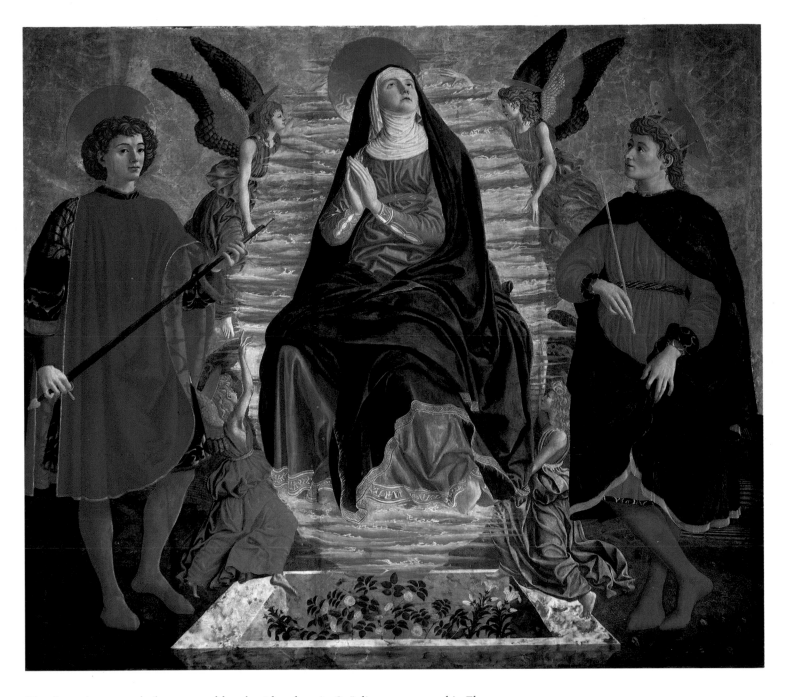

like damask, over a dark green, gold embroidered tunic. St Julian was revered in Florence as patron saint of innkeepers.

The conception of the two youthful figures and their noble features reveals the influence of Castagno's ideal and friend, Domenico Veneziano. They also anticipate his own *Uomini Illustri*, in the way they are silhouetted against the glory – though where real and transcendent worlds meet, their contours overlap the angels in a rather confusing and jarring manner. Castagno had yet to master spatial relationships. His use of a gold background, perhaps by request of the patron, was certainly anachronistic by 1450. Yet he has consciously integrated it in the colour composition, which rests on a dual contrast of gold with red, and blue with dark green. Against these accents, the diverse nuances of red – vermilion, carmine, reddish brown, wine red, violet, lilac – shimmer with a strange tension.

The idea of the Assumption of the Virgin, in a *mandorla* of clouds, is derived from Donatello's marble relief in the Brancacci monument in Naples, executed in Pisa in 1427.

Fra Filippo Lippi (*c*.1406–69)
The Virgin Adoring the Child
(Adoration in the Forest)
c.1459

Poplar, 129.5 × 118.5 cm (51 × 46⅝ in)
Signed: 'FRATER PHILIPPVS P[inxit]'
Acquired with the Solly Collection, 1821
Cat. no. 69

Fra Filippo Lippi was only about five years younger than Masaccio, whose works strongly influenced him, particularly the frescoes in the Brancacci chapel in S. Maria del Carmine which Masaccio executed while Fra Filippo was a Carmelite monk there. However, his artistic career did not begin until after Masaccio's untimely death. In 1434 Filippo was in Padua, then from 1452 to 1464 he worked in Prato near Florence, and finally, from 1466, in Spoleto. With Fra Angelico, Domenico Veneziano, and Paolo Uccello, Fra Filippo Lippi was one of the leading Florentine artists of the mid-fifteenth century. His pupils included his son, Filippino, and above all Sandro Botticelli.

The Berlin panel was commissioned in 1459 by the Medici family to grace the altar of the chapel in their Florentine palazzo, planned by Michelozzo and built in 1444. The chapel, originally completely windowless and illuminated only by candles, has frescoes on the walls by Benozzo Gozzoli representing a procession of the Three Magi moving towards the Virgin depicted in Lippi's altarpiece. This compositional feature suggests they were conceived in connection with Filippo's altarpiece. After the Medicis were expelled from Florence in 1494, the painting was taken to the Palazzo della Signoria, but in the mid-sixteenth century it seems again to have been in the Medici palace. In its place today is a contemporary copy by the Pseudo Pier Francesco Fiorentino (active *c*.1474–97).

The Adoration of the Child in the Forest is related compositionally and iconographically to two other altarpieces which Filippo Lippi executed during the 1450s and early 1460s – a panel for the altar of the Annalena Convent (Florence, Uffizi) done shortly after 1453; and a painting commissioned about 1463 by Piero de' Medici's wife for a cell in the convent of Camaldoli in the Casentino, east of Florence. All three paintings include a hermit in a monk's habit, witnessing the miraculous event deep in prayer. In the Berlin panel, this is St Bernard of Clairvaux, the founder of the Cistercian order. The two Medici panels have an additional figure representing the youthful John the Baptist, patron saint of Florence, but they do not include the figure of Joseph.

View inside the chapel
Florence, Palazzo Medici-Riccardi

The motif of the Virgin kneeling to adore the Christ Child on the ground, was inspired by such mystical writings of the fourteenth century as the *Visions* of Johannes de Caulibus, a Franciscan monk, and the Revelations of St Birgit of Sweden (1303–73). Both saw visions in which the Christ Child lay not in the manger but naked on the ground, with Mary kneeling beside him. In the painting, this mystical element is combined with the idea of penitence, embodied by the infant St John. The axe plunged into the tree stump at the lower left alludes to John's preaching to the multitudes, 'And now also the axe is laid unto the root of the trees: every tree therefore which bringeth not forth good fruit is hewn down, and cast into the fire' (Luke 3:9; Matthew 3:10). 'The intimate mood of this scene and its use of medieval symbolism indicate a revival of mystical tendencies and a turn to deeper and more personal religious feeling both of which can also be discerned in mid-fifteenth-century Netherlandish painting' (R. Oertel).

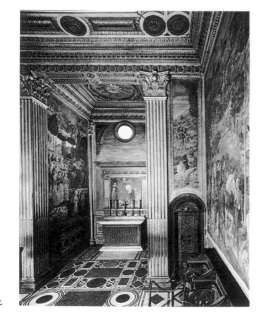

292

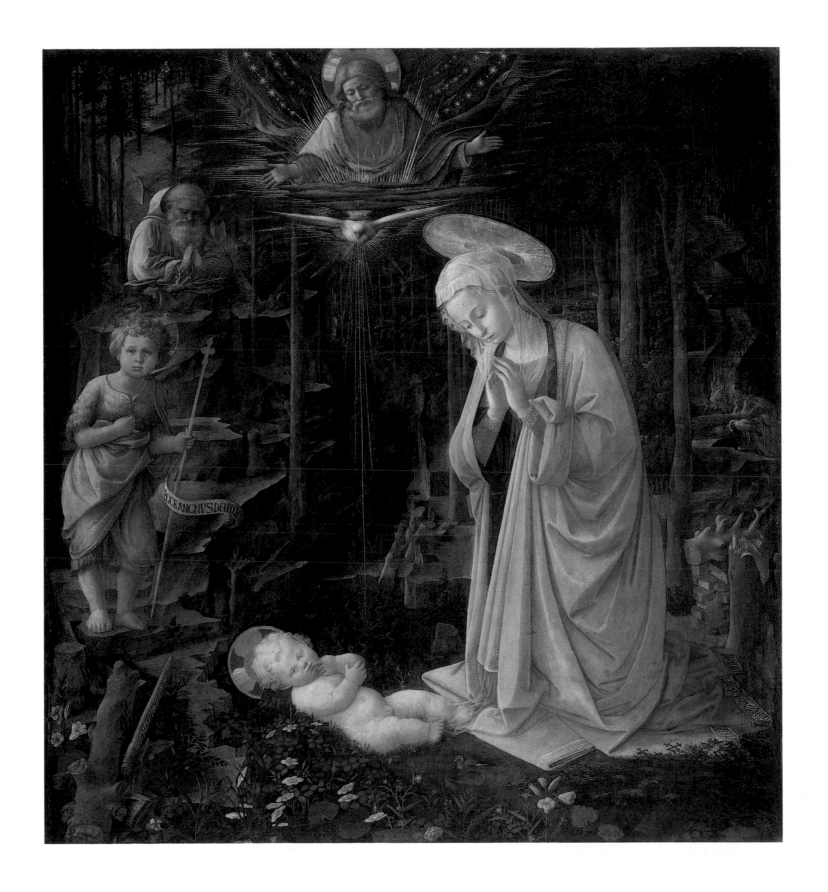

Antonio del Pollaiuolo (*c.*1431–98)
Portrait of a Young Woman in Profile
*c.*1465–70

Poplar, 52.5 × 36.5 cm (20⅝ × 14⅜ in)
Acquired 1894
Cat. no. 1614

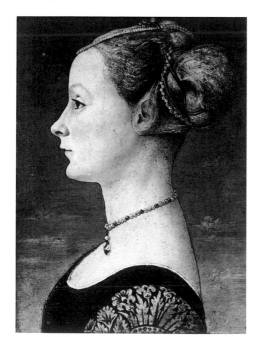

Antonio del Pollaiuolo
Profile Portrait of a Young Woman
Milan, Museo Poldi Pezzoli

This *Portrait of a Young Woman in Profile* is not only among the most popular paintings in the gallery, it is one of the most famous female portraits of the early Italian Renaissance. Yet nothing is known about its origin and history before 1800, and nothing certain about who painted it. After almost one hundred years of research since the painting came to light in 1894, art historians still disagree about its authorship. Initially it was considered to be a work by Piero della Francesca. Then, in 1897, recognizing its affinity to a profile portrait of a young woman in the Poldi Pezzoli Museum in Milan, also attributed to Piero della Francesca, Wilhelm von Bode ascribed both portraits to Domenico Veneziano. The gallery retained this attribution until 1972, though it had found little agreement from the beginning (Longhi, 1917; Van Marle, 1932) and today it must be considered invalid. After Berenson had given the portrait first to Verrocchio and then to Baldovinetti, in 1911 Adolfo Venturi attributed it to Antonio del Pollaiuolo. Though this has been accepted as sound by the majority of scholars, a considerable minority believe that Antonio's brother, Piero, painted the portrait. Over the past forty years, in other words, its authorship has been disputed only between the two brothers – despite L. Ettlinger's relegation of the portrait group back to anonymity in 1963 and in his recent book on Pollaiuolo (1978). It is true that among the principal works of the two Pollaiuolo brothers, no direct and convincing comparison with the female profile portraits can be found. The attribution to Antonio is based on a close scrutiny of certain stylistic elements that are not only characteristic but represent advances over earlier Florentine profile portraits. In the Berlin panel, these include the slight turn of the shoulders towards the spectator with the face remaining in strict profile, and the manner in which the contours are set off against a background of blue sky that covers almost the entire pictorial field, down to a narrow marble balustrade with encrusted discs (comparable to those in the altar panel in the chapel of the Cardinal of Portugal, S. Miniato al Monte). Also, the precise painting of the garment's ornamental pattern would seem to point to Antonio's experience as a goldsmith, a sculptor in bronze, and a designer of embroideries. In all events, in its purity of line, nobility of pose, and self-assured dignity of expression, this portrait is certainly one of the highest achievements in the field of portraiture of the Florentine early Renaissance.

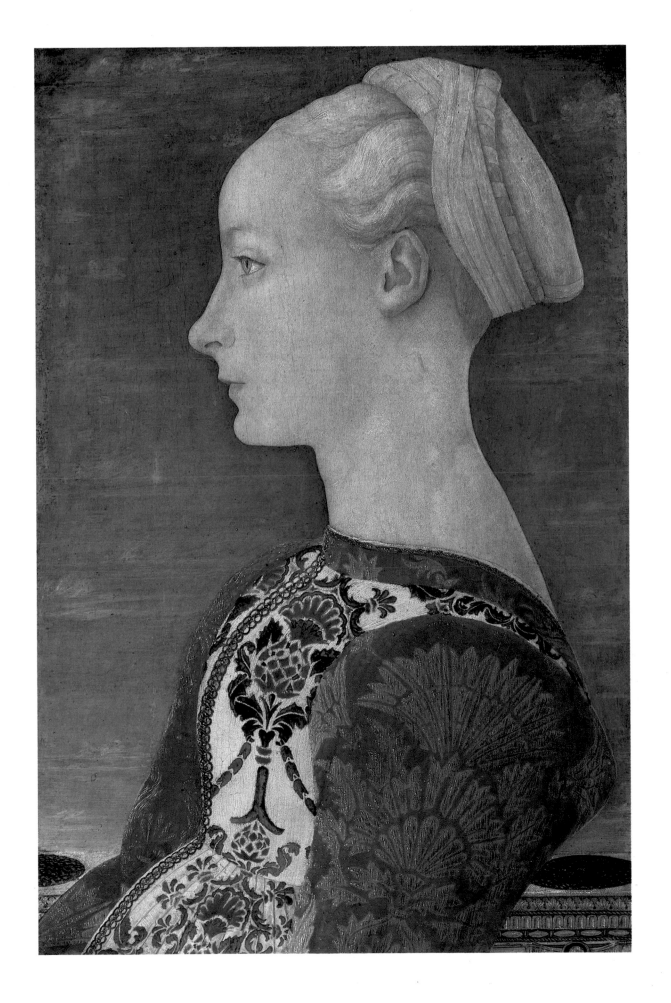

Piero del Pollaiuolo (1441–96)
The Annunciation
*c.*1470

Poplar, 150 × 174 cm (59 × 68½ in)
Acquired with the Solly
Collection, 1821
Cat. no. 73

Piero del Pollaiuolo was ten years younger than his more gifted and renowned brother Antonio. And unlike Antonio, who was primarily a goldsmith, sculptor, and designer, he (at least according to the pre-Vasari sources) was foremost a painter. Vasari tells us that he was a pupil of Castagno, though he can only have been fifteen or sixteen years old when Castagno died in 1457. In 1466 Piero collaborated in the decoration of the chapel of the Cardinal of Portugal in S. Miniato al Monte, Florence, followed in 1469 by the important commission to paint six *Virtues* for the hall of the Arte della Mercanzia; in this project his brother Antonio managed the workshop and was responsible for the quality of the work and the punctuality of its execution. Membership in the Compagnia di San Luca, the artist's guild, followed in 1473, and in 1483, finally, Piero signed and dated his altar panel in S. Agostino at San Gimignano.

The *Annunciation* is generally regarded as a work of Piero's, and is dated about 1470 on the basis of its close similarities with his *Virtues* in the Mercanzia. Both main figures are in the foreground, very close to the picture plane, in an ante-room separated by a step from the room behind, which is divided into sleeping and dressing chambers. Each figure appears against the backdrop of one compartment of the partitioned room. The angel, powerfully winged and clad in a red mantle and a green gown trimmed with pearls and precious stones in golden settings, kneels before the Virgin with a long-stemmed lily in his left hand, raising his right in salutation. Mary, seated on a folding chair encrusted with precious stones, wears a light blue mantle lined in reddish-brown over a gold embroidered gown. A little book on her knee, she receives the angel's message with her hands devoutly put over her breast. The background is certainly the most brilliant rendering in any known painting of a noble interior in the Florentine Early Renaissance style. This partitioned room on the *piano nobile* of a villa on the hills north of Florence is a *tour de force* in one-point perspective. The right angles lead the eye past the exquisitely patterned walls, where in the room on the left an open arcaded window reveals a distant view of the Arno Valley and the walled town of Florence, with cathedral and Palazzo della Signoria. The vanishing point lies approximately on the horizon, near the blue mountains above the Palazzo Vecchio. Leading up to the villa is a curving path along which horsemen approach. The two chambers have geometrically patterned stone floors, coffered ceilings, and walls divided by pilasters, with red bays at the left and elaborately embossed leather wall-coverings in the sleeping chamber at the right. Next to its richly decorated bed, a door in the rear wall leads to a loggia-like room where three angels kneel, playing musical instruments. Visible through the window of this loggia room are other fine houses dotting the distant hills.

The original destination of this large panel is obscure. Cruttwell, in his *Antonio Pollaiuolo* (1907), wrote that Lorenzo de' Medici might have ordered it for the altar of his chapel in his villa at Careggi, since its view of Florence was taken from the same point as that from the villa. Though the figures are generally attributed to Piero, the elaborate interior has been thought to reveal Antonio's hand, and indeed Busignani (*Pollaiuolo,* 1970) attributes the landscape to him.

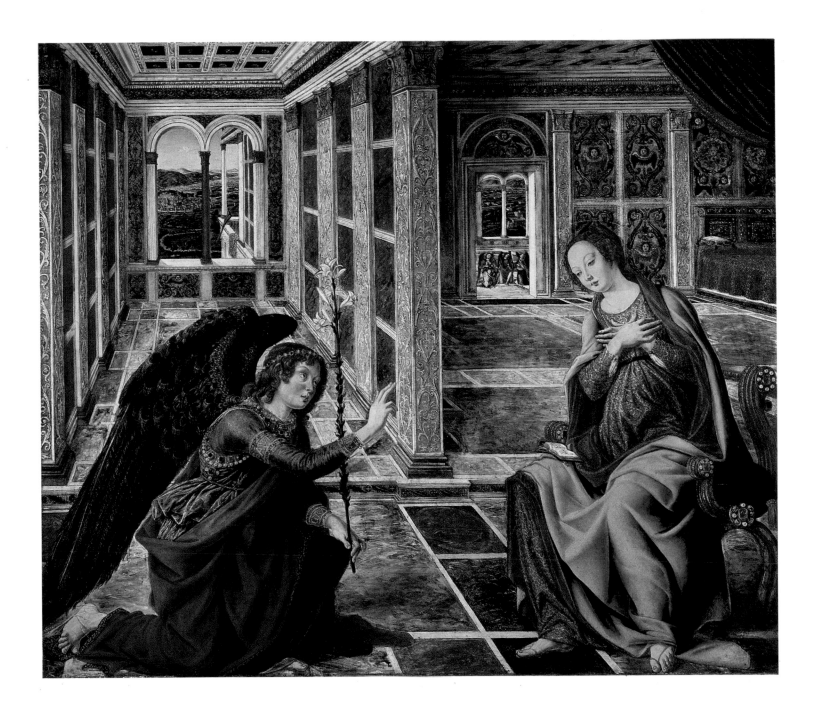

Andrea del Verrocchio (1435–88)
The Virgin and Child
*c.*1470

Poplar, 75.5 × 54.8 cm (29¾ × 21½ in);
original size of painted surface
68 × 51.5 cm (26¾ × 20¼ in), new strips of
wood added at top, right, and bottom
Acquired 1873
Cat. no. 104 A

Though Verrocchio originally trained as a goldsmith, it was his sculptures, particularly bronzes, that made him famous. We are less well informed about his activity as a painter. In 1468 he is recorded as having executed a banner, now lost, for the Medici *Giostra* in honour of Lucretia de' Donati. Only two existing works can be associated with him through documents or other sources: an altarpiece of *The Madonna with Saints* in Pistoia Cathedral, ordered from him in 1479 but executed by his workshop, mainly by Lorenzo di Credi, and not finished until 1485; and a *Baptism of Christ* painted for S. Salvi in Florence (now Uffizi), which he began around 1470 and on which his pupil, Leonardo da Vinci, worked in about 1476, painting an angel in profile and also part of the landscape background. The figure of the Baptist in this work provides the basis for our evaluation of Verrocchio's activity as a painter. He had a large workshop, which besides Leonardo included Lorenzo di Credi and Perugino, and he influenced numerous Florentine artists, among them Domenico Ghirlandaio, Francesco Botticini, and Cosimo Rosselli. A group of Madonnas has survived that were previously attributed to him, but though some have been given back to him recently (Oberhuber, 1978), most of them are now attributed to Ghirlandaio and Perugino. These Madonnas are compositionally related to Verrocchio's marble and terracotta reliefs of the subject, and some similarities between individual paintings have led to their classification in sub-groups. Among the questioned Madonnas is a Berlin panel (Cat. no. 108) which, though generally attributed to Perugino or Ghirlandaio, has recently even been called a work of the young Botticelli. These attributions are still highly controversial. The only Madonna panel which by relatively wide consensus is now ascribed to Verrocchio himself, is the one illustrated here.

It shows Mary seated before a mountainous landscape, turned slightly to the left and visible to the knees: in her lap the Christ Child extends his arms to her with a vivacious gesture. Berenson (*Bollettino d'Arte*, 1933–4) considered it the earliest by Verrocchio and dated it between 1467 and 1470; Passavant (*Verrocchio*, 1969), agreeing on a date of 1468–70, maintained that it was the only piece by his hand in the entire group of similar Madonnas. Oberhuber (*Revue de l'Art*, 1978), whose attempt to expand the Verrocchio œuvre and return some of the Madonnas to him has not sparked much agreement, dated the panel to the 1470s and, in its rhythmic flux of line and strong modelling, detected the influence of Antonio del Pollaiuolo. This he explained by Verrocchio's contact with Polliauolo – in this case, Piero – during his work on the *Virtues* in the *Arte della Mercanzia* in Florence (1469). Oberhuber, noting a difference in quality between the heavy rendering of the Child and the more delicate modelling in the head of the Virgin, concluded that the artist's workshop may have participated in the execution. Also Shearman (*Burlington Magazine*, 1967) emphasized the uneven quality and attributed the execution to Botticini. Fahy (*The Legacy of Leonardo*, 1979), who accepts the work as authentic, has pointed out that Leonardo's Munich *Madonna* (*c.*1476) owes much in terms of motif and composition to his teacher's work of about six years before.

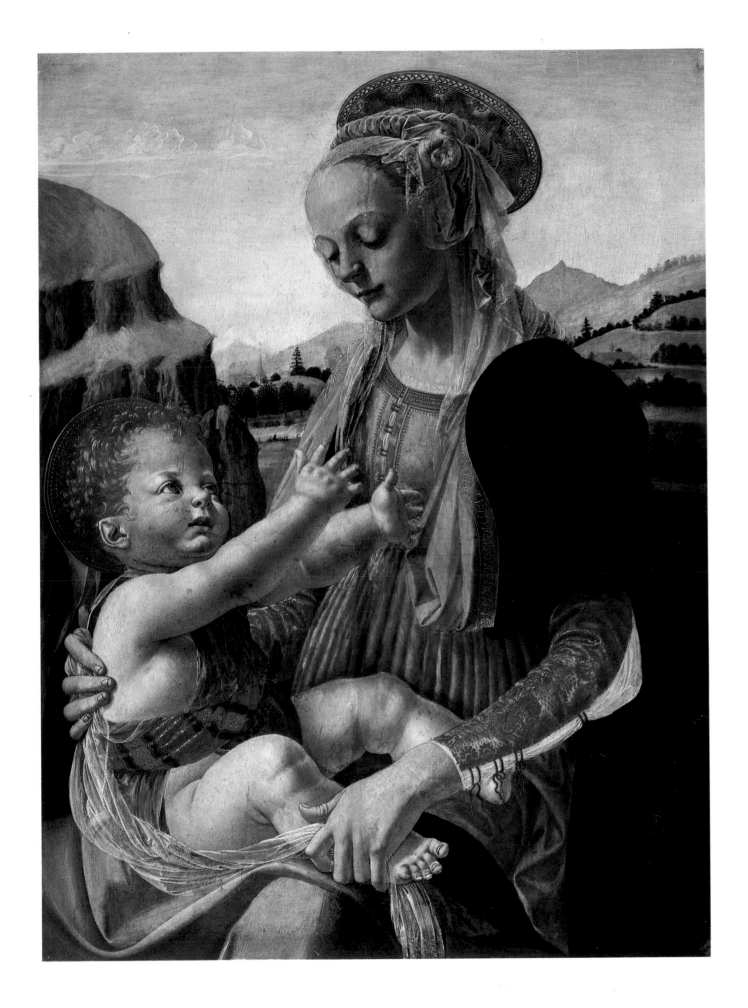

Sandro di Mariano Filipepi, called Botticelli (1445–1510)
The Virgin and Child Enthroned with the Two Johns
1484

Poplar, 185 × 180 cm (72⅞ × 70⅞ in)
Acquired through Rumohr in Florence,
1829
Cat. no. 106

Botticelli, probably the most famous Florentine artist of the late fifteenth century, is represented in the Berlin Gallery by six works, though three of them are admittedly only workshop paintings or replicas. Of the three others, his *St Sebastian* from S. Maria Maggiore is perhaps the greatest masterpiece. The most splendid, best preserved and documented – and the one whose original context is still easily accessible today – is this altarpiece for the Bardi Chapel in S. Spirito, Florence. It was executed for the Florentine merchant Giovanni d'Agnolo de' Bardi, who lived in England for over twenty years, where he worked as the managing partner of the London branch of the Medici bank. Returning to Florence in 1483, he had a family chapel built in S. Spirito, on the back wall of the choir of this church which was designed by Brunelleschi.

The erection of the chapel and its altar owes its existence to a fire that ravaged the church in 1471, destroying most of its interior decoration. The families who owned patronage rights to individual chapels had no choice but to finance their complete refurbishment. By March 1484 the stone-masons had finished their work on the altars and orders for altar paintings could go out.

The Bardi Chapel altar in its tall and shallowly rounded niche beneath a high window – exactly at the far end of the left side-aisle extension and visible from there – was among the new chapels erected in the niches of the choir and the transept, most of which still exist and have their original tabernacle frames. Such renowned artists as Filippino Lippi, Raffaellino del Garbo, and Cosimo Rosselli, but also lesser known ones like the anonymous Master of S. Spirito, received commissions for altar paintings. Unlike the majority of chapels in the transept, whose original altars have survived, the four altars on the back wall of the choir, including that in the Bardi Chapel, had new, larger, upright rectangular altar structures built in the late sixteenth and on into the seventeenth centuries. Botticelli's altar painting was replaced by a new one, with a quite different theme, by the Florentine Baroque painter Jacopo Vignali (1592–1664). When the Bardi family reclaimed Botticelli's painting, its original carved frame, designed by Giuliano da Sangallo, was apparently lost. Only the original *paliotto* remained *in situ* on the front of the altar table, with a depiction of John the Baptist, patron saint of the chapel, in an octagonal field. In 1825 the Bardis sold Botticelli's altarpiece to the dealer F. Acciaj, from whom it was bought in 1829 for the Royal Museums by Karl Friedrich von Rumohr.

Botticelli has painted Mary enthroned with the Child on a stone bench faced with marble, flanked by the standing figures of John the Baptist and John the Evangelist, the saints most revered by the artist's patron. The place of honour at the Virgin's right is held by the Baptist, titular saint of the chapel, Bardi's name saint, and patron saint of Florence. In terms of composition, the image is a classical example of the *Sacra Conversazione*, the Madonna seated and 'conversing' with the saints beside her, who recommend the faithful into her protection. The figures stand out against a background of abundant and thick-grown vegetation – three arbours in the shape of niches made of intertwined palm fronds, cypress branches, and branches of myrtle, with roses, lilies and olive branches in vases on the parapet in front of them. Banderoles wound among the foliage, bearing Latin citations from the Book of Ecclesiasticus, refer to the medieval belief that the Virgin Mary was the seat of divine wisdom.

Florence, Santo Spirito
Choir gallery with the Bardi Chapel

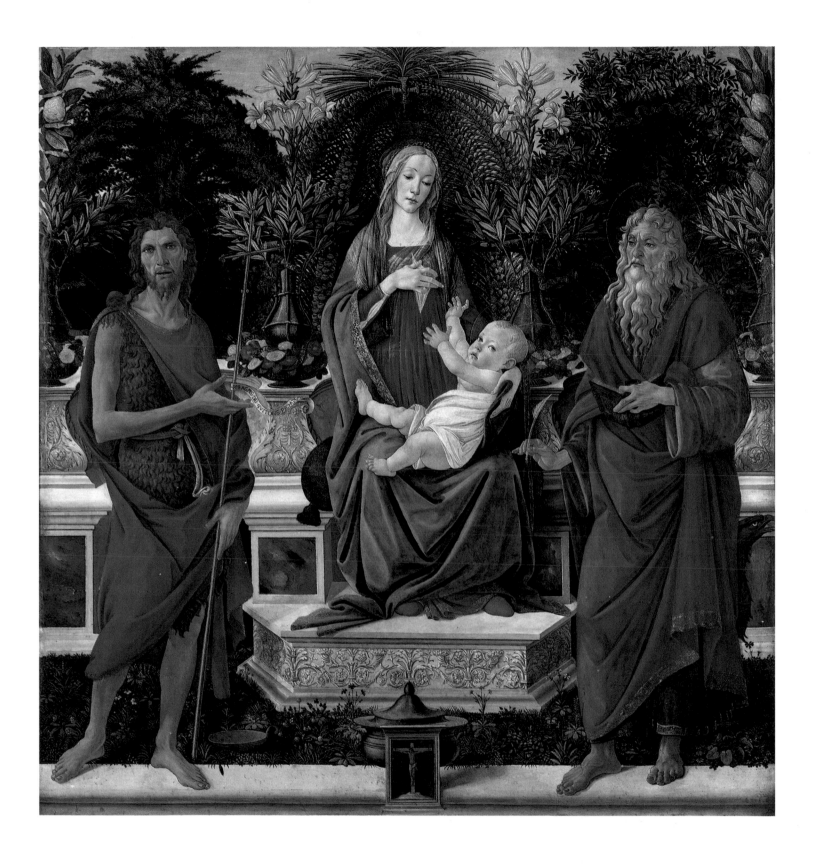

Piero di Lorenzo, called Piero di Cosimo (1461/2–1521)
Venus, Mars and Cupid
*c.*1505

Poplar, 72 × 182 cm (28¾ × 71⅝ in)
Acquired through Rumohr, 1828
Cat. no. 107

Piero di Cosimo 'painted a picture in which Venus and Mars, undressed, are asleep in a flower-strewn meadow; around them are various little gods of love who carry away the war god's helmet, arm-guards, and other weapons; we see a myrtle bower and Cupid frightened by a rabbit, and the doves of Venus and other symbols of love have not been forgotten. This work is in the house of Giorgio Vasari in Florence, who preserves it in memory of Piero, as he has always found pleasure in his curious inventions.' This is Vasari's description in 1568 of the painting he once owned, which is now in Berlin. Though nothing is known about the work's original destination, its theme and composition were certainly inspired by Botticelli's painting in the National Gallery, London, which is almost identical in format and was presumably ordered on the occasion of a marriage in the Vespucci family. Piero's painting may well have been done for a similar occasion. However, there are obvious differences between the two compositions. In Botticelli's the figures are crowded with much overlapping into the front of the narrow horizontal format, almost as if in a relief, and the landscape background, the myrtle bushes to left and right, and the lake between them, have a flat, abstract character, like a foil or backdrop. Piero's composition is less tight, with a greater feeling of space. The figures, whose contours at no point overlap, are truly bedded in the foreground of a landscape that extends unimpeded past the *amoretti*, playing with Mars's weapons in the middle distance, to the shores of a bay on the far horizon. Botticelli, by contrast, shows satyrs at war games, very close up, and one of them blows on a conch in Mars's ear to rouse the exhausted god to new fervour, for which Venus seems to be waiting (C. Gould, review of Lightbown, *Botticelli*, *Apollo*, 1978). Piero leaves out the satyrs and tones down the rather dramatic erotic allusions, and has small Cupids playing with the weapons in the background instead. And he introduces the new motifs of a pair of doves (Venus's symbol) and Cupid with a rabbit nestling against his hand. The rabbit is a symbol of fertility that refers to Venus, and it also has specific sexual meaning (*cuniculus* – *cunnus*: rabbit – vulva; cf. P. Barolsky, *Infinite Jest*, 1978). Venus is not draped as in Botticelli's painting but is almost nude; her eyes are open, but she leans back in a more relaxed attitude, not watching over Mars and impatiently awaiting his revival as she does in the Botticelli version. The pose of the sleeping Mars, which Botticelli may have derived from a terracotta figure by Verrocchio (Berlin), is quite different in Piero's painting – more feminine, more closely related to that of Venus.

The theme goes back to classical antiquity. An association of the union of Mars and Venus with the harmony and fertility of nature is found in Reposianus's *De concubitu Martis et Veneris* of the third century AD, and it crops up again in the late fifteenth century, in Giovanni Pontano's *Eridanus*. These sources can in turn be traced back to Lucretius (d.55 BC) and his *De rerum natura* (Panofsky, *Studies in Iconology*, 1939). The key motif of the painting is the triumph of love over war, the calming, domesticating influence of Venus on the belligerent Mars. It has been associated with verses in the *Stanze per la Giostra* by the poet Angelo Poliziano, a friend of Lorenzo de' Medici, and its theme inspired Neo-Platonic philosophers of the Early Renaissance to far-reaching moral and cosmological speculations (E. Wind, *Pagan Mysteries in the Renaissance*, 1958). Peaceful Venus was said to love Mars because opposite temperaments attract each other: the daughter born of their union, called Harmony, represented *discordia concors*, discord brought to concord. Marsilio Ficino (1433–99), a member of the Platonic Academy in Florence, interpreted the theme from an astrological point of view, saying that Venus, the planet, watched over the planet Mars and overcame its destructive forces, but that Mars could never overcome Venus (Gombrich, *Journal of the Warburg and Courtauld Institutes*, 1945).

In 1480 Piero di Cosimo assisted in the workshop of Cosimo Rosselli, the artist from whom his working name derives. He is said to have accompanied Rosselli to Rome in

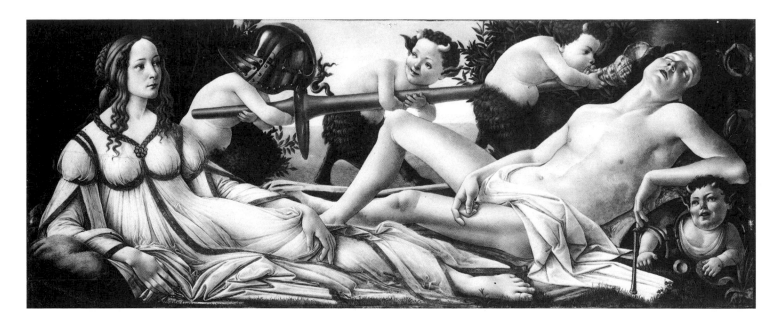

1481–2, and helped on his frescoes in the Sistine Chapel (1482–4). But much more important than the training he received from his teacher, an artist of limited talent, was the profound influence of Filippino Lippi's lively and highly expressive style. The penetrating realism of the figures in Hugo van der Goes's *Portinari Triptych*, which arrived in Florence in 1483 and was installed in S. Egidio, also made a lasting impression on the young Piero. Later he was also influenced by Ghirlandaio, Signorelli, and, as his biographer Vasari has written, by Leonardo da Vinci. Vasari describes Piero's eccentric, almost neurotic personality, which led to an increasing isolation from his contemporaries. He only belonged to the *Compagnia de San Luca* for a few years (1503–5), and though he applied for membership in the artists' guild *Arte dei Medici e Speziali* in 1504, he resigned the following year. The original, quite unacademic aspects of his art and the unorthodox and non-conformist style of his life have often been described. He was active in a period of political, intellectual, moral and religious crises marked by the expulsion of Piero de' Medici from Florence in 1494 and the rise of the Dominican monk Savonarola, who was convicted in 1497 and put to death in 1498. Evidently, Piero di Cosimo not only worked for the Medici and the families of their circle but also for the prosperous Del Pugliese, a family of rich merchants who opposed the Medici, supported Savonarola, and rose to public office towards the close of the century; he worked, too, for the Capponi, Vespucci and Strozzi families. Vasari emphasized Piero's imaginativeness and the bizarre character of his genius, which showed particularly in his secular imagery, and in his cycles with mythological themes as in this Berlin painting.

Sandro Botticelli
Mars and Venus
London, National Gallery

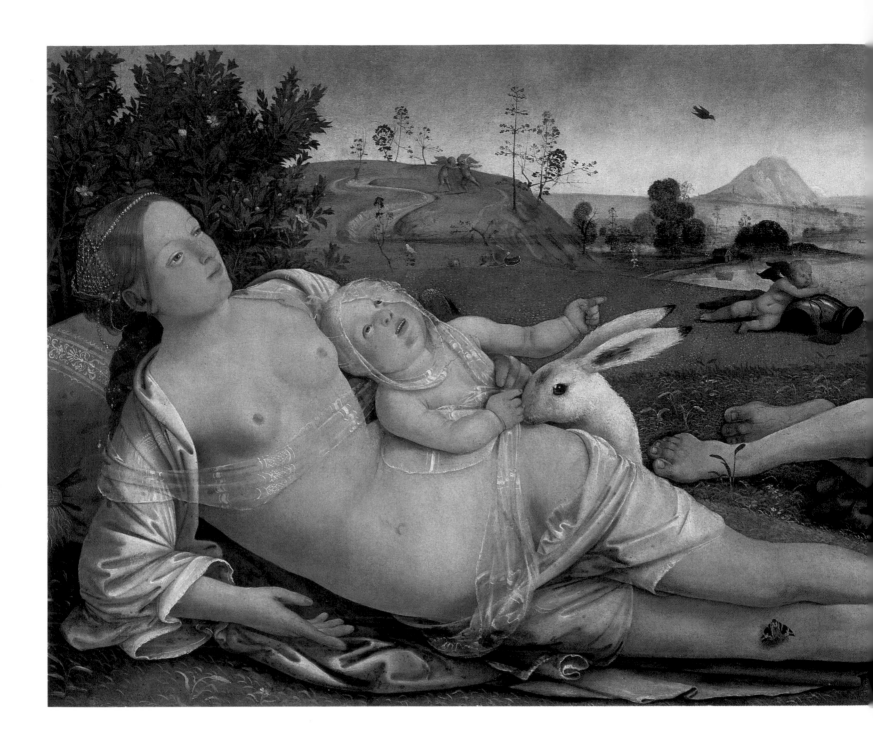

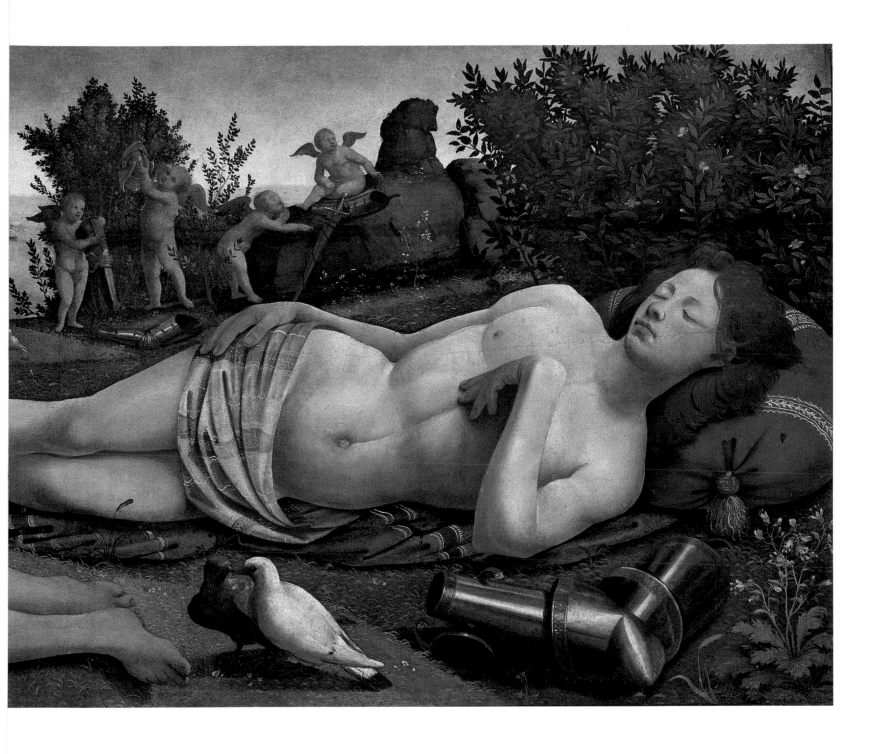

Raffaello Sanzio, called Raphael (1483–1520)
The Virgin and Child with the Infant St John
1505

Poplar, diameter 86 cm (33⅞ in)
Acquired from the Collection of the
Dukes of Terranuova, 1854
Cat. no. 247 A

Raphael
Composition Drawing
Lille, Musée des Beaux-Arts

after Raphael
Copy after *Composition Drawing* in Lille
Berlin, Kupferstichkabinett SMPK

All five Raphael Madonnas in the Berlin Gallery were acquired in the first half of the nineteenth century, from 1821 to 1854. Almost all of them are early works. Three stem from Raphael's Umbrian period, and the *Madonna Terranuova* from the beginning of his Florentine period (about 1505). Only the *Madonna Colonna* dates from the end of the Florentine period (1508); shortly before Raphael left for Rome. By the time the Berlin Museum was founded and began building its collection, Raphael's mature works were no longer available, having long before entered princely, royal and imperial collections (in Florence, Paris, Dresden, Munich, Vienna, etc.). The Berlin Gallery shares its involuntary emphasis on the early œuvre with two other public collections that were not founded until the nineteenth century; the National Gallery in London, and the Metropolitan Museum in New York.

Of the Berlin Madonnas, the *Madonna Terranuova* (named after the collection from which it was acquired) is the largest, most imposing, and most important, besides being the only one in tondo form. Except for the slightly earlier *Madonna Connestabile* of 1504 (Leningrad), it is the artist's first circular painting, a format he was only later to master fully. Interestingly, the painting was based on a pen drawing (Lille) with a rectangular composition in which the Virgin and Child with the infant St John are flanked by two further background figures, an angel (Michael) and St Joseph. This left no room for a landscape. The drawing was later trimmed to a semicircular shape at the top; a large section of the original rendering with the Child's legs, the Virgin's left forearm, and Joseph's hand was missing and has been restored by another hand. Though a contemporary copy of the drawing in Berlin (KdZ 2358) is believed to record the Lille drawing's original state, there are certain obvious differences. In the Berlin drawing, the Madonna's left forearm and open hand emerge from beneath her mantle, as in the painting, while the Lille drawing shows her entire arm uncovered and no mantle. There are similar discrepancies with Joseph's hands. Since the Berlin copy diverges from the original, it would be misleading to draw conclusions from it about the missing corner of the drawing at Lille. In fact, the Berlin drawing represents a later stage of Raphael's development of the composition. The question remains whether he intended the Virgin's left hand in the Lille drawing to extend to the right, as in the painting, or to hold the Child, as the early copyist who restored the original drawing believed. A fragment of the full-size cartoon with the head of the Madonna is also in the Kupferstichkabinett (KdZ 11659).

The composition with the Virgin flanked by two saints corresponds to an Umbrian design of the late fifteenth century, which Raphael adopted from Perugino (painting in the Louvre, dated 1493) and used in modified form in his earlier painting of 1502 (Berlin, no. 245). After deciding on the tondo format for the *Madonna Terranuova*, he left out the flanking saints (which he must have thought antiquated), and divided the background exactly along its horizontal axis into a lower half occupied by a parapet and an upper half with landscape under an expanse of sky, against which the contours of the Madonna's head and shoulders stand out in sharp contrast. Then, by offsetting the figure of the infant John at the left with a second figure of a semi-nude boy with halo at the right, he created a pyramidal or triangular composition of a type he was later to use often. The identity of this new figure is still obscure, though some commentators have suggested James the Lesser (Mark 15:40).

The soft *sfumato*, the gestures, which are freer and more expanding than those in earlier Umbrian Madonnas, the increased sense of space, and the more elaborate landscape, in which northern elements have been detected, reveal the influence of Leonardo da Vinci, who returned to Florence from Milan in 1503. Raphael was deeply impressed by Leonardo's art. As E. Fahy has noted (1979), the Madonna's gracefully extended left hand here was inspired by Leonardo's *Madonna of the Yarnwinder* (1501, known from copies).

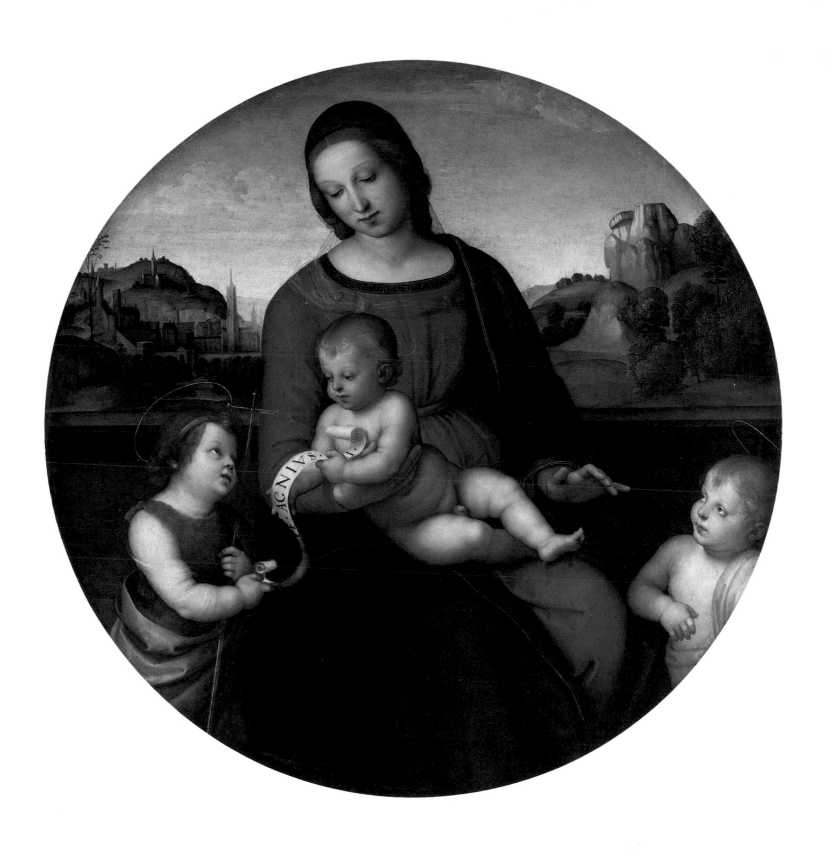

309

Giovanni Battista di Jacopo, called Rosso Fiorentino (1495–1540)
Portrait of a Young Man
*c.*1517–18

Poplar, 82.4 × 59.9 cm (32½ × 23½ in; including later additions), original dimensions 75.7 × 57.1 cm (29¾ × 22½ in)
Collection of the Marchese Patrizi, Rome
Acquired 1876
Cat. no. 245 A

Rosso Fiorentino was surely the most eccentric painter of early Florentine Mannerism. Like Pontormo, he was in conscious opposition to the classicizing art of Andrea del Sarto, who followed the tradition of Fra Bartolomeo. In this he had a particular affinity with Alonso Berruguete, a Spanish artist who worked in Florence from 1508–12 (perhaps to 1518) and who enjoyed Michelangelo's support. Rosso became a member of the Artists' Guild in 1517, and soon was working on the *Assunta* fresco in the forecourt of SS. Annunziata, and on an altarpiece for S. Maria Nuova (1518, now in the Uffizi). The Berlin *Portrait of a Young Man* also dates from his early period. Silhouetted against a background landscape, the seated model is in three-quarter view, his head turned back to face the viewer with what seems to be a scornful glance. His face is framed by long brown hair falling from beneath a flat, black barett. His angled left arm is supported by his hand at his waist, and his long slender fingers, emerging from the voluminous sleeve in greyish-black patterned damask, are parallel to the lower edge of the picture, stressing its horizontal line. His right hand, toying with the seam of the blackish-brown, fur-lined over-garment, has a large and very conspicuous ring on its index finger. Illuminated from the left, this hand forms a bright tone in the corner of the dark surface of the garment.

The painting was earlier attributed to Franciabigio. Its attribution to Rosso, suggested by Phillips in 1911, has since been widely accepted, with the exception of J. Shearman (*Andrea del Sarto*, 1965), who thinks it could be by Berruguete. In the pose and use of a landscape background, the artist uses a portrait type that was frequently employed in Florence by Andrea del Sarto and Franciabigio, and that goes back to Raphael's *Angelo Doni* (Florence, Galleria Palatina). Though the strange shift of the head out of the axis of the torso to the left is found in portraits by Franciabigio and Berruguete, it occurs in no other painting by Rosso. S. Freedberg writes that the sitter's expression gives '... no sense of a pacific and mutually interested inspection, as in Raphael's or Andrea's portraits, or of such deeply sympathetic interchange between sitter and spectator as in Pontormo's. Rosso's sitter inverts the normal relationship between spectator and the portrayed subject: he aggressively examines us, but does not permit us to examine him. We can look at him only with unease, and with the sense that association with him, even in this purely psychological world of art, might be dangerous: he is a male and anti-classical inversion of the *Mona Lisa*.'

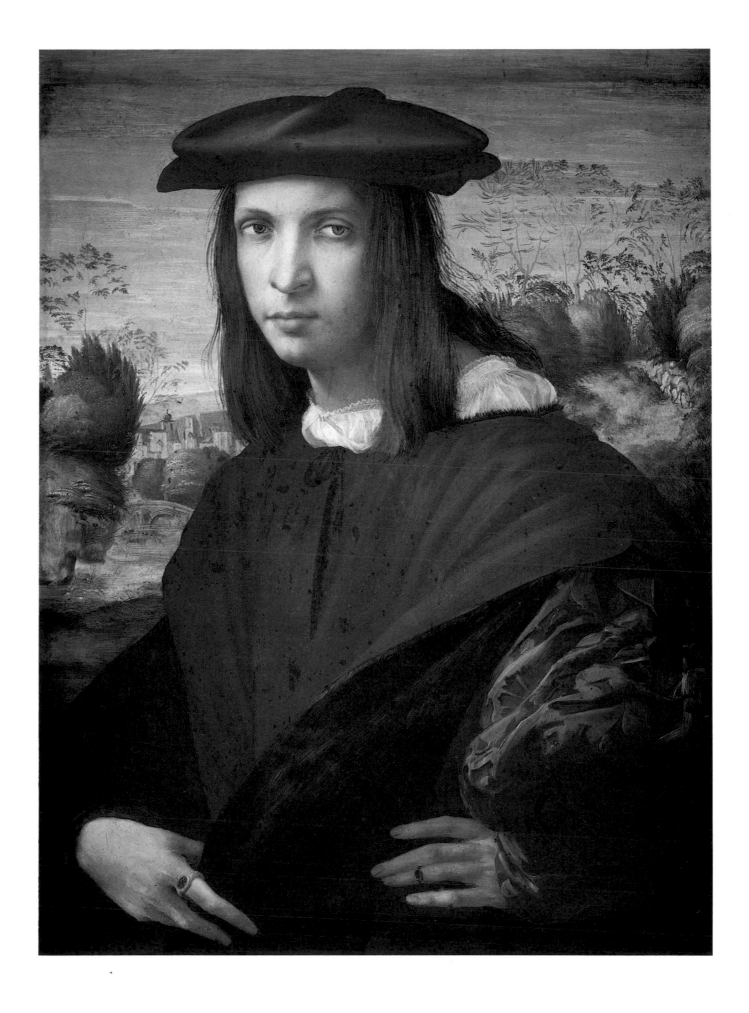

Agnolo di Cosimo di Mariano, called Bronzino (1503–72)
Ugolino Martelli
*c.*1535–6

Poplar, 102 × 85 cm (40⅛ × 33½ in)
Signed: 'BRONZO FIORENTINO'
Acquired in Florence, 1878
Cat. no. 338A

Bernardo Rossellino
David Martelli
Washington, National Gallery of Art

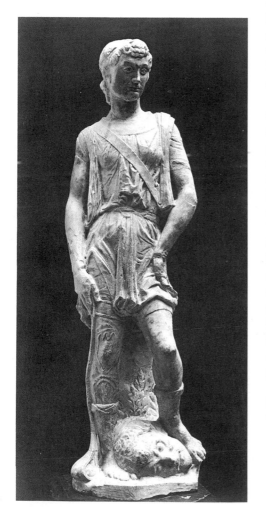

Pupil of Pontormo from 1522–6 and his assistant into the 1530s, court painter to Duke Cosimo I de' Medici from 1539–40, Bronzino became probably the most prominent portraitist of Florentine Mannerism, particularly under Cosimo. After the Siege of Florence, Bronzino went to the court of the Duke of Urbino, Francesco Maria della Rovere, where he worked from 1530–2. Between his return to Florence in 1532, and Cosimo's accession in 1537 and marriage with Eleonore of Toledo in 1539, Bronzino's art and career underwent transition and consolidation. By the latter half of the 1530s his portraits were more admired, and more in demand by the leading Florentine families, than those of any other artist. Yet of the long series of portraits of this period mentioned by Vasari, only a few have come down to us. Among the most important is that of the young *Ugolino Martelli* (1519–92), son of Luigi Martelli and Margherita Soderini, and a leading humanist and man of letters at the time.

Martelli is depicted among his books, at about the age of seventeen, which would date the portrait at about 1535–6. He is wearing a voluminous high-necked smock gathered at the waist and made of a dark olive-grey material that looks almost black, and close-fitting slashed trousers, and a flat, black barett. The scene is the courtyard of his father's palace, which was designed by Domenico d'Agnolo. A green cloth lies across the rose-coloured top of the stone table next to him, and on it is a volume of Homer's *Iliad*. The young man rests his hand on the open page, his finger at the ninth canto, which apparently he had just been reading when he was interrupted. At the far left edge of the painting is the corner of a volume of Virgil, marked with the letters [*Publius Vergilius*] MARO. Propped casually on Ugolino's knee is a book bound in blue, stamped with the name. M.P.BEMBO, the contemporary poet.

As in other Bronzino portraits of the period, the sitter is represented against an architectural background, whose perspective depth creates a tense contrast to the silhouette and static pose of the figure which is very close to the picture plane. And of these portraits, the background in his *Ugolino Martelli* is the richest and most logically constructed of all, a very accurate view of the Palazzo Martelli courtyard. Its perspective lines converge on a statue of David on the far wall at the left, a marble representing the *David Martelli* by Bernardo Rossellino after a wax modello by Donatello, to whom the marble was previously attributed. The marble is preserved in the National Gallery of Art in Washington. The perspective cone that opens out from the left background to the right foreground is, so to speak, capped by the sitter's figure, which interrupts the perspective lines and diverts them into the picture plane. This effect is heightened by the immobile calm of the sitter's pose and his cool, unapproachable expression and sidelong gaze, that might seem absent if it did not subtly reveal his awareness of the spectator's presence. The young man's attitude – seated at a table but with his legs stretching away from it and his upper body turned almost to face the front – is a highly artificial, stylized pose despite its apparent informality. It might well have been inspired by Michelangelo's seated figure of Giuliano de' Medici, a statue for the Medici Tombs in S. Lorenzo completed shortly before the present portrait.

Perhaps more compellingly than in any other portrait, Bronzino succeeded here in bringing his sitter to life, as John Pope-Hennessy has written, by portraying the individual 'in a physical setting ... and in an intellectual setting, too'.

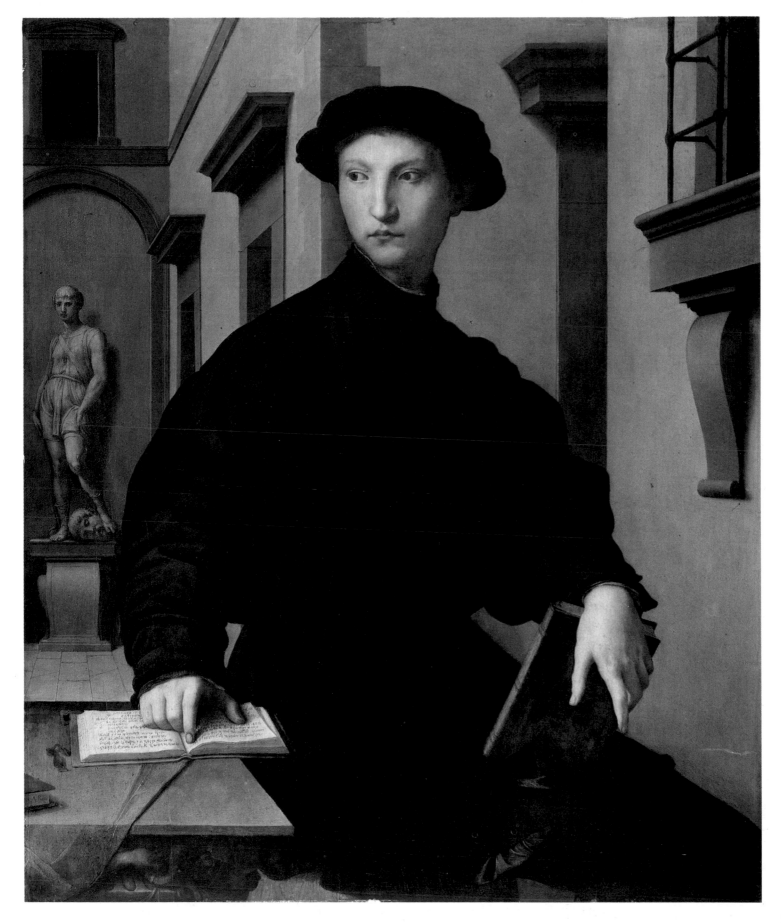

313

Ferrarese Master *c*.1450 (Angelo del Maccagnino?)
The Muse Polyhymnia as Inventor of Agriculture

Canvas (transferred from panel),
116.5 × 71 cm
Acquired 1894
Cat. no. 115 A

Though this panel is one of the most prominent paintings not only in the Berlin Gallery but of fifteenth-century Ferrarese art in general, its authorship is still uncertain, which is why it is illustrated here anonymously, as the work of a Ferrarese master of about 1450. Until recently, it was exhibited and catalogued (in 1978) as a Francesco del Cossa, but this attribution of Wilhelm von Bode's has been rejected by the majority of Italian as well as English art historians. The panel has also been ascribed by some to the almost mythical Galasso di Matteo Piva, an artist mentioned by Vasari who is recorded as having spent the years 1450–3 as a young painter in Ferrara and then worked in Bologna.

The young woman depicted here is a grape harvester, seen from a low vantage point against a hilly landscape with a low horizon and an expanse of pale blue sky. She stands with one foot on a stone step, shouldering a hoe and holding two ripe vines with her left hand while resting her right hand on a spade. Her statuesque pose and the pink gown with its twin girdles in the ancient Greek fashion point to the figure's allegorical significance. She was long thought to be a personification of Autumn or the month of October, when the vintage is gathered. Yet because of the plan for a cycle of the Muses outlined in 1447 by the great humanist philosopher, Guarino da Verona, in a letter to Margrave Leonello d'Este, she more probably represents Polyhymnia, the Muse celebrated as the inventor of agriculture. This interpretation is strengthened by the group of peasants threshing grain at the lower left.

Until recently, the work was thought to be among those associated with the decoration of a studio in Belfiore Castle outside Ferrara, which was owned by Margrave Leonello d'Este (who ruled in 1441–50) and his younger brother and successor, Duke Borso d'Este (who ruled 1450–71). These decorations were commissioned in 1447 from Angelo di Pietro of Sienna, called del Maccagnino, who did two paintings of the cycle. After his death in 1456, Cosmé Tura continued the project until about 1463. In 1483 the castle was demolished. According to contemporary sources (Cyriacus of Ancona, Lodovico Carbone), the sequence was devoted to the Muses, and was very probably based on the programme outlined in Guarino da Verona's letter.

Ferrarese Master (Angelo del Maccagnino?)
A Muse (Euterpe) and *A Muse (Melpomene)*
Budapest, Museum of Fine Arts

Recent research has led to a division of the group of paintings associated with the Muse cycle for the Belfiore *studiolo*. The first group, comprising figures of the Muses seated on thrones, apparently once decorated the room. The second group differs in representing the Muses from a very low vantage point: they stand in a landscape against the sky. The Berlin *Polyhymnia* and two panels in the Budapest Museum, *Euterpe* and *Melpomene*, belong to this group. These three paintings apparently formed part of another cycle devoted to the Muses. Though their original purpose and circumstances remain obscure, they have been hypothetically attributed to Angelo del Maccagnino (M. Boskovits, *Burlington Magazine*, 1978).

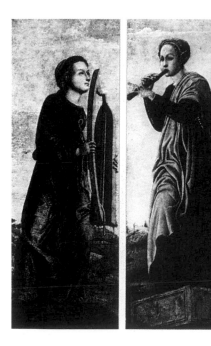

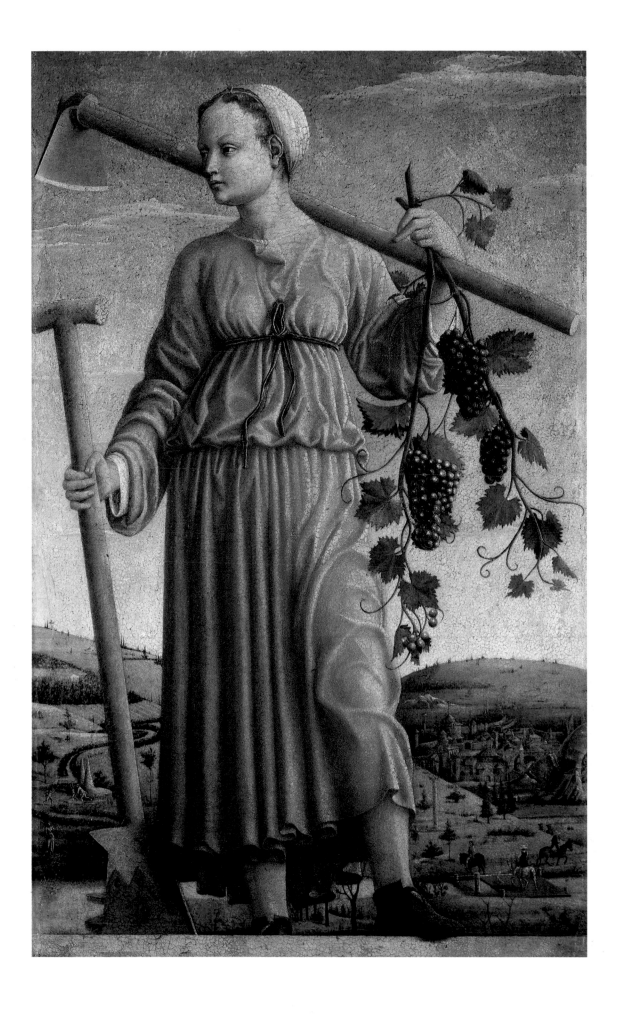

Andrea Mantegna (1431–1506)
The Virgin and Sleeping Child
1466–7

Canvas, 43 × 32 cm (17 × 12⅝ in)
Acquired as a donation from James
Simon, 1904
Cat. no. s 5

Born in 1431 near Padua, Mantegna was the same age as Giovanni Bellini, who became his brother-in-law in 1453 or 1454. Of all the painters of his generation who came from Venice or the Veneto, Mantegna was surely the greatest Quattrocento master, beside Giovanni Bellini. His interest in classical antiquity was awakened by the humanism of Padua University. His work reveals a profound understanding of classical architecture, sculpture and epigraphy. Trained in Padua from 1441–8 by his adoptive father, Francesco Squarcione, Mantegna was influenced by Donatello, who was active in Padua from 1443–53, as well as by Antonio Vivarini, Jacopo Bellini, and Andrea del Castagno's Venetian frescoes (S. Zaccaria, 1442). In 1459 he moved to Mantua, where he became court painter to Margrave Lodovico Gonzaga and his successors. He travelled to Florence in 1466, and worked in Rome in 1488–90.

In the Berlin Gallery Mantegna is represented with three masterpieces. The most intimate, delicate, and poetic of these is certainly his *Simon Madonna*, which came to the gallery in 1904 as part of a generous donation from the Berlin collector, James Simon. It is painted in distemper on unprimed canvas, a technique used in Mantegna's time by few other artists, and the paint has been applied very thinly, leaving the fine texture of the canvas clearly visible.

Dressed in a simple, dark blue gown with a neckline cut low at the back, the Virgin gently holds the sleeping Child to her breast, supporting his head in her right hand and nestling it to her cheek; her face is turned so that it brings a diagonal into the composition. A mantle of exquisite gold brocade with a pattern of pomegranates surrounds her and the Child, who is wrapped tightly in swaddling clothes. A scarf of the same or similar material, perhaps part of the mantle, covers her hair, a few locks falling over her cheek. The sweeping contour of the sharply folded mantle continues without a break into her shoulder and neck, and on through the fold of the scarf. If the gesture of her hands expresses profound care for the Child's safety, the Virgin's features and meditative gaze show a melancholy anticipation of His sufferings to come.

Mantegna was inspired by many of Donatello's compositions, among them a plaster relief that was in the Berlin Museum before it was destroyed in 1945. The dating of the canvas is still debated, with most scholars placing it in the artist's early Padua period, while others see it as a work of the Mantua period, done in or after 1466–7. Yet others, Berenson for instance, considered it a late work of about 1490.

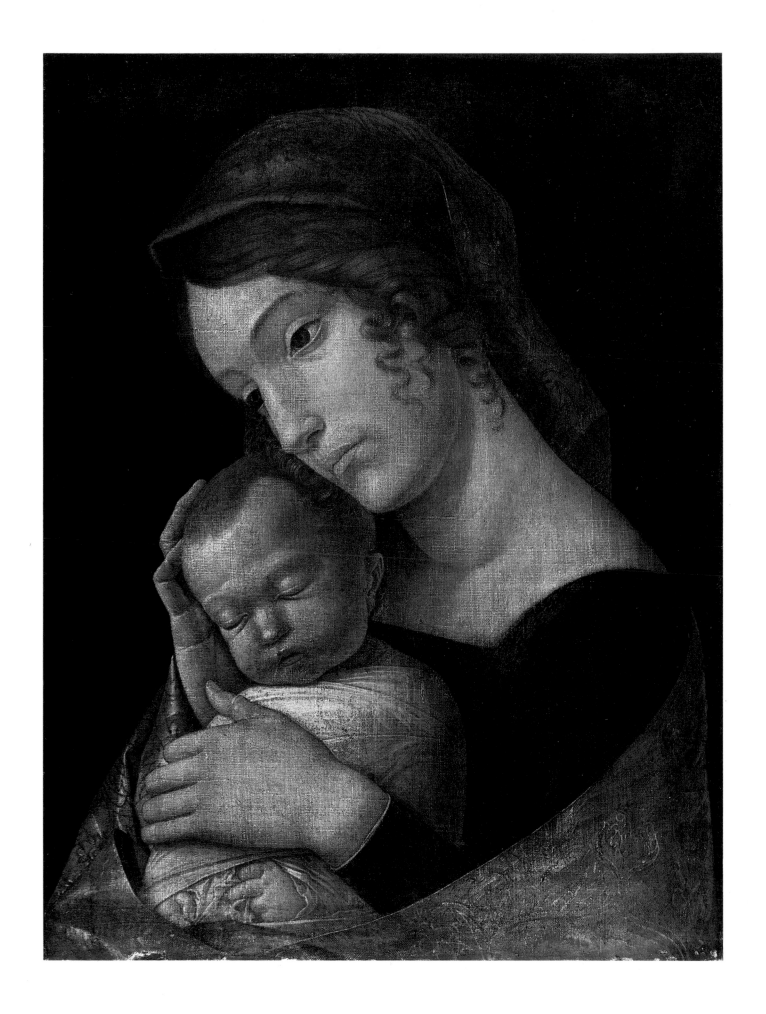

317

Giovanni Bellini (1430/1–1516)
The Dead Christ Supported by Two Mourning Angels
*c.*1480–5

Poplar, 83 × 67.5 cm (32⅝ × 26½ in)
Acquired with the Solly Collection, 1821
Cat. no. 28

Bellini was the most eminent painter in Venice in the second half of the fifteenth century. He became the leader of the Venetian school of painting, ran a large workshop and had many pupils; Giorgione and Titian were among the last, and their influence is reflected in the work of Bellini's final years. Born into a family of artists, his father and brother were both painters, and Andrea Mantegna was his brother-in-law. After an early period influenced by Mantegna and Donatello, Bellini began to develop his own personal style in about 1470, a style characterized by a completely unprecedented feeling for space, colour and light, a simplicity of composition and form, strong sculptural modelling, harmonious colour in mild, unifying light, and profound expression of human feelings.

The Dead Christ Supported by Two Mourning Angels is one of the most accomplished and classical works of his first mature period, which began in about 1480. The theme of a *pietà* with angels emerged in France in about 1400 and was used by Donatello before Bellini adopted it in several paintings that antedate the Berlin panel and are now in London, Rimini, and Venice (in the central compartment of the attic tier of the polyptych in SS. Giovanni e Paolo [1464]). The London work has sometimes been presumed to have held a similar position in another, unknown altarpiece, though both it and the more mature Berlin painting might have been intended as separate devotional images. In this rendering of *The Dead Christ*, Bellini at last achieved a figure of classical harmony and balance that could stand beside the sculpture of ancient Greece and Rome. The natural beauty of Christ's body even in death, the purity of line and the lucidity and force in the sculptural modelling, combine here with an unprecedented tenderness and depth of emotion into a perfect unity.

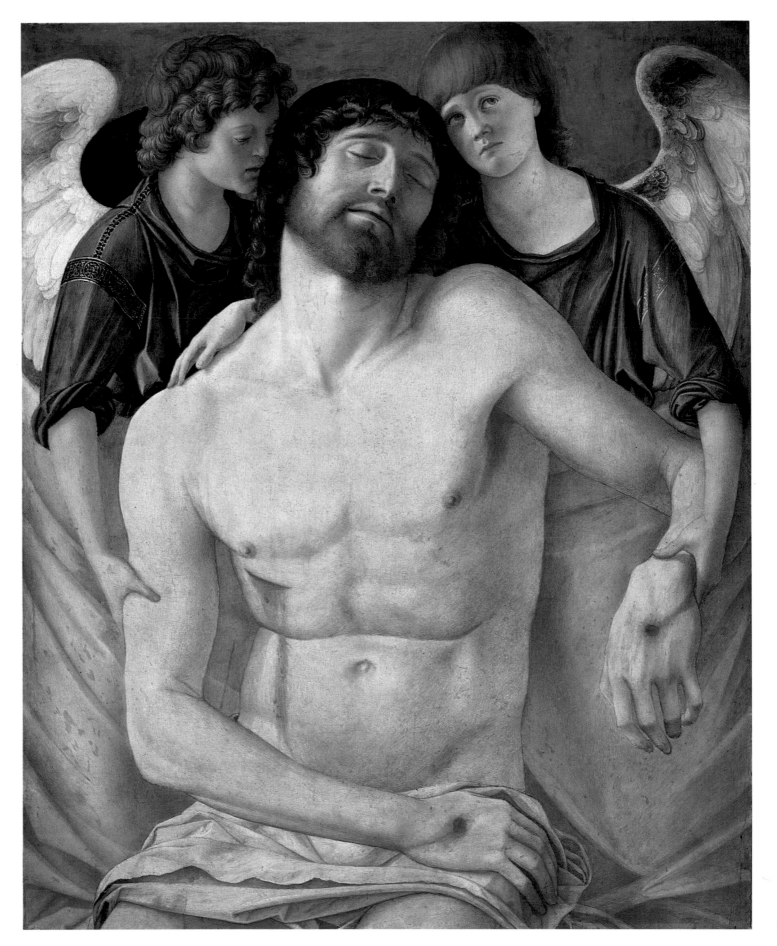

Giovanni Bellini
The Resurrection
1479

Poplar transferred to canvas, 148 × 128 cm
(58¼ × 50⅜ in)
Acquired 1903
Cat. no. 1177 A

The Resurrection was intended as an altar painting for the chapel built in 1475–8 by Marco Zorzi, a Venetian patrician, to the right of the choir in the Camaldoli church of S. Michele in Isola, on the island of S. Michele between Venice and Murano. Relatively small for an altar painting, it has justifiably been associated with others of similar format and date – *St Francis in a Landscape*, 1480–5 (New York, Frick Collection), and *St Jerome in a Landscape*, 1479 (Florence, Contini Bonacossi Bequest). In all these works Bellini was concerned with the relation of the figures to the landscape, or rather with the landscape as the true vehicle of the composition, and in which figures were integrated. Unlike Mantegna in his similar attempts, Bellini accomplished this on a stylistic level in which the painting of the rays of the rising sun, or the evocation of a spatial continuum by means of light and atmospheric perspective, took precedence. He may well have been influenced in this by some of Antonello da Messina's related Venetian works of 1475–6 such as the *Crucifixion* in Antwerp. Yet Bellini had essentially arrived at his new conception of landscape in the Pesaro altar (1471–4), even though there the landscape is limited to the background.

Instead of depicting Christ at the moment he rose from the grave, as Piero della Francesca and Donatello had done, Bellini shows him hovering in the air. In the foreground there is a rocky slope with the dark entrance to the tomb, and in front of that is the heavy slab which had sealed it. One of the soldiers (who some have identified as Longinus), seen in three-quarter view from behind, his right hand raised in astonishment, looks up at the resurrected Christ, who appears at an indeterminate distance above the hills, the banner of the Resurrection in his hand. A second soldier in full armour has fallen asleep, half sitting, half leaning against the rock, while a third has removed his armour and lies asleep on the ground. A path leads past the tomb to the right and into the middle distance, where the three Marys are approaching. In the far distance there is a town with a river and bridge, and behind it is a steep, conical hill with a castle on its peak – an imaginative view of the town of Monselice. Beyond the hilly horizon the sun is just about to rise, and tinges the sky a light yellow, almost a white colour that, interrupted by rose-coloured clouds, gradually becomes a deeper and deeper blue against which Christ's torso, head, hands and the banner stand out in great contrast. Here Bellini has consciously drawn an analogy between the natural phenomenon of the sunrise and Christ's resurrection.

The painting made a lasting impression on Venetian painters down to Titian (*The Resurrection*, Urbino), as copies by Filippo Mazzola and various borrowings of motifs by other artists prove. Cima in particular, to whom the work was ascribed from the seventeenth century onwards (Boschini, 1664), took it as the point of departure for the development of his style, not only in the rendering and proportioning of his figures and his treatment of landscape, but in the interrelation of these two. Landscape conceived as a unified spatial continuum evoked by grades of light – this was Bellini's innovation, which through Cima and Carpaccio reached its culmination in the landscape art of Giorgione.

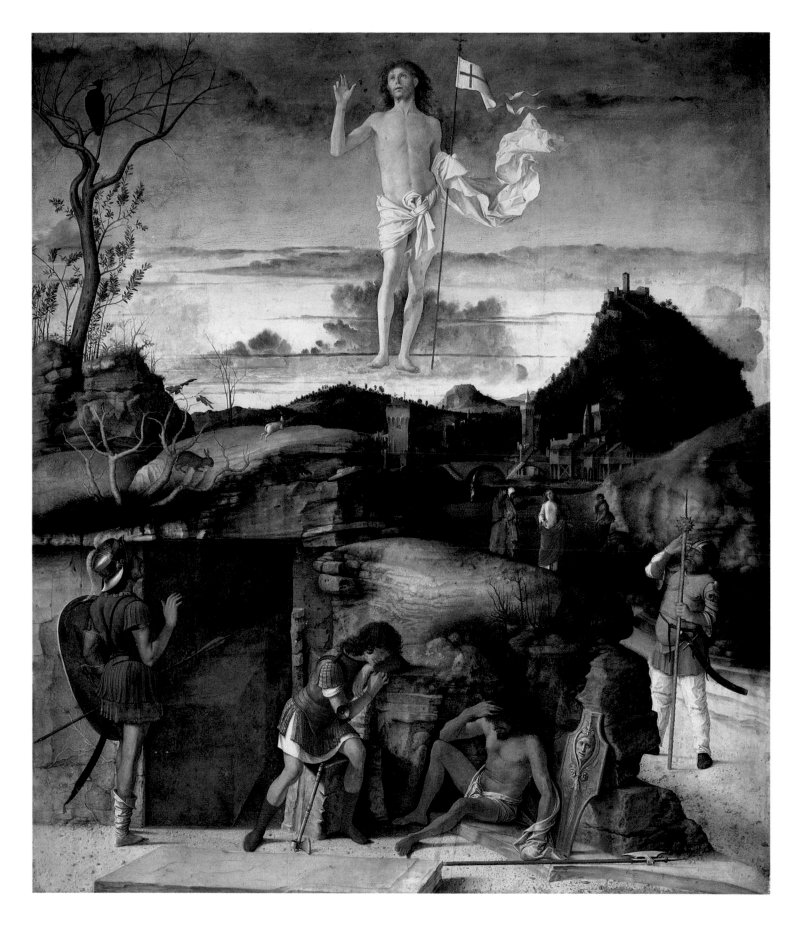

Giovanni Battista da Conegliano, called Cima (*c*.1459/60–1517/18)
St Mark Healing the Cobbler Anianus
1499

Poplar, 206 × 135 cm (81 × 53⅛ in), top rounded
Inscribed: 'Johannis Baptiste Coneglia/nesis opus'
Acquired with the Solly Collection, 1821
Cat. no. 2

This painting belongs to a series depicting various scenes from the legend of St Mark, the patron saint of Venice. It once decorated the Chapel of the Annunciation that belonged to the silk-weavers of Lucca in S. Maria dei Crocicchieri, Venice. Other paintings in the sequence were *St Mark Preaching* by Lattanzio da Rimini (1499, lost), *The Arrest of St Mark* by Giovanni Mansueti (also 1499; Vaduz, Prince of Liechtenstein Collection), and a further work about which the sources give no precise information. Cima has illustrated the scene described in Jacobus de Voragine's *Legenda aurea*, where, on the marketplace in Alexandria, the Apostle Mark healed the hand of Anianus after he had injured it with an awl. The cobbler, seated here outside his shop surrounded by onlookers, was baptized and later became bishop of Alexandria. In the background is a temple in the style of the Venetian Early Renaissance, with a central cupola on whose balustrade men are conversing or enjoying the view.

Cima came from Conegliano in the Veneto. Though nothing is known about his early training, he was active primarily in Venice, where his name was registered for the first time in 1492. However, as an altarpiece dated 1489 indicates, he must have seen Giovanni Bellini's *Madonna* of 1488 in the Frari Church. In addition to the works of Bellini's middle period, the greatest influence on Cima was Alvise Vivarini, who was probably his teacher. Characteristic of Cima's style are the clarity of pictorial space and the lucid, light-filled atmosphere, logical perspective, the comparatively slender and classical proportions of his firmly, sometimes even dryly modelled figures, and a planar, almost metallically brittle treatment of drapery. His brilliant if cool colours underline the self-contained dignity of the figures, who are almost invariably far under lifesize; and his work reveals a poetic sensibility for landscape as a pictorial element. Cima retained his style almost unchanged to the end of his life, despite the advances made by Giorgione and Titian. When he died, a year or two after Bellini, Titian was already at work on his *Assunta* for the Frari Church.

Giovanni Mansueti
The Arrest of St Mark, 1499
Vaduz, Prince of Liechtenstein Collection

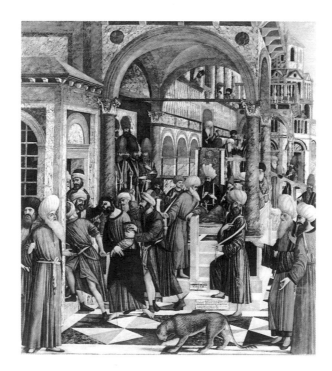

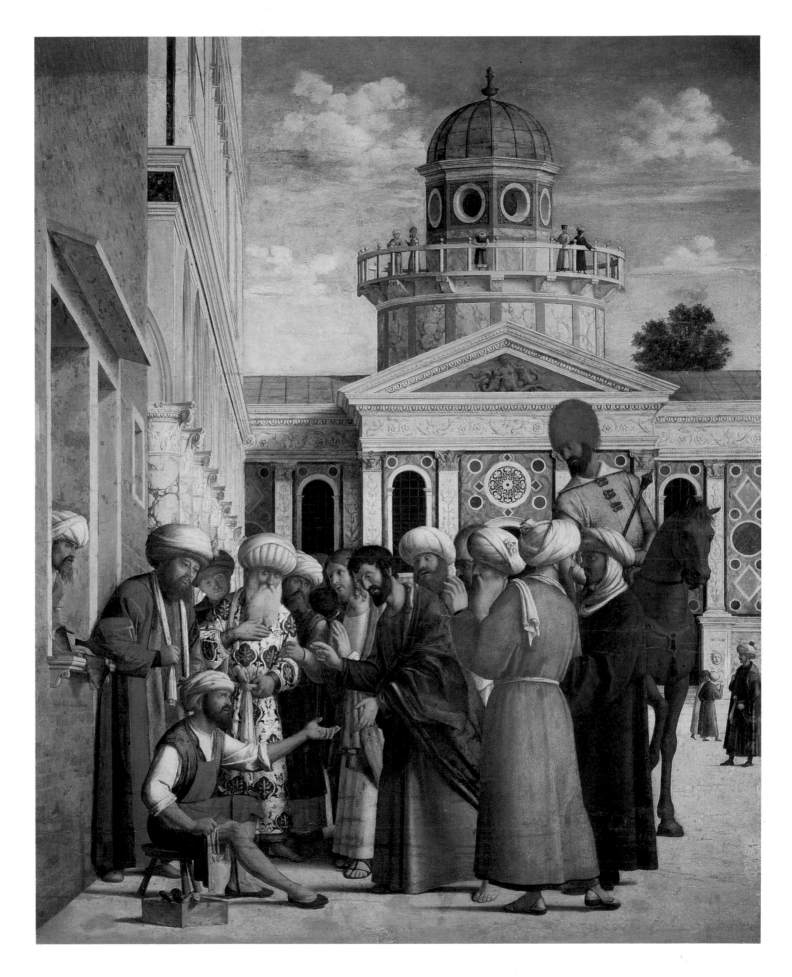

Vittore Carpaccio (1465/7–1525/6)
The Preparation of Christ's Tomb
*c.*1505

Canvas, 145 × 185 cm (57 × 72⅞ in)
Inscription forged in an early hand:
'ANDREAS MANTINEA F.'
Acquired 1905
Cat. no. 23 A

With Cima and Montagna, Carpaccio belonged to a younger generation of artists from Giovanni Bellini's circle who were born between about 1450 and 1460. Carpaccio soon became known for his narrative talent, which he was able to use to full effect in the large pictorial cycles he did for the assembly halls of Venice's powerful lay brotherhoods. While relying on Gentile Bellini's history paintings with their abundance of figures, he overcame their rather dry, documentary character to create images that are characterized by subtle handling, harmonious colouring and poetic mood. His first major work was a cycle devoted to the legend of St Ursula, painted from 1490–96/8 for the Scuola di S. Orsola; later, in 1511–20, he created a cycle for the Scuola di S. Stefano with scenes from the life of St Stephen, to which the Berlin *Ordination of St Stephen*, dated 1511, belonged. Between these two works, Carpaccio executed another celebrated cycle, that for the Scuola di San Giorgio degli Schiavoni of about 1505. *The Preparation of Christ's Tomb* dates from about the same period as this cycle. It is in many respects an enigmatic image, and reveals a profound sensibility. Combining meditative calm with rich detail and narrative, its composition of auxiliary scenes distributed around the central figure indeed has much in common with the scenes of Carpaccio's cycles. There is no evidence, however, that it once formed part of a Passion sequence.

Christ's body lies on a low stone table in the foreground. The red pillar at the centre of the table represents the Anointing Stone, a relic greatly venerated in the Eastern Orthodox Church in Byzantium during the Early Middle Ages before being taken to the Church of the Holy Sepulchre in Jerusalem. Behind Christ, seated with his back against a tree in silent meditation, is Job, whose devout and patient suffering made him an Old Testament precursor of Christ. In Venice, Job was venerated as a saint, and in 1493 the church of S. Giobbe was consecrated to him there. From his figure the eye is led to the group behind him, representing the prostrate Virgin comforted by Mary Magdalene and St John. In the left background, two men in Oriental costumes carry the stone away from the tomb while a third, probably Joseph of Arimathia, prepares the cleansing of Christ's body. The combination of Christ's figure lying on a low table, with Job in mourning, is certainly unusual in Renaissance painting, occurring only once again in this form, with Carpaccio – in a painting in the Metropolitan Museum, New York: in fact this and the Berlin *Preparation of Christ's Tomb* were in the same early seventeenth century collection of Robert Canonici in Ferrara. Both paintings were considered works by Mantegna at that time, and had forged Mantegna signatures. The one on the New York painting was removed in 1945 to reveal Carpaccio's signature beneath it.

Among his special qualities, apart from his narrative talent, Carpaccio's sense of colour was remarkable. In contrast to Cima's penchant for local colours, he strived for colouristic unity, a tendency which he shared with Mantegna. Distributed throughout the entire image in *The Preparation of Christ's Tomb* is that reddish-brown colour, like copper, so typical of Carpaccio – from the Anointing Stone to Job's and Mary Magdalene's clothes, from the fragment of column and the garment of the bearded man shouldering the gravestone, to the most distant minor figures. This tone, with the cool blue of the sky, forms a dominating chord that reverberates above the modulated greens and browns of the landscape.

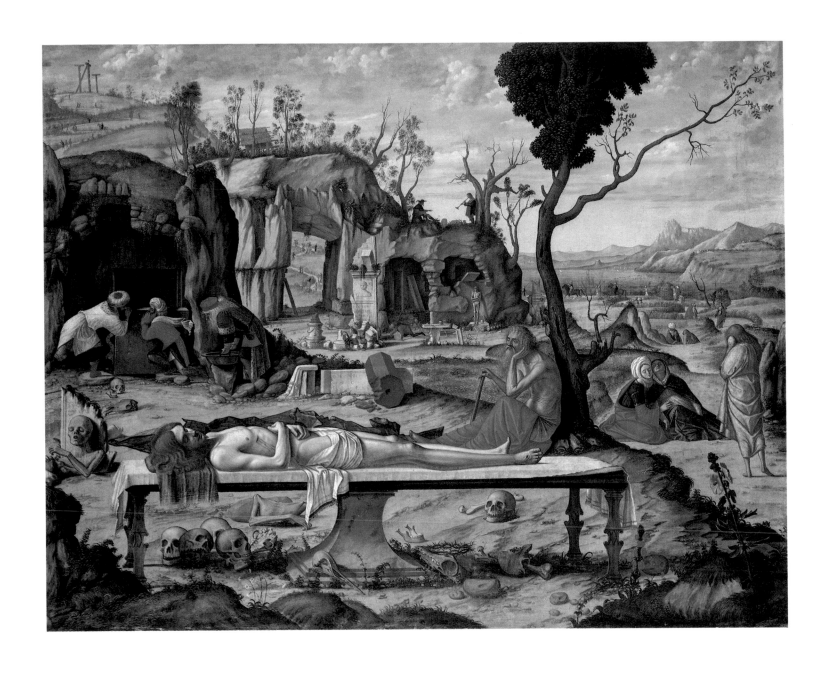

Sebastiano Luciani, called del Piombo (c.1485–1547)
Portrait of a Young Roman Woman
c.1513

Poplar, 78 × 61 cm (30¾ × 24 in)
Acquired 1885
Cat. no. 259 B

Sebastiano del Piombo first trained with Giovanni Bellini in his home town of Venice, and then, according to Vasari, turned to Giorgione, whose great influence on his early work is evident. In 1511, shortly after Giorgione's death, Sebastiano accepted the invitation of Agostino Chigi, a Roman banker then visiting Venice, to accompany him to Rome and help in the decoration of his villa on the Tiber (1511–12). Through Chigi, Sebastiano got to know Raphael, but this acquaintance was soon overshadowed by his friendship with Michelangelo, whose art had a deep impact on him and influenced his development from the mid-1510s.

The half-length portrait of a young Roman woman in Berlin, one of the most important works he produced during his first years in Rome, was probably painted in about 1513. Its composition is more accomplished, more formal than Sebastiano's portrait of a woman in Florence.

The sitter is represented in three-quarter view to the left, in front of a dark wall with a window on the left opening on a landscape vista with farms, mountains, and a sunset sky. She wears a superb, fur-lined mantle of ruby-red velvet, whose collar has slipped from her shoulder to reveal a dress whose light violet hue vibrates with a strange tension against the red. Her head thrown slightly back, she looks from the corner of her eye straight at the spectator, gathering the fur trim of her mantle to her breast with one hand; with the other she holds the handle of a basket of flowers and fruit. As this last is an attribute of St Dorothy, some have called the portrait an image of that saint, though the absence of a halo or palm fronds make this doubtful. All the same, a replica of the painting (Verona Museum) was called *St Dorothy* as early as 1657. The basket might well allude to the first name of the sitter, since the portrait is probably the same one Vasari saw in the home of Luca Torregiani in Rome in 1568. Later, when it was in the collection of the Dukes of Marlborough in England (1756–1885), it was attributed to Raphael, and thought to be a portrait of his woman-friend, 'La Fornarina'.

This is one of the last of del Piombo's Roman works containing Venetian elements. Recollections of Venice are seen in the conception of a half-length figure against an architectural background with a side window, in the palette, and in the cool, twilight mood of the landscape, shortly after sundown. Nevertheless, the pensive, musing expression typical of the Giorgione school has already given way to a tranquil dignity, even monumentality – characteristics of del Piombo's Roman style as it developed under Raphael's influence. The painting has often been compared to Raphael's *Donna Velata*, which may have been modelled on it. Though the architectural background is authentic, it was not in the original version of the composition, which showed the young woman in front of a laurel hedge, like Giorgione's *Laura* (Vienna). This suggests that it might have been intended as a portrait of a bride, which would explain why the young woman places her right hand over her heart; but this gesture can be traced with equal conviction to classical models.

Echoes of del Piombo's image are found in half-figures by Garofalo (formerly in the Duke of Northumberland Collection) and by a follower of Leonardo (private collection).

School of Leonardo
Portrait of a Young Woman
Private collection

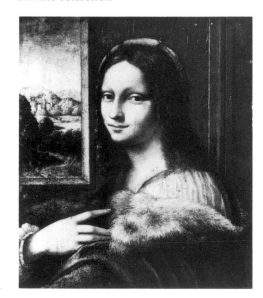

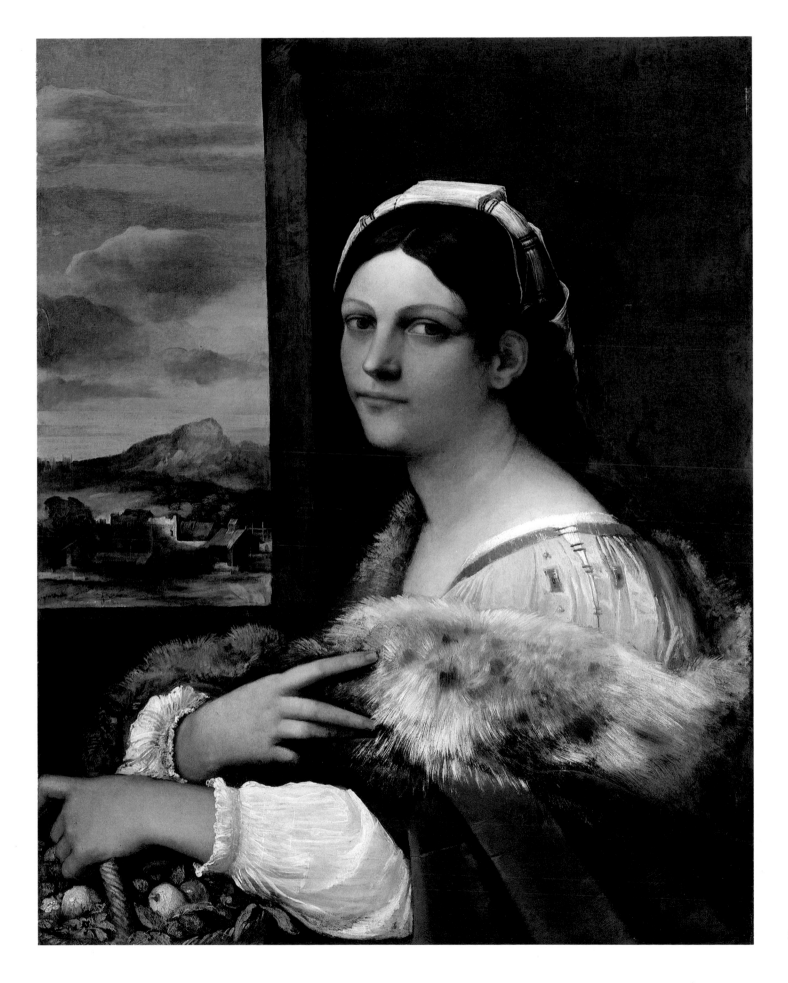

Lorenzo Lotto (*c.*1480–1556)
Christ Taking Leave of His Mother
1521

Canvas, 126 × 99 cm (49⅝ × 39 in)
Signed and dated: 'mo Laurenttjo lotto
pictor 1521'
Acquired with the Solly Collection, 1821
Cat. no. 325

After years of restless wandering from place to place – Venice, Treviso, Bergamo (1503–5), Recanati (1506–8), Rome (1509), the Marches – Lorenzo Lotto worked in Bergamo from 1513 to 1525 before returning to Venice. *Christ Taking Leave of His Mother* was painted in Bergamo, in 1521. According to Ridolfi's report (1648), the painting was kept in the Casa Tassi at the time; a century later, the biographer of Bergamasque artists, F.M. Tassi (*Vite de' Pittori* ..., Bergamaschi, 1793) noted that it was in the possession of Canon Giambattista Zanchi. According to Tassi, the woman donor in the painting represents Elisabetta Rota, the wife of Domenico Tassi. Domenico himself was depicted as the donor in a companion piece, an *Adoration of the Child*, which has not survived but whose composition some scholars believe is reflected in an early copy (Venice, Accademia). This is a *notturno* with almost the same dimensions as the Berlin canvas, and also includes a donor figure in profile, kneeling in a corner – in this case, the lower left corner.

The subject depicted here is relatively rare in Italian painting. After raising Lazarus and before entering Jerusalem, the event with which his sufferings began, Christ took leave of his mother in Bethany. The artist shows him accompanied by Peter and Thomas (?), kneeling before Mary and asking her blessing. She has fainted at her son's prediction of his fate, and sinks into the arms of his disciple, John, and Mary Magdalene. The scene is set in an arcaded hall with a barrel-vaulted ceiling. Between the columns at the far left there is open countryside and in the background the hall opens on a garden surrounded by high walls. Its pergola in the form of a cross with central dome is in turn surrounded by a fence with an open gate (an allusion to the *hortus conclusus* or enclosed garden, a metaphor from the Song of Solomon (4:12) applied to the Virgin and symbolizing the Immaculate Conception). The donor is kneeling in the right foreground, glancing up from her book to witness the leave-taking; she is seen in profile and is accompanied by a little dog. In the foreground at the bottom, darkly silhouetted against the floor and cut off by the picture edge, are a branch of cherries and an apple twig and leaf, allusions, respectively, to the Redeemer's blood and to his work of Salvation. Next to the apple is a *cartellino* with the artist's signature and the date.

Though this scene is not in the Gospels, it became a part of pictorial tradition in the late Middle Ages through the influence of the *Meditationes* of Pseudo Bonaventura; it was popularized through Passion Plays, and became associated with the cycle of the Seven Sorrows of the Virgin. In early renderings, particularly those by northern artists such as Dürer and Cranach, Christ stands before Mary and blesses her. The first depiction of him kneeling with his arms crossed submissively over his breast occurs in an early work by Correggio, executed before 1514 (London, National Gallery), a painting that evidently inspired Lotto. As X-rays of it have revealed, Correggio originally depicted Christ in a standing position, a direct reference to Dürer's woodcut from The Life of the Virgin sequence (1510). In an article on Lorenzo Lotto (*Atti del Convegno*, Asolo, 1980 [1981]), C. Gould says that on his return from Central Italy (Rome, the Marches) on the way to Bergamo Lotto may have met the young Correggio and seen the picture in his studio in Correggio, near Parma.

Correggio
Christ Taking Leave of His Mother
London, National Gallery

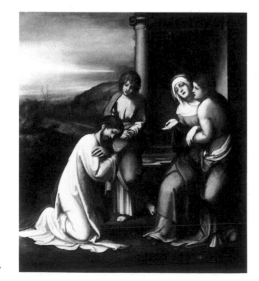

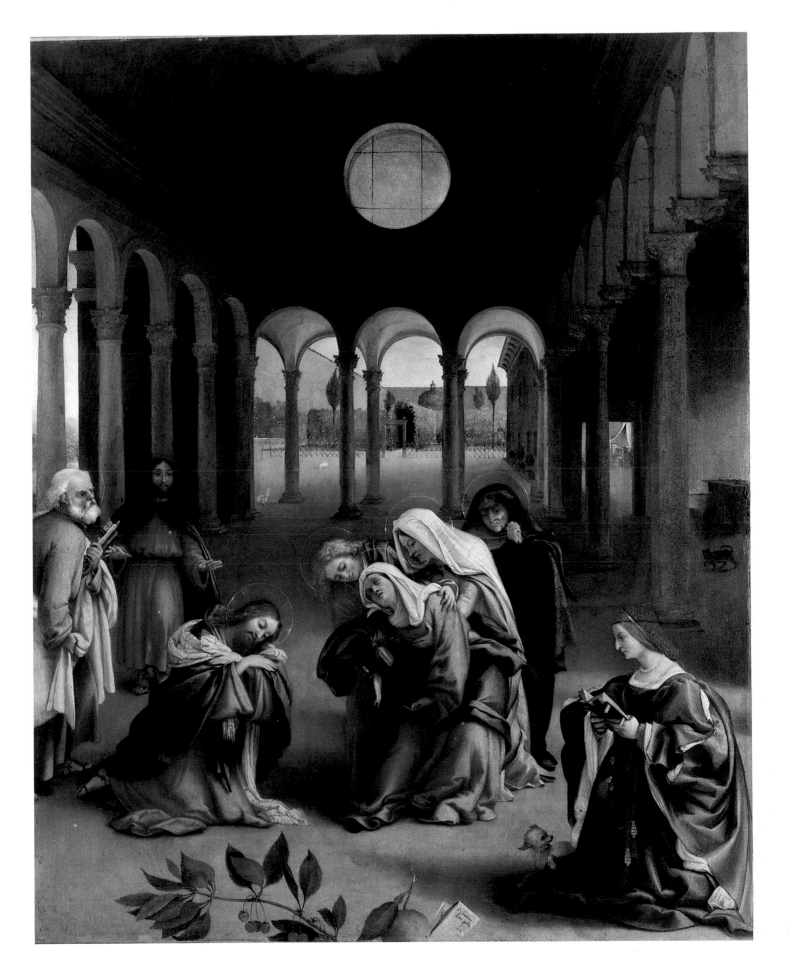

335

Antonio Allegri, called Il Correggio (*c.*1489–1534)
Leda and the Swan
*c.*1531–2

Canvas, 152 × 191 cm (59⅞ × 75¼ in)
From the Royal Palaces, Berlin
Cat. no. 218

Correggio
Danae
Rome, Galleria Borghese

Correggio
Ganymede
Vienna, Kunsthistorisches Museum

Correggio
Jupiter and Io
Vienna, Kunsthistorisches Museum

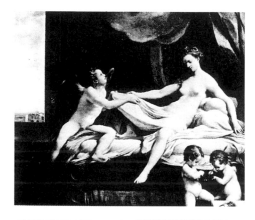

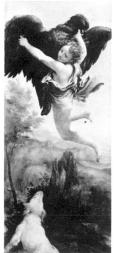 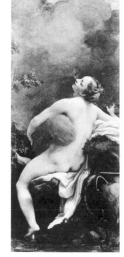

This painting belongs to a series of paintings depicting Jupiter's love affairs in various guises, commissioned by the Duke of Mantua, Federigo II Gonzaga, and painted in about 1530–2. Leda, the central figure in the Berlin painting, was the daughter of Thestios, King of Aetolia, and later wife of Tyndareos, King of Sparta. Of the very different versions of the Leda myth, Correggio has illustrated the best known, in which Leda, bathing on the banks of the Eurotas, is seduced by Jupiter in the guise of a swan. To the left of this central group, beside the grove of trees, two *putti* play wind instruments to accompany an adolescent, winged Cupid on the lyre, the instrument of Apollo's divine music.

Other paintings besides *Leda* have survived from Correggio's cycle – a *Danae* (Rome, Galleria Borghese) of almost the same dimensions, and two upright formats, *The Rape of Ganymede* and *Jupiter and Io* (Vienna, Kunsthistorisches Museum). Vasari, though he had not seen the pictures himself, was told of them by Giulio Romano, and reported (1550/68) that Correggio 'has made two paintings in Mantua for Duke Federigo II which were to be sent to the Emperor'. These were a *Leda* and a *Venus*, by which he may have meant the *Danae* though some details of his description suit the *Io* in Vienna better. Federigo might have ordered the four paintings for himself, as Verheyen believes and Gould thinks possible. However, as Gould suggests, he might also first have commissioned the two upright canvases (which Vasari does not expressly mention) for himself, and then, when Emperor Charles V saw and admired them, presented them to him with the promise to supply two more (*Leda* and *Danae*) which he then ordered from Correggio in order to present them to the Emperor.

Until recently, Vasari's information has been associated with the Coronation of Charles V in Bologna in 1530 (and with Federigo's accession to the Mantuan throne the same year). Gould thinks the events described by Vasari took place during one of the two visits the Emperor made to Mantua, probably the second, in November 1532. In September 1534, soon after Correggio's death, the Duke and the Governor of Parma began a correspondence about the artist's cartoons for the Jupiter cycle. Though Gould does not relate these cartoons to the four surviving paintings, Verheyen does, and, from the letters about them, he thinks the cycle must originally have contained more paintings. Verheyen supposes that the paintings were intended for the decoration of the Sala di Ovidio in the Palazzo del Té, the Duke's summer residence. This room belonged to an '*appartamento*' which perhaps was meant for the use of the Duke's official mistress, Isabella Boschetti. Gould, however, is sceptical about Verheyen's hypothesis and his reconstruction of the decoration of the room.

The subsequent history of the paintings was very chequered. According to Lomazzo (1584), the sculptor Leone Leoni owned two of the four (*Danae* and *Io*), which his son Pompeo had sent to Milan from Spain. Pompeo may have received them from Philip II's former secretary of state, Pérez, who fell out of favour in 1579 and who definitely owned the *Ganymede*, or he may have been given them by the King himself. In 1601, the Imperial Ambassador in Madrid bought the two paintings from Leoni for Emperor Rudolf II in Prague. He then, in 1603, bought the two others, *Leda* and *Ganymede*, from Philip III, the son of Philip II. The *Leda* is the only painting of the series to be listed in the inventory of Philip II's estate. Before shipping the paintings to Prague, Philip III had Eugenio Caxés copy them. While the two upright canvases were apparently taken from Prague to Vienna before 1621, the *Leda* and *Danae* were confiscated by the Swedish troops who captured Prague in 1648, and were taken to Stockholm. When Queen Christina of Sweden abdicated, she brought them with her to Rome in 1654. After her death in 1689, they passed through the hands of Cardinal Azzolino and Prince Livio Odescalchi, then in 1721 came into the collection of the French Regent, Duke Philippe d'Orléans (1674–1723). His son, Louis

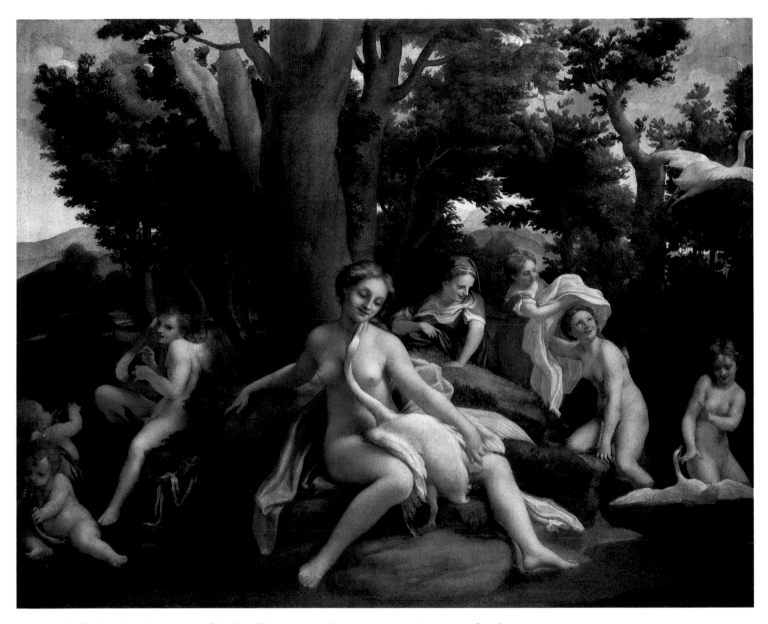

(1703–52), finding the depiction of Leda offensive, cut the canvas to pieces in a fit of religious fervour – probably between the death of his wife in 1726 and his entry into St Geneviève Abbey in 1731. He entrusted the pieces to his court artist and curator of his collection, Charles Coypel, who obtained permission to reassemble them and restore the painting. Coypel repainted the head of Leda, which had apparently been lost, and slightly altered the swan. Yet the canvas had evidently still not been reassembled when Coypel's collection was sold after his death in 1753. The remnants were bought by Pasquier, for whom the Widow Godefroi put them together again and Delyen painted the head of Leda for the second time. Pasquier died two years later, and at the auction of his collection, Count d'Epinaille bought the painting of *Leda* for Frederick the Great. It was hung in the Picture Gallery in Potsdam, where M.Oesterreich described it in 1770. When in 1806 Napoleon had it brought to Paris, Prudhon restored Leda's head for the third time. For the fourth and last time the head was painted in Berlin, by Jakob Schlesinger, in 1834–5, but not correctly. As the early copy by Caxés shows, Leda's head was originally inclined more to the right.

Tiziano Vecellio, called Titian (1488/90–1576)
Clarissa Strozzi at the Age of Two
1542

Canvas, 115 × 98 cm (45¼ × 38½ in)
Signed on the front edge of the tabletop:
'TITIANVS F.'; on the tablet, upper left:
'ANNOR. II. MDXLII.'
Acquired from the Palazzo Strozzi,
Florence, 1878
Cat. no. 160 A

As the inscription on the tablet at the upper left records, Titian painted this portrait of Clarissa Strozzi in Venice, in 1542. It is one of the few pure children's portraits in the artist's œuvre, and, with Bronzino's almost contemporaneous portraits of the Medici children, one of the first autonomous portraits of a child in the history of Italian painting.

Clarissa Strozzi (1540–81), the eldest daughter of Roberto Strozzi and Magdalena de' Medici of Florence, was presumably named after her grandmother, Clarissa de' Medici. She was born in Venice, where her parents lived in exile from 1536 to 1542. In a letter dated 6 July 1542, Pietro Aretino, the famous writer and a friend of Titian, wrote to him when he had just finished the portrait and praised its beauty and truth to nature.

The little girl is pictured feeding a biscuit to her dog, standing at a stone table with a marble relief of dancing *putti* in the manner of classical antiquity. She wears a long satin dress, and dangling from her belt on a chain reaching almost to her feet is a scent box known as a musk-apple. Through a window above the table at the right is a view of a park with two swans on a lake and trees extending into the distance. The artist apparently painted over the mountains on the horizon, continuing the blue of the sky down to the trees.

The brightest light in the picture is concentrated in the girl's figure, in the flesh tones and the colours of her dress; the wine-red drapery spread over the table at the right represents the strongest colour tones, which with the dark green of the landscape and the blue of the sky forms a colour triad in the right half of the painting. Its left half, by contrast, is without colour accents, being painted in dark tones that are interrupted only by the tablet at the upper left, which balances the relief at the lower right. The girl's figure is oriented along the vertical axis of the image; her pose and gaze, directed past the spectator, betray self-assurance. The lower edge of the window and the tabletop mark the horizontal axis, and, integrated in this co-ordinated system, the girl's apparently informal, playful pose has extra dignity.

In the same year as the portrait was completed, the Strozzi family were forced to leave the Republic of Venice because their close ties with the French court made staying undesirable. They had settled in Rome by 1544, where Clarissa was married to Cristofano Savelli in 1557. After her death, the painting remained in the family *palazzo* in Rome. In 1641 it was shown in one of the annual exhibitions held in the atrium of St Giovanni Decollato. An engraving of it was made in 1770, by Domenico Cunego. In the early nineteenth century, it was taken from Rome to the Palazzo Strozzi in Florence, where Wilhelm von Bode bought it for the Berlin Gallery in 1878.

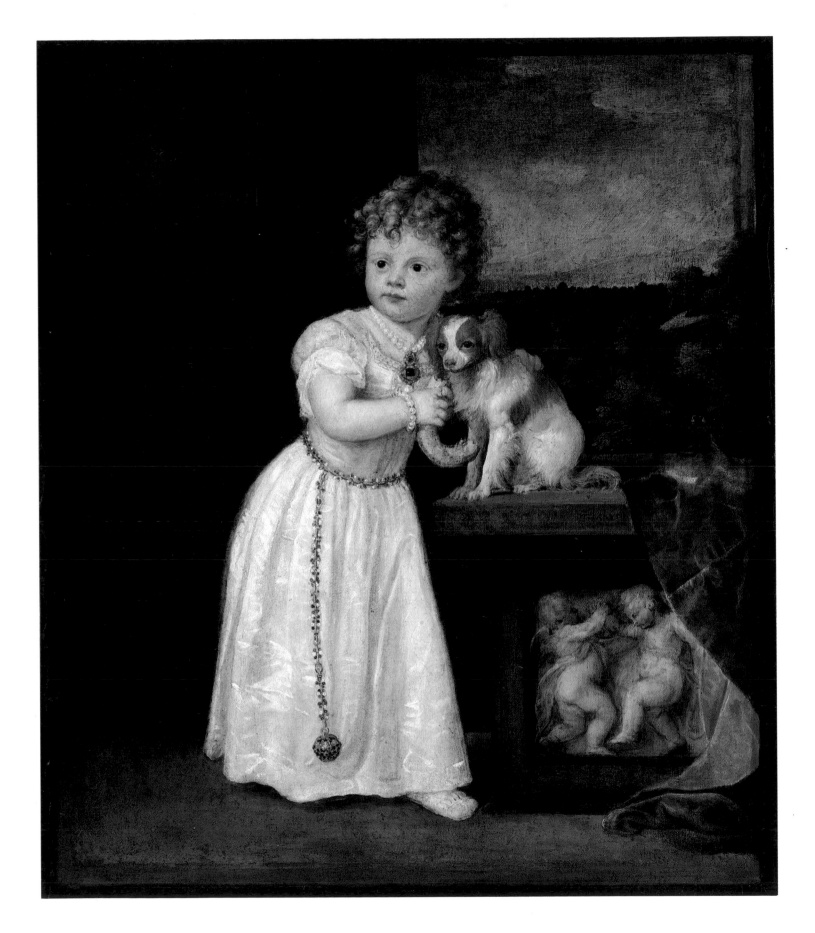

Titiano Vecellio, called Titian
Venus and the Organ Player
*c.*1550–2

Canvas, 115 × 210 cm (45¼ × 82⅝ in)
Signed: 'TITIANVS. F.'
Acquired 1918
Cat. no. 1849

Particularly in his later years, Titian was not above repeating, varying, and developing his own earlier compositions, frequently with the assistance of his workshop, to meet the wishes of his patrons. His depictions of Danae, the *Girl with a Platter of Fruit* (Berlin), of Venus and Adonis, Diana and Callisto, the penitent Magdalene, and The Entombment of Christ, are only a few examples. Another is the series of *Venus* paintings he executed from about 1545 to 1565–70, which included the present canvas.

On 8 December 1545 Titian wrote to Emperor Charles v from Rome to say that he hoped soon to be able to present him personally with a *Venus* he had painted. In 1547, the Emperor invited Titian to the Imperial Diet in Augsburg. Titian travelled with his son, Orazio, from Venice to Augsburg in January 1548, and after the court had retired to Brussels on 12 August they returned to Venice in September. On 1 September, writing to Antoine Perrenot de Granvella, Bishop of Arras, son of the Chancellor of Charles v, and his adviser in Venice, Titian mentioned a *Venus* he had painted by order of the Emperor and had brought from Venice to Augsburg. This work he now apparently sent to Brussels. Subsequently, Titian spent another period in Augsburg in 1550–1, and created a number of other paintings of Venus, which evidently included this one in Berlin.

Recent Italian scholars and, with reservations, H. Wethey (*The Paintings of Titian*, II–III, London, 1971, 1975) assume that the 1545 Venus is identical with the painting Titian mentions in his 1548 letter to Granvella, and that it was given to Granvella by the Emperor. Though C. Hope (1980, see below) doubts this, the Granvella collection indeed contained a *Venus with Organ Player*, which is now in the Prado, Madrid (no. 421, signed). According to Italian scholars and Wethey, this painting is the earliest surviving version in the series and the direct precursor of the Berlin piece, which recent research generally dates about 1550–2. Wethey, however, gives the year 1548–9 on the assumption that it was done in connection with Titian's meeting in Milan with Prince Philip, future king of Spain, in late December 1548, and that it was among the 'certain portraits' for which he received a payment of 1,000 ducats on 29 January 1549. Wethey's hypothesis, and the identification of the organ player with Philip II, has been rejected by C. Hope (in 'Tiziano e Venezia', Venice, 1980).

The relationship of the different versions to one another, their chronological sequence, degree of authenticity, dating, and of course their meaning, have remained controversial to this day. The interpretation suggested by O. Brendel (*Art Bulletin*, 1946) and developed by Panofsky (*Problems in Titian*, 1969), explained the image in terms of the Neo-Platonic idea of rivalry between hearing and seeing beauty when under the spell of love. Most recently this hypothesis has been rejected by C. Hope (1980) and E. Goodman (*Storia dell' Arte*, 49, 1983), who interpret the image in the spirit of Petrarchian love poetry. Both authors believe that the nude female figure in the versions with a male partner (organ or lute player) does not represent Venus but a woman or courtesan whose charms have inspired the gentleman's ardour. Cupid, instead of being an emblem of Venus, becomes the man's messenger, whispering his words of love into the lady's willing ear. Hope thinks the Florence version, which shows Venus (with Cupid) but without a male partner, is a workshop copy of the lost original *Venus*, painted for Charles v in 1545. As this author notes, the folds in the precious, carpet-like drapery on which the female figure rests, are identical in the Florence, Madrid (no. 421, with Cupid), and Cambridge versions, while in each of the other versions (Madrid, no. 420; Berlin, New York) it is arranged differently. Hope concludes that the three first-named paintings are directly derived from the original as far as the drapery is concerned, and that they are much closer to it than the other three, in which he sees second-degree workshop derivations. This would mean that the Berlin version depends on the signed Granvella version in the Prado (no. 421), which according to

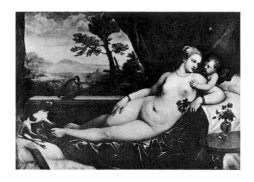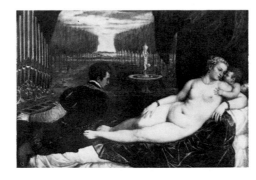

Titian (workshop)
Venus with Cupid
Florence, Uffizi

Titian
Woman with Organ Player
Madrid, Museo del Prado, no. 421

Hope is not the original version but a derivation of the first. In contrast to the Berlin painting, the background in the signed Madrid version (and in the other Madrid version) shows a beautifully planted garden with a fountain and poplar-lined avenues. The Berlin and all other versions (Florence, Cambridge, New York) have uncultivated, hilly landscape backgrounds with mountains on the horizon. Hope, like T.Hetzer before him (1940), considers the Berlin *Venus* to be merely a weak workshop product. Nevertheless, its painterly quality and the presence of *pentimenti* (particularly in the figure of the organ player) would tend to support the opinion of those scholars who see in it a product of Titian's own hand (H.Tietze, *Titian*, 1950; R.Pallucchini, *Tiziano*, 1969; Wethey, 1971, 1975).

The two paintings of Venus with a lute player in the Fitzwilliam Museum, Cambridge, and in the Metropolitan Museum, New York, were not done until the 1560s. According to Zeri (*Italian Paintings, Venetian School, The Metropolitan Museum of Art, New York*, 1973), the somewhat earlier Cambridge version is entirely by Titian's own hand, though Pallucchini (1969) and Wethey (1975) detect workshop assistance. The rather later New York painting is generally thought to be an authentic work that Titian left unfinished in his studio and that was later completed by another hand. It shares with the Berlin painting a provenance from the collection of the Princes Pio, Rome, and both are listed in an inventory of 1742 (as being in the Palazzo Falconieri). Wilhelm von Bode purchased the Berlin painting in Vienna, in 1917–18 – the last important Italian painting of the Cinquecento he was able to acquire. As Oskar Kokoschka reports in his memoirs, *Mein Leben* (Munich, 1971, pp. 131–4), the painting was in his studio for a time after it had been brought from Italy to Vienna by the artist Carl Moll before 1914. And before that it is said to have been in the possession of the Italian branch of the Bourbon family.

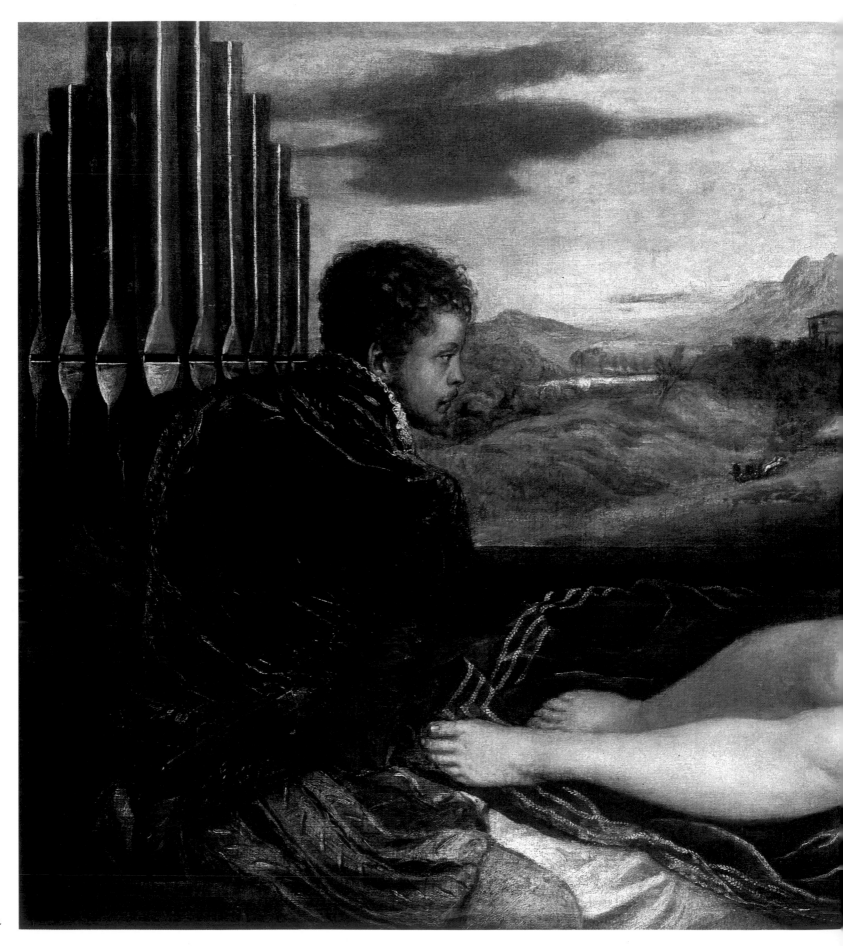

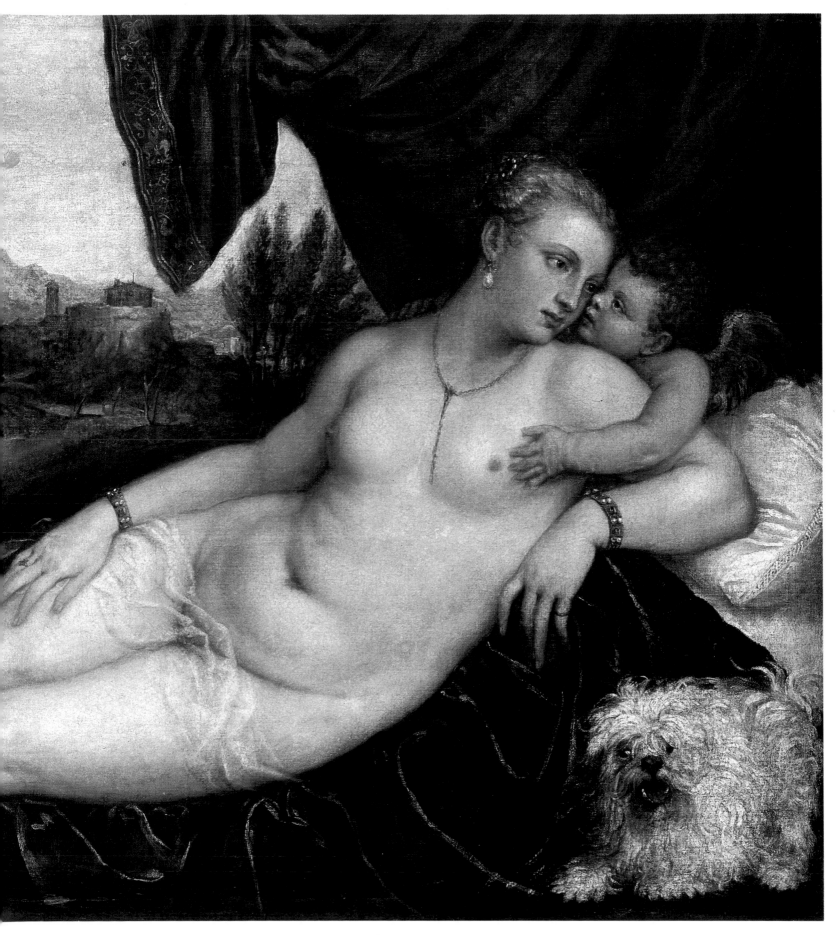

Giovanni Battista Moroni (1520/4–78)
Don Gabriel de la Cueva, Duke of Alburquerque
1560

Canvas, 114.5 × 90.8 cm (45 × 35¾ in)
Signed and dated: 'M. D. LX.
Io: Bap. Moronus. p.'
Above: 'AQVI ESTO SIN TEMOR
Y DELA MVERTE
NO HE PAVOR.'
Collections of Conte Teodoro Lecchi,
Brescia, 1812–26; Sir William Forbes,
London, 1827–42; King William II of the
Netherlands, The Hague, to 1850; Earl of
Warwick, Warwick Castle, 1850–1977
Acquired 1979
Cat. no. 1/79

Pietro Paolo Galeotti
The Duke of Alburquerque
Portrait medallion
Bologne, Museo Civico

After an apprenticeship with Moretto in Brescia, Moroni was active in his home town of Bergamo from 1554 to his death. He was, after Titian and Lorenzo Lotto, the most important and original portraitist in Northern Italy during the sixteenth century. While an artist like Tintoretto continued the detached and objective approach of Titian in his numerous official portraits, Moroni developed a portrait style of penetrating realism aimed at capturing the individual personality at its most vital and natural – an aim he shared with another artist who had worked, if temporarily in Bergamo, Lorenzo Lotto, though without emulating Lotto's underlying mood of troubled pessimism.

Bergamo, then part of the Republic of Venice, was an endangered and therefore fortified outpost in the immediate vicinity of Milan, which definitely succumbed to Spanish rule in 1559, at the Peace of Cateau-Cambrésis. Culturally, Bergamo had closer ties with Lombardy. It was in this climate of tense interplay of Venetian and Lombardian influence that Moroni portrayed the local aristocracy, clergy, prosperous citizens, scholars, poets, and tradesmen of many types. Though his sitters included supporters of Venice (G.G. Albani), more were leading representatives of the town's pro-Spanish party (Isotta Brembati, Gian Gerolamo Grumelli).

The clearest manifestation of the Spanish presence in Bergamo, at least as far as Moroni's art is concerned, is his portrait of Don Gabriel de la Cueva y Girón (1525–71). After the death of his older brother, the Fourth Duke of Alburquerque, Don Gabriel became Fifth Duke in 1563, and a year later was appointed Governor and Supreme Commander of Milan, a position he held until his untimely death in 1571, possibly by poisoning, at the age of forty-six. In Milan he represented the royal, civil legislature *vis-à-vis* the municipal government (the Senate) and the Church, whose new and powerful Archbishop, Carlo Borromeo, he had himself introduced into office in 1565. His relations with Borromeo were tense, for he saw the primacy of civil government threatened by the Church.

Moroni's portrait of the Governor is dated 1560, that is, a year after the Peace of Cateau-Cambrésis. At the time, Don Gabriel de la Cueva, Conde des Ledesma y de Huelma, First Marqués de Cuellar, was a Spanish grandee of the highest class, thirty-five years old, and, like his father before him, had just become Vice-Roy, Governor and Capitán General of the Kingdom of Navarra. His identity has been determined on the basis of inscriptions on the front and on the back of a contemporary variant of the portrait, not by Moroni's own hand (Solingen, Deutsches Klingenmuseum), and is corroborated by the sitter's similarity to the portrait medal of the Duke by Pietro Paolo Galeotti (active 1552–70).

Apart from Ludovico and Gian Federico Madruzzo, nephews of the Prince-Bishop of Trento to whom he devoted full-figure portraits, Alburquerque was by far the highest-ranking personality Moroni ever depicted. This is perhaps his most formal portrait, being based on portrayals of Philip II's court such as Titian's and Anthonis Mor's not only in pose and costume but in its *sosiego*, the calm and disdainfully casual attitude of the Spanish courtier. The figure is seemingly enclosed in the horizontal and vertical pattern of the almost abstract background, against whose cool light-grey the deep black, light brilliant red, and white of his clothes stand out. The high pedestal on which the Duke's hand rests, has, as in several other Moroni portraits, his sitter's motto: 'Here I stand, fearless, and death frightens me not.' This credo is emphasized by Albuquerque's reserved, even mistrustful expression and the icy coldness of his light blue eyes, which look directly past – if not through – the observer. The figure's pose corresponds to that in a portrait of a nobleman also dated 1560 (called *The Unknown Poet*) in Brescia, as well as that in Moroni's portrait of Gerolamo Vertova (Bergamo, private collection).

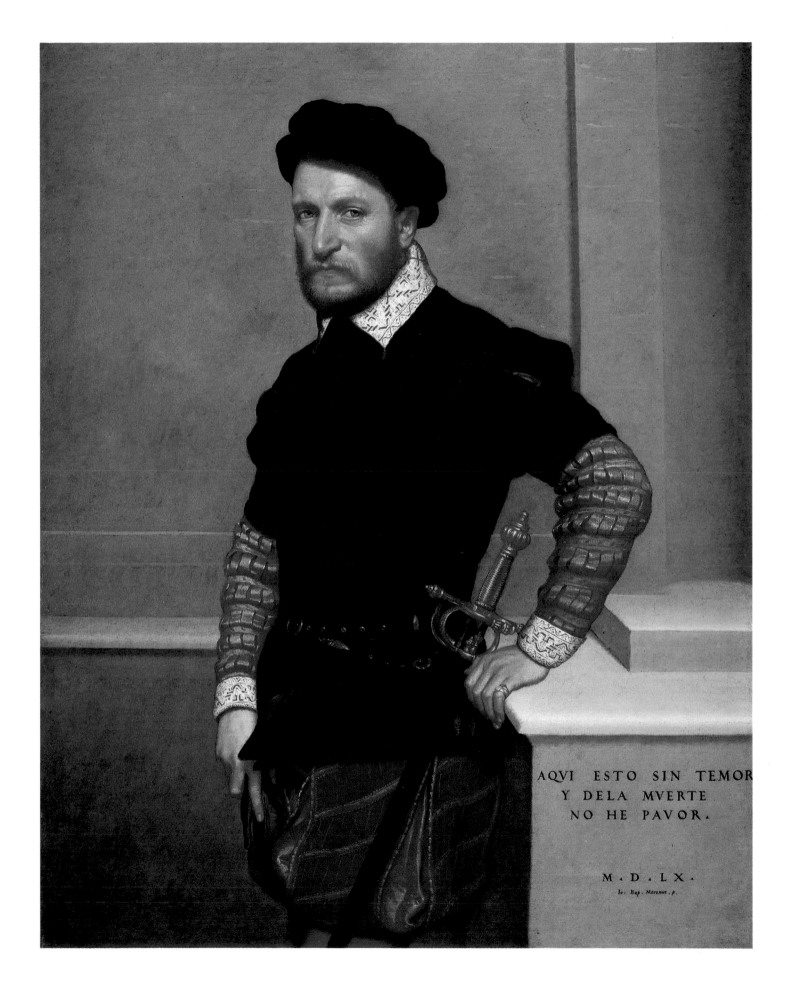

AQVI ESTO SIN TEMOR
Y DELA MVERTE
NO HE PAVOR.

M·D·LX·

Io: Bap. Moronus .p.

345

Jacopo Robusti, called Tintoretto (1518–94)
The Virgin and Child Adored by the Evangelists St Mark and St Luke
*c.*1570–5

Canvas, 228 × 160 cm (89¾ × 63 in)
Acquired in Venice, 1841
Cat. no. 300

The present painting is one of the few large-format works of the Venetian Cinquecento which the museum was able to recover from the anti-air-raid tower in Berlin-Friedrichshain shortly before the end of the Second World War. It is an altarpiece, which dates *c.*1570–5, i.e. from Tintoretto's mature period, just before he began work on the canvases for the Sala Grande of the Scuola di S. Rocco. Unlike the other large Tintoretto in the Berlin Gallery, *Three Venetian Chamberlains (camerlenghi) before St Mark* from the Palazzo dei Camerlenghi, Venice (1571), which in our opinion was painted with workshop assistance, this altarpiece is entirely by his own hand. The *pentimenti* on the Evangelists' books and at St Luke's shoulder are visible even to the naked eye, and X-ray photographs fully reveal the master's sweeping brushstrokes. The Christ Child's arm, raised in blessing, was seemingly extended further out in the original version, and another figure was apparently planned to the right or behind St Luke. Perhaps the artist originally intended to depict all four Evangelists. It is not known for what chapel or church the paintings was intended.

In contrast to the sweeping brushwork of the preparatory stage visible in the X-ray photograph, the final version shows an unusually striking plasticity of form, particularly in the two figures of the Evangelists, which are modelled in powerful chiaroscuro. The Virgin's pose, as von der Bercken (1942) has said, may have been derived from Michelangelo's *Madonna* in the Medici Chapel, S. Lorenzo (Florence).

The crescent moon and crown of stars simultaneously characterize Mary as the Woman of the Apocalypse (Revelation 12:1–17) and as the *Immaculata*. Though the Immaculate Conception theme was widely included in visual art during the Counter Reformation in the sixteenth century, it did not become one of the principal subjects of Catholic imagery until the seventeenth century. After 1600, its diverse iconographic versions began to be recurrent stereotypes. Tintoretto more than once in the 1570s depicted the Virgin (and Child) with the attributes of the Woman of the Apocalypse and Immaculata, together with adoring saints on clouds – in *The Virgin with St Cosmas and Damian* (Venice, Accademia), and *The Virgin with St Catherine* (formerly Chrysler Collection, now in the art trade). Nevertheless, this combination remained unusual in Italian painting as a whole, and its consequences were few. The only exception seems to be Ludovico Carracci's *Madonna Scalzi* (with St Jerome and St Francis) in the Pinacoteca, Bologna, which appears to have been directly inspired by Tintoretto's Berlin painting.

Tintoretto
The Virgin with Two Evangelists
X-ray photograph
Berlin, Gemäldegalerie SMPK

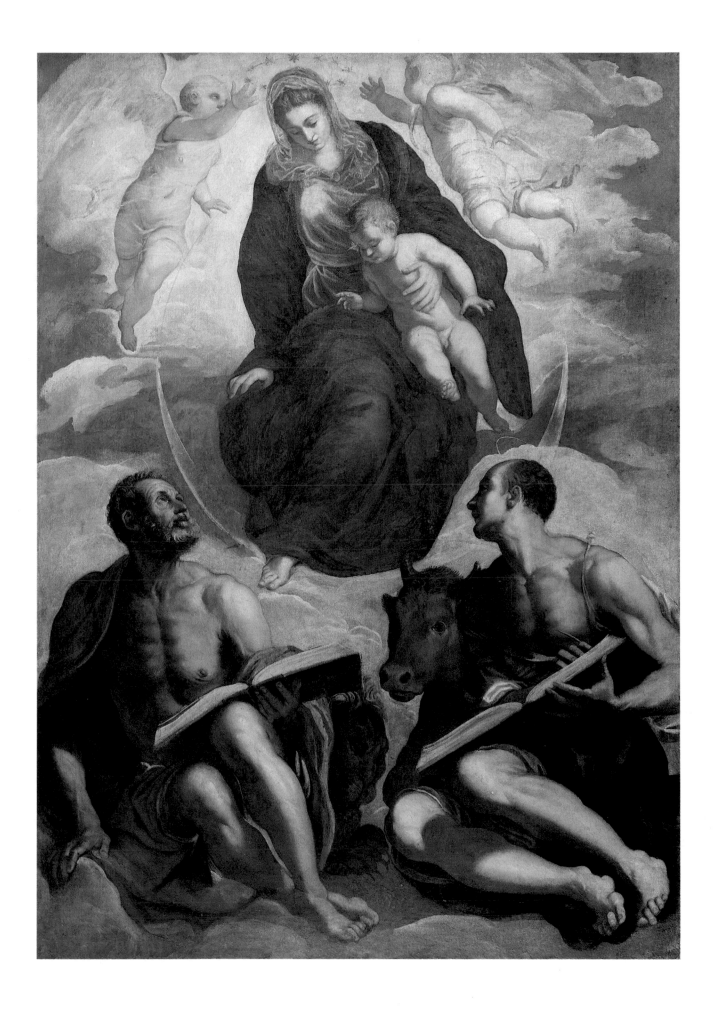

347

Adam Elsheimer (1578–1610)
The Holy Family with Angels and the Infant John the Baptist
*c.*1599

Copper, 37.5 × 24.3 cm (14¾ × 9½ in) top
rounded
Acquired 1928
Cat. no. 2039

Adam Elsheimer
The Baptism of Christ
London, National Gallery

In 1598, twenty years old, Adam Elsheimer left his birthplace of Frankfurt, where he had
studied with Philipp Uffenbach and associated with the Valckenborch family of painters
(Martin I, Frederik and Gillis) and with the Frankenthal painters. The first stop on his
way to Italy was Munich. If Frankfurt had brought an intensive involvement with Dürer's
art (the *Heller Altar*, graphics), in Munich he came to know the work of Altdorfer. When
exactly Elsheimer crossed the Alps and arrived in Venice is still debated, whether still in
1598, or the summer or early autumn of 1599 (K.Andrews, *Adam Elsheimer*, London,
1977; G.F.Koch, *Jahrbuch der Berliner Museen*, 1977). Nor can it be said whether an entry
in the Munich Court Pay-Office register about the payment of half a guilder in 'the second
half of 1599' to 'Adam Maller [painter] armen Studiosen' in fact refers to Elsheimer (Koch,
1977). If it does, he can have stayed in Venice only eight or nine months – no longer,
presumably, than in Munich – for in April 1600 he is recorded as being in Rome, where he
lived until his early death. In Venice, Elsheimer got to know the Augsburg painter Johann
Rottenhammer (active there in 1589 and 1595–1606), who like him, worked primarily in
cabinet format, usually on copper. He saw Dürer's *Madonna with the Rosary* and of
course the works of the great sixteenth-century Venetian artists, among which Veronese's
in particular made a deep impression on him. His *Holy Family with the Infant John the
Baptist*, and the related *Baptism of Christ* in London, are among the few paintings which
until recently were generally placed within Elsheimer's Venetian period. Both have similar
dimensions, and a similar, upright format with semicircular top.

In the Berlin panel, the artist combines elements of two themes, the Rest on the Flight
into Egypt, and the meeting between the Christ Child and the infant St John which legend
has it took place on the Holy Family's return. Mary, in a traditional red gown and blue
mantle, holds the Christ Child on her lap with her right hand, and with her left the infant
John, who embraces Christ. The 'palm tree' she is seated under looks more like a gnarled
old oak without much foliage, and without the dates that Veronese, for instance, often
included in his depictions (London, art trade; formerly Milan, Borletti Collection), where
angels pick the dates and present them on a platter. To the left of Mary, seen in profile, a
large angel in a superbly coloured deacon's gown holds the sleeve of her mantle. Before him
is the Baptist's symbol, the Lamb of the Lord, with cross and banderole inscribed *Ecce
[Agnus Dei]*. Joseph, seated with his carpenter's axe on a tree stump at the right, seems lost
in thought yet aware of the event taking place before him. His *repoussoir* pose might have
been derived from the analogous figure in Altdorfer's *Rest on the Flight* (1510; Berlin). In
the Veronese paintings just mentioned, Joseph is in a similar pose, viewed from slightly
behind his shoulder, from the side or back. The twisted tree trunk grows obliquely
upwards, to end abruptly with a few twigs that separate a heavenly area, the seat of divine
effulgence, from the natural blue of the sky to the rugged chasms of the background
landscape. A large angel peers over the treetop, pointing with a vigorous gesture, that
recalls Tintoretto, to the scene below; and at the right, another angel, also rendered with a
foreshortening worthy of Tintoretto, strews blossoms from his seat on an invisible cloud.
A ray of divine light passes through his hand to illuminate the falling blossoms. Between
the two large angels, who provide a compositional counterweight to the large figures
below, a charming and vivacious chain of infant angels with garlands in their hair descends
in gentle curves, the last in line presenting a garland to the Child and John in adoration.
Just as this meandering line connects the far-distant heaven with the events at the foot of
the tree in the foreground, shimmering light suffuses the space and combines figures and
landscape into a harmonious unity. Recollections are strong here of Altdorfer and the
fantastically delineated landscape details of the Danube school, and, as far as the figures
are concerned, of Venetian painters like Veronese and Rottenhammer. The poetic mood of

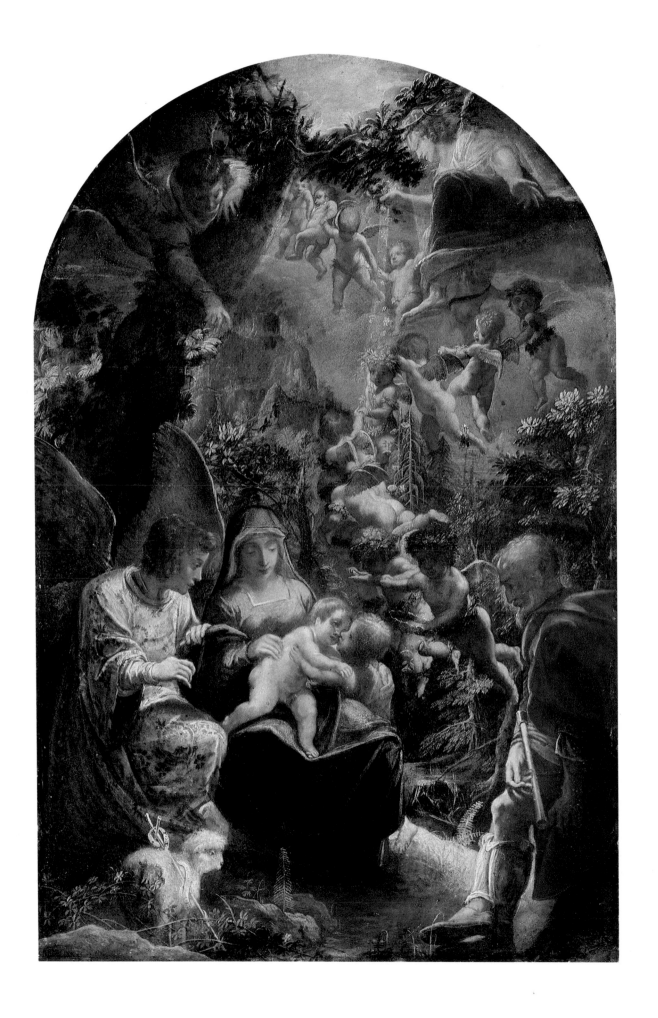

the scene, the deep and tender emotions expressed in the figures' faces and gestures, the naturalness and truth to life of the landscape despite its fairy-tale touches, and the intimacy of the small format – these are inimitable characteristics of Elsheimer's art. This small painting, created when he was just over twenty, is one of his first masterworks, even if the stylistic components derived from the Roman art scene which were to become so important to him are not yet evident in this picture.

As the latest investigations have shown (E.Cropper and G.Panofsky-Soergel, *The Burlington Magazine*, 1984, pp. 473–88), both the Berlin painting and the London *Baptism of Christ* were once among the many works by Elsheimer owned by the Flemish painter Karel Oldrago, who settled in Rome in the 1590s, knew Elsheimer, and died in Rome in 1619. Elsheimer himself must have taken both the Berlin and London paintings with him to Rome. Or is it conceivable that he executed them at the very beginning of his stay there?

Annibale Carracci (1560–1609)
River Landscape with Citadel and Bridge
c.1600

Working in Bologna in close collaboration with his cousin Ludovico and his younger brother Agostino, Annibale Carracci created a new figurative style in the 1580s that superseded the hollow formulas of Late Mannerism. By observing real appearances and the achievements of the great Venetian masters (Titian, Veronese, Tintoretto) the Carraccis reformed painting and established a point of departure for Italian Baroque.

In 1595 Cardinal Odoardo Farnese called Annibale to Rome, entrusting him with the execution of frescoes in his palace (Camerino, Gallery). This move to Rome was a turning-point in his career: confronted with Antiquity and the art of Raphael, Annibale Carracci became decisively oriented to the classical ideal of the High Renaissance. His style grew more severe, his compositions more structured, tectonic, more calculated and measured. Despite the opinion of some scholars (Longhi, Posner 1971), the Berlin *Landscape* is not a product of the Bolognese period but was done in Rome in about 1600, commissioned by Cardinal Farnese. It is evidently identical with a painting mentioned in a 1662 list of paintings in the Farnese palace that were to be sent from Rome to Parma, the residence of the Farnese Dukes. Presumably the *Landscape* belonged to the decoration planned as early as 1600 for a room in the so-called Palazzetto Farnese or Casino della Morte, a low annex to the Palazzo Farnese built in 1602–3 on the opposite side of Via Giulia (Whitfield, 1981). During his Bolognese period Annibale had been influenced by Titian's and Paolo Fiammingo's Venetian landscapes as well as those of the Bolognese artist Niccolò del' Abate, creating landscapes with hunters and fishermen, informal slices of nature in which the architectural element played very little part. In the Berlin *Landscape*, by contrast, a citadel rising at exactly the centre of the composition and underlined by a group of trees, gives the pictorial space a central emphasis with two lateral vistas and misty blue mountains on the horizon. These landscape views are in turn framed at the sides by groups of tall trees. The architecture of the citadel and the twin-arched bridge connecting it with the shore of the river on the right, were quite obviously inspired by the Tiber island (*isola tiberina*) with Ponte Fabricio in Rome (Whitfield, 1980, 1981). Groups of figures emphasize the three vertical aspects of the composition: a young, elegantly dressed couple playing music on the left; a heavy rowing boat with figures in the centre; and another boat with figures at the right. Further evidence that the picture was painted in Rome is the fact that another Bolognese artist of the Carracci school, G.F.Grimaldi, paraphrased Annibale's *Landscape* in about 1635–40, in a fresco in the Palazzo Peretti, Rome.

With the lunette-shaped landscape of *The Flight into Egypt*, in the Galleria Doria (from the chapel of the Palazzo Aldobrandini, *c*.1603–4), the Berlin *Landscape* is the most significant early example of classical landscape painting in Rome and one of the most monumental landscapes executed before Poussin. It strongly influenced not only Annibale's pupil and follower Domenichino, but also Poussin himself, not to mention Claude Lorrain. Despite the tectonic stringency of this 'structured' landscape, Annibale managed to retain the freshness of impression, translucency of surface, atmospheric vivacity, and the spontaneous rendering of details that characterize his early Bolognese landscapes.

Canvas, 73 × 143 cm (28¾ × 56¼ in)
Acquired 1815
Cat. no. 372

G.F.Grimaldi
Landscape
Fresco
Rome, Palazzo Peretti-Fiano-Almagià

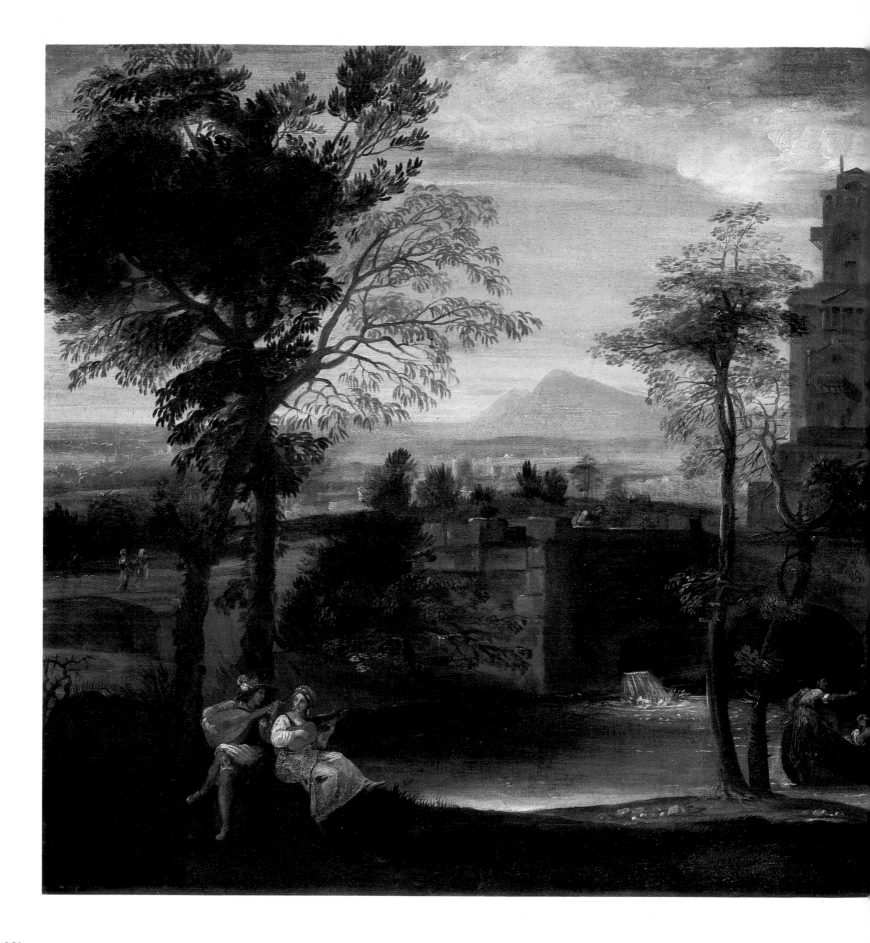

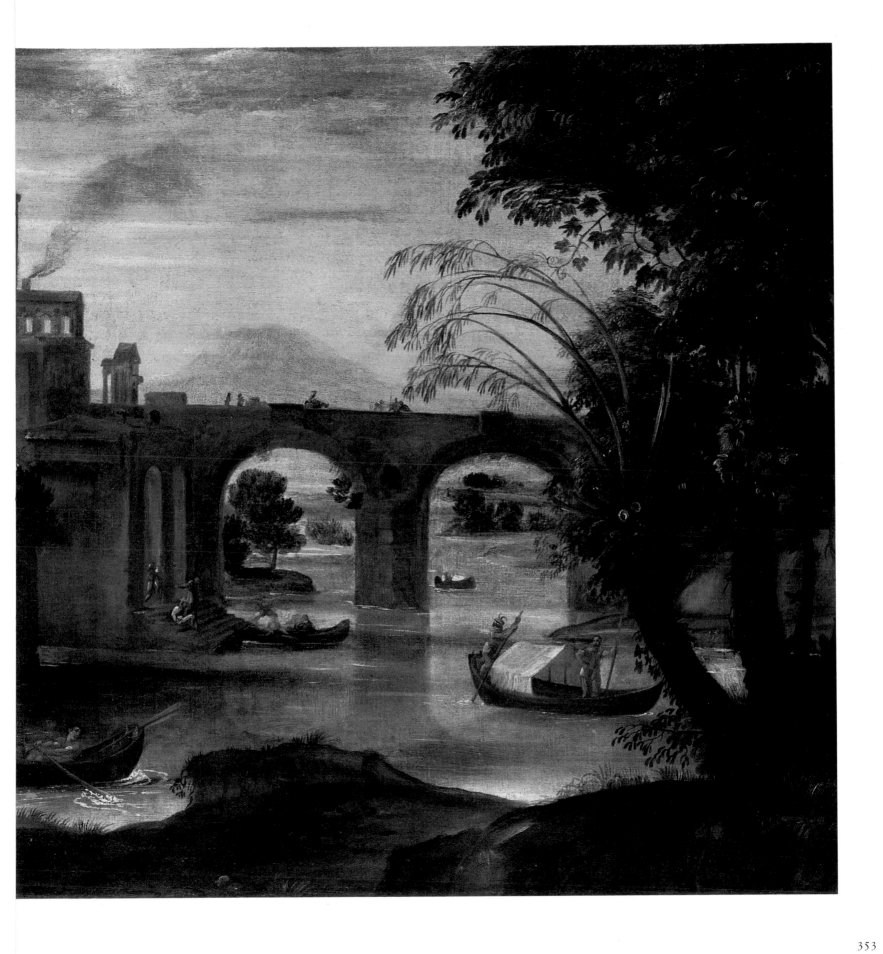

Orazio Gentileschi (1563–1639)
David with the Head of Goliath
*c.*1610

Copper, 36 × 28 cm (14⅛ × 11 in)
Acquired 1914
Property of the
Kaiser-Friedrich-Museums-Verein
Cat. no. 1723

Gentileschi was certainly the most important and independent of those artists in Rome who were influenced by Caravaggio. He knew Caravaggio personally and sometimes worked in competition with him during the first years of the century, until Caravaggio's flight from Rome in 1606. Yet he had not come into contact with his art until 1600–1, when Caravaggio's first publicly accessible works in Roman churches became known. While Gentileschi had been indebted to Roman Mannerism until 1600, in 1600–5 Gentileschi's style gradually began to take on Caravaggesque traits, a development that reached its peak in the years 1606–15, the period to which the present painting belongs.

Besides Caravaggio's influence and his own Tuscan heritage, during the first decade Gentileschi was impressed with the work of Adam Elsheimer, a German painter active in Rome – especially as regards the element of landscape and the use of small pictures on copper. *David with the Head of Goliath* is one of these.

It shows David bending over the giant's head, pondering his deed and its consequences. In comparison with previous interpretations of the theme, in which the action was represented at its brutal climax, Gentileschi's more introspective interpretation represented a new iconographical type, that is similar to Guido Reni's painting in the Louvre (*c.*1605) and goes back to Caravaggio's painting of the subject in the Galleria Borghese, Rome, which has David holding Goliath's just-severed and apparently not yet lifeless head up towards the spectator with a look of mixed disgust and pain. Yet instead of this direct look that follows the movement of his arm, Gentileschi, like Reni, gives David an attitude of pensiveness, turns his face out of the frontal plane to pure profile.

Unlike Caravaggio, whose genius would not allow him to repeat himself, Gentileschi frequently painted replicas or variants of his own compositions. The small copper panel in Berlin is just such a variant of his large painting with a life-size figure in the Galleria Spada, Rome. There, David's figure is cut off below the knee, and his right foot is not visible. The landscape background is completely different; the dark foil setting off the figure at the right does not consist of a grotto in a rugged cliff as here, but of a dark, tangled wood with two tree-trunks that catch the light, and dense foliage that fans out over the sky towards the left. Because of the full-length figure in the Berlin picture, some commentators have suggested that the Roman *David* may have been cropped along the bottom edge. However, this is apparently not the case. Gentileschi first conceived an even smaller format, as may be seen from the canvas, which consists of a central piece with strips of differently textured canvas added on all sides. Originally, the head of Goliath rested at the bottom edge of the canvas. In this seminal version, eye contact between David and the head of Goliath still existed, but it was weakened when the image was enlarged; in the Berlin version there is no eye-contact at all. Only now did the artist expand the figure to a full, standing figure, and alter David's stance by bringing his legs closer together, and making the figure more slender. Moreover, he altered the perspective by lowering the horizon line. The figure at this time was also given a completely different background, of that striated, slate-like, cool grey stone that Gentileschi was so fond of painting. He changed the position of Goliath's head, depicting it face down on the flat rock where David rests his foot. His sling lies in front of it, a detail absent from the Roman painting. David's right hand with the steel-grey sword is starkly silhouetted against the bright, partly overcast sky, and light from the right gleams on the tip of the blade.

Orazio Gentileschi
David with the Head of Goliath
Rome, Galleria Spada

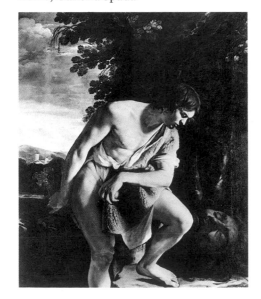

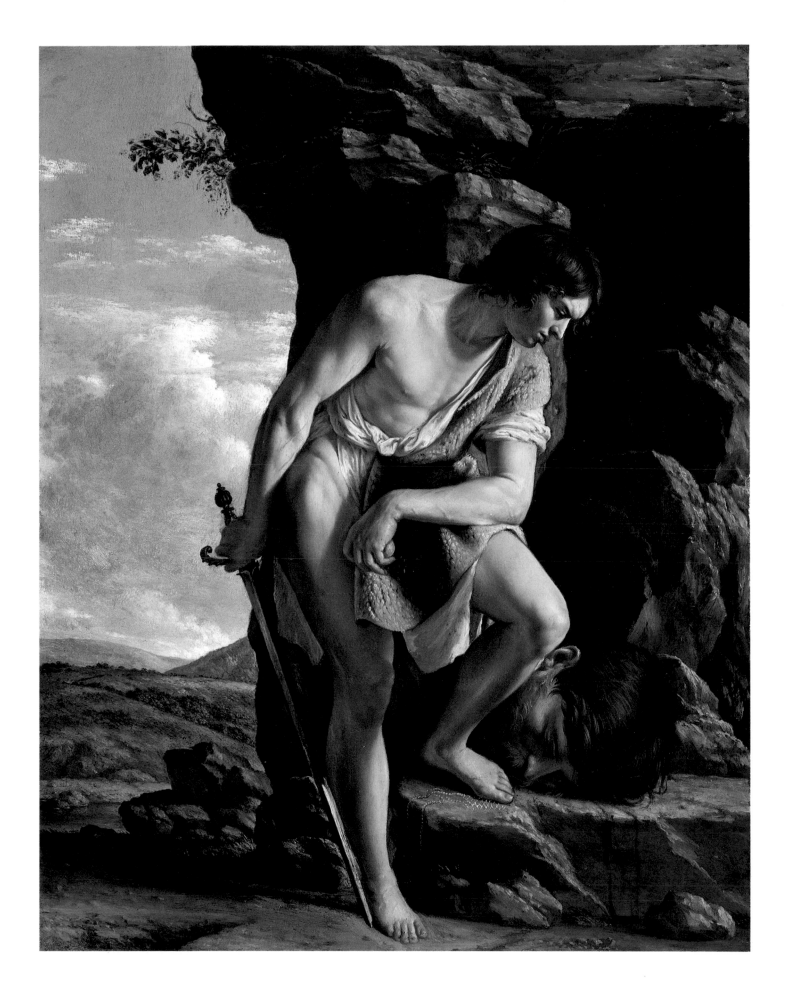

Georges de La Tour (1593–1652)
Old Peasant Couple Eating
*c.*1620

Canvas, 74 × 87 cm (29⅛ × 34¼ in)
Acquired 1976
Cat. no. 1/76

The work of Georges de La Tour, the great realist from Lorraine, named *peintre ordinaire du roi* in 1639 and extolled as a *peintre fameux* in 1644, fell into oblivion within decades after his death. Its rediscovery in the twentieth century was spurred by an essay written in 1915 by Hermann Voss, the outstanding connoisseur of Baroque painting who a few years later became a curator in the Berlin Gallery and whose efforts led to *The Finding of St Sebastian* being acquired in 1928 – one of those late *nocturnes* that once established La Tour's fame as the greatest *peintre de la réalité* alongside the Le Nain brothers. After the memorable 1972 La Tour exhibition in Paris, the Berlin painting proved to be a qualitatively inferior studio replica or copy of the original now in the Louvre, but the Berlin Gallery was able to compensate for the downgrading of this work in 1976 by buying *Old Peasant Couple Eating*. Unquestionably an authentic work of La Tour's earliest period, it was only discovered in 1974, after the Paris exhibition and the subsequent publication of monographs. This is one of the realistic 'daylight' scenes in which the artist depicted inhabitants of his home province of Lorraine: humble people, peasants, beggars, and itinerant musicians impoverished by war, plundering, and epidemics.

The old couple are almost life-size, in half-figure, on a tightly constricted format that brings them into extreme proximity to the spectator. Their simple meal consists of yellow split-peas eaten with short spoons from brown clay bowls. The old man on the right, bending forward, his shoulders hunched, looks down with a long-suffering, embittered gaze, holding his cane in a calloused, gouty hand. His wife, her spoon half-way to her mouth, pauses as if interrupted, the tendons in her neck protruding and her deep-set, dim eyes meeting ours. Bright, harsh and cool light falling obliquely from the left throws the couple's features into relief, revealing every wrinkle of their leathery skin, and glowing on the white cloak over the man's shoulder and on the greyed white of his wife's scarf.

The setting is indeterminate, in keeping with the tradition of Caravaggio's half-figure scenes, which may have been passed on to La Tour through the intermediary of Gerard Seghers of Antwerp, or by Hendrick Terbrugghen, who returned to Holland from Italy in 1614. The brushwork, incisive, nervous, clearly articulated and with very fine nuances in the faces and hands, grows much broader, more powerful and sweeping in the clothes, while the grey background has been applied lightly over a yellowish tone that shines around the contours of the heads.

The painting was executed at the start of La Tour's development in about 1620, when he had just moved from his birthplace, Vic-sur-Seille, to the burgeoning royal residence, Lunéville, where he enjoyed the status of master and spent the rest of his life. Yet despite its early date, *Old Peasant Couple Eating* became one of his more known works. Three seventeenth-century copies exist – one in the Musée Historique Lorain in Nancy, one in a German private collection and another in a French private collection. The subject of beggars and itinerant musicians performing or quarrelling originated in sixteenth-century Netherlandish art. In early seventeenth-century Lorraine it was particularly widespread: in the work of the court artist Jacques Bellange, and in that of Jacques Callot, who had returned from Florence in 1621. Callot's prints, especially his beggar sequence of 1622, were known to La Tour, though he definitely rejected their Mannerist, courtly tradition.

The allegorical significance of the image, its moral, is probably that poverty and need are human errors, self-inflicted sufferings that can be avoided. We are well informed about La Tour's prosperity and social behaviour. There is no reason to assume that the artist or his potential patron or buyer sympathized with the poor people he portrayed. The works most closely related to this one in artistic, thematic, and chronological terms are the two individual figures of peasants in San Francisco (probably inspired by popular street-theatre), and the *Beggars' Brawl* in the Getty Museum, Malibu (*c.*1625–30).

Jacques Callot
Two Beggar-women, 1622
Etching

358

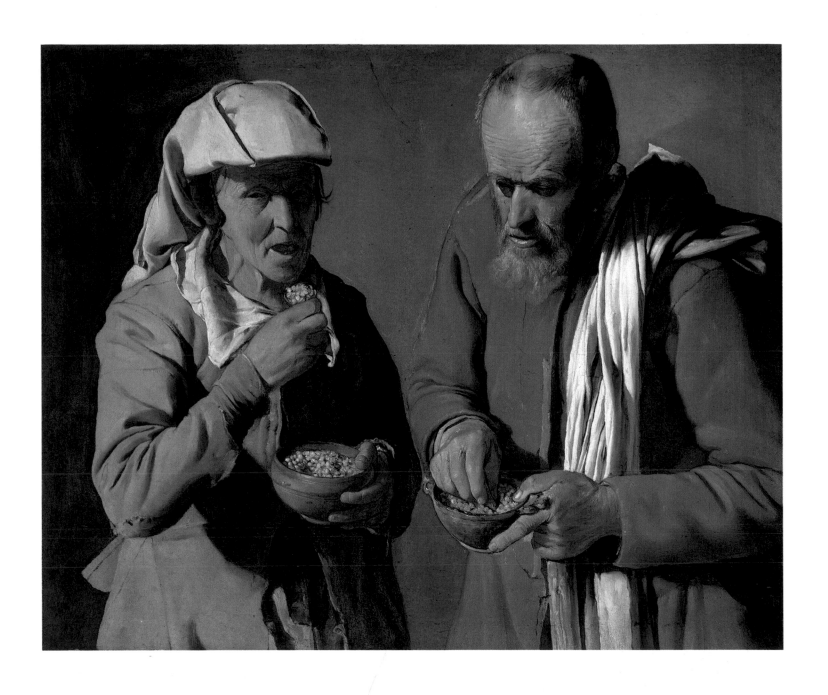

Claude Gellée, called Claude Lorrain (1600–82)
Landscape on the Italian Coast in Morning Light
1642

Canvas, 97 × 131 cm (38⅛ × 51½ in)
Inscribed: 'CLAUDE. IN. F/ROMAE 1642'
Acquired 1881
Cat. no. 448 B

Claude Lorrain
Composition Drawing
New York, Private Collection

Claude Lorrain
Drawing from the 'Liber Veritatis'
(detail)
London, British Museum

With Poussin and his brother-in-law Gaspard Dughet, Claude Lorrain was the third great French painter of the seventeenth century to spend most of his life in Rome and to die there. Unlike Poussin but like Dughet he was exclusively a landscape painter. During a creative career of almost fifty years, he brought the classical approach to landscape developed by Paul Bril, Elsheimer, Annibale Carracci, Domenichino and Agostino Tassi to one of its highpoints. His landscape style, devoted above all to rendering the effects of sunlight emerging on the far horizon, suffusing great spaces, was an antipode to the more tectonically structured landscapes of Dughet and Poussin, although for a while his style shows certain affinities with the works of both of them.

Claude was born in 1600 in the still independent Dukedom of Lorraine. He was sent to Rome in 1613, where he was apparently apprenticed to Agostino Tassi; then after working as an assistant to Goffredo Wals in Naples (1618–22), he returned in 1625 for a year and a half to Nancy, Lorraine's capital. The first painting he dated after his return to Rome is inscribed 1629. After assisting on frescoes as an apprentice and journeyman, Claude turned exclusively to easel painting, doing works for the King of Spain, the Pope, cardinals, noblemen, and collectors in Italy and France. In about 1635 he began to record the compositions of his paintings in subsequent drawings, which he collected in an album called *Liber Veritatis* (London, British Museum) that contains practically all the works he did from 1637 to his death.

Before the Second World War the Berlin Gallery owned two important works by Claude Lorrain. One, a large, early landscape painted in about 1630–5 for the Marchese Vincenzo Giustiniani, was until recently believed to have been destroyed by fire in 1945, but it survives, somewhat damaged, in the Bode-Museum in East Berlin. The painting now in West Berlin, dated 1642, is included as no. 64 in Claude's *Liber Veritatis*.

The complicated genesis of this painting begins with a pen-and-wash drawing (New York, private collection), a composition sketch of the landscape without figures. Its design basically conforms to that of the painting, though some details have been radically altered. The flanking trees in the right foreground, for instance, are developed much further in the painting than in the drawing.

A woman dressed as a shepherdess sits on a rock in the foreground, listening to a shepherd play the flute. Behind them a man with a stick over his shoulder walks across a bridge; at the other end of the bridge two more people are visible. To the shepherd's right a staff or rod is stuck in the ground, apparently for no reason. Yet a glance at the X-ray photograph of the painting and Claude's drawing of it in the *Liber Veritatis* reveals its meaning. In the drawing, the shepherd is replaced by a young man clad in a short garment resembling a Greek *chiton* that leaves his left shoulder bare. His face is turned in profile to the young woman, to whom he presents something with his extended right hand. In his left-hand he holds a staff in exactly the same position as the disembodied staff in the painting. The X-ray photograph, by contrast, reveals his left hand in a gesture of pointing, while the female figure appears to be holding a stick in her right hand and resting it on her shoulder. Her legs are crossed differently in the drawing and in the X-ray, and her left arm is slightly extended. In the drawing she looks up at the man.

We have interpreted this scene as representing the meeting of Judah and Tamar, told in the Book of Genesis (38:14–20). On the way to Timnath, Judah meets Tamar, his widowed sister-in-law, sitting by the side of the road. Not recognizing her, he takes her for a harlot and desires her, promising to reward her with a kid from his flock. When she demands the further pledge of his signet ring, bracelets, and staff, he gives them to her and seduces her. The moral of the story is in the apparent sinfulness of its virtuous heroine, and the hero's shame when he discovers his mistake and its injustice.

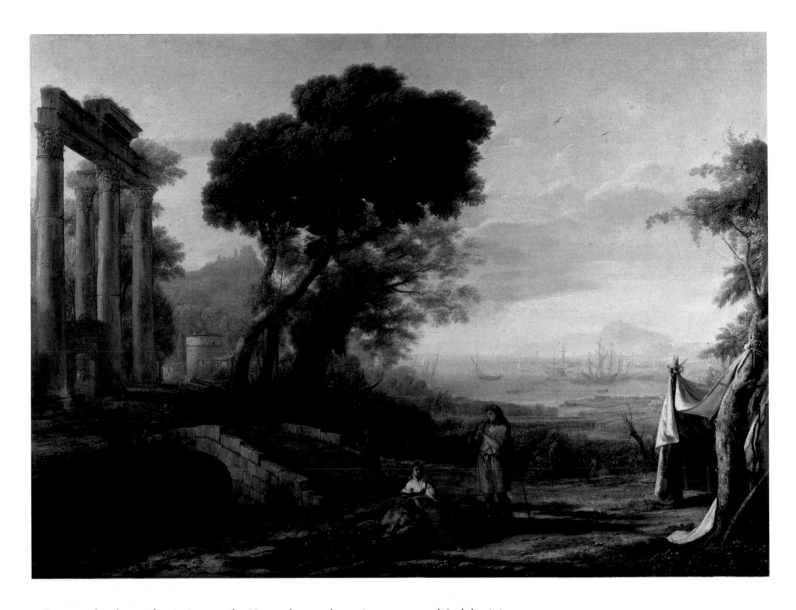

In an early phase of painting, as the X-ray shows, the artist represented Judah giving Tamar his bracelet, and Tamar already holding his staff. In a second, finished stage, similar to that recorded in the *Liber Veritatis* drawing, he is giving her the bracelet while holding his staff. The alteration of this group in the painting to a pastoral shepherd couple, was undoubtedly carried out in the seventeenth century. Though theoretically it could have been done by another hand, perhaps at the request of a patron, the change was probably made by Claude himself. When the painting was cleaned in 1952, the shepherd's staff, which had been deleted and painted over but which bled through the paint layer, reappeared. According to the *Liber Veritatis*, the painting was intended for a Parisian patron; from the early eighteenth century to 1818 it was in England, then came to Paris, where it was acquired by Wilhelm von Bode in 1881.

The Berlin painting (L.V. 64) was long assumed to be a companion piece to a painting recorded in drawing no. 65 of the *Liber*, which evidently originated in the same year and was also destined for Paris, but until recently it was thought to be lost (since 1784). Its subject, as in L.V. 65, was Tobias with the Angel, that is, another Old Testament scene. This painting was recently rediscovered in a private collection by Roethlisberger (*Master Drawings*, 1978); but though it was executed in the same year and is practically the same size as the Berlin landscape, Roethlisberger no longer believes that it is a companion piece.

Nicolas Poussin (1594–1665)
Landscape with the Evangelist St Matthew
1640

Canvas, 99 × 135 cm (39 × 53⅛ in)
Acquired 1873
Cat. no. 478 A

Nicolas Poussin
Landscape with St John on Patmos
Chicago, The Art Institute of Chicago

Gaspard Dughet
Chalk Drawing after Poussin's Landscape
with St Matthew the Evangelist
Düsseldorf, Kunstmuseum

After a lyrical and romantic phase in his early years, Poussin turned more and more to a classical ideal in the tradition of Annibale Carracci and Raphael. Though he did not begin to paint autonomous landscape compositions until the late 1630s, just before his Paris stay (1640–2), landscape has always played a significant role as a background, heightening the poetic mood particularly of his early, neo-Venetian works.

In early seventeenth-century Rome, where Poussin worked from 1624 on, new departures in landscape painting were introduced by some of the most important and advanced artists of the age. There were the northerners, Elsheimer and Paul Bril, whose innovative approach led by way of Agostino Tassi to the atmospheric, romantic, light-suffused compositions of Claude Lorrain, Poussin's great French opposite. And there were the Bolognese figure painters Annibale Carracci and Domenichino, who conceived more stringently structured landscapes that led to the 'heroic' style of Poussin and his brother-in-law Gaspard Dughet, a style that largely determined the look of later Roman landscape painting.

Poussin's landscapes were painted primarily during the 1640s and early 1650s, at a time when his work exuded a great inner calm, clarity, and classical balance, a phase that lay between the large, classicizing, frequently multi-figured compositions of the 1630s and the compositions of his late period with their tragic mood. The Berlin *Landscape with the Evangelist St Matthew* is the earliest surviving example of this intermediate phase.

That the Berlin painting is related to Poussin's *Landscape with St John on Patmos* in Chicago has been known for a long time. Some art historians think they might both have belonged to an unfinished sequence of landscapes with the four Evangelists. Since the Berlin painting is recorded as being in the Barberini family since 1671, some had conjectured that both it and the Chicago painting were executed for Cardinal Francesco Barberini, one of the two powerful nephews of Pope Urban VIII. The most recent findings (Barroero, 1979; Corradini, 1979) indicate that both paintings were paid for on 28 October 1640 (the day Poussin left for Paris) by the Pope's private prelate, Monsignor Gian Maria Roscioli (Foligno 1609–Rome 1644). In all events, Roscioli entered payment of 40 scudi for the two paintings in his cash-book on that date. This would indicate that he, not Cardinal Barberini, commissioned the works. Roscioli owned a considerable art collection that included several works by Poussin. In his last will and testament, dictated the day before his untimely death on 25 September 1644, he bequeathed the Berlin painting to Cardinal Antonio Barberini Senior, the brother of Urban VIII. When Barberini died in 1646 the painting went to his nephew, Cardinal Antonio Barberini Junior, who was Cardinal Francesco's younger brother and lived in the Palazzo Barberini ai Giubbonari, also known as Casa Grande. The painting hung there until his death in 1671. From 1692 at the latest, it was in the Palazzo Barberini alle Quattro Fontane. The Chicago painting was evidently among those in Roscioli's collection sold by his brother after his death. It soon came to France, where Louis de Chatillon (1639–1734) engraved it. While the Berlin painting was still in the Palazzo Barberini, Gaspard Dughet made a chalk drawing after it, though he finished only the background landscape (Kunstmuseum Düsseldorf). From the Palazzo Barberini, the Berlin landscape passed in 1812 through inheritance to the Palazzo Sciarra, where it was acquired for the Berlin Gallery in 1873.

Unlike Claude Lorrain, but like Dughet in his later, Poussin-influenced landscapes and like Salvator Rosa in many of his, Poussin has employed a very high horizon line bounded by hills, from which the eye follows the dominant lines of the meandering river into the foreground. The two figures here, St Matthew and an angel holding his Gospel, are surrounded by fragments of antique columns and pedestals; their central position is accentuated by a temple ruin reaching above the horizon. In a landscape suffused with

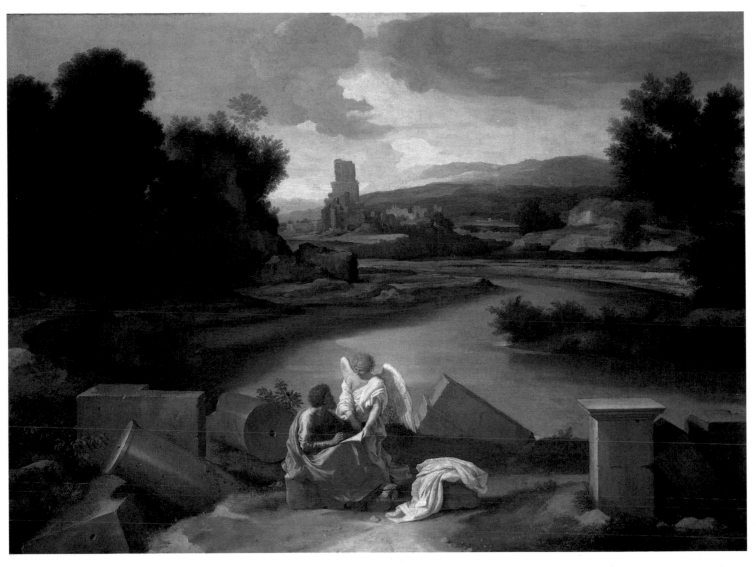

great peace and clarity, Poussin has at once inimitably captured the appearance and mood of the Tiber Valley north of Rome (near Acqua Acetosa) and raised it to a timeless world.

Bernardo Strozzi (1582–1644)
Salome with the Head of John the Baptist
After 1630

Canvas, 124 × 94 cm (48⅞ × 37 in)
Acquired in Rome, 1914
Property of the
Kaiser-Friedrich-Museums-Verein
Cat. no. 1727

Though Strozzi's works have always been admired above all for their painterly qualities – sweeping, sumptuous brushwork, rich impasto, softly modelled volumes, and luminous colour – his style went through many changes. In Genoa, he began in a style on the threshold between Late Mannerism and Early Baroque, whose cool, glistening colour and polished modelling was influenced by Beccafumi's frescoes, by the paintings of Barocci and his Siennese followers Vanni and Salimbeni (then temporarily active in Genoa); later he was inspired by the Milanese artists Cerano and G.C.Procaccini. A naturalistic, sometimes even rustic phase followed, characterized by genre subjects with still-life objects, including kitchen scenes, that was influenced both by Flemish painting and by Fiasella (who had returned to Genoa from Rome in 1616). Strozzi's palette now became warmer, darker, and more harmoniously composed. During his later years in Genoa, he was influenced by the Genoese works of Rubens and van Dyck, then by those of Feti; but when he arrived in Venice, the great sixteenth-century tradition represented by Veronese and Titian became predominant.

Strozzi fled to Venice when his mother died in 1630. As he was a Capucine monk who had been granted lay status solely to care for his mother, he would have been forced to return to the monastery. *Salome with the Head of John the Baptist* was among the works of his early Venice years. While fourteenth- and fifteenth-century artists usually depicted Herod, Tetrarch of Galilee and Salome's stepfather, watching Salome dance at a feast, followed by John's execution and the presentation of his head to Salome or Herodias, Strozzi's image exemplifies a type developed from the early sixteenth century in Northern Italy. It emerged in Lombardy with Leonardo's followers, but particularly in Venice, with the Giorgione circle, the young Titian, Sebastiano del Piombo, and others. They reduced the scene to Salome in half-figure, holding John's head on a salver, either alone or accompanied by the executioner or a maid, and often with an expression of remorse or sorrow. Caravaggio in Rome began to employ this half-figure conception shortly after 1600, deepening the remorse in Salome's expression and painting the maid's features as if petrified in pain. Salome became a female counterpart to David, musing over Goliath's head. Strozzi's *Salome*, for a long time erroneously referred to as *Judith*, is indebted both to Caravaggio's conception and to the Venetian tradition of the early sixteenth century. In Strozzi's painting, too, the maid's expression of melancholy sorrow is stronger than that of Salome herself, who gingerly fondles a lock of the Baptist's hair.

A half-figure image of the same dimensions, *Hagar with the Angel* (Seattle, Museum of Art, Kress Collection), has frequently been called a companion piece to the Berlin *Salome*.

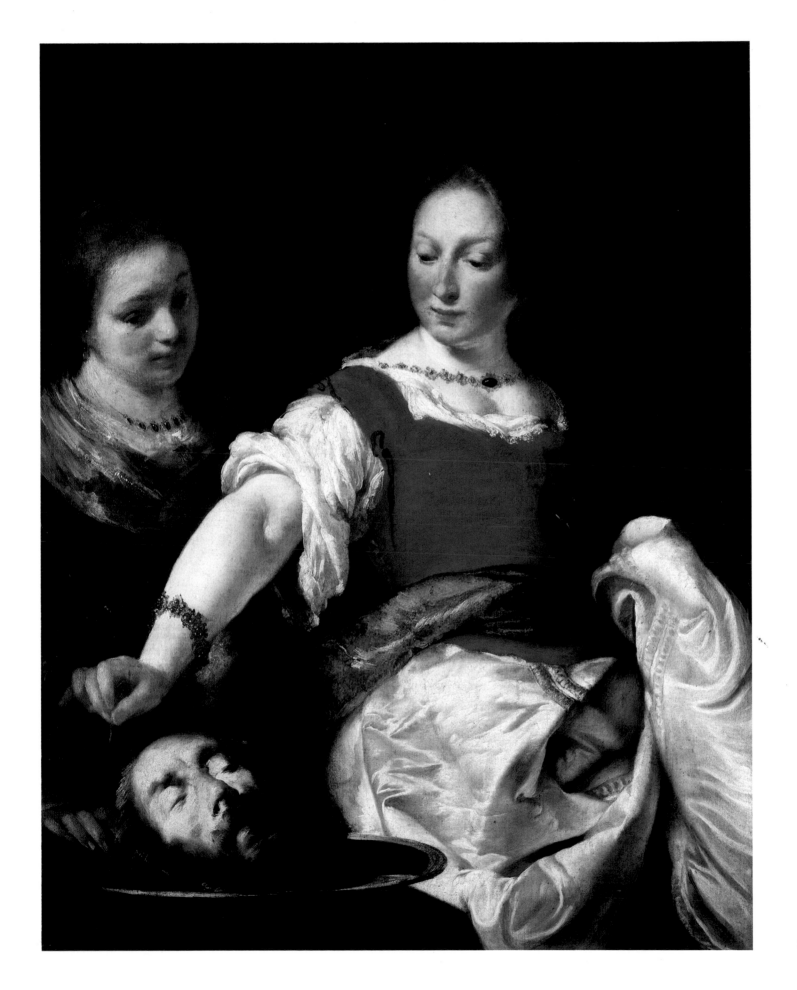

Johann Liss (*c*.1597–1631)
The Ecstasy of St Paul
c.1628–9

Canvas, 80 × 58.5 cm (31½ × 23 in)
Acquired 1919
Cat. no. 1858

Like the two other German artists, Elsheimer before him and, later, Schönfeld, Johann Liss of Oldenburg (Holstein) spent most of his productive life in Italy – primarily in Venice, but also in Rome. In 1616 he worked in Amsterdam and Haarlem, then presumably spent the years 1617–19 in Antwerp, where he was impressed by Jordaens's early painting. He then went by way of Paris to Venice, where his presence was recorded in 1621. During a stay in Rome (probably 1622–5), Liss was influenced by followers of Caravaggio such as Nicolas Regnier (who himself moved to Venice in 1626); Liss also became acquainted with the Baroque style of Guercino and Lanfranco, and with landscape painters of the Elsheimer circle such as Poelenburgh. His work in Venice was closely allied to that of the Mantuan, Feti (d. Venice 1623), whom he may already have met during his first years there; and it was influenced by the great sixteenth-century Venetian tradition, particularly as represented by Veronese.

The Ecstasy of St Paul stems from the final years of the artist's life. Towards the end of II Corinthians (12:2–4), St Paul says of himself, 'I knew a man in Christ above fourteen years ago . . . caught up to the third heaven. And I knew such a man . . . caught up into paradise, and [he] heard unspeakable words, which it is not lawful for a man to utter.' Liss depicts St Paul in the corner of his study, aroused by a vision of the Trinity in blinding light and glorious colour, with angels descending from on high. His hands are spread in a gesture partly of fright, partly of incredulous astonishment. A small book is open on a table, others are visible in the background, and pages are strewn on the floor in front of him. As one great angel pulls a curtain aside at the upper right, another, seen from the back and half in shade, has descended to Paul at the left, playing the lute. The descending diagonal of angels' figures crosses an ascending diagonal that connects the figure of St Paul with the Trinity group. In terms of colour, the deeper tones of the shadow at the bottom and right – a dark violet in Paul's mantle, the green of the curtain, and a dark blue in the angel to the left – culminate in lighter and more intense colours above – pinkish lilac in the violin-playing angel, white in the other angels, and a bright golden yellow in the representation of heaven. Fluent brushwork, the light, flocculent forms of the billowing, fluttering garments and swelling limbs of the angels, the gradual transitions from light to dark, and the luminous palette, merge into a whirling, sweeping, gloriously festive Baroque composition that anticipates the Venetian Settecento.

The composition is obviously related to Liss's almost contemporaneous *Vision of St Jerome*, his only known altar painting (S. Nicolò da Tolentino, Venice). Similarities between the angels in *The Ecstasy of St Paul* and those in Lanfranco's altarpiece in the Capucine church in Rome (1628–30) have led some critics to think that Liss may have made a second trip to Rome, in or after 1628 (Safarik, 1975). As a companion piece to Feti's *Ecstacy of St Peter*, Liss's painting was engraved in about 1655 by J.Falck for a volume devoted to the collection of Gerrit Reynst (1604–58), a wealthy merchant of Amsterdam. Reynst's brother, Jan, had lived in Venice for some time after 1625, and he may have acquired the painting there after Liss's death.

J.Falck
The Ecstasy of St Peter,
c.1655
Engraving after D.Feti

366

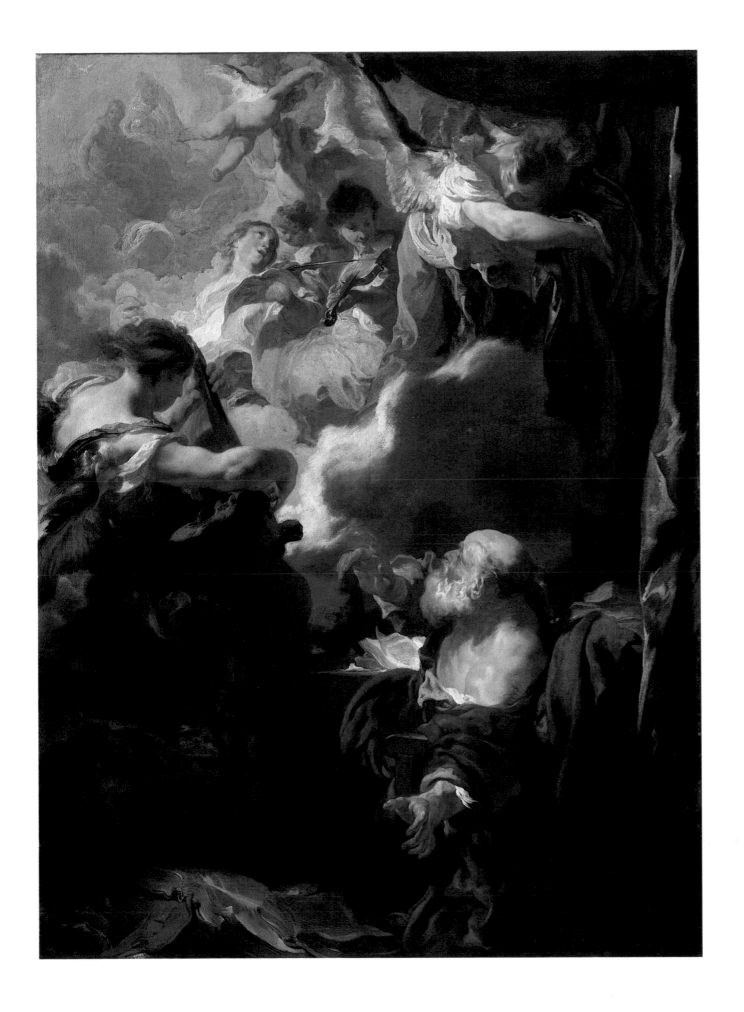

367

Diego Velázquez (1599–1660)
Portrait of a Lady
(Countess Monterrey?)
*c.*1630–3

Canvas, 123 × 99 cm (48½ × 39 in)
Acquired 1887
Cat. no. 413 E

Standing beside a chair in front of a neutral, greyish-beige background, a distinguished middle-aged lady looks out at us with a slight turn of the head. She is portrayed at three-quarter's length, turned to the left; in keeping with the then conventional formula of courtly Spanish portraits, she rests her right hand on the back of the chair, and lets her left fall to her side, holding a closed fan that is just discernable. Her elaborate gown is of black, patterned velvet, with plastron and sleeves of bluish-black, and gold brocade embroidered with stars and trimmed with gold lace. She also wears a jet brooch on a long, heavy, golden chain formed of rosettes, a rose made of diamonds in her hair, and pearl earrings, a pearl necklace, and exquisite rings.

Velázquez, court painter to Philip IV in Madrid and the outstanding artist in Spain's golden age of painting, executed this portrait in the early 1630s, after returning from his first journey to Italy. It was the period of his great equestrian portraits of King Philip IV and the Duke of Olivares, and his hunting portraits of the King and his children. After Caravaggesque beginnings, his art had developed to full maturity. The strong chiaroscuro contrasts had given way to a diffuse daylight brightness, a silvery-grey tone that lay over local colours and unified them. The Berlin portrait belongs to this silver-grey phase, as can be seen from its predominant combination of black gown and light grey background, from which the brightly illuminated, softly modelled face framed by dark hair and the small, delicate hands emerge as the main accents. The face is modelled with that absolutely free, fluent brushwork so characteristic of Velázquez, while the drawing and modelling of the hands and extensive parts in the garment show a certain stolid dryness. This last trait has led some critics to believe that these passages were executed by Velázquez's workshop, probably by Juan Bautista del Mazo, Velázquez's principal assistant who in 1634 became the artist's son-in-law.

The identity of the model was long debated, and is still uncertain. While early commentators, relying on an inscription, thought she was the artist's wife, later opinion tended to identify her as Doña Inés de Zúniga, wife of Conde Duque de Olivares, Philip's powerful Minister of State. It is more probable, however, that the artist's model was Doña Leonora de Guzmán, Countess of Monterrey, sister of Conde Duque de Olivares and wife of the Count of Monterrey (who from 1628–31, during Velázquez's first Roman sojourn, was Spanish Ambassador in Rome and then, from 1631–7, Viceroy of Naples). The Count and Countess of Monterrey gave Velázquez their patronage while he was in Rome, and arranged for his care during an illness. This identification is corroborated by a similarity of features between the portrait and a marble statue of the Countess made in Naples in 1636, for her grave in Salamanca. Moreover, the Countess mentioned in a letter that Velázquez had painted her portrait at the request of her brother.

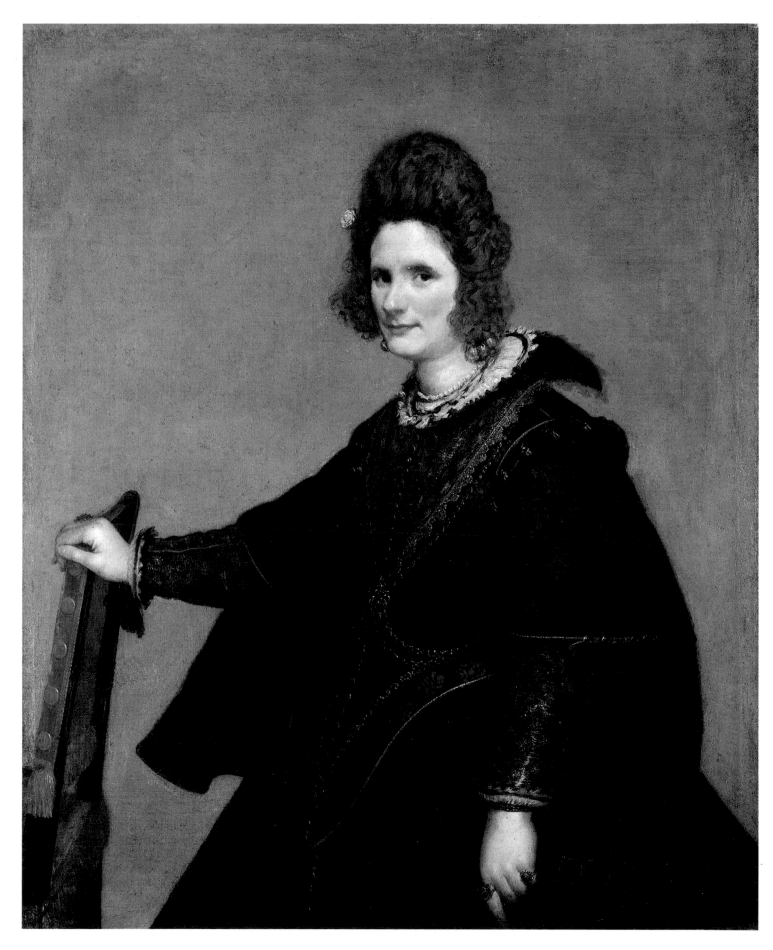

Francisco de Zurbaran (1598–1664)
Don Alonso Verdugo de Albornoz
c.1635

Canvas, 185 × 103 cm (72⅞ × 40½ in)
Inscribed lower right:
'fran. de zurbaran f./AETAS 12. A^S'
Acquired from the Alfred Morrison
Collection, London, 1906
Cat. no. 404 C

Most of the Spanish paintings of the seventeenth century which once belonged to the Berlin gallery did not survive the last war; two important works by Murillo, a Ribera, and Zurbaran's *St Bonaventura and Thomas of Aquino* from the early 1627 series for the Franciscan Convent in Seville were destroyed by fire in 1945. Of the few paintings which were saved, Zurbaran's portrait of *Alonso Verdugo de Albornoz* is certainly the most important.

This is the artist's only signed portrait and one of only two known to have been painted from life. The commission, its occasion, and the resulting image are all unusual. The type of portrait, representing the sitter full-length in three-quarter view, standing with legs apart follows the tradition of official Spanish court portraits, but the sitter is a mere boy, a twelve-year-old decked out in an officer's uniform, a swagger stick in his left hand and his right resting on the hilt of a sword. An assumed seriousness of expression and his disdainful, manly gaze, belie his age. The portrait records the promotion of Alonso Verdugo (1623–95) to Captain of Horse Lancers in the bodyguard of his uncle, the influential Cardinal Gil de Albornoz, which had happened a year before in Carmona, a town near Seville. Since Alonso was born in 1623, and the inscription records that he was twelve at the time, the portrait must have been painted in 1635. The boy's rank is indicated by the red sash across his breastplate; his membership in the renowned Alcántara Military Order is shown by the green cross suspended beneath the family arms in the upper right corner of the picture.

Zurbaran painted this portrait soon after his return from Madrid, where in 1634 he had completed a Hercules cycle and two battle pictures for the Salón de Reinos, the throne chamber in the new royal palace, Buen Retiro, and where Philip IV had named him court painter. Though Velázquez had contributed his *Surrender at Breda* to the same sequence of battles, the style of his first maturity with its free and fluent brushwork left Zurbaran's rendering unaffected: for instance, the illumination in a hard light coming from the side, the pronounced chiaroscuro, and the modelling emphasize the shape of the figure and the density of every surface. The treatment of the highlights on the armour, the sharply delineated slashes in the breeches, and the hard contours of the white stockings, recall the Caravaggesque traits of Velázquez's early period, just as the overall conception recalls his portraits of the 1620s (*Don Carlos*, c.1626; Madrid, Prado).

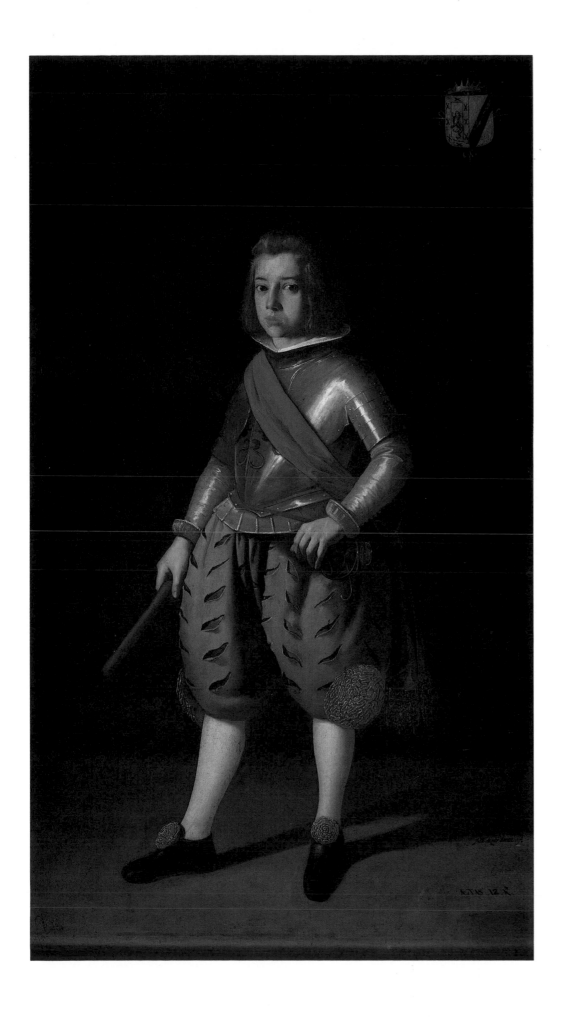

Bartolomé Esteban Murillo (1618–82)
The Baptism of Christ
c.1655

Canvas, 233 × 160 cm (91¾ × 63 in)
Authentic signature, originally on lower
cropped edge, reinserted at lower centre:
'MR.^llo f.'
Acquired 1968
Cat. no. 2/68

Bartolomé Esteban Murillo
John the Baptist and the Pharisees
Cambridge, Fitzwilliam Museum

Bartolomé Esteban Murillo
John the Baptist Pointing at Christ
Chicago, The Art Institute of Chicago

Murillo spent almost his entire life in his home town of Seville. Orphaned at ten, he was brought up by his brother-in-law, then apprenticed to Juan de Castillo. A trip to Madrid followed, in 1645 according to his biographer Palomino, but more likely some time between 1648 and 1650. While his early work with its strong, hard chiaroscuro modelling reveals the influence of Zurbaran, his mature style and especially his late '*estilo vaporoso*', are characterized by rich impasto, the forms softly modelled in a warm light, and a light palette. His style was influenced by the works of Rubens and van Dyck, and to a lesser extent, by Velázquez and sixteenth-century Venetian painting, all of which Murillo may have seen in Madrid, not in Seville. Also, he frequently based his compositions on engravings after Italian, Flemish, and French works. His first large commission was a cycle of eleven paintings for the small cloister in the convent of S. Francisco in Seville (1645–6). These established his reputation, and soon Murillo had eclipsed Zurbaran to win official honours in 1655 as the city's leading artist. In 1660, he helped to found the Academy of Painting and later became its first president. Besides fulfilling this function, he devoted himself entirely to his work and his family. Among the major accomplishments of his mature period were series of paintings for the Capuchine monastery (1665–6 and 1668–70) and the Hospital de la Caridad (1670–4) in Seville.

The Berlin *Baptism of Christ* belongs to a group of four large, upright canvases representing scenes from the life of John the Baptist, which were originally in the refectory of S. Leandro, the convent of the Augustine nuns in Seville. All four works were seen and described there by F.Bruna as late as 1781; in 1812 the nuns sold them. Two of the series, *John the Baptist Pointing at Christ* (now in Chicago, Art Institute) and a lost painting whose subject is unknown, entered the famous collection of King Louis-Philippe of France in 1838. The Berlin painting and the fourth one, *John the Baptist with the Pharisees and Scribes* (now in Cambridge, Fitzwilliam Museum), were bought by Nathan Wetherell in 1812 and taken to England. The three surviving canvases were temporarily united at the Murillo exhibition recently held in Madrid (1982) and London (1983).

Very little is known about the circumstances of the commission or about its precise date of execution. According to A.Bravo (1837), the commission may have been related to the veneration of John the Baptist and John the Evangelist, in which the two Augustine convents Encarnación and S. Leandro competed with one another. The series is generally dated about 1655, to the beginning of Murillo's mature period, when he had overcome the hardness of modelling of his early style derived from Zurbaran, but still retained echoes of the strong chiaroscuro contrasts and dark palette. (A fifth painting, *St Augustine Washing Christ's Feet*, was earlier believed to be part of the group, forming the centre panel of a large retable, but this has since been disproved.)

In all three surviving paintings of the series the main figures are depicted standing, full-length, before a landscape background. The Berlin painting has been cropped on all sides, truncating the inscription with God's words in the sky. The composition was probably influenced by Rubens's *Baptism of Christ*, the altarpiece in St John's Church in Malines, which Murillo could have seen either in an engraving by W.Panneels dated 1630, or in one by A.Lommelin published by G.Hendricx.

In an attitude of humble submission, Christ's figure is subordinated to the looming figure of St John, whose features and gestures evoke great contained emotion. Both figures are subtly integrated into a harmonious composition based on a diagonal from lower left to upper right which is emphasized by the landscape.

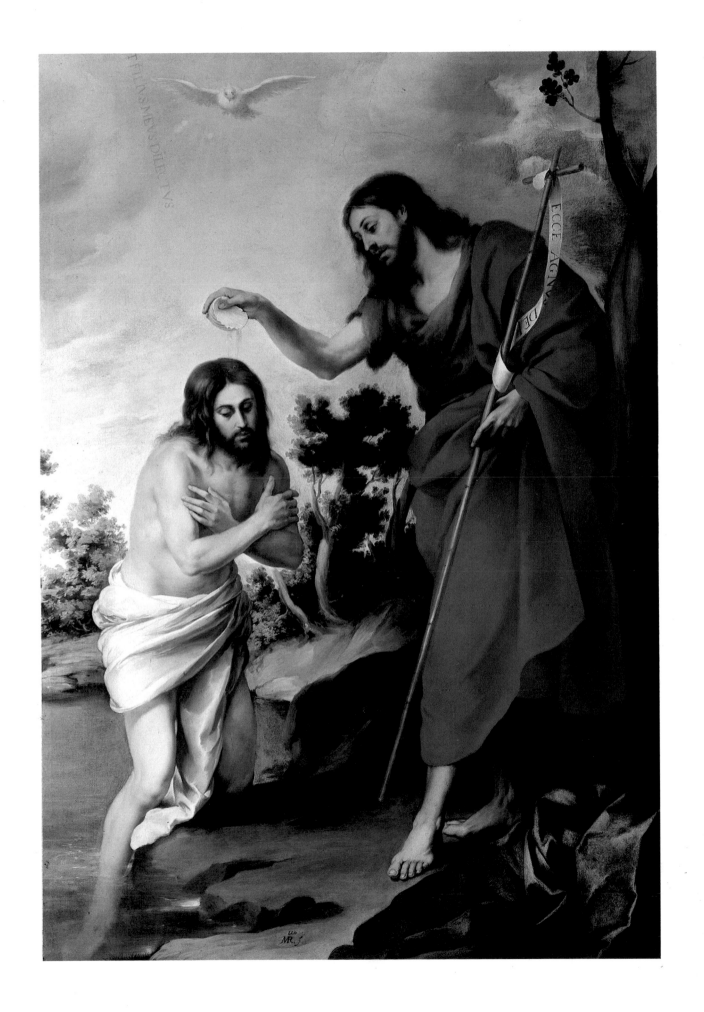

Luca Giordano (1634–1705)
St Michael
c.1663

Canvas, 198 × 147 cm (78 × 57⅞ in)
Signed lower left: 'Giordano ./.F.'
Acquired 1971
Property of the
Kaiser-Friedrich-Museums-Verein
KFMV 261

Guido Reni
St Michael
Rome, Santa Maria della Concezione

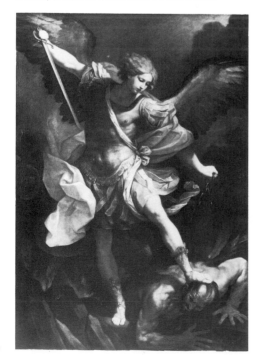

St Michael Triumphing Over Satan and the Rebellious Angels is apparently an altarpiece that, judging by its dimensions, was intended for a side chapel rather than for a high altar – in what church we do not know. It was executed in about 1663, when Giordano had overcome the influence of Mattia Preti (active in Naples 1656–60) and the Venetian, Veronese-derived aspect of Preti's style, and began a short phase inspired by the great Bolognese painter, Guido Reni. Reni's influence made itself felt in brushwork of great fluency and lightness of touch, an airy translucence of surface particularly in passages of drapery, and a high-keyed, lucid palette. Reni's late masterpiece, *The Adoration of the Shepherds* in the choir of S. Martino, the church of the Carthusian convent in Naples, made a deep impact on Neapolitan painting. Its predominant colour triad of blue, white and red is found again in Giordano's *St Michael*. Still more direct inspiration came from Reni's famous altar painting, *St Michael*, executed shortly before 1636 for the Capuchine Church in Rome, the mother church of that order in Italy. Echoes of that painting merge here with those of still another renowned prototype: Raphael's *St Michael*, dated 1518, a painting presented to King Francis I of France by Lorenzo de' Medici. Giordano knew this composition from an engraving by Beatrizet. The motif of the lance which the angel grips with both hands, in the act of striking, and his almost dancing pose with his left leg extended behind him, were both inspired by Raphael. From Reni, on the other hand, came the diagonal composition, the inclination of the angel's head (though Giordano turns it from three-quarter into profile view), the facial type and wavy blond hair, and particularly the light, brilliant colours of the blue mail shirt and the pink, fluttering drapery. Finally, the influence of Giordano's presumed teacher, Ribera, is apparent in the figure of Satan – in the firm modelling of the body, the desperate gestures, and the grimacing face with its gaping mouth and bared teeth. These features are directly derived from an engraving by Ribera, dated 1622.

The influence of Ribera is even more evident (while that of Reni not yet detectable) in a much larger and darker altarpiece of *St Michael* in Vienna (Kunsthistorisches Museum), done about five or six years before the Berlin *St Michael*. Giordano devoted yet more altarpieces to the subject, which was widespread in sixteenth- and seventeenth-century art. St Michael, *miles christianus*, was a symbol of the triumph of the Catholic church over both Protestantism and the Turkish threat. Depictions of the saint were particularly numerous during the wars against the Turks: after Johann Sobieski's victory at Chozim in 1672, the liberation of Vienna in 1683 and of Budapest in 1686, the war against the Turks ended in an enthusiastically celebrated success. The triumphal character of Giordano's image, reflecting the optimism of the Roman church, is specially achieved by a festive, light palette. The elements derived from Raphael, Reni and Ribera have been transformed here into a High Baroque composition. The scene fairly bursts with the Baroque exuberance of the expansive movement with which St Michael quells Satan's final spasm.

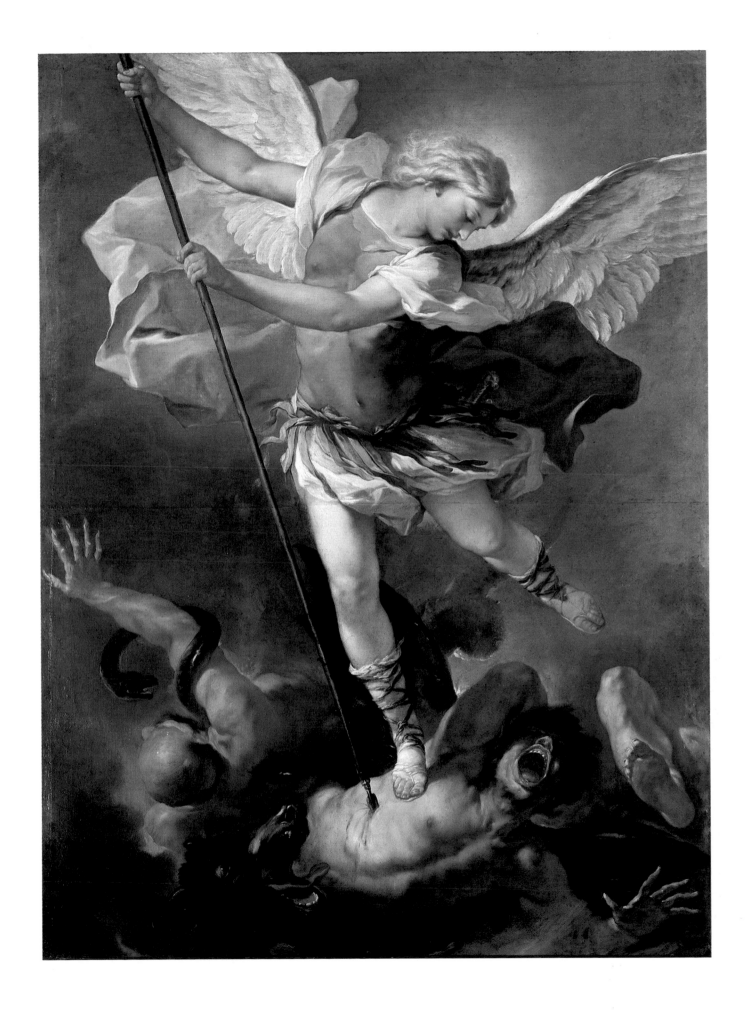

Francesco Solimena (1657–1747)
The Virgin and Child Enthroned, with St Dominic and St Catherine of Sienna
(The Madonna of the Rosary)
*c.*1680–2

Canvas, 247 × 168 cm (97¼ × 66⅛ in)
Acquired 1971
Cat. no. 1/71

Francesco Solimena
Madonna of the Rosary
X-ray photograph
Berlin, Gemäldegalerie SMPK

With Solimena's *Madonna of the Rosary*, acquired in 1971, the Berlin Gallery now also owns a work by the second great master of High and Late Baroque painting in Naples. The first was Giordano: during his ten-year absence from Naples, when Giordano lived in Madrid as court painter (1692–1702), Solimena's advance began, until by Giordano's death in 1705 he dominated the Neapolitan art scene. *The Madonna of the Rosary* is an early work, painted just two decades after Giordano's *St Michael*, when Solimena had yet to develop his cool, classicizing and academically oriented mature style characterized by strong chiaroscuro contrasts modelled in a cool palette. Here, as in other works of the early 1680s, his colour is still light and lucent with an emphasis on white and light red, the volumes burgeoning, the modelling loose, the impasto rich and the brushwork fluent – stylistic symptoms of the influence of Luca Giordano and Pietro da Cortona (the latter active in Rome and Florence). *The Madonna with the Rosary* – that is, the Virgin enthroned with the Christ Child who hands a rosary to St Dominic, founder of the Dominican order, while St Catherine of Sienna, the order's most important female saint, looks devoutly up at him – must have been intended as an altar painting for the Rosary Chapel of a Dominican church. It may be the work that Solimena's biographer, De Dominici (1743), mentions as being in the convent church at Sessa Aurunca in northern Campania, of which today only scant ruins remain. The theme appeared in visual art late in the fifteenth century, in connection with the spread of the brotherhood of the Rosary, but became frequent only in the course of the sixteenth century, particularly after Pope Gregory XIII established the Feast of the Rosary in 1573, to commemorate the Virgin's intercession in the Battle of Lepanto against the Turks (1571). While in most sixteenth-century depictions throughout Italy, and in seventeenth-century ones outside Rome, the Madonna is surrounded by many worshippers, Solimena paints only the two principal saints of the Dominican order, its founder and St Catherine of Sienna (1347–80; canonized 1461).

This compositional scheme with only these two saints rapidly came to dominate Roman painting. It was introduced into Naples by Giovanni Lanfranco, who had worked in Rome from 1602–33 and moved to Naples in 1634. His altarpiece of the Virgin Enthroned with two Carthusian Saints (based on his own *Madonna with the Rosary* in Perugia) for S. Martino in Naples (now Afragola, 1638), became the prototype for many altarpieces, including Solimena's in Berlin. Similarities are evident in the general conception, in the saint at the right with his foot on a pedestal and his face turned in profile to the Child, and in the column motif in the right background. Another similarity is the flowing red drapery, which in Lanfranco's painting is drawn up to the corner by a large angel at the upper left. Solimena, too, originally painted an angel in much the same position, holding a rose garland over the Virgin's head, and to his right, another flying putto holding up the drapery. The two figures are very clearly visible in the X-ray photograph. Though they were completely finished, the artist deleted them, perhaps to give the crowded composition more clarity and the diagonal orientation it now has. The golden green section of drapery was once part of the larger angel's garment, and in the space previously occupied by the angels there are now groups of cherubs' heads.

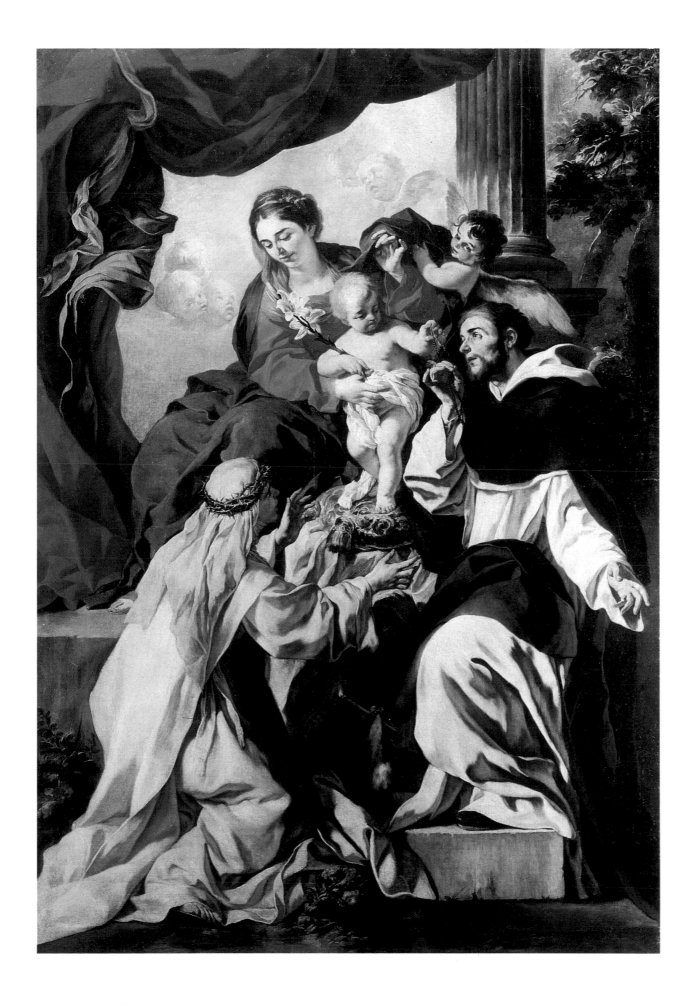

Sebastiano Ricci (1659–1734)
Bathsheba in her Bath
*c.*1725

Canvas, 109 × 142 cm (43 × 56 in)
Acquired by Frederick II before 1773
From the Royal Palaces, Berlin
Cat. no. 454

Sebastiano Ricci, a generation older than Tiepolo, was the first painter of the Venetian Settecento to liberate painting from the tenebrist tradition in Venetian painting of the later seventeenth century, inaugurating a new era that culminated in the work of Tiepolo. While in Rome from 1690–4, Ricci became acquainted with the High and Late Baroque style of Cortona and Gaulli, then saw the work of Magnasco in Milan and Giordano's frescoes in Florence. After returning to Venice in 1697, he created ceiling paintings in the Palazzo Mocenigo (*c.*1700; now Berlin, Gemäldegalerie SMPK) which reveal the influence of Giordano. A large ceiling fresco at Schönbrunn Castle in Vienna, followed in 1702. He spent 1706–8 in Florence, then returned to Venice, where in 1708 he executed a crucial work, the altarpiece in S. Giorgio Maggiore that marked an obvious recourse to the art of Veronese as well as to the composition of Titian's *Pesaro Madonna*. Passing through Paris in 1716 after four years in England, Ricci met Watteau and Lafosse, who celebrated him as a new Veronese.

The Berlin *Bathsheba* is a work of the artist's late Venetian period, probably painted in about 1724–5. It was acquired between 1764 and 1773 for the Picture Gallery at Sanssouci by Frederick the Great, who characteristically considered it to be a work of Veronese. Its true artist was not recognized until 1909, by Molmenti. Nor did the fact that its subject was the story of Bathsheba impress itself upon early commentators. In every Berlin catalogue from 1830 to 1921 the painting was listed as *After the Bath*, and in the 1931 edition as *The Toilette of Venus*. These misnamings are perhaps excusable because of the absence of David. The theme was finally identified solely by the figure of the girl messenger bringing a letter in the far left background.

The Bible story relates how David seduced Bathsheba, and when she became pregnant, sent her husband, Urias, into 'the forefront of the hottest battle', where he was soon killed. In Ricci's rendering, the moral of the story – David's punishment for the sin of leading Bathsheba into adultery – is entirely secondary to a celebration of feminine beauty. This treatment is typical of seventeenth- and eighteenth-century Italian painting, in which other female figures from the Old Testament and heroines of Roman history were assimilated in

Sebastiano Ricci
Bathsheba in her Bath
Budapest, Museum of Fine Arts

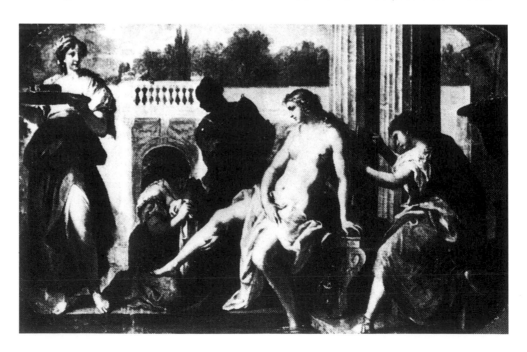

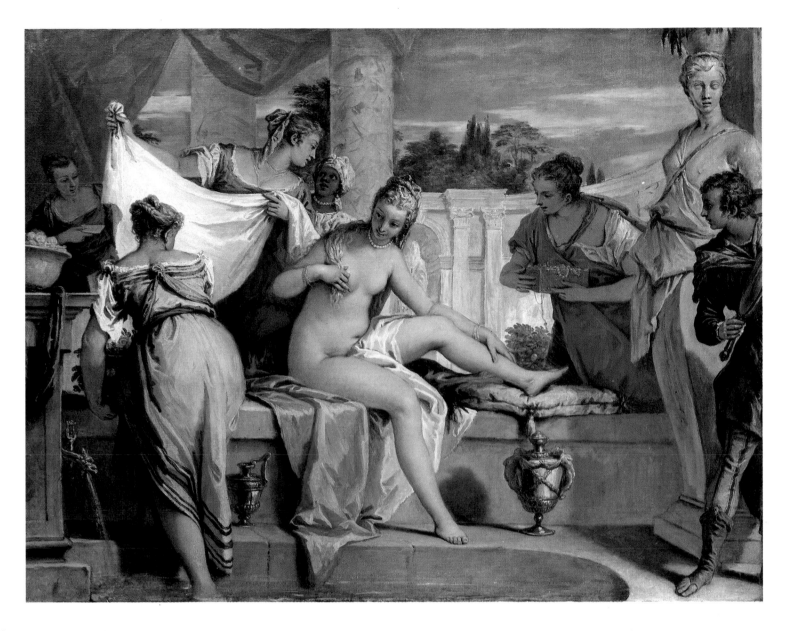

a similar way (Susanna, Lucretia, Cleopatra). The setting here, a Venetian Renaissance villa, is an architectural ambience often used especially by Veronese. Ricci also evokes the art of his great ancestor Veronese in the rendering of the figures and their luxurious garments, and in a festive colour scheme based on combinations of white, yellow, blue and red.

The same subject occurs in another Ricci painting of about the same date, a horizontal but somewhat larger format (Budapest, Museum of Fine Arts) of which two replicas exist, one and possibly both by his own hand. In this version, Bathsheba's head, instead of being shown frontally with a carefully arranged coiffure decked with pearls, and partly covered with a scarf, is seen in profile, her long, blonde hair loose and being combed by a maid. The scene is also set in a Palladian villa, though its background architecture is flat and parallel to the picture plane, while in the Berlin painting the bath has rounded ends and the background wall with its niches and pilasters describes an oval curve. This has a compositional counterbalance in the sweeping up of the white cloth by the maid at the left to protect Bathsheba from prying eyes.

Giovanni Battista Tiepolo (1696–1770)
The Martyrdom of St Agatha
c.1750

Canvas, 184 × 131 cm (72½ × 51½ in)
Acquired 1878
Cat. no. 459 B

Giandomenico Tiepolo
Engraving after Giovanni Battista
Tiepolo's altar painting

If Sebastiano Ricci and the somewhat younger Pellegrini and Amigoni rang in the Venetian Settecento, Tiepolo brought it to culmination. Particularly in his ceiling frescoes, he evoked heavenly realms of unprecedented vastness, and peopled them with mythological, historical, and allegorical figures in whose Baroque, declamatory, and yet ironically tinged pathos the declining Venetian aristocracy saw its former greatness.

One of Tiepolo's most classical images is the former high altarpiece of St Agatha, the church of the Benedictine Convent in Lendinara near Rovigo, painted in about 1750. It represents the death of the church's titular saint, who lived during the first half of the third century in Catania and suffered martyrdom in the year AD 251. Agatha came from a rich and noble family, and devoted her life to Christ from an early age. After being subjected to various temptations by the young Quintian, she was arrested and tortured. An executioner cut off her breasts. In the dungeon, St Peter appeared to her and healed her. When she was again being tortured, part of the building suddenly caved in, burying her tormentors beneath it, and an earthquake struck the town of Catania. After thanking the Lord for keeping her body inviolate, St Agatha died. During a later earthquake, the faithful took up the shroud covering her grave and quelled a flow of lava with it; her protection has been invoked against earthquakes ever since.

While Italian painters of the Early Baroque generally depicted St Agatha in the dungeon, being healed by St Peter, Tiepolo has represented her martyrdom. Collapsed on the steps of an ancient, ruined temple, she looks submissively towards heaven as a maid covers her wounds with a cloth and a servant holds a plate with her cut breasts. Intensely dramatic as the scene is, the artist none the less shied away from depicting the terrible moment itself. What dominates here is the impression of St Agatha's steadfast and tranquil faith in God. The composition centres around her figure, which is supported and, as it were, framed by the boy with the salver, and the maid bending tenderly towards her, in contrast to the violent and threatening figure of the executioner, his muscular arm angled to the right. The energy with which he twists his head to the left is met by a huge column opposite, whose vertical form symbolically repeats the vertical of St Agatha's pleading, trusting gaze.

As may be seen from an etching by Giambattista's son, Giandomenico, the painting originally had a semicircular upper edge, and the column extended higher, its top broken off, perhaps to evoke the collapse of the palace and the ensuing earthquake. Represented at the left was St Agatha's vision, Christ's heart in an aureole of flames, encompassed by a crown of thorns, and flanked by the heads of two angels. The painting was reported to be in poor condition as early as 1795. It was sold or otherwise removed from the church perhaps when the convent was secularized in 1810, but by 1832–5 at the latest. The church building was purchased in 1832 from the Austrian administration by a priest who presented it to the Capuchines; they refurnished it and dedicated the high altar to St Francis. St Agatha was venerated in a side altar, which in 1834 received a new altar painting. Tiepolo's canvas was apparently removed, and later a strip of about 15 cm wide was cut off the bottom edge.

Two preliminary drawings for the head of St Agatha are preserved in the Berlin Kupferstichkabinett, and a study for the hands of the boy holding a salver is in the Museo Correr, Venice.

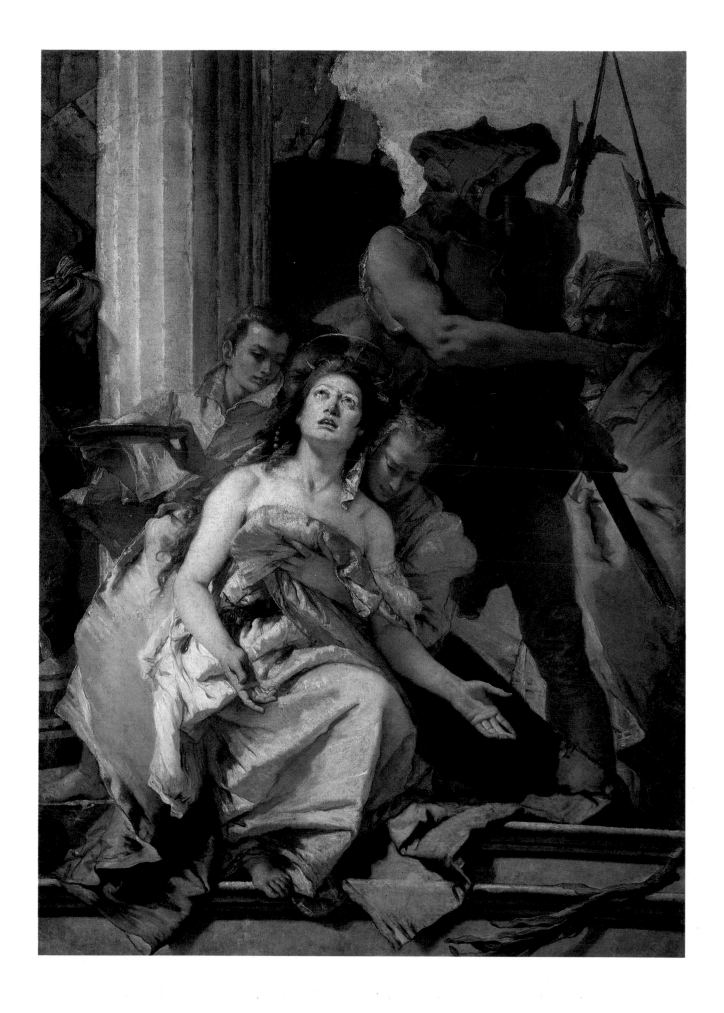

Giovanni Battista Tiepolo
Rinaldo and Armida in Armida's Magic Garden, Overheard by Carlo and Ubaldo – Rinaldo Bidding Armida Farewell

Canvas, 39 × 62 cm (15⅜ × 24⅜ in) (459 D)
and 39 × 61 cm (15⅜ × 24 in)
Acquired 1908 (459 D) and 1979
Cat. nos 459 D and 3/79

Tiepolo's agreement to execute works for the Würzburg Residence of Prince-Bishop Carl Philipp von Greiffenclau is first mentioned in an official letter of 29 May 1750. On 12 December of that year Tiepolo and his two sons, Domenico and Lorenzo, arrived in Würzburg, where the artist stayed for almost three years. With the ceiling fresco above the main stairwell, dated 1753, Tiepolo's art reached its greatest fulfilment. Besides frescoes in the *Kaisersaal* and paintings for the chapel (both 1752), his decorations of 1753 evidently included two medium-sized canvases (105 × 140 cm/41⅜ × 55 in) for other rooms of the Würzburg Residence. These were scenes from one of the best-known and most frequently illustrated love stories in Torquato Tasso's verse epic, *La Gerusalemme Liberata* (1581): *Rinaldo and Armida in Armida's Magic Garden* and *Rinaldo Bidding Armida Farewell*. For a long time the two paintings were shown in Munich (Alte Pinakothek), but they have again been on view in the Residence since 1974.

A small, *modello*-like sketch for the first of the two Tasso scenes was acquired for the Berlin Gallery in 1908, but it was not until 1979 that it also acquired a sketch for the other, from Cailleux in Paris. The two sketches for the Würzburg companion pieces are now reunited and their original context is restored, for they are related in composition and content. What is still debated is whether they represent preliminary, finished renderings (*modelli*) for the Würzburg canvases, as most scholars believe, or whether they are altered repetitions on a smaller format or *ricordi*, 'small variants' (*riduzioni in piccolo*) by the master's own hand, as suggested by Rizzi (1971), who dates them accordingly, to about 1755–60. As regards the first scene, the 'sketch' and finished painting are substantially similar in terms of composition, figures, and essential landscape details, though the placing of these does differ considerably. For the other scene, the compositions themselves diverge.

Tasso's verse epic and Ariosto's *Orlando Furioso* (1516) were the two main contemporary sources for imagery of this type in seventeenth- and eighteenth-century painting. The subject of these poems, the defence and victory of Christianity over the heathen Saracens, bore obvious analogies to such significant movements and events of the day as the Counter Reformation and the Turkish Wars. Nevertheless, instead of depicting scenes from the main plot involving Godfrey of Bouillon like the siege and fall of Jerusalem, most artists chose romantic and bucolic episodes. One of these was the encounter between Rinaldo, Christian crusader from the house of Este, and Armida, a sorceress sent from Damascus to spread confusion in the Christian camp. At first she succeeds. Infatuated by her charms, ten knights escort her out of camp, and others follow. When Rinaldo manages to free some of them from her magic spell, Armida calls a siren to lull him to sleep. Yet falling in love with him herself, she spirits him off to the Islands of Bliss far out in the sea. There, in her enchanted garden, Armida holds her magic mirror with her own image up to his eyes, and Rinaldo succumbs.

This scene from Canto XVI is represented in Tiepolo's first painting. Perched on the edge of the fountain is the parrot that in Tasso's poem sings praises of nature's beauty, of love, and of the transience of earthly things. Approaching from the right, the knights Carlo and Ubaldo come to reclaim Rinaldo for the Christian cause, armed with the Sage of Ascalon's overpowering diamond shield and wand.

In the second scene, Carlo and Ubaldo break the spell, tearing Rinaldo from Armida's arms. One of them supports the dazed Rinaldo, trying to restore him to reality as Armida, reclining at the left, points to the high garden wall as if to say there is no escape, though her pose and features bespeak resignation. Rinaldo's shield and helmet still lie beside her on the ground; her magic mirror, now powerless, lies forgotten in the shadow of the wall; Rinaldo still holds a garland of flowers. In the right background, a boat waits to take the crusaders back to their camp, where Godfrey of Bouillon will forgive Rinaldo and entrust

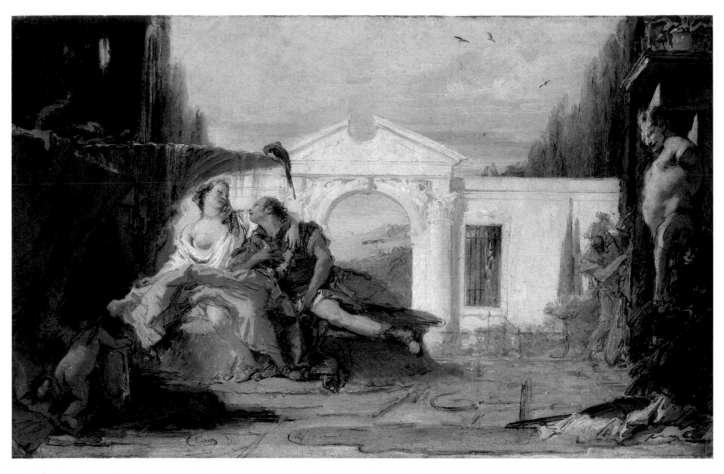

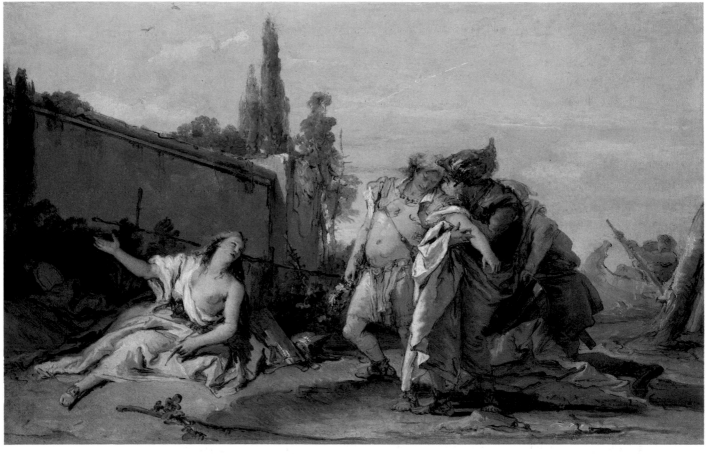

Giovanni Battista Tiepolo
Rinaldo and Armida in the Magic Garden
Würzburg, Residenz

Giovanni Battista Tiepolo
Rinaldo Bidding Armida Farewell
Würzburg, Residenz

him with new missions. This boat is absent from the Würzburg painting, whose format is not as long and narrow as the Berlin painting (which might be a fact against it being a preparatory sketch). The scene is reversed in the final painting. The only compositional element shared by both is the group of trees behind the garden wall. In the Würzburg painting Armida reclines in the right foreground, in the same direction as in the sketch, with her outstretched leg in an identical position, but looking to the left and holding a handkerchief to dry her tears. Rinaldo stands to the left, in front of the wall, in classical counterpoise, looking back over his shoulder at Armida as if to ask her forgiveness, his left hand to his breast in a gesture of pathos. The two knights turn towards Armida, holding up the diamond shield that makes her powerless. The figures' actions, so spontaneous in the Berlin painting, have here frozen into declamatory poses and theatrical gestures, and the relationship between the figures and landscape is altered to correspond. In the final version, the figures act out the scene on a foreground stage brought close by stronger chiaroscuro, while the landscape recedes further into the background.

Tiepolo had already treated the same theme ten years earlier, in about 1742, in Tasso scenes (now in Chicago and London) for the decoration of an entire room: Knox (1978) thinks these may have been in the Palazzo Dolfin-Manin in Venice. A pen drawing in Frankfurt for this early series contains a portico in the Palladian style which the artist employed in painting for the first time in the Berlin and Würzburg Rinaldo and Armida scenes. Tiepolo was again inspired by Tasso in 1757, with his frescoes for the Villa Valmarana, near Vicenza.

Giovanni Antonio Canal, called Canaletto (1697–1768)
The Campo di Rialto
1758–9

This view of the Campo di Rialto, once the main marketplace and commercial centre of Venice, was painted in Canaletto's final years after his return from England, where he worked with short intervals from 1746 to 1755. It was commissioned by Sigismund Streit, a Berlin businessman and long-time resident of Venice. He also commissioned a companion piece with a view of the Canal Grande and Palazzo Foscari, where his home and office were located. The two paintings, together with other paintings, his library and fortune, were intended for Streit's former school, the Gymnasium Zum Grauen Kloster in Berlin. Streit also ordered two more paintings from Canaletto, depictions of Venetian festivities in *vedute* form: the *Festival on the Eve of St Martha's Name Day*, before the church of S. Marta on the Giudecca canal; and the *Festival of the Vigil of St Peter*, near S. Pietro di Castello. These paintings were the same size as the first two *vedute*, and they were perhaps meant to introduce a series on Venetian festivals. Streit indeed commissioned just such a series from the young Antonio Diziani, apparently because he was not satisfied with Canaletto's *Vigilia di S. Marta*. Both Canaletto's festival paintings are nocturnes; they form a pair and complement the two 'daylight' scenes, *Canal Grande* and *Campo di Rialto*.

Sigismund Streit (1687–1775) arrived in Venice in 1709, and by 1715 had established his own trading office. In 1739, at the age of fifty-two, he sat for his portrait to Amigoni, ten of whose Biblical and mythological paintings he later acquired, though probably not then intending to donate them to his former school or create a collection. Streit retired from business in 1750 and in 1754 moved permanently to Padua. Since he was a bachelor and had fallen out with his nephew who had been in his firm, Streit began to correspond with his old school about a donation from his estate. With this bequest in mind, he ordered four allegories with moral and educational allusions from Nogari in 1751–2, probably for the school library, and then the four Canaletto paintings, which were shipped to Berlin in 1763.

The Campo di S. Giacomo di Rialto, the city's main business and banking centre, was located across the Canal Grande from Streit's residence and office building, the Palazzo Foscari. Canaletto had depicted the square twice, looking in the opposite direction, with a view of the façade of S. Giacometto (Dresden and Ottawa), before this first attempt to paint the less interesting end of the square with its plain façades of the Fabbriche Vecchie di Rialto. These, built by Antonio Abbondi in 1520–2, were now the headquarters of the government Trade, Maritime and Food Agencies. The choice of this view evidently went back to Streit's wish to have a record of the graceful Porticato del Banco Giro, where the Venetian State Bank had its office.

We see clerks in black gowns and white ties working there at their desks; behind them in the passageway are notaries' windows; the offices of insurance agencies are not far away. Businessmen stroll through the square, conversing, negotiating. In his own description of the scene, Streit mentions the Jews with their compulsory red caps, and Armenians in long gowns and pointed hats. On the central column of the arcade is the *Gobbo di Rialto*, a sculpture by Pietro da Saló (1541) of a hunchbacked figure supporting a little staircase up the squat granite column, the *Colonna del bando*, where a *comandador* publicly announced new laws, proclamations, punishments, information about ships' arrivals and departures, and similar matters. Foreign businessmen were granted permission to convene at this column.

On the left is the *ruga degli orefici*, named after the goldsmiths who had their shops under the eaves and whose characteristic signs are clearly visible. High in the background is the campanile of S. Giovanni Elemosinario. Outside the shops, booths offer meat, fruit and vegetables, and pottery; awnings are spread over the perishable goods to protect them from the sun. In the foreground and along the right arcade, household goods, furniture (at

Canvas, 119 × 186 cm (46⅞ × 73¼ in)
On loan from the Streitsche
Stiftung, Berlin

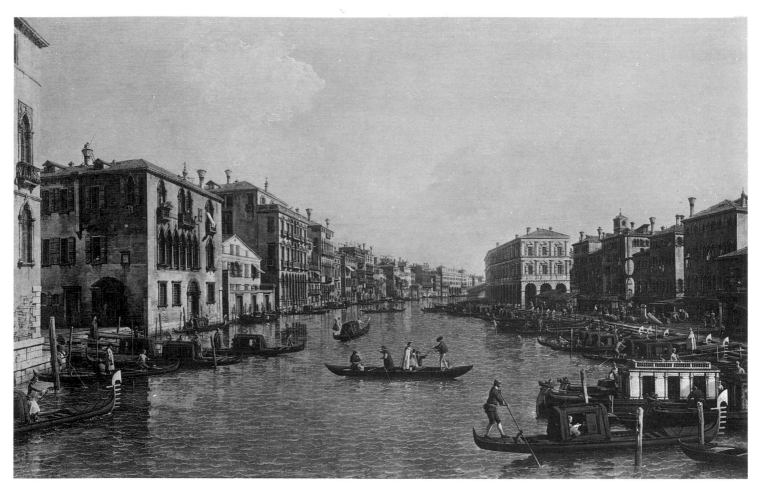

Canaletto
The Canal Grande, Venice, with Palazzo Foscari, Streit's Residence
Berlin, Gemäldegalerie SMPK, on loan from the Streitsche Stiftung

the far right, a *capoletto*), paintings, and other craft objects are on sale.

The wide-angle perspective makes the square appear much larger and more monumental than it actually is. The paving with meandering rectangular white stones still exists today. It was apparently carried out in 1758, which provides a *terminus post quem* for Canaletto's painting.

The monumentality of the space, the cool lucidity of its atmosphere, a great precision in the rendering of architectural detail, calligraphic brushwork, the palette with its dominating sandy beige, brown and red hues, and finally, a penchant for genre-like elaboration of detail – all these are characteristics of Canaletto's late style.

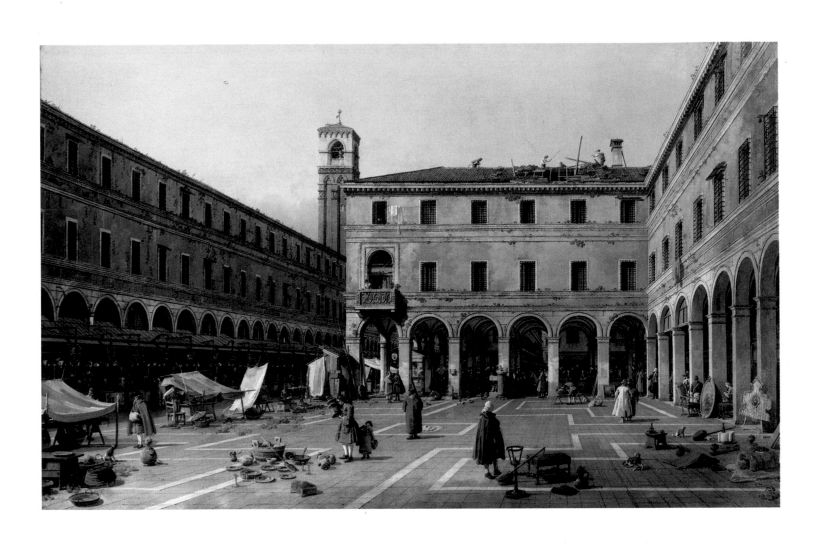

Francesco Guardi (1712–93)
The Balloon Ascent
1784

Canvas, 66 × 51 cm (26 × 20 in)
Acquired 1901
Property of the
Kaiser-Friedrich-Museums-Verein
Cat. no. 501 F

With Canaletto and Marieschi, Guardi was the third great eighteenth-century Venetian painter of views or *vedute*. In contrast to Canaletto, who focused on architecture and attempted a highly objective description of space, Guardi, in the painterly tradition of the Riccis and Magnasco, took figures and landscape as his point of departure. His approach was subjective, imaginative; his brushwork sketchy and nervous, giving his surfaces a vibrating effect that spread like a veil over the entire scene. In his late period he began to develop a reporter's eye for current events, as the present painting shows. It is devoted to the first balloon ascent in Venice, in 1784, a year after the Montgolfier brothers' pioneering flight. The balloon, or rather its gondola, was commissioned by the Procurator of S. Marco, Francesco Pesaro, and built by the Zanchi brothers. Though there is still some question as to who piloted the balloon, it cannot have been Count Francesco Zambeccari, as is frequently stated, because he was in London at the time. The balloon remained aloft for two hours and landed in a swampy area of the lagoon; and its flight was reported in newspapers, engravings, poems and commemorative medals. Though one of the engravings shows the ascent at the mouth of the Grand Canal, opposite the Piazzetta, above the Bacino di S. Marco, Guardi has it take place at the entrance to the Giudecca Canal. From a vantage point in the shade of the portico of the Customs House (*Dogana del Mar*) on the land between the Grand Canal and Giudecca Canal, a crowd of onlookers watches the balloon, which has just risen clear of a wooden platform surrounded by gondolas. In the background, on the far shore of the canal, is Palladio's Il Redentore church and the church of Le Zitelle. The charm of this unusual composition lies in the contrast between the repoussoir-like dark frame of the portico architecture in the foreground, and the expanse of blue, translucently clouded sky opening out behind it.

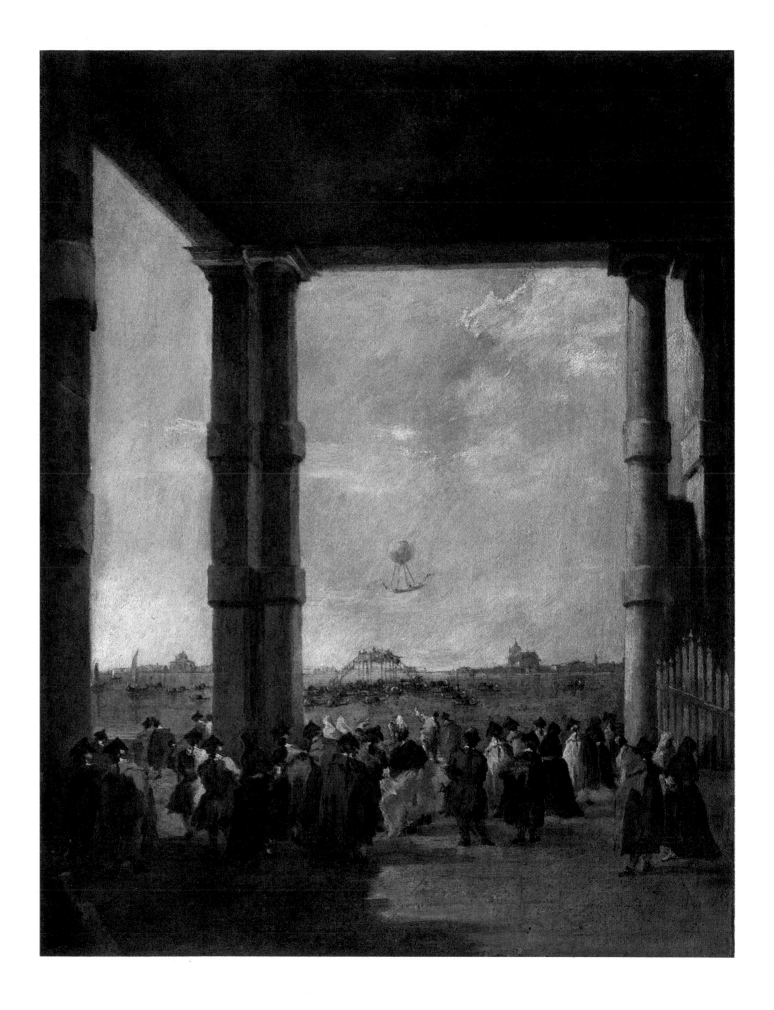

Giovanni Paolo Panini (1691–1765)
The Duc de Choiseul's Departure on St Peter's Square in Rome
1754

Canvas, 152 × 195 cm (59⅞ × 76¾ in)
Signed lower left: 'I. P. PANINI/1754'
Collections of Hubert Robert, Paris;
Mme V.e Robert, Paris, 1821
Donated by the Deutsche Klassenlotterie
Berlin for the 150th anniversary of the
Berlin Museums
Cat. no. 2/80

G.P.Panini
Figure Study
London, British Museum

G.P.Panini
Figure Study
London, British Museum

G.P.Panini
Figure Study
Berlin, Kupferstichkabinett SMPK

Panini, the leading painter of views, architecture, and ruins in eighteenth-century Rome, is represented in the Berlin Gallery with five works. The most outstanding among these is surely his *View of St Peter's Square with the Departure of the Duc de Choiseul*, which was acquired in 1980. Its large format, the number and unusual size of its figures, but particularly the importance of the scene depicted and the prominence of its patron and main protagonist, rank the painting high among Panini's works in Berlin and within his extensive œuvre as a whole.

Represented here is the ceremonial departure (from St Peter's) of the French Ambassador to the Holy See, Etienne-François de Choiseul, Comte de Stainville, later Duc de Choiseul, following his audience in St Peter's with Pope Benedict XIV in 1754, to inaugurate his three-year period in office. Choiseul had obtained this position, the first in his diplomatic career, thanks to the sponsorship of Madame de Pompadour. Choiseul's main objective was to negotiate with the Pope about dissension within the French church, which culminated in a conflict between the nationally oriented Gallicans and Jansenists, and the Roman oriented Jesuits. By the autumn of 1756, the deliberations were over. When on 16 October the Pope handed down to Choiseul his encyclica *Ex omnibus* – an event recorded by Batoni in a famous painting (Minneapolis Institute of Arts) – the Ambassador's mission had been accomplished, and he returned to Paris the following year.

Before the Berlin painting came to light in Paris in 1978, the only four works commissioned by Choiseul from Panini which were known were in a series to commemorate the Duke's diplomatic activities in Rome and his status as connoisseur and collector of classical and contemporary art: a *View of St Peter's Square with the Duke's Procession after a Papal Audience* (Scotland, Collection of the Duke of Sutherland); a *View of the Interior of St Peter's with Choiseul's Visit* (Boston, Atheneum); and two imaginary gallery interiors with *vedute* of ancient Rome (Stuttgart, Staatsgalerie) and modern Rome

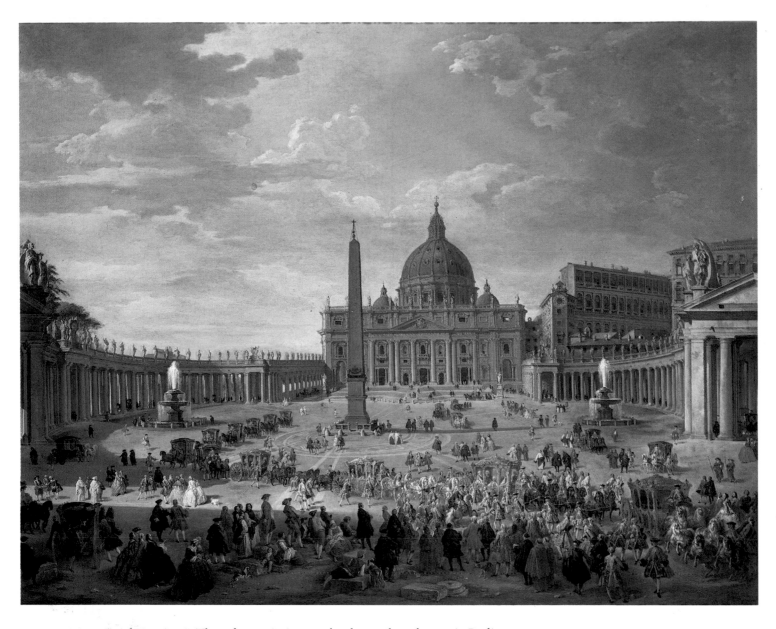

(Boston, Museum of Fine Arts). These four paintings, rather larger than the one in Berlin, were executed in about 1756–7, towards the end of Choiseul's service in Rome; the *Gallery with Views of Modern Rome* is dated 1757. The Berlin painting is dated 1754, which places it at the beginning of Choiseul's ambassadorship. It probably represents the only surviving piece of the first series of views painted in 1754, which for unexplained reasons remained in the artist's possession until he passed them on to his pupil and friend, the painter Hubert Robert. Robert, who had come to Rome in Choiseul's retinue, owned over thirty paintings by Panini. Among these were the above-mentioned first series of four views of Rome commissioned by Choiseul, two of which – the imaginary galleries – were auctioned in Paris in 1809, a year after Robert's death, and whose whereabouts are still unknown. The other two were sold in 1821, after Robert's widow had died. The Berlin painting is apparently one of these, though the other is lost.

In terms of subject-matter and general conception, the Berlin painting corresponds to a similar view in the second series now in the Duke of Sutherland's collection. The long train of carriages sweeping in a wide curve across the square is arranged in much the same way in the two paintings, particularly in the foreground, though it does diverge in the background. Similarities are also evident in the strong lighting from the left, a swath of light glowing through the colonnade's narrow entrance across the square and picking out the Duke's carriage. By contrast, the large foreground figures of well-dressed ladies and gentlemen,

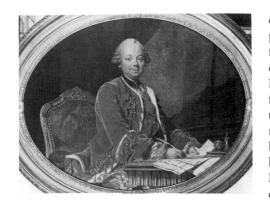

Louis Michel van Loo
Etienne François de Choiseul
Versailles, Musée National

clergy and humble onlookers, are in an area of shade and set off the scene behind. Vantage points and perspectives differ in the two paintings. In the Berlin view, the vantage point lies further to the right, and correspondingly, the obelisk appears to the left of the central axis of the church façade. The entire square appears to be rather nearer the spectator in the Berlin piece, and the architecture of the Vatican Palace is given with a different perspective foreshortening it. The figures represented in the Berlin work are quite different. Unlike those in pure or realistic views, where they play a subordinate role, here the figures play a much more important role. Their scale is larger than usual, and their careful rendering is based on preliminary drawings. Chalk drawings of individual figures and sections of buildings, and sketches of the square are preserved in an album in the British Museum, London; others are in the Berlin Kupferstichkabinett. In his Berlin painting, the artist has combined the *veduta reale* with an eye-witness account of a historical event.

FRENCH AND ENGLISH PAINTING OF THE EIGHTEENTH CENTURY
BY HENNING BOCK

Nicolas de Largillierre (1656–1746)
The Sculptor Nicolas Coustou in his Studio
*c.*1710–12

Canvas, 197 × 132 cm (77½ × 52 in)
Acquired 1980
Cat. no. 1/80

Jean le Gros
Nicolas Coustou, 1725
Engraving after a painting by Dupuis,
1730

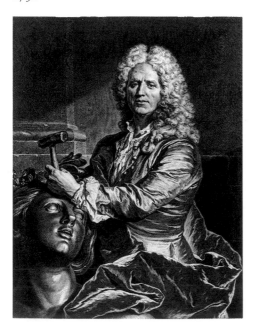

During the late seventeenth and early eighteenth centuries, Hyacinthe Rigaud (1659–1743) and Nicolas de Largillierre were the two leading portraitists in France – Rigaud more for the court society in Versailles, and Largillierre for the rich bourgoisie and nobility in Paris. Building on the Flemish tradition and the austere approach of English portraiture, and with the help of a well-organized workshop, Largillierre created an enormous œuvre of roughly two thousand portraits, still lifes, and history paintings. Pre-eminent among them are a small number of portraits of family members and friends, and of artists and writers on the Parisian scene. These are invariably works of unusual quality, and entirely by the artist's own hand. While some have the dignified distance of official portraits, others far transcend the conventions and compellingly capture the individuality of their sitters, making them the most personal and beautiful of Largillierre's works. This portrait of Nicolas Coustou is a particularly striking example of his ability to portray a man in all his individuality and strength of character while at the same time creating an image of an entire profession.

Nicolas Coustou, about the same age as Largillierre, was one of the most important sculptors of the period. Under Louis XIV and Louis XV he received extensive commissions to decorate great parks, churches in Paris, and above all the royal palaces in Trianon, Versailles, and Marly. A native of Lyons, he had come to Paris in 1676 and received his training from his uncle, the sculptor Antoine Coysevox. After spending the years 1683–6 in Rome on a scholarship he was accepted into the Académie in 1693. He became a professor in 1702, advanced to the position of rector in 1720, and finally, in 1733, to that of chancellor of the Académie.

The portrait shows Coustou in his studio. Though he is wearing a grand dress wig, his informal working clothes give the impression that he has just been interrupted at work. With a turn of the shoulders he faces us, frank and self-assured, extending his hand as if to invite perusal of the objects in his studio and the attributes of his profession. His right hand rests on a tripod before the clay model of a sculpture in progress. Though the colour scheme of the painting is dominated by a finely modulated range of brown, contrasting accents glow in the white of the shirt, in touches of complementary turquoise on the lining of the coat, and on the gold buttons.

There has been some controversy about the model's identity, with some commentators arguing that he may possibly be the sculptor René Fremin (1672–1744). Yet this would seem unlikely since, first, the established portraits of Fremin bear little facial resemblance to the man depicted here; and secondly, the *bozzetti* or models given such prominence in the portrait are quite obvious clues to his identity. The *bozzetto* on the tripod is evidently a model for a large group called *Spring* that Coustou executed about 1712 for the garden façade of the Hôtel des Noailles on Rue St Honoré, Paris (the present site of the St James and Albany Hotel). The only surviving view of this side of the demolished building is found in an engraving by Blondel, while the sculpture itself has disappeared without a trace. An even more convincing argument for the sitter's identity is provided by the figures on the shelf at the upper right. The small armless *putto* occurs in several paintings by other artists of the eighteenth and nineteenth centuries. Chardin included it in his allegorical work *Le singe peintre* of 1743 (Chartres, Musée des Beaux-Arts); Cézanne had a plaster cast of this *putto* in his Aix-en-Provence house and employed it in a series of still lifes collectively titled *Amour en plâtre*. Still legible on the plinth of this cast is the fragmentary inscription, 'Fa...N. Cou...', quite concrete evidence that the sculptor portrayed here is indeed Nicolas Coustou.

The figurine of the standing youth on the right is apparently a small-scale replica of the famous Roman statue, *Antinous*, the original of which is in the Belvedere sculpture collection at the Vatican. From its discovery in the early sixteenth century, this piece

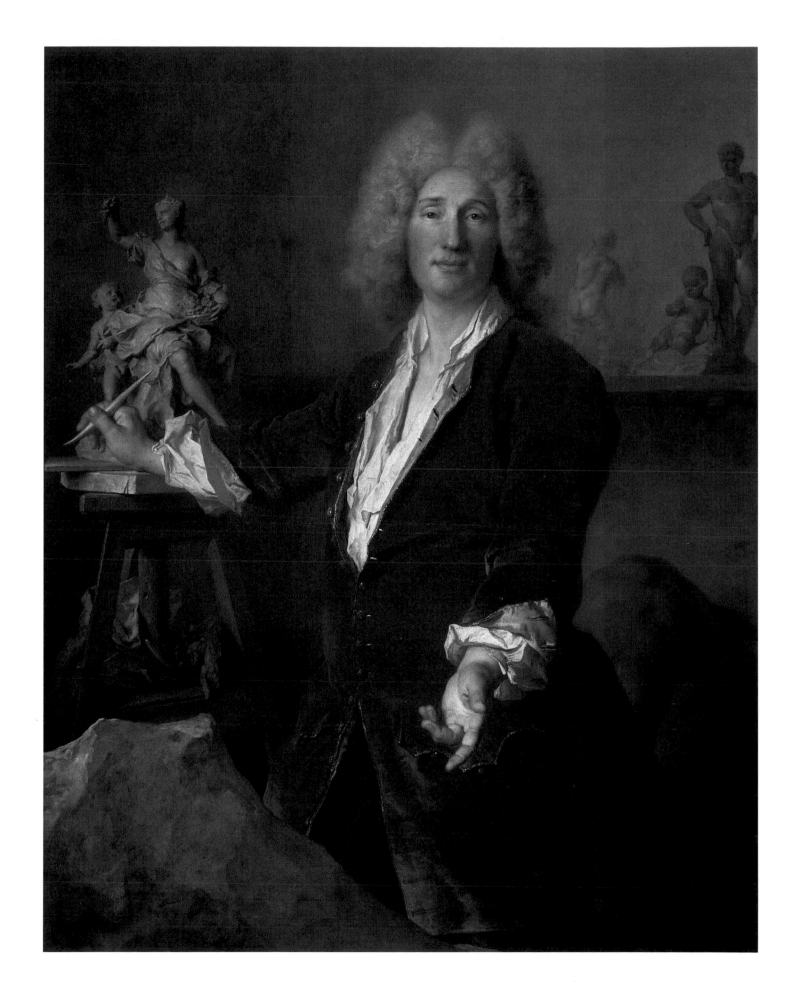

figured as one of the most perfect examples of classical art and as an ideal embodiment of the proportions of the human body. Largillierre himself had previously included it in his *Portrait of Charles Lebrun* (1686; Paris, Louvre) and a short time later in his *Portrait of Gerard Edelink* (c.1690; Norfolk, The Chrysler Museum), as an allusion to every artist's dependence on the doctrine of classical proportions and on the Greek and Roman ideal in art. Hence the *bozzetti* in this portrait of Coustou not only refer to a particular sculptor's work, but also convey a more general message about the artist's mission and his place within the history of his medium.

Still another feature of the portrait invites interpretation. Not by chance has Largillierre depicted his friend in working clothes, standing between a rough-hewn block of stone in the foreground and a lump of clay in the background. According to an academic theory then current, the artist was called upon to reveal the true idea in nature, which was veiled by imperfections and marred by accidental appearances. Only the work of art could reveal true perfection; only the creative imagination could infuse life into amorphous matter, give shape to a more beautiful, ideal world. The sculptor in the portrait accordingly, rather than presenting a finished piece, rests his working hand on a model, which like the crumpled drawing between the legs of the tripod evokes the intellectual process involved in the realization of a *prima idea*.

Beneath the surface of this apparently so realistic and informal portrait of a sculptor in his studio is a fundamental self-definition on the part of one of the major artists of the age.

Antoine Watteau (1684–1721)
The French Comedy
The Italian Comedy
After 1716

When Watteau died in 1721, barely thirty-seven years old, he left an œuvre whose most significant works had been created in the space of just over a decade. Born in Valenciennes in 1684, he had come to Paris in 1702 and been accepted into the Académie Royale in 1712, with the quite unusual distinction of being allowed to choose the subject of his reception picture himself. Though *Embarkation for Cythera* (now in the Louvre) was not finished until 1717, it immediately established Watteau as the painter of *fêtes galantes*, his own pictorial invention. Watteau travelled abroad only once, to England in 1719–20. Few of his works, including the two theatre paintings in Berlin, have come down to us in good condition, for Watteau's technique was often more than careless, and many of his paintings give only a faint idea of their original glory. His reputation as the greatest painter in early eighteenth-century France, however, stands undiminished.

The two Berlin theatre paintings were purchased by Frederick the Great for the small Picture Gallery at Sanssouci some time before 1766. They came to the Berlin Gallery in 1830, the only Watteaus from the Royal Collection and still, as P.Rosenberg noted in the catalogue to the great jubilee exhibition of 1984–5 (Washington, Paris, Berlin), among the artist's most famous works.

They figured as companion pieces from an early date, being already titled *L'amour au théâtre français* and *L'amour au théâtre italien* in the engravings made after them in 1734, when they were in the collection of Henri de Rosnel. In terms of subject-matter they are indeed related, though the dramatic principles followed by the two theatre groups could not be more different – improvisation with the *commedia dell'arte* and strict rules with the *comédie française*. Whether the two paintings were actually executed concurrently and intended as companion pieces, however, is impossible to say. They vary so widely in theme and composition that in the catalogue to the recent exhibition, one author suggested that the first version of *The French Comedy* was painted in about 1712, to which the artist added the central figures in about 1716. *The Italian Comedy*, according to the same essay, might not have been done until about 1718. This hypothesis is difficult to follow, let alone prove; a dating of both paintings to after 1716 would still seem justified by the concrete references they contain, to the return of the Italian actors to Paris in 1716 after their expulsion from France in 1697, and to the actor Poisson, whom Watteau portrays in the role of Crispin.

In *The French Comedy*, a mixed group of actors is depicted in a sunny clearing of a park. A few musicians and people clad as shepherds stand on the left, in the shadow of the trees, among them Pierrot and Gilles; in the centre, a couple is about to begin a courtly dance. Behind them, two actors touch glasses in a toast, one dressed as Amor with a quiver of arrows and elegant bow, the other as Bacchus with panther skin and vine wreath. Between them, in a dress of yellow and green and a shawl trimmed with bells, is Columbine as *La Folie*, a personification of the absurdity of sensual love. On the right, two couples look on: Harlequin turning to a young lady, and next to them, Crispin with a girl at his side. Crispin is the only figure in the painting who can still be identified with a known personage. His features are those of Paul Poisson (1658–1735), an actor brought to the Comédie Française in 1716 by the Duchesse de Berry, daughter of the regent.

None of the many attempts to explain the scene in terms of known contemporary plays has been quite convincing. Possibly Watteau's model was the 'Reconciliation of Amor and Bacchus', third intermezzo in the third act of the pastoral play *Les Fêtes de l'Amour et de Bacchus* by Molière, Benserade, Quinault, and Lully. Given its premiere performance in 1672, this play went on to become a great success, and was staged in Paris for the last time in 1716. Although it would explain the action in Watteau's painting, it falls short in terms of the figures involved. For instance, neither the prominent herm on the wall, nor the

Canvas, each 37 × 48 cm (14½ × 19 in)
From the Royal Palaces, Berlin, 1830
Cat. nos 468 and 470

Antoine Watteau
Study for Amor
Basle, formerly Hirsch Collection

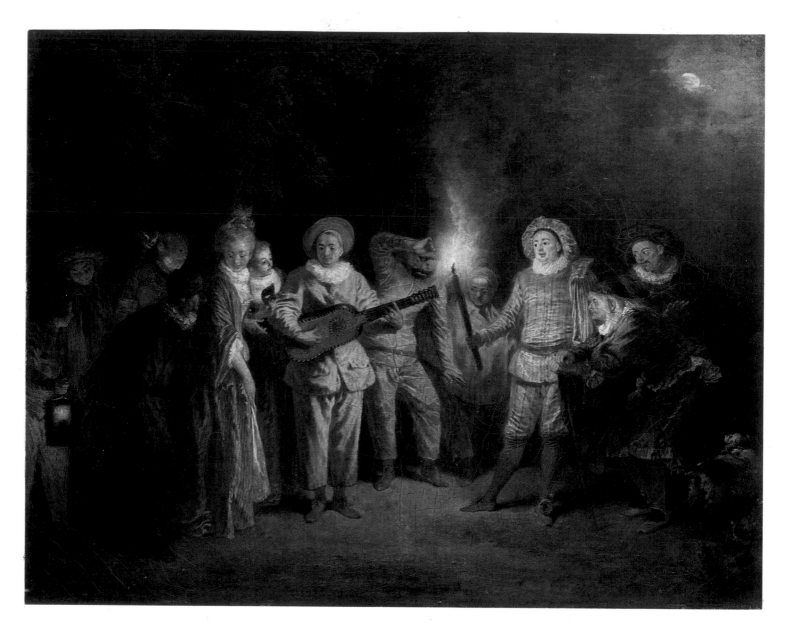

presence of Columbine (*La Folie*), can be explained by reference to this play. Some commentators interpret the hooded herm as Momus, Son of the Night and symbol of foolish fault-finding. This would make Bacchus and Amor the embodiments of a reconciliation of spiritual and sensual love, as opposed to Momus and La Folie, who stand for blind passion. The young man and woman moving towards each other in a dance are involved in this conflict between spiritual and physical love.

The Italian Comedy, the only nocturne Watteau ever painted, shows twelve actors gathered out of doors, after a performance. Pierrot with his guitar stands in the centre; to his left are Columbine (with mask) and Isabella, who glances over at old Pantalone. To Pierrot's right are Harlequin throwing his arm up as if startled, then perhaps Pulcinella,

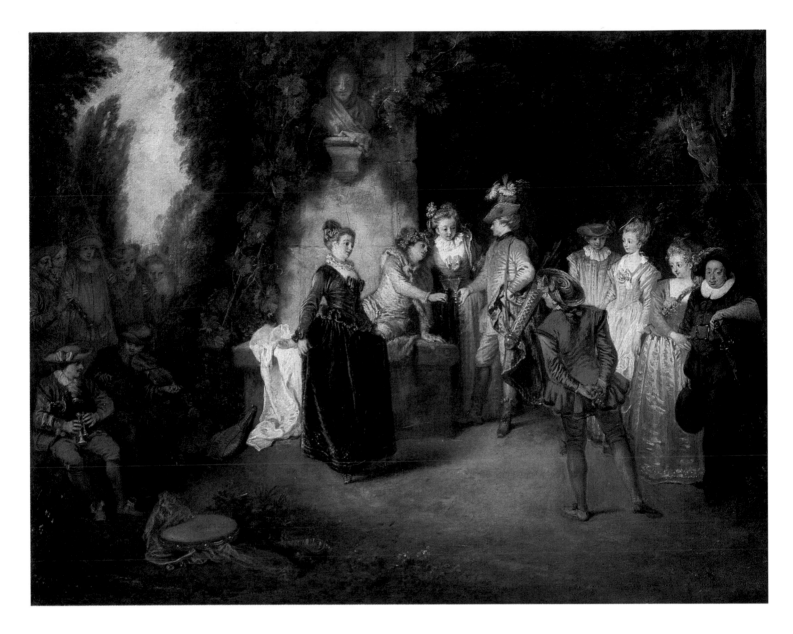

and Mezzetin with a torch, Doctor Marcisino leaning on his cane, and Scaramuccia. Attempts have been made to associate the image with a night scene in *L'heureuse surprise*, the first play performed by the troupe, at the Palais Royal, when they returned to Paris in 1716. Yet here, too, the correspondences are of only a very general nature. According to an advertisement for the 1734 engravings of the paintings that appeared in *Mercure de France* (1733), in this piece Watteau simply depicted his friends in costume. It should probably be understood as a kind of final scene, what Rosenberg has called a vaudeville of all the troupe's performances, in which the artist depicted characters from the *commedia dell'arte* in a nocturnal scene, combining theatrical illusion with reality.

Many preliminary drawings exist for both the Berlin theatre paintings.

Antoine Watteau
The Dance
(Iris)
*c.*1719

Canvas, 97 × 166 cm (38⅛ × 65⅜ in)
From the Royal Palaces, Berlin, 1830
On loan from the Federal Republic of
Germany

Nothing is known about the genesis of this painting. It was first illustrated in the comprehensive volume of engravings *Recueil des dessins gravées*, published from 1721 to 1739 by Jean de Jullienne, after Watteau's death. In the facsimile engraving by Charles-Nicolas Cochin (before 1726?) the painting was titled *The Dance* and accompanied by this quatrain:

> '*Iris c'est de bonne heure avoir l'air à la danse,*
> *Vous exprimez déjà les tendres mouvemens,*
> *Qui nous font les jours conoitre à la Cadance,*
> *Le goust que vôtre Sexe a pour les intrumens.*'

The painting shows four children performing a pastoral play on a meadow at the edge of a wood. They have no audience apart from ourselves, who are invited to look on. Iris, the little dancer in her festive dress, seems to have just come on stage and to be waiting for her cue. She looks expectantly and, for all her childish innocence, rather self-consciously out at the spectator as she turns to face her imaginary audience. A few pastoral attributes lend deeper meaning to her dance – a heart, Cupid's arrow, and the basket of white and red roses. Symbols of the joys and sorrows of love, they allude to the fact that the little dancer will soon have grown out of her childish games.

Her three friends sit and watch from the shade of a tree. They are dressed as shepherds, one boy holding a long shepherd's crook while the other has just begun to play a tune on his flute; the girl between them leans back to watch, and beside them a brown and white dog has gone to sleep, oblivious of everything around him.

Yet the children's pastoral costumes are elegant and fashionable, and their play is an imitation of their elders' *fêtes galantes*. Nor is the stage really unsullied nature, but a wonderfully composed and artificial setting in which the shepherd and his flock and the old church in the background are included merely as evocative props.

This statement must be qualified, however, for as X-rays have shown, the round, central section of the painting is the only part that belongs to its original version, the corners having been added later. Yet Cochin's engraving, probably made before 1726, shows the painting in its present state. Who altered it and why, are questions no one has been able to answer. The painting itself must have been executed in 1719–20, when Watteau was in England for about a year.

Preliminary drawings of the heads of the three seated children have been preserved.

Antoine Watteau
The Dance
Without pieced-on sections

400

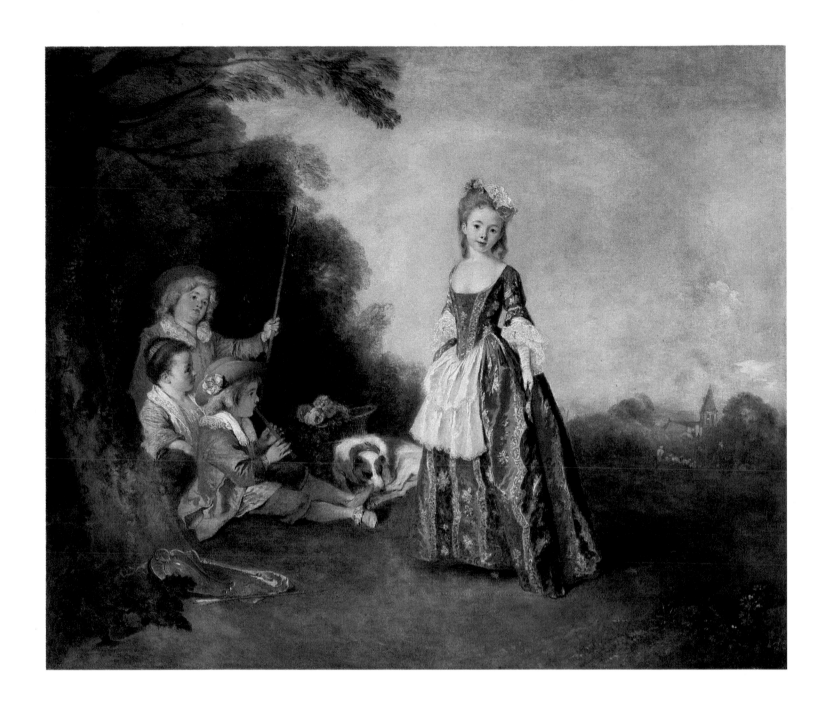

Jean François de Troy (1679–1752)
Bacchus and Ariadne
1717

Canvas, 140 × 165 cm (55⅛ × 65 in)
Signed: 'DE TROY 1717'
Acquired 1961
Property of the
Kaiser-Friedrich-Museums-Verein
Cat. no. KFMV 241

Two episodes from Ovid's *Metamorphoses*, that inexhaustible source of subjects both dramatic and frivolous from the realm of Greek gods and goddesses, inspired two paintings by de Troy for the Regent of France, probably executed in 1717. The first recounted how Bacchus was reared by nymphs after the jealous Juno had driven his foster mother Ino mad, because she had adopted this son of Jupiter and his mistress, Semele (Ovid, *Metamorphoses III*, 310–17).

The second painting (colour plate) pictures the meeting of Bacchus and Ariadne on the island of Naxos (*Metamorphoses VIII*, 174–82). Ariadne, daughter of Minos, King of Crete, had assisted Theseus in his battle with the Minotaur and his escape from the labyrinth. On his return to Athens Theseus abducted the princess, but left her behind on Naxos. Bacchus, passing by with his revellers, discovered the abandoned girl and took her to be his wife. Four sons were born to them: Thaos, Staphylos, Oinopion and Peparethos. After Ariadne's death, Bacchus led her out of the underworld and up to Mount Olympus, where he threw her crown of light into the sky to shine forever in her memory among the stars (as the constellation *Corona Borealis*).

De Troy here represents the dramatic turning point of the story. Still visible in the far left distance is the ship on which fickle Theseus is sailing away. Bacchus has just arrived on the scene, climbed out of his panther-drawn chariot, and is listening with a gesture of commiseration to the desperate Ariadne's tale. Though she still points longingly to the ship, Cupid is already descending with the nuptial torch to enflame her with love for the god, as he is already enflamed by her charms. Yet Ariadne still seems not to notice Bacchus's advances, nor the bacchanalian revels in full swing around them. Maenads, nymphs and satyrs dance to their tambourines as Silenus, Bacchus's old mentor, approaches, fat and drunk on his donkey, supported by a satyr and led by a maenad. There is noise, frenzy, alcoholic and erotic transports on all sides. Yet the artist has depicted them without crass allusion: he has staged a riotous scene with the perfect taste and composure so typical of the Regency and Rococo.

The composition itself helps contain the turbulence, in a solidly constructed, almost classical arrangement. The main group acts as if on a stage bounded by the dark backdrop of trees in the centre and middle ground, while in the right and left foreground auxiliary groups of figures flank the main characters, leaving the centre free and yet remaining oriented towards it. An almost off-hand elegance characterizes both this image and its companion piece, *The Training of Bacchus*, and distinguishes both of them clearly from the great models for such bacchanalian themes in seventeenth-century Flemish painting, particularly the drastic revels of Jacob Jordaens.

Jean François de Troy belonged to a generation of French painters who were initially trained according to the strict observances of the Académie, but who then, under the impression of sixteenth- and seventeenth-century Italian and Flemish painting, translated the *grand goût* into a new idiom elegant in form and warm in palette. De Troy was a versatile talent, devoting himself as much to portraiture as to landscape, genre scenes, and mythological and historical subjects. The two Berlin paintings belong to his early period, having been executed after his return from Italy in 1708, when he was immediately accepted as a history painter into the Académie Royale.

Jean François de Troy
The Training of Bacchus
Berlin, Gemäldegalerie SMPK

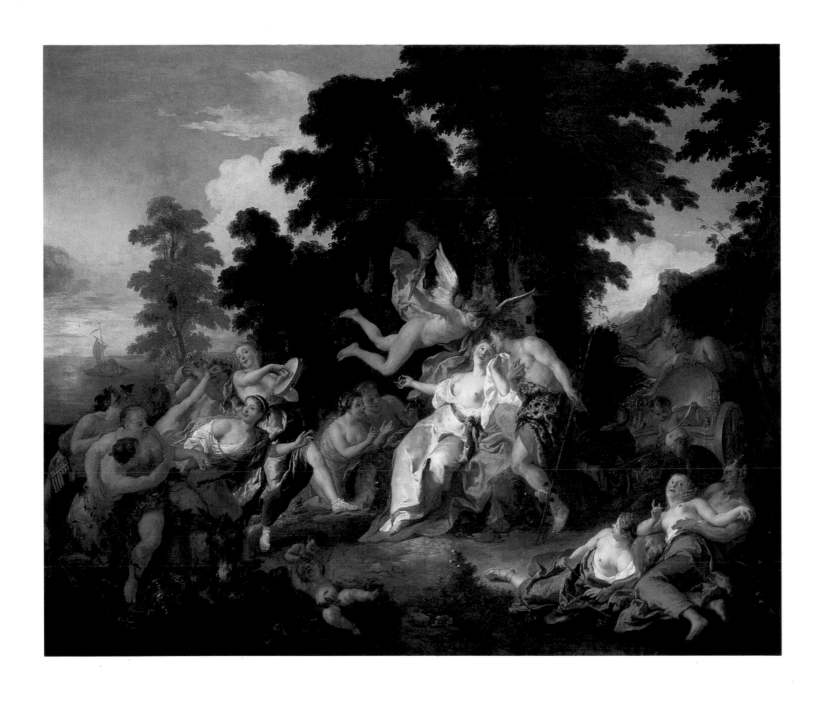

403

Jean Restout (1692–1768)
The Magnanimity of Scipio
1728

Canvas, 132 × 197 cm (52 × 77½ in)
Signed: 'Restout 1728'
Rauceby Hall Collection, Lincs.
Acquired 1983
Cat. no. 3/83

In his history of Rome (*Ab urbe condita*, XXVI, 50) Titus Livius reports an event that took place during the Roman campaign against the Carthaginians in Spain. After the taking of New Carthage (Cartagena), a maiden of extraordinary beauty fell into the hands of the Roman commander, Publius Cornelius Scipio (*Africanus maior*, c.235–183 BC). Asked about her origins, Scipio's prisoner replied that she was the bride-to-be of Allucius, one of the noblest youths among the Celtiberians. Scipio sent for her parents and bridegroom, assured them that the girl's purity had been respected, and said that he was willing to set her free – on one condition, that Allucius become a friend of the Roman state. Declining the fine gifts offered to him by her parents, Scipio gave them instead to the young couple as a wedding present. Allucius, moved by Scipio's kindness and magnanimity, agreed to the deal and joined the Roman ranks.

Restout's painting follows its literary source very closely and represents the climax of the story. The Romans have erected their camp beneath the walls of the captured city. A low flight of steps under a baldachin provides a platform for their commander, who is distinguished by a red cloak even more brilliant than the many vivid colours around him. Allucius kneels down before him, grasping his hand in thanks, as Scipio indicates the young man's bride dressed in white, who approaches with her eyes demurely averted. At the right, her parents entreat the commander to accept their exquisite gifts, which are spread out before him on the ground like an opulent still-life. Auxiliary figures to left and right frame the composition and serve to focus our attention on the central event, as do the stage-like setting, the gestures of all the other figures, and the dramatic *mise en sène* of the whole.

This composition relies entirely on the classical canon of French history painting. As they advance from both sides, the actor's movements and gestures heighten the dramatic tension of the plot, which culminates in the figure of Scipio, its main character, at once reaching its climax and entering its dénouement. The local colours red, blue and white, are distributed in a manner that underlines the clear and logical placement of figures and accessories. Due to the low vantage point, only hints of the background landscape are visible, while the drama of virtue and magnanimity is played out large in the foreground as if just behind the footlights of a stage.

That the image has a moralizing tendency is undeniable. By relinquishing his prisoner, Scipio shows the true greatness of soul and noble selflessness which made him the finest embodiment of a virtuous man. And Restout, accordingly, concentrates less on the historical aspect of the event than on the example of humanitarian behaviour its represents. In this he may have drawn inspiration from several great seventeenth-century predecessors. As early as 1660–1, Charles Lebrun (1619–90) had already chosen a related subject from Roman history as a metaphor of a ruler's magnanimity, in his large painting *The Family of Darius Before Alexander* (Versailles, Musée National). Pierre Mignard (1612–95) and Jean Jouvenet (1644–1717) – the latter Restout's teacher – had developed the theme further, introducing important stylistic changes which allowed Restout, in his version, to take the decisive step from seventeenth-century Baroque pathos to the elegance in form and palette of the early Rococo. Actually, Restout was a religious painter who depicted few historical subjects. One of these was a large *Triumph of Bacchus*, commissioned in 1757 by Frederick the Great for the decoration of the Festival Hall in the Neues Palais, Potsdam.

The Magnanimity of Scipio once formed a companion piece to *Hector Taking Leave of Andromeda*, which was exhibited at the 1727 Salon. The two paintings were kept together in the Calonne Collection, Paris, until their sale in 1788. Though the companion piece is lost, its composition is recorded in a copy in the Halle Museum. By combining the two themes, Restout expanded on his fundamental message of the importance of virtue and selfless heroism. In this he conformed to one of the main purposes of history painting,

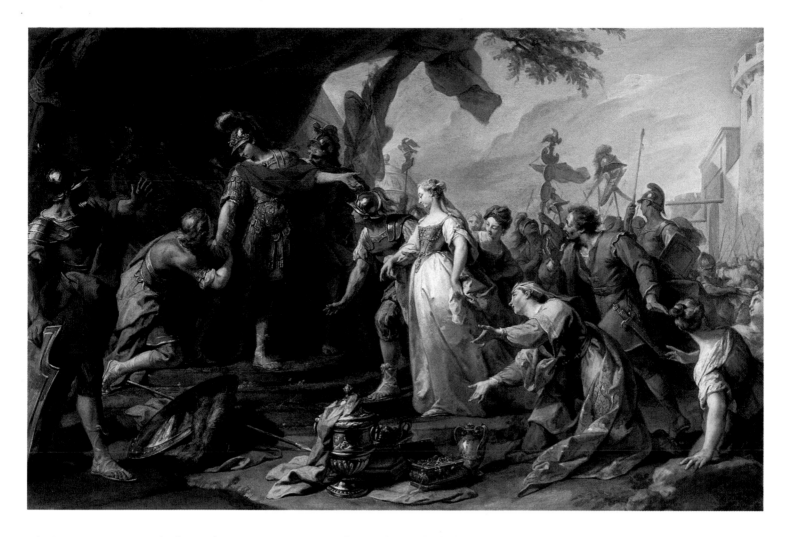

which was to inspire and educate by representing scenes of a timeless and ideal nature. It was to this high moral purpose that history painting owed its first rank among all the academic genres, a position it was able to maintain far into the nineteenth century.

Jean Baptiste Siméon Chardin (1699–1779)
The Young Draughtsman
1737

Canvas, 81 × 67 cm (31⅞ × 26⅜ in)
Signed: 'Chardin 1737'
From the Royal Palaces, Berlin
Acquired 1931
Cat. no. 2076

The subject of this painting is an allegorical one that was fairly common during the seventeenth and eighteenth centuries – a young artist at the beginning of his long and arduous training. This particular student, fine-featured and almost feminine, leans over a drawing table with his arm on a portfolio, sharpening the black crayon in a holder. He wears an apron to protect his fashionable coat, and his dark, three-cornered hat with a dangling ball for decoration serves not only elegance but also keeps his curly brown hair out of his eyes, the long back locks of which he has plaited in a loose braid. He has just finished a drawing on blue paper of the head of an old man or satyr, perhaps a copy after some Old Master, for that is what art students of the day were required to practice before going on to studies from life and, finally, free composition. Chardin is known to have been highly critical of this type of academic training.

The picture itself admittedly reveals little of this deeper, allegorical significance. What probably strikes the contemporary eye most about it is the superb feeling of calm it emanates. The boy's kindly, open gaze remains inward; the way he is poised over the table gives an impression of immobility, which lends the image more the appearance of a figurative still-life than an anecdote or scene. And though the motif might have something emblematic in its simplicity, this effect arises not so much from its symbolic meaning as from the solid structure of its composition and the lucidity of its colour scheme. The composition is built up of an interlocking scaffolding of planes and lines roughly parallel to the picture surface, beginning with the table edge and continuing through the offset diagonals of the portfolio and the boy's torso to run back and forth in a series of tense but balanced rhythms. These movements are finally brought back in upon themselves by the wide hat-brim and the direction of the boy's gaze. The background surrounds the figure like a protective cloak. Colour accents are few but emphatic – a blue in the drawing paper, and especially a small but forceful touch of red in the ribbons on the portfolio.

This high degree of abstraction with which the artist treated the theme was greatly admired during the nineteenth century, when an appreciation for this kind of noble simplicity of form finally developed. Painters ever since have admired the same qualities in Chardin – the painterly qualities which are so much in evidence here: a tranquillity and motionlessness that yet vibrate with the tension of a poised composition developed out of an interplay of pure forms, and a reserved mood resulting from a disciplined and rational employment of artistic means.

Two versions of *The Young Draughtsman* exist, both of them originals. One has been in the Louvre since 1944, and can be traced as far back as a sale in England in the year 1741. The other was acquired in 1931 by the Picture Gallery, after having been in the possession of the Prussian Royal House since its purchase for Frederick the Great in 1747, probably by Count Rothenburg – and after having been on the American art market for a short time following the partition of the royal estate in 1926. Both versions are signed and dated 1737, and hence are both authentic works by Chardin. They differ in details, but not at all in terms of their high quality.

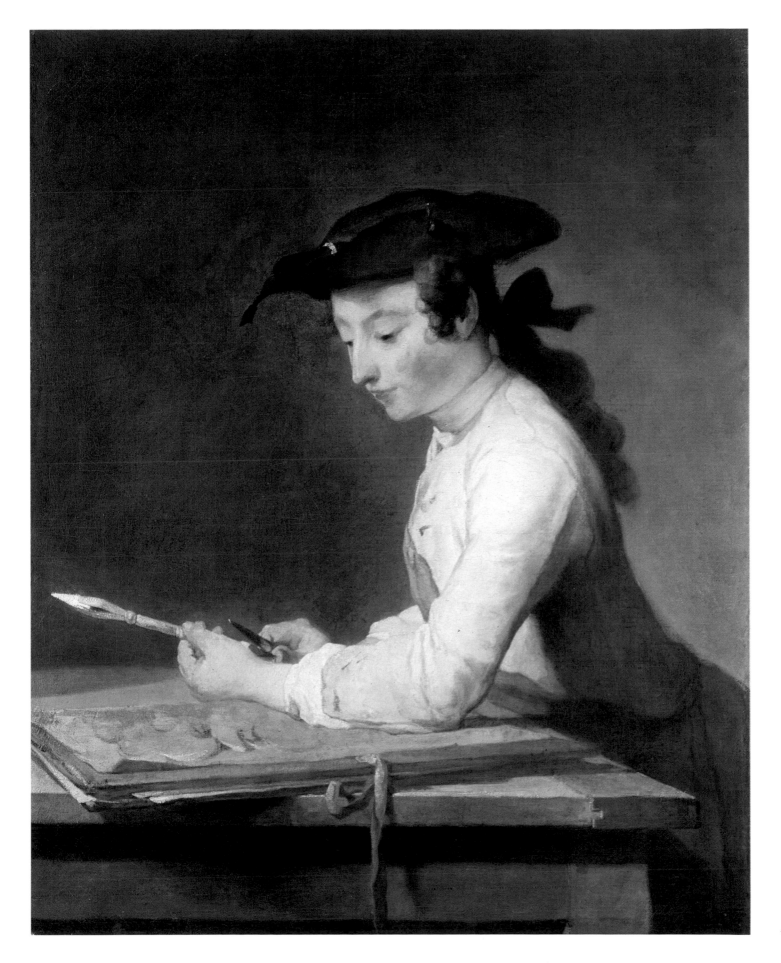

Antoine Pesne (1683–1757)
Frederick the Great as Crown Prince
1739

Canvas, 78 × 63 cm (30¾ × 24¾ in)
Inscribed on the reverse: 'Original De
S.A.R. Monseigneur le/Prince R. Peint a
Reinsberg/par ant. Pesne en l'année
1739/et parvenue au Trone le 31 may
1740'
Acquired 1841
Cat. no. 489

Antoine Pesne
Frederick the Great
Holland, Huis Doorn

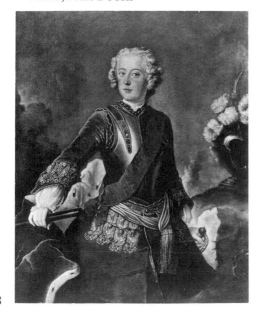

408

Probably no other artist contributed more to our present picture of eighteenth-century Prussia than Antoine Pesne. Born in Paris in 1683, he became artist to the Prussian Court in 1711 and served under three monarchs: Frederick I, Frederick William I, and Frederick the Great. His portraits of the royal house, members of the court and nobility are both objective and effectively staged and, except perhaps for those turned out in series by his large workshop, of high artistic quality.

The true features of Frederick the Great remain shrouded in legend to this day. In monuments and portraits of the eighteenth and nineteenth centuries, he is invariably pictured as the great statesman or the military commander renowned for his victories in three Silesian Wars; or on the other hand, as the lonely old man and sage of Sanssouci. From Chodowiecki to Menzel, from Rauch's monument to Otto Gebühr's films of the 1930s, 'Old Fritz' has been the great king whom fate destined to lead Prussia to its belated place among the great powers of Europe.

Yet none of these images was truly authentic. Even as a young monarch, Frederick refused to sit to anyone for his portrait. The countless medals, commemorative coins, painted and modelled portraits, and the over 642 depictions of him in prints and drawings of the eighteenth century alone, may confirm his legendary fame, but they seldom give more than a stereotyped or idealized image of his features and bearing. Only while still Crown Prince did Frederick deign to have his likeness made – by Court Artist Pesne, and by the architect and artist Knobelsdorff. Of the few portraits antedating his accession to the throne on 31 May 1740, the present one, painted in 1739 at Rheinsberg, the Crown Prince's residence, is not only the last authentic portrait of Frederick but also the most human and characteristic.

'The King of Prussia is small, and quite well-fed without being fat. An intelligent physiognomy, attractive eyes, a round face, good-tempered and vivacious, quite lovely teeth, well-groomed brown hair, a noble appearance ... He interrogates one in a penetrating, witty way, and his questions require, even demand concise replies ... He is polite and goes out of his way to say obliging things,' wrote Duke Charles Philippe de Luynes in 1742. Pesne's portrait of Crown Prince Frederick, painted shortly before, captures many of these characteristics. Frederick appears here as Field Marshal in breastplate and orange riband of the Order of the Black Eagle over his shoulder, and a red velvet mantle embroidered with golden crowns. The large eyes in a regular, somewhat chubby face are directed straight at the observer. Frederick's contemporaries again and again emphasized the brilliance of his eyes in their attempts to describe his unusual personality and the vivacity of his presence.

X-ray photographs of the painting have revealed that Pesne initially intended a partial reprise of his full-figure portrait of the Crown Prince of 1736 (Holland, Huis Doorn). In this very traditional portrait, Frederick stands to attention in commander's uniform with swagger stick, facing the observer frontally. A medal struck for Frederick's accession in 1740 shows exactly the same pose and half-length figure which the Gallery's portrait originally evinced.

In other words, the artist first literally repeated his earlier portrait, shortening it to half-length, but then decided to alter it considerably. After his reworking, all that remained of the original pose was the position of the head. The torso was turned from half-right to full-left, so that the Crown Prince now looks out at us over his left shoulder. With this change from the rather conventionally official and military posture of the earlier painting, Pesne transformed it into an image of a distinguished and self-assured prince on the threshold of sovereign power.

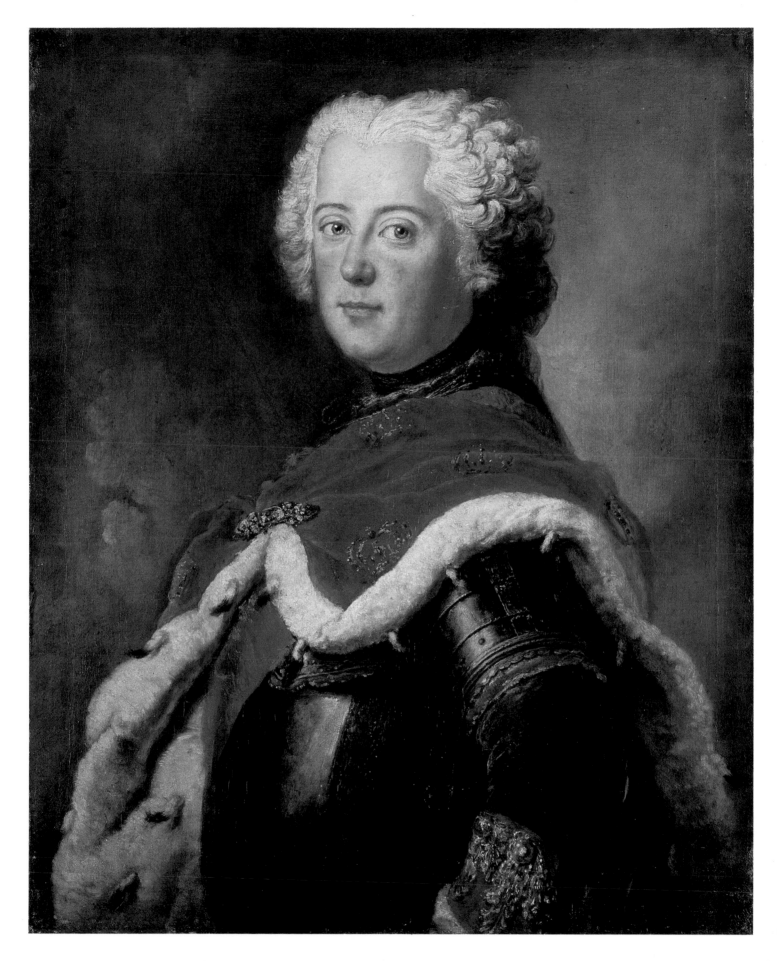

François Boucher (1703–70)
Venus and Cupid
*c.*1742

Canvas, 56 × 72 cm (22 × 28⅜ in)
Signed: 'F. Boucher'
Acquired 1978
Property of the
Kaiser-Friedrich-Museums-Verein
Cat. no. KFMV 272

The scene is set in a twilit clearing among the trees, near a mossy fountain, over the undulating edge of whose shell-shaped bowl water trickles into a brook. Venus reclines on an exquisite shawl of striped Indian silk shot through with gold threads. Her coyly innocent pose and coquettishly dislodged chemise reveal more of her charms than they were ever meant to conceal. Cupid, childishly engrossed, is playing with two white doves which he has tethered on a delicate blue ribbon. His red quiver is propped against Venus's seashell-chariot, which is decorated with white and red roses. Water, shell, and roses, together with the pearls in her blond hair, are the goddess's traditional attributes, evoking her mythical origin in the waves of the sea: Venus born of the foam.

Mythology, however, was for Boucher merely a welcome pretext to celebrate feminine beauty and, embodied in its goddess, the primal power of love. An engraving of the painting by Pierre Duclos (1742–1806) emphasized this more comprehensive significance by quoting a verse by Moraine:

> '*Déesse, qui donnés de si préssants desirs,*
> *Qui remplissés nos cœurs d'ardeurs, d'inquiétude,*
> *De sentimens jalous et de vifs déplaisirs,*
> *Livrés-vous au sommeil dans cette solitude,*
> *Césses de nous causer tant de tourmens divers;*
> *Votre repos sera celui de l'Univers.*'

Only when Venus sleeps is the world at peace; otherwise, everything is in constant restless motion, transient as the action on the stage of a theatre.

Boucher has masterfully translated a sensual theme into sensuous, delicately orchestrated colour. Between the muted browns of the background and the cool greens of the foreground foliage, light, glowing flesh tones, nuances of white, purple and opalescent violet luxuriously expand. It was with just such small-format paintings as this, probably intended for some expensively tasteful boudoir, that Boucher created his finest and most intimate works.

The picture in our collection originally had a companion piece, a *Diana at Rest* – the virginal goddess of the hunt contrasted with the goddess of love. The whereabouts of this painting has remained unknown since the pair was separated in 1783, at the auction of the Blondel d'Azaincourt collection in Paris.

With his scenes of pastoral dalliance, his landscapes and mythological subjects, designs for tapestries and decorations, and engraving sequences, Boucher shaped the taste of an entire epoch. He remained in royal favour for almost thirty years after having been admitted, as a history painter, into the Académie Royale in 1734 and commissioned by Louis XV only a year later to decorate the chambers of Queen Marie Leczinska at Versailles. His great benefactress, however, was Madame Pompadour, whom Louis XV raised to the rank of *Maîtresse en titre* in 1745 and who deluged Boucher with commissions. The artist later estimated his œuvre to comprise about a thousand paintings and ten thousand drawings. It certainly bears witness to a veritably inexhaustible flow of ideas, despite the routine touch of an overworked master which they sometimes reveal.

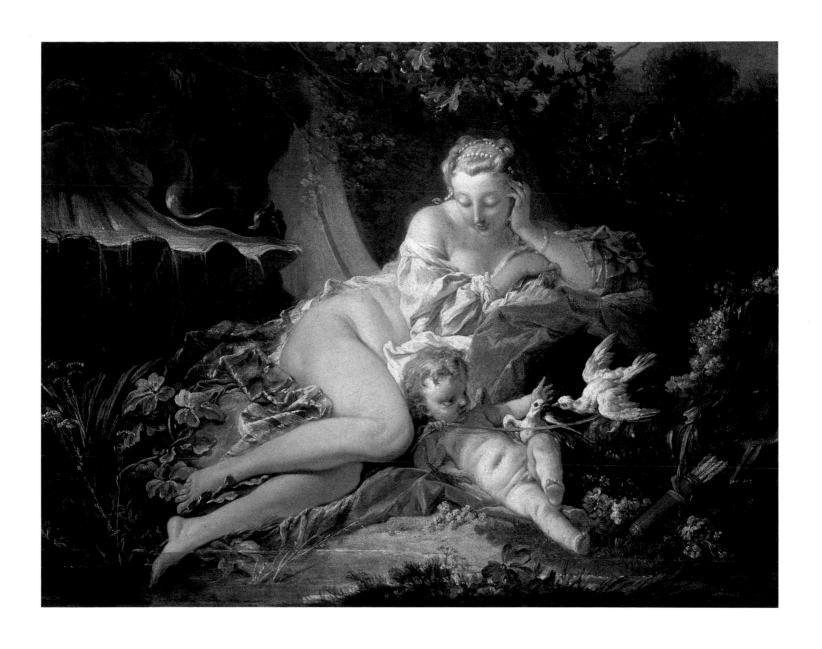

Joseph Vernet (1714–89)
View of Nogent-sur-Seine
1764

Canvas, 75 × 113 cm (29½ × 44½ in)
Signed: 'J. Vernet 1764'
Cailleux Collection, Paris
Acquired 1975
Cat. no. 2/75

Vernet was probably the most influential and highest regarded landscape painter in Europe during the eighteenth century. Connoisseurs and collectors deluged him with orders, which in his later years he was able to fulfil only with the assistance of a great workshop. An enormous life's work comprising almost two thousand paintings attests to his fame. His dramatic or idyllic landscapes and seascapes, cycles on the times of day or seasons, depictions of calm or stormy seas, and of ships returning home or wrecked and abandoned on treacherous rocks, met the sentimental tastes of his age to perfection.

After a long sojourn in Rome (1734–54) during which he established his reputation as a landscape artist, Vernet was honoured on his return to France by a commission to paint twenty-four views of the country's most important harbours – doubtless a significant political commission. Due to the years of travel its execution entailed, the artist was not able to settle finally in Paris until 1763.

That year brought a commission from the wealthy Jean de Boullongne, former Minister of Finance, to paint two views of Nogent-sur-Seine, a small village north of Paris at the point where the Paris–Troyes road crosses the Seine. Since the river was navigable up to the dam there, the village developed into a trading centre for goods of all kinds. Nearby, the local count had built a castle, La Chapelle-Godefroy, where he lived in retirement, devoting himself to the arts. He also established a stocking factory in a former convent there, which Vernet has portrayed in his painting. The companion piece showed the village itself, but only a fragment of it has survived, and is today in an English private collection.

The highroad crosses the Seine near Nogent over two bridges, one of which appears here – the Pont-Saint-Nicolas, built in 1728. To its right, before the machine building, lies the small harbour, and the stocking factory itself is located in the group of buildings in the background. The idyllic yet precisely rendered scene is suffused with the mild, warm light of morning, an illumination for which Vernet was renowned.

As in all of his pictures of this type, however, the landscape rendering goes beyond mere topographical exactness, and the figures serve the important function of making the landscape appear inhabited and busy, integrating nature in the human sphere. And accordingly, all social strata are represented. The gentleman accompanying two elegantly dressed ladies might well be the factory owner out on a tour of inspection. Of the other classes, there is a fisherman pulling in his nets; his wife with a basket of freshly caught fish on her arm; boatmen loading or unloading a barge; and a farmer with his wife riding on a mule. The landscape and its inhabitants merge into a well-ordered microcosm where everyone and everything has its proper place in the social system.

Vernet exhibited both views of Nogent-sur-Seine in the 1765 Salon, which definitely confirmed his triumph. It was this exhibition that inspired Diderot's famous review of Vernet's work, which begins with the dramatic cry, 'Twenty-five paintings, my friend! Twenty-five paintings? But what paintings!' He then goes on to describe them in detail, as though they were actual stretches of countryside, only at the end admitting that they were entirely invented by a great artist. But the highest praise he could give was to compare Vernet to the unchallenged old master of landscape, Claude Lorrain. 'Vernet is just as good as Claude Lorrain in the art of conjuring up mist on canvas; but he far surpasses him in the invention of scenes, the design of figures, the variety of his events, etc. The earlier man is only a great landscape painter; the latter, in my opinion, is truly a history painter. Claude chooses the rare moods in nature, and on that account is perhaps more exciting. The atmosphere in Vernet is more in the common run, and accordingly is more reassuringly familiar.'

Joseph Vernet
Nogent-sur-Seine
England, Private Collection

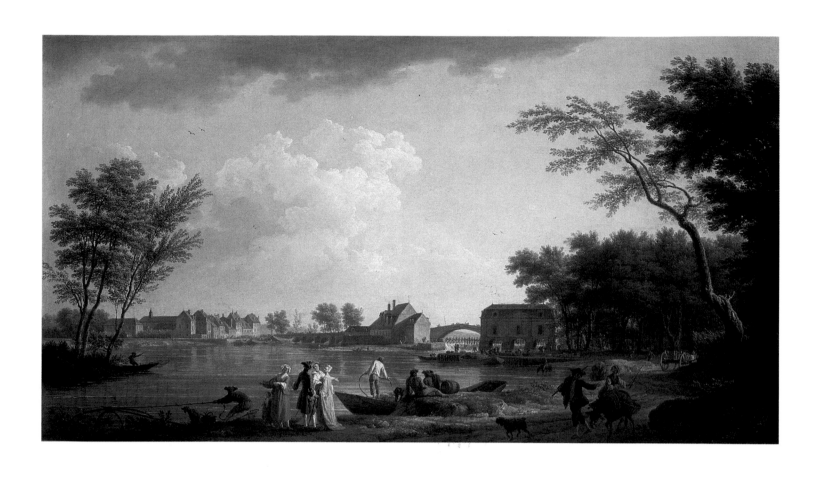

Elisabeth-Louise Vigée-Lebrun (1755–1842)
Prince Henry Lubomirski as the Genius of Fame
1789

Oak, 105 × 83 cm (41⅜ × 32⅝ in)
Collection of Isabella Lubomirska, Paris,
Warsaw, Lancut
Acquired 1974
Cat. no. 4/74

In autumn 1785, Princess Isabella Lubomirska, her opposition to King Stanislav August Poniatowski having become too apparent, left her Polish homeland to begin a six-year journey through Europe. She arrived in Paris in November 1786, where until the outbreak of revolution she resided in the Palais Royal and held a salon that became a favourite gathering place of Parisian society.

Among those accompanying her was the young Prince Henry Lubomirski (1777–1850) from a branch of her family in Kiev. The boy's extraordinary beauty and the childishly soulful cast of his features caused a great stir wherever he appeared. The rich princess, herself a collector and patron of the arts, not surprisingly had a series of portraits made of the boy, in Rome, Paris and London. The most significant of these was painted in Paris, in the early summer of 1789, when on the eve of revolution the princess offered Elisabeth Vigée-Lebrun, court artist to Queen Marie Antoinette, the unheard-of sum of twelve thousand francs to portray young Henry in the latest style, *à la grecque*.

The artist has placed her winged Cupid on a red drapery in the foreground of an expansive but mistily undefined landscape. He turns his head with its soft blond locks gently to the side, letting his large brown eyes stray into the distance. The expression on his regular features is perfectly described by Lavater's phrase, 'innocence and simplicity'. He holds a wreath of myrtle and laurel leaves, and a quiver with arrows lies forgotten before him on the ground. The delicate yet powerful-looking wings shimmer in subtle transitions from white to soft violet and a bluish-pink, echoing the light flesh tones, the strong red of the drapery, and the green wreath against a grey-blue sky. These colour nuances perfectly complement the idealized beauty and precociously knowing expression of the boy's face, to superbly exemplify the sentimental, Neo-Classical approach to portraiture.

The reference to Classical art is present in the attributes, but even more in the figure's pose, which refers directly back to a statue known as *Crouching Venus*, by Doidales. This Hellenistic sculpture of the third century BC was represented in many collections by Roman copies, cameos, and gems; but even more importantly, it was widely and popularly known through a figurine based on it. The *Portrait of Henry Lubomirski* relates quite directly to this sculpture. Despite all its refinement of colour and painterly surface, and despite the model's sentimental expression, the sculptural quality of the ancient Roman statue is its most striking characteristic. The emphasis on the principal view, the almost feminine softness of limb, the crouching pose, and the typical Roman movement of the body within a closed contour line, stylistically corroborate the artist's citation from antiquity. And nudity, in the eyes of a true Neo-Classicist, was inalienably part of the ideal style – even Napoleon had to succumb to Canova's apotheosis of him in a larger-than-life, nude statue of a Roman imperator.

Considering the Princess Lubomirska's admiration for Winckelmann, and also her enthusiasm for Lavater and Rousseau, it is no wonder that this portrait of a child should have had a special meaning. All the allegorical depictions of young Henry executed at the Princess's request during her European tour – as Amor, Bacchus, Amphion, Seraphim, or the Spirit of Fame – reflect not only her affection for him, but also her belief that his childish beauty contained the essence of a higher, ideal nature that only art could make visible.

Crouching Venus
third century BC
Rome, Museo Vaticano

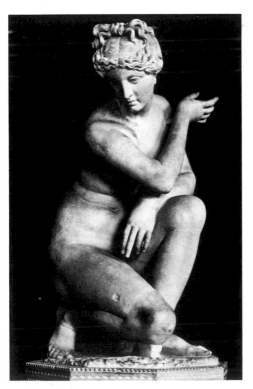

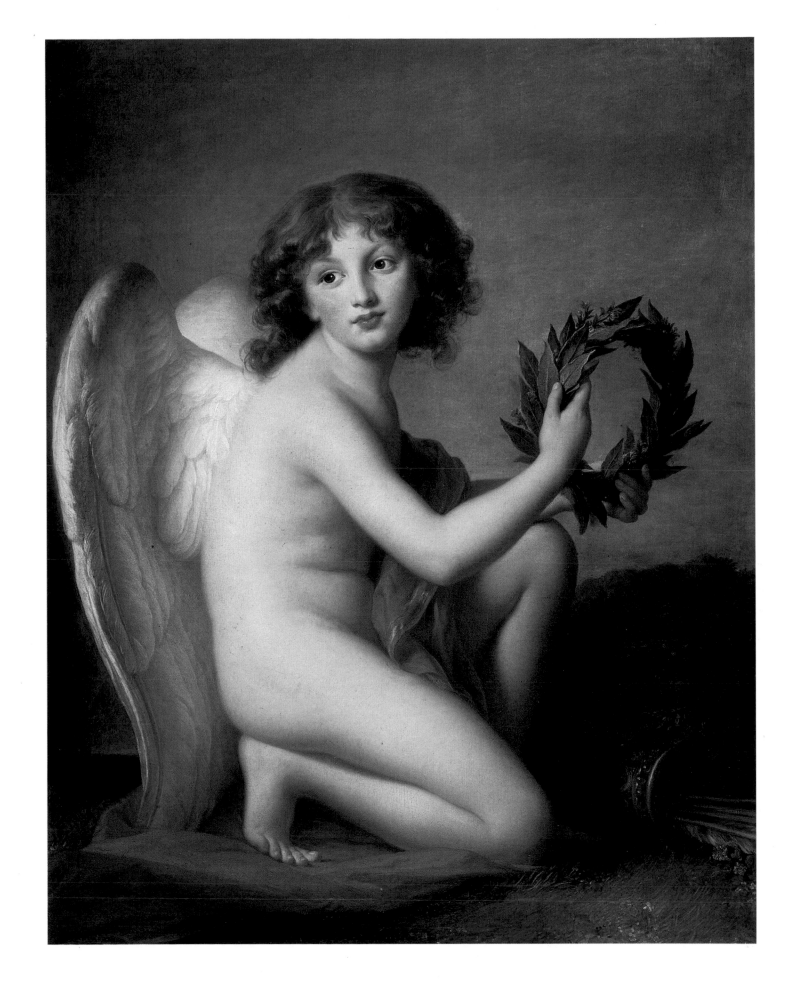

Joshua Reynolds (1723–92)
George Clive and his Family with an Indian Servant Girl
*c.*1765

Canvas, 140 × 171 cm (55¼ × 67⅜ in)
Earl of Ellesmere, Bridgewater House, London
Acquired 1978
Cat. no. 1/78

Vying with the other European powers for political and economic supremacy during the eighteenth century, the British triumphed particularly in India. In 1757, Robert, Lord Clive of Plassey (1725–74) conquered and occupied the Bengal State, then during his service from 1764–7 as High Commander in East India, contributed decisively to British military successes. Among his personal aides was his cousin, George Clive (*c.*1720–79). Son of a clergyman, Clive joined the army and saw service in all the Indian campaigns. He returned to England a prosperous man and in 1763 was elected to Parliament as member for Bishop Castle. That same year he married Miss Sidney Bolton (1740–1814). In 1772, he commissioned the architect Robert Tayler to build him a fine estate, Mount Clare, in Roehampton outside London.

The Clives' eldest daughter was born in 1764, but she died in childhood. From her age in Reynolds's portrait of the family, we may conclude that it was executed about 1765–6.

As in so many of his large portraits, Reynolds relied here on the classical tradition of seventeenth-century Italian and Flemish portraiture, while enlivening it with a touch of the latest 'Indian' mode. For all its apparently relaxed atmosphere, the image is a masterpiece of formal representation, and its composition is arranged and balanced with extreme care. The family stands as if on an open veranda in the foreground, behind Clive lies a stretch of open hilly countryside with the golden glow of sunset still suffusing the horizon. Behind mother and child on the right, by contrast, a purple curtain obscures the view, closing out the world as if to evoke the family's domestic intimacy. The curtain is also a set-piece from centuries of official portraiture, the symbol of royal dignity and honour, used here to signify the social standing of the artist's sitters.

George Clive leans with easy self-assurance on the back of a red upholstered chair. Since the picture was not intended for official purposes, despite its open and veiled allusions, Clive wears the rather elaborate yet everyday clothes of a country gentleman. The group to his right is quite different, being separated from him not only physically. Mrs Clive and her Indian maid concentrate all their attention on the little girl, who, like her mother – and the maid – is superbly attired in the latest fashion.

Of special interest are the details here, which the artist has intentionally rendered with great precision. The exotic costumes worn by daughter and servant are intended to strike the eye, and to allude to the Clive family's close ties with the new British colony. The girl wears a light Indian cotton dress (an *anjarika* or *jama*) with pastel blue trim, of a kind worn by children of rich families at the courts of Indian princes. A scarf of fine silk with gold-embroidered border (*chaddar*) is fastened to her hair with a jewelled brooch, worn much as a contemporary Indian girl might wear a pretty flower. The charm bracelet (*bazuband*), worn Indian-style on her upper arm, has an arrangement of nine stones in the centre (*nauratna*) representing the nine planets, which play an important role in Indian astrology. The servant, judging by her ethnic type and her jewellery, may come from southern India, perhaps from the Madras region. Her hair, gathered in a topknot, and her necklace with three charms (*tali*) indicate that she is married. The medallion on her hairpin bears an ornament that is surely of magical significance, and on her wrist is a bracelet consisting of an ivory ring dyed with madder (*manjistha*) with gold ornaments and several black rings of a type still to be found today.

These numerous details are subtly integrated into the image and contribute to its opulent effect. A dominating, warm combination of brown (on the left), red and white (centre), and delicate grey (right) lends the painting that compelling colour which reveals Reynolds's debt to Flemish art. This consciousness of tradition, combined with an apparently unconstrained ease in conveying social status, lend Reynolds's portrait exactly the air of understated ceremony which his patrons expected of him.

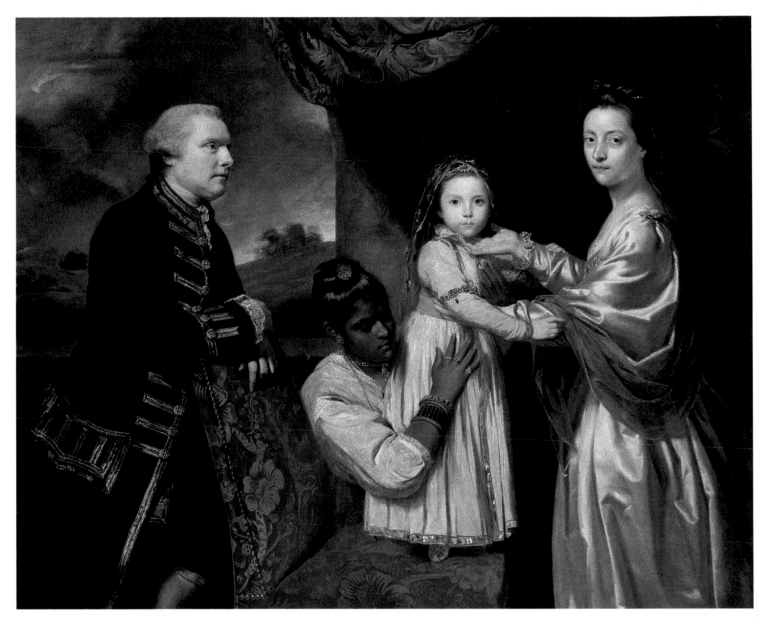

X-rays of the painting show that his workshop contributed much to its execution, as was common practice with Reynolds. Evidently, only the three figures on the right were first blocked out on a smaller canvas. Then, to expand the composition, a piece of heavier canvas was spliced on to the left of the maid's figure, and certain passages were repainted – the landscape for instance, which was extended to Clive's right and behind the maid's head. As regards the figure of Mrs Clive, Reynolds obviously executed only the face, indicating the gown with a few cursory brushstrokes. The final and very careful rendering was probably undertaken by the foreman of Reynolds's workshop, who was responsible for drapery, or possibly by the well-known 'drapery man', Peter Toms. The child and servant, on the other hand, appear to have been painted entirely by Reynolds himself.

Joshua Reynolds
Lady Sunderlin
1786

Canvas, 236 × 145 cm (93 × 57 in)
Baron Ferdinand de Rothschild; Lord
Burton
Acquired 1983
Cat. no. 4/83

The *Portrait of Lady Sunderlin*, among the most significant of the artist's late works, was executed almost contemporaneously with Gainsborough's fine late canvas in the Berlin Gallery, his group portrait of the Marsham children of 1787. Lady Sunderlin (1745–1831) was the eldest daughter of Godolphin Roopers of Great Berkamstead (Hertfordshire). In 1778 she married Richard Malone, a well-to-do London barrister who in 1785 was raised by George III to Baron Sunderlin of Lake Sunderlin. It was on this occasion that Reynolds received the commission for a full-length portrait of the Baron's wife, for which he was paid the sum of £157. 10s in November 1786.

For his life-size portrayal Reynolds chose the classical, Baroque scheme that van Dyck had introduced into England in the seventeenth century and that remained the prototype for official portraits far into the eighteenth century. In his annual lectures on the occasion of the Royal Academy awards, Reynolds, its President since 1768, repeatedly argued the importance of traditional pictorial formulas for the modern painter. Whenever his own work demanded an official portrait in the 'grand style', he did not hesitate to quote artists from Holbein and Michelangelo to van Dyck, frequently even giving his citations of the Classical masters an ironic twist. This is why a knowledge of Reynolds's borrowings and allusions and their translation into his own style is so crucial to an understanding of his portraits. If the composition, pose, and background landscape in the Berlin portrait rely on van Dyck, then the artist's reference to the courtly and official seventeenth century mode was surely meant to underline the social rank of his sitter.

The tall and slender Lady Sunderlin, forty-one years of age at the time, is portrayed in a light gown in front of a dark backdrop of trees. To her right, suffused in evening light, the landscape extends from bushes and hills in the foreground to a far horizon. Thanks to its warm hues and a free, vivid rendering, this landscape contributes much more to the superb effect of the portrait than is generally the case with such backdrops. Another touch of vivacity is the way Lady Sunderlin was apparently about to gather the folds of her long, white, sweeping silk gown when the artist caught the motion of her hand. While features such as these still go back to seventeenth-century tradition, contemporary details like the exquisite chiffon veil shot through with gold, the rich gold embroidery on the gathered sleeves, the nonchalantly looped golden girdle, and the blue turban *à bandeau* on the high-piled coiffure, reveal the influence of the latest Turkish mode. As early as 1777, the *Magazin à la Mode* had remarked about this oriental craze that 'with little or no operation, an English lady, taken from one of our polite assemblies and conducted to Constantinople, would be properly dressed to appear before the Grand Signior.'

The artist's combination of current fashion with a traditional portrait type, and of a subtle idealization of the model with a paint handling very modern in its fluency, make the image a particularly striking and lovely example of Reynolds's portrait art during the final years of his life.

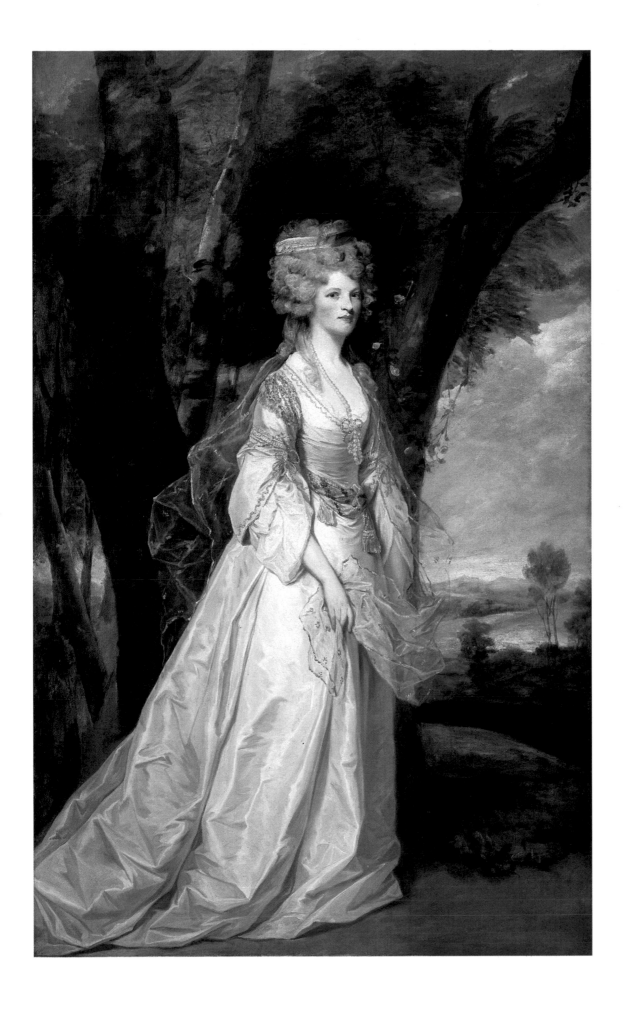

Thomas Gainsborough (1727–88)
The Marsham Children
1787

Canvas, 243 × 182 cm (95⅝ × 71⅝ in)
Collection of Baron Elie de Rothschild,
Paris
Acquired 1982
Cat. no. 4/82

In July 1787 the First Earl of Romney, Charles Marsham (1744–1811), commissioned the sixty-year-old Thomas Gainsborough to portray his four children, Charles (1777–1845), Frances (1778–1868), Harriot (1780–1825), and Amelia Charlotte (1782–1863). The Marsham family originated from Norfolk, had resided in Kent since the seventeenth century, and had been raised to the peerage in 1716. During the latter half of the eighteenth century, various members of the family had their likenesses painted by the best artists in London, among them Romney, Hoppner, Gardener, Zoffany, Reynolds, and of course Gainsborough.

The format of the painting is large and imposing. Yet between the life-size figures space has been left for an idyllic, late-summer landscape that contributes astonishingly to the effect of the image – the mild illumination and delicately tinted atmosphere create an outdoor mood verging on the romantic, a setting perfectly suited to complement the children's natural charm. Their everyday clothes reveal the artist's – or perhaps his patron's – intention to depict them not as miniature adults and future pillars of society, but simply as children at play. English painting of the eighteenth century is rich in such portraits of children who are as yet wonderfully free of the social airs of their elders.

The composition nonetheless subtly suggests the children's differences in age and status. The ten-year-old Charles, only son and heir of his father's title, is clearly distinguished from his sisters. He stands alone on the right, handing some hazelnuts to Frances, the next eldest at nine, who holds her skirt up to receive them. She in turn embraces the seven-year-old Harriot, while the youngest girl, red-headed Amelia Charlotte sits alone on the left with her arm around the family's favourite dog, Fidèle. She is the only one of the children to gaze out earnestly at the observer, while the others seem reserved and grouped statically.

As in many of Gainsborough's compositions, which were usually painted in dim studio light and sometimes even by candlelight in order better to gauge the overall effect, this one is entirely determined by alternating passages of light and dark. Numerous *pentimenti*, however, indicate that the artist altered certain details of the conception during the painting process. His short, nervous brushstrokes pull figures, landscape, and foliage together into a strangely vibrating, dense web of colour that recalls the early Rococo – Gainsborough had a high regard for Watteau – more than it anticipates the romantic style of Lawrence, not to mention Constable's realism. Reynolds greatly admired the evocative force of this open and in many passages even sketchy paint handling which during his final years Gainsborough developed into a unique stylistic technique, though it was certainly a far cry from Reynolds's own, very conscientious approach.

The development of English painting soon left Gainsborough's mature style behind. In the same year that he portrayed the Marsham children Thomas Lawrence arrived in London, and from then on, this young artist's romantic portraits set the standard. The extent to which taste changed may be seen from Lawrence's 1807 portrait of *The Angerstein Children* (colour plate p. 423). Though its composition is similar, it is nevertheless much more traditional than Gainsborough's, even employing the age-old symbol of sovereign dignity, the dark red curtain. And the warm, lucent palette brings a moodiness and sentimentality into the image that Gainsborough's cool and disciplined portraiture would never have countenanced.

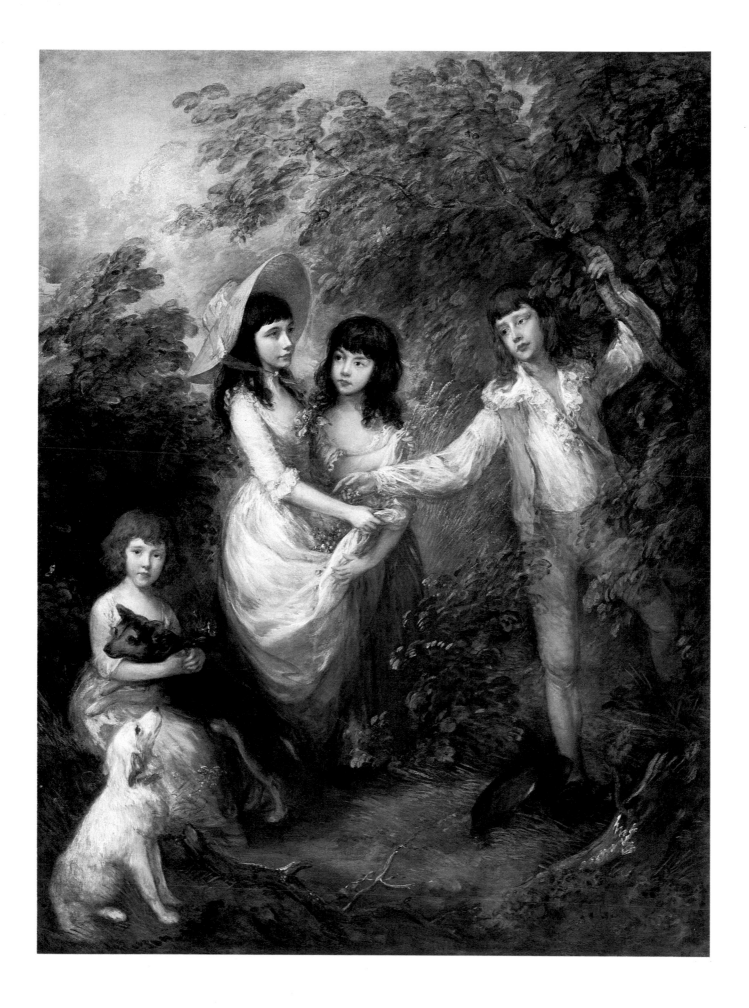

Thomas Lawrence (1769–1830)
The Angerstein Children
1807

Canvas, 184 × 149 cm (72½ × 58⅝ in)
Acquired 1979
Cat. no. 2/79

Thomas Lawrence
The Angerstein Children
Paris, Musée du Louvre

In 1787 an eighteen-year-old pastel artist by the name of Thomas Lawrence arrived in London. Three years later this unknown young man was working on a life-size portrait of Queen Charlotte (London, National Gallery). His rapid success was enough to convince London that he, not the older Hoppner or Raeburn, was the true successor to the great Sir Joshua Reynolds. Lawrence was inundated with portrait commissions, but even more importantly, was accepted as a friend by many of the city's first families – the Lockes, the Boucheretts and the Angersteins. The rich banker John Julius Angerstein (1735–1823) in particular, co-founder of Lloyd's and advisor to Prime Minister Pitt, became Lawrence's paternal friend, advised him in his often terribly confused financial affairs, and supported him in his work. A welcome guest at Angerstein's Pall Mall residence and his country house, Woodlands, near Greenwich, the artist in turn advised the banker concerning his collection of Old Masters, and after his death in 1825, helped arrange its purchase by the English government to form the core of the National Gallery collections.

The Berlin portrait is one of the many Lawrence painted for the Angerstein family over the course of almost thirty years. It was begun on 17 August 1807, at Woodlands; but just two days later the artist was complaining in a letter that he was forced to do this most difficult of all subjects all at once. Everybody, the children included, ran back and forth, and nothing he could say would prevent them. Whether for this or other reasons, the painting was never finished, as so often with Lawrence; nevertheless, it was exhibited the following year at the Royal Academy.

The old John Julius Angerstein's four grandchildren, two boys and two girls, are shown at play in a garden based on the park at Woodlands. Grasping a broom on the right is the eldest, John Julius (1801–66), who is set off from the others by his pose and dark attire. In the centre the youngest Angerstein, Henry Frederick (1805–21), awkwardly attempts to dig with a spade much too big for him, and is prevented from falling by his sister, Carolina Amelia (1802[?]–79), as Elizabeth Julia (1803[?]–?) looks on. This carefully arranged and integrated composition of figures is still very much in the classical tradition of the eighteenth century.

The charm of the young faces, the children's chubby-cheeked engrossment in their play, and particularly the warm, luminous colours set among greyed whites, brilliant reds, and dark background hues, show Lawrence to be a true Romantic. It was above all in his renderings of children and mother and child groups that the notorious bachelor created the finest Romantic portraits in English art. Their moods range from natural insouciance to elegiac sentimentality; their apparent spontaneity and lightness of touch never reveal the slow and painstaking work that went into their composition and execution. The present work also shows signs of the afterthoughts so characteristic of Lawrence: a small bucket once lay in the left foreground, but was painted over as work progressed; and the red curtain at the top, a traditional symbol of nobility meant to suggest the portrait's official nature, was likewise a later addition. Moreover, whether at the request of his dissatisfied client or on his own account no one can say, Lawrence repeated the group in a completely new composition (Paris, Louvre). Here, a massive column, another traditional aristocratic attribute, heightens the more official, formal arrangement of the group, which lacks the relaxed charm of the somewhat earlier Berlin canvas.

BIBLIOGRAPHY

A detailed history of the Berlin Museums has never before been written, although the subject would be interesting and important, including a look at the fourteen departments of the State Museums SMPK. However, in 1971 Rüdiger Klessmann produced an excellent outline of the history of the collection for the Gemäldegalerie. The following bibliography, therefore, lists only the more important works and the older relevant literature.

<p style="text-align:center">*</p>

Waagen, G.F. *Verzeichnis der Gemälde-Sammlung des Königlichen Museums zu Berlin*, 1st edn, Berlin 1830; 14th edn, Berlin 1860.

Kugler, F. *Beschreibung der Gemälde-Galerie des Königlichen Museums zu Berlin*, Berlin 1838.

Meyer, J. and Bode, W. *Königliche Museen, Gemäldegalerie. Beschreibendes Verzeichnis . . . der Gemälde*, 1st edn, Berlin 1878; 9th edn, Berlin State Museum, Berlin 1931.

Staatliche Museen zu Berlin. *Die Gemäldegalerie*, 5 vols with illustrations, ed. by Irene Kunze, Berlin 1929–32.

Gemäldegalerie Berlin, Staatliche Museen Preussischer Kulturbesitz. *Verzeichnis der ausgestellten Werke des 13.–18. Jahrhunderts im Museum Dahlem*, 1st edn, Berlin 1956; 10th edn, Berlin 1966; English edn, Berlin 1968.

Redslob, E. *Gemäldegalerie Berlin-Dahlem, ehemals Kaiser-Friedrich-Museum*, Baden-Baden 1964.

Klessman, R. *Gemäldegalerie Berlin*, Essen 1971, English edn, London 1971.

Kaiser-Friedrich-Museums-Verein, Berlin. *Erwerbungen 1897–1972*, Berlin 1972.

Gemäldegalerie Berlin, Staatliche Museen Preussischer Kulturbesitz. *Katalog der ausgestellten Gemälde des 13.–18. Jahrhunderts*, Berlin 1975.

Gemäldegalerie Berlin, Staatliche Museen Preussischer Kulturbesitz. *Catalogue of Paintings 13th–18th Century*, translated by Linda B. Parshall, 2nd edn, Berlin 1978.

Gemäldegalerie, Berlin, Staatliche Museen Preussischer Kulturbesitz, from the series *Museum*, Braunschweig 1979.

Belser Kunstbibliothek *Die Meisterwerke aus der Gemäldegalerie Berlin, Staatliche Museen Preussischer Kulturbesitz*, Stuttgart and Zürich 1980.

Bock, H. and Köhler, W. H. *Gemäldegalerie; Staatlich Museen Preussischer Kulturbesitz, Berlin*, Touring Club Italiano, Milano 1982.

Gemäldegalerie, Berlin, Staatliche Museen Preussischer Kulturbesitz. *Gesamtverzeichnis der Gemälde*, Berlin/London 1986.

<p style="text-align:center">*</p>

Illustrated booklets for the Staatliche Museen Preussischer Kulturbesitz:

Warnke, M. *Flämische Malerei des 17. Jahrhunderts*, Book 1, Berlin 1967.

Arndt, K. *Altniederländische Malerei*, Book 5, Berlin 1968.

Klessmann, R. *Holländische Malerei des 17. Jahrhunderts*, Books 11 & 12, Berlin 1969; 2nd revised edn 1983.

<p style="text-align:center">*</p>

Bernhard, M. and Martin, K. *Verlorene Werke der Malerei. In Deutschland in der Zeit von 1939 bis 1945 zerstörte und verschollene Gemälde aus Museen und Galerien*, Munich 1965.

Bock, H., Gutbrod, R. and Riede, B. 'Die neue Gemäldegalerie. Einblicke – Einsichten – Aussichten', from the *Arbeit der Staatlichen Museen Preussischer Kulturbesitz*, special volume, 1983, pp. 133–51.

Bode, W. von 'Das Kaiser-Friedrich-Museum. Zur Eröffnung am 18.10.1904', *Museumskunde*, 1, 1905, pp. 1–16.

Bode, W. von 'Bruno Pauls Pläne zum Asiatischen Museum in Dahlem', *Jahrbuch der Preussischen Kunstsammlung*, 36, 1915, pp. 1–5.

Bode, W. von *Mein Leben*, 2 vols, Berlin 1930.

Börsch-Supan, H. 'Die Gemälde aus dem Vermächtnis der Amalie von Solms und aus der Oranischen Erbschaft in den brandenburgisch-preussischen Schlössern', *Zeitschrift für Kunstgeschichte*, 30, 1967, p. 143 ff.

Clemen, P. et al. 'Das Kaiser-Friedrich-Museum', *Zeitschrift für bildende Kunst NF.*, 16, 1905, p. 20 ff.

Eckhart, G. *Die Gemälde in der Bildergalerie von Sanssouci*, Potsdam 1980.

Geismeier, I. 'Gustav Friedrich Waagen – 45 Jahre Museumsarbeit', *Forschungen und Berichte/Staatliche Museen zu Berlin/DDR*, 20/21, 1980, pp. 130–7.

Geismeier, I. 'Fünfundsiebzig Jahre Bodemuseum 1904–1979', *Forschungen und Berichte/Staatliche Museen zu Berlin/DDR*, 23, 1983, pp. 130–7.

Girardet, C.-M. 'James Simon', *Jahrbuch Preussischer Kulturbesitz*, 19, 1982, pp. 77–98.

Hildebrand, J. and Theuerkauff, C. 'Die Brandenburgisch-Preussische Kunstkammer. Eine Auswahl aus den alten Beständen', exh. cat. *Staatliche Museen Preussischer Kulturbesitz*, Berlin 1981.

Kadatz, H.-J. and Murza, G. *Georg Wenzeslaus von Knobelsdorff, Baumeister Friedrichs II*, Leipzig 1983.

Kühn, M. 'Der Gemäldebesitz der brandenburgisch-preussischen Schlösser', *Gedenkschrift Ernst Gall*, Munich 1965, pp. 403–43.

Kühnel-Kunze, I. 'Bergung – Evakuierung – Rückführung, Die Berliner Museen in den Jahren 1939–59', *Jahrbuch Preussischer Kulturbesitz*, 1984, special volume 2.

Lowenthal-Hensel, C. 'Die Erwerbung der Sammlung Solly durch den preussischen Staat. Neue Forschungen zur Brandenburg-Preussischen Geschichte', 1, Cologne and Vienna, published from the archives of the *Preussischer Kulturbesitz*, 14, 1, pp. 109–59.

Lübbe, H. 'Wilhelm von Humboldt und die Berliner Museumsgründung 1830', *Jahrbuch Preussischer Kulturbesitz*, 17, 1980, pp. 87–110.

Lüdicke, R. *Die Preussischen Kulturminister und ihre Beamten im ersten Jahrhundert des Ministeriums 1817–1917*, Stuttgart and Berlin 1918.

Mielke, F. *Potsdamer Baukunst. Das klassische Potsdam*, Frankfurt, Berlin and Vienna 1981.

Plagemann, V. *Das deutsche Kunstmuseum 1790–1870*, Munich 1967.

Platz-Horster, G. 'Zur Geschichte der Berliner Gipssammlung', exh. cat. *Berlin und die Antike*, II, Berlin 1979, p. 273 ff.

Poensgen, G. 'Schinkel, Friedrich Wilhelm IV. und Ludwig Persius, in: Schinkel in der Mark', *Brandenburgische Jahrbücher*, 7, 1937, pp. 51–62.

Reuther, H. *Die Museumsinsel in Berlin*, Frankfurt, Berlin and Vienna 1977.

Staatliche Museen zu Berlin, (East), in cooperation with the Staatliche Schlösser und Gärten Potsdam-Sanssouci and with support from the Institut für Denkmalpflege der DDR, exh. cat. *Karl Friedrich Schinkel 1781–1841*, Berlin 1980–1.

Verwaltung der Staatlichen Schlösser und Gärten/Nationalgalerie, Staatliche Museen Preussischer Kulturbesitz, exh. cat. *Karl Friedrich Schinkel: Architektur, Malerei, Kunstgewerbe*, Berlin 1981.

Schöne, R. *Die Gründung und Organisation der Königlichen Museen in Berlin. Festschrift zur Feier ihres fünfzigjährigen Bestehens am 3. August 1880*, Berlin 1880, pp. 31–58.

Seidel, P. 'Zur Vorgeschichte der Berliner Museen', *Jahrbuch der Preussischen Kunstsammlungen*, 49, 1928, supplement pp. 55–174.

Spiero, S. 'Schinkels Altes Museum in Berlin. Seine Baugeschichte von den Anfängen bis zur Eröffnung', *Jahrbuch der Preussischen Kunstsammlungen*, 55, 1934, supplement pp. 41–86.

Stock, F. 'Urkunden zur Vorgeschichte des Berliner Museums', *Jahrbuch der Preussischen Kunstsammlungen*, 51, 1930, pp. 205–22.

Stock, F. 'Urkunden zur Einrichtung des Berliner Museums', *Jahrbuch der Preussischen Kunstsammlungen*, 58, 1937, supplement pp. 1–88.

Berliner Museen ed. Horst-Johs, catalogue and discussion, *Tümmers. Verzeichnis der Kataloge kunst- und kulturgeschichtlicher Museen in der Bundesrepublik Deutschland und Berlin (West)*, 1, Berlin 1975.

Waetzoldt, S. *Museumspolitik – Richard Schöne und Wilhelm von Bode. Kunstverwaltung, Bau- und Denkmal-Politik im Kaiserreich*, ed. E. Mai and S. Waetzoldt, Berlin 1981, pp. 481–90.

Waetzoldt, W. 'Die Staatlichen Museen zu Berlin 1830–1930', *Jahrbuch der Preussischen Kunstsammlungen*, 51, 1930, pp. 189–204.

Wescher, P. *Kunstraub unter Napoleon*, Berlin 1976.

INDEX OF COLOUR PLATES